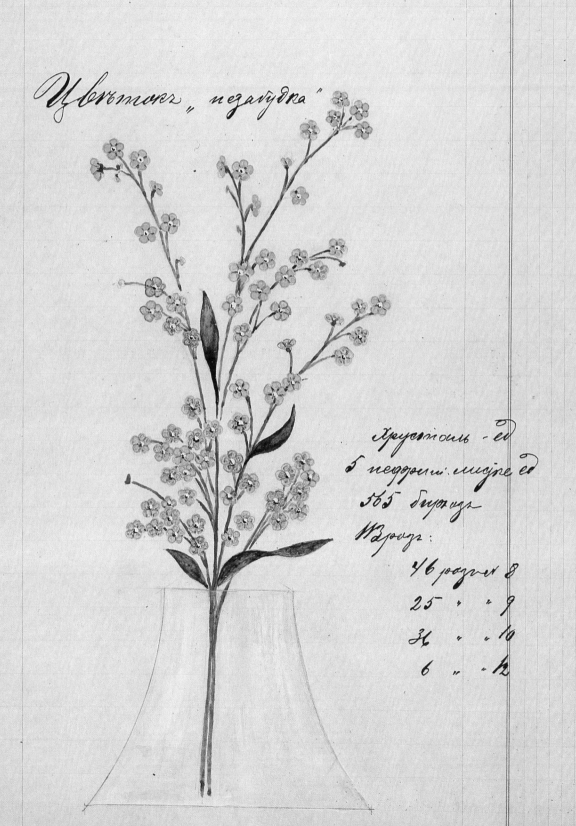

Цвѣтокъ „незабудка"

FABERGÉ

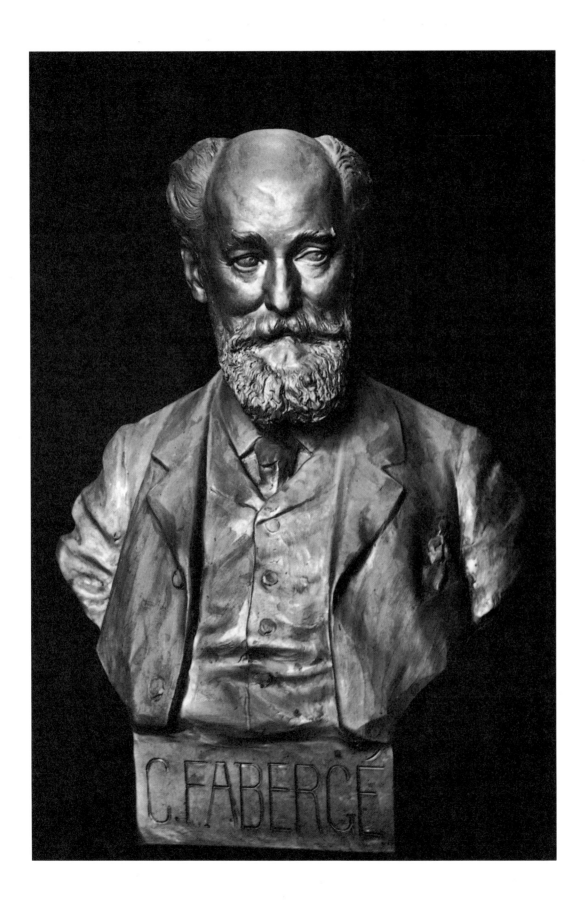

Géza von Habsburg

FABERGÉ

with essays by
Christopher Forbes, A. Kenneth Snowman,
Alexander von Solodkoff and
Dr. Alexander Herzog von Württemberg

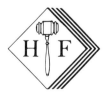

Habsburg, Feldman Editions, Geneva

Revised edition of a catalog of the exhibition
organized by The Bavarian National Museum
and The Hypo Kulturstiftung,
at the Kunsthalle of the Hypo Kulturstiftung, Munich
from December 5, 1986 to March 8, 1987

The texts by Dr. Géza von Habsburg, Dr. Alexander Herzog von Württemberg
and Alexander von Solodkoff have been translated into English
by Christopher Baker and Judith Harrison

Published in the United States and Canada
by The Vendome Press, 515 Madison Avenue, New York City

Library of Congress Cataloging-in-Publication Data

Habsburg-Lothringen, Géza von
Fabergé, Hofjuwelier der Zaren, English
Fabergé/Géza von Habsburg: with essays by
Christopher Forbes...
(et al)
Translation of Fabergé, Hofjuwelier der Zaren
Bibliography : p.
Includes index
ISBN O-86565-108-6 (U.S.): $ 85.00 (U.S.)
1. Fabergé, Peter Carl, 1846-1920-Exhibitions
2. Faberzhe (Firm) - Exhibitions. I. Forbes, Christopher
II. Bayerisches Nationalmuseum. III. Hypo-Kultur-stiftung
(Munich, Germany). Kunsthalle. IV. Title.
NK 7398. F 32 A4 1988.

Originally published in German
© 1986 by Kunsthalle der Hypo-Kulturstiftung München
and Hirmer Verlag München

© 1987 by Habsburg, Feldman Editions, Geneva
Printed and bound by Passavia, Passau
Lithographs by Eurocrom 4, Villorba (in color) and
Brend' amour, Simhart & Co., Munich (in black and white)
ISBN 0-89192-391-2
Printed in The Federal Republic of Germany

Dedicated to my wife Monica

Lenders

PRIVATE LENDERS

H.M. King Bhumipol Adulyadej of Thailand · H.M. Queen Elizabeth II of Great Britain
H.M. Queen Margrethe II of Denmark · H.M. King Carl XVI Gustaf of Sweden
H.M. Queen Beatrix of the Netherlands · H.M. Queen Elizabeth, The Queen Mother
H.R.H. Grand Duchess Josephine Charlotte of Luxemburg

Marie-Alexandra Barton-Miller · Harry Beyer · H.S.H. Princess Ann-Mari of Bismarck
H.R.H. Princess Benedikte of Denmark · Malcolm Forbes · H.R.H. The Prince of Hanover
H.R.H. The Princess of Hesse and the Rhine · H.S.H. Princess Beatrice of Hohenlohe-Langenburg
H.S.H. The Prince of Hohenlohe-Langenburg · Samuel Josefowitz · J.B. Langard
Royal Danish Life Guards · The Marquess of Milford-Haven · Adelaide Morley
Lord Ivar Mountbatten · Stavros S. Niarchos · H.R.H. Duchess Marie Cecile of Oldenburg
H.I. and R.H. Dr. Louis Ferdinand Prince of Prussia · Count Simeon Rylski
Princess Nicholas of Rumania · Maurice Y. Sandoz Collection
H.S.H. Prince Philip-Ernest of Schaumburg-Lippe · H.R.H. Princess Birgitta of Sweden
Me. Pierre Sciclounoff · Mme. Josiane Woolf

MUSEUM AND INSTITUTIONS

Baltimore, The Walters Art Gallery · Brooklyn, The Brooklyn Museum
Copenhagen, The Rosenborg Palace Collection · Darmstadt, The State Museum of Hesse
Doorn, Stichting Huis Doorn · Dresden, The State Art Collection, Albertinum
Freising, The Museum of the Diocese of Freising · Geneva, Musée Cartier
Geneva, Collection Baur · Geneva, Fabergé Archives · Geneva, Fondation Igor Fabergé
Hamburg, Museum of Applied Arts · Idar-Oberstein, Museum of Local History and Culture
Leningrad, The State Hermitage · London, The Victoria & Albert Museum
Lugano, The Thyssen-Bornemisza Collection · Luton Hoo, The Wernher Collection
Moscow, The State Historic Museum · Moscow, The Kremlin Museum
Munich, Bayerisches Nationalmuseum · New York, The Metropolitan Museum of Art
New Orleans, Museum of Art, Matilda Geddings Gray Foundation
Paris, Musée des Arts Décoratifs · St. Gallen, The Historical Museum
Stockholm, The National Museum, Department of Applied Arts
Washington, The Hillwood Museum · Vienna, Art History Museum

Galerie Almas, Munich · A la Vieille Russie, New York
Antique Procelain Company, New York · Ermitage Ltd., London · Eskenazi Ltd., London
H. Beyer, Munich · Heide Hübner, Würzburg · Leo Kaplan, New York
Oy A. Tillander AB, Helsinki · Wartski, London

Contents

Foreword

Research into 19th century art has led to increasing interest in the historicist era, which is now finding the recognition it has always deserved as a result. Works of art from this period now fetch top prices on the international art market and are being acquired increasingly by museums worldwide. Therefore, an exhibition on Carl Peter Fabergé in Munich is an event of great topical interest. Co-organizer of the exhibition is the Bayerisches Nationalmuseum, which was built during the period in question, namely between 1894 and 1900, and which has concentrated its acquision policy on the purchase of art nouveau and historicist objects in recent years. Although the museum was only able to contribute a few Fabergé pieces to the exhibition, the preparations for this large project were carried out within its walls with the assistance of museum employees.

At the turn of the century which was to see the downfall of most European monarchies, Fabergé's oeuvre brought the magnificent world of the ancien régime, with its precious objects and gold and silver jewelry, back to renewed life. Compared to the situation in England and the USA, his work has not yet been discovered in Germany on a broad scale, where it is known, at best, by a handful of specialists, collectors and other persons having access to the palaces where objects made by this great jeweler and his celebrated workmasters are kept. At the turn of the century however, the name of Fabergé was not unknown to those citizens of Munich interested in art. In 1899, a collection of his objects belonging to Grand Duchess Victoria Melita of Hesse, granddaughter of Czar Alexander II and sister-in-law of the last Czarina, was exhibited at the Munich *Secession,* where it was highly praised by the press. Several of these objects can now be seen in Munich again.

A number of Fabergé's objects can be attributed to art nouveau, and others belong to the period of historicism. However, the questions raises itself as to whether they are independent artistic products of their time, known for a style of art which was inspired by objects from earlier periods, which were then modified; or whether they are simply imitations, if not copies, of corresponding pieces from the 17th and 18th centuries. Perhaps this exhibition will contribute towards the clarification of this point and other open questions.

It can be regarded as a stroke of luck that it was possible to engage the services of my cousin, Archduke Géza von Habsburg, a Fabergé specialist of international renown, for this exhibition. Without his experience, his degree of involvement and his knowledge of numerous private and public collections in Europe and America, where Fabergé objects are kept, the exhibition would not have taken place. He alone is responsible for the basic concept and it was he who wrote the descriptions for the catalog. Therefore it is to him in the first place that we must express our thanks. We are also greatly indebted to the many friends, relations and collectors who took up the idea of the exhibition with enthusiasm and encouraged us to go through with it.

The exhibition would have lost much of its splendour without the active collaboration of our colleagues at the Kremlin Museum and Historic Museum in Moscow and at the State Hermitage in Leningrad, who enabled us the loan of many objects in a most generous manner. Our deepest thanks however must go to the Hypo-Kulturstiftung, and all those employed there who were involved in the project. We are greatly indebted to this foundation for having taken up the exhibition into their excellent program, despite the high costs and risks involved. It is our hope that through Carl Fabergé, jeweler to the czars, this relatively new institution will meet with the international acclaim it deserves.

JOHANN GEORG PRINZ VON HOHENZOLLERN

Preface

Carl Peter Fabergé, jeweler to the czars, has proved time and time again to be an absolute favorite with the public wherever his work is exhibited. The splendour and perfection of his exquisite *objets d'art*, created for the sumptuous courts of Russia and Europe, stir the imagination and arouse feelings of nostalgia. All the Fabergé exhibitions held in recent years in London (1977)[1], Helsinki (1980)[2], New York (1983)[3] and London (1985)[4] were a success; the 1977 exhibition, which was held at the Victoria and Albert Museum and introduced Fabergé's work for the first time on a broad basis, led to mile-long queues and a total of 120,000 visitors. The question is therefore why it is necessary to hold an exhibition on Fabergé again.

The English-speaking public has indeed been spoilt by a whole series of exhibitions, books and successful auctions, documenting the lively interest taken in his art and drawing further attention to it at the same time. Since Queen Alexandra became "Fabergé's great patroness of the West", British interest in this Russian jeweler has never been known to flag and the Collection of Her Majesty Queen Elizabeth II of Great Britain is still the largest in the world. Wartski's of London have also done much to publicise Fabergé's oeuvre with books, articles and exhibitions. On the other side of the ocean, Fabergé's fame has been spread due to the efforts of Armand and Victor Hammer and A la Vielle Russie, who have helped form American taste as well as some of the world's most famous collections. Thus, in English-speaking countries, Fabergé is an established concept.

While in England and the USA, visitors eager for a glimpse of czarist Russia have every opportunity to view over a thousand pieces of Fabergé's work in museums and private collections, no more than a dozen of his objects are to be seen on the Continent, scattered in museums as far apart as Darmstadt and Doorn, Freising and Hamburg, Helsinki and Munich, Paris, St. Gallen and Stockholm, where they are generally relegated to the Arts and Crafts Departments. In Germany his work may be known to cultivated circles, but the general public seems to be unaware of his existence, unless in connection with the hardstone reproductions of his animals, flowers and *objets d'art* that are made in Idar-Oberstein. However, neither these products nor the many fakes which constantly turn up at German auction-rooms can be considered a fair introduction to Fabergé's oeuvre.

Yet Germany can boast a rich tradition in Fabergé objects, leading back to the late 19th century. The Russian Imperial family was related to half the ruling or royal houses of that country (see p. 15 ff.), and Fabergé objects were coveted presents at Christmas and Easter and for birthdays and name days in these circles. Although many of the collections gathered by these families have since been dispersed, numerous objects are still guarded as precious family heirlooms and can be seen here for the first time. Moreover, Carl Fabergé himself and his son Eugène also sought contact to Germany, maintaining personal links with the German

centers of stone-cutting and jewelry in Idar-Oberstein and Hanau, as recently discovered documents prove.

Thus for the first time, this exhibition displays a number of pieces generally inaccessible to the general public, since they are still in private German possession. Items have also been included that belong to the Royal Families of Bulgaria, Britain, Denmark, Holland, Sweden and Thailand.

It was one of the aims of this exhibition to win as many items as possible from the Soviet Union, which is still the primary source of many valuable Fabergé objects, despite the fact that many of them were sold to the West between 1925 and 1938. Indeed, a number of important pieces, including ten Imperial Easter eggs, are still to be found in Russia, many of them hidden away in otherwise inaccessible depositories.

Another of the avowed aims of this exhibition was to assemble as many Fabergé objects as possible that had not previously been exhibited or publicised. Nevertheless major pieces of work from Western collections, already exhibited at earlier events, have also been included. The other aim of the exhibition is didactic, for, apart from one inaccessible exception[5], Fabergé's work has never been shown in its historical context. Specialists have traced his sources back to the 17th and 18th centuries and now for the first time, some of his objects are juxtaposed with their "originals" from these periods.

The Munich exhibition also touches on new ground in that it exhibits objects made by Fabergé's numerous competitors. Until now, objets 'art and jewelery by Hahn, Köchli, Tillander and Bolin had never been considered of sufficient interest to be worth exhibiting. The same applies to silver and enamels by Sazikov, Ovchinnikov, Chlebnikov and Gratchev. However, the inclusion of such works demonstrates that Fabergé was not an isolated phenomenon, working in an artistic vacuum. Moreover, his supremacy in the field of Russian applied arts becomes all the more apparent when his work is exhibited in conjunction with other jewels and items of high artistic merit. His ideas are also known to have influenced the output of jewelers working in such distant capitals as Paris, London, Vienna and Berlin, and therefore a selection of items from these cities, including objects made by Cartier and Boucheron, have also been included.

The catalog also breaks new ground by bringing together not only general information but also scattered material that is not always easily accessible. At the same time it presents new and valuable facts on specialized subjects such as Russian and European genealogy (p. 15 ff.), the newly discovered volumes of jewelry drawings, (p. 45), Fabergé's hardstone figures (p. 75 ff.) and his links with Idar-Oberstein (pp. 74 & 323).

Most of the private collectors, owners and museums spontaneously agreed to part themselves from their cherished possessions for almost four months. In this respect they cannot be thanked enough. However, requests for extremely fragile or especially valuable objects had to be rejected for conservational reasons and the difficulties involved in obtaining items from such distant countries as Thailand, Finland, the United States and the Soviet Union entailed further restrictions. Yet, in a time when a Fabergé Easter egg changes hands for 1.7 million dollars, the fact that twelve such eggs, including such famous examples as the Coronation Egg from the Forbes Magazine Collection (cat. no. 539) and the Kremlin Trans-Siberian Railway Egg (cat. no. 540), could be brought together must indeed be considered a rare occurence.

The organizers are greatly indebted to Her Majesty Queen Elizabeth II of Great Britain and Her Majesty Queen Elizabeth, The Queen Mother, for their gracious loans, granted in spite of the many requests otherwise made of them. Our deepest thanks also go to Her Majesty Queen Margrethe of Denmark, who generously agreed to loan objects from the

Danish Royal Collections. We are also indebted to Her Majesty Queen Beatrix of the Netherlands, His Majesty King Carl XVI Gustaf of Sweden and His Majesty King Bhumipol Adulyadej of Thailand and all other lenders, both named and anonymous, for their friendly support.

I owe heartfelt thanks to Mr. Malcolm Forbes, who rendered the exhibition a great service by making exceedingly generous loans from his famous and unique collection, without doubt the most important of its kind. These loans were obtained through the mediation of Mr. Christopher Forbes, Vice-President of The Forbes Magazine Collection, New York, and a well-known Fabergé enthusiast. He also sacrificed much of his precious time to write a chapter for the catalog on Fabergé collecting in America, for which I extend him my hearty thanks. Mrs. Margaret Kelly, of The Forbes Magazine, who answered so many despairing telephone calls with the utmost of patience, is also to be acknowledged in this context.

I would like to extend further thanks to a number of well-known friends, colleagues and Fabergé experts. Mr. A. Kenneth Snowman of Wartski's, London, was of immense help in securing elusive loans. He very kindly put his archive material and his vast experience at my disposal, wrote a fascinating chapter for the catalog and loaned the exhibition a number of objects from the Wartski collection.

Mr. Peter Schaffer and Mr. Paul Schaffer, both of New York, were not dismayed to see my long list of requested loans. They spent much time procuring objects from American collections and added many beautiful items from the collection of their company, A La Vieille Russie.

Mrs. Ulla Tillander-Godenhielm, of Helsinki, kindly agreed to organize loans from private Finnish collections. She also provided archive material from her catalog to the 1980 Fabergé exhibition in Helsinki and loaned items from the Tillander company collection.

I am indebted to Dr. Alexander Herzog von Württemberg for having solved so many genealogical and physiognomical problems as well as contributing a valuable chapter on the extensive family connections of the Russian Imperial Family.

Special acknowledgements are due to Mr. Marke Zervudachi of Niarchos, London; Mr. Geoffrey Munn of Wartski's and Mr. Luigi Bandini of Eskenazi, London, for their friendly help, as well as to Mr. Alexander von Solodkoff of the Ermitage Gallery, who kindly provided an erudite chapter on Fabergé's hardstone figures.

I am also indebted to the following Museum Curators, who gave me their personal support in acquiring loans, photographs and other material from their Departments, namely to Mrs. Claire Le Corbeiller of the Metropolitan Museum of Art, New York; Mr. Roy D.R. Betteley of the Marjorie Merriweather Post Collection, Hillwood, Washington, D.C.; Mr. Edgar John Bullard III of the New Orleans Museum of Art; Miss Frances Dimond of the Windsor Photo Archives; Dr. Rudolph Distelberger of the Kunsthistorisches Museum, Vienna, Sammlung Plastik und Kunstgewerbe; Mr. Mogens Bencard and Mr. Jorgen Hein of the Rosenborg Castle Collections, Copenhagen; Mr. R.W. Lightbown and Mr. R. Edgecombe of the Victoria and Albert Museum, London; Mr. Ole Willemsum Krog of the Royal Danish Collections, Copenhagen; Dr. Joachim Menzhausen, Director of the Grünes Gewölbe, Dresden; Mr. Kevin Stayton of the Brooklyn Museum; Mr. W.R. Johnson of the Walters Art Gallery, Baltimore; and Mr. M. Urwick-Smith of the Wernher Collection, Luton Hoo.

My heartfelt thanks go to my cousin, Dr. Johann Georg Prinz von Hohenzollern, General Director of the Bayerisches Nationalmuseum in Munich, who had the idea for the exhibition. He took active part in the preparations and negotiated for loans, above all with the Soviet Union. Without his enthusiastic interest, the exhibition would not have have taken place. I am also indebted to Mrs. Irmengard Scrinzi of the same museum and Mrs. Ingrid Krause of

the Hypo-Kulturstiftung, who mastered all the problems involved in the preparations and who dealt with the mail and telephone calls involved.

I would also like to express my sincerest thanks to Mr. Albert Hirmer; Mrs. Aenne Hirmer, his mother; Mrs. Irmgard Ernstmeier-Hirmer, his sister; and Dr. Till Leberecht Lahusen; all of Hirmer Verlag. Without their angelic patience, this project might well have failed in the end.

Last but not least, Dr. Hans Fey, President of the Hypo-Kulturstiftung, and Mr. Peter Ade, of the same foundation, must be thanked and congratulated. Not only did they unflinchingly accept to bear the expense of such a complicated venture, it was also due to their cooperation that the exhibition was able to find such a worthy *mis en scène*.

<div align="right">GÉZA VON HABSBURG</div>

Second Preface

So great was the attraction of the Munich Exhibition that it had to be prolonged by one month. 250,000 enthusiastic viewers, who acquired 36,000 catalogs or books, made the exhibition into one of the most successful ever to be held on German ground. The visitors often queued patiently for hours in sub-zero temperatures or pouring rain, only to find a fearful crush inside (the record was 4,165 visitors in one day). Peasants elbowed aristocrats, and workmen and film stars vied with each other to get a glimpse of the exhibits. Some returned several times - one person admits to having made six visits altogether. Thus the exhibition proved once again that the fascination exerted by Fabergé on the public has not waned in the least.

Without doubt, the success of the exhibition was partially due to the lavish and painstaking presentation, designed to re-create the *ambience* of St. Petersburg, coupled with a *Schatzkammereffekt*. (The effect was that of a mysteriously lit Aladdin's cave.) This was a feather in the cap of the gifted interior designer and architect, Dr. Patrick Uterman, whose enthusiasm was boundless and who spared not a minute of his time.

If there was one thing to criticize, it would be that the exhibition was not able to travel and be made available to a wider section of the public. This was unfortunately quite out of the question due to logistical problems. For this reason, the author has taken upon himself the Herculean task of producing and publishing English and French translations of the catalog, which turned out to be more of a book and a reassessment of the entire Fabergé scholarship than simply a catalog. He has also been able to correct some of the numerous mistakes that crept in due to the pressure under which the catalog had been produced, adding recent discoveries and new publications and exhibitions in the process.

The English-speaking public has (hopefully) no longer any reason for its justified complaints.

<div align="right">GÉZA VON HABSBURG</div>

1 Fabergé 1846–1920. The Victoria and Albert Museum, London, 1977.
2 Carl Fabergé and his Contemporaries. Museum of Applied Arts, Helsinki, 1980.
3 Fabergé, Jeweler to Royalty. Cooper-Hewitt Museum, New York, 1983 and Fabergé. A La Vieille Russie, New York, 1983.
4 Fabergé from the Royal Collection. The Queen's Gallery, Buckingham Palace, London, 1985/86.
5 The 1980 exhibition in Helsinki, which was organized by the firm of Tillander, showed numerous objects by other contemporary goldsmiths in addition to Fabergé pieces.

14

The International Family Connections
of the Russian Imperial Family

ALEXANDER HERZOG VON WÜRTTEMBERG

The royal houses of Europe were closely related during the 19th and at the beginning of the 20th centuries, in spite of occasional political differences. Strict family laws stipulated that marriages had to take place within the narrow circle of ruling houses. This was originally intended to protect them from outside influences. The process of intermarriage brought about a permanent sense of "belonging to the same class" and a supranational feeling of solidarity, which however did not prevent governments from waging war against each other in the name of their respective monarchs. The First World War, in which the armies of Kaiser William II fought against those of King George V of Great Britain, appears very irrational when one takes into account that the Kaiser's mother was the sister of the King's father.

Many branches of Europe's royal families can be traced back to the same common roots. The House of Holstein-Oldenburg ruled over not only its own duchies in northern Germany but also over Denmark, Russia, Greece and Norway. The House of Saxe-Coburg reigned in Belgium, Portugal, Bulgaria and Great Britain, while the Bourbons were monarchs of France, Spain, Sicily and Parma, some only until the middle of the 19th century. The House of Habsburg encompassed so vast an empire that there was no need for it to lay claim to further realms. Members of the Hohenzollern family were Kings of Prussia and Emperors of the German Reich, and their cousins in southern Germany were chosen to be Kings of Rumania. The Kings of the Netherlands and the Grand Dukes of Luxemburg belonged to the House of Nassau and it was the House of Wittelsbach that provided the first King of Greece. These dynasties were affected in no way by national borders and as a result, tended to think in European terms and dimensions. However, religious denomination affected marriage considerations in some cases. This was no problem to the ruling houses of northern Europe, including those of England and Russia, but it affected those of Western, middle and southern Europe, which were of Roman Catholic faith, limiting the choice of potential marriage candidates. In the end, this led to a division of the Royal Houses of Europe into two closely interrelated separate groups.

Fabergé's clientèle, which mainly consisted of artistocrats, was a reflection of these circumstances. The products of his workshops were popular in the royal families and were frequently exchanged as gifts. Diplomats and members of royal delegations travelling to Russia on dynastic occasions would bring back Fabergé objects with them as luxurious "souvenirs".

Many historical affiliations which, at first glance, seem incomprehensible to us today, become clear when the family relationships that existed between the purchasers and recipients of Fabergé gifts are regarded in depth. Considered from a genealogical point of view, three large family groups will be seen to emerge. By its very nature, the Russian Imperial family with its numerous members and extensive dynastic interconnections should be con-

sidered first. The second group includes the Danish royal family and descendents of King Christian IX (1818-1906) who, via the female line, extended into the English and Russian royal houses and the House of Hanover as well as entering the Greek and Norwegian royal families via the male line. The third and final group comprises the House of Hesse-Darmstadt, which was closely connected to the Russian Imperial family through marriage.

Turning now to the first group, we can see that of the six emperors who ruled in the 19th century until their respective monarchies were abolished, five were married to German Princesses from the Houses of Württemberg, Baden and Prussia as well as that of Hesse-Darmstadt, which provided two Empresses. On the other hand, Russian Grand Duchesses became Queens of Holland, Greece, and Württemberg (twice), and were also Grand Duchesses of Mecklenburg-Schwerin and Saxe-Weimar, also through marriage. The fact that the Russian Imperial house mainly took up relationships with the smaller royal houses of Germany can be explained by the fact that the latter were not only of equal birth, but also unlikely to exercise influence on Russian political affairs.

The descendents of Czar Nicholas I (1796–1855) increased considerably in the four generations before the outbreak of the First World War (table A). The Czar had four sons and three daughters and his heir, Alexander II (1818–1881), also had seven children, consisting of six sons and one daughter. Three sons and two daughters were born to Alexander III (1845–1894) while Nicholas II (1868–1918) had four daughters and one son. Although some marriages remained without issue, the Imperial House continued to grow, especially through the branches founded by Alexander II's three brothers, who, as sons of Nicholas I, were called the "Nicholaievitches". Only two of Alexander III's five brothers had children, one of them with numerous progeny flourishing until today. Nicholas II had two brothers, one of them dying unmarried, the other only having morganatic descendants. Towards the end of the 19th century, morganatic marriages (which were not in accordance with the family laws) reduced an even stronger growth of the Imperial House. The issue of these marriages bore other names and titles and were excluded from the succession to the throne. Even so, the House of Romanov comprised 40 members in 1885, including Grand Duchesses bearing other names through marriage. The Imperial House itself consisted of 35 members (including the wives). By 1900 this ratio had increased to a total of 51 members, with 46 bearing the Imperial name, and was to increase in 1914 to 61 and 55 respectively. In the end the Revolution took its bloody toll, killing not only the Czar and his family but also nine other Grand Dukes and Princes of royal lineage.

It must be pointed out at this stage that the brothers, sisters, children and grandchildren of the Czar bore the title of Grand Duke or Duchess of Russia with the qualification of Imperial Highness, while the great-grandchildren were given the title of Prince or Princess of Russia with the qualification of Highness.

Of the three brothers of the Czar Alexander II mentioned above, namely the Grand Dukes Constantine Nicholaievitch (1827–1892), Nicholas Nicholaievitch (1831–1891) and Michael Nicholaievitch (1832–1909), numerous progeny were alive at the turn of the century.

Four of Grand Duke Constantine's children are also to be mentioned in this context. The older son, Constantine Constantinovitch, (1858–1915) became President of the Academy of Sciences, while his brother, Dimitri, (1860–1919) supervised the Imperial Stud. The oldest child, Olga, (1851-1926) married King George I of Greece and Vera, (1854–1912) married Duke Eugene of Württemberg (1846–1877; see table I).

Grand Duke Nicholas Nicholaievitch had two sons, Nicholas (1856–1935), sometime Viceroy of the Caucasus, and Peter (1864–1931). They both survived the revolutionary bloodbath (table II).

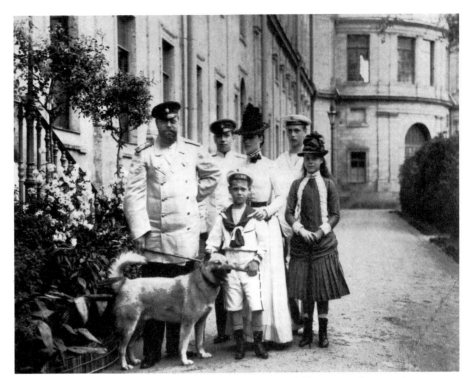

Czar Alexander III with Czarina Marie Feodorovna and their children at Gatchina Castle, ca. 1885.

The Russian Imperial Family, 1913. From left to right: Grand Duchess Maria, Czarina Alexandra Feodorovna, Czarevitch Alexei, Grand Duchess Tatjana, Grand Duchess Olga, Czar Nicholas II and Grand Duchess Anastasia.

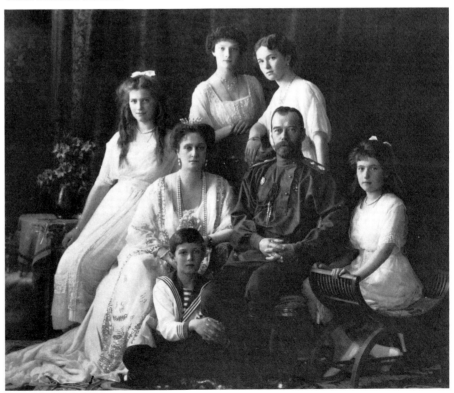

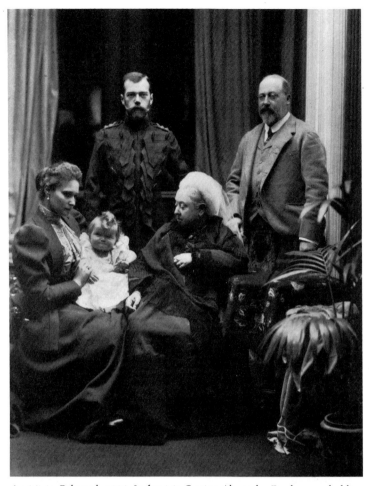

A visit to Balmoral, 1896. In front is Czarina Alexandra Feodorovna holding
Grand Duchess Olga, with Queen Victoria sitting next to her. Czar Nicholas II
and the Prince of Wales are standing behind them.

The youngest and most capable of Alexander II's brothers was Grand Duke Michael
Nicholaievitch, Governor of the Caucasus and later long-standing President of the Council
of the Empire. Of his children, Grand Duke Nicholas (1859–1919) became an eminent
historian and President of the Imperial Geographical Society, while Alexander (1866–1933)
was Admiral of the Russian Navy and author of critical memoirs. He was married to Grand
Duchess Xenia (1875–1960), the sister of Czar Nicholas II. In 1919, the scholarly Grand Duke
Nicholas and two further brothers were murdered by the Bolsheviks, but Alexander succeeded
in escaping to the Crimea with his family and his mother-in-law, the aged Dowager Empress,
Marie Feodorovna (1847–1928), where they survived the turmoils of the Revolution. Alexander's fourth brother, Michael, also survived because he had been living in England since his
morganatic marriage to Sophie, Countess Merenberg, who was granted the title of Countess
Torby for herself and her children. Anastasia (1860–1922), the only sister of these five
brothers, married Grand Duke Frederick Francis III of Mecklenburg-Schwerin in 1879 (table
III).

Of the brothers and sisters of Alexander III, Vladimir (1847–1909) stands out most
clearly. He and his wife, Maria, Duchess of Mecklenburg-Schwerin, (1854–1920) were among

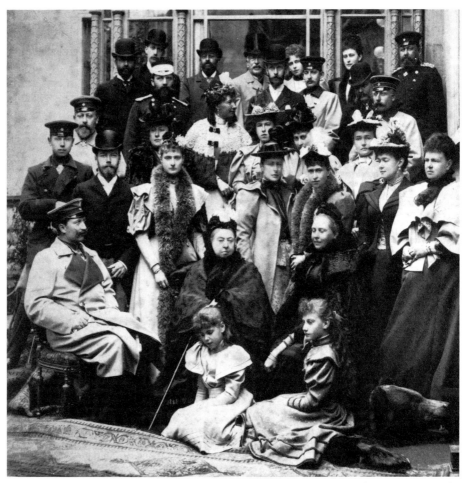

Family gathering on the occasion of the marriage of Princess Victoria Melita of Saxe-Coburg-Gotha to Grand Duke Ernest Louis of Hesse, which took place in Coburg, April 1894. Nicholas, the Czarevitch of Russia, became engaged to Princess Alix of Hesse at the same time. Front row, seated: Kaiser Wilhelm II, Queen Victoria of Great Britain, Dowager Empress Frederick of Germany. Second row, standing: Czarevitch Nicholas (with bowler hat), Princess Alix of Hesse, Princess Victoria of Battenberg, Princess Irene of Prussia, Grand Duchess Vladimir of Russia and Duchess Marie of Saxe-Coburg-Gotha (Duchess of Edinburgh). Third row, extreme left, light-colored uniform: the Prince of Wales (Edward VII). Last row, extreme right: Duke Alfred of Saxe-Coburg-Gotha (formerly Duke of Edinburgh)

the most dazzling figures at the Imperial Court, with Maria being known for her excellent international relationships and her appreciation of beautiful jewelry. Their descendents include the present head of the House of Romanov and are to be found in the Houses of Leiningen and Prussia as well as those of Yugoslavia, Toerring and Great Britain. Vladmimir's sister, Maria Alexandrovna (1852–1920), is also worthy of mention in this context. In 1874 she married Alfred, Duke of Edinburgh, the second son of Queen Victoria of Great Britain, who in 1893 succeeded his uncle, Ernest II, as Duke of Saxe-Coburg in Germany. The daughters of this union were to marry into the Houses of Rumania, Russia, Hohenlohe-Langenburg and Orléans (genealogical table G).

Of the brothers and sisters of Nicholas II, Grand Duchess Xenia has already been mentioned. Another brother, Michael (1878–1918), (whose wife was given the title of Countess Brassow since she was not of equal rank), refused the crown after Nicholas's abdication and was later executed in 1918.

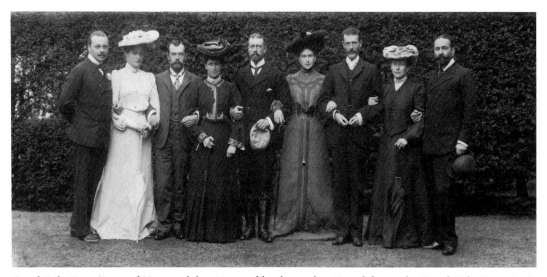

Grand Duke Ernest Louis of Hesse with his sisters and brothers-in-law. From left to right: Grand Duke Ernest Louis, Czarina Alexandra Feodorovna, Czar Nicholas II, Princess Irene and Prince Henry of Prussia, Grand Duchess Elizabeth and Grand Duke Sergei of Russia, Princess Victoria and Prince Louis of Battenberg

The related monarchs of Europe, assembled on the occasion of the burial of King Edward VII of Great Britain at Windsor Castle, May 20, 1910. First row, seated, from left to right: King Alfons XIII of Spain, King George V of Great Britain, King Frederick VII of Denmark. Second row, standing: King Hakon VII of Norway, King Ferdinand I of Bulgaria, King Manuel II of Portugal, Kaiser Wilhelm II, King George I of Greece and King Albert I of Belgium

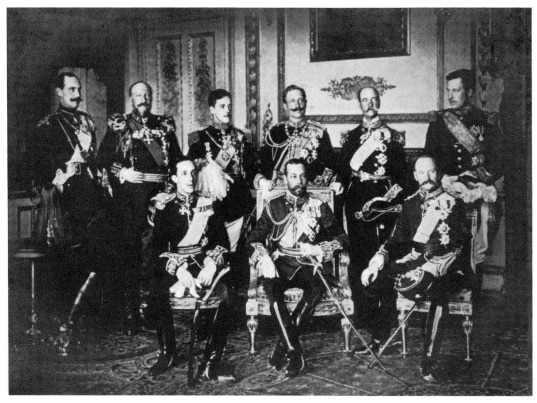

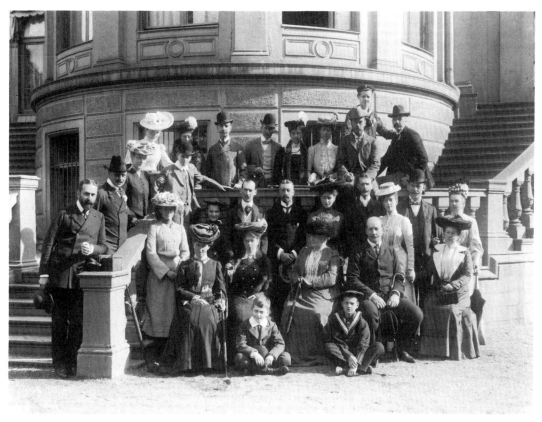

Family gathering in Darmstadt in front of the Neues Palais, before 1905
First row, seated: Princess Irene of Prussia, Dowager Empress Marie Feodorovna, Duchess Vera of Württemberg, Prince George of Greece and Grand Duchess Maria of Russia. Second row, standing: Princess Louise of Battenberg, Grand Duchess Maria Pavlovna, Prince Nicholas of Greece, Prince Henry of Prussia, Grand Duchess Elizabeth, Grand Duke Sergei, Queen Alexandra of Great Britain, Crown Prince Constantine of Greece and the Duchess of Saxe-Coburg. Along the parapet, from the left: Prince Louis of Battenberg, the Grand Duke of Hesse, Princess Victoria of Battenberg. Behind the parapet: Czarina Alexandra Feodorovna, Princess Margaret of Hesse, King George I of Greece, Prince Frederick Charles of Hesse, Crown Princess Sophie of Greece, Hereditary Princess Charlotte of Saxe-Meiningen, Czar Nicholas II, Hereditary Prince Bernhard of Saxe-Meiningen

Not without reason was King Christian IX of Denmark (1818–1906) (and Prince of Schleswig-Holstein-Sonderburg-Augustenburg until 1863) known as Europe's father-in-law. In 1863 his oldest daughter, Alexandra, (1844–1925) married the Prince of Wales, who succeeded his mother, Queen Victoria, to the throne of England as Edward VII in 1901. Queen Alexandra was to become one of Fabergé's most enthusiastic customers. In 1866 Dagmar, King Christian's second daughter, married the heir apparent to the Russian throne, later Alexander III. The third daughter, Thyra, was married to the Duke of Cumberland, the eldest son of King George V of Hanover, who had been exiled in 1866. King Christian's eldest son succeeded him as King Frederick VIII and his second son, William, (1845–1913), married to Olga, Grand Duchess of Russia in 1867, accepted the Greek crown as King George I in 1863, thereby becoming the founder of the Royal House of Greece, which ruled there until recently. King Christian's grandson, Charles (1872–1957), the younger son of Frederick VIII, ascended the Norwegian throne in 1905, taking the name of Hakon VII. He became the father of King Olaf V, the present King of Norway (Table B).

We now turn to the last of the groups mentioned at the beginning of this chapter, namely to that of the House of the Grand Duchy of Hesse-Darmstadt. The close relations between the houses of Hesse and Romanov began in 1841, with the marriage of Czar Alexander II, then heir apparent, to Princess Maria of Hesse (1824–1880), who was the sister of Grand Duke Louis III (1806-1877). Another brother, Alexander (1823–1888), became the founder of the House of Battenberg due to his morganatic marriage to Julie, Countess Haucke (1825–1895). The close ties already in existence between these two Houses were renewed in 1884, when Princess Elizabeth of Hesse (1864–1918) married Grand Duke Sergei of Russia (1857–1905), a brother of Czar Alexander III. Her sister Alix (1872–1918), whose life was to end so tragically, became the wife of Nicholas II in 1894 and therewith the last Empress of Russia. Elizabeth and Alix were daughters of Grand Duke Louis IV of Hesse and his wife Alice (1843–1878), herself a daughter of Queen Victoria of Great Britain, and their brother was Ernest Louis, the last Grand Duke of Hesse and by Rhine (1868-1937), who ruled until 1918 (table D).

On surveying the connections which have been portrayed in this chapter – in which only the most important have been described, – a network of close relationships, which embraced the whole of Europe, will be seen to emerge. On the eve – both heyday and zenith of Fabergé's career – of the downfall of the aristocracy, five of the reigning monarchs of Europe, namely Kaiser Wilhelm II, King George V of Great Britain, Grand Duke Louis of Hesse, Duke Carl Eduard of Saxe-Coburg and Queen Victoria Eugenia of Spain were all grandchildren of Queen Victoria of Great Britain and therefore first cousins (table F). Seen from the Danish angle, it will be noticed that the Emperor of Russia, the Kings of Great Britain, Greece, Denmark and Norway and the Duke of Brunswick were all first cousins as well, and that Norway and Denmark were ruled by brothers (table B). Despite the fact that these royal houses were so closely related, fate was to assign them very difficult roles during the First World War, which tragically brought death to some and loss of throne to many of the dynasties.

Genealogical Tables

The spelling of the proper names is in accordance with conventional genealogical handbooks
Abbreviations: ⚭ = married – D. = Duke – dau. of = daughter of – Dch. = Duchess – div. = divorced – Emp. =
Emperor – Gr. D. = Grand Duke – Gr. Dch. = Grand Duchess – K. = King – morg. = morganatic – Pr. = Prince –
Prss. = Princess – Q. = Queen
© Dr. Alexander Herzog von Württemberg

A. Russia

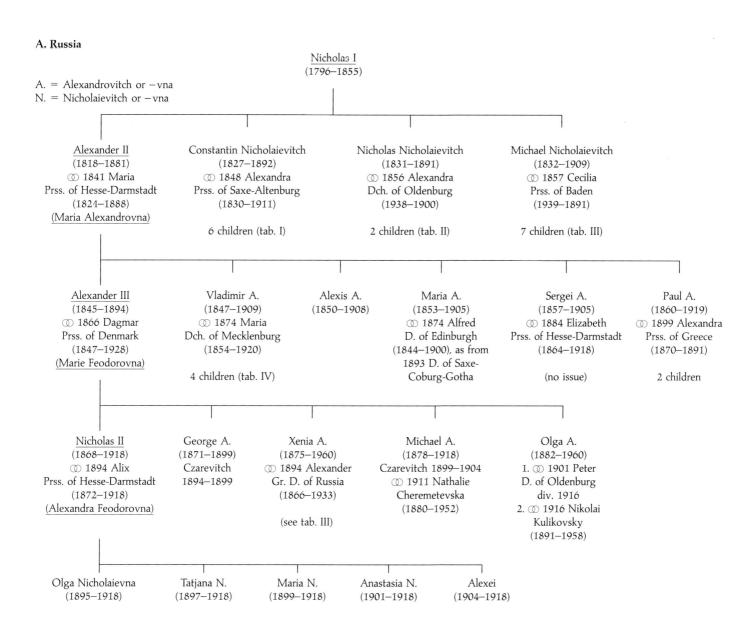

A. = Alexandrovitch or –vna
N. = Nicholaievitch or –vna

Nicholas I
(1796–1855)

Alexander II	Constantin Nicholaievitch	Nicholas Nicholaievitch	Michael Nicholaievitch
(1818–1881)	(1827–1892)	(1831–1891)	(1832–1909)
⚭ 1841 Maria	⚭ 1848 Alexandra	⚭ 1856 Alexandra	⚭ 1857 Cecilia
Prss. of Hesse-Darmstadt	Prss. of Saxe-Altenburg	Dch. of Oldenburg	Prss. of Baden
(1824–1888)	(1830–1911)	(1938–1900)	(1939–1891)
(Maria Alexandrovna)			
	6 children (tab. I)	2 children (tab. II)	7 children (tab. III)

Alexander III	Vladimir A.	Alexis A.	Maria A.	Sergei A.	Paul A.
(1845–1894)	(1847–1909)	(1850–1908)	(1853–1905)	(1857–1905)	(1860–1919)
⚭ 1866 Dagmar	⚭ 1874 Maria		⚭ 1874 Alfred	⚭ 1884 Elizabeth	⚭ 1899 Alexandra
Prss. of Denmark	Dch. of Mecklenburg		D. of Edinburgh	Prss. of Hesse-Darmstadt	Prss. of Greece
(1847–1928)	(1854–1920)		(1844–1900), as from	(1864–1918)	(1870–1891)
(Marie Feodorovna)			1893 D. of Saxe-		
	4 children (tab. IV)		Coburg-Gotha	(no issue)	2 children

Nicholas II	George A.	Xenia A.	Michael A.	Olga A.
(1868–1918)	(1871–1899)	(1875–1960)	(1878–1918)	(1882–1960)
⚭ 1894 Alix	Czarevitch	⚭ 1894 Alexander	Czarevitch 1899–1904	1. ⚭ 1901 Peter
Prss. of Hesse-Darmstadt	1894–1899	Gr. D. of Russia	⚭ 1911 Nathalie	D. of Oldenburg
(1872–1918)		(1866–1933)	Cheremetevska	div. 1916
(Alexandra Feodorovna)			(1880–1952)	2. ⚭ 1916 Nikolai
		(see tab. III)		Kulikovsky
				(1891–1958)

Olga Nicholaievna	Tatjana N.	Maria N.	Anastasia N.	Alexei
(1895–1918)	(1897–1918)	(1899–1918)	(1901–1918)	(1904–1918)

Table I

Issue of the Grand Duke <u>Constantine Nicholaievitch</u> (1827–1892)

1. Nicholas Constantinovitch, 1850–1918, ⚭ morg. 1882 Nadejda Dreyer (1861)

2. Olga Constantinovna, 1851–1926, ⚭ 1867 George I, King of Greece (1845–1913)

3. Vera Constantinovna, 1854–1912, ⚭ 1874 Eugene, Duke of Württemberg (1846–1877)

4. Constantine Constantinovitch, 1858-1918, ⚭ 1884 Elizabeth, Princess of Saxe-Altenburg (1865–1927)

5. Dimitri Constantinovitch, 1860–1919

Table II

Issue of Grand Duke <u>Nicholas Nicholaievitch</u> (the Elder), (1831–1891)

1. Nicholas Nicholaievitch (the Younger), 1856–1929, ⚭ 1907 Anastasia (Stana), Princess of Montenegro (1868–1935)

2. Peter Nicholaievitch, 1864–1931, ⚭ 1889 Militza, Princess of Montenegro (1866–1951)

Table III

Issue of Grand Duke <u>Michael Nicholaievitch</u> (1831–1909)

1. Nicholas Michailovitch, 1859–1919

2. Anastasia Michailovna, 1860–1922, ⚭ 1879 Frederick Francis III, Grand Duke of Mecklenburg-Schwerin (1851–1897)

3. Michael Michailovitch, 1861–1929, ⚭ morg. 1891 Sofia, Countess of Merenberg (1868–1927), since 1891 Countess of Torby (descendents: Torby, see below)

4. George Michailovitch, 1863–1919, ⚭ 1909 Marie, Princess of Greece (1876–1940)

5. Alexander Michailovitch, 1866–1933, ⚭ 1894 Xenia, Grand Duchess of Russia (1875–1960)

6. Sergei Michailovitch, 1869–1918

 Counts and Countesses of Torby
 a) Anastasia (Zia), 1892–1977, ⚭ 1917 Sir Harold Wernher (1893–1973), (Lady Anastasia Wernher)
 b) Nadejda (Nada), 1896–1963, ⚭ 1916 George, Prince of Battenberg, since 1917 Lord George Mountbatten, since 1921 2nd Marquess of Milford Haven (1892–1938)
 c) Michael, 1898–1959

Table IV

Issue of Grand Duke <u>Vladimir</u> (1847–1909)

1. Cyril, 1876–1938, ⚭ 1905 Victoria Melita, Princess of Saxe-Coburg and of Great Britain (1876–1936), (see table G)

2. Boris, 1877–1943, ⚭ morg. 1919 Zenaïda Rachevsky, div. Elisséeff (1898–1963)

3. Andrew, 1879–1956, ⚭ morg. 1921 Maria Krzesinska (1872–1971)

4. Helena, 1882–1957, ⚭ 1902 Nicholas, Prince of Greece (1872–1938)

24

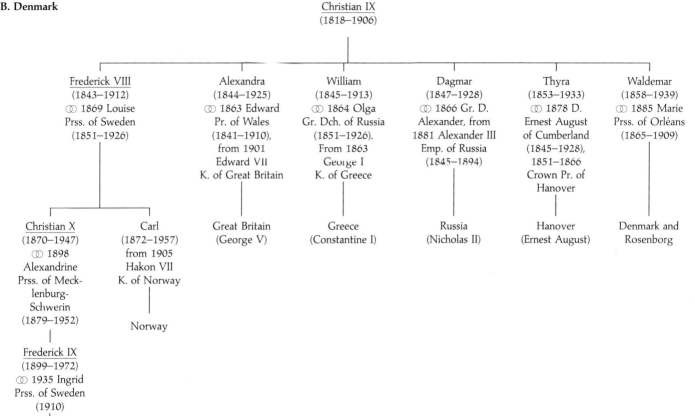

Christian IX
(1818–1906)

Frederick VIII
(1843–1912)
⚭ 1869 Louise
Prss. of Sweden
(1851–1926)

Alexandra
(1844–1925)
⚭ 1863 Edward
Pr. of Wales
(1841–1910),
from 1901
Edward VII
K. of Great Britain

William
(1845–1913)
⚭ 1864 Olga
Gr. Dch. of Russia
(1851–1926).
From 1863
George I
K. of Greece

Dagmar
(1847–1928)
⚭ 1866 Gr. D.
Alexander, from
1881 Alexander III
Emp. of Russia
(1845–1894)

Thyra
(1853–1933)
⚭ 1878 D.
Ernest August
of Cumberland
(1845–1928),
1851–1866
Crown Pr. of
Hanover

Waldemar
(1858–1939)
⚭ 1885 Marie
Prss. of Orléans
(1865–1909)

Christian X
(1870–1947)
⚭ 1898
Alexandrine
Prss. of Meck-
lenburg-
Schwerin
(1879–1952)

Carl
(1872–1957)
from 1905
Hakon VII
K. of Norway

Norway

Great Britain
(George V)

Greece
(Constantine I)

Russia
(Nicholas II)

Hanover
(Ernest August)

Denmark and
Rosenborg

Frederick IX
(1899–1972)
⚭ 1935 Ingrid
Prss. of Sweden
(1910)

Margrethe II (1940)

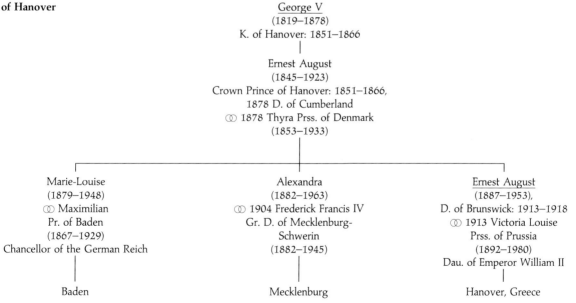

George V
(1819–1878)
K. of Hanover: 1851–1866

Ernest August
(1845–1923)
Crown Prince of Hanover: 1851–1866,
1878 D. of Cumberland
⚭ 1878 Thyra Prss. of Denmark
(1853–1933)

Marie-Louise
(1879–1948)
⚭ Maximilian
Pr. of Baden
(1867–1929)
Chancellor of the German Reich

Baden

Alexandra
(1882–1963)
⚭ 1904 Frederick Francis IV
Gr. D. of Mecklenburg-
Schwerin
(1882–1945)

Mecklenburg

Ernest August
(1887–1953),
D. of Brunswick: 1913–1918
⚭ 1913 Victoria Louise
Prss. of Prussia
(1892–1980)
Dau. of Emperor William II

Hanover, Greece

25

D. Hesse-Darmstadt

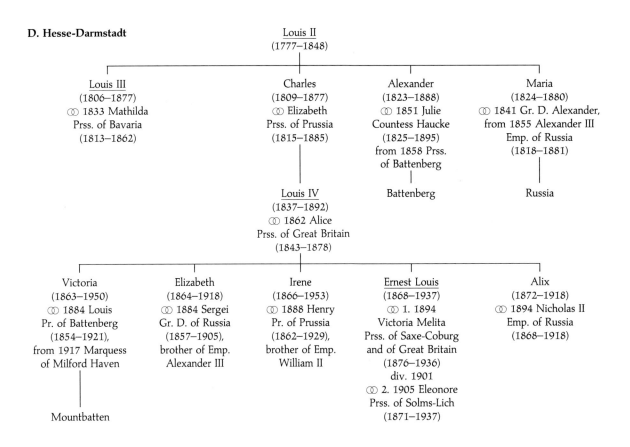

Louis II
(1777–1848)

Louis III
(1806–1877)
⚭ 1833 Mathilda
Prss. of Bavaria
(1813–1862)

Charles
(1809–1877)
⚭ Elizabeth
Prss. of Prussia
(1815–1885)

Alexander
(1823–1888)
⚭ 1851 Julie
Countess Haucke
(1825–1895)
from 1858 Prss.
of Battenberg

Maria
(1824–1880)
⚭ 1841 Gr. D. Alexander,
from 1855 Alexander III
Emp. of Russia
(1818–1881)

Louis IV
(1837–1892)
⚭ 1862 Alice
Prss. of Great Britain
(1843–1878)

Battenberg

Russia

Victoria
(1863–1950)
⚭ 1884 Louis
Pr. of Battenberg
(1854–1921),
from 1917 Marquess
of Milford Haven

Elizabeth
(1864–1918)
⚭ 1884 Sergei
Gr. D. of Russia
(1857–1905),
brother of Emp.
Alexander III

Irene
(1866–1953)
⚭ 1888 Henry
Pr. of Prussia
(1862–1929),
brother of Emp.
William II

Ernest Louis
(1868–1937)
⚭ 1. 1894
Victoria Melita
Prss. of Saxe-Coburg
and of Great Britain
(1876–1936)
div. 1901
⚭ 2. 1905 Eleonore
Prss. of Solms-Lich
(1871–1937)

Alix
(1872–1918)
⚭ 1894 Nicholas II
Emp. of Russia
(1868–1918)

Mountbatten

E. House of Battenberg

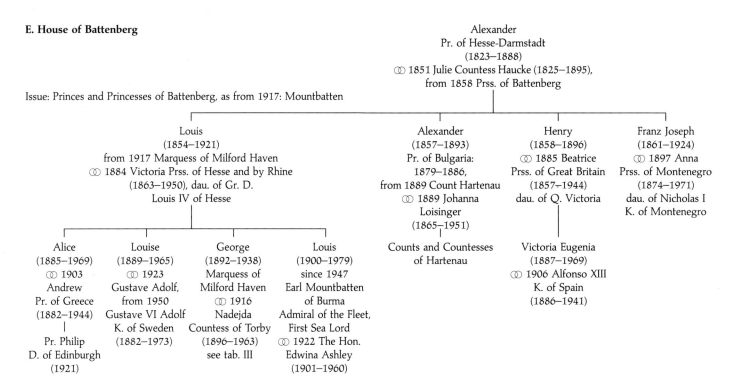

Alexander
Pr. of Hesse-Darmstadt
(1823–1888)
⚭ 1851 Julie Countess Haucke (1825–1895),
from 1858 Prss. of Battenberg

Issue: Princes and Princesses of Battenberg, as from 1917: Mountbatten

Louis
(1854–1921)
from 1917 Marquess of Milford Haven
⚭ 1884 Victoria Prss. of Hesse and by Rhine
(1863–1950), dau. of Gr. D.
Louis IV of Hesse

Alexander
(1857–1893)
Pr. of Bulgaria:
1879–1886,
from 1889 Count Hartenau
⚭ 1889 Johanna
Loisinger
(1865–1951)

Henry
(1858–1896)
⚭ 1885 Beatrice
Prss. of Great Britain
(1857–1944)
dau. of Q. Victoria

Franz Joseph
(1861–1924)
⚭ 1897 Anna
Prss. of Montenegro
(1874–1971)
dau. of Nicholas I
K. of Montenegro

Alice
(1885–1969)
⚭ 1903
Andrew
Pr. of Greece
(1882–1944)

Pr. Philip
D. of Edinburgh
(1921)

Louise
(1889–1965)
⚭ 1923
Gustave Adolf,
from 1950
Gustave VI Adolf
K. of Sweden
(1882–1973)

George
(1892–1938)
Marquess of
Milford Haven
⚭ 1916
Nadejda
Countess of Torby
(1896–1963)
see tab. III

Louis
(1900–1979)
since 1947
Earl Mountbatten
of Burma
Admiral of the Fleet,
First Sea Lord
⚭ 1922 The Hon.
Edwina Ashley
(1901–1960)

Counts and Countesses
of Hartenau

Victoria Eugenia
(1887–1969)
⚭ 1906 Alfonso XIII
K. of Spain
(1886–1941)

26

F. Great Britain

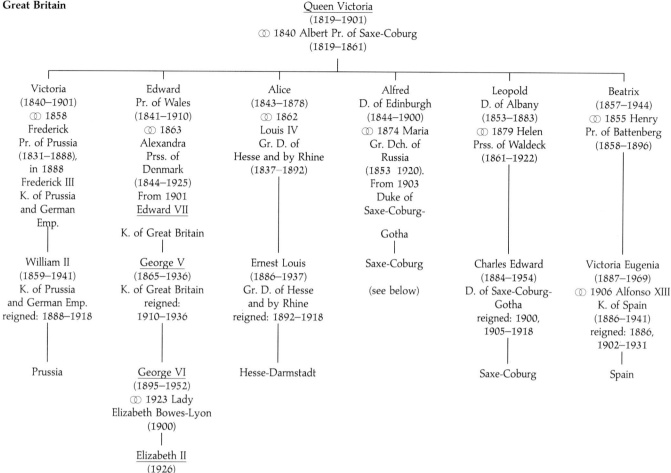

Queen Victoria
(1819–1901)
⚭ 1840 Albert Pr. of Saxe-Coburg
(1819–1861)

Victoria (1840–1901) ⚭ 1858 Frederick Pr. of Prussia (1831–1888), in 1888 Frederick III K. of Prussia and German Emp.	Edward Pr. of Wales (1841–1910) ⚭ 1863 Alexandra Prss. of Denmark (1844–1925) From 1901 Edward VII K. of Great Britain	Alice (1843–1878) ⚭ 1862 Louis IV Gr. D. of Hesse and by Rhine (1837–1892)	Alfred D. of Edinburgh (1844–1900) ⚭ 1874 Maria Gr. Dch. of Russia (1853 1920). From 1903 Duke of Saxe-Coburg-Gotha Saxe-Coburg	Leopold D. of Albany (1853–1883) ⚭ 1879 Helen Prss. of Waldeck (1861–1922)	Beatrix (1857–1944) ⚭ 1855 Henry Pr. of Battenberg (1858–1896)
William II (1859–1941) K. of Prussia and German Emp. reigned: 1888–1918	George V (1865–1936) K. of Great Britain reigned: 1910–1936	Ernest Louis (1886–1937) Gr. D. of Hesse and by Rhine reigned: 1892–1918	(see below)	Charles Edward (1884–1954) D. of Saxe-Coburg-Gotha reigned: 1900, 1905–1918	Victoria Eugenia (1887–1969) ⚭ 1906 Alfonso XIII K. of Spain (1886–1941) reigned: 1886, 1902–1931
Prussia	George VI (1895–1952) ⚭ 1923 Lady Elizabeth Bowes-Lyon (1900)	Hesse-Darmstadt		Saxe-Coburg	Spain
	Elizabeth II (1926)				

G. House of Saxe-Coburg

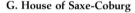

Alfred
D. of Edinburgh
(1844–1900)
from 1893 D. of Saxe-Coburg-Gotha
⚭ 1874 Marie Alexandrovna
(1853–1920)
dau. of Emp. Alexander II of Russia

Alfred (1874–1899) from 1893 Hereditary Prince of Saxe-Coburg-Gotha	Maria (1875–1938) ⚭ 1893 Ferdinand, from 1914 K. of Rumania (1865–1927)	Victoria Melita (1876–1936) 1. ⚭ 1894 Ernest Louis Gr. D. of Hesse (1868–1937) div. 1901 2. ⚭ 1905 Kyrill Gr. D. of Russia (1876–1938)	Alexandra (1878–1942) ⚭ 1896 Ernest Pr. of Hohenlohe-Langenburg (1863–1950), Regent of the Duchy of Saxe-Coburg-Gotha from 1900–1905	Beatrix (1884–1966) ⚭ 1909 Alfonso Pr. of Orléans Infante of Spain (1886–1975)
	Rumania	Russia	Hohenlohe-Langenburg	Bourbon (Galliera)

27

History of the House of Fabergé

Extensive research into the history of the house of Fabergé has been conducted by both Henry Bainbridge and Kenneth Snowman, who published the results of their findings in detail in 1949[1] and 1953[2] respectively. Bainbridge had access to first-hand information, having been a personal friend and collaborator of Fabergé's as well as manager of the London branch from 1907 until 1917. Snowman for his part was able to obtain additional information and valuable documents and photographs from Fabergé's children, especially from Eugène, who had settled down in Paris. Little else of substance has come to light since, despite the clarification of specific issues in certain monographs.[3] However, the discovery of Fabergé's London sales ledgers[4] in 1979 brought about valuable insights into the activities of this highly successful company. Additional information about a number of Fabergé's craftsmen came to light at the 1981 exhibition in Helsinki. Unfortunately, disappointingly little has emerged from the archives of the Soviet Union, except for the publication (by Marina Lopato[5]) of a short list of Imperial presents that has been recently discovered. It was also only very recently that three volumes of Fabergé's sketches made an appearance, providing much information on the kinds of objects produced by Holmström's workshops in the period between 1909 and 1917.[6]

What is known about the history of Fabergé is readily recapitulated. Little documentary evidence has been preserved and most of the information is based on oral tradition. Fabergé's family was of Hugenot extraction and originally came from the Picardy area of France. Following the Revocation of the Edict of Nantes by Louis XIV in 1685, they emigrated to eastern Germany and settled down at Schwedt-on-the-Oder, north-east of Berlin. In 1800, Carl Fabergé's grandfather, Peter, moved to Pernau on the Baltic, where Gustav, Fabergé's father, was born in 1814 (cat. no. 1). Like hundreds of other aspiring craftsmen, Gustav travelled to St. Petersburg, where he went into apprenticeship with the goldsmith Andreas Ferdinand Spiegel[7] and the goldsmith and jeweler Johann Wilhelm Keibel[8].

In 1841, he earned the title of master goldsmith and the following year he opened up a workshop at 12 Bolshaya Morskaya Street (Maison Jacot), where he worked as a jeweler with Johann Alexander Gunst and Johann Eckhard[9], taking on August Wilhelm Holmström as head jeweler in 1857. He married Charlotte Jungstedt, the daughter of a Danish painter, in 1842 and their first son, Peter Carl, who was also called Carl Gustavovitch in acordance with Russian custom, was born on May 30, 1846 and later educated at the fashionable German-speaking school of St. Anne's. In 1860 Gustav left his business in the hands of Hiskias Pendin, his friend and partner[10] and V.A. Zaianchovski, a talented jeweler, and retired to Dresden, where his son Agathon was born in 1862.

Carl was confirmed in the Dresden Hofkirche in 1861 and attended a commercial course at the Dresden Handelsschule before setting off on a European Grand Tour. His first stop

Carl Fabergé's parents, Gustav and Charlotte Fabergé

Fabergé's mother, St. Petersburg, 1842

A copy of Gustav Fabergé's birth certificate, made out on the occasion of his marriage in 1842

Augusta Fabergé (1851–1925)

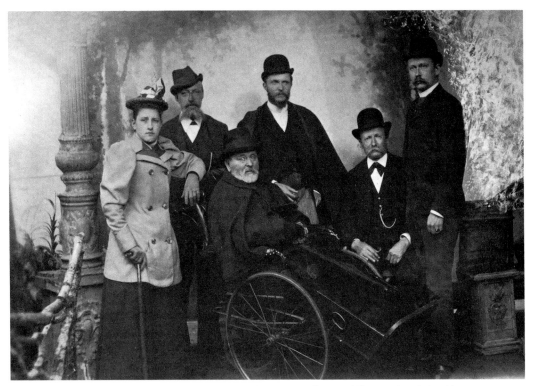

Carl Fabergé, about 1895, sitting in a wheelchair, with his son, Agathon (middle), standing behind him

Carl Fabergé in a wheelchair and Augusta Fabergé to his right; Wiesbaden, 1918

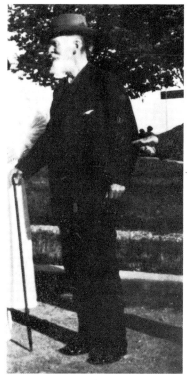

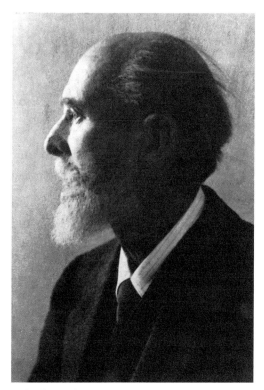

Carl Fabergé in Pully,
two months before his death

Carl Fabergé about 1918

Carl Fabergé sorting precious stones, photographed by H. Oeberg about 1915

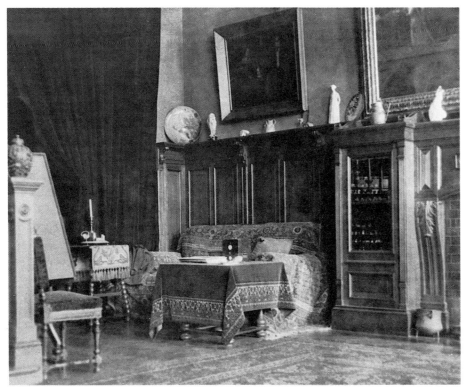

Rooms in Carl Fabergé's house at St. Petersburg. The glass cabinet with the netsuke collection can be seen at the back

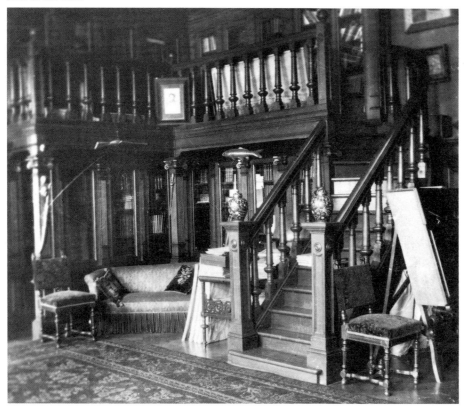

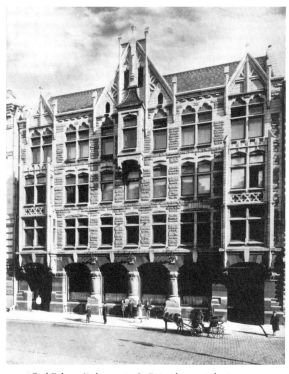

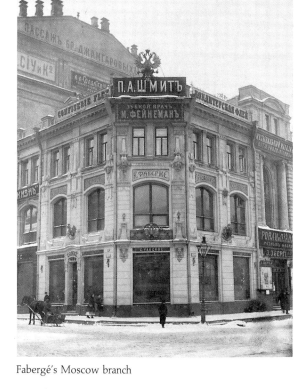

Carl Fabergé's house in St. Petersburg at the turn of the century

Fabergé's Moscow branch

Fabergé's Moscow branch

Fabergé's Moscow branch

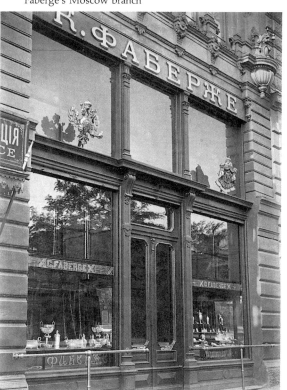

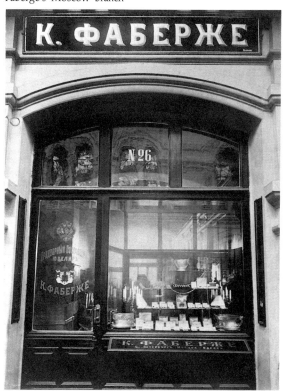

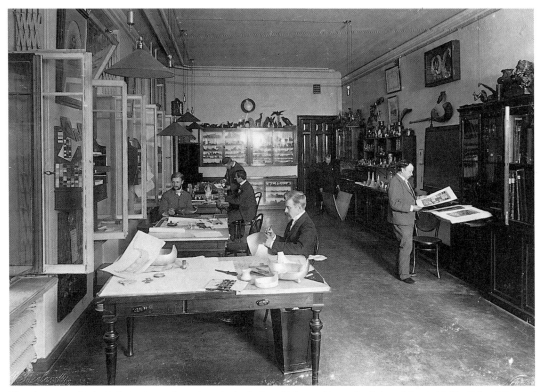

The design studio in St. Petersburg. From front to back: Ivan Lieberg, Alexander Fabergé (seated left), Oskar May and Eugène Fabergé. To the right: A. Ivashov

Michael Perchin's workshop in St. Petersburg, about 1903. To the left: Henrik Wigström, with Michael Perchin (bearded) behind. The 1904 Chanticleer Egg and Wilhelm II's ornamental helmet (cat. no. 74) are to be seen on the workbench

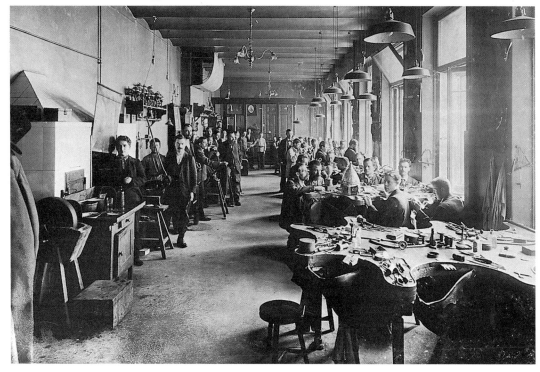

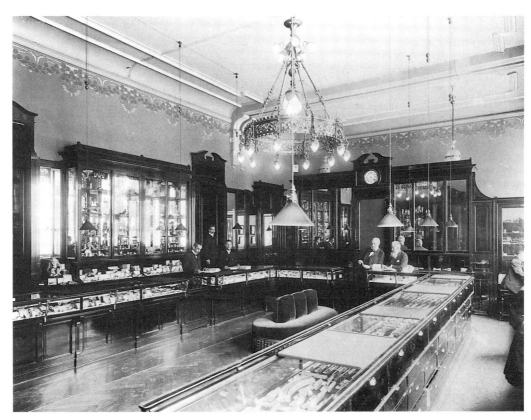

Fabergé's sales-rooms. Above: Moscow, below St. Petersburg. From left to right: Charles Bowe, Oswald Davies, ?, N. Hobé, O. Jarke, Lehmkuhl, G. Piggot, T. Juvé and Oliver

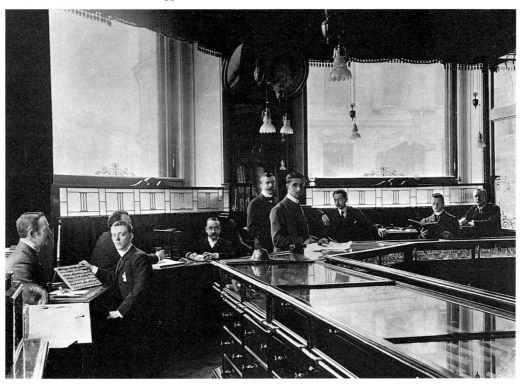

was in Frankfurt, where he was apprenticed to the jeweler Friedman.[11] Oral tradition also confirms a journey to Italy in the company of a young jeweler named Julius Butz, where a visit was made to Florence and the *Opificio delle Pietre Dure*, the Florentine hardstone-carving workshops. Having seen Italy, Carl then made the usual obligatory visits to Paris and London.

Carl Fabergé returned to St. Petersburg in 1870 as a fully fledged craftsman, ready to take over his father's business at the age of 24 under the guidance of Hiskias Pendin. In 1872 he married Augusta Jakobs, daughter of an overseer at the Imperial furniture workshop, and had four sons; Eugène (1874–1960), Agathon (1876–1951), Alexander (1877–1952) and Nicholas (1884–1939), all of whom were to subsequently work in their father's business.

The little that we know about Gustav Fabergé's output is that it must have been very modest indeed, as nondescript pieces of jewelry such as agate necklaces, bracelets (cat. nos. 2–4) and spectacles prove. It can be safely assumed that it was his son Carl who introduced new designs to the business, based on the revivalist style he had seen on his journeys through western Europe. These new ideas, which were carried out with the help of August Holmström's workshops from 1870 on, differed greatly to the traditional art of jewelry carried out in Russia at the time. However, it is very difficult to reconstruct this early phase of Fabergé's oeuvre, due to both the lack of hallmarks on so many pieces of jewelry and the impossibility of dating much of the work made before 1899 with any degree of precision.[12]

1882 is generally regarded as being a turning-point in Fabergé's career, for this was the year his brother Agathon, a brilliant designer and jeweler, joined him in St. Petersburg. At the same time, it was also the year in which the important Pan-Russian Exhibition took place in Moscow under the patronage of Czar Alexander III during the second year of his reign. The work that was exhibited at this event was very much in a style based on the art of Kremlin workshops active during the 17th century, as colorful enamel and silverwork objects by the companies of Sazikov, Chlebnikov, Ovchinnikov and Gratchev prove. During this exhibition, Fabergé's company was awarded a gold medal, (probably for its jewelry and the copies of the Kertch treasures), which brought it to the attention of the Imperial family.

With the death of Hiskias Pendin in 1881, Fabergé felt free to move into larger premises at 16/18 Bolshaya Morskaya Street, where he would not only be able to expand further if necessary, but where he would also be able to take up the production of novel enamel, hardstone and silver articles. By 1885, he had already been made "goldsmith by special appointment to the Imperial Crown" and in 1890 he had the honor of being nominated appraiser of the Imperial cabinet with the jewelers Zeftingen and Kechli (Köchli). He was also awarded the Third Class Order of St. Anne.

Fabergé made his international debut at the Nuremberg Exhibition of 1885, where he was awarded a gold medal for the gold copies of the Scythian treasures found at Kertch that his head-workmaster Erik Kollin[13] had made (cat. no. 88). In 1885, he made the first (cat. no. 532) of a series of 55 Easter eggs (for Alexander III), as a recently discovered document proves.[14] These eggs justifiably caused Fabergé's fame to spread rapidly and in 1887 it became necessary to open a branch in Moscow with others following in Odessa (1890), London (1903) and Kiev (1905). Fabergé's fame also spread to Scandinavia, where he was awarded a special diploma at the 1888 Nordic Exhibition in Copenhagen. The 1897 Nordic Exhibition in Stockholm saw not only the purchase of one of his objects for the first time by a museum (cat. no. 236), but also his appointment as court goldsmith to the crowns of Norway and Sweden.

He attained international recognition at the widely acclaimed 1900 World Fair held in Paris, where he was a member of the jury and where a selection of his Imperial Easter eggs

and miniature diamond-set replicas of the Russian Imperial Insignia[15] were exhibited at the request of the Imperial Family. His works of art shown *hors concours* caused a stir and earned him the Legion of Honour as well as the title of *maître* in the Paris Guild of Goldsmiths. The commissions that now poured in from his rapidly-growing clientèle made it necessary to move (for the last time) into premises at 24 Bolshaya Morskaya Street, which he had bought for 422,592 rubles and 22 kopecks in 1898. In 1904 he received an invitation from the Court of Siam, which took him to the Far East, resulting in a substantial number of commissions from his new patrons.[16]

In view of the rapidly growing competition, in 1903 Fabergé decided to direct his attention to the Western market, making use of his business association with Arthur Bowe in Moscow in order to have his work exhibited at various places in London. A London branch, which mainly catered to the English Royal Family and their circle, was officially opened in 1906 at 46 Dover Street under the management of Nicholas Fabergé and Henry Bainbridge. A move was made in 1911 to 173 New Bond Street. Collections of Fabergé objects were now being regularly shown in Paris (every December), Nice, Cannes, Monte Carlo and Rome (every Easter).

By the turn of the century, more than 500 employees were working for the company under the supervision of the head-workmaster Henrik Wigström (1903–1907), making it the largest in Russia by far.[17] Over 100,000 objects were produced in silver, enamel, jewelry and hardstone and no less than twenty craftsmen were employed in the production of the maplewood cases every single object was packed in. Fabergé's fame reached its absolute height in 1913, when the Tricentenary Jubilee of the Romanov family was celebrated with oriental splendour with Fabergé gifts being exchanged en masse.

Fabergé's world began to disintegrate with the onset of the First World War, when his clientèle began to dwindle or become empoverished. The company now started to make hand-grenades as a contribution to the war effort. In 1915 the London branch was officially closed down, although Bainbridge continued conducting business until 1917. After the outbreak of the October Revolution in St. Petersburg, a "Committee of the Employees of the K. Fabergé Company" was formed, which existed until November 1918. The company was assessed as being worth 3 million rubles and it was decided that Fabergé should hold 459 shares in it and three of his sons 40 each, while the remaining 176 were to be allocated to eight other partners. On this, Fabergé decided to emigrate, making stops in Riga and Berlin, before settling down briefly in Wiesbaden. In 1920 he and his wife then moved into the Bellevue Hotel in Lausanne, Switzerland where he died the same year on September 24. In 1929, his remains were transferred to a cemetery in Cannes, where they were buried with those of his wife, who had died in 1925.

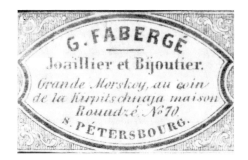

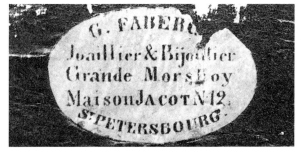

1 Bainbridge, London, 1949/68. Bainbridge's autobiography "Twice Seven" (London 1933), also contains a number of anecdotes in a chapter dedicated to Fabergé.
2 Snowman, 1953. Quoted here according to the 1962/64 edition.
3 Habsburg/Solodkoff, 1979; Snowman, 1979.
4 Habsburg/Solodkoff, op. cit., p. 134 (footnote 3).
5 Marina Lopato, "New Light on Fabergé", *Apollo*, January 1984, pp. 43–49.
6 Cf. pp. 45.
7 Andreas Ferdinand Spiegel (1797–1862), goldsmith and jeweler in St. Petersburg and master craftsman from 1830 on.
8 Johann Wilhelm Keibel (1788–1862), gained the title of master in 1840 and became an alderman in 1828. Specialized in gold boxes and enameled jewelry.
9 Cf. L. Bäcksbacka, St. Petersburgs Juvelare, Guld- och Silversmeder 1714–1870, Helsingfors, 1951, pp. 53 and 64.
10 Hiskias Magnusson Pendin (1823–1881), who attained the master title in 1840, exerted major influence on Carl Fabergé with his sense of quality and wealth of ideas.
11 Josef Friedman was born in Burgkunstadt on May 14, 1811. He married Pauline Goldschmidt in Offenbach in 1845, took the Citizen's Oath on June 27, 1849, in Frankfurt and built up a jewelry business there. In 1864 he made his brother Adolph, who had been working in the busines since 1846, an associate of the firm. This information is to be found in two petitions to the Senate in the Frankfurt City Archives (519/10 and 837/7). I am indebted to Mrs. Karin Carl of the City Archives for this information.
12 Cf. Russian hallmarks on page 334.
13 Catalog of the International Exhibition of Precious Metals and Alloys in Nuremberg, 1885, p. 103. Fabergé's copies of Scythian gold, which had been ordered by the President of the Imperial Archeological Commission, Count Sergei Stroganoff, were very much in keeping with examples of revivalist art as produced by the firm of Castellani in London.
14 Marina Lopato, op. cit., (footnote no. 5), Central State Historical Archives of the USSR, stock 468, inventory 7, file 372.
15 Hermitage Treasury (cf. Snowman, 1962/64, plates 289 f.).
16 Krairiksh, 1984.
17 By comparison, Ovchinnikov employed 300 craftsmen and Chlebnikov 200.

Fabergé's Renown

During the 1860s, the applied arts of both Europe and Russia were carried out in the bombastic, overladen style associated with the reigns of Napoleon III of France and Wilhelm I of Prussia. The following decades experienced a period of economic prosperity and the newly rich displayed their wealth with acquisitions of lavish jewelry, silverware and *objets d'art*. All the arts of the period exhibited a tendency to overstatement, which was dubbed *style pompier*. Diamond-encrusted bouquets and diadems were borne by the ladies of the period rather than worn, and ugly snuffboxes, encrusted in diamonds both real and imitation, were presented on every occasion of note. The Austrian, Prussian and English courts reflected this ostentative and pompous style in both their furnishings and silver.

In the eighties taste began to change. Decorative and overladen demonstrations of wealth were no longer considered fashionable and there was a demand for more discretion in the applied arts. In answer to this new urge for "aesthetic" values, jewelers such as Castellani, Giuliano and Fouquet began to produce objects in the revivalist style. Without doubt, the jewelry Fabergé made on his return to St. Petersburg in 1870 was very much in this manner. However, he was soon to produce elegant and beautifully crafted creations of his own in a kind of neo-Empire style that differed from anything previously produced in Russia.

Although Fabergé was content to run his father's business for the first ten years of his career and remained a jeweler for the rest, he is remembered by posterity as being the originator of *objets de fantaisie*. These were combinations of the traditional *objet d'art* with modern functional requirements, carried out in exquisite taste and to the highest degree of technical perfection. Today, such objects are known as *style Fabergé*.

Fabergé's novel *objets de fantaisie* were in tune with the change in taste taking place at the time, for his chief concern was for elegance and quality and not for sumptuousness. He avoided a showy use of precious jewels, preferring to use semiprecious cabochons instead, and he also developed his own extensive range of delicate enamel colors. He ignored the expanses of burnished gold usual during that period and combined his enamels with surfaces worked in the *guilloché* technique of 18th century France, applying them with garlands of flowers in varicolored gold. This pioneering activity was begun around 1884 with the help of his brother Agathon. The replacement of his first chief jeweler, Erik Kollin, with the highly gifted Michael Perchin in 1886 proved to be a major step forward in the development of the *objets de fantaisie*, for Kollin had been a specialist in the revivalist style, which was now out of date. While August Holmström continued to produce the company's jewelry as usual, the genius of the Fabergé brothers and the craftsmanship of Perchin were creating a revolution in the world of *objets d'art*.

Wide family and diplomatic connections were one of the advantages involved in having Imperial patronage. Among the earliest pieces of Fabergé's work that can be dated with any

certainty is a box presented by Alexander III to Chancellor Bismark in 1884, a piece of work very much in mid-19th century taste (cat. no. 404), with the heaviness of the object still reminiscent of articles made by Geneva workshops during the reign of King Louis-Philippe (1830–1848). The ostentatious use of diamonds (which were later replaced) and the lifeless quality of the red *guilloché* enamel makes it very different to the work that followed in the decade to come. Indeed, the creation of the so-called Serpent Clock Egg[1] three years later was a demonstration of perfect enameling, with the ingenious design being very much in accordance with the spirit of 18th century French art.

By 1896, the year of Czar Nicholas III's coronation, Fabergé had established himself in Russia as the creator of stimulating and novel objects. The coronation brought him valuable commissions, including one from the merchants of Novgorod, who ordered an exquisite basket of lilies-of-the-valley (cat. no. 401) for the Czarina. This piece of work shows Fabergé in full possession of his means. The coronation also brought a host of foreign royalty to Russia. They were given Fabergé objects by the Imperial couple or aquired them themselves, soon helping to spread Fabergé's fame throughout the rest of Europe.

Alexandra, Princess of Wales (and later Queen of England), sister of the Czarina Marie Feodorovna, became Fabergé's "Great Patroness of the West" (Bainbridge). An early example of Fabergé's work in her collection is an elegant mauve enamel frame with a portrait of the young Czarina. This piece (cat. no. 524) can be dated to around 1890 and is proof again of Fabergé's commitment to 18th century French art during the early period of his work. A yellow enameled cigarette-case, embellished with the Imperial crown and presented by Nicholas II in 1897 to his friend King Chulalongcorn of Siam also brought Fabergé into connection with royal patronage from the Far East for the first time.[2]

The Coronation Egg that Czar Nicholas II gave to his wife Alexandra Feodorovna in 1897 is probably the most famous of the Imperial eggs and the earliest that can be dated with any certainty. This object demonstrates Fabergé in full possession of his inventive genius, for it shied away from all plagiarism. At the same time, it also makes clear that his workshops had mastered every kind of technical skill, including the extremely difficult art of enameling curved surfaces.

The Exposition Universelle in Paris, where Fabergé exhibited his latest creations (at the request of Czar Nicholas II), did much to establish his fame abroad in 1900. As the jury commented, "his work reaches the limits of perfection, with jewels being transformed into real *objets d'art*. The objects exhibited by Fabergé are distinguished by their perfect execution and the precise settings. This is apparent in the miniature Imperial crown[3] set with 4,000 stones and in the enamel flowers, which are so perfectly imitated as to seem real, as well as all the other *articles de fantaisie* which have been examined by the Jury at length."[4]

The growth of Fabergé's international reputation is made apparent by the move that had to be made in 1900 to larger premises at Bolshaya Morskaya Street, which had been bought for the impressive sum of a half a million rubles. Fabergé's fame abroad was also furthered by the Dowager Empress, Marie Feodorovna, and by Czarina Alexandra, who showered Fabergé gifts onto their close relatives, such as the Kings of Denmark and Greece, the Duchess of Cumberland and Queen Alexandra of England (who were brothers and sisters of Marie Feodorovna) as well Princess Irene of Prussia, Princess Victoria of Battenberg, the Grand Duchess Sergei of Russia and the Grand Duchess of Hesse, who were all related to the Czarina (see pp. 25 of this book). Through presentation or acquisition, the Kings and Queens of Bulgaria[5], Italy, Norway, Portugal, Spain and Sweden also came to join the circle of Fabergé admirers and were soon followed by Edward VII of England and his "set". Fabergé's international clientèle also included personages such as Empress Eugènie, the Aga

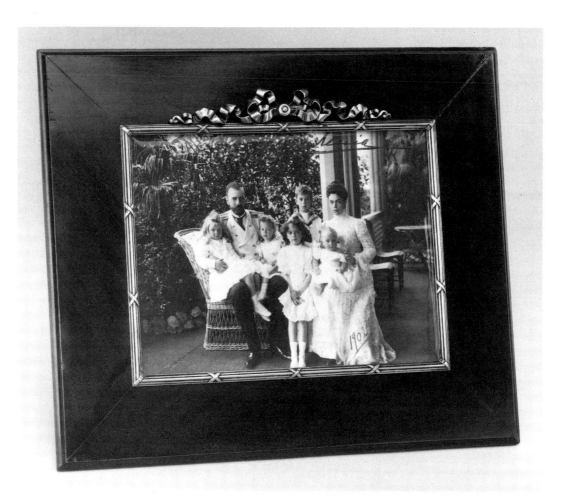

Fabergé frame, Wm: Anders Nevalainen, Hm: St. Petersburg 1899–1908. The photograph shows Grand Duke and Grand Duchess Alexander Michaelovich with their children, dated 1902 (cat. no. 29)

Khan, the Maharaja of Bikanir, Leopold de Rothschild, Baronne Eduard de Rothschild, Princess Cécile Murat, Grand Duke Michael and Countess Torby.

As a special distinction, a selection of Fabergé's objects was kept in a room in the Winter Palace, (called the Imperial Cabinet), where the Czar or a Palace official responsible for State Gifts could choose the most appropriate piece for each occasion. State Visits to destinations like Frederiksborg, Balmoral or Windsor were always accompanied with Fabergé presents in the form of silver, golden or enameled cigarette-cases in red morocco cases embossed with the double-headed eagle.

Foreign visitors attracted to St. Petersburg because of Fabergé's renown included the Duchess of Marlborough, who bought her salmon pink enamel Serpent Egg[6] there in 1902, and Lady Diana Cooper and Lady Sackville, who returned from Russia literally "laden with treasures from Fabergé". J.P. Morgan (cat. no. 485) was also a visitor to St. Petersburg as well as Henry Walters of Baltimore, who sailed up the Neva in his yacht in 1900. (On this occasion he acquired several parasol handles and hardstone animals (cat. no. 483)).

Fabergé was referred to on a rare occasion in a contemporary Russian publication as having a firm "...which is one of the best and most famous in the world, renowned above all for its *objets d'arts*. Articles made in Fabergé's workshops are known for their technical

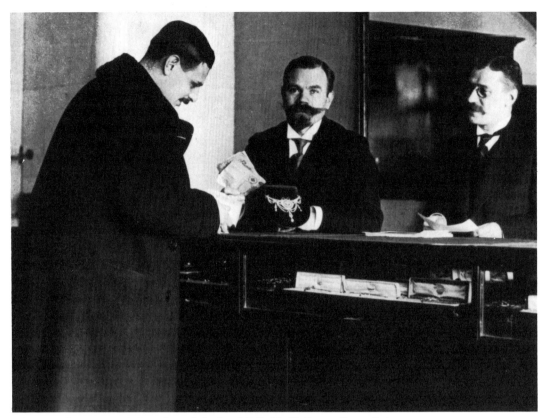

Fabergé's sales rooms in St. Petersburg. Left: Grand Duke Kyrill. Centre: Georg Stein

excellence, especially with regard to enameling, stone polishing and engraving". This was written in 1907.[7] At Easter, 1914, the Dowager Empress expressed her admiration more succinctly, telling Fabergé, "Vous êtes un génie incomparable!" (You are an incomparable genius!)[8]

In the second decade of the present century, Fabergé was so well known in Russia that a Fabergé competition was held by the Art and Industrial Society for Silver and Goldsmith Articles. 152 objects were submitted.

The fact that Fabergé's fame spread to such an extent was largely due to his business acumen and his intelligent sales methods. He introduced the notion of fashion into salesmanship, as exemplified by one of his catalogs: "The products of our firm are frequently renewed due to the bizarre demands of fashion; new objects are offered for sale every day...we always try — and our customers can rest assured of it — to offer a large quantity of newly designed articles. Old items which are out of fashion are not kept in stock: once a year they are collected and destroyed."[9] His objects in enamel became the craze of fashion-conscious Edwardian society. Edwardian ladies selected their ball-gowns to match the colors of Fabergé's objects (he had a range of 144 colors altogether) and we also know from Bainbridge that the ladies of his London clientèle eagerly awaited his return from trips to St. Petersburg, when he would come back loaded down with buckles, hat-pins, fans, vanity-cases and scent-bottles, since they would not order new gowns or hats beforehand.

Fabergé delivered novel and functional *objets d'art* for every occasion. His genius turned objects of daily use into works of art that were elegant in design, often amusing in character and carried out with the highest degree of precision. A businessman could furnish his office

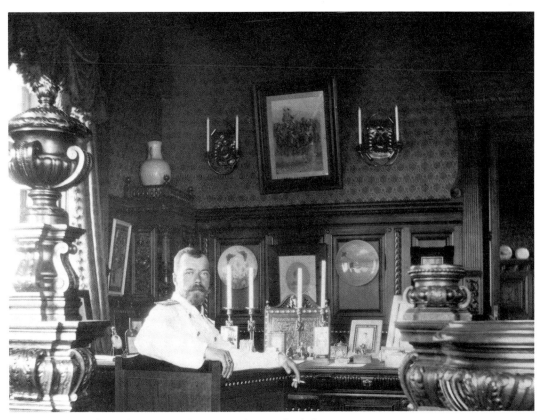

Czar Nicholas II. Fabergé frames are to be seen standing on the desk

with entire desk-sets, as well as stamp-moisteners, agendas, calendars, paperknives, stamp-dispensers, glue-pots and desk-seals and there were cigarette-cases, snuffboxes, calling card-cases, magnifying glasses, menthol-holders, opera glasses and bonbonnières for dandies. Gourmets could choose between caviar and vodka sets, copper casseroles and tcharki, while there were chess sets, games of draughts, clockwork models, toys, miniature models of furniture, precious flower arrangements, animals and amusing little folkloristic figures for the idle rich. Fabergé had silver-mounted furniture for the home, as well as tea services, flatware, mantlepiece and desk clocks, barometers and thermometers; and the ladies could take their choice of toilet-sets, perfume bottles, atomizers, patch and pill boxes, crochet hooks and knitting needles.

In many cases, Fabergé made use of technical discoveries. The invention of photography led to the replacement of miniature frames by photograph frames, which were well-suited to cluttered Victorian interiors where they stood in large numbers on mantelpieces, grand pianos and tables. The invention of the lighter helped Fabergé perfect one of his most celebrated creations, the cigarette-case in varicolored gold. This piece of elegant design, with its cabochon thumbpiece, invisible hinges and closely-fitting mounts, replaced the traditional cigarette-case with its compartment for matches and tinder-cord, and is still popular today, all the more so because it fits most modern brands of cigarettes. The electric bellpush is also an item that was incorporated into Fabergé's repetoire, provided in an endless variety of enamel and hardstone designs.

From our point of view, Fabergé's must have been the ideal gift shop, a combination of Cartier, Gucci and Tiffany's. His search for constantly new ideas – one is reminded here of

King Edward's wish to "...have no duplicates"[10] — meant that the shopper was certain to discover a highly original present at a fairly reasonable price. Fabergé summed it all up in an interview in 1914: "There are people who already have enough of diamond and pearls. Sometimes it is not even suitable to give jewelry as a present, but such a small thing is the right thing".[11] Fabergé's objects were not acquired as collectors' items, but were bought as a passing whim. As Bainbridge said, "Except in rare cases, I never remember the Edwardian ladies buying anything for themselves; they received their Fabergé objects from men, and these gifts were purely for the psychological moment".[12] It was this combination of novelty, elegance, usefulness, taste and perfection that ensured Fabergé's renown throughout the whole world.

1 Solodkoff, 1984, p. 73.
2 Krairiksh, 1984, p. 174 f.
3 Fabergé exhibited the miniature replicas of the Imperial insignia (see Snowman, 1953, plates 289 ff.).
4 Rapport du Jury International (Joaillerie), 1902.
5 Czar Ferdinand of Bulgaria regularly ordered Fabergé objects, including a presentation box (cf. Victoria & Albert 1977, no. 204) and later decorated their maker with the Order of St. Alexander.
6 The Forbes Magazine Collection, New York (see Waterfield/Forbes, 1978, no. 9).
7 Foelkersam, 1907.
8 Taken from a letter from Empress Marie Feodorovna to her sister Queen Alexandra (April 8, 1914), quoted from Solodkoff, 1984, p. 78.
9 Ibid., p. 35 f. However, it has been proved that "old items...out of fashion" were *not* "collected once a year and destroyed".
10 Bainbridge, 1949/66, p. 100.
11 Stolitsa i Usadba, 1914, p. 13 ff.
12 Bainbridge, 1933.

Two Books of Revelations

A. KENNETH SNOWMAN

As a result of a happy sequence of events, two of the original design books collated by the jewelry workshops at Fabergé's in St. Petersburg have come to light; more specifically, they turn out to be Holmström's stock books recording, it seems, every jewel made from March 6th, 1909 to March 20th, 1915. Seeing them for the first time in May, 1986, was as though the original manuscript score of a favorite and familiar piece of music that one had been playing and enjoying for most of one's life had quite suddenly, as if by a miracle, been thrust into one's hands.

Here were these princely volumes, containing a total of twelve hundred and twenty-one large pages, each measuring 16⅛ inches by 10¼ inches, crammed with drawings in pen or pencil, the great majority washed with watercolor, showing in meticulous detail exactly how each individual design had been carried out by the jeweler and, where necessary, the chaser, lapidary or enameler working at Fabergé's. This was the seed-corn one had scarcely dared believe was still in existence, let alone available.

On the right of each of the colored diagrams which follow one another down the page, a neatly handwritten description of the materials and quantities of stones needed with exact weights is set out and, in the early entries, the prices in code are sometimes given on the far right of the page. The cost of any work carried out in connection with the specific object illustrated is also supplied.

It is entirely as a result of the single-minded determination of one man, a diamond-setter from August Holmström's workshop, Oswald K. Jurison, that these books have become available to us today, some seventy years after Fabergé's was closed down. His best friend in the firm was the workmaster Julius Rappoport, who controlled the silver workshop.

It was Jurison, then a young man of thirty-three, who had the imagination and vision to appreciate their potential interest to future generations, carrying them with him from St. Petersburg to Latvia in 1925.

No mark existed in Russia for stamping platinum and it is quite clear, as one turns the pages of these books, that many platinum jewels by Fabergé — and there are hundreds of them here — must often have changed hands anonymously without either the seller or the buyer recognizing the distinguished provenance involved; a situation which must presumably prevail to this day.

A number of the designs are frankly a touch conventional and the possibility that the firm may have carried out work for other Houses — trade commissions — cannot, in the opinion of the present writer, be dismissed. There are, for example, many designs for diamond-set wrist watches which one does not easily connect with what one knows of Fabergé's work. The workshops were extensive, the craftsmen numerous and Fabergé, in addition to being himself a consummate artist, was a wise and practical man with a business to run, who

would, one imagines, not be above generating extra income to help finance his more imaginative, complicated and possibly speculative projects.

It is also possible, of course, that more ordinary jewels were produced for home consumption, rather in the way that a great number of traditional silver objects were manufactured in the Moscow house for the same purpose.

Most of the designs of these books, however, are of great distinction and in many cases, stylistically ahead of their time. This, remembering the inventiveness of Fabergé's objects of vertu, is hardly surprising.

The fact that every one of the drawings is precisely dated is of inestimable value to the historian. Take for example some of the brooch designs illustrated on page 52. Without the knowledge that they date from 1913, one would assume that they were conceived and created in the late twenties in Paris. It is not difficult to understand why, as Hans Nadelhoffer in his splendid book reminds us, the Cartiers always retained a healthy respect for the creative energy of the House of Fabergé.

Among the many joys to be found in this vast collection of drawings are quite a number of jewels one has actually known and, in some cases, handled in their final finished form.

To demonstrate just how faithfully the jewelry workshops followed the designs they were given, two photographs accompany this note in which the actual jewel is shown resting upon the page with the painted drawing from which it was created. There are pages devoted to drawings for brooches, badges, tiepins und cuff links, destined for what is designated here as His Imperial Majesty's Cabinet and incorporating Imperial cyphers and monograms set beneath the Romanov crown designed by Pauzié.

To celebrate the Tercentenary of Romanov sovereignty, a variety of pendants and decorations were specially prepared by Fabergé, many of them including an elaborately enameled version of Peter the Great's sable-trimmed *shapka* or cap of Monomach.

Bainbridge, writing about jewelry commemorating State occasions, notes that "there were the large number of brooches and pendants with Imperial emblem designs made for the Coronation of the Czar Nicholas II, and the brooches made to commemorate the Tercentenary of Romanov rule in 1913, in diamonds, different colored stones and pearls, following motifs of the Imperial Crown and emblems, all different, of course, and presented to each of the Grand Duchesses and ladies of the Court. It is to be noted that the designs for the latter were based on the original drawings which the Czarina Alexandra Feodorovna herself prepared and sent to Fabergé for elaboration".

Ample evidence is provided of the legendary dinner parties given by Dr. Emanuel Nobel, the Stockholm petrol tycoon (and nephew of Alfred Nobel of Prize and gunpowder fame), where, at such nocturnal gatherings, every lady present found, cunningly concealed in the place-setting before her, an ice jewel, normally composed of rock-crystal and diamonds by Fabergé. Several pages of the design books are devoted to veritable flurries of frost flower brooches and pendants formed as icicles, naturalistically carved drops of rock-crystal sometimes burnished, sometimes matt, to which cling a twinkling diamond-set gossamer webbing of "frost" (ill. p. 33). There are even a couple of bracelets carried out in this decor. This winter theme is further reflected in many of the designs for the miniature Easter eggs so beloved of Russian ladies.

These tiny egg pendants are generously represented in countless guises in silver, gold or semi-precious stones. We find solemn little stone owls, small portly oviform elephants and pigs in nephrite or orletz, each one shining with tiny diamond or ruby eyes.

Numerous miniature eggs were designed to be entirely enameled in translucent or opaque colors or striped or quartered or decorated with stars in the form of gold *paillons*, applied

with chased colored gold mounts or set with small gemstones. The variety seems as endless as the demand for these gleaming symbols of the Resurrection.

When the 1914 war broke out, a favourite theme was a red cross boldly expressed on a small oyster-enameled egg, a reference to the Czarina's dedication to that eponymous organization.

Examining the repeating columns of small exquisitely painted sketches of jewels, the seemingly endless procession of pendants, brooches, rings, necklaces, diadems, earrings, tiepins, and clasps is interrupted quite without warning by a life-sized drawing of one of Fabergé's characteristic flower studies, a generous spray of forget-me-nots in a pot.

Occupying most of page 106 in the second book and dated May 12th, 1912, the painting indicates exactly how the flower was to be carried out: the flower heads of turquoise petals with rose-diamond centres supported on lightly engraved gold stems; leaves of nephrite, the whole spray casually placed in a rock-crystal pot, the mandatory receptacle for these studies carved by the lapidary to give the impression of being nearly filled with water.

The very fact that a flower design should figure among those for jewels seems to demonstrate that, although the stems of these studies are sometimes physically stamped with the marks of the goldsmith, their nature is, in a sense, ambiguous, existing in some sort of no man's land or neutral soil between *objet de vitrine* and jewel.

The particular example we have in our book certainly calls upon the skill of the jeweler to a greater extent than is the case of most of the flowers and this possibly accounts for its appearing in notable isolation in this context. Included also within the jeweler's domain we find meticulously detailed designs for gem-set tortoise-shell fans, cigarette-holders and an evening bag as well as, less surprisingly, hair combs and cuff links which are, after all, jewelry.

This cross-fertilization is characteristic of Fabergé's method of work, which naturally involved the most appropriate craftsman for the job in hand. A stone carving of an animal or a bird requiring gold additions such as legs, feet, claws, beak or a perch or cage would invariably be sent to Michael Perchin's workshop or, after his death in 1903, to Henrik Wigström's, to be finished off.

On page 371 of the second book under the date July 27th, 1913 (ill. p. 53), we find a small, carefully finished water-color drawing of a circular brooch which is to be carried out by the setter in colored gemstones in mosaic technique, with the surrounding borders to be composed of half pearls and enamel. This provided the germ for what was to become the Mosaic Egg presented in 1914 to Alexandra Feodorovna by the Czar and presently in the Collection of Her Majesty Queen Elizabeth II. This beautiful object, as we now know, thanks to be careful research of Ulla Tillander-Godenhielm and Christina Ehrnrooth in Helsinki, was designed in the workshops of August Holmström by his grand-daughter Alma Theresia Pihl, the daughter of the Fabergé workmaster Knut Oscar Pihl and Fanny Florentina Holmström. She had already designed the Winter Egg, one of Fabergé's most ravishing creations, for presentation to the Czarina in the previous year of 1913. At the time of writing, the whereabouts of this egg are, alas, unknown. The catalog of the memorable exhibition "Carl Fabergé and his Contemporaries", held in Helsinki in 1980, records of Alma Pihl that she was employed by her uncle Albert Holmström, the son of August, who ran the workshop after his father's death in 1903.

We learn that she "was first employed by her uncle to draw ornaments and other precious articles for the archives ... Alma Pihl was exceptionally talented. She was equal to the most demanding challenges ... she quickly taught herself to calculate how much material and what precious stones would be needed for any particular article so that she could reckon its cost

continue page 56

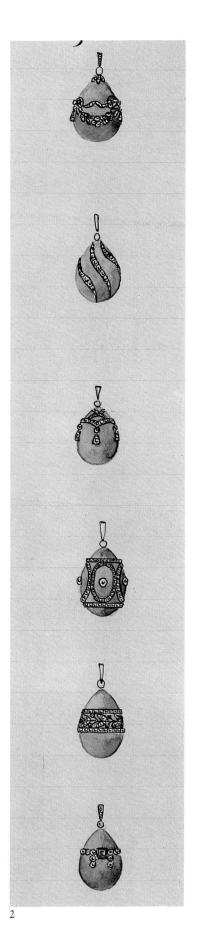

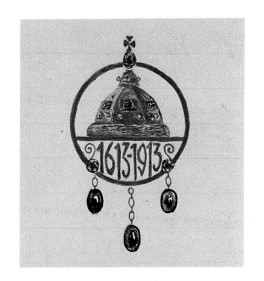

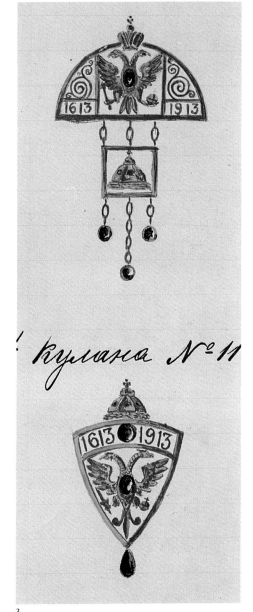

Кулона № 11

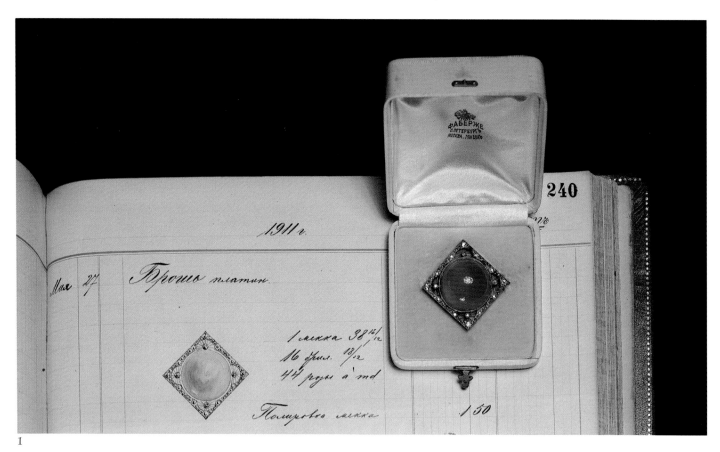

1

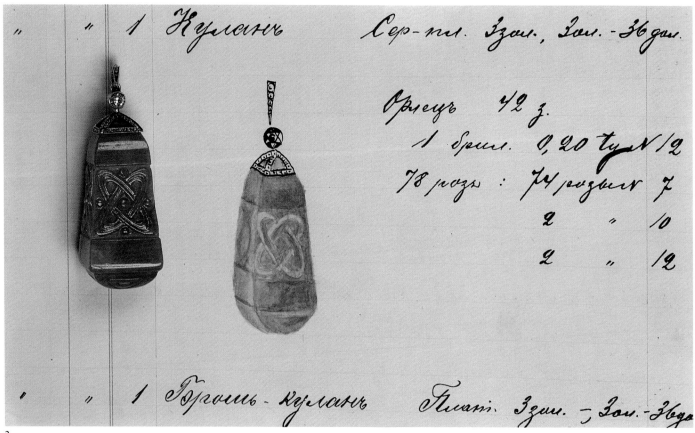

2

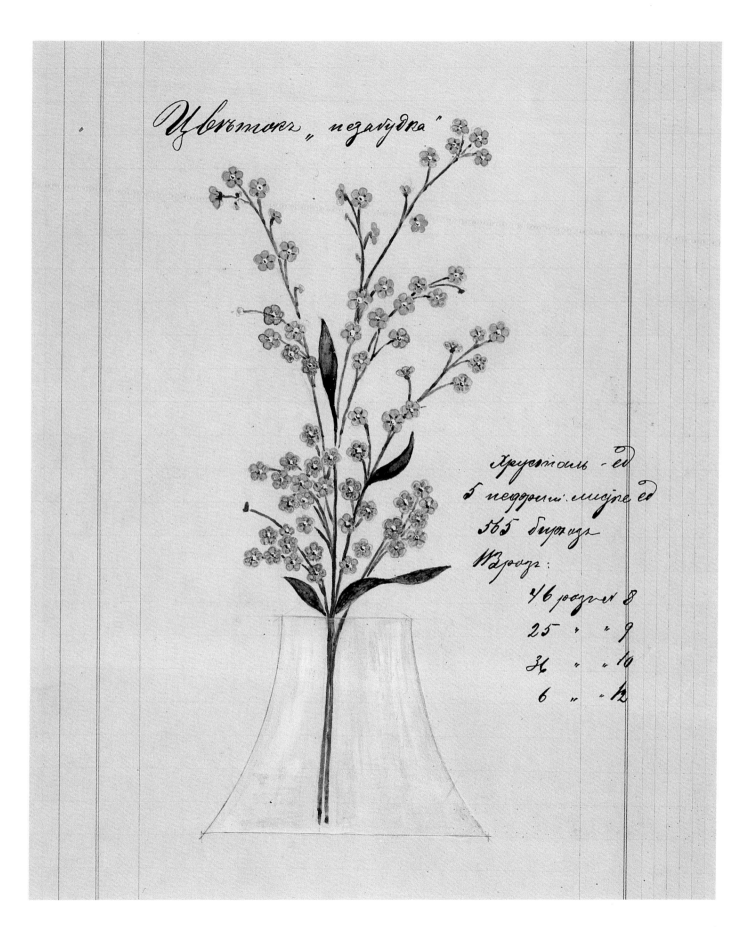

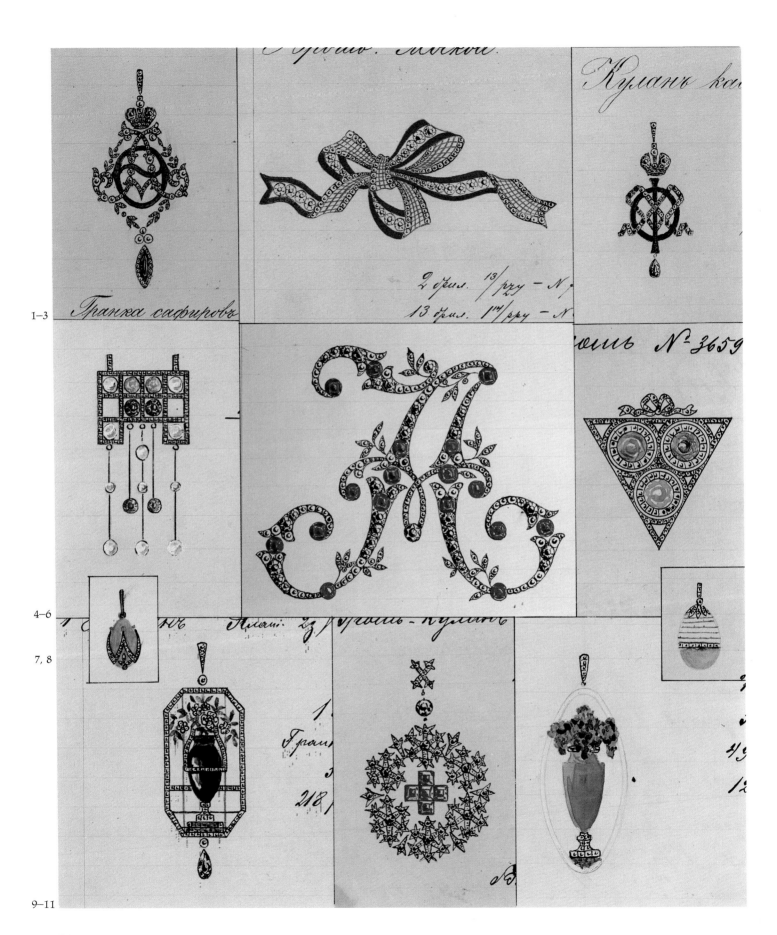

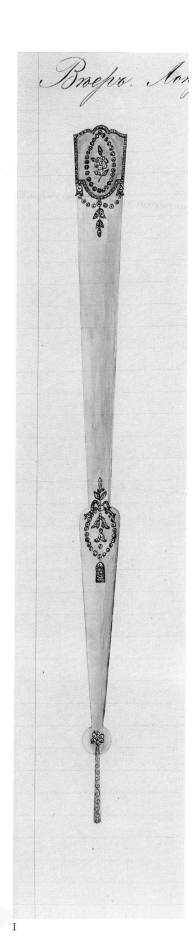

1

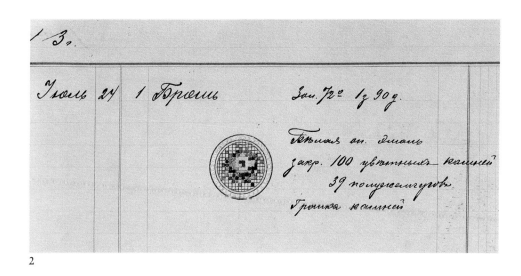

Июль 24 1 Брошь Зол. 72° 1 з 90 д.

Бываль от. эмаль
закр. 100 цветными камней
39 полужемчугов
Дрошка камней

2

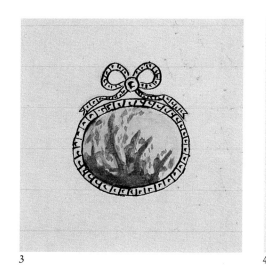

3

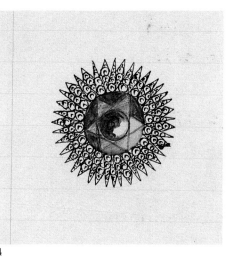

4

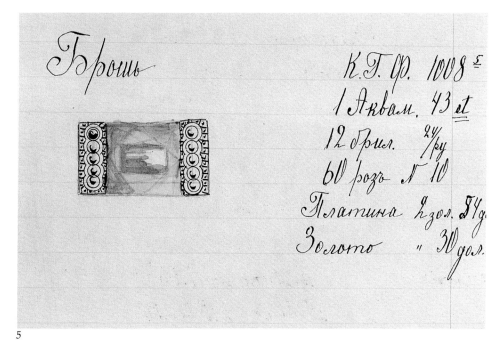

Брошь

К.Т. Ф. 1008 с
1 Аквам. 43 st
12 Брил. 24/ру
60 розъ № 10
Платина 2 зол. 54 д.
Золото " 30 дол.

5

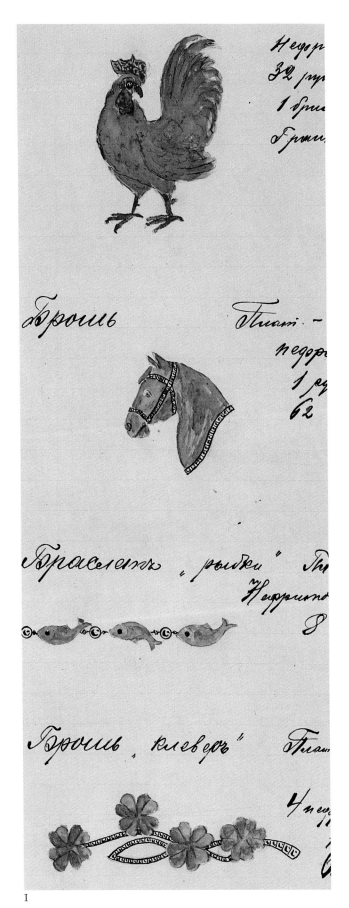

Брошь

Брошь

Брослетъ „рыбки"

Брошь „клеверъ"

2

3

4

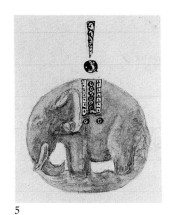

5

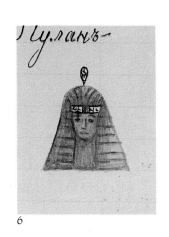

6

7

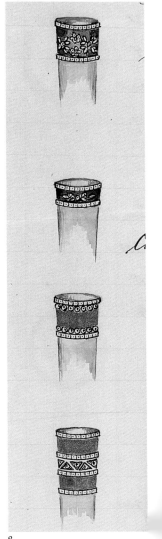

8

1

54

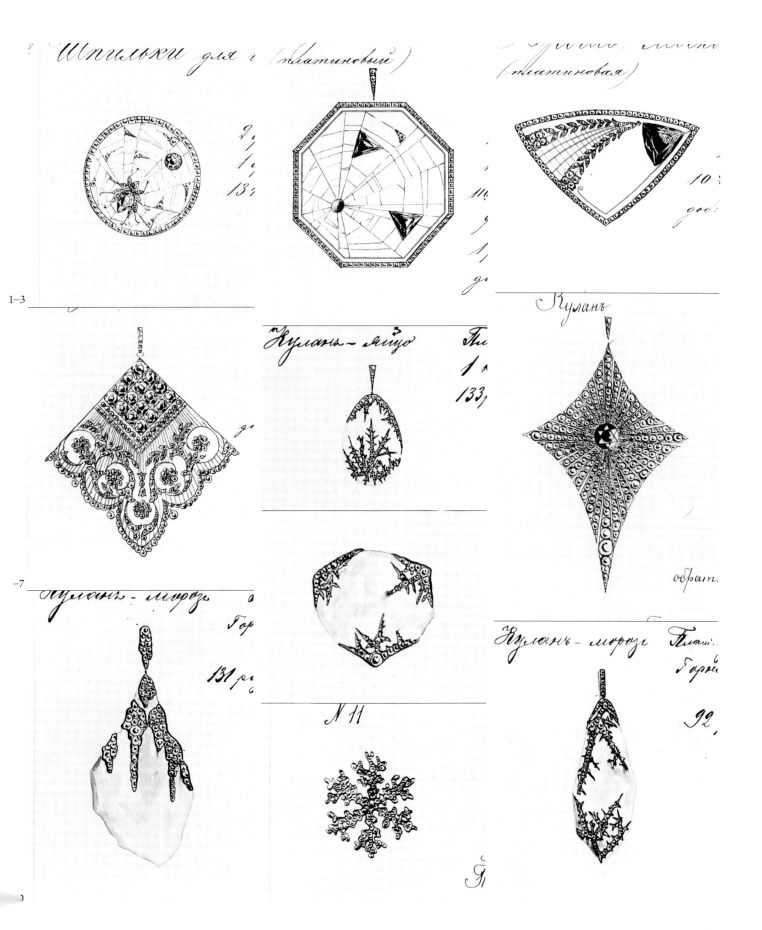

Шпильки для г (платиновый)

(платиновая)

1–3

Кулонъ – яйцо

Кулонъ

Кулонъ – морозъ

№ 11

Кулонъ – морозъ

обрат.

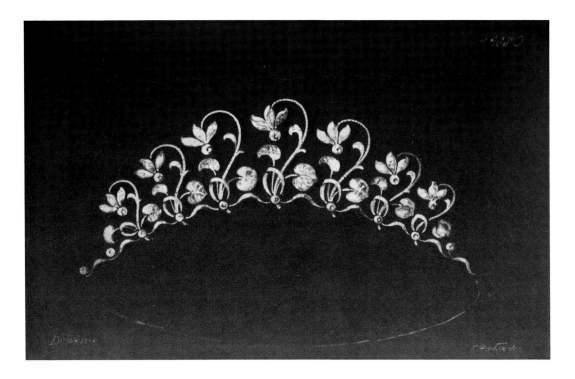

Continuation of page 48, legends to page 54

6, 7 Carved nephrite head after an ancient Egyptian model, mounted as a pendant in platinum and set with a brilliant diamond, 23 roses and a ruby.
The initials ФБ (F.B.) for Francois Birbaum, Fabergé's chief designer, accompany this water-color drawing. Dated August 8, 1914.

8 Four amber cigarette-holders, with silver and platinum mounts; the top two enameled translucent blue, the lower two finished in mat silver; all set with rose diamonds. Dated January 7, 1914.

Page 55

1 Circular hat pin set with brilliant and rose diamonds depicting a spider's web with rain drops. Dated December 18, 1909.

2 Platinum pendant of octagonal form, similarly set but for the addition of a small cabochon ruby, possibly suggesting a ladybird, and two large triangular diamond rain drops. Dated June 30, 1910.

3 Platinum brooch of curved wedge form, set with brilliant and rose diamonds. The same date as the previous jewel.

4 Platinum pendant of a lace design, set with brilliant and rose diamonds. Dated November 30, 1911.
These first four jewels were made for the Moscow branch.

5 Pendant Easter egg, carved in rock crystal with platinum frost mounts set with rose diamonds. Dated April 10, 1913.

6 Platinum pendant set with brilliant and rose diamonds. The initials of Carl Fabergé (КГФ) accompany this drawing. Dated September 10, 1914.

7 Carved rock-crystal frost brooch, mounted in platinum and set with rose diamonds. Dated April 30, 1913.

8 Carved rock-crystal frost pendant, mounted in platinum and set with 30 brilliant and 131 rose diamonds. Dated May 2, 1913.

9 Frost-flower brooch mounted in gold and platinized silver, set with one brilliant and 208 rose diamonds. Dated August 27, 1914.

10 Carved rock-crystal frost pendant mounted in platinum and set with 15 brilliant and 92 rose diamonds. Dated May 2, 1913.

Page 56

Water-color drawing for a diadem (cat. 131) to be carried out in brilliant and rose diamonds; mounted in silver and gold designed as a row of cyclamen flowers and leaves. As the drawing indicates, the diadem may also be worn as a flexible necklace. The original jewel is included in this exhibition. $10^{7}/_{8} \times 6^{3}/_{4}$. Wartski, London.

Page 57

Working drawing, faintly washed with watercolor, for the model of the Royal Yacht "Standart". Shown from three different angles. This is the preparatory design for the Imperial Standart Egg of 1909, now in the Armory Museum in the Kremlin, Moscow. c. 1908. $6^{2}/_{4} \times 5^{1}/_{2}$. Privately owned.

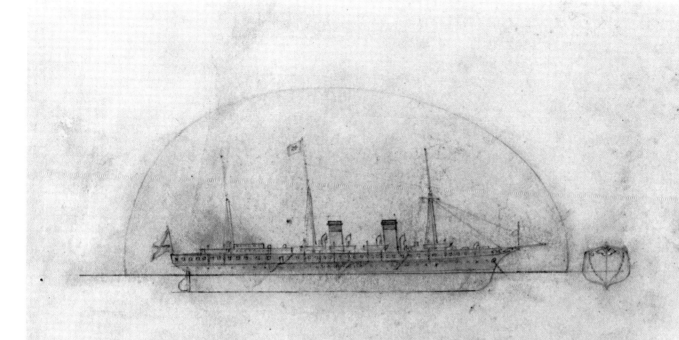

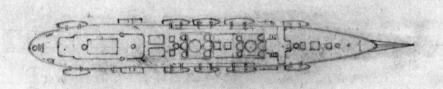

ЯХТА "ШТАНДАРТЪ.

before it was made. After her marriage in 1912 she was allowed to continue as a designer with Holmström, since she wasn't much good in the kitchen". Our two books are presumably part of what are referred to here as "the archives"; and it seems clear from the clue of the mosaic gem alone that they formed an integral part of Holmström's workshops.

Further valuable evidence emerged as a result of conversations and correspondence with Ulla Tillander at the time of the splendid exhibition "Fabergé, Hofjuwelier der Zaren", arranged in Munich by Dr. Géza von Habsburg.

We look forward with great interest to the article that Miss Tillander hopes to write on Alma Pihl-Klee. For the present, permission has been given to set down the relevant parts of letters sent from Helsinki; the first, dated December 30th, 1986, runs:

'The Holmström sketch books are a thrilling discovery. I talked to my old friend Miss Pihl, here in Helsinki, who for years literally sat at the side of her aunt, Alma Klee, listening to her stories from the workshop of Uncle Albert's.

Having seen the article in the Munich catalog, she says: "The text of the sketch books seems to be in Alma's handwriting. Her job in 1909 and 1910 at Holmström's was to sketch the ready-made pieces of the workshop into the books.

In 1911 she got a chance to do designs of her own. Alma remembered very vividly the day there was an order from the Nobel office, very urgently, to make up 40 small pieces, preferably brooches, in a *new* design. The pieces were not to be valuable, the material such that if the pieces were broken up there would be no mentionable value to them. These pieces were not to be understood as bribes. Alma got her chance to make the designs to this order. As ice crystals were very frequent on the draughty window glasses in those days, she suddenly got her inspiration from those. This is how the Nobel snowflakes came about." The year was 1911 or 1912.'

Following a visit to London where she was able to study the books in some detail, Miss Tillander writes on February 4th, 1987, as follows:

'Alma's handwriting and sketches end December? *1911*. Somebody else took over this mechanical work of copying pieces into the books. 6 different models of snowflake brooches were pictured in the books early in the year 1912. If the number on the side of each piece *6 (7)* for the fourth model means that altogether 37 brooches were made, the above story told by Miss Pihl seems to be correct.

After the first snowflake brooches comes an absolute mass production based on the same idea and I noted with interest how the idea developed, finally to become very stereotyped and to be a boring chore for the poor designer.

As far as the sketchbooks and their purpose goes, I noted with interest that Holmström's had the same system our firm had a few years back, in the glorious past when one could afford to have a big staff.

A piece made at our workshop was submitted to the following 'paperwork'.

1. Designer's sketch;
2. entered into production book and given a production number;
3. entered into a new book, the inventory book and scratched with the inventory number. Drawing of piece in the inventory book, all details of piece noted;
4. parallel to this, a 'stock card' was made with all the details of the piece and a good sketch of the piece.
5. A so-called sketchbook was compiled chronologically, the piece was nicely sketched, a few details of the piece were added. This book was compiled more or less to be of service to the retail shop and in order to plan the production.

It seems to me that the Holmström sketchbooks are of category 5.'

Page 213 of the first volume is devoted to six drawings of pendant frames and brooches designed to accommodate likenesses painted in enamel on silver or gold panels of selected members of the Siamese Royal Family. King Chulalongkorn was, for a number of years, an enthusiastic patron of the House of Fabergé.

A vividly-colored book recently published in Thailand (it seems to be innocent of date), evidently entitled 'Fabergé' (the name is inscribed on the spine – no title-page or author appear to be vouchsafed, although we are given a charming foreword by Her Majesty the Queen), nevertheless offers much new material which is both fascinating and welcome, including an amusing double stone figure of Tweedle Dum and Tweedle Dee to which Henry Bainbridge made an oblique reference in the form of a rhetorical question in his own book, entitled *Peter Carl Fabergé* and published by Messrs. Batsford in 1949.

It is a gross error to suggest that Carl Fabergé ever for a moment relinquished his role of artistic director of the firm. Every piece was required to pass the rigorous test of his personal judgement before it was allowed to be cased up, put on display and offered for sale. An extraordinary paragraph in this Thai book runs: "Fabergé's main job was not so much on the actual manufacturing side as in organization and management. This perhaps explains why no piece can be proved to have come from Fabergé's own hand. It could be said that Fabergé saw himself not as an artist in his own right, but as the leader and co-ordinator of a body of outstanding artists and craftsmen." The reason that Fabergé never signed any of the works he may have wholly or partly designed was quite simply that he was indeed a designer all his adult life and not a working goldsmith at the bench or a workmaster. To relegate him to a managerial role and not to regard him as being "an artist in his own right" is to misunderstand and denigrate one of the most lively artists in the recorded history of the goldsmiths' art. As he himself made clear in an interview given in 1914 at the age of sixty-eight, he was not to be counted among merchants – he was, he emphasized, an artist-jeweler.

The great bulk of the material contained in these books is anonymous, but happily, this is not the whole story and the following details need to be recorded.

The names or initials of particular members of the firm presumably responsible, in one way or another, for many of the examples illustrated for just over a fortnight in December 1913 and for part of the following year, appear above their descriptions. The name recurring most frequently at these particular times, which date from December 5th to the 23rd, 1913 and later from June 19th to November 27th, 1914, was that of Ivan Antony, a Balt, and one of the first managers of the Odessa branch of the firm which had opened in 1890.

Judging by the frequent appearance of his signature, Ivan Antony seems to have been virtually in charge of the studios at these periods. Antony has not hitherto been assessed or for that matter even identified as a designer and we still cannot pronounce with any certainty upon his main function in the business, though it does seem to have been, in essence, managerial.

The mystery surrounding his role is further compounded by the discovery that the several entries under the name Antony appearing during that first fortnight in December 1913 are all prefixed, not by the initial I for Ivan as is the case during the subsequent five month period dating from June 1914, but by the initial G. Two almost identical frost flowers (see ill. p. 55), one next to the name G. Antony and dated December 19th, 1913, and the other with the name I. Antony, dated August 27th, 1914, are certainly from the same hand, namely that, we now know, of Alma Pihl, who actually designed them. Any imagined father and son theory seems highly unconvincing here, especially in view of the following evidence. The majority of the names (four in number) in this shorter period are given

this same initial of G, and finding it difficult to explain the proliferation of G's, the thought presents itself that the initial stands not for any Christian name, but for the Russian title Gospodin or Mister.

The name of K. Gust, short presumably for Karl Gustavovitch Fabergé, appears in this early period, but he, after all, was the governor and would in all probability not be set down in the same form as the others, just as Ev. Karl and Ag. Karl, which also figure at this same time, must stand for Eugène Karlovitch Fabergé and Agathon Karlovitch Fabergé, the two oldest sons of Carl Fabergé.

Knowing nothing of any books before 1909, this fortnight seems to be the very first time names of individuals were set down at all and the preferred style to be employed had evidently not yet been finally settled.

In addition to the Russian initials K. P. and B. П (translating as K. R. and V. P.), the names G. Antony, G. Gurié and G. Kazak are found (referred to in the 1914 period as Ivan Antony, M. Gurié and A. Kazak respectively), as well as that of G. Piggott, who would have been entitled to his G. on both counts since his name was George – he was a Moscow Englishman recorded as an early manager of the Odessa branch.

The most distinguished of the personalities so vividly brought to life in the later section of the books covering five months of 1914, is that of the master himself; the initials, in Cyrillic characters standing for Carl Gustavovitch Fabergé, appear above eighteen jewel designs which must surely have been of his own inspiration.

Three others appear beneath the signature E. Fabergé, and one other with the initials EKF, all expressed in Cyrillic. They are those of Carl's son Eugène, the initials standing for Eugène Karlovitch Fabergé, whose main function, as he explained during the course of many conversations with the writer of these notes, was designing.

Bainbridge confirms this cooperation between father and son: "Eugène devoted himself almost entirely to designing, thus following in the tradition of his uncle Agathon. Quiet and unassuming, he worked behind the partition in the shop, in collaboration with his father, on initial ideas."

The other most significant name or initials to appear (8 times) during this brief and not necessarily typical span of five months was that of Fabergé's chief designer, François Birbaum. It should perhaps be pointed out here that these few months of what might be called the nomenclature now strikes us as being entirely arbitrary in the face of the earlier years of complete anonymity.

Some sort of policy decision must have been taken at this point. Could it have been Ivan Antony's, on being given a new, possibly administrative, responsibility? We shall probably never know.

One thing is certain however, and that is that seemingly random cross sections of this nature cannot be taken as reliable guides to the composition of the design studios over a period of a generation. Neither are we entitled to reject out of hand the possibility that the signatures merely point to some administrative responsibility for the project currently under way – after all, we do not even know for certain from whose hand or hands all the drawings derive. It would seem, to judge by the discernably varied techniques employed, that a group of different artists was involved. Eugène has stated that both he and his genial brother Alexander spent much of their time creating and carefully executing just such designs.

The name or initials of Paul Blomerius referred to by Bainbridge as of Swedish extraction, extremely international in outlook and known as the live wire at Fabergé's, but not a hint of his being a designer, appears, either in full (once) or with initials P. B., or P. P. B., above fourteen designs. The other names, not previously mentioned, which are set down are I.

Akvam, and V. Pugolovki in addition to the initials F. B., and N. R. Unfortunately we know nothing of these men or women.

Pressing enquiries in Russia nearly forty years ago had seemed to preclude the possibility of material of this nature ever turning up and becoming available for study. Research in that particular area at that time was not encouraged since objects of unashamed luxury epitomized precisely that which was anathema to the young socialist republic — they were scornfully rejected as toys for the rich which they unarguably were and happily continue to be.

Things have taken a turn for the better of late and Marina Lopato of the Ermitage, the most recent of a small band of scholars, has done valuable work in this documentary field, as evidenced in her article in the January 1984 issue of the *Apollo* magazine.

A third volume, a very exalted scrap-book, and not connected in any way with the two stock books we have been discussing, although acquired at the same time, is packed with original drawings and painted designs pasted cheek by jowl on each of its fifty-five pages. These would be listed as No. 1 in Miss Tillander's numbering. Two elegant drawings of the same subject depict a particularly romantic conception — it is composed of a row of cyclamen flowers and leaves to be expressed in brilliant and rose diamonds mounted in silver and gold. It was designed to be worn either as a diadem fitted on a prepared mount or as a flexible necklace. The original jewel has been found and was included in the recent exhibition (cat. no. 131) in Munich:

Finally, a working drawing for the model of the Royal Yacht "Standart" is shown from three different angles with a suggestion of how it was to be accommodated within the rock-crystal shell of an Easter egg. This is the preparatory design for what we now refer to as the Standart Egg of 1909, one of the Imperial eggs in the permanent collection of the Armory Museum in the Kremlin in Moscow.

When confronted with the finished composition, it has to be said that this beautifully-made 19th century miniature steamer, afloat on its aquamarine sea, imprisoned within an equally beautifully made Renaissance revival oviform casket based on a design by the 16th century goldsmith Jurg Ruel, really does strike a distinctly eccentric note.

Henry Bainbridge, in his invaluable book, writes of the well-known and very similar Easter egg, also in the Armory and dated 1891, containing a comparable model of the cruiser Pamiat Azova made by August Holmström "exact in every detail of guns, chains, anchor and rigging in which Nicholas II, when heir to the throne, made his voyage round the world".

Our Standart drawing comes from the same studio, not from the hand of August Holmström who had died six years earlier, but, in all probability, from that of his son Albert who, in Bainbridge's words, "continued in the fine tradition of his father." Convincing evidence of that fine tradition is happily preserved in these two books of Fabergé revelations.

Fabergé Design

On his educational travels throughout Western Europe between 1860 and 1870, the young Fabergé became acquainted with the neo-Gothic, Renaissance and Louis XV styles, taking them up in his repertoire along with Louis XVI, Empire and neo-classicism. Like many of his contemporaries, he was also attracted to the exotic forms of Oriental art, but unlike other European goldsmiths—let the name of Reinhold Vasters[1] suffice — he transformed these idioms into a highly personal language of his own. While Vaster's work must be regarded as being purely eclectic in style, Fabergé's took on an extremely individual form of its own in this period of artistic vacillation. The styles prevalent in the West during the 1860's and 1870's, with their pompous and overladen forms, had no bearing on the birth of the *style Fabergé*. Of course he owed much to earlier periods and has even been dubbed "a cultural sponge" (Snowman). Some of his work also came dangerously close to the very styles he was seeking to avoid, but it cannot be denied that his absolutely individual combination of European and Russian elements was very much in keeping with the best of Russia's artistic tradition.

From the 17th to the 19th centuries, Russian artists and craftsmen were continually exposed to the influence of Western art. On the one hand, the Czars received many important works of art as gifts from abroad (making the Kremlin Armory the unique repository of Western European 17th century silver that it is today), on the other, several monarchs, including Catherine the Great, commissioned works of art on a grand scale from Western capitals such as Paris, London and Vienna. Artists and craftsmen from the West also started trying their luck in Russia. This constant exposure left its mark on the applied arts of Russia. The work of Russian silversmiths was decisively influenced by German silver of late 17th century and rococo origin, as well as by French Empire *objets d'art*. Yet in all these cases, the work that was produced in Russia differed considerably from that of the West. Even master craftsmen who had come from West Europe to work in Russia soon found themselves carrying out work in a truly Russian idiom. This "genius loci", which was inspired by visions of vastness and the Oriental splendor of the Russian Empire, led to exaggeration in both format and ornamentation. Russian snuffboxes tended to be bigger than their Western counterparts and silver was more opulent; the jewelry was more lavish and decorative rococo elements found a more exuberant expression.

Fabergé's tribute to his mother country was not to be found in such typically Russian means of expression. On the contrary, his objects were carried out in a style diametrically opposed to this tendency for exaggeration. The essence of his work was understatement, and his objects tend to be miniature in format (although they invariably seem larger in memory). Indeed, the work that left his St. Petersburg workshops consisted of highly elegant but diminutive *objets d'art*. Even the Imperial Easter eggs, which are often enlarged in reproductions, sometimes only measure about 4" in height and rarely exceed 8".

Eugène Fabergé (1874–1960), ca. 1905

The designer François Birbaum in Switzerland, ca. 1935

A study for an inkstand (cat. no. 13) from Fabergé's design studio

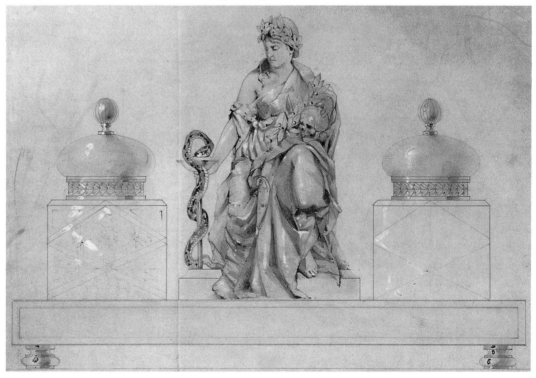

In St. Petersburg, Fabergé catered to the wishes of a cultivated, Western-oriented clientèle, which appreciated his sense of humor and his discreet use of understatement. Here retrospective tendencies were kept to a minimum – there were none of the copies of 17th century Russian work that Fabergé otherwise produced for the sober merchants of Moscow. Indeed, unlike his competitors, he made no concessions to the awakening consciousness of Russian identity and was more subtle in his use of patriotic elements. The restrained use of Empire features in his later *oeuvre* was a discreet reminder of the Russian victory over Napoleon in 1812 at the Battle of Bordino, which was otherwise loudly celebrated at the centenary festivities of 1912 (cat. no. 542). As can be expected, Fabergé did produce typically Russian objects however, such as icons, pectoral crosses, bratinas and kovches. In Moscow these were designed in accordance with local requirements while in St. Petersburg they took on the form of small, delicately-crafted *objets d'art*.

The year 1913 with its festivities celebrating three hundred years of Romanov rule brought about a profusion of objects embellished in double-headed eagles in the so-called "Romanov Tercentenary Style". Fabergé's Moscow branch followed this trend, producing commemorative pieces which were more refined and better-made than those of its competitors. In St. Petersburg, Fabergé paid tribute to Czar Nicholas II in a more restrained manner, as exemplified by the 1913 Romanov Tercentenary Egg[2], which was decorated with miniatures of the 18 Romanov czars as well as containing a globe made of gold and steel displaying the borders of the Russian Empire in 1613 and 1913.

It is not easy to determine to what extent the style of Fabergé's workmasters was influenced by the Master himself. Suffice it to say that the style and period of each one of the three chief jewelers employed in St. Petersburg are easy to distinguish, despite the fact that they overlap at times. Each one of them, whether Kollin, Perchin or Wigström, impressed his own personal mark on the products made under his supervision, giving rise to the assumption that Fabergé allowed his leading craftsmen a certain amount of leeway in their work.

Erik Kollin (1870–1886), who came to Fabergé at the age of 34, is the embodiment of the company's revivalist period. Probably a stolid worker (he had taken twenty years to achieve the title of master craftsman), very little of his work has survived to this day. His fame is based on his copies of the gold Scythian treasures which won Fabergé distinction in 1882 for the first time. Kollin's forms were simple and solid and and his preference for polished, hammered and fluted gold makes them easily recognizable..

Despite the fact that revivalist objects continued to be produced after Kollin had left the company, the influence of the new workmaster, Michael Perchin (1886–1903), a young and talented jeweler of 26 years of age, opened up the workshops to new techniques from the West. Kollin had been somewhat limited in his range of technical possibilities[3], but Perchin was brilliant in this field. He was responsible for practically every piece of Renaissance-style work that was to leave Fabergé's workshops as well as virtuoso pieces of goldsmiths' work. He favored the use of ornamental Louis XV elements and made continual use of *rocailles* as a kind of leitmotif. Fabergé was now able to fulfill the highest of technical requirements with Perchin at his side, and the latter's mastery of enamel *en ronde bosse* (curved surface) made the creation of exquisite little Easter eggs a technical possibility. Perchins's mastery of the varicolored gold technique also brought an air of refinement to Fabergé's objects that was reminiscent of small pieces made in 18th century France.

It was also under Perchin that Fabergé's art nouveau creations came to be produced in the years between 1898 and 1903. Although this was only a passing phase in Fabergé's *oeuvre*, he nevertheless became one of its leading exponents and he is known to have

associated with the *Mir Iskusstva* movement[4], a union of artist and writers, which was founded in 1898 and which published a magazine of the same name and which was comparable to Western associations such as the German *Die Jugend, De Stijl* in Holland, the *Arts and Crafts* movement in England and the French *Revue Blanche*. The 1898[5], 1899[6] and 1902[7] Imperial Easter eggs were celebrations of the decorative language of plants. On the whole however, Fabergé's adherence to art nouveau was confined to a naturalistic approach, as exemplified by his flower arrangements, which were not in the abstract idiom of work carried out by René Lalique[8] for example. Nevertheless, in the production of art nouveau silver, which was mainly carried out in Moscow (cat. nos. 56 ff.), Fabergé adapted his work to satisfy the taste of his clients. The results are carefully designed pieces of excellent workmanship, frequently set with jewels, that can be effortlessly assigned a place in the long tradition of Russian art.

What is known as the *style Fabergé* is also exemplified by Fabergé's functional pieces, such as cigarette-cases, which followed the most subtle of artistic impulses in the achievement of a practical purpose. These creations of Fabergé's art nouveau phase, made in the late 19th century, are of great versatility and originality and seem to anticipate the style of the 20's that was to come.

Indeed, one of the secrets of Fabergé's style lay in the modernity of his work, as he was ever ready to point out. He was forever absorbing the most diverse kinds of impulses and using them as a point of departure for new ideas. Numerous novelties were developed in his workshops or taken up by him and improved on. It is difficult to prove where the first atomizer, the first petrol lighter, the first powder compact and the first electric table bell were produced, but we know that Fabergé immediately made these ideas his own and improved and refined them. Another secret of his work is the fact that all his objects clearly bear the imprint of his personality, whatever the style they were made in. Whether produced by Kollin, Perchin or Wigström, whether classicist, Renaissance, baroque and Empire in form, Fabergé smolt these extreme opposites together in such a way that an easily identifiable style emerged. The *style Fabergé* is absolutely his own and one that has never been able to be imitated satisfactorily.

1 Yvonne Hackenbroch, "Reinhold Vasters, Goldsmith", The Metropolitan Museum Journal, 19/20, 1986, pp. 163-268.
2 Snowman, 1979, p. 114.
3 A group of objects, marked EK without any Fabergé hallmarks, but perfectly in keeping with Kollin's style, date from after 1899, with some occuring in Fabergé boxes. This seems to prove that Kollin occasionally produced objects for Fabergé between 1886 and 1901 after he had left the workshops.
4 Habsburg/Solodkoff, 1979, pp. 32-41.
5 Snowman, 1979, p. 98.
6 Ibid., p. 100.
7 Habsburg/Solodkoff, 1979, p. 128.
8 Baron Stieglitz and his School of Applied Arts also pioneered the introduction of art nouveau in St. Petersburg. In 1902 the Baron bought a series of Lalique objects (now in the Hermitage Treasury) in Paris, including the silver gilt vase on page 305 (cat. no. 630). Further illustrations of these objects are to be found in the 1986 Lugano catalog, cat. nos. 155–158.

Fabergé and 19th Century Historicism

In certain respects, Fabergé's early work was a logical result of the development of industrialisation and the historicist movement, both typical of the last three decades of the 19th century.

During the 1860's, when Fabergé undertook his *grand tour*, the historicist movement was gaining in momentum in Europe. Alessandro Castellani and Carlo Guiliano from London and Eugène Fontenay, Alexis Falize and Alphonse Fouquet from Paris were distinguishing themselves with jewelry at international exhibitions in London (1862), Paris (1867) and Vienna (1873). Without doubt, Fabergé came across these avant-garde exponents of *revivalist* jewelry and was inspired by their work in the Etruscan, Japanese and Renaissance styles. In search of artistic identity, he presumably also sought the contact of goldsmiths such as Reinhold Vasters in Aachen and Hermann Ratzerdorfer in Vienna, who were specialists in medieval and Renaissance pastiches. However, it can also be assumed that he was scarcely impressed by the overladen work being carried out by most silversmiths and goldsmiths of the period, with its pompous idiom typical of Victorian England and France of Napoleon III, Kaiser Franz-Joseph's Austria and Kaiser Wilhelm I's Germany.

Above and beyond these contacts to contemporary art movements, Fabergé's interest in Renaissance, baroque and 18th century art led him to visit numerous cities and princely collections. His studies in the Grünes Gewölbe in Dresden not only led to a direct copy of an 18th century object kept there (cat. no. 661), they also brought him into contact with the art of his great 18th century predecessor, Melchior Dinglinger (1664–1731), and his circle, as well as with the consumate work of the Saxon jewelers, hardstone-carvers and enamelers working in Dresden at the beginning of the 18th century. Dinglinger's art heralds many an aspect in Fabergé's *oeuvre*. The highest level of craftsmanship, as manifested by the miniature world of the "Court of the Grand Mogul", an object which predated Fabergé's art by over 150 years, anticipated his predilection for technical virtuosity in miniature. Figures composed of varicolored hardstones, valuable hardstone vessels mounted in enameled gold and *Kunstkammerobjekte* (rare collector's items), all preciously guarded in this incredible treasury, left an indelible mark on the young Fabergé, as did most especially the incredible fertility of Dinglinger's mind. The collections of the Medici family in Florence must have made a deep impression on him too, as did the craftsmanship of hardstone-carving carried out there at the *Opificio delle Pietre Dure*. It is also probable that he spent some time in Vienna, visiting the Imperial Collections there with their hardstone objects, jeweled flowers and 18th century Easter eggs. The most decisive impulses came without doubt from Paris. The elegance of French 18th century art and the exquisite quality of the workmanship involved, as exemplified by objects made of translucent enamel on *guilloché* surfaces decorated with girlands of flowers in *quatre couleurs* gold must have impressed the young artist deeply. It was also during this

period of study in Paris that he was to absorb the refined techniques of French goldsmiths and jewelers that he was later to make such versatile use of.

In this respect it must not be forgotten that from at least 1885 on, when he was appointed Court Jeweler, Fabergé had direct access to the Imperial Collections housed in St. Petersburg at the Winter Palace and the Hermitage, where the gold finds from Kertch and hundreds of original objects from the 18th century were kept. From an artistic point of view, Fabergé's *grand tour* can be regarded as having been superfluous to a certain extent, since exceptionally fine examples of French, German, Italian and English art were well represented in the Imperial Collections. The Czars had not only collected the work of Saxon hardstone-carvers as well as jewel encrusted gold boxes from Potsdam and objects by Dinglinger but had also acquired Italian pietra-dura articles and *objets d'art* from France and Switzerland, which were to be a constant source of inspiration to Fabergé throughout the late 19th and the early 20th centuries. Most of his early themes were based on objects kept in the Imperial Collections. His flower arrangements for example, were most certainly influenced by 18th century bouquets made by Pauzié (cat. no. 656) and single flowers, such as the diamond-and-pearl-set lily in a crystal vase (cat. no. 657). Miniature Easter eggs of the 18th century (cat. no. 651), enameled gold cane handles (cat. no. 649), miniature furniture and enameled French or Swiss gold boxes all served as points of departure for much of Fabergé's work. He imitated a set of four 18th century eggs (cat. no. 654) and a French 18th century necessaire in his

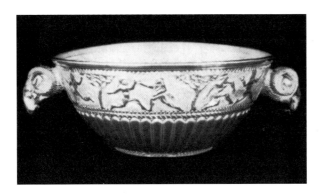

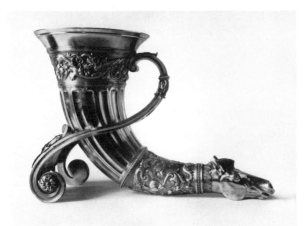

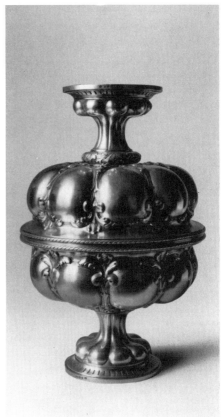

Gold bowl modeled on the style of the Kertch finds, Fabergé, St. Petersburg, ca. 1882
Silver rhyton, after an Achaemenid original, Fabergé, St. Petersburg, ca. 1882 (cat. no. 11)
Silver marriage cup in the Renaissance style, Fabergé, St. Petersburg (cat. no. 9)

continual search for new ideas for the Imperial Easter eggs, while James Cox's clockwork peacock, which was kept in the Winter Palace, and a *Régence* necessaire carried by two Arabs, stood model for his clockwork sedan-chairs (see illustrations on p. 69) He also made use of silver objects in the Imperial collection, which he either copied or modified in some way. His bagpipe-player was based on a German 17th century original in the Kremlin Armory (see illustrations on p. 70), while his toy vintage car was inspired by a Russian filigree toy belonging to the same collection.

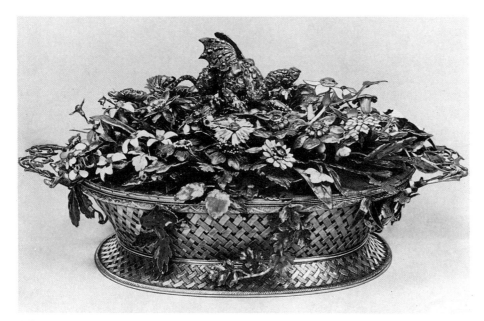

Basket of flowers made of colored enamels and jewels, G.C. Dinglinger, Dresden, late 17th century (formerly of Moritzburg Castle). This was possibly the inspiration for the basket of lilies-of-the-valley (cat. no. 401) made by Fabergé in 1896

This dependence on earlier sources is especially apparent in the work he carried out as a young artist (until ca. 1890). In his search for artistic identity, he tended to copy or pastiche during this period, but in doing so he was following the mainstream of West European historicism. Moreover, these eclectic creations never failed to bear the imprint of his creative personality and were always elegant and refined in character.

Fabergé's *oeuvre* was characterized by the *neo-antique* or revivalist style during the period when his workshops were being run by Erik Kollin (1870–1886). Kollin mainly made use of matt yellow-gold surfaces, both in plain and reeded form, and he frequently produced gold-mounted hardstone objects (mostly of rock-crystal) made in an antiquarian vein. It was during Kollin's tenure that Fabergé took on the task of copying selected items from the golden treasures found in Kertch for Count Sergei Stroganov, President of the Imperial Archeological Commission, in 1885. When the few pieces to survive this first documented commission are compared to the originals, it will be seen that Fabergé translated the archaological find (cat. no. 648) into a a handsome, sturdy bracelet made of burnished gold (cat. no. 88). Eugène Fabergé can remember that when the original and the copy were shown to the Czar, he was not able to distinguish between the two. Such work forms a pleasant contrast to the *neo-Etruscan* jewelry that was being made in England at the time. Fabergé also introduced the

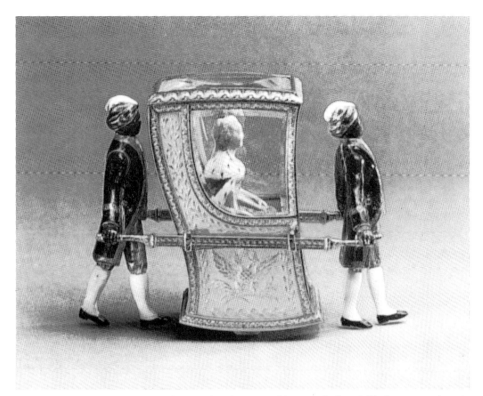

Czarina Catherine the Great seated in a sedan-chair carried by two clockwork blackamoors. Fabergé. Wm: H. Wigström, Hm: St. Petersburg, 1908–1917. (Sir Charles Clore Collection)

Necessaire with sedan bearers in Dinglinger's style, Dresden, ca. 1730. (The Hermitage, Leningrad)

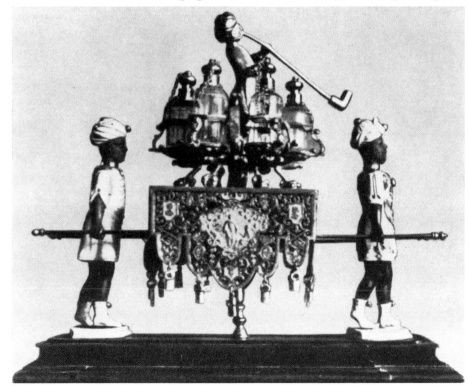

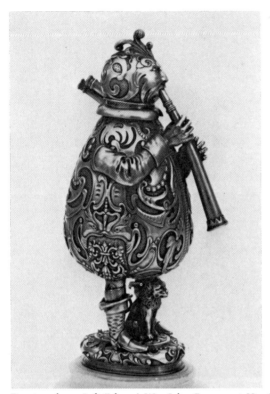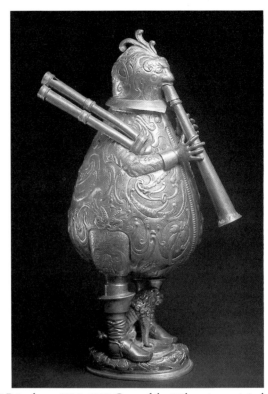

Bagpipe-player. Left: Fabergé, Wm: Julius Rappoport, Hm: St. Petersburg, 1899–1908. Copy of the 17th century original (right), kept in the Kremlin Armory Museum

Detail of a Royal presentation tray made of nephrite in the Renaissance style by Fabergé. Wm: Michael Perchin, St. Petersburg, 1901

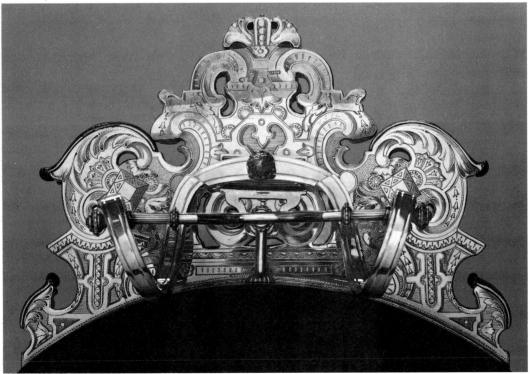

techniques of granulated and filigree gold to Russia as carried out by Castellani in London and by Eugène Fontenay of Paris for their copies of the Campana jewels. (These *bijoux étrusques* were exhibited at the Universal Exposition in Paris, 1867).[1] His *archeological* jewelry met with some following in Russia, as seen in the output of an Odessa workshop active towards the end of the 19th century, which was connected with the production of the famous Tiara of Saitapharnes made by Israel Rouchmovsky in 1895.[2]

The *neo-Gothic* style that was so popular in Germany does not seem to have influenced Fabergé to a great extent. His main pieces of work carried out in this idiom were a monumental and highly expensive (125,000 rubles) table-service for a Gothic room in Alexander Ferdinand-ovitch Kelch's mansion as well as a pair of vases for another Gothic room, this one in a house belonging to a Mr. Fischer, who was one of Fabergé's Moscow customers. In both cases, these were special commissions. Another neo-Gothic piece of work from the St. Petersburg workshops was a gold-mounted nephrite box, made by a later head-workmaster, Perchin, in the form of a reliquiary (cat. no. 246).

Fabergé's creations in the *neo-Renaissance* style consisted of a small number of showpieces produced by his head jeweler, the above-mentioned Michael Perchin (1886–1903). The Renaissance style was apparently considered as being especially appropriate for court circles, since most of Fabergé's works of art in this vein were specially commissioned for pieces made for presentation to Royal Houses. As in the case of work done by Reinhold Vasters and the the Vienna school, these objects were generally made of gold-mounted rock-crystal and had enameled ornamentation set with gem-stones. One such object is the 1894 Renaissance Egg (cat. no. 538), which is a copy of a casket made by the Amsterdam goldsmith, Le Roy (cat. no. 661). Further examples are a rock-crystal vase made by Perchin, which was presented to King George V and Queen Mary on the occasion of their coronation in 1911 by Leopold de Rothschild (cat. no. 279), as well as an oval dish with the coat of arms of St. Petersburg, which was presented to Czar Nicholas II on the occasion of his coronation in 1896 by the nobility of the same city (cat. no. 282). A further example is a presentation tray made of nephrite which was presented to Queen Wilhelmina of Holland by the Dutch colony of St. Petersburg on the occasion of her wedding in 1901.[3]

Fabergé's predilection for *rococo*, especially the Louis XV style of the mid-18th century, is also linked to the name of Perchin, and *rocaille* and other forms of Louis XV ornamentation are regarded as being synonomous with his signature. This baroque tendency in Fabergé's *oeuvre* derived mainly from mid-18th century French sources. The shell of the 1891 Pamiat Azova Egg (cat. no. 535), a copy of an 18th century bloodstone *bonbonnière*, led a contemporary French critic to rebuke Fabergé for imitating "French styles" too faithfully, saying: "We think he could easily have chosen some less well known but equally decorative means of ornamentation for each one of these objects"[4] However, both the Pamiat Azova Egg and the Richmond 1903 Peter the Great Egg[5] (illustrated on p. 96), which is a copy of a French necessaire kept in the Hermitage Treasury (cat. no. 653), are modifications of their originals in that changes were made in function.

The graceful *Marie-Antoinette style*, which is generally identified with the work of Henrik Wigström (Fabergé's third head-workmaster from 1903–1917) and *Empire* modes, were the most predominant idioms by far in Fabergé's *oeuvre*. The neo-Gothic, neo-Renaissance, neo-classicist and neo-baroque styles came and went, but the *style Marie-Antoinette*, which appeared towards the end of the 19th century, was to set the tone in the applied arts of Europe until the First World War, along with art nouveau. This courtly style of the 18th century was very much favored by the aristocracy of St. Petersburg and Wigström was able to combine Louis XVI and Empire elements while giving them a distinctly Russian touch.

The Empire style went down particularly well in Russia, because it called to mind the defeat of Napoleon by the Russian armies in the War of Liberation. This political aspect of Fabergé's work was very much in conformity with the political convictions of the conservative ruling classes.

While the exotic *Oriental styles* (whether Egyptian, Moorish, Persian or Chinese in character) only affecteed Fabergé's work in a peripheral sense, *Japanese* art was to exert a long-lasting influence on him.[6] In following the examples set by the Parisian jeweler, Falize, the London silversmith, Roskill, and Tiffany of New York, he proved himself to be a child of his time. Fabergé is also known to have possessed a collection of 500 netsuke. A number of his animals were based on these Japanese belt toggles (cat. nos. 63 ff.) but when compared to the originals, it will be seen that Fabergé used different kinds of materials and modified them in function, turning them into *objets de vitrine*. A series of Fabergé flowers, of which three pieces[7] are still in existence today, derive from *ikebana* arrangements, and Chinese and Japanese (Meiji) bronzes also served as prototypes for his work. He also adopted certain Japanese techniques, such as that of *shakudo*. Objects of Oriental origin, such as hardstone scent bottles from China, Mogul dagger clasps, seals from Syria or amulets from Arabia, were also mounted in gold by the Fabergé workshops.

In Russia, a rebirth in nationalist feeling led to the development of a style based on the country's artistic heritage, following a trend which was already taking place in Europe. This new idiom, based on Russian work of the 17th century, the Golden Age of Russian applied arts, was known as the *Pan-Russian* style. This form of historicism, typically Russian in character, was the only style of any originality to occur before the appearance of the *style Fabergé* and was much favored by the traditionalistic Boyar families and wealthy merchants of Moscow. It obtained offical sanction at the 1882 Pan-Russian Exhibition held under the sponsorship of Czar Alexander III and reached its peak during the festivities celebrating three hundred years of Romanov rule in 1913. The objects produced at the Moscow branch were Fabergé's contribution to this revival in national feeling, where the kinds of articles in popular demand were created with the help of the enameler Fedor Rückert. However, Pan-Russian art was only to maintain a peripheral position in Fabergé's *oeuvre*.[8]

In conclusion, it must be admitted that Fabergé owed much to styles of the past, whether Russian or foreign in origin. However, this copying was merely a first step, a means of acquiring stylistic elements which then found new expression in novel combinations and innovative uses. Fabergé was never guilty of purely stereotype copying. The distinguishing element between his work and that of his contemporaries is the development of a personal idiom, which blended traditional Russian forms with elements drawn from international movements in art.

1 Henri Vever, *La Bijouterie Française du XIXe* Siècle, Paris, vol. II, p. 144 ff.
2 Geoffrey Munn, *Castellani and Giuliano*, Fribourg, 1984, p. 153.
3 Habsburg/Solodkoff, 1979, ill. 51 on p. 44.
4 Chanteclair, 1900, p. 66 ff.
5 Solodkoff, 1984, table 87.
6 For a discussion of Fabergé and Japan, see Munn, 1987, p. 37 ff.
7 The London sales ledgers mention 6 Japanese flowers sold between 1907 and 1917. For extant examples cf. Habsburg & Solodkoff, 1979, pl. III; A la Vieille Russie, 1983, no. 472; Victoria & Albert, 1977, E 13.
8 For a recent discussion on Fabergé and the origins of his style, see Habsburg, 1987, p. 72 ff.

The Hardstones

Fabergé's interest in hardstones came about as a result of visits to European centers of hardstone-cutting in Dresden (Saxony), Idar-Oberstein and Florence. The art of hardstone-carving in Saxony harks back to the 16th century. Collections belonging to the Electors of Saxony (and later kings of Poland) comprise countless precious objects made of hard and semiprecious stones, mounted in gold, silver or enamel. The stones used included local jasper, agate, amethyst as well as serpentine and marble. During the 18th century, the Saxon tradition of stone-cutting was pursued by both the Dinglinger family and the producers of ornamental hardstone boxes in Dresden, where objects made of amethyst and agate were a speciality, with master craftsmen such as Heinrich Taddel, Johann Martin Heinrici, F.F. Hoffmann, Johann Christian Neuber and Gottlieb Stiehl producing snuffboxes made of semiprecious stones found in the Saxon mines (cat. no. 655).

Fabergé's studies in Frankfurt on Main with the jeweler Friedmann brought him within close reach of Idar-Oberstein, Germany's other main center for hardstone-cutting, where objects exhibiting certain proof of his style are still being made today. Several documents proving that specialists from Idar-Oberstein were engaged to work for Fabergé in his St. Petersburg workshops bear witness to this connection, which will be referred to again at a later point (see pages 74 & 79).

Tradition also links Fabergé's name to that of the *Opificio delle Pietre Dure* in Florence. This major Italian hardstone cutting factory, still in existence today, was founded by the Medici family who had a passion for antique stone vessels mounted in gold as well as for virtuoso pieces of goldsmith work from the 15th and 16th centuries. A speciality of the *Opificio* in Florence were the polychrome hardstone tabletops which were produced from the 17th until the end of the 19th century. Many of these works of art made in Florence were collected by most of the Royal Courts of Europe, including that of St. Petersburg. At the same time, Florence was also well-known for its religious figures made of stones set together out of different colors, an art in which Fabergé was later to distinguish himself. The use of purpurine in 17th century Florence may well be the origin of what has hitherto been regarded as Fabergé's exclusive use of it during the late 19th and early 20th centuries.

During the 18th and 19th centuries, Russian sovereigns maintained good political relationships with most European courts, (as proved by many of the objects reaching back as far as the 17th century which are now stored in the Kremlin Armory) and had received or acquired numerous Western *pietra-dura* objects, many of which are still visible in the Hermitage treasury today. Local jewelers were permitted access to these treasures and there can be no doubt that Fabergé initially sought inspiration from objects belonging to the Imperial Collection, making clever pastiches of existant examples at the beginning but later letting them inspire him to develop new ideas of his own.

Russia was also able to boast of a century-old tradition of hardstone-carving, with major centers at Ekaterinenburg and Peterhof on the Baltic coast, which were active throughout the 18th and 19th centuries for the Imperial court in the imitation of Western mosaics and tabletops. Another center was at Kolyvan, where the master craftsmen possessed special virtuosity in the production of monumental stone receptacles intended for St. Petersburg's palaces. The stones employed invariably originated in Russia and included jasper from Kalgan as well as polychrome marble and malachite. However, it would seem that the hardstone-cutting centers of Russia were only capable of carving softer kinds of stones with their antiquated equipment, meaning that harder materials such as agates, obsidian, quartz and rock-crystal may have had to be cut abroad.

On his return to Russia in 1870, Fabergé decided to diversify the production of his father's jewelry workshop by adding a new line in hardstone objects, as the choice of Erik Kollin as first head-workmaster proves. Kollin worked in yellow gold in the *archeological style* but also mounted hardstone objects, many of them in smoky quartz, in yellow-gold mounts reminiscent of the 16th century.

Fabergé's dislike of costly materials led him to examine his country's own potential in hardstones and to select them according to need and preference. The stones came from rich deposits in the Ural and Caucasus Mountains as well as from Siberia. Fabergé's favorite stones were nephrite, (spinach-green jade with dark inclusions), bowenite (a pale green or yellowish milky serpentine called after G.T. Bowen, who discovered it), and all kinds of chalcedony and agate, including agate stained to the color of honey. He also liked jasper, bloodstone and a gray kind of jasper found in Kalgan as well as lapis lazuli (a dark blue stone with golden spangles or pyrites), faultless specimens of rock-crystal and smoky quartz, obsidian (a dark gray or almost black kind of natural vulcanic glass with a velvety sheen) as well as aventurine (a green, brown or more rarely, blue or black quartz with gold flecks, which is mined in the Altai). To a lesser extent, Fabergé also used rhodonite (a pink marble with small black inclusions), purpurine (a heavy dark red vitreous substance produced by crystallization of lead chromate in a glass matrix) and malachite, (a bright green stone with pale veins which is applied in thin layers and found on the Russian border to Afghanistan).

Following the success of the Pan-Russian Exhibition in 1882, Fabergé took up the search for a hardstone-carving center outside Russia which would be capable of working the hardest of semiprecious stones. His journey led him to Idar-Oberstein, a little town specialized in the cutting and engraving of Brazilian agate, familiar to him from his time of study in Frankfurt. Here Fabergé took up contact with Elias Wolff and the Stern workshop, where he was provided with semiprecious stones cut to his wishes. It seems proven that Fabergé's famous gem-cutter, Derbyshev, also spent some time in Idar-Oberstein. Alfred Heine, a craftsman from the area who worked for the Wolff company, where he produced stone animals for Fabergé (cat. nos. 291 & 292), was also trained here.[1] Fabergé's numerous commissions not only brought about a new flowering for the old stone-cutting center, but also meant the introduction of the horizontal carborundum wheel to the town.

Fabergé soon engaged the services of a hardstone cutting factory belonging to Karl Woerffel and situated on the Obvodny Canal. This factory, which was later bought by Fabergé and run by Alexander Meier, played an important role in the production of his hardstones. Two of the craftsmen employed by this company, Kremlev and Derbyshev, were exceptionally gifted and also did work for other companies, including that of Cartier.

No matter where Fabergé's stones were cut, his elegant and subtle objects were carved with the greatest of virtuosity, often cut to almost paper-thin slivers and polished to the highest degree. His master craftsmen cut cigarette-cases, blades for paperknives, desk-sets,

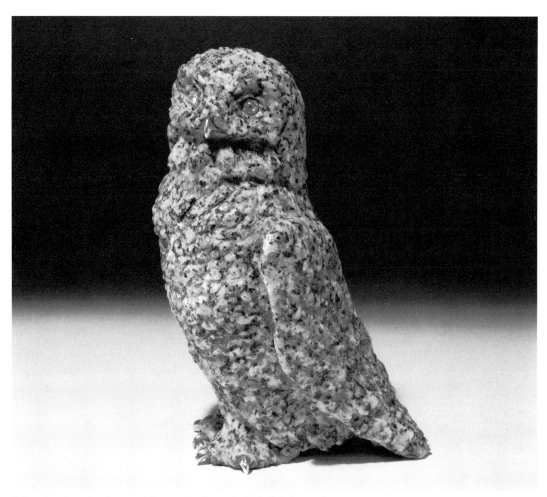

Fabergé owl made of gray-white granite (formerly Nobel Collection)

Fabergé obsidian seal lying on a rock-crystal ice floe

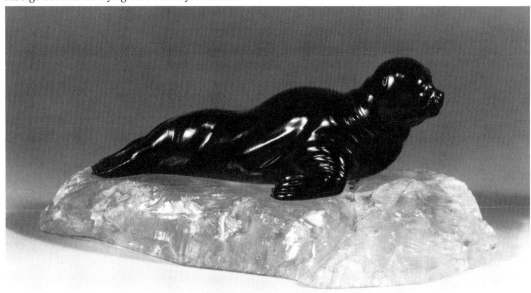

cane and umbrella handles, ashtrays, clocks, frames and handbells from nephrite for example. Bowenite was mainly used for glue-pots, picture frames, clocks, cane and parasol handles, handbells, desk-sets and tcharki, while objects in rock-crystal included snuffboxes, scent bottles, vodka cups, clocks, picture frames, bonbonnières, card-cases, ashtrays and spoons.

The stones, which were cut by unknown craftsmen, masters of their trade, were then given into the hands of gold and silversmiths, enamelers and jewelers, who refined them still further to a state where they could really be said to be Fabergé objects. This transformation generally took place in the workshop of Fabergé's head jeweler, where stones were enhanced with the use of colored enamels under his supervision. Thus nephrite and bowenite were always mounted in yellow gold or silver gilt for instance and embellished with dark red, white or salmon pink enamels while rhodonite and purpurine were generally framed in white enamel borders.

Originally, Carl Fabergé chose all the stones himself, until his son Agathon, who was later appointed by the Soviet government to restore and catalog the Imperial Crown Jewels, became company gemologist. The stones were chosen with the greatest of care in order to guarantee faultless work. Rare color effects were sought, either to satisfy the whims of fashion or to make the characteristics of a plant or animal seem more realistic.

Fabergé's Animal Figures

The origins of Fabergé's animal figures seem to go back to two very different sources. On the one hand, the creation of stone objects in the shape of animals or animal heads was very much part of Saxony's hardstone-carving tradition, with Dresden being a central production area for such objects which were generally made of amethyst. Several magnificent examples of these, including diamond-set jasper and bloodstone lions and dogs, were accessible to Fabergé in the Hermitage vaults. At the same time, we find very close affinities to Japanese and Chinese art. Fabergé is known to have possessed a collection of about 500 netsuke, which he probably bought at "Japan", a shop dealing in Japanese objects on the Newsky Prospect in St. Petersburg.[2]

The close affiliation between Fabergé's animals and Japanese netsuke has been known for some time. Snowman published a small number of comparative examples in the catalog of the Fabergé Exhibition at the Victoria and Albert Museum in 1977[3], with further examples being published in 1979.[4] A small exhibition of netsuke and Fabergé copies was also organized in London in 1978.[5] Further examples are constantly turning up, as this exhibition clearly proves (cat. nos. 363 ff.).

The influence Japanese animal carvings had on Fabergé can be explained by the very similar approach to nature shared by the Japanese and Fabergé, for like Fabergé, the craftsmen who carved the netsuke tried to make their animals seem as true to life as possible, studying every move that a particular animal made in order to represent its very essence in the turn of a head, the curve of a neck and in the stance it took up. Both Fabergé and the netsuke carvers were able to "catch" their animals to perfection. Both portrayed amusing antics or unnatural but humorous poses and sometimes exaggerated the shapes of bodies. Even in cases where no immediate derivation can be proved, Fabergé seems to have been fascinated by the compact forms of these Japanese toggles, for some of his animals are almost spherical in shape. A further connection is to be found in the mutual fascination for "tactile values", with the fur of a mouse being portrayed as lovingly as the warted skin of a toad or the slippery body of a worm.

Fabergé chose his stones especially carefully in order to imitate the natural coloring of an animal as closely as possible and was able to go beyond the possibilities of the ivory or

wooden netsuke in this respect. Speckled amazonite would be chosen for a toad and flecked pink aventurine quartz taken for a pig, while pink agate with black markings would be used for an earthworm. Stripes of black and orange portrayed the fur of an agate tiger and speckled black and white granite were used to represent the feathers of a fledgling Ural owl. In a few cases, polychrome hardstone elements were combined in order to increase the illusion of nature, as in the case of an obsidian cockerel with a purpurine comb, or that of a gray jasper tucan with an orange agate beak. Sometimes the tusks of an elephant and the horns of a buffalo were made of ivory, but these effects were (mercifully) rare.

The majority of Fabergé's animal carvings, such as dogs, cats, rabbits, koala bears, anteaters, monkeys, kiwis, poultry, boars and mice, which were portrayed in loving detail, were made of various shades of agate, including a version which was dyed by being cooked in a honey solution. Frogs, elephants and bears were often made of polished bowenite while nephrite was employed for snails, elephants and frogs. Obsidian was Fabergé's favored stone for seals, rats, pelicans, buffaloes, turkeys and horses while frequent use was made of pink aventurine quartz for pigs, squirrels, anteaters and horses as well as gray chalcedony for mice, dogs, swans and pelicans.

Special attention was paid to the eyes, which often consisted of rose-cut diamonds, giving the animals a lively, natural look. In larger models, the eyes were sometimes set in gold mounts or were made of olivines, emeralds, alamandines or rubies, either facetted or cut to the form of cabochons, depending on the animals being portrayed. The largest animals were given eyes made of circular-cut diamonds foiled with yellow enamel (as in the case of the granite owl on page 75) or rock-crystal set in yellow and black enamel (as in the case of the purpurine cat).

Few of Fabergé's animals turned out to be slavish imitations of nature. His best examples show psychological depth and are studies in animal behaviour: a rabbit for example is fearful, a cockerel glances up curiously and a donkey looks stubborn; a kitten plays, a mongrel cringes and an enraged elephant makes a wild attack. The rare caricatures in Fabergé's animal world were clever exaggerations of nature's foibles, as elephants as round as balls or laughing hippopotami seated on their hindquarters prove. These effects were often underlined by a "surrealistic" choice of color, as in the case of red elephants, blue rabbits and pale green baboons in a taste of the Walt Disney world to come.

The most celebrated collection of naturalistic animals, which was born of Queen Alexandra's love of animals, is to be found at Buckingham Palace. As sister of the Russian Dowager Empress, Queen Alexandra knew and admired Fabergé's work. This inspired Mrs. George Keppel, a close friend of Edward VII, to suggest having Fabergé make copies of the Queen's zoo at Sandringham as a birthday present for her. Fabergé's London agent's frantic cries for help brought the modelers Boris Froedman-Cluzel and Frank Lutiger to Sandringham, where they portrayed the Queen's favorite animals from life. Edward VII gave his blessing to this venture on December 8, 1907, whereupon the wax models were sent to St. Petersburg, to return as finished hardstone carvings. Edward paid for them in due order and they were given to the Queen on her birthday in 1908. Numerous additions were then made to the collection, either by the King himself or by some member of the Edwardian set. The only stipulation that the King made of Bainbridge, Fabergé's London agent, was that "We do not want any duplicates". Today the collection consists of over 350 animals, each and every one of them different. Indeed, all of Fabergé's creations are unique, a few exceptions set aside. If certain models had to be repeated, they were usually carved out of other materials. The duplications that are most likely to be discovered will generally be ones of elephants, which

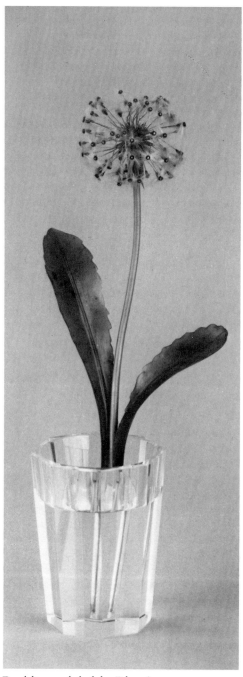

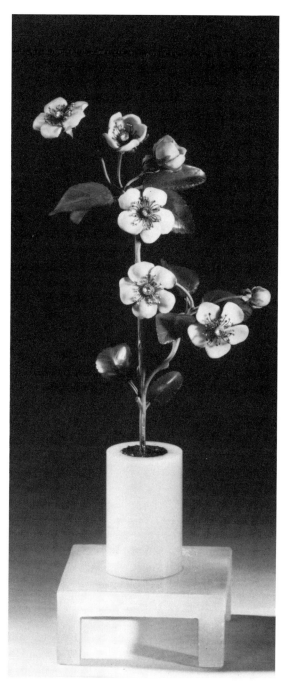

Dandelion seed clock by Fabergé

Japanese wild cherry in blossom by Fabergé (Robert Strauss Collection)

were always very popular, as well as of pigs, hippopotami, squirrels and mice, which do not allow much scope for variation.

The evident differences in style between certain types of animals puzzled experts for a long time. We may safely assume that animals which were designed by Fabergé, modeled by Boris Froedman-Cluzel, Eugenia Ilinskaya-Andreolotti or Elena Shishkina and carved in stone in his own workshops on the Obvodny Canal are consistent in style.

We now possess proof that Fabergé sent models of his animals to Germany, where a number of them were carved by Alfred Heine at the Stern worshop in Idar-Oberstein. Two dogs which were made by Heine in 1913, but not delivered to Russia, are still in existence there today as visible evidence of this fact (cat. nos. 291 & 292).

The recently published Cartier Archives[6] provide further information about the situation in Russia and Paris just after the turn of the century. For example, Cartier tried to lure away some of Fabergé's rich clients and travelled all the way to St. Petersburg in order to acquaint himself with the facilities for hardstone-cutting. By 1904 he had ordered about 160 items from the carver Svietchnikov, whom he found too expensive,[7] Karl Woerffel's factory on the Obvodny Canal, which also delivered to Cartier, proving to be more competitive in price.[8] In addition, further competitors of Fabergé's, such as Ovchinnikov, Dennisov-Uralski, Sumin and Britzin also set up their own stone-carving workshops. This naturally complicates the attribution of objects to Fabergé, especially since it is almost certain that he also acquired objects from his competitors. Virtually none of his animals were signed, but for a few that bear his carved signature. Animals with gold beaks or feet would be assembled in the workshop of the head-workmaster. Where hallmarks occur — and these are equally rare — they almost invariably belong to Henrik Wigström. The few animals with Perchin marks are exceptions to the rule.

Fabergé animals face the unexperienced collector with a very real problem. While the quality of enameling, chasing, hallmarks, wooden cases and the style in general are generally sources of valuable information in the identification of an object of vertu, hardstone animals can generally only be judged according to the quality of the craftsmanship involved, making judgement a very subjective matter indeed. For this reason, a certain amount of uncertainty may be involved in determining whether a stone animal can be attributed to Fabergé or not.

Fabergé's Flowers

In Russia with its long winters, flowers are regarded as being the harbingers of spring and as such they also represent the rebirth of nature. In winter they were transported (on ice) all the way from the South of France to St. Petersburg, where they were used to decorate lavish parties. Even to this day, the love of flowers is still evident in Russia at airports or memorials, where a few, lovingly chosen flowers seem to have more meaning than the exotic bouquets of the West. Seen within this context, it is not surprising that Fabergé's never-wilting blossoms soon achieved immense popularity with rich Russian society. The ladies of St. Petersburg liked to receive presents of Fabergé flowers particularly at Easter time. Whether because of their fragility or the high prices involved[9], Fabergé's flowers are as rare in number as his celebrated Easter eggs. [10]

The most likely source of Fabergé's flower-vases is probably to be found in the magnificent bouquets made by Court jewllers for their monarchs during the 18th century[11]. These bouquets, which were originally intended to be worn, are among the most beautiful objects to be found in European treasuries, including those of Vienna [12] and St. Petersburg (cat. no. 656). The Hermitage possesses three such arrangements, which must have been known to Fabergé. One of these now stands in a rock-crystal vase of undefined, later date. Another prototype to be found in the Hermitage is an elegant diamond-and-pearl-set lily (cat. no. 657), strongly reminiscent of Fabergé's later work. Much like his animals, Fabergé's flowers were partially derived from Oriental sources. Several Chinese hardstone flowers of the late 18th/ early 19th century display a similar use of stone, with technically perfect renderings of drooping nephrite leaves and semiprecious stone blossoms.

The flowers made by Fabergé are among his most delightful and elegant of creations, for no pains were spared in the production of an object that would imitate nature as closely as possible. The flowers were stood in vases of flawless rock-crystal which appear to contain water, the result of a *trompe l'oeil* technique which never ceases to amaze the public. In rarer cases – which experts unjustly tend to regard with suspicion – the vases are carved out of opaque semiprecious stone (such as agate, jasper and lapis lazuli) in imitation of flower-pots or tubs. The delicately shaped golden stems[13] of these flowers are finely engraved with microscopically thin lines, while their veined undulating leaves are usually carved of nephrite as thin as a wafer, or, more rarely, of enameled gold. Flowers and fruit were fashioned out of semiprecious stones or enameled gold and often have rose-cut diamond centers.

Fabergé did not seek a slavish imitation of nature with his flower arrangements; rather, his main concern was to achieve a decorative effect. For this reason, changes of season were sometimes ignored, as evidenced by a sprig of wild cherry bearing both blossoms and fruit.[14]. Naturalists may also deem it odd to find bunches of buttercups and cornflowers (cat. no. 394) and oats and cornflowers (cat. nos. 398 & 399) growing from the same stalk.

The large majority of Fabergé's flowers – of which only some 60 genuine examples are known to exist[15] – can safely be regarded as being unique. A small number of "favorites" however were duplicated, such as the popular rowan-berry sprig, the dandelion seed clock and several versions of lily-of-the-valley. The most famous of Fabergé's flower creations must be the basket of lilies-of-the-valley presented by the merchants of Nijni-Nowgorod to the Empress Alexandra Feodorovna on the occasion of her coronation in the year 1896 (cat. no. 401). This is the earliest dated flower arrangement to be made by Fabergé and the only one to have been hallmarked by the workshop of August Holmström.

Jewels in the form of diamond-crusted flowers became popular with French jewelers during the 1870's and 1880's, with stylized but quite naturalistic examples being produced by Loeulliard and Gallois for Boucheron[16] and by Massin[17], Lalique[18] and Vever[19]. This increase in floral themes heralded the development of art nouveau, which began to become evident in French decorative arts around 1893/94. Fabergé's flowers are his tribute to this movement, as expressed by the Easter egg of 1898, which is smothered in lilies-of-the-valley[20] or by another egg decorated with pansies, which was made in 1899[21]. Fabergé's involvement in art nouveau went hand-in-hand with his interest in Japanese art. A whole series of his flower arrangements was strongly influenced by the Japanese art of ikebana. No less than five Japanese flowers are mentioned in the London sales-ledgers. One of them, a Japanese pine which was sold to the Prince of Wales for £52.10 still belongs to the Royal Collection[22], while a Japanese wild cherry blossom surfaced during the Robert Strauss Auction[23] in 1976 (see p. 78).

Genuine Fabergé flowers rarely bear any hallmark, as the stems were considered too delicate to disfigure. Of the twenty flowers belonging to the Collection of Her Majesty, Queen Elizabeth of Great Britain, only two bear Wigström's initials. Only fakes display clear sets of hallmarks, including Fabergé's full name. Moreover, only the technically least demanding of Fabergé's flowers tend to be imitated - the raspberry being the most common choice by far. Idar-Oberstein, center of Fabergé imitations, produces lifeless-looking flowers with thick nephrite leaves. Parisian forgers, who started becoming active in the twenties, used to specialise in imitating bouquets of flowers such as bunches of anemones set in rock-crystal vases. These vases, with their tell-tale bases enameled with stripes, and the numerous visible flower-stems, make the identification of this kind of forgery an easy matter.[24]

1 I am indebted to Mr. A. Peth, Director of the Idar-Oberstein Museum, and to Mr. Klaus-Eberhard Wild for having drawn my attention to the fact that there was a connection between St. Petersburg and Idar-Oberstein (cf. "Über die Nachbildungen Fabergescher Figuren in Idar-Oberstein" by K.-E. Wild in the February 1981 issue of the *Goldschmiedezeitung*). Both associated companies lost their archives in the Second World War. Georg Wild, who was a well-known gemologist and hardstone-carver in Idar-Oberstein, supplied Eugène and Theo Fabergé with carved hardstones. Later, Eugène Fabergé sent Michael Ivanov, one of the designers at the Moscow branch, to Idar-Oberstein where animals, flowers and other *objets d'art* were created according to his models in the workshops of Hermann Dreher and Richard Becker.

2 In a photograph of Fabergé's salon in St. Petersburg, a cabinet can be seen in the background, filled with his collection of Netsuke (p. 32). The collection is said to have been sighted at the Hermitage in Leningrad, but no trace of it can be found today. The earliest examples in the Hermitage Collection are from the Stieglitz Collection.

3 Victoria & Albert, 1977, p. 36.

4 A.K. Snowman, 1979, pp. 64/5 and pp. 74/5.

5 Luigi Bandini, "Fabergé, the Netsuke Collector", *The International Netsuke Collector's Journal*, vol. 8, no. 2, September 1980, pp. 27–32.

6 Nadelhoffer, 1984, chapter 6.

7 Svietchnikov demanded 50 rubles for a nephrite beaker and 20 rubles for a parasol handle.

8 Woerffel's prices for the same objects consisted of 30 and 17 rubles respectively. In 1904, Cartier bought 8 parasol handles, 2 letter-openers, 2 ashtrays, 1 seal in the form of a mushroom, 2 tomatoes, 2 pears and 1 apple from Woerffel.

9 They cost between £10.10 for a pansy and £117 for a chrysanthemum.

10 The London sales ledgers describe 34 such flowers sold between 1907 and 1917, of which 22 alone are in the possession of the Royal Family.

11 A jewel-set bouquet made in 1788 by Bapst for Marie Antoinette, is illustrated on page 121 of *La Bijouterie Francaise au XIXe Siècle* by Henri Vever, Paris 1906, I.

12 A bouquet made by Grossner for Empress Maria Theresia is conserved in the Schatzkammer in Vienna.

13 None of Fabergé's flowers are known to have silver stems.

14 The Collection of Her Majesty The Queen (see Victoria & Albert 1977, E17).

15 Series of "Fabergé" flowers, all acquired from the same source, are exhibited in several American museums. These imitations, mostly in the art deco style, were made in France or Germany from 1938 on.

16 Vever, op.cit. (note 13), III, p. 409, pp. 411, 417, 423 & 472.

17 Ibid., p. 485.

18 Ibid., pp. 692, 694, 696 & 699.

19 Ibid., pp. 657 & 659.

20 Solodkoff, 1984, p. 76.

21 Ibid., p. 78 f.

22 Victoria & Albert 1977, E13.

23 Habsburg/Solodkoff, 1979, ill. III.

24 Whereas Fabergé's flowers invariably stand at an angle within their vases and lean against the edges, copies often stand upright with no visible means of support.

Fabergé's Hardstone Figures

ALEXANDER VON SOLODKOFF

The Fabergé figures, which were assembled from various kinds of semiprecious stones, are the strangest and most controversial objects to have been produced by the Fabergé workshops. Usually depicting genre figures, these stone sculptures are all characterized by a high degree of realism.

Along with the Imperial Easter eggs, these figurines are also the rarest of objects to be produced by Fabergé. Bainbridge maintains that no more than 50 were made[1] but since 47 have been traced to date, the total production may have amounted to between 60 and 80 figures altogether.

These little folkloric studies (standing between 4″ and 10″ in height) are subject to much dispute and are cited by some critics as being the worst possible kind of kitsch. In some cases they have even been compared to garden gnomes. In pre-Revolutionary times they did service as table decorations in a manner that has since gone out of fashion. Today such a use would appear to us as being in extremely bad taste.

The historical and artistic factors leading to the development of these little figures are the subject of this chapter. With regards to the means of portrayal, parallels can be discovered between the Fabergé figurines and Russian porcelain figures made during the second half of the 19th century, especially with regard to those produced by the Gardner manufactory in Moscow, as illustrated by the accordion-player seated on a bench (see illustration p. 84). The Gardner and Kuznetsov manufactories produced certain biscuit-ware figures from 1860 onwards which were to become extremely popular in Russia until the turn of the century. Whereas porcelain figures produced in the first half of the century were narrative and humorous in character, being based on figures taken from contemporary literature and the popular Lubok picture stories, they tended to become more realistic from 1860 on, probably being influenced by the work of the "Peredwizhniki"[2] or "Travelling Art Exhibition Association". This movement propagated a realistic and socially critical approach to painting, an idea which found expression in the work of Repin, Wasnetsov and Makovski, who were mainly concerned with portraying the life of the Russian people. This subject matter was taken up and typified in the porcelain figures, with the Gardner manufactory producing figures of a building worker yielding a spade and an inebriated peasant performing a dance for example. This interest in realistic representation is not only witnessed by the detailed reproduction of the costumes but also by the movements of the figures and the total impression they make.

These biscuit-ware articles, which were known as "concièrge figures" since they were frequently to be seen in porter's lodges, were in mass production by 1900 and had become very popular on a broad basis. Fabergé was able to make them acceptable to more exclusive circles by making use of other materials. He also added the occasional element of caricature

to his versions too, "petrifying" the dancing peasant in his exaggerated movements and capturing the stiffness of the soldier standing "at attention". This element of caricature is also to be found in the detailed portrayal of a marriage-broker and a painter.

Fabergé's use of semiprecious stones for such figures probably refers back to the Florentine art of hardstone carving of the 17th century, for it is known that he was inspired by the most diverse of art trends during the period of eclecticism and historicism that was characteristic for the second half of the 19th century. One possible example of such an influence can be seen in the statues of six apostles, an evangelist and an archangel, which are preserved in the Museo degli Argenti in Florence. These figures, which are about 14" high, were designed by Giovanni Bilivert sometime after 1605 for the ciborium in the Chapel of San Lorenzo in Florence. They were modeled in wax by the sculptor Orazio Mochi and sculpted of semiprecious stones by Milanese hardstone cutters, using the commesso technique. The emotional way in which the holy figures have been portrayed and the vivid choice of color for the stones corresponds well to the pompousness typical of the late period of mannerism.[3]

It was an obvious step for Fabergé to start producing similar work, especially in view of the fact that the wealth of semiprecious stones to be found in the Urals and Siberia was already being made extensive use of in the production of his *objets d'art*.

In contrast to figures carved of only one kind of stone (such as a caricature of Queen Victoria of England commissioned by Grand Duke Nicholas Nicholaievitch), those made of several kinds of stone date from after the turn of the century. The first figure sold in London for example, was registered in the year 1908, while others are engraved with the years of 1913 to 1915. Assay marks stamped into parts made of silver or gold date the figures to the period between 1908 and 1917.

The figures can be classified into three groups: folkloristic genre figures, portrait sculptures and figures modeled on characters taken from history and literature. The folkloristic category is the most extensive one and includes the figures of peasants and their wives, craftsmen, street vendors, coachmen, tradesmen, policemen and soldiers. Each individual character is imbued with remarkable liveliness, whether in posture or facial expression. The peasant youth, sitting on a wooden bench and singing to his balalaika, can be regarded as the epitome of Russian country life.

In some figures the use of realism led to a portrait-like quality, as in the case of the errand boy who worked at Fabergé's premises in St. Petersburg and who is shown wearing a peaked cap with the address of *24 Morskaya*. Although the move to portrait sculpture seemed a logical one, very few such figures were ever made. The most famous of these however is that of Varya Panina, a gypsy who sang in a village near Moscow named Yar, renowned above all among officers of the Guard for its boisterous parties. Varya Panina, who became an attraction because of her fascinating voice, was the cause of a tragic scandal when she died on stage singing "My heart is breaking ...", having taken poison as the result of an unhappy love affair. Fabergé's stone sculpture of her, measuring an unusually tall 6½", shows her in a green jasper dress, with a red and white marbled shawl and a purpurine headsquare.

A further example of a portrait figure is the one of Pustinikov, Czarina Marie Feodorovna's bodyguard, who accompanied the Empress on all her journeys from 1894 on. Both this figure and one portaying the bodyguard of Czarina Alexandra are said to have been commissioned by Nicholas II in 1912.[4]

With the exception of the historical figure of a boyar, which was probably based on a character from the opera *Boris Godunov*, most of the figures originating from literary characters seem to have been taken from the West, with Fabergé immortalizing not only "Tweedledum

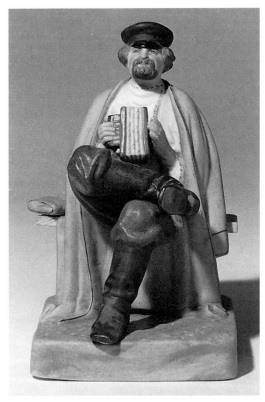

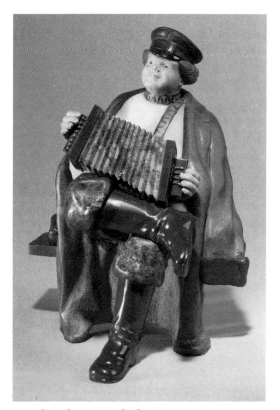

Accordion-player, Gardner Porcelain Manufactory, Moscow, end of the 19th century

Accordion-player, signed Fabergé, 1913, (formerly Nobel Collection)

and Tweedledee" from *Alice in Wonderland*, but also John Bull, Arbuthnot's satirical idea of the Englishman, as well as Uncle Sam, the typical American.

All the stone figures were made in St. Petersburg under the supervision of the head workmaster, Henrik Wigström, but the fact that his mark appears on silver and gold parts does not mean to say that he carried out the actual stone cutting himself. In St. Petersburg initial drawings would be made of a subject (with Pustinikov, the bodyguard of the Czarina, being ordered to stand model for Fabergé in one case), and then a wax model would be prepared, based on the drawing. Despite the fact that the names of several animal modelers are known, such as those of Boris Froedman-Cluzel, George Malychev and Alfred Pocock, no one artist can be directly connected with the modeling of the stone figures. The wax models were carved in hardstone and assembled in Karl Woerffel's workshop under the supervision of Alexander Meier, with artists such as Derbychev and P.M. Kremlev being employed at this stage.

The individual stones were carved in accordance with the model in question, then fitted together, glued into place and polished. The different parts were assembled so perfectly that the joints are invisible to the naked eye and frequently cannot even be detected with a needle. Attention was paid to the natural grain of a stone when a selection was being made for a certain model, in order to achieve the desired effect. Thus Varya Panina's cashmere shawl was rendered in speckled jasper for example. Finally the eyes would be made, fitting them with cabochon sapphires or more rarely, with rose diamonds.

The figures can be divided into two classes, according to the stone used for the faces and hands. In the first category they were made of pink skin-colored quartz, a relatively hard

stone which was carefully carved and polished, resulting in a shiny surface. This group includes the Varya Panina figurine, the figures from the former Collection of Sir William Seeds including the balalaika player mentioned before, and the Chelsea Pensioner.

In the second category a soft, porous stone, much like porcelain, was employed. This pale pink stone, which often used to be mistaken for a synthetic composition, consists of a whitish kind of porous opal known as cachalong. Due to the softness of this stone, Fabergé's craftsmen were able to carve facial features in exact detail, giving the figures an even more life-like appearance. Fabergé used cacholong predominately after 1913, especially in the figures made for the Nobel family.

Most of the figurines are unique pieces of work. Fabergé made it a principle to never mass produce his articles or make them in series. Duplicates were only made on rare occasions, as the result of a special request and in all such cases, Fabergé reserved the right to make slight alterations. In the case of the John Bull figure, for example, which was repeated several times, the version in the Collection of the King of Siam was given a nephrite jacket, while the one in the Sir Charles Clore Collection wears a frock coat made of purpurine. A third example is also mentioned in the London sales ledgers.[5] Duplicates of the Izvoshchik coachman and a painter are still extant and it is said that Fabergé also made a second version of the Varya Panina figure.

Most of the figures are signed under one foot with the name FABERGÉ; sometimes with the initial "K", in Russian or, more rarely, in Latin script; with the year and occasionally the inventory number. In addition to the firm's mark, silver and gold parts were stamped with the initials of the head-workmaster, Henrik Wigström, along with the St. Petersburg assay mark.

Emanuel Nobel, a Swedish oil industrialist living in Russia and a nephew of Alfred Nobel, probably owned the largest collection of stone figures before 1914 and he and his brother, Gustav, were among Fabergé's most important customers. Emanuel Nobel is said to have ordered a series of more than thirty stone figures. Many of the figures known today were originally in his possession, including a coachman (Legkovoi) sitting in a horse-drawn sleigh, made in 1914 as the largest piece of work Fabergé ever did of this kind. The coachman and sleigh are made up of different kinds of stones and the horse, with its silver harness, is carved out of red-brown quartz.

In the period between 1907 to 1917, only four stone figures were listed in the London sales ledgers, as follows:

John Bull, nephrite coat, white onyx waistcoat, yellow orletz trousers, black obsidian hat, boots, gold stick, buttons and watch-chain. Nr. 17099. 27 November 1908, S.Poklewski, £70.
Uncle Sam, white onyx hat, shirt and trousers, obsidian coat, orletz face, gray and red enamel waistcoat, gold watch-chain and buttons. Nr.17714. 10 September 1909, Mrs. W.K. Vanderbilt, £60.
Model of a Chelsea Pensioner in pourpourine, black onyx, silver, gold, enamel, 2 sapphires. Nr. 18913. 22 November 1909, H.M. The king, £49.15 s.
Sailor, white onyx, orletz, lapis lazuli, black onyx etc. Nr. 17634. 14 October 1913, Mme Brassow, £53.

The Chelsea Pensioner bought by Edward VII is still in the Collection of H.M. Queen Elizabeth II (cat. no. 385). A John Bull figure was acquired by the King of Siam along with a coachman (Likhatch) and Tweedledum and Tweedledee, which are all now to be found in Bangkok.[6] The Kremlin Museum in Moscow also houses the figure of a cook (cat. no. 388).

The following is a list of known figures from Fabergé's *oeuvre*, with details of provenance or current place of repository:

1. John Bull (formerly S. Poklewski)
2. Uncle Sam (formerly Mrs. W.K. Vanderbilt)
3. Chelsea Pensioner (Queen Elizabeth II) (cat. no. 385)
4. Sailor (formerly Mme. Brassow)
5. John Bull (King of Siam)
6. Coachman (ditto)
7. Tweedledum and Tweedledee (ditto)
8. Cook (Kremlin, Moscow; cat. no. 388)
9. Varya Panina (A la Vieille Russie, New York)
10. Bodyguard Pustinikov (formerly Hammer Galleries)
11. Dvornik, errand boy at Fabergé's shop (formerly The Sir William Seeds Coll.)
12. Boyar (ditto)
13. Balalaika player (ditto)
14. Carpenter (Plotnik) (ditto)
15. Manual laborer (Zemlekop) (ditto)
16. Man from the Ukraine (Hohol) (ditto)
17. Soldier in the Preobrazhenski Regiment (ditto)
18. Coachman (ditto)
19. Merchant (Kupets) (ditto)
20. Policeman (ditto)
21. Cherkess, 1915 (formerly The Lady Edward Reid Collection)
22. Street peddler (Raznoshchik) 1914 (ditto) (cat. no. 389)
23. Coachman (Izvoshchik) (ditto)
24. John Bull (formerly Sir Charles Clore)
25. Dancing peasant (Muzhik) (Forbes Magazine Collection, New York)
26. Officer of the 4th Kharkovsky Ulans 1914–1915 (ditto) (cat. no. 386)
27. Sailor (cf. No.4, The Pratt Collection, Richmond, Virginia)
28. Coachman (Likhatch) (A la Vieille Russie, New York)
29. Pastry vendor (Pirozhnik) (ditto)
30. Peasant woman with a parcel of cloth (Krestyanka) (ditto)
31. Peasant girl with a white blouse (ditto)
32. Officer of the Horse Guards (ditto)
33. Coachman with enamel belt (formerly The Collection Lady Howard de Walden)
34. Peasant girl with purpurine scarf (Metropolitan Museum) (cat. no. 387)
35. Merchant (Kupets) (Christie's, Geneva, November 1980)
36. Marriage-broker (Svatka) (Christie's, Geneva, May 1981)
37. Painter (Christie's, Geneva, May 1981)
38. Painter (formerly The Emanuel Nobel Collection)
39. Street vendor selling woollen material (ditto)
40. Bourgeoise woman carrying a purpurine parcel, 1913 (ditto)
41. Accordion-player (Garmonist), 1913 (ditto)
42. Peasant woman with a milk-can (ditto)
43. Lemonade vendor (ditto)
44. Peasant woman with basket and milk-can (ditto)
45. Bourgeoise woman with fur coat (ditto)
46. Coachman (Legkovoi) on a horse-drawn sleigh, 1914 (ditto)
47. Religious peddler (Bogomolets) (Parke-Bernet, New York 1970)

1 Bainbridge, 1949/66, p. 113.
2 Popov, V., *Russkii Farfor* (Russian Porcelain, Private Factories), Leningrad 1980, p. 220.
3 Piacenti Aschengreen, C., *Il Museo degli Argenti a Firenze*, Milano, 1968, p. 29.
4 Bainbridge, 1949/66, p. 112.
5 Solodkoff, 1984, p. 27.
6 Krairiksh, 1984, pp. 160-165.

The author would like to thank Dr Cristina Piacenti, of the Museo degli Argenti in Florence, for her kind help in locating the Florentine stone figures. He is also indebted to Mr Bernhard Magaliff, of Stockholm and Dr. Fabian Stein, of Ermitage Ltd., London, for providing technical information and corrections to the text.

Techniques and Materials Used in the Fabergé Workshops

Enamel

The quality of Fabergé's enamel was justly celebrated. The techniques he used were unique for their time and a closely-guarded company secret. His profound knowledge of this material undoubtedly went back to the time of his studies in Paris during the 1860's, when enameled objects of the Louis XV and Louis XVI periods, such as snuffboxes, etuis and chatelaines, had a great influence on him.

On his return to St. Petersburg, these studies bore fruit. The collaboration with the young goldsmith Michael Perchin brought about a change of policy within the company. While during the first decade, the firm specialized in jewelry , the mid-1880's saw the introduction of enamels and varicolored gold. A snuffbox presented to Bismarck by Czar Alexander III in 1884 (cat. no. 404), which is signed by the gifted young goldsmith, Michael Perchin (who was not yet working for Fabergé as head-workmaster) is typical of this period. The *guilloché* enameling is reminiscent of earlier work produced in Geneva and the combination of large expanses of wave patterns with brownish-red enamel is still unattractive in effect.

When Michael Perchin became head-goldmaster in 1886, many technical skills had been developed. This is evidenced by the 1887 Imperial Easter Egg[1], the earliest dated example of enameling and varicolored gold decoration to be made in Fabergé's workshops in the Louis XVI style. Here it is evident that Fabergé had now mastered the difficult technique of enameling curved surfaces (*en ronde bosse*). It was also during this period that Fabergé accepted the challenge to "reproduce" a golden 18th century Louis XVI snuffbox from the Imperial Collection. Fabergé's imitation was carried out so perfectly that the Czar was not able to tell the two apart. Both the original and the successful copy are now in The Forbes Magazine Collection (cat. nos. 403 and 403A). A number of similar pastiches show that Fabergé was fascinated by this kind of work and are evidence of his ability to to re-create every type and hue of French 18th century enamel (cat. nos. 439, 444, 466 & 472).

The enameling process itself involves heating a compound of glass and metal oxides until it begins to liquidize, with clear enamel melting at about 1470–1560 °F. (grand feu) and opaque enamel at about 1320–1470 °F. (petit feu). The liquid mass is then applied to a metal surface, generally of silver or more rarely, of gold, in a process requiring several firings. In the Fabergé workshops, successive coats of enamel were applied at gradually decreasing temperatures, the finest examples having up to six layers. Fabergé's famous "oyster" enamel was obtained by applying several coats of clear white enamel onto a layer of semi-transparent enamel a warm orange in color, creating an iridescent effect when the object was held to the light. In some cases the penultimate layer was painted with flowers or trees, creating an illusion of dendritic moss agate reminiscent of the French snuffboxes made by craftsmen such

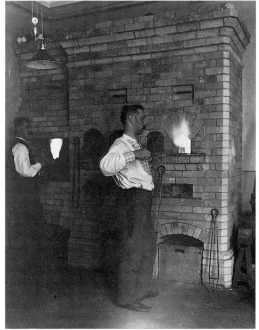
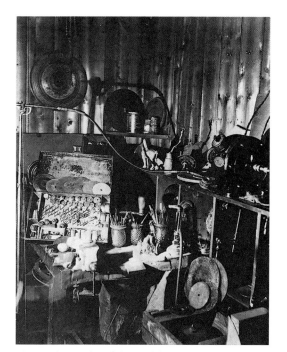

The enamel firing kiln at the St. Petersburg workshops The London studio of the modeler A. Pocock, 1914

as Jean-Étienne Blerzy. This technique was used for a group of snuffboxes, highly prized by the aristocracy, which were made with panels of pink or sepia *camaieu* enamel painted with views of palaces (cat. nos. 470 & 471). Objects such as Fabergé's sedan chairs[2] however, in which Louis XVI motifs were painted in gold under the final *fondant* coat (cat. no. 485), were the ultimate peak in the art of enameling.

Like French 18th century goldsmiths, Fabergé decorated the metal surfaces of his enamel work using a machine called the *tour à guilloche*, which functioned similarly to a turning-lathe. With this method he was able to produce any kind of pattern, animating the surface of enamelwork still further, his favorite motifs being moiré, sunburst and wave designs. Enamel treated in this way was sometimes embellished with hand-engraved flower swags, and special brilliance could be obtained by applying a coat of platinum over the silver *guilloché* ground.

The texture of Fabergé's enamel has never been equalled. His objects are famed for their velvety feel, which can only be obtained when the enamel is dedicatedly polished with a wooden wheel and chamois leather for many hours - a lengthy process indeed.

As in the case of hardstone-carvers, the work done by enamelers was generally anonymous, for neither group of craftsmen possessed a hallmark of their own. However, thanks to Eugène Fabergé, the names of the men who produced Fabergé's enameled works of art are known. They are Alexander Petrov, his son, Nicholas, and Vassili Boitzev, all assisted by a staff of lesser craftsmen. Objects in translucent enamel were also produced by the branch workshop in Moscow. Though generally of a lesser quality, some rare examples did attain the exceptional beauty of St. Petersburg enamel (cat. nos. 486 & 505). The names of the Moscow enamelers however, remain unknown.

Fabergé catered to the more traditional taste of his Moscow clientèle by producing articles in *cloisonné* enamel, a technique which enjoyed a very long tradition in Russia, going back to the 16th century and reaching its peak during the second half of the 17th century. During the 19th century it was revived by Russian craftsmen and examples are known which

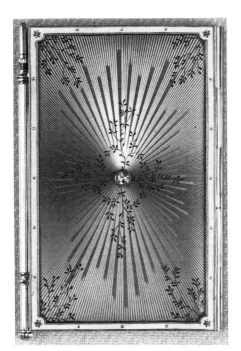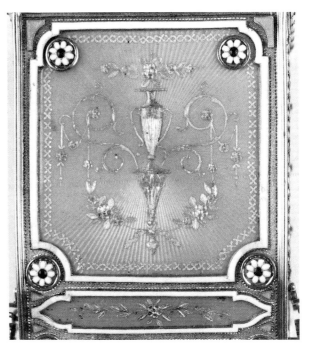

Two examples of enamelwork produced by the Fabergé workshops

were made during the 1880's. According to this method, metal wires are soldered onto a silver surface to form little cells (*cloisons*) which are then filled with colored opaque, or more rarely, with translucent enamel, to form stylized floral patterns and arabesques.

Initially Fabergé retailed *cloisonné* enamels made by his competitors, as evidenced by products made and hallmarked by the workshops of Maria Semenova, Saltikov (cat. no. 80) and Ovchinnikov, which were sold in Fabergé boxes and also bore his hallmark. In some cases, these early enamels bear the Fabergé punch alone, indicating that they might have originated from some other source, possibly even from Fabergé's own workshops. From 1887 on, Fabergé employed the enameler Fedor Rückert in Moscow, whose style differed greatly from that of Fabergé's competitors, being strongly influenced by art nouveau. Rückert also worked in the *cloisonné* technique, but in his case the metal wires took on a life of their own, often forming spirals or pellets. Moreover, Rückert filled every possible space with enamel, even the background areas, and preferred colors which were mainly pastel in tone, such as cream, pale gray, steel blue and olive green ones. Rückert combined his *cloisonné* technique with enamel *en plein* in the form of panels painted with scenes from Russian history or mythology. In rare cases he combined polychrome and black *cloisonné* enamels to startling effect. Another unusual feature of his work was that the wires were not gilded until after the enameling process had been completed, giving his work a lighter touch.[3]

Gold, silver and other materials

The surfaces of objects made of enameled gold or silver, or hardstone (as described in the previous two chapters), were often embellished and enlivened with borders chased with reed-and-tie and laurel-leaf decorations, or applied with flower swags, acanthus foliage, laurel wreathes and stylized scrolls. Soon Fabergé was also adopting the technique of varicolored gold common to French boxes made during the 18th century. As is well-known, varicolored

gold can be obtained by adding small quantities of certain minerals to yellow gold. For instance, the addition of silver will bring about a greenish hue, and copper will produce a red one, while nickel or palladium will result in a whitish tone. Including yellow gold, these four basic colors form what is known as *or à quatre couleurs*, a technique which snuff box makers of the 18th and early 19th centuries excelled at. But Fabergé went further and by experimenting with various additives, achieved even rarer shades such as blue, orange and gray. Contrary to the 18th century technique however, in which varicolored gold decorations were chased as part of the object, Fabergé attached these embellishments to the enamel or hardstone surface by means of pins. These embellishements took on the form of lavish swags and garlands, in which the green-gold foliage was set off by individual flowers in other colors of gold. There are also abundant examples of silver gilt articles adorned by such varicolored gold swags.

One of Fabergé's absolute novelties was to juxtapose surfaces of metals or different colors of gold, as in his cigarette-cases, for example. Some of these masterpieces of craftsmanship are unbelievably intricate in design, having ribbed or fluted bands of platinum (or red, yellow and green gold) radiating from a single point (cat. no. 159), while others have waved surfaces in varicolored gold, which is technically even more demanding. The hinges on these cigarette-cases are invisible and the lids fit so tightly that catches seem superfluous. They close with the gentle hiss of escaping air, remaining shut of their own accord, and most of them only have one single embellishment, namely that of a cabochon sapphire catch.

Occasionally Fabergé used the *samorodok* technique on some of his gold or silver pieces, in order to obtain a kind of "nugget" effect. This was done by heating the metal to just below melting point and then abruptly cooling it down again.[4] Fabergé also used the *niello* method in a very few pieces (cat. no. 43), one example being a Louis XV style milk jug made in the Moscow branch to complete an 18th century tea set.[5]

It should be noted that Fabergé used silver, vermeil and gold as a means of artistic expression, and not for their intrinsic value. This is particularly true of cigarette-cases in red gold, which were given an additional coat of yellow gold (cat. no. 156).

Fabergé's *silverwork* was a speciality of the Moscow branch, where small articles, such as art nouveau cigarette-cases, and the most gigantic of presentation pieces were made. Here the local bourgeoisie could take their choice of a seemingly endless selection of table-silver, flat-ware, cutlery, candlesticks, center-pieces, beakers, tankards and kovches fashioned in every kind of style, neo-rococo being the favorite (cat. nos. 44 ff.).

The Moscow craftsmen worked silver in varying techniques, burnishing, chasing, embossing and matting it, and even oxidizing it in a novel technique that Fabergé developed. Although silverwork from the Moscow workshop does not necessarily differ from that produced by competitors, it can be distinguished by the high quality of the workmanship involved and by the sheer weight. Indeed, some pieces can be attributed to Fabergé simply by being picked up.

A number of animal models are among the more endearing silver articles produced in Moscow. Some are purely ornamental in function, standing on hardstone bases (cat. no. 61) while others fulfill some practical purpose, such as that of a bellpush, a vase or a wine jug (cat. no. 73). Silver-mounted furniture was also produced by Fabergé in Moscow.[6] Fabergé used *platinum* mainly for jewelry, (it was not considered very valuable at the time), because of its optical and technical qualities. Unfortunately, since a hallmark was not required for platinum in Russia, the identification of Fabergé creations in this metal is very difficult. It is possible that many a family safe contains unrecognized pieces of Fabergé jewelry, unmarked and without their original cases. The discovery of design books from the Fabergé jewelry

workshops (see p. 45 ff.) will throw much-needed light on the subject and may permit new attributions to be made. Fabergé also used platinum in conjunction with rock-crystal for commissions, as for the 1913 Winter Egg[6], as well as for the snow-flake jewelry made for the Nobel family (cat. nos. 109-111).

Steel and *copper* were sometimes made use of to achieve special effects. For example, the egg which was made in 1913 to commemorate the Romanov Tercentenary (and which is now in the Kremlin), contained a blue steel globe with the borders of the empire inlaid in gold.[7] During the First World War, Fabergé's clients also favored steel cigarette-cases mounted in gold (cat. no. 20) and countless ashtrays and cigarette-cases were produced in copper (or silver) and embossed with Fabergé's name and the inscription of "1914 War" (cat. nos. 52 & 54) Fabergé also produced a small number of miniature copper kitchen utensils (cat. no. 19) during the war.

Fabergé's firm did not baulk at the idea of using wood for certain articles, as a number of palisander cigarette-cases prove (cat. no. 22). The wood was carefully chosen, beautifully stained and polished, and decorated with applied gold scrolls, as in the case of polished birchwood frames which were combined with pastel-colored enamels. Such examples document Fabergé's attitude to materials, which was so so very different to that of his competitors. He was not concerned with intrinsic value, choosing his materials according to artistic merit instead and enhancing his choice with superb craftsmanship.

In addition to the materials already mentioned, Fabergé also provided the settings for articles made of *stone, porcelain, faïence* and *glass*, which were made elsewhere. The porcelain, a rarity in Fabergé's *oeuvre*, originated in the Imperial porcelain factory in St. Petersburg, while earthenware pots, often conspicuous in color, came from the Stroganoff School in Moscow, the Kuznetzov factory, from Rörstrand in Sweden and from England (cat. nos. 35 & 37). For a time Fabergé-mounted art nouveau glasses made by Loetz, Gallé and Tiffany were also popular.[9] And finally, even simple stone was made use of, being hollowed out into the shape of animal figures to do service as receptacles for matches, which could be lit by being struck on rough areas of the stone (cat. nos. 38 & 40).

1 Habsburg/Solodkoff, 1979, plate 89 f.; Solodkoff 1984, p. 73.
2 Habsburg/Solodkoff, 1979, plate 89 f.
3 Rückert did not work exclusively for Fabergé. While items with Fabergé's hallmark, (often obliterating Rückert's) were obviously made for the company of Fabergé, objects marked only with Rückert's hallmark were sold via other outlets. However, there is no stylistic difference between both groups.
4 Snowman, 1962/64, ill. 87.
5 Ibid., ill. 98.
6 Habsburg/Solodkoff, 1979, plate 3.
7 Snowman, 1979, p. 111.
8 Ibid., p. 114.
9 Snowman, 1962/64, ill. 58.

Fabergé and the Easter Egg

Easter presents in the form of sumptuous eggs with contents which are both amusing and unexpected enjoy a tradition of long standing in Western Europe. Extant French, Danish and Austrian examples made in the 18th century, all of royal provenance, represent a small fraction of what must have been customary at these extravagant courts. These Easter gifts include a pair of ivory eggs containing miniatures of bucolic scenes, which were given by Louis XVI to his aunt, Madame Victoire, and which are now kept at the Musée Lambinet in Versailles.[1] Two other eggs, both very similar, are to be found in the Imperial Collection in Vienna and as part of the Royal Danish Collection (cat. nos. 663 & 662 respectively). Both belong to a series of small eggs which were found to contain a chick when opened up, a theme which was continued into the 19th century, as enameled examples from Vienna indicate (cat. no. 660). The tradition of exchanging Easter eggs was also known in Munich, with King Ludwig II presenting his mother, Queen Marie, with the most lavish of examples (see ill. 5).

In Russia, Easter is the most important feast day by far and it is common among the population to exchange Easter eggs made of all kinds of materials, whether porcelain, Lukutin papier-mâché or hardstone. Wealthy courtiers sought more opulent presents and the Hermitage treasure vaults contain several valuable examples from the 18th century, which are all connected with the Imperial family in some way. Potemkin for example, is said to have given Catherine the Great an egg-shaped enameled *brûle-parfum* made by Duc[2], while a little egg-shaped sewing case is traditionally said to have belonged to Czarina Elizabeta Petrovna[3] (cat. no. 653). A series of four ribbed goblets, made of gold and glass in the form of an egg, were also in Imperial possession (cat. no. 654).

Pendants in the form of miniature Easter eggs did not appear until the 18th century. Diamond-set examples of these, housed in the vaults of the Hermitage, undoubtedly served Fabergé as models (cat. no. 651). His countless variations on the theme made the miniature eggs very popular. They were worn by both girls and ladies of good society, dangled from chains which got longer and longer since they were constantly being added to. Some came to number over one hundred eggs (cat. no. 531). Fabergé, the inveterate innovator, designed thousands of these little pendants, scarcely repeating himself in the process. They ranged in form from simple models made of monochrome *guilloché* enamel to lavishly painted ones, from unadorned hardstone versions to examples of more complex design and shape, from plain smooth gold varieties to exquisitely fashioned ones made of jewels, with further specimens existing in the forms of fish, insects, flowers, helmets, and birds (cat. no. 528).

Fabergé also used the motif of the Easter egg for *objets d'art* such as spirit burners (cat. no. 194), bonbonnières (cat. nos. 177, 214, 229 & 249), parasol handles (cat. nos. 170, 171 & 173), glue-pots (cat. no. 195) and seals (cat. no. 192).

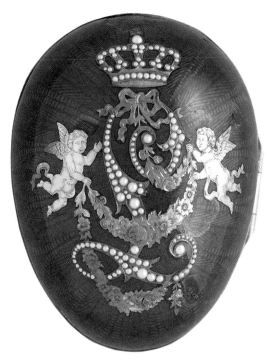

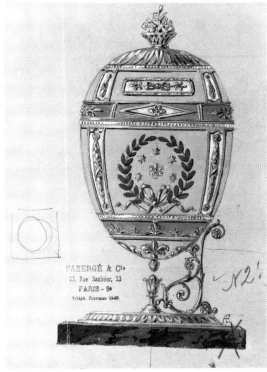

Royal Easter Egg, 1881, a present from King Ludwig II of Bavaria to his mother (King Ludwig II Museum, Herrenchiemsee, inv. no. 18908231)

Water-color study of an Easter egg from the Fabergé workshops, signed A. Fabergé

The Imperial Easter Eggs

Fabergé's series of Imperial Easter eggs has been described with some justification as being "the last blossoming of European art in the service of great patrons"[4]. The forty-seven examples still in existence are without parallel in the history of art, for here a jeweler's genius was granted free rein without the usual constriction of financial considerations.

The story of these commissions has often been told, but the appearance of new information makes a revision necessary. Fabergé's first commission for an Easter egg, granted him by Alexander III, is usually connected with his appointment as Court Jeweler in 1884. However, at the beginning of a list of Fabergé Easter gifts, which has been recently published[5], a "white enamel Easter egg with a crown set with rubies, diamonds and roses" is mentioned as having been made in 1885. The egg, which is probably in The Forbes Magazine Collection (cat. no. 532), can therefore be dated as having been made for 1885. This list invalidates all previous attempts to date the earliest eggs since, while it confirms the dates for two unknown eggs (1885, 1887), it describe five more eggs which have since been lost, namely those for 1886, 1888, 1889 and 1890, thus eliminating other traditional candidates for these years.

However, what does appear certain is that Alexander III, encouraged by the successful result of his first commision for a Fabergé egg in 1885, decreed that an Easter egg be made every year hereafter. His son, Nicholas II, carried on the tradition after Alexander's death in 1894, giving his mother, the Dowager Czarina Marie Feodorovna, and his wife, Alexandra Feodorovna, an Easter egg every year. Therefore at least ten eggs were produced during the reign of Alexander III and a further forty-six were made during the term of Nicholas II.

Today, forty-seven of the original fifty-six are known to exist. Ten are kept in the Kremlin Armory while a further eleven are part of The Forbes Magazine Collection in New York. Another sixteen are in American collections with eight more belonging to private European ones. There are also photographs of two further eggs, leaving only nine unaccounted for.

Since the appearance of the Russian list, it has become apparent that not all the fifteen eggs ascribed to Alexander III's reign can be accounted for in the nine years available. Therefore, several eggs will have to be redated, possibly using style as a criterium.

In the following list the years set in bold type refer to eggs still in existence that can be dated with certainty; those in normal type can be dated, but are lost, while those set in italics are of uncertain date.

Imperial Easter Eggs made by Michael Perchin, 1885-1903

Eggs given by Alexander III
to Marie Feodorovna:

to the Czarevitch (?):[6]

1885	First "Hen Egg" (Forbes) (ML)[7]		
1886	Egg with a Hen in a Basket (ML)		
1887	Serpent Clock Egg (Forbes) (ML)		
1888	Angel with an Egg in a Chariot (ML)	1888	Angel with A Clock in an Egg (ML)
1889	Pearl Egg (ML)		
1890	Emerald Egg (ML)	*1890 (?)*	Ribbed Egg (Niarchos)
1891 (?)	Egg with Twelve Monograms (Hillwood)	**1891**	Azova Egg (Kremlin)
1892 (?)	Egg with Danish Portraits (Fabergé Family Archives photograph)	*1892 (?)*	Resurrection Egg (Forbes)
1893	Caucasus Egg (New Orleans)		
1894	Renaissance Egg (Forbes)		

Eggs given by Czar Nicholas II
to Marie Feodorovna:

to Alexandra Feodorovna:

1895	Egg with Danish Palaces (New Orleans)	**1895**	Rosebud Egg (Forbes)
		1896	Revolving Frame Egg (Richmond)
1897	Pelican Egg (Richmond)	**1897**	Coronation Egg (Forbes)
1898	Lily of the Valley Egg (Forbes)		
1899	Pansy Egg (U.S.A.)	**1899**	Lily Egg (Kremlin)
1900	"Cuckoo" Egg (Forbes)	**1900**	Trans-Siberian Railway Egg (Kremlin)
1901	Gatchina Egg (Baltimore)		
		1902	Clover Leaf Egg (Kremlin)
		1903	Peter the Great Egg (Richmond)
1903 (?)	Spring Flowers Egg (Forbes)		

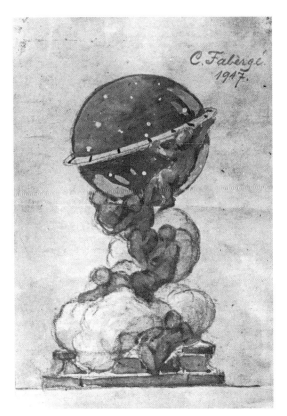

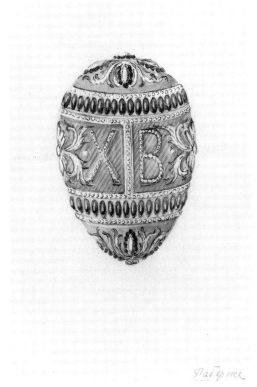

A sketch for an Easter egg, drawn by
Carl Fabergé and signed and dated 1917

Colored crayon study for an Easter egg, signed Fabergé

Many specialists enjoy the task of tracing back the origins of Fabergé eggs to their sources. Most of the earliest examples are clearly derivative, as in the case of the 1885 "Hen Egg" in The Forbes Magazine Collection (cat. no. 532), which is very similar to 18th century creations found in both Rosenborg Castle (cat. no. 662) and in the Vienna Kunsthistorisches Museum (cat. no. 663). The blue-ribbed egg of 1890 (?) (cat. no. 533), now belonging to Stavros Niarchos, was clearly influenced by a series of four vodka cups in the form of Easter eggs kept in the Hermitage treasure vaults (cat. no. 654). The 1892 (?)[8] Resurrection Egg, now part of The Forbes Magazine Collection, is probably a pastiche of a Renaissance reliquary and another egg from the same collection, the 1894 Renaissance Egg (cat. no. 538), was undoubtedly based on a casket by Le Roy that Fabergé saw in the Grünes Gewölbe in Dresden on his grand tour (cat. no. 661). The 1891 Azova Egg (cat. no. 535), which is now kept in the Kremlin, derives from an 18th century jasper bonbonnière, while the exterior of the Peter the Great Egg (Richmond, Virginia)[9] is copied from a Louis XV necessaire[10] in the Kremlin Armory Museum (cat. no. 653). Other derivations are more subtle: for example the 1887 Serpent Clock Egg in The Forbes Magazine Collection[10] and the 1899 Lily Egg[11], also kept in the Kremlin, reflect the style of Louis XIV clocks and the Forbes 1911 Orange Tree Egg[12] would appear to have been inspired by Louis XIV orange tubs[13]. The 1904 Uspenski Cathedral Egg (now in the Kremlin)[14] is obviously a variation of the theme of the Renaissance *Prunkpokal*.[15] Further connections are also to be observed between the 1908 Peacock Egg in the Sandoz Collection[16] and the James Cox automaton kept in the Winter Palace[17] as well

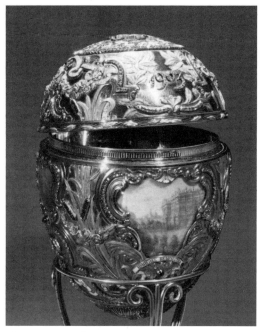

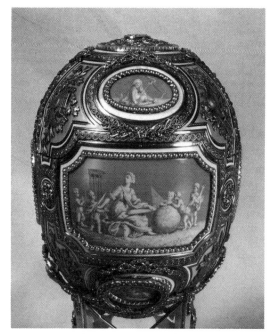

The 1903 Peter the Great Egg, (now in the Lillian Thomas Pratt Collection in Richmond, Virginia) was based on an 18th century necessaire now kept in the Hermitage Treasury (cat. no. 653)

The 1914 Grisaille Egg (now part of the Marjorie Merriweather Post Collection in Hillwood, Washington, D.C.) was made by Fabergé in the Louis XV style (cf. cat. no. 105)

Louis XIV orange tree automaton by Richard, Paris, about 1757 (formerly in the Collection of the Earl of Roseberry, Mentmore)

Fabergé's 1911 Orange Tree Egg (now in The Forbes Magazine Collection, New York)

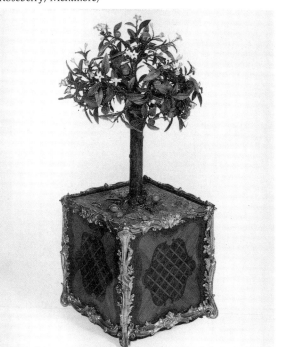

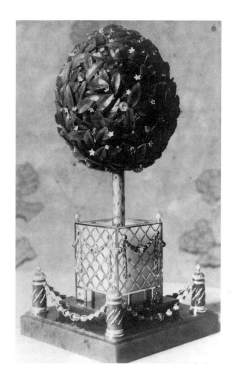

The dome designed by Joseph Maria Olbrich for the Viennese Secession exhibition building (1897/1898). This dome may have inspired Fabergé when designing the 1911 Orange Tree Egg

as between the Sandoz 1906 Swan Egg[18] and another Cox automaton which was exhibited at the Paris World Exhibition in 1867.

All these parallels serve to place Fabergé within the context of the European *revivalist movement*, so typical of the 19th century historicism. Yet even in these cases of obvious derivation, Fabergé never simply copied, but interpreted, modified and adapted. The enclosure of little surprizes (many of which have since been unfortunately lost) frequently lent his objects a dimension lacking in their precursors. His restless imagination was constantly in search of new sources of inspiration and any object could catch his roving eye and become the point of departure for a new creation. However, by making changes in scale and function, this virtuoso goldsmith was able to transform the work of an earlier craftsman into a true Fabergé creation.

The low-key formats and cautious subject matter of the early Easter eggs soon gave way to more ambitious and daring creations. By the late 1890's Fabergé was demonstrating complete freedom of expression, as exemplified by the Forbes 1898 Lily-of-the-Valley Egg[19], the 1899 Pansy Egg[20] —both masterly interpretations in the art nouveau idiom — and the celebrated Forbes Coronation Egg of 1897 (cat. no. 539), which is probably his most famous creation of all. The series progressed, always in *crescendo*, from the Baltimore Gatchina Egg (cat. no. 541) and the Kremlin Clover Leaf Egg[21], which were both made in 1901/02, to the year 1913 when the Winter Egg[22] and the Romanov Tercentenary Egg[23] were made in commemoration of three hundred years of uninterrupted Romanov rule. In 1914, on the eve of the First World War, two final masterpieces were created, namely the Hillwood Grisaille Egg[24] and the Mosaic Egg (cat. no. 544) in the Collection of Queen Elisabeth II. By 1915 Fabergé's workshops were producing grenades and bandages for the front and the Czar had other worries. The eggs made during the war years are characterized by Red Cross themes and are no longer embellished in diamonds. Fabergé's final word on the subject was the 1916

Military Egg, which was produced in steel[25], for although the 1917 eggs had been made, they were never delivered because of the imprisonment of the Czar's family. These last eggs were made of Karelian birch and lapis lazuli.[26]

In his constant quest for new subjects and surprize contents, Fabergé fell back on numerous events in the lives of the Imperial family, such as the Czarevitch's world tour made during 1890 and 1891 or the coronation celebrations held in 1896. The centenary celebrations of one of Marie Feodorovna's favorite charities in 1897 was the theme of one of his eggs, as were the opening of the Trans-Siberian Railway in 1900 and the 1903 bicentenary of the founding of St. Petersburg. The tenth anniversary of the death of Alexander III and the birth of the long-awaited heir to the throne in 1904 were soon the subject of further Easter eggs, as was also the case with the fifteenth anniversary of Nicholas II's accession to the throne in 1911, the centenary of Russian victory over Napoleon (1912) and the tercentenary of Romanov rule, which took place in 1913. Other eggs portray some of the family's favorite palaces and residences, such as Abastuman (1893), royal Danish palaces (1895), Gatchina (1901) and the Alexander Palace (1908). Further eggs incorporated miniatures and photographs of members of the family. Only very few speciments have no bearing at all on the Czar's family, almost certainly due to the loss of the contents.

The Imperial Easter eggs proved to be Fabergé's most important commission each year and demanded much time and thought. Planning was also an important element, since some eggs took years to complete, such as the Sandoz 1908 automaton Peacock Egg, which was worked on by workmaster Dorofeiev for three years. The coach made for the 1897 Coronation Egg (cat. no. 539) occupied George Stein and head-workmaster Henrik Wigström for fifteen months, during which time they had to make numerous visits to the original in order to ensure exactness of copy. Strict secrecy was also necessary. Although the work was supervised by the Court Minister (who made meticulous instructions on the 1886 Egg, which has since been lost)[27], Fabergé appears to have been accorded complete freedom in technical matters, possibly with the exception of suggestions made by the Czar. The eggs were delivered personally by either the master himself or his son, Eugène, and were the subject of much interest and comment. Attempts made by the Czar himself to pry into the secret of the next Easter egg to come would be tactfully parried by comments of "Your Majesty will be content".

The fate of the Imperial Easter eggs becomes unclear after the tragic annihilation of the Czar and his immediate family. Only one specimen, the 1916 Order of St. George Egg (now in The Forbes Magazine Collection) was taken out of the country by its owner, the Dowager Empress. After the Revolution, the treasures from Czarskoje Selo and Gatchina were packed into crates and sent to Moscow, where they remained until Lenin's death in 1924. In 1925 the Soviet government took up contact with Western dealers and it was also in this year that Armand Hammer returned to the U.S.A., loaded with Imperial eggs. Emanuel Snowman of Wartski's was able to procure five of their number. The Soviet government permitted the sales of numerous specimens in London, Berlin and Paris, but in 1927 it retained ten of the finest specimens.

Non-Imperial Easter Eggs

Fabergé's Easter eggs aroused the attention of other nouveau riche customers, wishing to follow the example of the Imperial family. The wealthiest of these was Alexander Ferdinando-vitch Kelch, a Siberian gold magnate and millionaire. His wife Barbara, née Bazanov, was given seven eggs between the years 1898 and 1904. However, with a few exceptions, the

Kelch eggs do not come up to the standard of their Imperial counterparts.[28] In the Kelch series, the 1898 "Hen Egg", the 1899 Twelve Panel Egg and the 1904 Chanticleer Egg are reproductions of Imperial models, namely the 1885 "Hen Egg", the 1902 Gatchina Egg, the 1887 Serpent Clock Egg and the 1900 Cuckoo's Egg. Two further eggs, the 1901 Apple Blossom Egg and the 1902 Rocaille Egg, are of apparently lesser quality and tend to resemble the products of a chocolate factory. Only one single egg in this Kelch series is a work of art in its own right – namely the 1900 Pine Cone Egg. The Kelch eggs, which had disappeared, made a reappearance in 1920 at the Paris firm of A la Vieille Russie, where they were identified by Alexander Fabergé and sold, after some difficulty, to an American buyer in 1928. The series was then dispersed. Since then, the bourgeois monogram of "BK" has been removed from some of the eggs and replaced with the Imperial insignia.

Further Easter eggs were originally owned by Princess Zenaïde Yousoupoff (cat. no. 543), Consuelo Vanderbilt, the Duchess of Marlborough [29] and Dr. Nobel, of dynamite fame.[30]

1 Snowman, 1962/64, ill. 307 & 308.
2 Habsburg/Solodkoff, 1979, ill. 120.
3 Lugano 1986, no. 142.
4 Habsburg/Solodkoff, 1979, p. 107.
5 Marina Lopato, 1984, pp. 43-49.
6 Presentations to the Czarevitch after his 21st birthday (in 1890) are quite probable, thereby allowing three eggs, the style of which would seem to indicate an earlier date, to be included in this short period. It would seem that the Azova Egg might well have been a present to the Czarevitch to commemorate his world tour on the cruiser "Pamiat Azova".
7 ML= Marina Lopato's list.
8 Solodkoff, 1984, p. 55.
9 Lesley, 1976, p. 40 f.
10 Solodkoff, 1984, p. 73.
11 Snowman, 1979, p. 99.
12 Solodkoff, 1984, p. 97.
13 Sotheby's Mentmore Sale, May 18, 1977; no. 49.
14 Snowman, 1979, p. 103.
15 Snowman, 1979, p. 92, where it is compared with a Nuremberg goblet made of gilded copper and now housed in the Victoria & Albert Museum, London.
16 Solodkoff, 1984, p. 94.
17 Snowman, 1953, ill. 311 & 312.
18 Solodkoff, 1984, p. 92.
19 Solodkoff, 1984, p. 76.
20 Ibid., p. 78 f.
21 Ibid., p. 85.
22 Snowman, 1979, p. 111.
23 Ibid., p. 114.
24 Solodkoff, 1984, p. 101.
25 Ibid., p. 107.
26 Habsburg/Solodkoff, 1979, p. 165, cat. no. 57.
27 Lopato, 1984, pp. 43-4.
28 Habsburg/Solodkoff, 1979, ill. 141.
29 Ibid., ill. 142.
30 Ibid., ill. 141.

Fabergé Collecting in America

CHRISTOPHER FORBES

Pre-1917

At the turn of the century, the fashionable fame of Fabergé having been firmly established among moguls and monarchs from Belgravia and Bavaria to Bulgaria and Bangkok, it is not surprising that it should have behoved robber barons from Boston to Baltimore to buy the odd, bejeweled bagatelle there as well. And indeed those plutocrats whose yachts dropped anchor in the Neva invariably made their way to pick up the perfect little something.

Among the best known Americans to arrive in St. Petersburg under their own steam in this period were J. P. Morgan, Jr., and Henry Walters. Morgan's best documented purchase was a miniature pink enameled sedan chair lined with mother-of-pearl (cat. no. 485) a gift for his fabled financier father. It was not among the treasures Morgan left for public enjoyment with his Library but was given back to his son and sold with his estate at a three-day sale in 1944.

The case of Baltimorian Henry Walters is more interesting — like Britain's German-born Queen Mary and Russian-born Lady Zia Wernher, Walters was a Fabergé customer who turned collector after the collapse of the czarist régime. He was spirited off to the firm's new premises at 24 Morskaya Street by Princess Cantacuzène, née Julia Dent Grant, granddaughter of America's eighteenth President, Ulysses S. Grant. When he departed the Imperial capital aboard his 224-foot, 505-ton yacht *Narada* in 1900, among his souvenirs was a selection of hardstone animals and enameled gold parasol handles (cat. no. 483) for his nieces. Then in the late 1920's he acquired in Paris from a dealer named Poltsov two of the splendid series of Imperial Easter eggs made for Nicholas II — the Gatchina Palace (cat. no. 541) and Rose-Trellis Eggs. Walters proceeded to set a precedent by having his Fabergés put on view in the museum he bequested to Baltimore in 1931.

The one American lady of lasting fame who ventured as far as Faberge's St. Petersburg headquarters (many other American ladies made it to his London outpost) was Consuelo Vanderbilt. With her maternally-selected husband, the Duke of Marlborough, she visited Russia in 1902 and was recieved by the Dowager Empress, whose Serpent Clock Egg inspired Her Grace's own commission from the house of Fabergé. Consuelo varied not only the color (pink rather than blue) and obviously the monogram, but also the size — the heiress to one of America's greatest railroad empires made sure her egg was an inch larger than that made for the consort of the absolute ruler of one of the largest empires on the face of the earth.

The Duchess eventually parted with both husband and Fabergé egg clock — the former by divorce and the latter at a charity auction at the Cercle Interallié in Paris in 1926. Polish-born soprano and would-be actress Gannawalska used some of the fortune she reaped from a very profitable marriage to Chicago's Harold Fowler McCormick to secure the egg, which eventually became the first major acquisition of yet another American collection.

1920–1950 (The Hammer Era)

Lenin's Union of Soviet Socialist Republics was not yet three years old when a young graduate of Columbia University's College of Physicians and Surgeons arrived there in 1921. Dr. Armand Hammer wanted to help the refugees of the famine in the Volga region – and he may also have wanted to help collect funds owed to his family's Allied Drug and Chemical Company for medical supplies already received by the Soviet government but not yet paid for. Robert Williams in his book *Russian Art and American Money 1900–1940* chronicles how Hammer pioneered barter deals between America and a government it would not recognize for another twelve years – Soviet furs, platinum, emeralds and asbestos for American grain, tractors and technicians, with Hammer getting a 5% commission and eventually a concession to manufacture pencils. However, by 1929 Stalin made it clear he wanted to eliminate all foreign concessions, so in early 1930 Hammer negotiated a price that included permission to remove all "household effects" – which by then included a vast quantity of art, jewels and antiques. However, with the Depression in full swing in America, liquidating these proved a challenging task. "As his brothers despairingly pointed out, their Fabergé Easter eggs were beautiful but not edible … People were selling apples on every street corner, and Victor [Hammer's younger brother] had nightmares of himself selling icons the same way," recounts John Walker, former director of the National Gallery in *Self Portrait with Donors*. Armand was undaunted and evolved an ingenious scheme of selling through department stores – starting with Scruggs Vandervoot in St. Louis and eventually ending up at Lord and Taylor's in 1933 after a stop at Marshall Field's in Chicago.

Four major American collections were formed during this period and selections from Hammer's Romanov treasure are prominent among them all. Interestingly, all four were assembled by women.

Lillian Thomas Pratt was the least prepossessing of the four *grand dame* collectors (a salesman at the Hammer Galleries mistook her for the cleaning woman when she first came in), but she was also the most dedicated in her pursuit of Fabergé objects. Her obsession bordered on addiction and her husband, John Lee Pratt, a connoisseur of American furniture with little tolerance, let alone appreciation, for the bejeweled gewgaws which mesmerized his wife, at one point threatened to sue the Hammer Galleries if they continued to extend her credit. Her buying continued apace, however, and between 1933 and 1946 she assembled a collection which at the time was second only to that of the Kremlin in the number of Imperial Easter eggs and rivalled that of the British Royal Family in overall number of pieces. It took the Virginia Museum, which was willed the collection in 1947, seven years to come up with an adequate installation to show it completely.

India Early Minshall was described by Henry Hawley in his book cataloging her bequest to the Cleveland Museum as "an example of a … rare species, the intellectual hobbyist." She even attempted to master the Russian language. Her collection, while smaller than those of her major collecting contemporaries, reflects all aspects of Fabergé's *oeuvre*, ranging from an Imperial Easter egg to a covered pot with brass handles made as part of the war effort.

Matilda Geddings Gray was a gifted sculptress in her own right and a collector of collections as well as residences in which to house them. She generously determined that upon her death the broadest possible public should enjoy her Russian treasures – so through the efforts of the Foundation she established, her three Imperial Easter eggs (cat. nos. 537–542) and monumental basket of lilies-of-the-valley (cat. no. 401) have travelled to such American metropoli as Huntsville, Alabama; San Antonio, Texas; Elmira, New York; Little Rock, Arkansas; Memphis, Tennessee – and Oshkosh, Wisconsin; where the eggs were stolen and

finally recovered months later halfway across the country after a spectacular police chase worthy of any James Bond thriller. The collection is now on extended loan to the New Orleans Museum in a specially designed (and secured) gallery.

Marjorie Merriweather Post was perhaps the grandest of the four American *grande dames* collecting Fabergé in a big way during the "Hammer Era". Fabergé was just one aspect of her much broader interest in Russian art. From her first purchase in 1927 of an amethyst quartz box from the Yussupov collection, she ultimately acquired around ninety pieces, including two Imperial eggs. During the same period, she also acquired four husbands, of whom the third, Joseph Davies, served as American Ambassador to the Soviet Union from 1936–38. The Davies sailing up the Neva on board the 350-foot *Sea Cloud* was an arrival reminiscent of those of Royalty and robber barons of a previous generation – and régime. Ironically, the cargo with which the yacht departed was probably richer than that secured by any American under the Czars. Mrs. Post's two Imperial eggs were not, however, among the treasures carried home on the *Sea Cloud*. The 1914 Catherine the Great Egg was a present from her daughter Eleanor (by husband number one) while the Silver Anniversary Egg (cat. no. 534) is described in the handbook of Mrs. Post's collection as having been acquired "from an Italian source". All of the late Mrs. Post (Close Hutton Davies May)'s collections, including the Fabergé, are open to the public at "Hillwood", her 25-acre estate in northwestern Washington, D.C.

Outside the *grande dame* quartet two personages make interesting footnotes to this period – President Franklin Roosevelt and Mrs. Henry Talbot de Vere Clifton. Roosevelt had a passion for ship models, so in 1933 ex-convict Charles Ward gave him the miniature paddle steamer (originally presented to the Czarevitch Alexis by the Volga shipbuilders) as a "thank you" for his Presidential pardon (on manslaughter charges) – not something that the President of the United States could accept under similar circumstances today.

Mrs. de Vere Clifton (née Lillian Lowell) was the great-niece of the president of Harvard University, whose divorce from Merrill Griswold and hasty marriage to Clifton scandalized proper Bostonians in 1937. She is the only recorded target of a Fabergé missile – the Rosebud Egg (cat. no. 534) was hurled at her during a particularly heated domestic quarrel. When the egg recently appeared on the market, the damage to the enamel on one of the panels not only corroborated the story but helped also confirm the authenticity of the piece. The de Vere Clifton's also owned the Renaissance Egg (cat. no. 538), which happily was not closer to hand for that particularly pitched argument!

1950 to the Present

By the 1950's the Hammer Galleries ceased dealing in Fabergé and the Schaffer's A La Vieille Russie supplanted them as the nation's preeminent purveyor of the court jeweler's *objets de luxe*. Auction houses also emerged as increasingly interesting sources, although no Imperial eggs appeared in a sale in America until 1985.

The generation of collectors which has emerged since 1950 has tended to prefer anonymity – with a few notable exceptions. Lenders to the A La Vieille Russie Fabergé exhibitons in 1949, 1961 and 1983 included such names as Mrs. Vincent Astor, Mrs. H.H. Flagler, Mrs. Barbara Hutton (Troubetsky in '49, Reventlow in '61 – she went through even more husbands than her aunt by marriage, Mrs. Post). Mr. and Mrs. Henry Ford II (whose lovely miniature Fabergé roulette wheel "disappeared" one night, alas not to be seen since), Jan Mitchell, Mr. and Mrs. Arthur Gilbert and Evelyn and Leonard Lauder. For these prominent Americans their Fabergé purchases were an occasional indulgence rather than the focus of a collecting passion.

The non-anonymous major collectors of Fabergé during this period included and include Jack and Belle Linsky, Mr. and Mrs. Lansdell K. Christie, Mrs. Bing Crosby and Malcolm Forbes.

The Linsky's stapler fortune permitted them, in Mrs. Linsky's own words, to assemble a collection "second only to that of the Queen of England". Their assemblage of *fin-de-siècle objets*, however, did not impress the then director of the Metropolitan Museum of Art, James Rorimer, who urged them to collect "more serious things".

The Linskys were justifiably furious when less than a decade after the Metropolitan's chief belittled their Fabergés, the museum accepted many of the very pieces they had disposed of on "permanent loan" in a special gallery off the Great Hall — on this time the property of shipping tycoon Lansdell Christie. In Rorimer's defense, the Linsky's collection of 18th century decorative arts now occupies a series of the galleries at the Met, while Christie's "permanent loan" was dispersed by his heirs in the mid-1960's.

This dispersal was to provide Malcolm Forbes with over two dozen key pieces within less than a year after he convinced Alexander Schaffer that he was a "serious" collector by outbidding him for Consuelo Vanderbilt's Serpent Clock Egg at Parke-Bernet in 1965. The star of the Christie collection, the Chanteclair Egg, was also coveted by another prominent American collector. Mrs. Bing Crosby wanted the piece for two reasons — it sings and the enamel is the same vivid blue as her husband's unforgettable eyes. Although she was not successful in securing the egg, Katherine Crosby has assembled an impressive collection, including a pair of jade Buddhas made for the King of Siam and perhaps the most sumptuous pair of opera glasses crafted by the house of Fabergé.

The FORBES Magazine Collection of Fabergé objects, now comprising almost 300 pieces, of which over 40 are included in this exhibition, follows the American tradition established by pioneer collector Henry Walters in being available for the enjoyment of all as part of a series of galleries open to the public in its New York headquarters.

America's love affair with Fabergé is far from over, and as new collectors emerge and current collectors continue, more eggs and other *objets* by the house of Fabergé will find their way into baskets stamped "Made in U.S.A."

Fabergé's Prices – Then and Now

Fabergé's objects of luxury have always been expensive items and his clientèle belonged to an unbelievably wealthy class of artistocrats, bankers and the *nouveau riche*. Each of the tiny hardstone animals Queen Alexandra gave her friends in 1911 as a token of her affection would have enabled a stay of 45 nights at the luxurious hotel of Claridges in London (for the grand total of £25) or would have paid for as many *à la carte* meals at the Ritz. The flower arrangements, which were the most expensive *objets de fantaisie*, cost as much as £100 (or 1,000 rubles) in London and a purpurine elephant cost 55 rubles to make and was sold for twice as much. As a comparison, the 1902 edition of Baedeker states that a meal could be obtained at the Cuba Restaurant in St. Petersburg for 3 rubles.

Logically, jewelry was even more expensive, with a diamond diadem being sold in London for £1,400. Special commissions had their price too: each of the Imperial Easter eggs cost an average of about 30,000 rubles (or £3,000). A large table-service, made in the Gothic style for Kelch, the oil and gold magnate, cost 125,000 rubles (£12,500) while a pearl necklace bought by Nicholas II for his wife cost a record 250,000 rubles (£25,000). It is therefore not surprising that Fabergé was able to buy new premises in St. Petersburg for 500,000 rubles in 1898.

Empoverished emigrés were forced to sell much of their jewelry and many *objets d'art* as a result of the collapse of numerous monarchies after the First World War, causing prices to tumble. In Paris, 6 Easter eggs from the Kelch series were sold for 48,000 francs (about £900) in 1920 (Léon Grinberg being able to sell them for 280,000 francs (about £2,000) in 1928) and stone animals cost between only £1 and £5 at Wartski's during the twenties. Queen Mary was able to buy the Colonade Egg in 1929 for as little as £500.

The mid-thirties saw a revival in Fabergé's prices when Armand Hammer began to exhibit his treasures from the Imperial collections. In 1934 two relatively innocuous Easter eggs were auctioned at Christie's for £80 and £100 each and Wartski's obtained £950 for the Forbes Orange Tree Egg.

Market prices remained relatively stable for the next few decades, despite the fact that the Soviet Union sold most of the Imperial Easter eggs and hundreds of other Fabergé *objets* between 1927 and 1938. Once these sales stopped however, the first major auction to be held after the war (the Egyptian Palace Sale in 1953) brought about a staggering increase in prices, with a small egg of the "Hen" variety fetching £4,200 and the Sandoz 1906 Swan Egg being sold for a proud £6,400. By 1958 flowers were being auctioned for at least £900 and animals could cost £1,500 or more, with the St. George Egg being sold for £11,000 in 1961. The 1967 auction of the Landsell K. Christie Collection in New York set the pace for the following decades (with a record price of £13,300 being obtained for an Imperial presentation box) as did sales in Geneva, where the 1900 Cuckoo Egg was sold for £80,000 in 1973. (Twelve years later it was to fetch $1,600,000 at another sale.) A hardstone figure was also sold here for 410,000 Swiss francs in 1980, while in 1983 the clockwork model of a sedan-chair fetched 1,300,000 Swiss francs. There is still no sign of these prices abating.

CATALOG

Abbreviations

Am	Assay mark, or assay-master's mark
Coll.	Collection
Hm	Hallmark
Inv.	Inventory number
Iwm	Imperial warrant mark
Mm	Maker's mark
Wm	Workmaster's mark

Unless otherwise stated, silver standard marks are of 84 zolotniks and gold marks are of 56 zolotniks. The assay-masters for the period between 1899 and 1908 were Jakov Ljapunov for St. Petersburg and Ivan Lebedkin for Moscow, unless otherwise stated.

With the exception of the Russian loans, the descriptions in this catalog have been written by Géza von Habsburg. The entries for the Russian loans have been made by T.N. Boris, (T.N.B.); L.A. Jakoveva (L.Y.); Ju. P. Kalashnik (Ju. K.); K.N. Katjazina (N.K.); O.G. Kostjuk (O.K.).

Documentation

1 Copy of Gustav Fabergé's birth certificate, 1842

Framed, 13" x 8"

This copy was established on the occasion of Gustav Fabergé's marriage in Pernau on October 12, 1842, to Charlotte Jungstedt. His parents are mentioned as being Peter Fabergé and Maria Louise, née Elsner. Illustration p. 29

Fabergé Family Archives

2 Gold-mounted carnelian demi-parure

Mm: CO

Original fitted case with the firm's address on a paper label: "G. Fabergé, Joaillier et Bijoutier, Grande Morskoy, Maison Jacot N. 12, St. Petersbourg"

Twenty-nine carnelian beads with gold links and clasp; ear-pendants with three carnelian beads; brooch with two beads and an oval cabochon in foliate mount.
One of a small group of items made by an unidentified workmaster for Gustav Fabergé. For the firm's address, cf. illustration p. 37

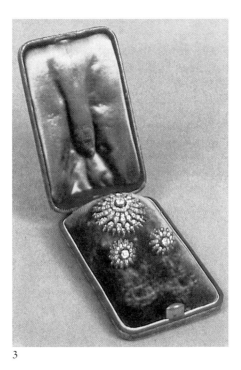

3

3 Gold-mounted diamond-set brooch and ear-studs

Diameter of brooch: 1³/₈"

Original fitted case with the address of Gustav Fabergé's company

Star-shaped brooch set with rose-cut diamonds; similar ear-studs (originally pendants). With original invoice dated 1867.

Exhibited: Helsinki 1980, cf. cat. ill. 50 f.

4 Gold-link bracelet

Mm: Savaro
Length: 7"
Original fitted case stamped with the firm's address: "Gustav Fabergé, Joaillier, St. Petersbourg"

Sets of three superimposed gold half-beads alternating with burnished gold links.

Provenance: Acquired in 1984 by the Acquisitions Commitee of the State Hermitage

State Hermitage, Leningrad (Inv. E-17 798)
(L.Y.)

4

5 Plaster bust of Peter Carl Fabergé, 1903

Signed and dated: "Joseph Limburg, 1903"
Height: 47¹/₄"

The 57-year-old Fabergé is shown full face with beard, wearing tie, coat and waistcoat. Inscribed on the base: "C. Fabergé". Illustration p. 2 (frontispiece)

Fabergé Family Archives

6 Portrait of Carl Fabergé

Signed and dated: "Eugène Fabergé, 1942"
Lithograph, framed
Height: 8¹/₂"

Posthumous colored lithograph portrait in profile, drawn by Fabergé's eldest son, inscribed: "Fabergé, joaillier de la Cour de Russie (1846–1920)".

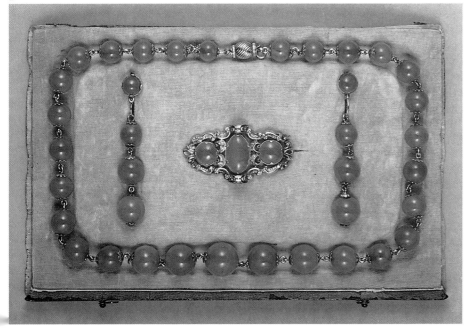

2

7 Photograph showing the interior of Fabergé's house in St. Petersburg

Framed, 6″ x 6⅝″

Inscribed: "Une pièce de la maison de Mr. et Mme. Carl Fabergé à St. Petersbourg".
Illustration p. 32

Fabergé Family Archives

8 Photograph of Augusta Fabergé

Framed, 8½″ x 5¹⁵⁄₁₆″

Inscribed: "Mme. Carl Fabergé 1851–1925".
Illustration p. 29

Fabergé Family Archives

9 Photograph of a silver marriage-cup in the Renaissance style

Framed, 8¼″ x 5¾″

Inscribed: "Pièce d'argenterie executée à St. Petersbourg, dans les ateliers FABERGE".
Illustration p. 67

Fabergé Family Archives

10 Photograph of a silver-mounted nephrite cup

Framed, 7½″ x 5½″

Inscribed: "Pièce d'argenterie avec coupe en néphrite de jade, executée à St. Petersbourg, dans les ateliers FABERGE".

Fabergé Family Archives

11 Photograph of a silver rhyton after the Antique rhyton

Framed 6″ x 8¼″

After an Achaemenid original. Inscribed: "Pièce d'argenterie executée à St. Petersbourg, dans les ateliers FABERGE".
Illustration p. 67

Fabergé Family Archives

12 Photograph of a jasper hippopotamus

Framed, 4½″ x 6⁵⁄₁₆″

Post-war figure based on a plaster model by Alexander Fabergé, probably made in Paris. Inscribed: "Hippopotame (jaspe), modèle

d'Alexandre Fabergé. Executée à Paris après la Revolution Russe".

Fabergé Family Archives

13 Pencil sketch for an inkstand

Framed, 9¼″ x 13³⁄₁₆″

Model for a silver and crystal inkstand. Inscribed: "modèle au crayon d'un encrier executé par la masion FABERGE de St. Petersbourg, montrant la façon de créer une pièce".
Illustration p. 63

Fabergé Family Archives

14 Watercolor of an Easter egg

Inscribed in pencil: "Fabergé"
Framed, height: 9⁷⁄₁₆″.

Rare colored crayon sketch by the Fabergé workshop for an enameled egg, with the Russian letters "Ch. W.", for "Christ is risen".
Illustration p. 95

15 Album with photographs from the Fabergé workshop

Red leather binding with applied gilt Imperial double-headed eagle
14″ x 11¹⁄₁₆″

Contains original photographs of seventeen of Fabergé's Imperial Easter eggs. For illustrations cf. Habsburg/Solodkoff, 1979, p. 98, 109.

Fabergé Family Archives

16 Invoice from Fabergé's St. Petersburg office

Inscribed: "Dernier papier à entête, de la maison Fabergé à St. Petersbourg".

Fabergé Family Archives

17 Accounts book for petty cash from Fabergé's London branch

Red leather binding
12¹³⁄₁₆″ x 8½″

270 pages, 137 with entries dated from November 30, 1906 until February 13, 1917.

Fabergé Family Archives

18 Two sales ledgers from Fabergé's London branch

Red leather bindings
13″ x 12³⁄₈″

1. 302 p., 297 with entries dated from October 29, 1906 until June 8, 1912.
2. 300 p., 164 with entries dated from June 14, 1912 until January 9, 1917.
For a discussion of these ledgers and illustrations, cf. Habsburg/Solodkoff, 1979, p. 140 f. and Solodkoff, 1982, p. 105 ff.

Fabergé Family Archives

Unusual Materials

COPPER, STEEL

19 Miniature copper cooking-pot

Iwm: K. Fabergé and "Woijna (War) 1914"
Height: 5$^1/_2$"

Copper soup kettle with brass handles. An example of objects (cf. also nos. 52, 54) made during the war to "pretend" austerity.
For a similar item in the India E. Minshall Collection, cf. Hawley, 1967, no. 60.

Exhibited: A la Vieille Russie 1983, no. 10

20 Gold-mounted steel cigarette-case

Mm: Fabergé – Wm: Henrik Wigström
Length: 3$^1/_4$"

Blue steel with gold borders, gold thumb-piece set with cabochon sapphire; match-compartment, tinder-cord with steel bead.
A rarely used material, probably dating from the First World War.

21 Gold-mounted steel cigarette-case

Mm: Fabergé
Length: 3$^3/_4$"

White reeded steel, with gold-mounted cabochon sapphire thumbpiece, match-compartment and opening for tinder-cord.

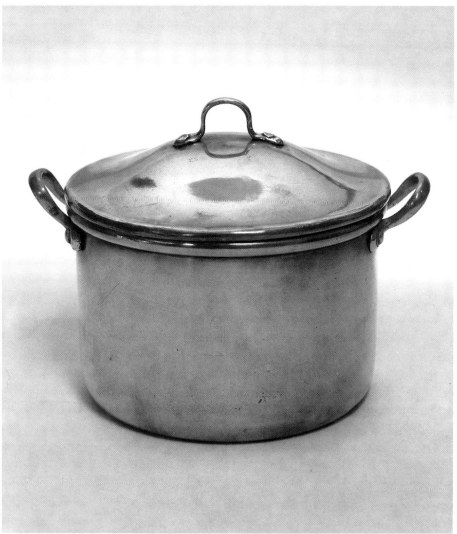

19

20, 21

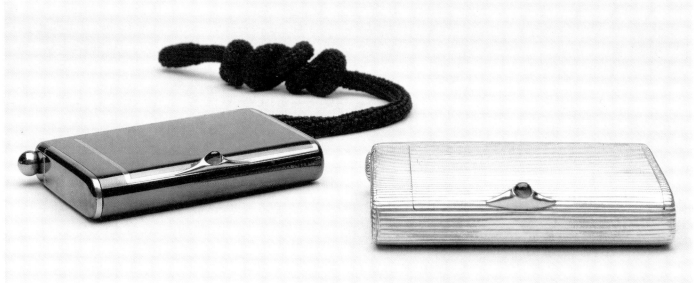

WOOD

22 Gold-mounted palisander-wood cigarette-case

Unmarked
Height: $3^1/_2$"

Red stained palisander-wood case of oval section with applied laurel swags in red and yellow gold, set with four cabochon moonstones.

23 Heart-shaped photograph frame

Inv: 53 829
Height: $4^5/_{16}$"

Stained birchwood, rectangular opening with silver gilt palm-leaf border, surmounted by a tied gold ribbon.

24 Triangular photograph frame

Unmarked
Height: $5^7/_8$"
Original fitted cardboard box stamped with Iwm, K. Fabergé

Birchwood, with circular photograph of Czarina Alexandra Feodorovna, applied with silver laurel branches and gold tied ribbon.

25 Photograph frame shaped like a column

Mm: Fabergé – Wm: Victor Aarne – Hm: St. Petersburg, 1899–1908
Height: $5^1/_4$"

Silver-mounted stained oak truncated column applied with oval miniature of Princess Elisabeth of Hesse and the Rhine (1864–1918) in laurel-leaf surround, surmounted by silver vase.

26 Curved dagger-shaped art nouveau letter-opener

Unmarked
Length: $5^5/_{16}$"
Original fitted brown velvet case stamped with Iwm, St. Petersburg, Moscow

Polished birchwood, applied with silver acanthus foliage and ribbons, gold-mounted cabochon moonstone.

Provenance: Presented by Grand Duchess

Victoria Melita (1876–1936) and her husband Grand Duke Ernest Louis (1868–1937) of Hesse and the Rhine (pencilled note: "Happy Xmas from Ducky and Ernie")

27 Photograph frame shaped like a column

Mm: Fabergé – Wm: Victor Aarne – Hm: St. Petersburg, 1899–1908
Height: $4^3/_4$"

Silver gilt mounted birchwood truncated column surmounted by oval miniature of Nadejda Marchioness of Milford-Haven, in red *guilloché* enamel frame with laurel swags and gold tied ribbon.

28 Photograph frame shaped like a column

Wm: Anders Nevalainen – Hm: St. Petersburg, before 1899
Height: $5^{15}/_{16}$"

Variant of no. 25. Silver gilt mounted stained oak truncated column surmounted by oval miniature of Princess Alexandra of Saxe-Coburg-Gotha (1878–1942), later Princess of Hohenlohe-Langenburg.

22 23 144

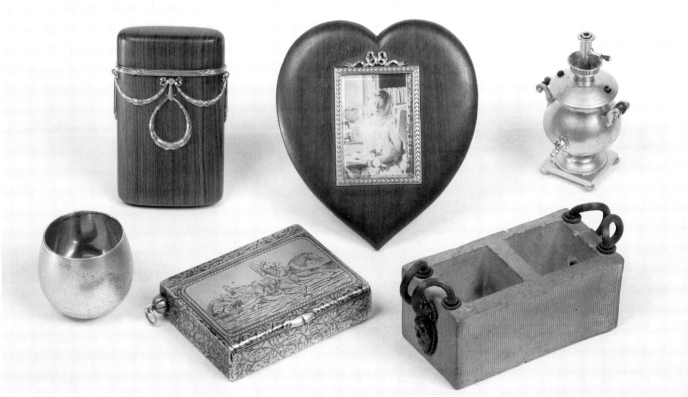

42 43 38

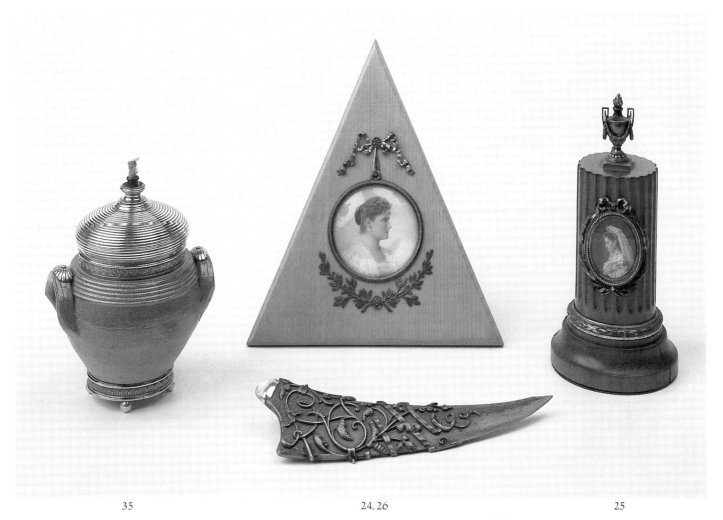

35 24, 26 25

29 Rectangular palisander-wood photograph frame

Mm: Fabergé — Wm: Anders Nevalainen — Hm: St. Petersburg, 1899–1908
Height: $9^1/_4$"

Red stained palisander, silver gilt reed-and-tie border surmounted by gold tied ribbon, silver gilt strut. Photograph of Grand Duchess Xenia, her husband Grand Duke Alexander and their five children, signed and dated: "Xenia, 1902".

Grand Duchess Xenia (1875–1960), daughter of Czar Alexander III; Grand Duke Alexander Michaelovitch (1866–1933).
Illustration p. 41

30 Duck-shaped kovch in the Old Russian style

Mm: K. Fabergé
Hm: Moscow, 1908–1917
Length: $7^1/_2$"

Stained birchwood, applied with silver scrolls and pellets; "head" with silver beak, cabochon ruby eyes, suspending two egg-shaped emeralds, surmounted by pear-shaped emerald.
Illustration p. 123

Provenance: Grand Duchess Maria Pavlovna

Mrs. Josiane Woolf

31 Carelian birchwood photograph frame

Wm: Anders Nevalainen — Hm: St. Petersburg, 1898–1903 — Am: A. Richter
Height: $5^1/_2$"

Polished birchwood with dark grain. Applied silver gilt palm-leaf border to photograph, four rosettes, laurel wreath; wooden back and strut. Photograph of the Czarevitch Alexei Nikolaievitch (1904–1918) on board the Imperial yacht "Standart".

Provenance: Princess Henry of Prussia

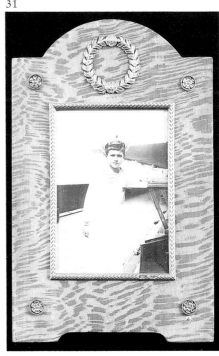

111

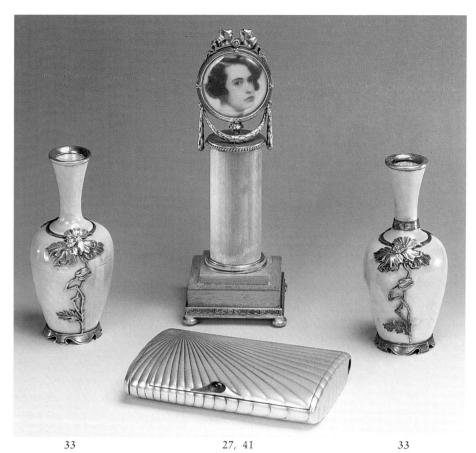

33 27, 41 33

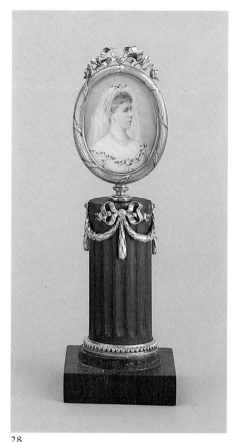

28

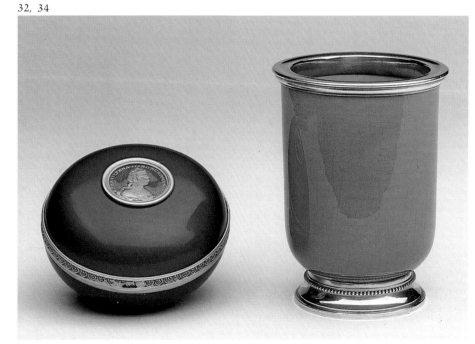

32, 34

(1866–1953), née Princess Irene of Hesse and the Rhine, younger sister of the Czarina
Literature: Waterfield/Forbes, 1978, no. 83
Exhibited: Lugano 1987, no. 33
The Forbes Magazine Collection, New York

32 Circular Lukutin box

Wm: Anders Nevalainen – Hm: St. Petersburg, 1899–1908 – Inv: 6756

Diameter: 2⁷/₁₆″

Diameter: $2^7/_{16}''$

Prussian blue base and cover, silver gilt mounts chased with anthemion, central silver half-ruble of Catherine the Great with red *guilloché* enamel background.

CERAMICS

33 Pair of art nouveau vases

Mm: Fabergé – Wm: Michael Perchin
Hm: St. Petersburg, before 1899 – Inv: 4765
Height: $3^{15}/_{16}''$

Miniature yellow-glazed pottery vases with applied silver peonies in the Japanese style.

34 Cylindric vase

Mm: AR – Inv: 5499
Height: $2^{15}/_{16}''$

Sky-blue glazed pottery with burnished silver gilt mounts. Original price label with Inv: 5499 and price: 15 rubles.

For unidentified maker "AR", cf. Snowman 1962/4, p. 128

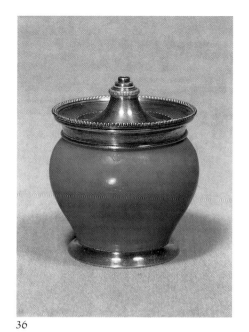

36

35 Vase-shaped table-lighter

Mm: Fabergé – Wm: Julius Rappoport – Hm: St. Petersburg, before 1899 – Inv: 1332
Height: 3⁷/₈″

Spherical brown earthenware pot with reeded domed silver gilt cover, mounts chased with anthemion; with three ball feet. Illustration p. 111

37

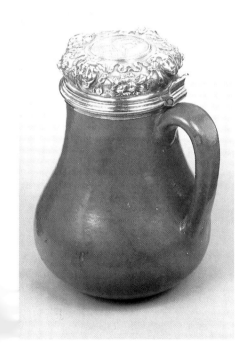

36 Spherical table-lighter

Mm: Fabergé – Wm: Anders Nevalainen
Hm: St. Petersburg
Height: 2⁷/₈″

Red glazed pottery, plain silver mounts with pellet border.

Provenance: Living-room of Queen Louise of Denmark

Chronological Collection of the Queen of Denmark, Rosenborg Castle, Copenhagen

37 Tankard in the 17th century style

Mm: Fabergé – Wm: Julius Rappoport – Hm: St. Petersburg, before 1899
Height: 6⁷/₈″

Brown earthenware, silver gilt cover chased with masks, flowers and ribbons.
Inspired by an English 17th century original.

Literature: Habsburg/Solodkoff, 1979, ill. 68

BRICK, STONE

38 Match-container shaped like a brick

Wm: Erik Kollin
Length: 3³/₄″

Miniature brick with two double handles in oxidized silver chased with Silenus masks. Typically ingenious and functional invention of Fabergé's. Illustration p. 110

Literature: Snowman, 1979, p. 46

39 Silver table-lighter shaped like a baboon

Mm: Fabergé – Wm: Julius Rappoport – Hm: St. Petersburg, before 1899
Height: 3¹¹/₁₆″

Naturalistically chased seated baboon holding its tail containing the wick; hinged head. Several examples of this popular model exist, including one auctioned at Sotheby's, London, February 20, 1985, lot 571.

Exhibited: Hammer 1949, no. 41 – A la Vieille Russie 1983, no. 404

40 Match-container shaped like a rhinoceros

Mm: Fabergé – Wm: Julius Rappoport – Hm: St. Petersburg, before 1899
Height: 3¹/₈″

The spherical, caricatured pachyderm is of fine-grained sandstone with silver feet, horn and ears, and cabochon garnet eyes.

39, 40

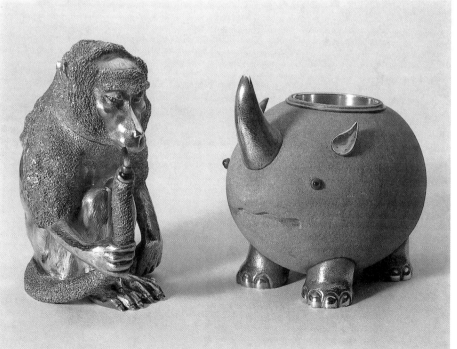

Inventive functional object from a series including a fantastic bird (Snowman, 1979, p. 47).

Exhibited: A la Vieille Russie 1983, no. 409

Silver

41 Cigarette-case

Mm: Fabergé – Wm: Anders Nevalainen
Hm: St. Petersburg, before 1899
Inv: 11 474
Length: $3^{15}/_{16}''$

Rectangular, burnished silver, chased with diagonal fluting. Gold-mounted cabochon garnet thumbpiece.
Illustration p. 112

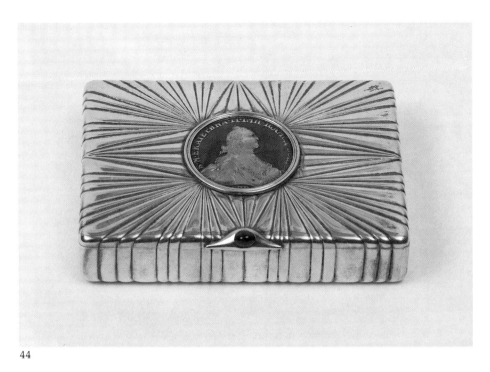

44

45

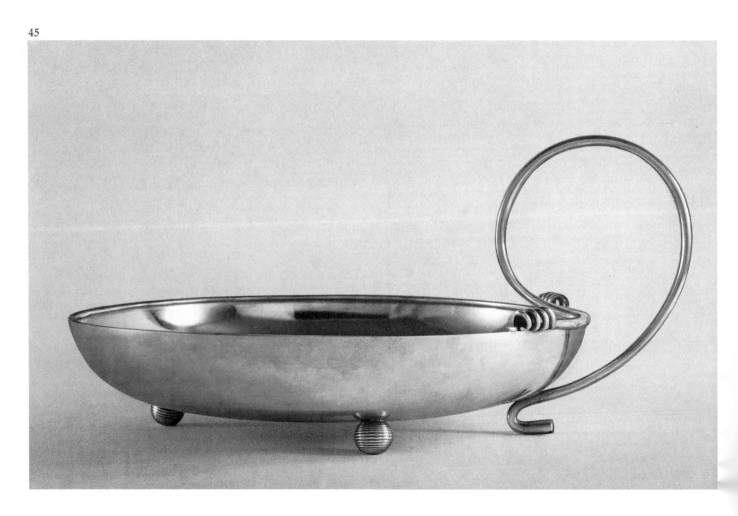

42 Spherical tumbler-cup

Mm: Alexander Wäkevä – Hm: St. Petersburg, 1908–1917
Height: 1¹¹/₁₆″

Plain burnished silver with gilded interior. Modelled on a late 18th century original.
Illustration p. 110

43 Nielloed cigarette-case

Mm: K. Fabergé – Hm: Moscow, 1899–1908
Length: 3¹/₄″

Rectangular, burnished silver, the cover nielloed with a traditional Russian troika scene; cover, sides and base with nielloed scrolled foliage.
Illustration p. 110

Literature: Bainbridge, 1949/68, pl. 119 (top)
Snowman, 1962/64, ill. 94 – Snowman, 1979, p. 36

44 Cigarette-case

Mm: Fabergé – Wm: Anders Nevalainen
Hm: St. Petersburg, before 1899
Length: 3⁹/₁₆″

Rectangular, burnished silver, chased with sunray patterned fluting, centering on a silver ruble of Catherine the Great dated 1764, with red *guilloché* enamel background.

Exhibited: Hanau 1985/86, no. 217

Stichting Huis Doorn

45 Circular bowl

Mm: K. Fabergé – Wm: A.S. (Russian) – Hm: Moscow, 1895
Diameter: 8″

Burnished silver shallow bowl with loop-shaped double silver-wire handle and three ball feet.
Modernistic functional shape with art nouveau influence.
Maker's initials hitherto unrecorded.

Literature: Hamburg, Museum für Kunst und Gewerbe, cat. 1979, no. 650

Hamburg, Museum für Kunst und Gewerbe

46 Crystal claret jug

Mm: Fabergé – Hm: St. Petersburg, 1899–1908
Height: 18³/₁₆″

Pear-shaped cut crystal carafe with art nou-

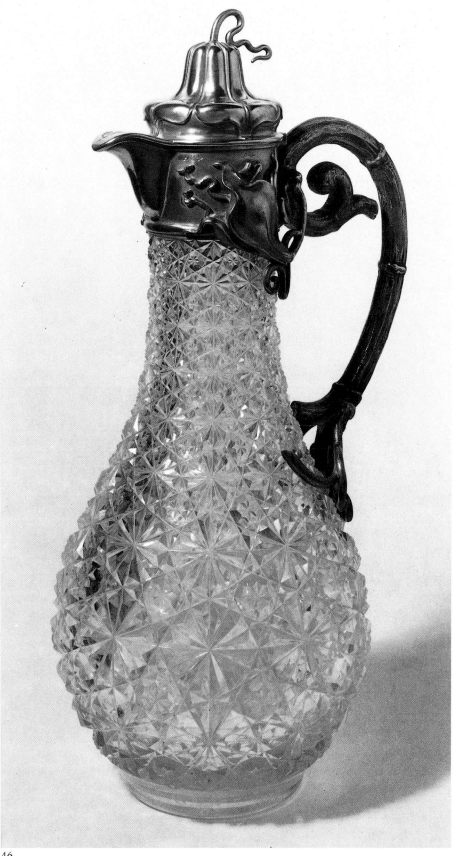

46

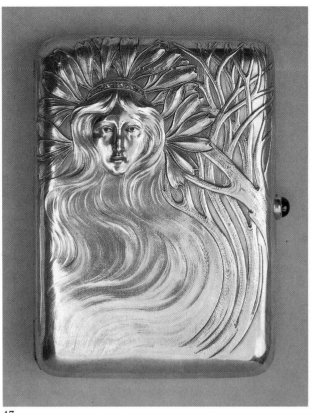

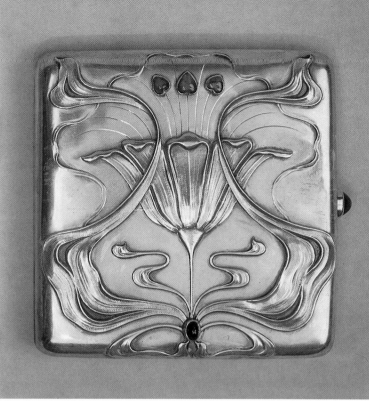

47 48

veau silver mounts engraved "1874–1899" and "1874–1924".

Literature: Hamburg, Museum für Kunst und Gewerbe, cat. 1979, no. 641

Hamburg, Museum für Kunst und Gewerbe

47 Art nouveau cigarette-case

Mm: K. Fabergé – Hm: Moscow, 1899–1918
Inv: 13 002
Length: 3⁷/₈"

Rectangular, chased silver with head of Daphne with open loose hair and wearing diamond-set diadem, issuing from foliage and branches; cabochon sapphire pushpiece. Interior inscribed: "For darling Ernie from your devoted old "Sunny", 1900".

Provenance: Presented to Grand Duke Ernest Louis of Hesse and the Rhine (1868–1937)

48 Art nouveau cigarette-case

Mm: K. Fabergé – Hm: Moscow, 1899–1908
Inv: 12 348
Length: 3⁹/₁₆"

Square, burnished silver, chased with water-lily and with scrolling foliage, set with three heart-shaped and an oval cabochon sapphire; cabochon sapphire pushpiece.

49 Tankard in the 17th century style

Mm: K. Fabergé – Wm: K.W. – Hm: St. Petersburg, 1899–1908
Height: 7¹/₂"

Tankard set with silver rubles of Peter the Great, Catherine the Great and Alexander I, chased with foliage and strapwork, standing on three ball feet.
Workmaster K.W. hitherto unrecorded.

50 Art nouveau table-bellpush

Mm: K. Fabergé – Hm: Moscow
Length: 3³/₁₆"

Shaped like a butterfly with female head and ruby-set diadem (the middle ruby acting as a pushpiece), the wings set with four gold-mounted cabochon emeralds.

Exhibited: A la Vieille Russie 1983, no. 297

51 Racing trophy

Mm: K. Fabergé – Hm: Moscow, 1899–190[]
Height: 19¹¹/₁₆"

Vase-shaped, standing on three ball feet an[] three double-headed eagles, chased with in[] scription: "First prize of the Imperial Mu[] covite Stud", a laurel-leaf border beneath an[] acanthus and anthemion border above; th[] fluted body surmounted by an Imperi[] crown and two laurel wreaths.

For this popular shape, cf. also Sotheby'[] New York, lot 490, June 11, 1985 and Chri[] tie's, Geneva, May 11, 1983, lot 281

116

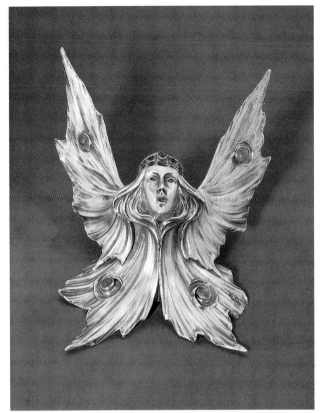

50

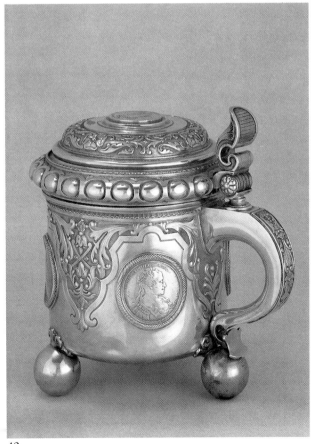

49

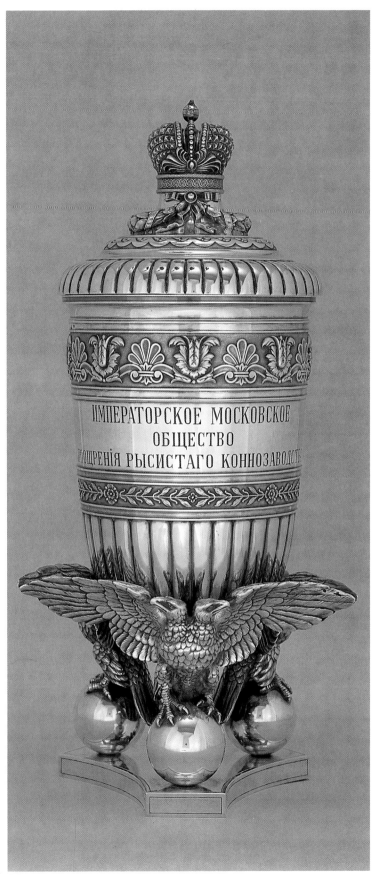

51

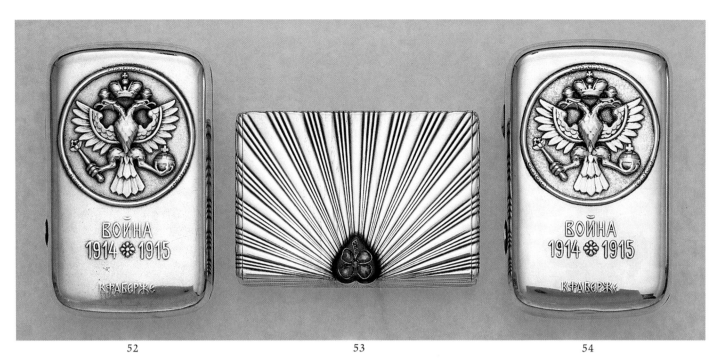

52 53 54

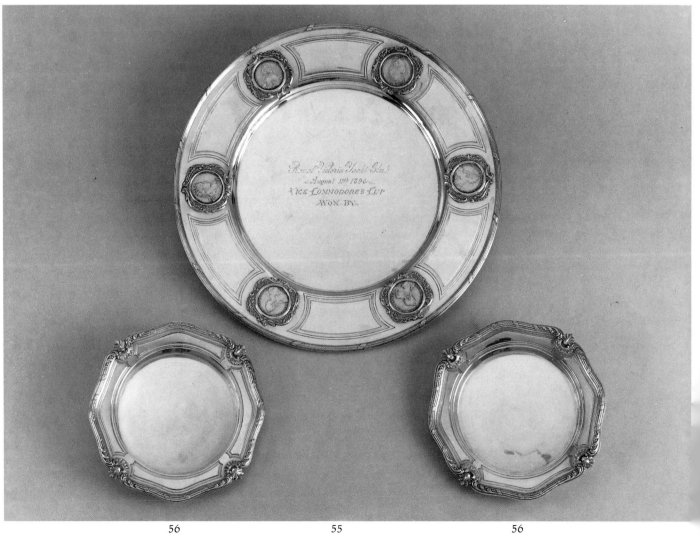

56 55 56

52 Cigar-case

Iwm: K. Fabergé – Hm: Moscow, 1908–1917
Length: $3^3/_4''$

Burnished silver embossed with double-headed eagle, and chased with "Woijna (war), 1914/1915".
Example of the firm's products made during the First World War, which were also produced in copper (cf. A la Vieille Russie 1983, no. 8).

53 Cigarette-case

Mm: Fabergé – Wm: August Hollming – Hm: St. Petersburg, 1899–1908
Length: $3^9/_{16}''$

Chased with triple reeds alternating with burnished silver surfaces centering on a heart-shaped red *guilloché* enamel thumb-piece set with four diamonds in a four-leaf clover.

54 Cigar-case

Iwm: K. Fabergé – Hm: Moscow 1908–1917
Length: $3^3/_4''$

Identical to no. 52.

55 Racing trophy shaped like a dish

Iwm: K. Fabergé – Hm: Moscow 1895
Inv: 6220 – Diameter: $14^9/_{16}''$

Burnished silver, the border with six silver rubles of Czarina Elisabeta Petrovna and Catherine the Great in foliate surrounds. Inscribed: "Royal Victoria Yacht Club, August 11, 1896, Vice Commodore's Cup won by ..."

Provenance: According to tradition from "Aurora", the yacht of Kaiser Wilhelm II

56 Pair of dessert plates

Iwm: K. Fabergé – Mm: KB – Hm: Moscow, 1893 – French import marks
Diameter: $7^7/_8''$

Octagonal in shape, the reeded border chased with acanthus leaves.
Made by a hitherto unrecorded workmaster KB or HB.

57 Cylindrical bottle stand

Mm: Fabergé – Wm: Julius Rappoport – Hm: St. Petersburg, before 1899
Diameter: $3^7/_8''$

Chased in the 17th century style with acanthus foliage and set with silver rubles of Peter the Great, Empress Elisabeth and Catherine the Great; standing on three ball feet.

Mrs. Adelaide Morley, Miami

58 Cylindrical pot

Mm: Fabergé, double-headed eagle – Wm: Julius Rappoport – Hm: St. Petersburg, 1899–1908 – French import marks
Diameter: $4^1/_4''$

Shaped like a late 17th century toilet-box; the center with a medal of Duke Louis of Braunschweig and Lüneburg, 1683, the rim with spiralling flutes.

Literature: Habsburg/Solodkoff, 1979, ill. 28

Mrs. Adelaide Morley, Miami

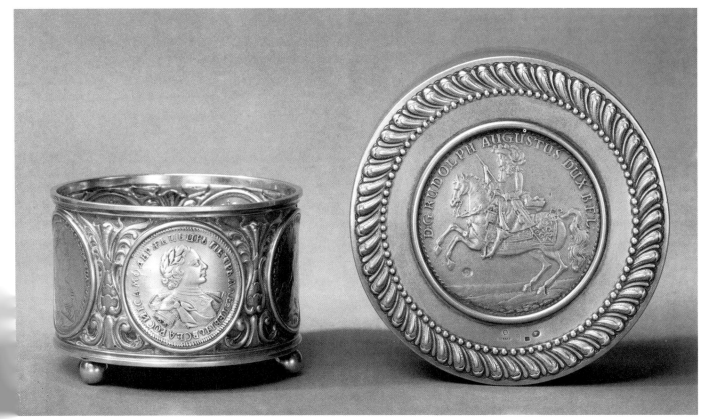

57

58

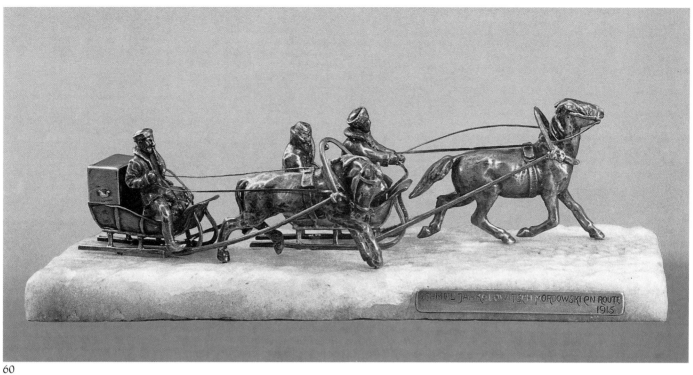

60

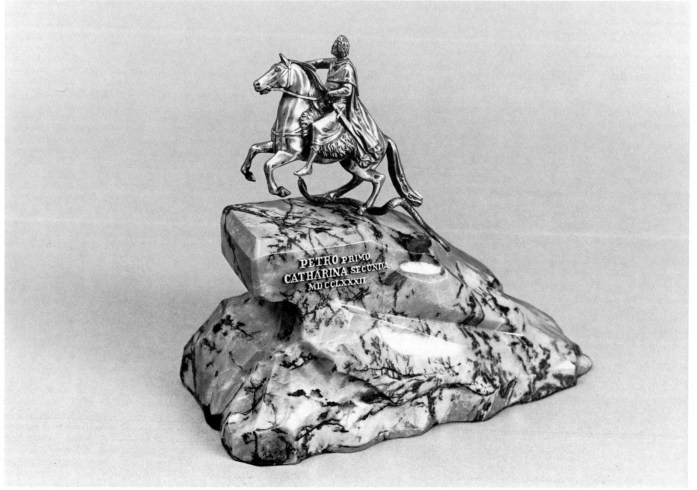

59

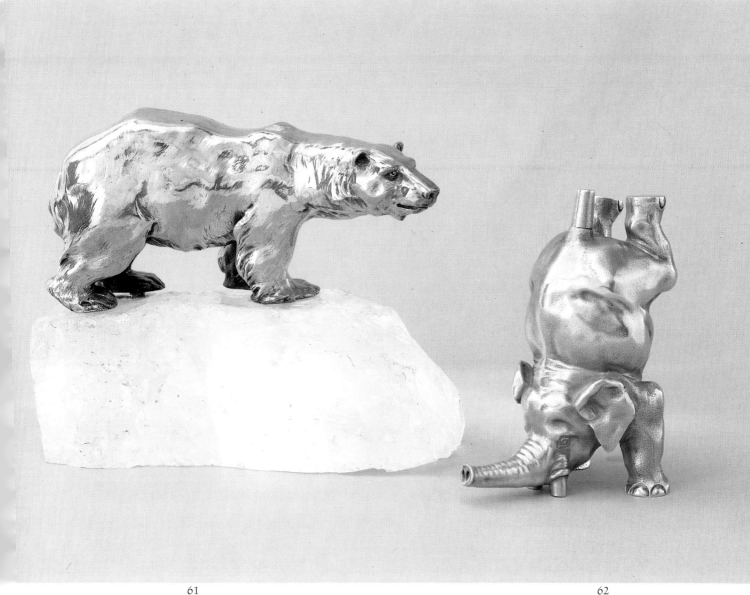

61

62

59 Silver model of the equestrian statue of Peter the Great

Mm: K. Fabergé, double-headed eagle
Wm: Julius Rappoport – Hm: St. Petersburg, 1899–1908
Height (including base): 7⁷/₈″

Modelled on a bronze monument in St. Petersburg by Etienne-Maurice Falconet. On rhodonite base with applied silver inscription of "Petro Primo, Catharina Secunda, MDCCLXXXII".

Exhibited: Helsinki 1980, cat. ill. 77

60 Silver model of two sledges

Mm: Hjalmar Armfelt – Hm: St. Petersburg, 1908–1917
Height: 3¹⁵/₁₆″

Two sledges, each drawn by one horse, racing side by side, one with a coachman, a large trunk behind him, the other with a coachman and passenger. On rectangular chalcedony slab simulating snow, applied with engraved inscription: "Schmul Jankelowitsch Mordowski en route, 1915". Commissioned to commemorate a practical joke (cf. Helsinki Catalog, 1980, p. 96 f).

Exhibited: Helsinki 1980, cat. ill. 94

61 Silver model of a polar bear

Iwm: K. Fabergé – Hm: St. Petersburg, 1908–17 – London import marks for 1908
Length: 5¹⁵/₁₆″

Naturalistically chased, standing on a rock-crystal base simulating an ice floe.

62 Glue-pot in the shape of an elephant standing on its head

Mm: Fabergé – Wm: Julius Rappoport – Hm: St. Petersburg, before 1899 – Inv: 15 497
Height: 4¹/₄″

Silver, cast and naturalistically chased, the removable tail acting as brush.

Exhibited: A la Vieille Russie 1983, no. 405

121

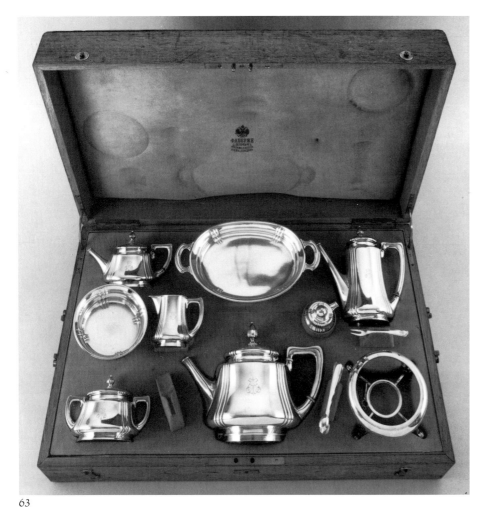

63

the silver workshops. Set with garnet eyes in the workshops of two successive head-workmasters.

Provenance: Acquired by the Acquisitions Committee of the State Hermitage in 1966
Exhibited: Cologne 1982, no. 94/95 – Lugano 1986, no. 124/125

The State Hermitage, Leningrad (Inv. ERO-8964/85) (M.K.)

67 Brush stand shaped like a tree trunk

Mm: Fabergé – Wm: Victor Aarne – Hm: 1899–1908
Height: 3^1/$_{16}$"

Varicolored banded agate, carved in the Chinese style. Applied art nouveau silver branch with bowenite fruit.

Mrs. Josiane Woolf

68 Square tea caddy in the Chinese style

Iwm: K. Fabergé – Hm: Moscow, 1891
Height: 3^{15}/$_{16}$"

The cover chased with a Chinese dragon, the sides with swirling flutes and rococo scrolls.

Mrs. Josiane Woolf

63 Tea and coffee set

Iwm: K. Fabergé – Mm: Alexander Wäkeva
Hm: St. Petersburg, 1899–1908, Inv: 17127
Original fitted wooden case stamped with Iwm, St. Petersburg, Moscow, Odessa, Kiew, London

Burnished silver, partly fluted, engraved with monogram "AT", comprising kettle, stand and burner, tea- and coffee pot, cream jug, sugar bowl and tongs, marmalade bowl and fork, large oval bowl.

64 Electric obsidian table-bell

Mm: Fabergé – Wm: Michael Perchin – Hm: St. Petersburg, before 1899
Height: 2^5/$_8$"

Of cylindrically domed shape, on silver base chased with anthemion, applied with laurel

swags. Silver-mounted circular-cut diamond as bellpush.

Literature: Uljanova, Fabergé, p. 18

Historic Museum, Moscow (Inv. 53352- ok 4555) (N.P.)

65/66 Two elephant-shaped tcharki

1. Mm: Michael Perchin – Hm: St. Petersburg, 1899–1908 – Am: 88 zolotniks
Inv: 9858
2. Mm: Henrik Wigström – St. Petersburg, 1899–1908 – Am: 88 zolotniks – Inv. 12937
Height: 2^1/$_8$"

Vodka beakers shaped like almost spherical elephants with cabochon garnet eyes.
Interesting examples of identical models which were obviously popular, produced by

64

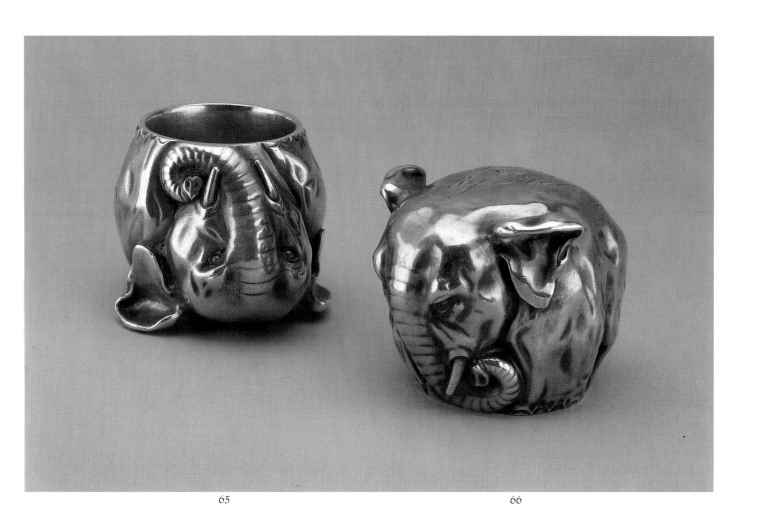

65 66

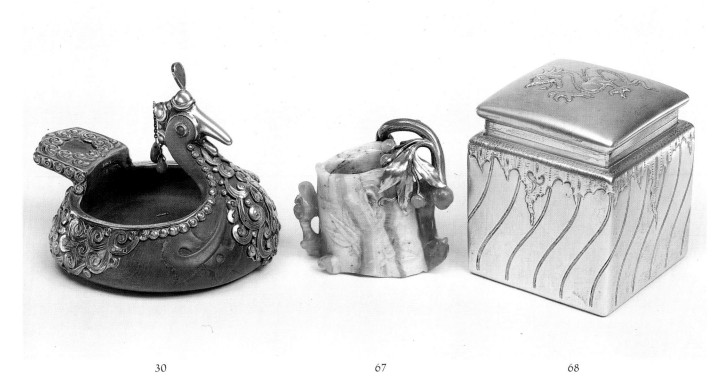

30 67 68

123

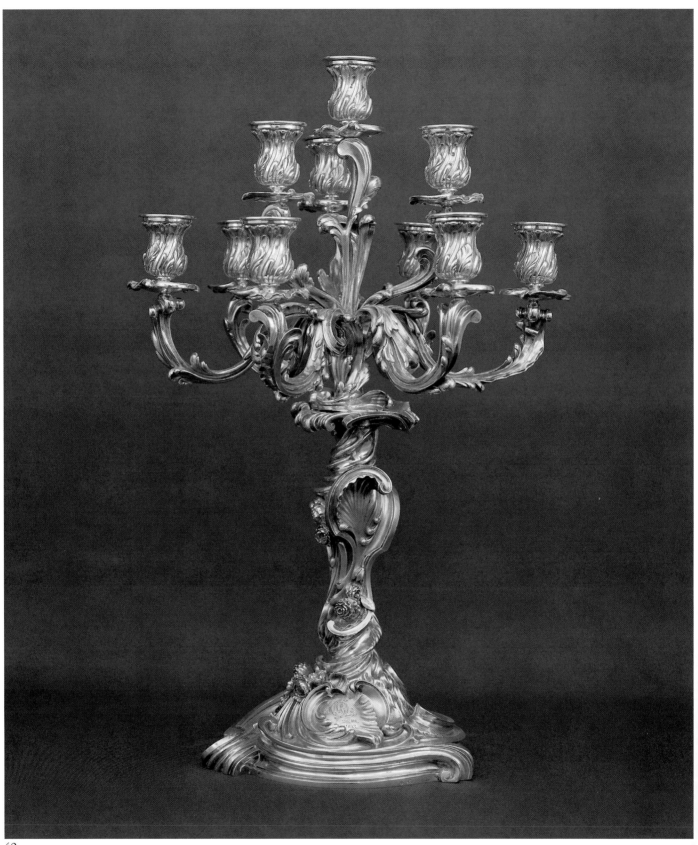

69

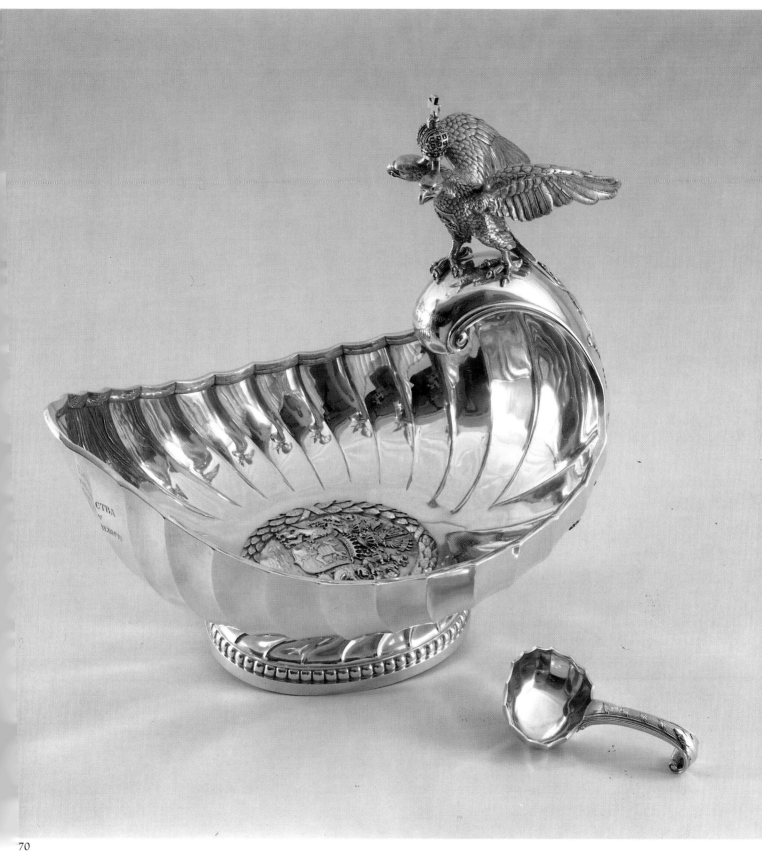

70

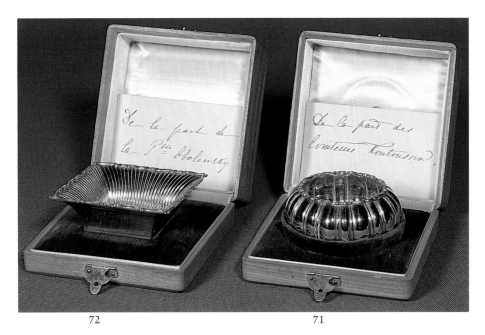

72 71

69 Pair of massive ten-branch candelabra in the Louis XV style

Iwm: K. Fabergé – Mm: K. F. – Hm: Moscow, before 1899
Height: 27^9/$_{16}$″

Original fitted oak case with chamois leather lining, stamped with Iwm

Vigorously chased with scrolls and foliage in the rococo style. Probably after a design by Juste-Aurèle Meissonier.

Provenance: Ludwig Nobel (Christie's, Geneva, November 17, 1981, lot 8)

Mrs. Adelaide Morley, Miami

70 Punch bowl shaped like a kovsh, and ladle

Iwm: K. Fabergé – Mm: ICA (First Moscow Silver Artel) – Hm: Moscow, 1908–1917
Length: 35^7/$_{16}$″

Monumental kovsh of burnished silver, the sides and base chased with swirling flutes, the handle surmounted by a crowned double-headed eagle. The center with a coat-of-arms in a laurel wreath, the front inscribed: "To their Commander, from the Chevalier Guards 1908–1912, Major General of his Majesty's Suite, Count Georgjewich Mengden."

Exhibited: Zurich, Musée Bellerive: "Die Muschel in der Kunst", 1985, no. 96

Literature: Catalog St. Gallen 1969, Collection Commendadore Giovanni Züst, no. 134

Foundation of the Museums of St. Gallen

71 Melon-shaped salt cellar, 1892

Mm: Fabergé – Wm: Julius Rappoport – Hm: St. Petersburg, before 1899

Diameter: 2^1/$_2$″
Original fitted box with green velvet lining stamped with Iwm

Fluted *bombé* sides, gilt interior.

Provenance: Presented by Countess Kutusov on the occasion of the Golden Wedding of King Christian IX and Queen Louise of Denmark, 1892

H. M. Queen Margrethe II of Denmark

72 Square salt cellar, 1892

Mm: Fabergé – Wm: Julius Rappoport – Hm: St. Petersburg, before 1899
Width: 2^3/$_4$″

Original fitted box with green velvet lining stamped with Iwm

Silver with red gilding; of fluted everted shape with foliate border.

Provenance: Presented by Princess Obolensky on the occasion of the Golden Wedding of King Christian IX and Queen Louise of Denmark, 1892

H. M. Queen Margrethe II of Denmark

73 Wine jug shaped like a beaver

Mm: Fabergé – Wm: Julius Rappoport – Hm: St. Petersburg – Am: 88 zolotniks
Height: 9^7/$_8$″

The animal standing on its hind legs, naturalistically chased, with hinged head, gilt interior.
Belongs to a group of naturalistic and functional animals modelled by Fabergé.

Provenance: From the State Museum Depository, 1924
Exhibited: Leningrad 1981, no. 501 – Cologne 1982, no. 98

State Hermitage, Leningrad (Inv. ERO-5001)
(N. K.)

74 Cigar-box shaped like a helmet

Mm: Fabergé – Hm: St. Petersburg, 1899–1908
Height: 16^9/$_{16}$″

Silver, parcel gilt, set with semiprecious cabochons. The top is removable, revealing a compartment for storing cigars.
Modelled on a Russian 17th century helmet similar to "The Helmet of Jericho" by the armorer Nikita Davidov in the Armory Museum, Moscow.

Provenance: Presented by Czar Nicholas II to Kaiser Wilhelm II
Exhibited: Hanau 1985/86, no. 105
Literature: Habsburg, 1987, p. 86

Stichting Huis Doorn

75 Monumental punch bowl of the Royal Danish Life Guards, 1908

Mm: Fabergé – Hm: Moscow 1899–1908
Height: 25^5/$_8$″ – Weight: 35^1/$_4$ lb.

Silver, parcel gilt. Standing on triangular-shaped base and three lions, the hemispherical bowl with laurel swags and medallions chased with monograms "MF" (Russian), "A III" and "1658–1908". Cover with laurel wreath, domed and fluted center surmounted by Imperial double-headed eagle. The base inscribed (in Danish): "To the beloved Guards in remembrance of their 250th Jubilee".

Provenance: Presented by Czar Alexander III and Czarina Marie Feodorovna (daughter of Christian IX of Denmark), to the Royal Danish Life Guards on the occasion of their 250th Jubilee

The Officers Corps of the Danish Life Guards

73–75 ▷

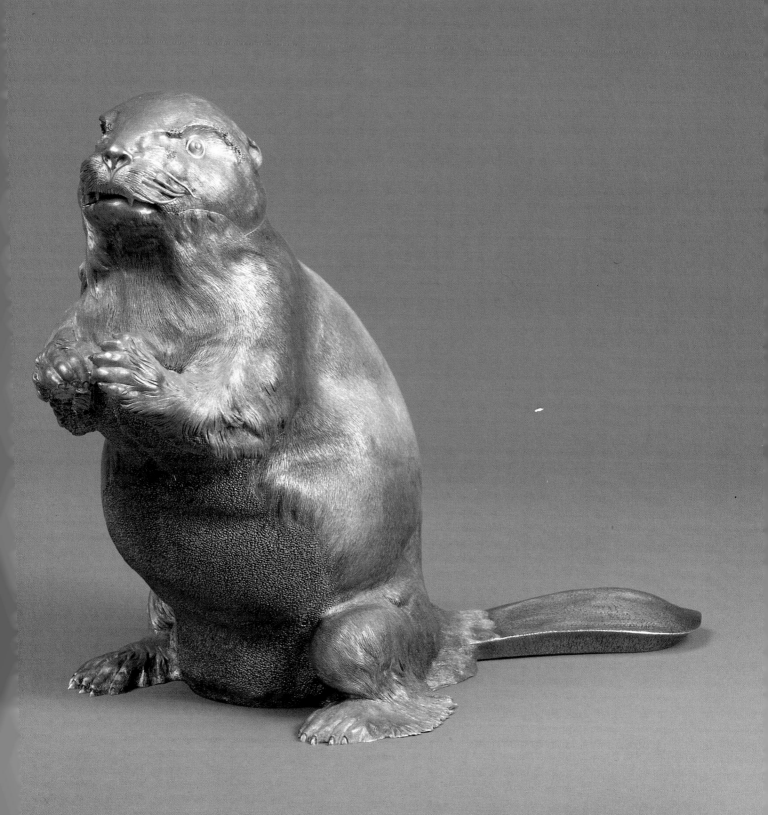

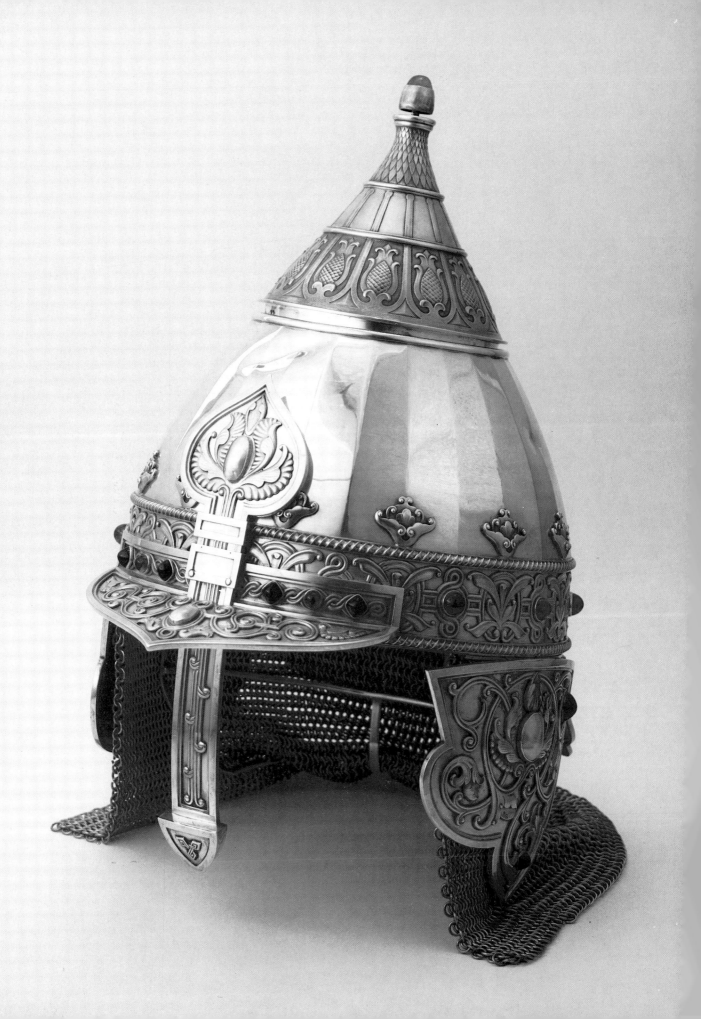

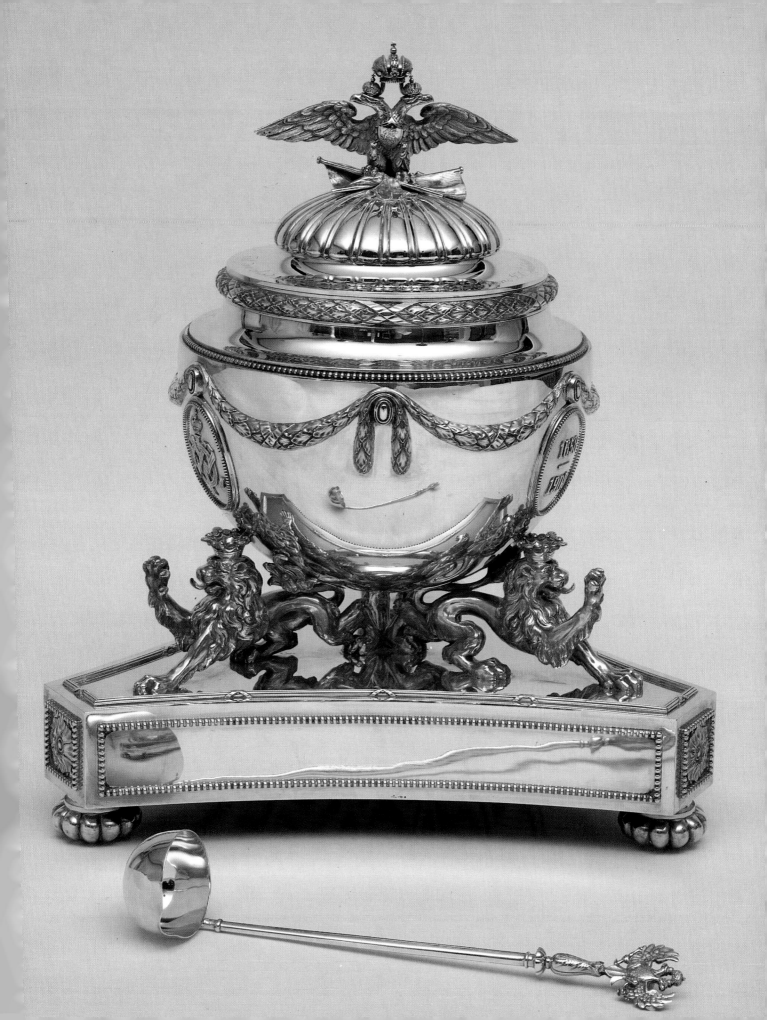

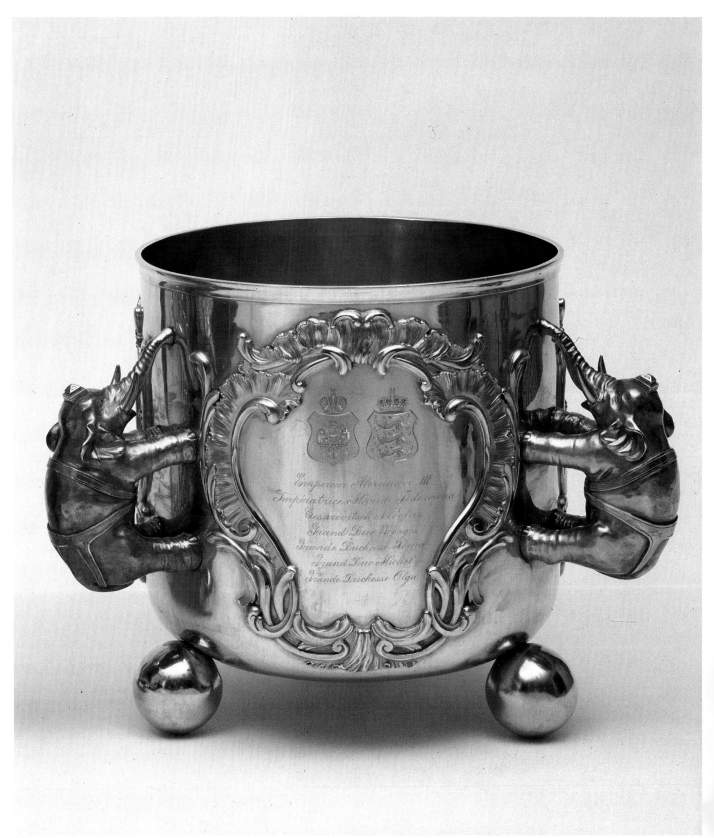

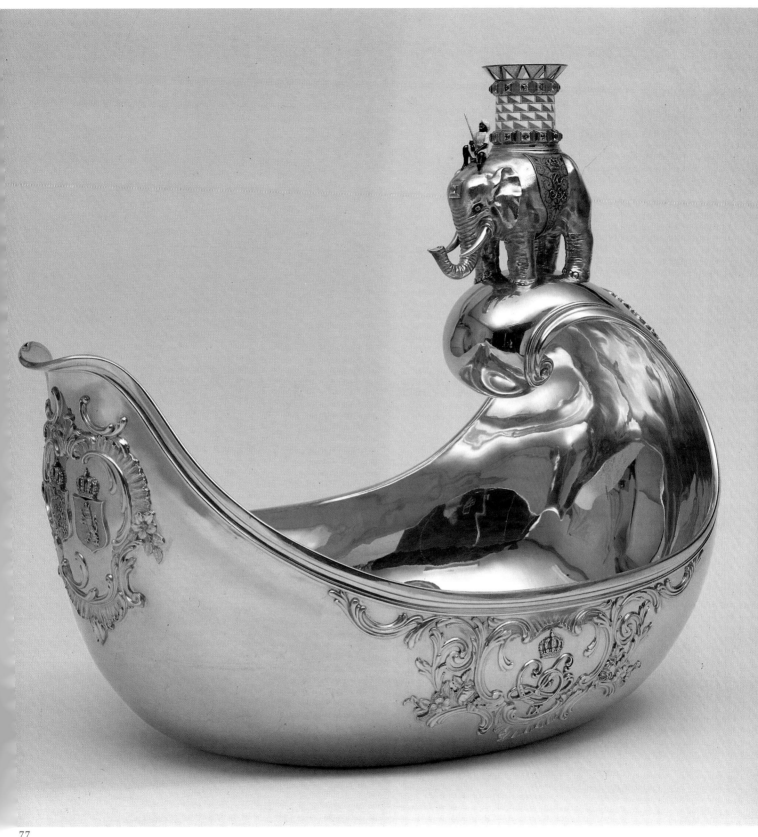

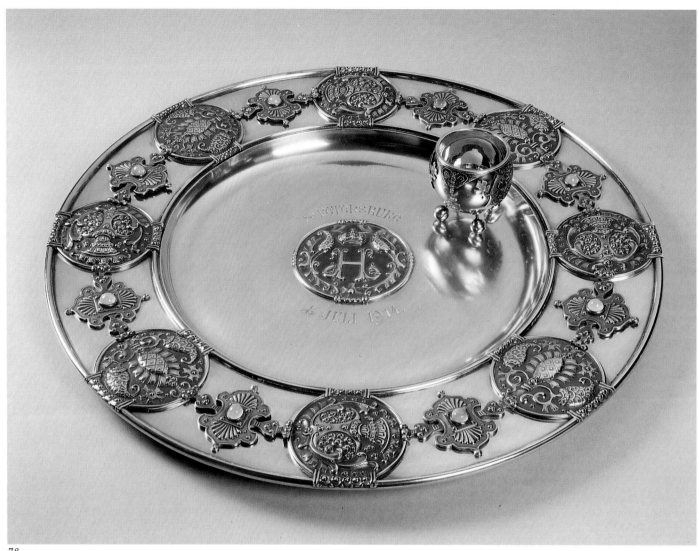

78

76 Pair of monumental silver gilt wine coolers, 1892

Mm: Fabergé – Wm: Julius Rappoport – Hm: St. Petersburg, 1892
Height: 13"

Standing on three ball feet, the cylindrical body with three elephant-shaped handles and three rococo cartouches engraved with coats-of-arms and names of donors: "Empereur Alexandre III, Imperatrice Marie Feodorowna, Cezarevich Nicolas, Grand Duc Georges, Grande Duchesse Xenia, Grand Duc Michel, Grande Duchesse Olga. Duc de Cumberland, Duchesse de Cumberland, Princesse Marie Louise, Prince Georges Guillaume, Princesse Alexandra, Princesse Olga, Prince Christian, Prince Ernest Auguste.
Prince Waldemar, Princesse Marie d'Orleans,

Prince Aage Christian, Prince Axel, Prince Erick.
Prince de Galles, Princesse de Galles, Prince Albert Victor, Prince Georges, Princesse Luise, Princesse Victoria, Princesse Maud.
Roi des Hellenes, Reine des Hellenes, Prince Royal des Hellenes, Princesse Royale des Hellenes, Gde. Duchesse Alexandra Georgiewna, Grand Duc Paul de Russie, Prince Nicolas, Princesse Marie, Prince André, Prince Christophore.
Prince Royal de Danemark, Princesse Royale de Danemark, Prince Christian, Prince Carl, Princesse Louise, Prince Harald, Princesse Ingeborg, Princesse Thyra, Prince Gustav, Princesse Dagmar."

Provenance: Joint present from the Russian Imperial Family and the Houses of Hanover, Denmark, England, Greece and Sweden to King Christian IX and Queen Louise of Den-

mark on the occasion of their Golden Wedding Anniversary on May 26, 1892. They are still in use in Fredensborg Castle.

Literature: Ole Willumsen Krog: "Fabergé and the Danish Royal House" in Apollo, July 1986, Vol. 124, CXXIV, no. 293, pp. 46 ff.

H.M. Queen Margrethe II of Denmark

77 Monumental silver gilt kovsh, 1892

Mm: Fabergé – Wm: Julius Rappoport – Hm: Moscow, 1892
Length: 34⁴/₄"

Traditional Russian kovsh shape, the sides chased with crowned monogram "C IX", "L" and date "26 Mai 1842–1892", the front with two coats-of-arms, all in rococo cartou-

ches. The scrolling handle surmounted by a Danish silver elephant bearing an enameled turret set with quartzes on a blue enamel saddle-cloth, applied with crowned monogram "C IX, L", with a blackamoor seated on the elephant's head.

Provenance: Presented by Czar Alexander III and Czarina Marie Feodorovna to King Christian IX and Queen Louise of Denmark on the occasion of their Golden Wedding Anniversary in 1892

Literature: cf. no. 76

H.M. Queen Margrethe II of Denmark

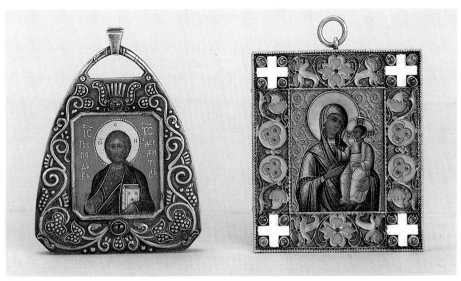

79, 81

78 Silver gilt presentation dish and salt cellar, 1914

Dish – Iwm: K. Fabergé – Hm: Moscow, 1908–1917 – Inv: 20149 – English import marks for 1912
Diameter: 16⁵/₈″
Saltcellar-Mm: K. Fabergé – Am: 91 zolotniks – Inv: 23631
Height: 2⁷/₈″

Burnished silver gilt, decorated in the Old Russian style, the rim with circular medallions filled with matt green and purple enamels and chased with stylized foliage, alternating with turquoise enamel motifs set with cabochon moonstones; the center with crowned initial "H" and engraved inscription "St. Petersburg, 1/14 Juli 1914". The salt-cellar *en suite.*

Provenance: Presented to Prince Henry of the Netherlands (1876–1934) on the occasion of a visit to St. Petersburg, 1914

Stichting Historische Verzamlingen van het Huis Oranje-Nassau

79 Portable pendant icon

Iwm: K. Fabergé – Hm: Moscow, 1908–1917 – Inv: 31988
Height: 3¹/₈″

Of ogee shape, in oxydized silver, decorated in the Old Russian style with stylized foliage, set with two cabochon sapphires, the center with a painted icon of Christ Pantocrator. Wooden backing inscribed: "From Prince Jusupov, 17 September 1913".

Literature: Snowman, 1979, p. 25 (both sides illustrated)

Cloisonné Enamel

80 Octagonal tcharka

Mm: I. Sazikov – Retailer's mark: K. Fabergé
Hm: Moscow, 1896 – Inv: 6661
Height: 2″

Silver gilt, decorated in the Old Russian style with stylized foliage, mainly in turquoise and white enamels.
Example of Fabergé's activity as a retailer.

81 Portable pendant icon

Iwm: K. Fabergé – Hm: Moscow, 1899–1908 – Inv: 15459
Height: 2⁷/₈″

80

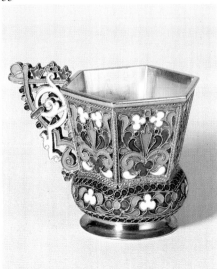

Original fitted case stamped with Iwm, Moscow, Petrograd, Odessa

Silver gilt, enameled with stylized foliage mainly in turquoise and blue, the corners with white crosses. Icon of the Virgin of Iversk in turquoise enamel okhlad. Red velvet backing.

82 Art nouveau three-part tea service

Iwm: K. Fabergé – Mm: Fedor Rückert
Hm: Moscow, 1908–1917 – Retailer's mark: I. Marshak
Height of tea-pot: 4¹⁵/₁₆″

Teapot, sugar bowl and cream jug in silver gilt, decorated in shaded enamels with stylized motifs in the Old Russian style, mainly in gray and blue hues.
Typical example of Rückert's art nouveau interpretations, commissioned by Fabergé, a rare case of Fabergé's wares being retailed by another jeweler.

83 Oval two-handled bowl

Iwm: K. Fabergé – Mm: Fedor Rückert
Hm: Moscow, 1908–1917
Length: 10¹/₂″

Silver gilt, decorated with birds and stylized foliage on pale green ground, the two scroll handles incorporating Chinese motifs.
The base engraved with inscription (in Russian): "Presented to Nadejda Michailovna Countess Torby by the Board of Directors and the Members of the Russian Government Committee, London, under the Presi-

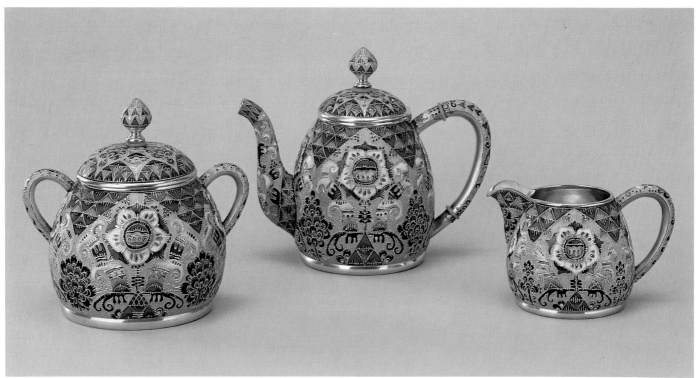

82

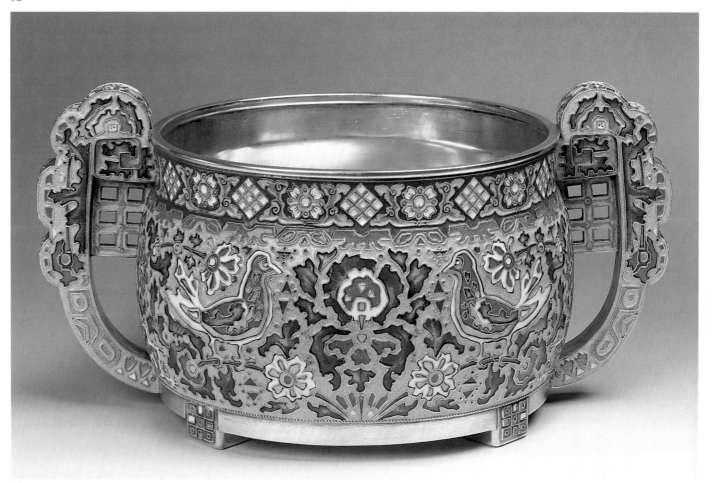

83

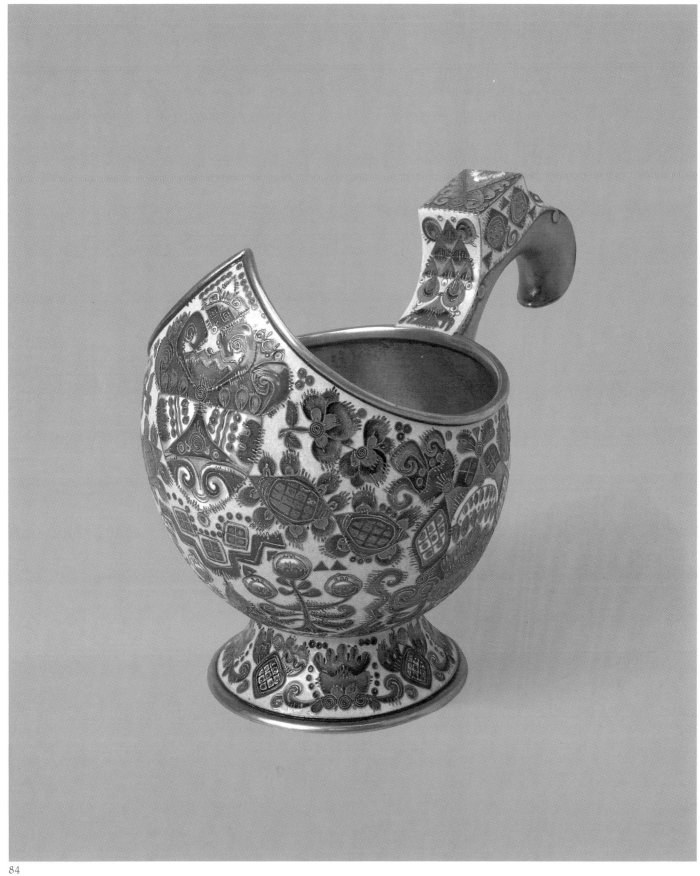

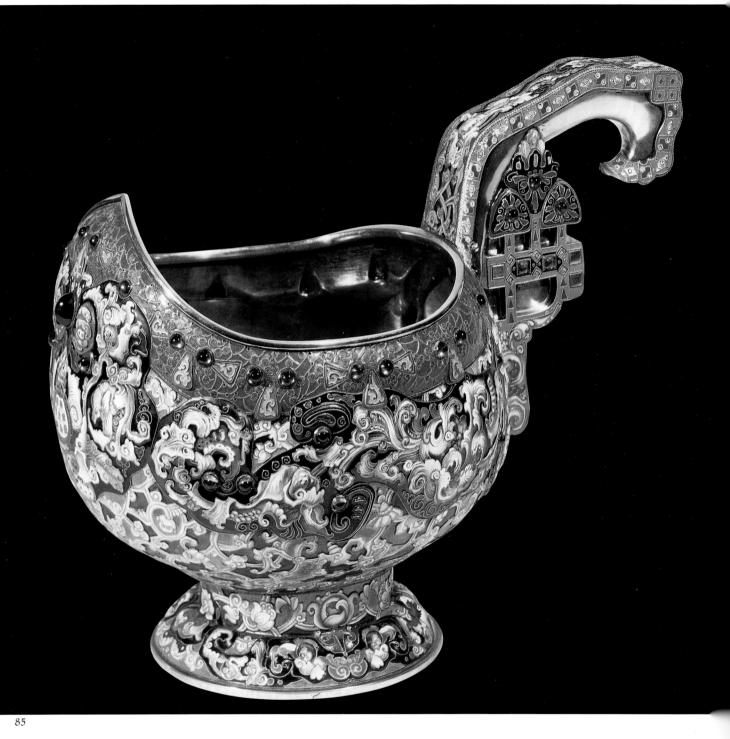

85

dency of H.R.H. Grand Duke Michael Michaelovich, 2/15 Nov. 1916".
Interesting example of the combination of Oriental and art nouveau styles in Rückert's production (cf. also no. 85).

Provenance: Nadejda Countess Torby (1896–1963), daugther of Grand Duke Michael Michailovich (1861–1929), who was morganaticly married to Sophie, Countess Merenberg (1868–1927) in 1891. She was granted the title of Countess Torby for herself and her children

84 Kovsh

Iwm: K. Fabergé – Hm: Moscow, 1908–1917 – Inv: 20 245 – Length: 7⁵/₁₆"

Silver gilt, decorated with stylized flowers and foliage in blue and olive-green shaded enamels on pale blue background.

85 Art nouveau presentation kovsh

Iwm: K. Fabergé – Mm: Fedor Rückert – Hm: Moscow, 1899–1908 – Am: 91 zolotniks – Inv: 212 714– Length: 14"

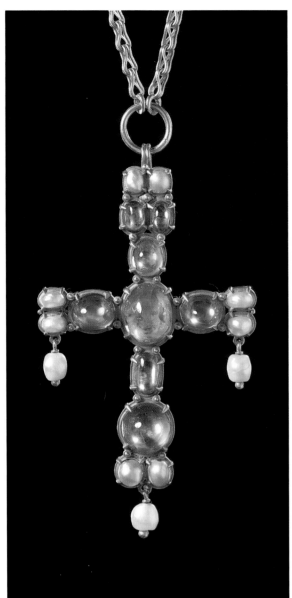

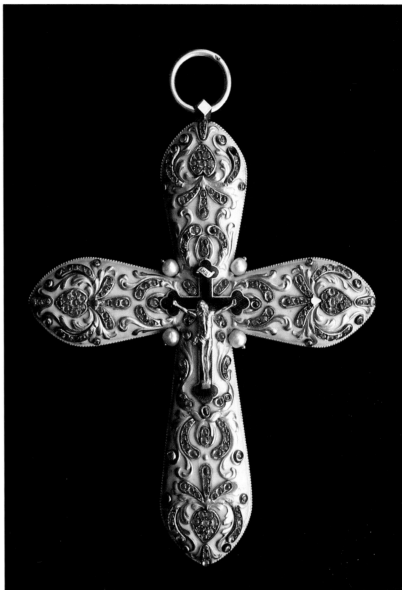

86
87

Original fitted wooden case stamped with Iwm, St. Petersburg, Moscow; applied with silver plaque bearing a dedication inscription.

Silver gilt, elaborately decorated in shaded enamels with polychrome stylized foliage and set with cabochon amethysts.
Another rare example of the combination of Chinese and art nouveau styles in Rückert's œuvre (cf. also no. 83).

Provenance: Presented by the workmen of the Nobel Factory to a director of the firm, Ivan Olsen, son-in-law of Ludwig Nobel

Exhibited: A la Vieille Russie 1983, no. 56

Jewelry

86 Jeweled pectoral in the Merovingian style

Hm: St. Petersburg, 1899–1908 – Inv: 73 891
Height: $3^{15}/_{16}$"
Gold chain – Wm: FR (Russian)
Original fitted case stamped with Iwm, St. Petersburg, Moscow, Odessa

Gold-mounted pendant crucifix richly decorated with seven cabochon sapphires, six pearls and three pendant pearls.
Inspired by the pendant cross of King Rec-

cesvinthus (649–672) in the Musée de Cluny, Paris (cf. Habsburg 1986, p. 78, ill. 16 – the author is indebted to Mr. Geoffrey Munn of Wartski's for this information).

Literature: Habsburg, 1987, p. 78

Bayerisches Nationalmuseum, Munich (Inv. 77/40–124)

87 Jeweled and enameled gold pectoral

Mm: Fabergé – Wm: Hjalmar Armfelt – Hm: St. Petersburg, before 1899 – Inv: 18 780
Height: $5^3/_8$"

Opaque pinkish-white enamel, chased with

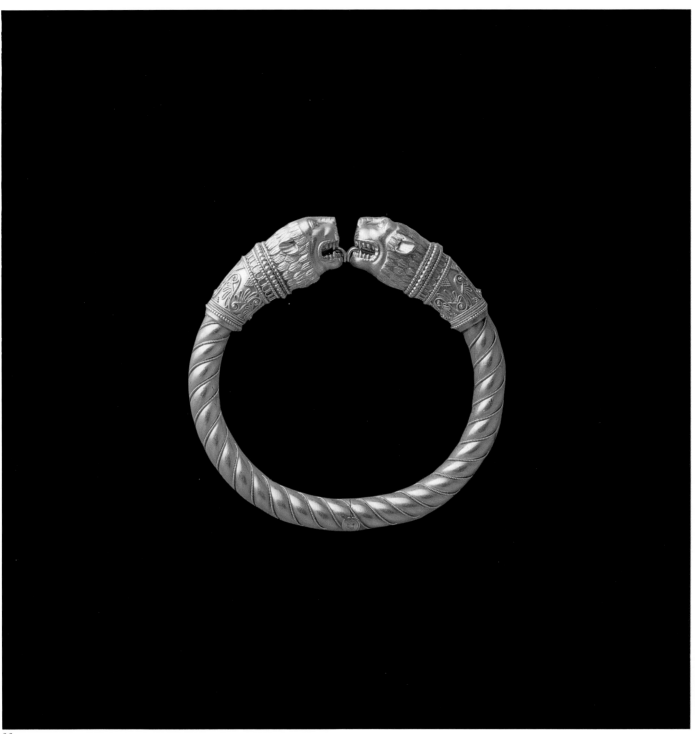

88

gold foliage, partially set with cabochon rubies. Gold figure of Christ on black enamel crucifix.

Provenance: Cardinal Michael Faulhaber (1917–1952), Archbishop of Munich and Freising

Museum of the Diocese of Freising

88 "Scythian" gold bracelet

Wm: Erik Kollin – Hm: St. Petersburg, before 1899 – Inv: 56 187

Yellow gold, cast and chased. Bangle hinged at center, with swirling flutes and applied filigree gold wire; each end with a lion's head, a band of stylized foliage and pellets.

One of the rare extant examples of Kollin's imitations of objects from the Scythian Treasures found in Kertch (Crimea); made in 1882 upon the suggestion of Count Sergej Stroganov, President of the Archaeological Society in St. Petersburg. They were first shown at the Pan-Russian Exhibition in 1882 and brought the firm its first international

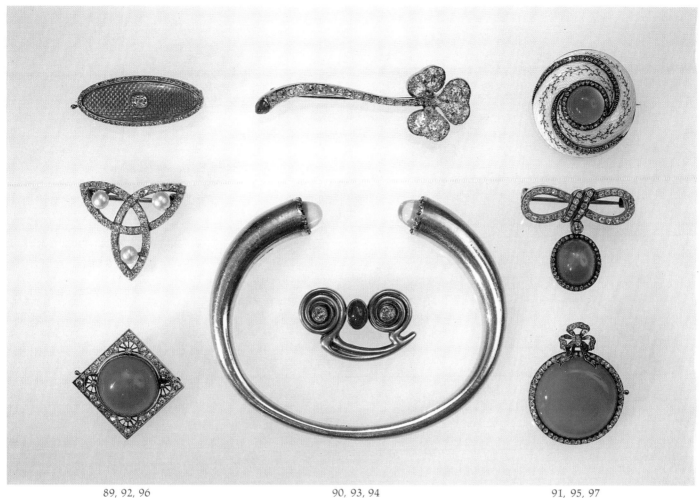

89, 92, 96 90, 93, 94 91, 95, 97

gold medal at the Nuremberg Fair in 1885. For the original, cf. no. 648.

Exhibited: A la Vieille Russie 1983, no. 347 – Lugano 1987, no. 94

Literature: Habsburg, 1987, p. 72

The Forbes Magazine Collection, New York

89 Elliptic enamel brooch

Wm: August Holmström – Hm: St. Petersburg, before 1899 – Inv: 52 297
Length: $1^5/_{16}$"

Gold-mounted; orange *guilloché* enamel with central circular-cut diamond and border of rose-cut diamonds.

90 Jeweled clover-leaf brooch

Inv: 29 367
Length: $2^1/_4$"

Yellow gold, set with circular-cut diamonds and a cabochon ruby.

91 Circular brooch

Inv: 29 367
Diameter: $1^1/_8$"

Silver and gold mounted; white *guilloché* enamel painted with dendritic motifs, set with cabochon mecca-stone and rose-cut diamonds.
For another brooch from the same set, cf. Christie's, Geneva, April 26, 1978, lot 312

Provenance: Grand Duke Vladimir (1847–1909), brother of Czar Alexander III

92 Jeweled trefoil brooch

Mw: W. F. (Russian) – Hm: St. Petersburg, before 1899 – Inv: 58 057
Width: $1^3/_{16}$"

Gold-mounted, set with rose-cut diamonds and three pearls.
For this workmaster also cf. nos. 95, 102, 590 and p. 332

93 Jeweled silver bangle

Mm: Fabergé – Wm: EH – Hm: St. Petersburg, 1908–1917 – Am: 95 zolotniks
Diameter: $3^1/_8$"

Burnished, virtually pure silver, set with two cabochon moonstones in rose-cut diamond surrounds.
The workmaster signing EH is hitherto unrecorded.

94 "Merovingian" brooch

Wm: Edward Schramm – Hm: St. Petersburg, before 1899 – Inv: 35 737 – Length: $1^1/_4$"

Yellow gold, two spirals, each centering on a circular-cut diamond, flanking a cabochon ruby.
Probably an early work of the workshops, inspired by a 7th century original.

95 Jeweled brooch with pendant

Wm: W. F. (Russian) – Hm: St. Petersburg, 1899–1908 – Inv: 41 198 – Width: $1^1/_4$"

139

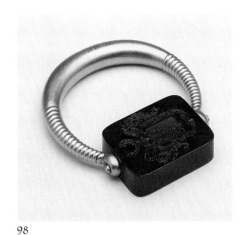

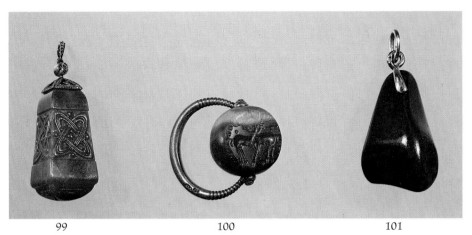

98

99 100 101

Yellow-gold brooch shaped like a love-knot set with rose-cut diamonds, suspending a cabochon star sapphire in rose-cut diamond surround.

For further objects by this workmaster, who apparently supplied Fabergé occasionally, cf. also nos. 92, 102, 590 and p. 332

96 Square jeweled brooch

Wm: Alfred Thielemann – Hm: St. Petersburg, 1899–1908 – Inv: 93 659 – Am: 72 zolotniks
Width: $^3/_4$″

Platinum and gold-mounted; central cabochon mecca-stone in an openwork mount set with rose-cut diamonds.
For Fabergé's design, cf. ill. p. 50

97 Circular jeweled brooch

Wm: illegible – Hm: St. Petersburg, 1899–1908 – Inv: 72 562
Height: $1^1/_4$″

Red-gold mount. Circular cabochon mecca stone surrounded by rose-cut diamonds, surmounted by diamond-set tied ribbon.

98 Revolving seal

Wm: Erik Kollin
Length: $1^3/_8$″

Ring-shaped matt yellow-gold, partly gadrooned mount; rectangular carnelian seal cut with a coat-of-arms and with date: "20 March 1895".
A typical piece of work by Kollin imitating the Antique.

99 Jeweled rhodonite pendant

Inv: 98 264
Height: $1^7/_8$″

Platinum mount set with rose-cut diamonds. Four-sided rhodonite pendant carved with interlaced ellipses.
For Fabergé's design produced in Holmstrom's workshop, cf. p. 50.

100 "Sassanian" revolving seal

Wm: Erik Kollin – Hm: St. Petersburg
Diameter: $1^1/_4$″

Partly gadrooned silver mount; Antique Sassanian hemispherical agate seal carved with two stags.
Rare example of a Fabergé mount for an Antique object.

Exhibited: Victoria & Albert 1977, no. Q 26

Literature: Snowman, 1979, p. 48

101 Pear-shaped lapis lazuli pendant

Mm: KF (Russian)
Height: $1^9/_{16}$″

Irregular pear-shaped polished lapis lazuli; gold pendant ring.

102 Jeweled lily-of-the-valley brooch

Wm: W. F. (Russian) – Hm: St. Petersburg, before 1899 – Inv: 38 502
Length: $1^7/_8$″

Three mobile blossoms and stem set with circular-cut and rose-cut diamonds; yellow-gold mount.
For this workmaster cf. also cat. 92, 102 and 590.

103 Jeweled silver bangle

Mm: Fabergé – Wm: Vladimir Soloviev
Hm: St. Petersburg, 1908–1917 – Am: 95 zolotniks
Diameter: $2^{15}/_{16}$″

Burnished, almost pure silver, the ends se[t] with an oval sapphire and ruby, each sur[?] rounded by rose-cut diamonds.

102 103, 104

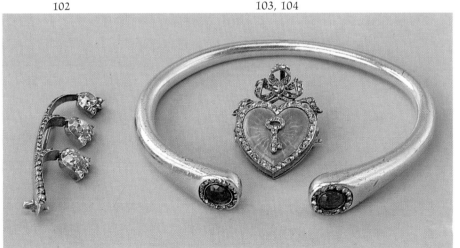

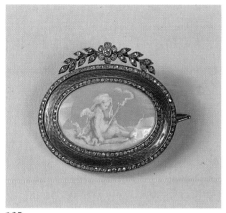

105

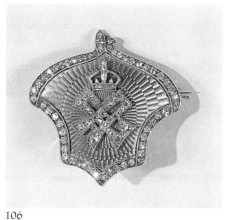

106

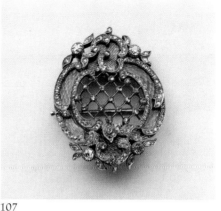

107

104 Heart-shaped gold brooch

Wm: A. Holmström
Height: 1³/₁₆″

Pink enamel over waved sunray *guilloché* ground; applied diamond-set key, diamond-set borders and ribbon.

105 Oval "grisaille" enamel brooch

Mm: Fabergé – Wm: A. Holmström
Length: 1¹/₂″

Oval *camaieu-rose* enamel plaque painted with winged Cupid, allegorical of Winter, after François Boucher; gray *guilloché* enamel border between two bands set with rose-cut diamonds, surmounted by diamond-set ribbon; gold mount.

Repetition of the subject on the "Grisaille Egg" of 1914 (Marjorie Merriweather Post Collection, Hillwood, Washington) – cf. Ross 1965, p. 38 ff.

Exhibited: Lugano 1987, no. 90

The Forbes Magazine Collection, New York

106 Jeweled Edwardian brooch

Mm: Fabergé(?)
Width: 1⁵/₈″

Shaped gold-mounted brooch with gray *guilloché* enamel, applied diamond-set crowned monogram "EA" and diamond-set border.
The initials are those of King Edward VII and of Queen Alexandra

Exhibited: Lugano 1987, no. 88

The Forbes Magazine Collection, New York

107 Jeweled "rococo" brooch

Unmarked
Height: 1¹/₂″
Original fitted case stamped with Iwm, St. Petersburg, Moscow

Shaped like a rococo cartouche; gold-mounted, with pink *guilloché* enamel and rose-cut diamonds, the center with diamond-set trelliswork. *En suite* with no. 482.

108 Sapphire brooch

Wm: A. Hollming – Hm: St. Petersburg, 1899–1908
Width: 1¹/₄″

Oval star sapphire in an elegant Louis XVI – style gold and silver-mounted brooch set with rose-cut diamonds.

Exhibited: Helsinki 1980, cat. ill. 52

109 Circular "snowflake" brooch

Wm: A. Holmström
Diameter: ⁷/₈″

Gold-mounted platinum, set with rose-cut diamonds.
Cf. cat. 115 for the origin of this motif.

Exhibited: Helsinki 1980, cat. ill. 93

110 Small "snowflake" brooch

Wm: A. Holmström – Hm: St. Petersburg, 1908–1917
Diameter: ¹¹/₁₆″

108

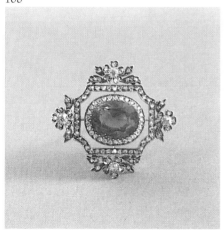

109, 110, 111

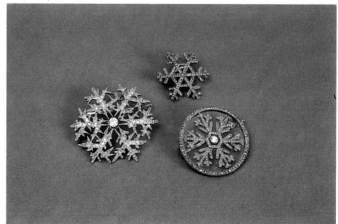

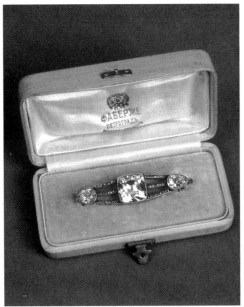
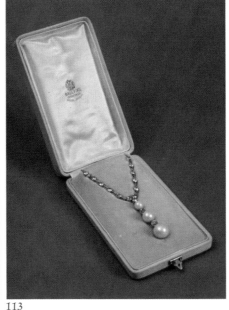
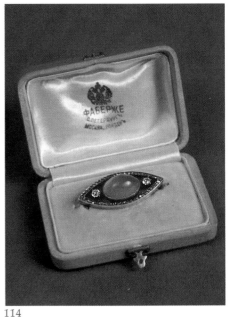

112 113 114

Gold-mounted platinum, set with rose-cut diamonds.

For exhibition and note, cf. cat. 109 and 115

111 "Snowflake" brooch

Unmarked
Diameter: 1"
Original fitted case stamped with Iwm

Gold-mounted platinum, set with rose-cut diamonds.

For exhibition and note, cf. cat. 109 and 115

112 Diamond-set brooch

Wm: A Holmström – Hm: St. Petersburg, 1908–1917 – Length: 1³/₄"
Original fitted case stamped with Iwm, St. Petersburg, Moscow, London

Gold-mounted platinum brooch set with a cushion-shaped diamond flanked by two pear-shaped diamonds, connected by three bands set with rose-cut diamonds.

Exhibited: Helsinki 1980, cat. ill. 91

113 Pearl pendant necklace

Unmarked
Height of pendant: 1³/₁₆"
Original fitted case stamped with Iwm, St. Petersburg, Moscow, London

Three graduating fresh-water pearls, alternating with diamonds; platinum chain set with rose-cut diamonds.

Exhibited: Helsinki 1980, cat. ill. 89

114 Navette-shaped brooch

Wm: Alfred Thielemann – Hm: St. Petersburg, 1899–1908
Length: 1³/₁₆"
Original fitted case stamped with Iwm, St. Petersburg, Moscow, London

Red-gold and platinum mount, set with oval cabochon mecca-stone flanked by two rose-cut diamonds; openwork mount set with rose-cut diamonds.

Exhibited: Helsinki 1980, cat. ill. 90

115 "Snowflake" necklace from the Nobel family

Unmarked
Length: 13¹/₈"
Original fitted case stamped with Iwm, St. Petersburg, Moscow

Fifteen platinum links with "snowflake" motifs set with rose-cut diamonds on rock-crystal background and with diamond-set borders; platinum medal with profile of Ludwig and Emmanuel Nobel, inscribed on reverse: "1882–1912/Mechanical Labor/Nobel". Can be worn as two bracelets.
Example of the numerous objects and jewels with the "snowflake" motif favored by the Nobel family (cf. also nos. 109/111), including the (lost) Nobel "Ice Egg" (Habsburg/Solodkoff, 1979, no. 69).

Provenance: Given by Dr. Emmanuel Nobel to this wife Edla Ahlsell-Nobel
Exhibited: Lugano 1987, no. 92

The Forbes Magazine Collection, New York

115

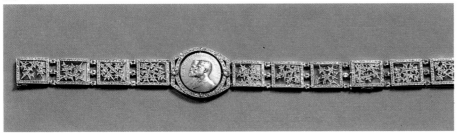

116 Rectangular trelliswork brooch

Length: 1"
Original fitted box with Iwm

Openwork brooch with diamond-set trelliswork applied with a diamond-set and enameled basket of flowers; white *guilloché* enamel border. Illustration p. 287.

117 Combined paperknife and bookmark

Wm: Michael Perchin – Hm: St. Petersburg, before 1899
Length: 4¹/₈″
Original fitted case stamped with Iwm, St. Petersburg, Moscow

Tapering bowenite blade, gold-mounted pink *guilloché* enamel handle with palm-leaf borders and diamond-set finial.

118 Paperknife

Wm: Michael Perchin – Hm: St. Petersburg, before 1899 – Inv: 41 783
Length: 3³/₁₆″
Original fitted case stamped with Iwm

Tapering nephrite blade, matt yellow-gold handle chased with scales; cabochon sapphire finial.

Provenance: Given by Prince William of Denmark (1845–1913), as George I King of the Hellenes (1863–1913), to his sister Thyra, Duchess of Cumberland (1853–1933) The case is inscribed: "Willy – 1891"

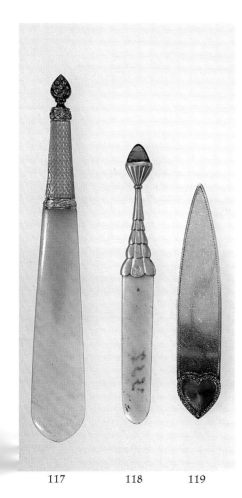

117 118 119

119 Combined paperknife and bookmark

Wm: Erik Kollin – Hm. St. Petersburg, 1899–1908 – Inv: 4505
Length: 2³/₄″
Original fitted case stamped with Iwm, St. Petersburg, Moscow

Tapering burnished red-gold blade; heart-shaped handle in red *guilloché* enamel with diamond-set borders.
The late hallmark on this and a number of other items by Kollin (who died 1901), suggests that he continued to collaborate with Fabergé even after he had been replaced by Perchin as head-workmaster in 1886.

Provenance: Given by the Dowager Empress of Russia to her sister Thyra, Duchess of Cumberland (pencil note: "Til min Thyra – Lille Bogmarke fra Minny, 1901 Jul.)

120 Combined paperknife and bookmark

Wm: Edward Schramm – Hm: St. Petersburg, before 1899
Length: 4³/₄″

Matt yellow gold, set with three cabochon sapphires and six circular-cut diamonds. Not illustrated.

121 Vase-shaped jeweled pendant

Inv: 15 412 – Height: 2⁹/₁₆″
Original fitted case stamped with Iwm, St. Petersburg, Moscow, Odessa

Oval pale mauve cabochon mecca-stone; platinum and yellow-gold base, handles, flower basket, chain and ribbon, all set with rose-cut diamonds; platinum chain.

122 Parasol handle

Mm: Fabergé – Wm: Michael Perchin – Hm: St. Petersburg, before 1899
Length of handle: 2¹/₁₆″

Red-gold, chased with spiralling flutes, applied with gold snakes, each with cabochon ruby head; cabochon star sapphire finial. Original parasol.

123 "Ice pendant"

Unmarked
Height: 1³/₈″

Heart-shaped rock-crystal in platinum mount set with rose-cut diamonds simulating ice-crystals.

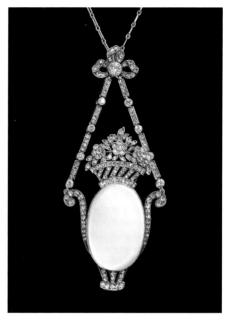

121

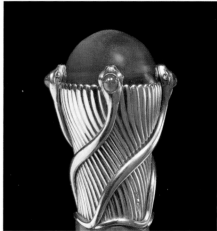

122

123

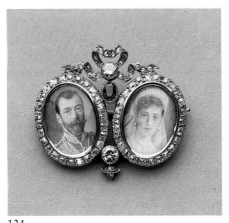

124

For the original design from the Holmström workshop, cf. ill. p. 55.

Provenance: Acquired from Fabergé's London branch by Mr. Oppenheim on December 23, 1913 for £60
Exhibited: Lugano 1987, no. 93

The Forbes Magazine Collection, New York

124 Double portrait brooch

Mm: Fabergé – Wm: Michael Perchin
Width: 1⁹/₁₆″

Pair of oval miniatures of Nicholas II and Alexandra Feodorovna mounted in gold and platinum, set with circular-cut diamonds; flanking a diamond-set ribbon, sapphire and rose-cut diamond.

For a similar brooch in the same collection, with portraits of the Dukes of Oldenburg, cf. Ross, 1965, p. 28.

The Marjorie Merriweather Post Collection, Hillwood, Washington D. C.

125 Fob watch

Wm: Henrik Wigström – Hm: 1908–1917
Am: 72 zolotniks

Gold, the back with opalescent white enamel over waved sunray *guilloché* ground, rose-cut diamond border between opaque white enamel stripes; chased gold rosette in the middle.

Exhibited: Victoria & Albert Museum 1977, no. Q 9

126 Pair of cuff links

Wm: August Hollming
Original fitted case stamped with Iwm, St. Petersburg, Moscow

Pair of double gold links with opalescent pink enamel over *guilloché* sunray ground; central circular-cut diamond and rose-cut diamond borders.

Exhibited: Victoria & Albert 1977, no. Q 22

127 Seal of the Czarevich

Wm: Fedor Afanassiev – Inv: 14 855
Height: 1¹/₄″
Original fitted case stamped with Iwm, St. Petersburg, Moscow

Egg-shaped bowenite handle; tapering gold base with pink *guilloché* enamel and yellow-gold laurel-leaf border; agate matrix carved with crowned initials "AN".

Provenance: Czarevich Alexei Nicholaievich (1904–1918)
Exhibited: Victoria & Albert 1977, no. K 32
Literature: Snowman, 1979, p. 43

128 Lady's ring

Wm: Victor Aarne – Hm: St. Petersburg, before 1899 – Diameter: ¹³/₁₆″

Gold double ring with alternating opaque pale blue enamel panels and half-pearls.

Literature: Snowman, 1962/64, pl. XXXI

125, 128 126, 129 127, 130

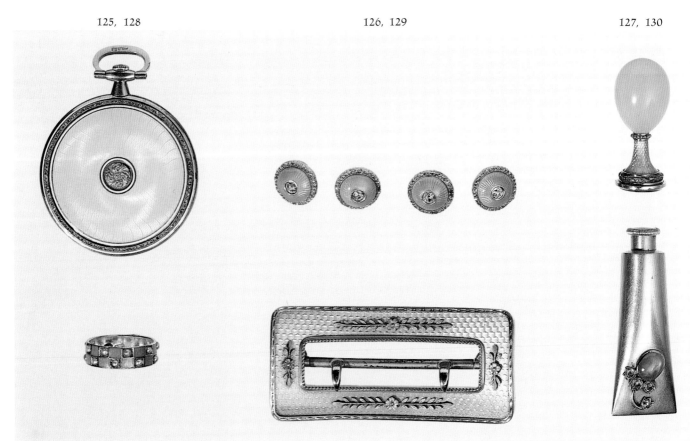

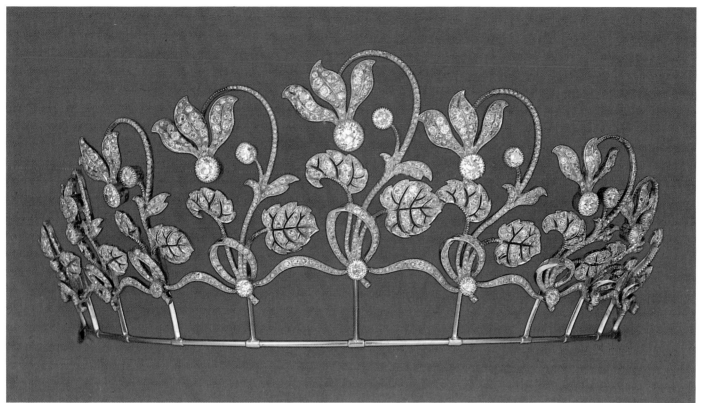

131

129 Belt buckle

Wm: Henrik Wigström – Hm: St. Petersburg, 1899–1908 – Length: 2⁵/₈"
Original fitted case stamped with Iwm, St. Petersburg, Moscow, London

Silver gilt, with salmon pink translucent enamel over waved *guilloché* ground, applied yellow-gold laurel branches and red-gold rosettes.

130 Scent bottle shaped like a tube of oil paint

Wm: Erik Kollin – Hm: St. Petersburg, before 1899 – Inv: 58 331 – Length: 2¹/₈"

Yellow gold, with applied flower set with a cabochon star sapphire and rose-cut diamonds; screw-on cap.

Amusing novelty from Fabergé's workshops.

131 Jeweled art nouveau diadem

Wm: Albert Holmström – Hm: St. Petersburg, 1908–1917
Original fitted case stamped with Iwm, St. Petersburg, Moscow, Odessa

Ten cyclamens in graduating sizes set with circular-cut and rose-cut-diamonds, linked by a diamond-set band; platinum and gold mounts.

Rare example of an important art nouveau jewel, well documented through an extant sketch from Fabergé's workshop (cf. ill. p. 56).

132 Art nouveau pendant

Iwm: K. Fabergé
Width: 1¹³/₁₆"

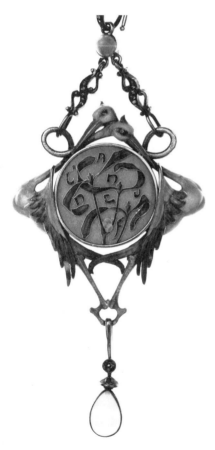

133

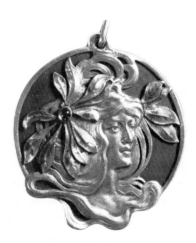

132

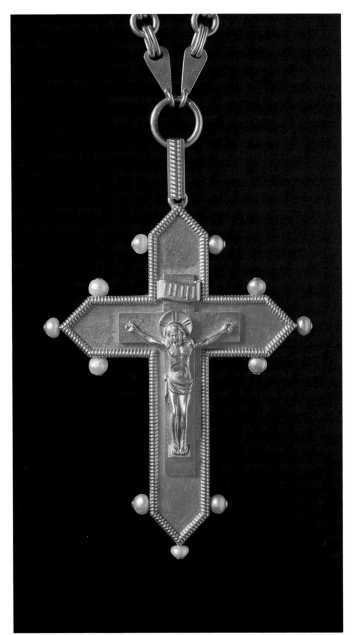

134

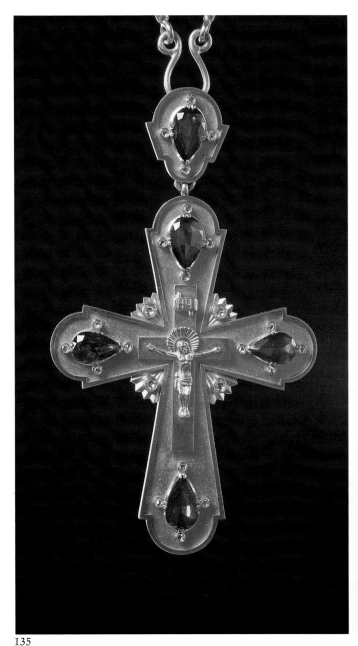

135

Original fitted case stamped with Iwm, Moscow, St. Petersburg, Odessa

Silver, chased with the head of Daphne, with flowing hair and purple enameled foliage set with cabochon ruby; green enamel background. The interior fitted with mirror. – Based on a design by Hans Christiansen, 1900

Literature: Charlotte Gere, *European and American Jewellery*, 1975, ill. 172 – Darmstadt 1982, no. 101

Hessisches Landesmuseum, Darmstadt

133 Art nouveau pendant

Mm: KF (Russian)
Height: $4^3/_8''$

New Year charm in gold; two storks supporting a circular medallion enameled with pale green mistletoe and inscription: "L'AN NEUF" on yellow ground; chain with two chrysoprases and rose-cut diamonds.

Literature: Darmstadt 1982, no. 102

Hessisches Landesmuseum, Darmstadt

Gold

134 Gold pectoral

Mm: Fabergé – Wm: Erik Kollin – Hm: St. Petersburg, before 1899
Height: $4^5/_{16}''$
Gold chain – Wm: CA – Hm: St. Petersburg, before 1899
Original fitted red morocco case with applied double-headed eagle

Matt yellow-gold crucifix with pointed

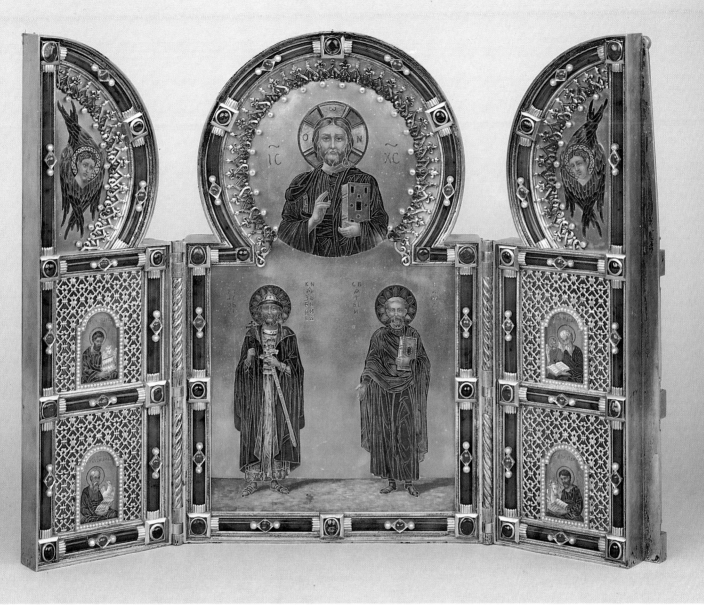

136

arms, gadrooned border, gold figure of Christ; flanked by eleven pearls; gold chain.

Bayerisches Nationalmuseum, Munich (Inv. 77/40–122)

135 Gold pectoral

Wm: Gabriel Niukkanen – Hm: St. Petersburg, before 1899
Height (with pendant): 4¹⁵/₁₆"
Gold chain: Wm: AK
Original fitted red morocco case stamped with double-headed eagle and the mark of the Imperial Cabinet

Matt yellow-gold crucifix with tapering arms, each with pear-shaped garnet flanked by four rose-cut diamonds; pendant *en-suite*; four rose-cut diamonds at the intersections; gold chain.

Interesting case of a Fabergé workmaster working directly for the Imperial Cabinet (no Fabergé case).

Bayerisches Nationalmuseum, Munich (Inv. 77/40–120)

136 Portable tryptich in the Byzantine style

Mm: Fabergé – Wm: Michael Perchin – Hm: St. Petersburg, before 1899
Height: 10¹/₄"
Original fitted case stamped with Iwm, St. Petersburg, Moscow

Shaped as a cross-section of an Orthodox church. Gold, decorated in the Byzantine 11th century style in *cloisonné* enamels with Christ Pantocrator, beneath him St. Boris and St. Kyrill; on the sides, cherubim and the four Evangelists; the frame applied with nephrite

bands, cabochon rubies, sapphires and pearls; applied trelliswork.

For an almost identical icon, cf. Victoria & Albert 1977, No. 0 26

Provenance: Given by Czar Nicolas II to his godchild Boris (1894–1943), later Czar Boris III of Bulgaria, on the occasion of his baptism into the Orthodox Church on February 15, 1896 (St. Boris and Kyrill are the Patron Saints of Bulgaria)

137 Silver gilt powder compact

Mm: Fabergé – Wm: Henrik Wigström
Hm: St. Petersburg, 1908–1917
Length: $3^1/_8$"

Waved engine-turned pattern, the cover with empty cartouche, the borders chased with laurel leaves within white and blue enamel frames, circular-cut diamond push-piece; the interior fitted with mirror and three compartments.

138 Lady's gold cigarette-case

Mm: Fabergé – Wm: August Hollming – Hm: St. Petersburg, 1899–1908 – Inv: 7773
Length: $3^1/_4$"

Reeded yellow and red-gold, with match-compartment, tinder-cord with gold ring and cabochon sapphire thumbpiece.
The interior with signature (in Russian): "Grand Duke Michael Alexandrovich, 1903".

Provenance: Presented by Grand Duke Michael Alexandrovich (1878–1918), brother of Czar Nicolas II

139 Burnished gold cigarette-case

Wm: Gabriel Niukkanen
Hm: St. Petersburg
Length: $3^5/_8$"

Gold-mounted cabochon sapphire thumb-piece, the cover (later) applied with double-headed eagle set with rose-cut diamonds.

140 Reeded gold cigarette-case

Wm: Edward Schramm – Hm: St. Petersburg, before 1899
Length: $3^9/_{16}$"

With match-compartment and opening for tinder-cord, cabochon sapphire thumbpiece; the interior with dedication inscription.

Provenance: Given by Czar Nicolas II to Grand Duke Michael Michailovich in 1898

The Wernher Collection, Luton Hoo

141 Cigarette-case in the Empire style

Mm: Fabergé – Wm: Henrik Wigström
Hm: St. Petersburg, 1908–1917
Height: $4^1/_8$"

Red gold, engraved with eagles, laurel crowns, arrows and cornucopiae; with match-compartment and diamond-set thumbpiece. Probably made in 1912 to commemorate the 100th anniversary of the Napoleonic Wars.

Exhibited: A la Vieille Russie 1983, no. 136

142 Reeded gold cigarette-case

Mm: Fabergé – Wm: August Hollming
Hm: St. Petersburg, 1908–1917
Length: $3^3/_4$"

Engine-turned, with alternating wide and narrow bands; cabochon sapphire thumb-piece.

143 Reeded silver cigarette-case

Wm: A. Holmström – Hm: St. Petersburg, before 1899
Length: 4"

Applied with numerous gold crowned monograms and "MM" in the center; with match-compartment and opening for tinder-cord.

Provenance: Grand Duke Michael Michailovich (1861–1929)

The Wernher Collection, Luton Hoo

144 Miniature gold samovar

Mm: Fabergé – Wm: Hendrik Wigström
Hm: St. Petersburg, 1908–1917
Height: $1^7/_{16}$"

Yellow-gold miniature replica of a samovar "intended as" a table-lighter. Engraved: "4 cups of tea – Palata Buckhurst Park Jubilé 9 Nov. 1933–7".

Provenance: Lydia, Lady Deterding (Christie's, Geneva, April 26, 1978, lot 333)
Literature: Snowman, 1962/64, ill 103
Illustration p. 110

Mrs. Josiane Woolf

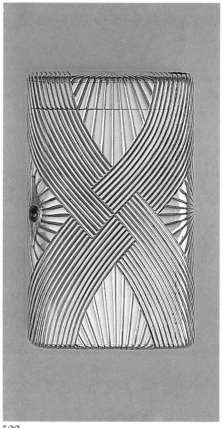

599

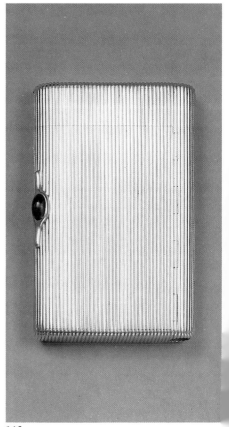

140

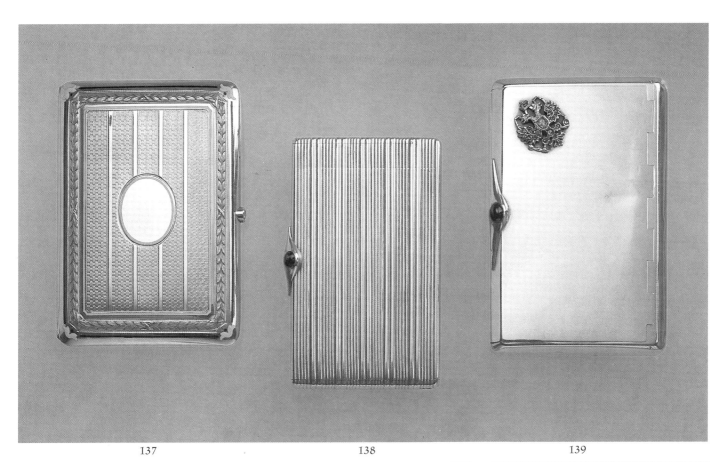

137 138 139

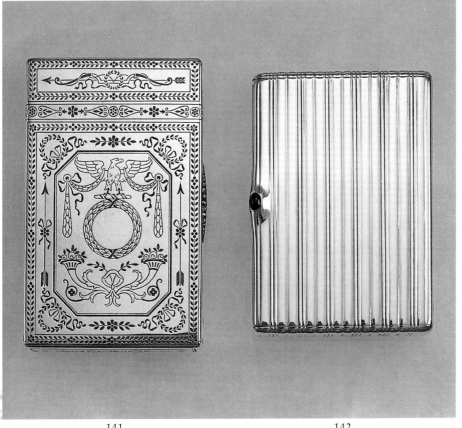

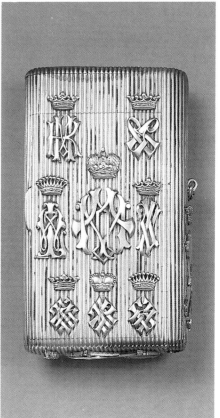

141 142 143

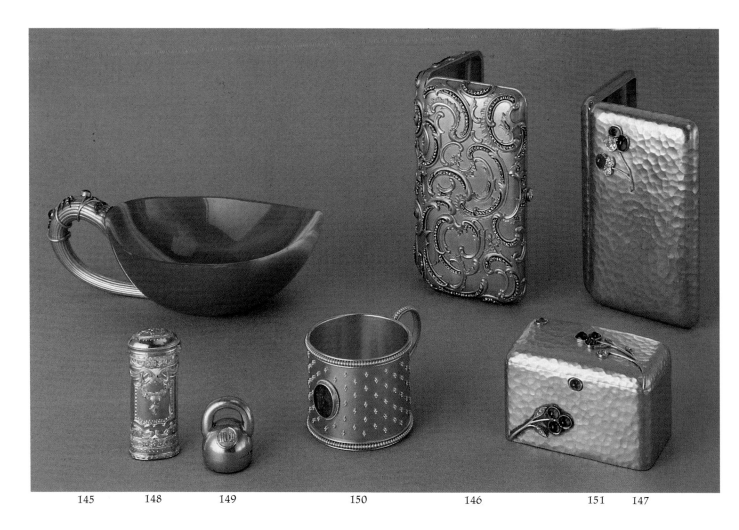

145 148 149 150 146 151 147

145 Gold-mounted kovsh

Wm: Michael Perchin – Hm: St. Petersburg,
before 1899
Length: 4$^{15}/_{16}$"

Pear-shaped striated agate bowl with loop-
shaped reeded yellow-gold handle applied
with flowers and set with rose-cut diamonds
and cabochon rubies.
Early product of Perchin, still in the manner
of his predecessor, Kollin.

146 "Rococo" cigarette-case

Mm: Fabergé – Wm: Michael Perchin – Hm:
St. Petersburg, before 1899 – Inv: 47 386
Length: 3$^5/_{16}$"

Matt yellow gold applied with rococo scrolls
in red and yellow gold, partially set with
rose-cut diamonds; circular-cut diamond
pushpiece.

147 Hammered gold cigarette-case

Wm: Edward Schramm – Hm: St. Petersburg,
before 1899 – Austrian import mark
Length: 3$^1/_8$"

Red gold overlaid in yellow gold, applied
with two blossoms set with rubies and sap-
phires and circular-cut diamonds; cabochon
sapphire pushpiece.
Example of Fabergé's use of a cheaper alloy,
perhaps because of its greater malleability;
made to look more attractive by a coat of
yellow gold.

H.I. and R.H. Prince Louis Ferdinand of
Prussia, Berlin

148 Vesta-case in the Louis XVI style

Wm: Michael Perchin – Hm: St. Petersburg,
before 1899 – Inv: 40(?)60
Height: 1$^3/_4$"
Original fitted red morocco case stamped
with Iwm

Polished red gold, chased and applied with
flower-swags and foliage in four-color gold.

An original imitation of a Louis XVI needle-
case transformed into a match-box with
roughened base for striking matches.

149 Gold pendant seal

Wm: August Holmström – Hm: St. Peters-
burg, before 1899
Height: $^{13}/_{16}$"

Shaped like a Russian three-pound weight
(IIIF), the base with lapis lazuli matrix cut
with Hanoverian coat-of-arms; opening to
reveal two photographs of Duke Ernest
August of Cumberland (1845–1923) and his
wife, Thyra (1853–1933).

150 Cylindrical vodka cup

Wm: Erik Kollin – Hm: St. Petersburg, before
1899
Height: 1$^5/_{16}$"

150

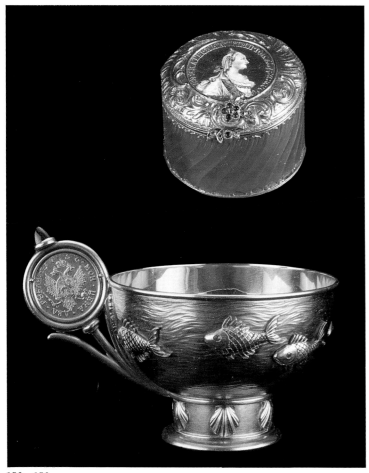

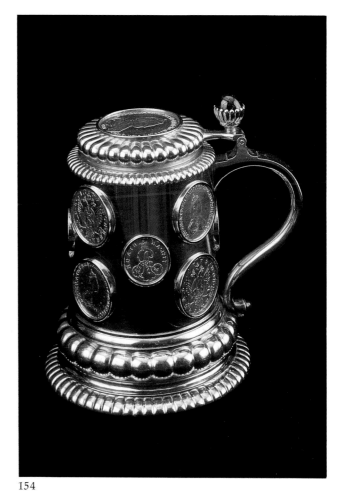

152, 153 154

Matt yellow gold set with oval carnelian intaglio and applied with gold granulation. Early example of gold granulation, which was rediscovered by Castellani from Etruscan jewelry.

151 Rectangular bonbonnière

Wm: August Holmström – Hm: St. Petersburg, before 1899 – Inv: 5039
Length: 2³/₁₆″

Hammered red gold, applied with two flower sprays, each set with three cabochon sapphires and rose-cut diamonds; cabochon ruby pushpiece.

152 "Rococo" bonbonnière

Mm: Fabergé – Wm: Michael Perchin – Hm: St. Petersburg, before 1899 – Inv: 41691
Diameter: 1⁹/₁₆″

Cylindrical, yellow gold, the sides chased with spiral fluting; the cover with gold ruble of Catherine the Great, 1767, in colored enamel, within border chased with rococo scrolls; thumbpiece set with cabochon rubies and rose-cut diamonds.

H. R. H. Henrik Prince of Denmark

153 "Chinese" tcharka

Mm: Fabergé – Wm: Michael Perchin – Hm: St. Petersburg, before 1899
Height: 1⁷/₈″

Red gold, applied with white and red-gold fishes with ruby eyes, swimming on a yellow-gold waved background; foot chased with six scallops; handle set with gold ruble of Empress Elizabeth, 1756, and cabochon sapphire.

Exhibited: Lugano 1987, no. 9
Literature: Waterfield/Forbes, 1978, no. 123

The Forbes Magazine Collection, New York

154 Miniature coin tankard

Wm: Erik Kollin – Hm: St. Petersburg, before 1899 – Height: 3³/₈″

Burnished gold, with gadrooned cover and base, the cover inset with a ruble of Catherine the Great, 1783; the sides with eight rubles and four half-rubles dated 1779 and 1777; the handle set with two cabochon sapphires.
Miniature replica of a 17th century coin tankard.

Exhibited: Victoria & Albert 1977, no. L 6 – Lugano 1987, no. 8
Literature: Waterfield/Forbes, 1978, no. 118 Solodkoff, 1984, p. 17

The Forbes Magazine Collection, New York

155 Cigarette-case

Wm: Edward Schramm – Hm: St. Petersburg, before 1899
Length: 3¹/₁₆″

Red gold, covered in yellow gold; applied with a flower spray set with heart-shaped cabochon rubies and circular-cut diamonds. Illustrated on p. 152.

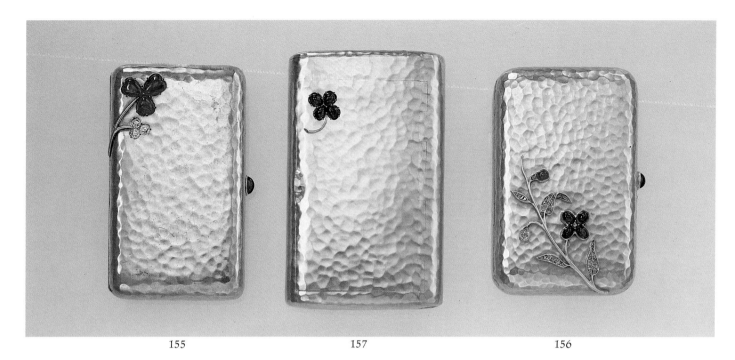

155 157 156

156 Cigarette-case

Wm: August Holmström – Hm: St. Petersburg, before 1899
Length: 3$^1/_8$"

Hammered red gold, covered in yellow gold; applied with leaves set with rose-cut diamonds and flowers set with cabochon rubies and sapphires; cabochon sapphire pushpiece. An example of the technique mentioned above (see p. 90), used by Fabergé. The red gold used as base was more malleable and cheaper.

157 Cigarette-case

Wm: Edward Schramm – Hm: St. Petersburg, before 1899
Length: 3$^7/_{16}$"

Hammered red gold, covered in yellow gold; applied flowers set with four cabochon sapphires; with match-compartment and violet tinder-cord with gold suspension ring.

158 Cigarette-case

Mm: Fabergé – Wm: August Hollming
Hm: St. Petersburg, 1899–1908
Length: 3$^{11}/_{16}$"

Reeded yellow gold, with match-compartment, tinder-cord with gold suspension ring and cabochon sapphire thumbpiece. The interior inscribed: "Waidmann's Dank für schöne Tage in Skole. Adam Zamojskj 1909." Applied emblem with stag's tusks and oak leaves.

159 Gold cigarette-case

Wm: Gabriel Niukkanen – Hm: St. Petersburg, before 1899
Length: 3$^7/_8$"

Chased with fan-shaped motifs; match-compartment and tinder-cord with gold ring, cabochon sapphire pushpiece.

Exhibited: Victoria & Albert 1977, no. R 13
Literature: Bainbridge, 1949/68, pl. 106 (above) – Snowman, 1979, p. 48

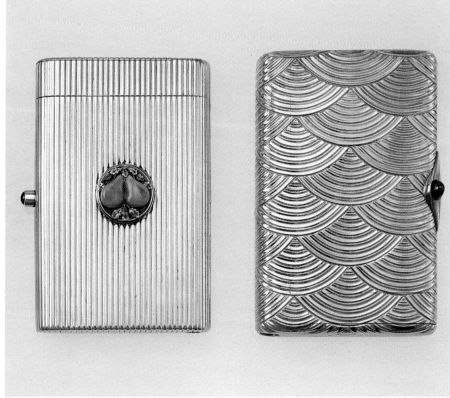

158, 159

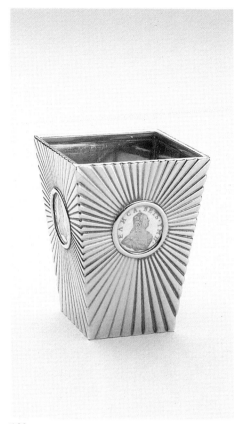

160

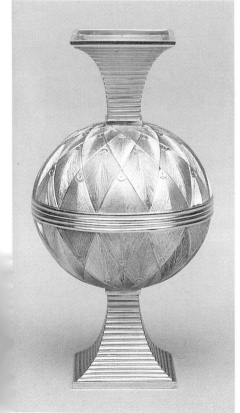

61

162, 163

160 Match holder shaped like a wastepaper basket

Mm: Fabergé – Wm: Michael Perchin – Hm: St. Petersburg, before 1899 – Inv: 54 481
Height: 1¹³/₁₆"

Alternating yellow and red-gold fields engine-turned with sunray pattern, centering on four gold rubles of Catherine the Great and Empress Elizabeth, partially enameled in white.
Typical example of a Fabergé novelty.

Exhibited: Lugano, 1987, no. 11

The Forbes Magazine Collection, New York

161 Gold "loving cup"

Mm: Fabergé – Wm: Michael Perchin – Hm: St. Petersburg, before 1899
Height: 3¹/₂"

The interlocking double cup chased with "peacock feather" motifs on yellow, red and white-gold ground; reeded red and white-gold feet.
Original novelty of Fabergé's in a modern design heralding art déco.

Provenance: Sir Charles Clore
Exhibited: Victoria & Albert 199, no. 0 22
Literature: Snowman, 1962/64, pl. XXIX

162 Gold cigarette-case

Mm: Fabergé – Wm: August Hollming
Hm: 1899–1908 – Am: 72 zolotniks
Length: 3³/₁₆"

Basket-weave design with interlacing bands of red and green gold and platinum, the green-gold bands chased with laurel leaves; circular-cut diamond pushpiece.

Exhibited: Victoria & Albert 1977, no. R. 17
Literature: Snowman, 1979, p. 54

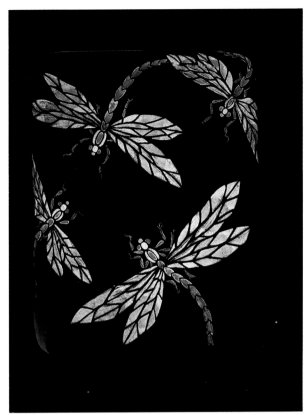

164

165

163 Gold cigarette-case

Mm: Fabergé – Wm: August Hollming –
Hm: St. Petersburg, 1908–1917
Length: 3^{11}/$_{16}$"

Alternating waved and reeded triple bands
of red and yellow gold; cabochon sapphire
thumbpiece.
One of the most classical and popular de-
signs introduced by Fabergé.

Provenance: Max Harari
Literature: Snowman, 1962/64, pl. VI –
Snowman, 1979, p. 54

164 Art nouveau cigarette-case

Iwm: K. Fabergé – Hm: Moscow 1899–1908
Inv: 19 234
Length: 3^{3}/$_{4}$"

Burnished gold, decorated with four blue
and white *plique-à-jour* dragonflies. Interior
with dedication: "For my darling Ernie from
Nicky and Alix, Xmas 1900".
Rare product in this technique from Fab-
ergé's workshops, made in the year of the
Paris World Fair, when art nouveau was offi-
cially sanctioned.

Provenance: Given by Nicholas II and Alex-
andra to Alexandra's brother, Grand Duke
Ernest Louis of Hesse and the Rhine

165 Gold frame shaped like an easel

Unmarked
Height: 4^{15}/$_{16}$"

Three poles with cabochon emerald ends
enameled with white stripes tied with gold
ribbons and with four-color flower-swags;
oval photograph of Grand Duke Michael
Nikolajevich of Russia (1831–1909), grand-
father of Queen Alexandrine of Denmark.
Example of Fabergé's adaption of the
Louis XV technique of varicolored golds (in-
cluding black gold).

H. M. Queen Margrethe II of Denmark

166 Art nouveau bonbonnière

Iwm: K. Fabergé – Hm: Moscow 1899–1908
Diameter: 2^{1}/$_{8}$"

Gold, chased and enameled in green with
lily-of-the valley leaves, applied with flower
sprays set with pearls.

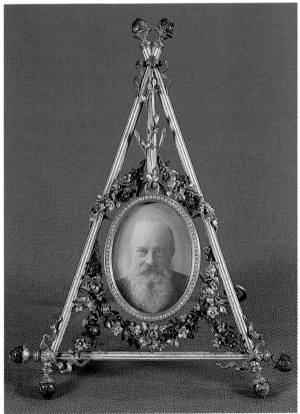

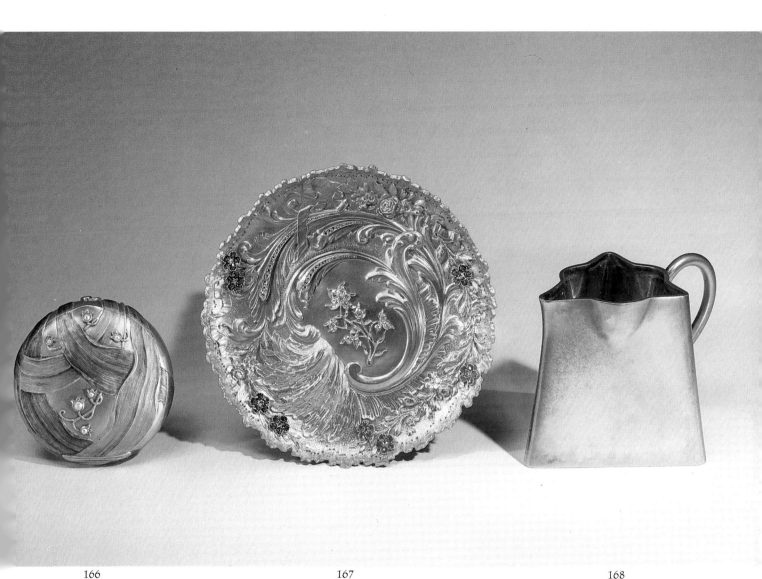

166 167 168

167 Gold art nouveau dish

Wm: Edward Schramm – Am: 72 zolotniks
Inv: 24 870
Diameter: 4$^1/_2$″

Yellow gold, chased with vigorously scroll-
ing acanthus foliage, with diamonds in open-
work settings, the center applied with flower
sprays set with rose-cut diamonds, the sides
with flowerheads in cabochon rubies, sap-
phires and diamonds.
One of Fabergé's most explicit art nouveau
objects made before the turn of the century.
For another similar item by Schramm cf.
Sotheby, New York, December 12, 1979,
lot 3.

Exhibitions: Victoria & Albert 1977, no. 0
27

Mrs. Josiane Woolf

168 Silver gilt art nouveau cream jug

Iwm: K. Fabergé – Hm: Moscow, before
1899
Height: 2$^9/_{16}$″

Of tapering triangular shape, with scalloped
rim and foliate handle.
Original Fabergé design combining art nou-
veau and art déco elements.

Literature: Habsburg/Solodkoff, 1979, ill. 36
Snowman, 1979, p. 57

Mrs. Josiane Woolf

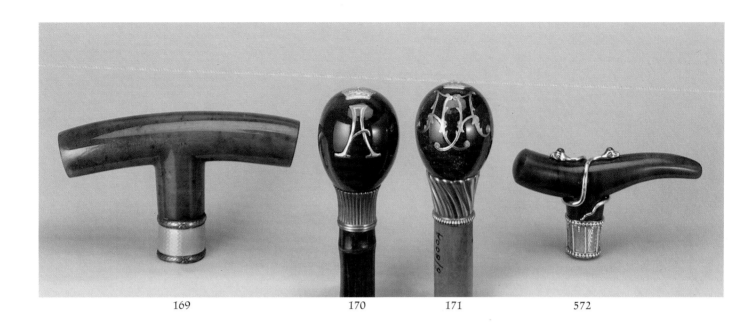

169 170 171 572

Objects in Hardstone

169 "T"-shaped cane handle

Wm: Henrik Wigström – Hm: St. Petersburg, 1898–1903 – Am: A. Richter
Width: 4$^{15}/_{16}$"

Nephrite, silver gilt mount with pink *guilloché* enamel within palm-leaf borders.

From a cane once belonging to Czar Ferdinand of Bulgaria

170 Parasol handle

Wm: Erik Kollin – Hm: St. Petersburg, before 1899
Height of handle: 2$^9/_{16}$"

Egg-shaped bloodstone handle inlaid with gold crowned initial "A"; reeded matt yellow-gold mount.

Provenance: Alfred, Duke of Edinburgh (1844–1900)

171 Cane handle

Wm: Michael Perchin – Hm: St. Petersburg, before 1899
Height of handle: 2$^9/_{16}$"

172 173 174 175 176

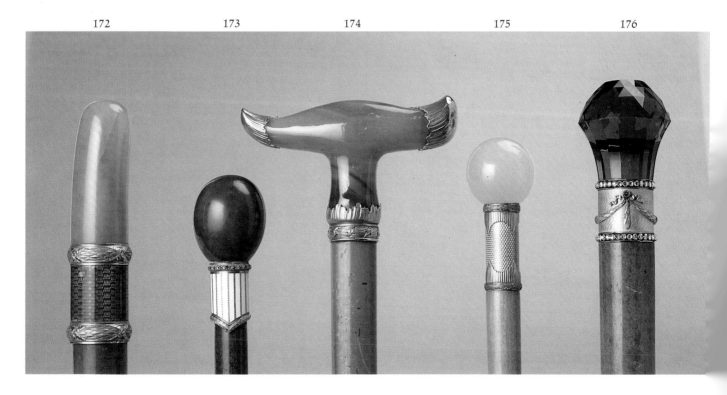

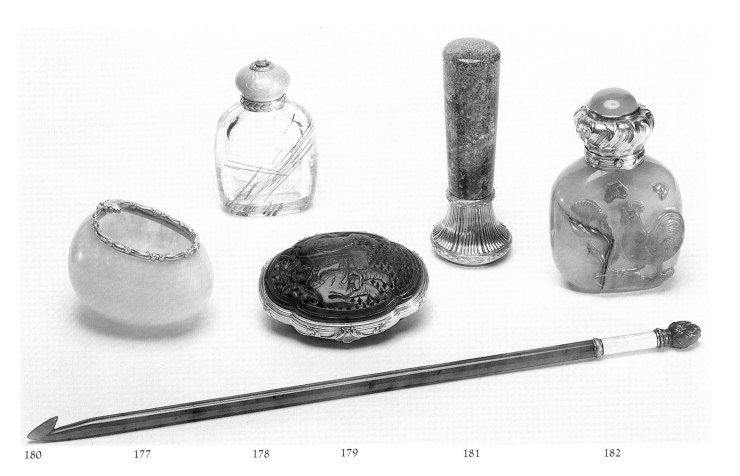

180 177 178 179 181 182

Egg-shaped bloodstone handle inlaid with gold crowned monogram "AA"; spirally fluted polished yellow-gold mount.
Interesting parallels between the styles of two consecutive head-workmasters.

Provenance: Grand Duke Alexei (1850–1908), son of Czar Alexander II and brother-in-law of Alfred, Duke of Edinburgh

172 Cane handle

Mm: Fabergé – Wm: Michael Perchin – Hm: St. Petersburg, before 1899
Height of handle: $4^5/_{16}$"

Cylindrical bowenite handle; gold mount with red *guilloché* enamel between laurel-leaf borders.

173 Cane handle

Wm: Michael Perchin – Hm: St. Petersburg, 1899–1908
Height of handle: $2^{11}/_{16}$"

Egg-shaped nephrite handle; gold mount with white opaque enamel stripes, ruby and diamond-set border above, palm-leaf border below.

174 "Rococo" cane handle

Wm: Julius Rappoport – Hm: St. Petersburg, before 1899
Height of handle: $2^5/_8$"

"T"-shaped banded agate handle with Louis XV style gold mounts.
Exceptional work by Rappoport, otherwise known as a silversmith.

175 Parasol handle

Wm: Michael Perchin – Hm: St. Petersburg, 1899–1908
Height of handle: $2^{13}/_{16}$"

Ball-shaped handle, reeded gold mount with pale mauve *guilloché* enamel and palm-leaf borders.

176 Parasol handle

Unmarked
Height of handle: $2^{15}/_{16}$"

Mushroom-shaped facetted smoky-quartz handle with gold mounts enameled in pale green over waved *guilloché* ground; applied gold laurel swags and cabochon rubies, rose-cut diamond borders.

177 Egg-shaped recipient

Wm: Erik Kollin – Hm: St. Petersburg, before 1899 – Inv: 44 897
Length: $2^1/_8$"

Bowenite, with yellow-gold rim chased with rococo scrolls.
Fabergé novelty, unusual for Kollin, probably dating from the late 19th century.

178 Scent bottle

Mm: Fabergé – Wm: Henrik Wigström
Hm: St. Petersburg, 1908–1917
Height: $2^3/_4$"

Rutilated quartz, the gold cover with pink *guilloché* enamel, yellow-gold laurel-leaf border and cabochon moonstone finial.

Exhibited: A la Vieille Russie 1983, no. 265

179 Quatrefoil bonbonnière

Mm: Fabergé – Wm: Henrik Wigström
Hm: 1908–1917
Length: $2^{13}/_{16}$"

Dark green jade, pierced and carved with an

elephant; gold mount with white opaque enamel stripes and applied gold foliage. Reutilisation by Fabergé of a Chinese cricket cage.

Mrs. Josiane Woolf

180 Crochet hook

Wm: Henrik Wigström — Inv: 17 411
Length: 10¹/₄″

Nephrite, gold-mounted with white enamel on waved *guilloché* ground, rose-cut diamond border and nephrite artichoke finial.

Exhibited: Victoria & Albert 1977, no. P 21
Literature: Snowman, 1962/64, ill. 224

181 Triple seal

Mm: Fabergé — Wm: Henrik Wigström
Hm: St. Petersburg, 1908–1917
Height: 3⁹/₁₆″

Cylindrical turquoise handle, reeded red and yellow-gold mount with laurel-leaf borders; hinged, revealing two further agate seals. For a similar triple seal, cf. A la Vieille Russie 1983, no. 244. Illustration p. 157.

182 Chinese scent bottle

Mm: Fabergé — Wm: Henrik Wigström
Hm: 1908–1917 — Height: 3¹/₈″

Honey-colored agate, carved with a cockerel, butterflies and flower; yellow-gold cover chased with rococo scrolls, orange cabochon agate finial; reeded mount chased with foliage; rose-cut diamond pushpiece. Reutilisation by Fabergé of a Chinese snuffbottle. Illustration p. 157.

Exhibited: A la Vieille Russie 1983, no. 264

183 Rectangular photograph frame

Mm: Fabergé — Wm: Michael Perchin — Hm: St. Petersburg, before 1899 — Inv: 40 847
Height: 3¹/₈″

Nephrite, in *à cage* gold mounts chased with laurel leaves; gold backing and strut. Photograph of Thyra, Duchess of Cumberland with her son, William.

184 Empire-style pencil tray

Wm: Erik Kollin — Hm: St. Petersburg, before 1899 — Inv: 40 583 — Length: 9¹/₁₆″

Concave nephrite tray; gold mounts with four hoof-shaped feet and foliate borders. Uncommon object for Kollin, probably dating from the late 19th century.

185 "Louis XVI" beaker

Mm: Fabergé — Wm: Michael Perchin — Hm: St. Petersburg, before 1899 — Inv: 46 379
Height: 2″

Nephrite; gold mount with laurel swags suspended from six cabochon sapphires, standing on three claw and ball-feet.

186 Magnifying glass

Mm: Fabergé — Wm: Michael Perchin — Hm: St. Petersburg, before 1899
Length: 4³/₄″

Nephrite handle with cabochon sapphire finial in rose-cut diamond mount and reeded gold stem; glass in yellow-gold mount with gold laurel leaves on opaque white enamel ground.
For a similar item, cf. A la Vieille Russie 1983, no. 238

183 184 189

185 186 187 188

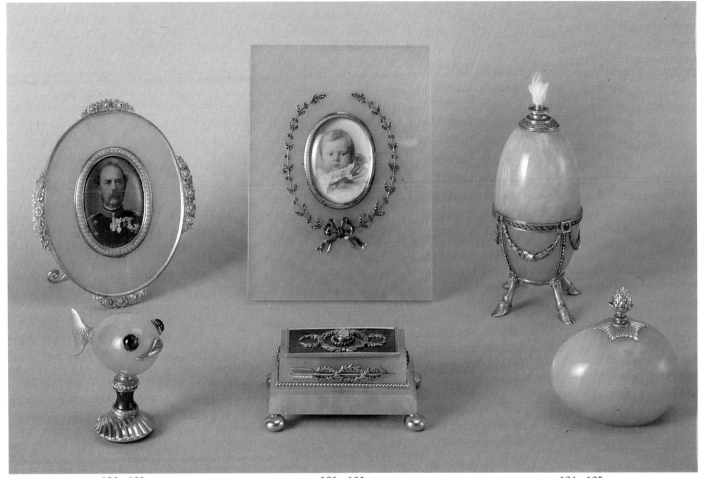

190, 192 191, 193 194, 195

187 Art nouveau paperknife

Mm: Fabergé – Wm: Michael Perchin – Hm:
St. Petersburg, 1899–1908 – Inv: 1979
Length: $7^{1}/_{16}$"

Nephrite blade; gold handle chased with
bat's wings, set with three cabochon moon-
stones and two cabochon rubies.

188 Oval art nouveau bowl

Mm: Fabergé – Wm: Michael Perchin – Hm:
St. Petersburg, before 1899 – Inv: 40 886
Height: $3^{9}/_{16}$"

Nephrite with yellow-gold scroll handles
and base.
Typical example of Perchin's favorite combi-
nation of art nouveau and rococo motifs.

189 Nephrite cigarette-case

Mm: Fabergé – Wm: Michael Perchin – Hm:
St. Petersburg, before 1899
Length: $3^{7}/_{16}$"

Highly polished nephrite; yellow-gold
mount chased with laurel-leaf border; cir-
cular-cut diamond pushpiece.

190 Oval bowenite frame

Wm: Michael Perchin – Hm: St. Petersburg,
before 1899 – Inv: 48 657
Height: $3^{1}/_{4}$"

Gold mount applied on four sides with
flower swags in four-color gold; ivory back-
ing with gold strut; miniature of King Chris-
tian IX of Denmark (1843–1912).

191 Rectangular bowenite frame

Mm: Fabergé – Wm: Michael Perchin – Hm:
St. Petersburg, before 1899 – Inv: 5755
Height: $4^{1}/_{16}$"

Applied with two laurel-leaf sprays set with
rose-cut diamonds and red enamel berries;
ivory backing with gold strut; photograph
of Prince Frederick (1899–1972), the later
King Frederick IX of Denmark, as a baby.

192 Table seal shaped like a fish

Wm: Henrik Wigström – Hm: St. Peters-
burg, 1899–1908 – Height: $1^{5}/_{8}$"

Egg-shaped bowenite handle designed like
a fish with red-gold mouth and tail and cab-
ochon garnet eyes; scallop-shaped gold base
with agate matrix, red enamel stem with
seed pearl border.

**193 Rectangular electric
table-bellpush**

Mm: Fabergé – Wm: Michael Perchin – Hm:
St. Petersburg, 1899–1908 – Inv: 4391
Length: $2^{1}/_{8}$"

Bowenite, on four gold feet, Louis XVI style,
decoration of applied arrows and laurel
leaves; red *guilloché* enamel top with ca-
bochon moonstone pushpiece.

194 Bowenite table lighter

Mm: Fabergé – Wm: Michael Perchin – Hm:
St. Petersburg, before 1899 – Inv: 47 394

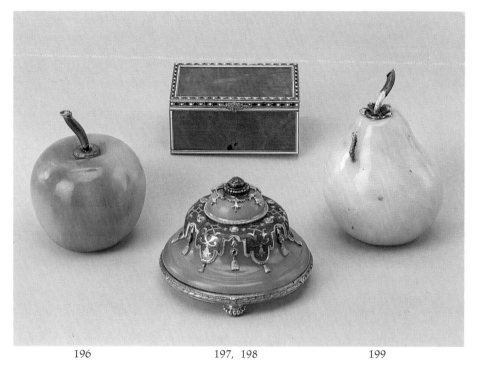

196 197, 198 199

Shaped like an elongated egg, with Louis XVI style gold mounts; standing on four hoof-shaped feet, applied with laurel swags, vertical diamond-set bands and four facetted rubies.

195 Bowenite glue-pot

Mm: Fabergé – Wm: Michael Perchin – Hm: St. Petersburg, 1899–1908 – Inv: 5275
Length: 2⁷/₈″

Original fitted case stamped with Iwm, St. Petersburg, Moscow, Odessa

Egg-shaped; gold-mounted opening chased with sunray pattern, gold-mounted brush with artichoke finial.
Illustration p. 159

196 Apple-shaped glue-pot

Mm: Fabergé – Wm: Henrik Wigström – Hm: St. Petersburg, 1898–1903 – Am: A. Richter
Height: 2³/₈″

Pink aventurine quartz; gold-mounted brush with brown and green stem set with a diamond.
For a similar apple, cf. A la Vieille Russie 1983, no. 228

197 Rectangular rhodonite box

Mm: Fabergé and initials CF – Hm: St. Petersburg, 1908–1917 – English Import marks for 1911 – Inv: 23331
Length: 2¹/₄″

À cage panels in gold mounts with opaque white enamel stripes, the cover with Louis XVI style decoration of green enamel leaves and white pellets; diamond-set thumbpiece.

198 "Régence" table bellpush

Mm: Fabergé – Wm: Michael Perchin – Hm: St. Petersburg, before 1899 – Inv: 58052
Diameter: 2⁶/₈″

Domed bowenite bellpush applied with gold and red guilloché enamel "cloth" set with rose-cut diamonds and suspending tassels; laurel-leaf border, three stud feet, cabochon ruby pushpiece.

199 Pear-shaped bowenite glue-pot

Wm: Michael Perchin – Hm: St. Petersburg, 1899–1908 – Inv: 56768
Height: 2⁷/₈″

The over-ripe pear is shown with spots and a gold worm; the brush with a brown and green enamel stem is set with a diamond.

Literature: Habsburg, 1977, p. 77

200 Nephrite kovsh

Unmarked
Length: 4″
Original fitted case stamped with Iwm, St. Petersburg, Moscow, Odessa

Oval bowl with hook-shaped handle applied with gold Russian inscription: "Drink, that you may become wise".

Provenance: Ambassador Jean Herbette, en poste in Moscow 1925–30 (Christie's, Geneva, November 19, 1970, lot 138)

201 Oval nephrite pencil tray

Wm: Michael Perchin – Hm: St. Petersburg, before 1899
Length: 6³/₈″

Red-gold rim enameled with white navettes and red pellets.

202 Nephrite paperknife

Mm: KF (Russian) – Hm: Moscow, 1899–1908
Length: 10″

Gold mount chased with palm-leaf borders, applied with navette-shaped panel enameled in red.

203 Large nephrite paperknife

Inv: 3598
Length: 14″

Gold handle, enameled in red on one side over guilloché sunray pattern and set with pink foiled moss agate in rose-cut diamond frame; yellow-gold laurel-leaf border.
For a similar paperknife in the Forbes Magazine Collection, cf. Waterfield/Forbes 1978, no. 109

204 Rock-crystal paperknife

Mm: KF (Russian) – Hm: 1899–1908
Length: 6⁷/₈″
Original fitted case stamped with Iwm, Moscow, St. Petersburg

Applied with yellow-gold laurel-leaf mount, red-gold ribbon and set with rose-cut diamond.

Pencilled dedication: "For dear Miss Jackson with loving Xmas wishes from Alix, 1900"

Provenance: Given by Czarina Alexandra Feodorovna to her nurse
Literature: Snowman, 1979, p. 137

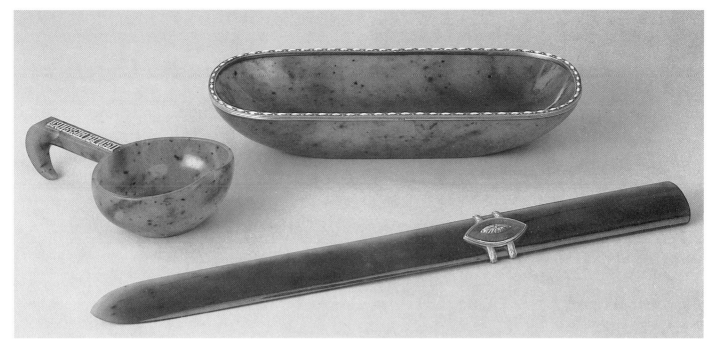

200, 201, 202

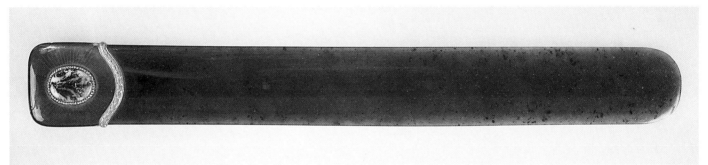

203

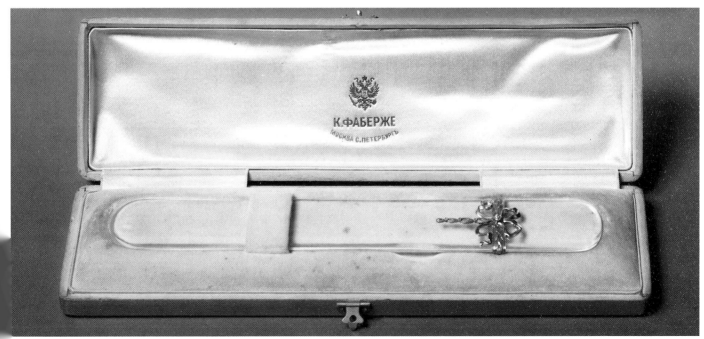

204

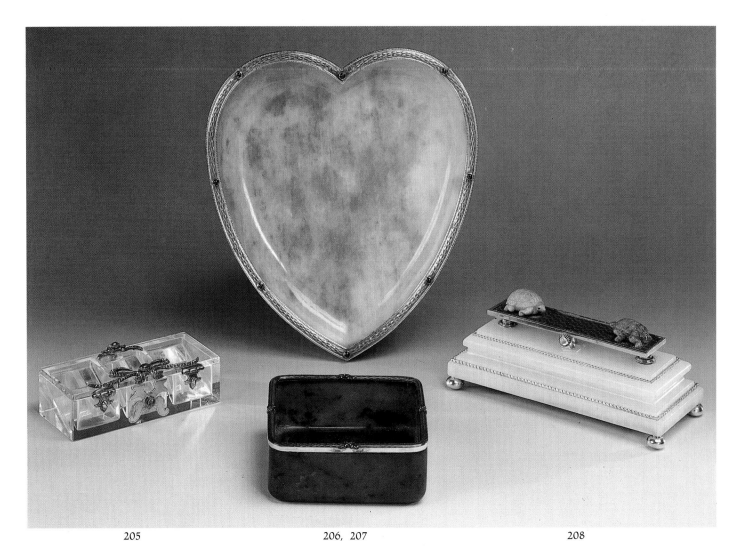

205

206, 207

208

205 Rock-crystal stamp box

Wm: Michael Perchin
Length: 2⁷/₈″

With three sloping compartments, the cover applied with tied ribbons set with rose-cut diamonds and cabochon rubies.

206 Heart-shaped dish

Mm: Fabergé – Wm: Michael Perchin – Hm: St. Petersburg, before 1899
Length: 5¹/₂″

Mottled brownish aventurine quartz; red and yellow-gold mount chased with laurel-leaf border, set with cabochon sapphires. For a similar dish, cf. Helsinki 1980, cat. p. 98

207 Rectangular ashtray

Wm: Henrik Wigström – Hm: St. Petersburg, 1899–1908
Length: 2⁹/₁₆″

Nephrite, with yellow-gold rim enameled in red and tied with diamond-set ribbons.

208 Double table-bellpush

Mm: Fabergé – Wm: Michael Perchin – Hm: St. Petersburg, 1899–1908 – Inv: 5720
Length: 3¹⁵/₁₆″

Stepped bowenite base on four gold stud feet; with two jade turtles on a red enameled gold seesaw, set with two cabochon moonstones.

209 Hemispherical tcharka

Hm: St. Petersburg, before 1899
Diameter: 2⁷/₈″

Dark smoky quartz; matt yellow-gold rim set with cabochon rubies and rose-cut diamonds in lozenge-shaped mounts.

210 Miniature kovsh

Unmarked
Length: 2⁷/₁₆″

Oval rock-crystal bowl; hook-shaped gold handle enameled in green, set with rubies.

211 Cylindrical gray agate pot

Wm: Michael Perchin – Hm: St. Petersburg, before 1899 – Inv: 51 441
Height: 2⁵/₁₆″

Standing on four gold hoof-shaped feet, applied with yellow-gold laurel swags, four emerald cabochons and a red enameled gold band.

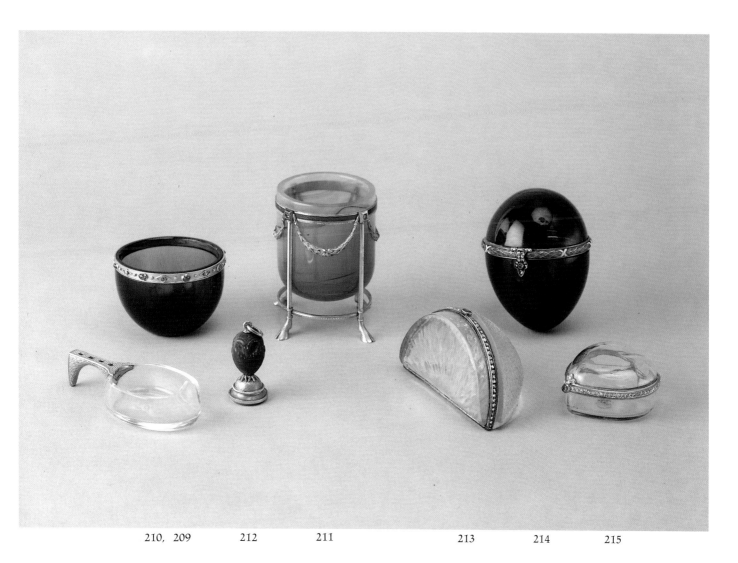

210, 209　　　212　　　211　　　213　　214　　215

212　Owl-shaped fob seal

Wm: Fedor Afanassiev – Hm: 1908–1917 –
Inv: 20 183
Height: 1³/₈"
Original fitted case stamped with Iwm,
St. Petersburg, Moscow, London

Dark gray striated agate bird standing on a
domed base enameled in pink, with gray
agate matrix.

**213　Bonbonnière shaped
like a slice of lemon**

Wm: Michael Perchin – Hm: St. Petersburg,
before 1899 – Am: 72 zolotniks – Inv: 48 594
Length: 2¹/₁₆"

Smoky quartz; yellow-gold mount set with
rose-cut diamonds; thumbpiece set with oval
facetted ruby.

For another, similar bonbonnière, cf. Snow-
man, 1979, p. 50

**214　Oviform smoky quartz
bonbonnière**

Mm: Fabergé – Wm: Michael Perchin – Hm:
St. Petersburg, before 1899
Height: 2¹/₈"

Gold-mounted, with green enamel laurel-leaf
border and white ties; diamond and ruby-set
clasp.

For another oviform bonbonnière, cf. cat.
229

215　Heart-shaped bonbonnière

Inv: 2337
Length: 1⁹/₁₆"
Original fitted case stamped with Iwm,
St. Petersburg, Moscow

Rock-crystal; yellow-gold mount set with
rose-cut diamonds; cabochon ruby thumb-
piece.

216　Electric table-bellpush

Inv: 58 838
Length: 2⁵/₁₆"

Obsidian elephant, standing on a white and
red enamel carpet; on a stepped bowenite
base with four stud feet.

Provenance: Office of King Christian IX of
Denmark

Chronological Collection of the Queen of
Denmark, Rosenborg Castle

217　Paperknife

Unmarked
Length: 5¹/₄"

Bowenite with inlaid gold Russian inscrip-
tion: "May you reap".

H. M. Queen Margrethe II of Denmark

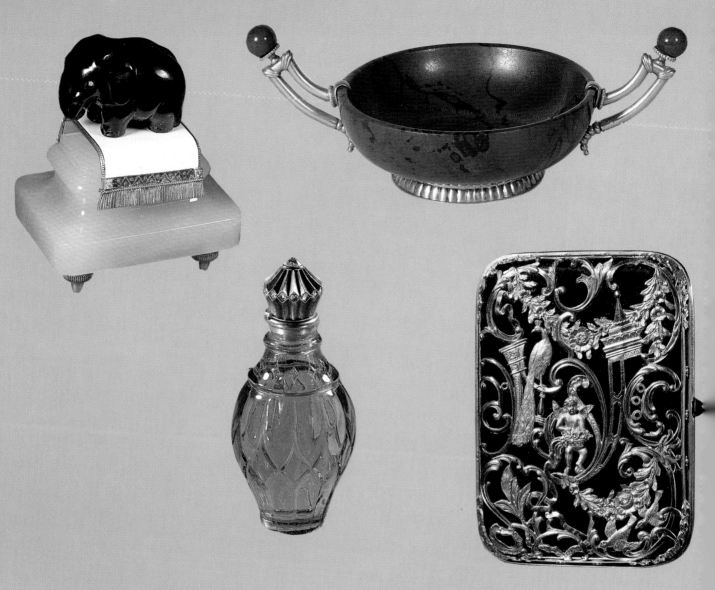

ПОМНИ

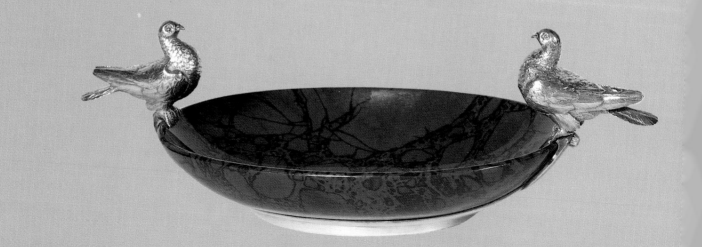

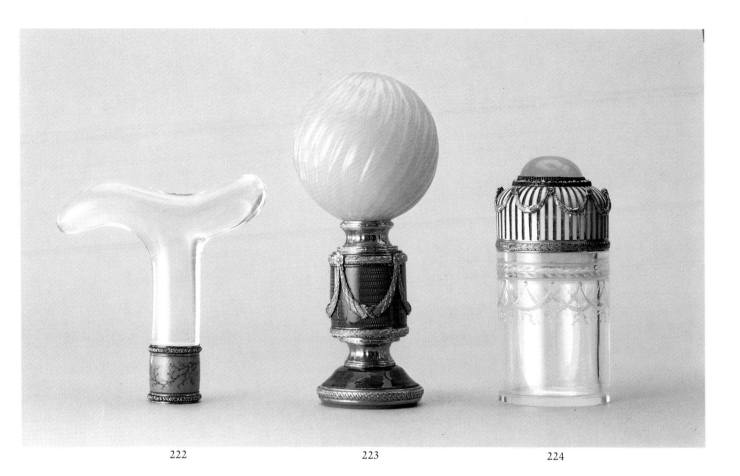

222 223 224

218 Scent bottle

Wm: Michael Perchin– Hm: St. Petersburg,
before 1899 – Inv: 55 141
Height: 2$^7/_8$″

Smoky quartz, carved with overlapping
scales; hinged fluted top set with rose-cut
diamonds.

H. M. Queen Margrethe II of Denmark

219 Oval ashtray

Mm: Fabergé – Wm: Michael Perchin – Hm:
St. Petersburg, before 1899
Length: 7$^1/_{16}$″

Mottled brown-black obsidian, with two
silver handles shaped like doves and with a
silver base.

H. R. H. Henrik Prince of Denmark

**220 Cigarette-case in the rococo
style**

Mm: Fabergé – Wm: Michael Perchin – Hm:
St. Petersburg, before 1899 – Am: 72 zo-
lotniks
Length: 3$^9/_{16}$″

Gold-mounted rock-crystal cigarette-case
applied on both sides with four-color gold
scrolls, flower swags, foliage, putti and birds.

H. R. H. Henrik Prince of Denmark

221 Circular ashtray

Mm: Michael Perchin – Hm: St. Petersburg,
before 1899
Length: 5$^1/_8$″

Mottled brown-black obsidian; gold handles
with lapis lazuli beads, gadrooned gold base.

H. R. H. Henrik Prince of Denmark

222 "T"-shaped parasol handle

Inv: 14 982
Height: 2$^1/_4$″

Polished rock-crystal; gold mount with pink

guilloché enamel painted with *camaïeu-brun*
dendritic motifs; rose-cut diamond borders.

H. R. H. Henrik Prince of Denmark

223 Gold-mounted bowenite seal

Height: 3$^7/_{16}$″
Original fitted case stamped with Iwm,
St. Petersburg, Moscow, Odessa

Spherical handle carved with swirling flutes,
Louix XVI-style gold mount with blue *guil-
loché* enamel applied with green-gold laurel
swags; agate matrix cut with the arms of
Hohenlohe-Langenburg.

224 Cylindrical scent bottle

Wm: Michael Perchin – Hm: St. Petersburg,
1899–1908 – Inv: 7488
Height: 2$^9/_{16}$″

Carved with laurel-leaf band and swags, the
openwork gold cover enameled in opaque
white, applied with laurel swags and cab-
ochon rubies, set with a central cabochon
chalcedony in rose-cut-diamond mount.

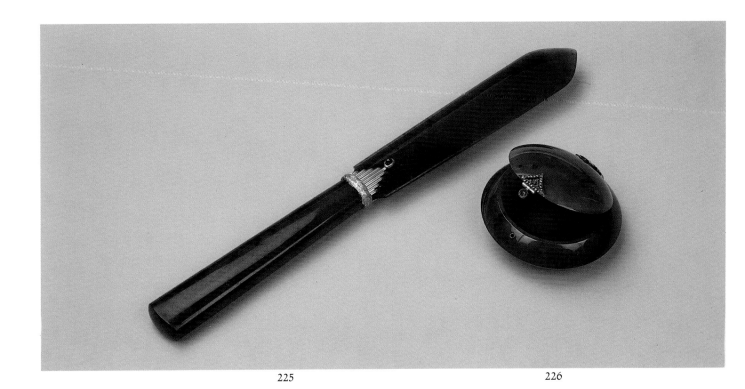

225 226

225 Nephrite paperknife

Wm: Michael Perchin – Hm: St. Petersburg,
1899–1908
Length: 8¹/₁₆″

Tapering blade with handle of oval section;
reeded gold mount with palm-leaf border
and two cabochon garnets.

Provenance: Prince Nicholas of Rumania

226 Circular nephrite bonbonnière

Mm: Fabergé – Wm: Henrik Wigström –
Inv: 21 000
Diameter: 2¹/₈″

Compressed *bombé* shape, the mount and
hinge set with cabochon rubies and rose-cut
diamonds.

Provenance: King Manuel of Portugal. List-
ed in Fabergé's London sales ledgers: "Sep-
tember 26, 1911, King Manuel, bonbonnière,
nephrite, gold 56°, 2 cabochon rubies (Stock)
no. 21 000, (sales price) £23–10 s., (cost
price) 124 rubles"

227 Agate tcharka

Mm: K. F. (Russian) – Hm: Moscow, before
1899
Height: 1⁵/₈″

Honey-colored banded agate; gold mount
with four pomegranate feet, applied with

yellow-gold laurel swags and cabochon
emeralds, the handle shaped like tied ribbons
and set with a rose-cut diamond.

Mrs. Josiane Woolf

228 Dish shaped like a chestnut leaf

Mm: Fabergé
Width: 4¹/₈″
Original fitted case stamped with Iwm,
St. Petersburg, Moscow, London

Honey-colored banded agate, naturalist-
ically shaped, applied with two chestnuts in
granulated gold and with cabochon garnets.
For a similar nephrite chestnut leaf, cf. Bain-
bridge, 1949/68, pl. 29 (above)

Mrs. Josiane Woolf

229 Oviform jasper bonbonnière

Mm: Fabergé – Wm: Michael Perchin – Hm:
St. Petersburg, before 1899
Height: 2⁹/₁₆″
Original fitted case stamped with Iwm,
St. Petersburg, Moscow

Orange banded agate; gold mount with
opaque white enamel stripes and green *guillo-
ché* enamel leaves, the thumbpiece set with
an emerald and rose-cut diamonds.

Mrs. Josiane Woolf

230 Cylindrical nephrite tcharka

Height: 1⁵/₈″

Yellow-gold handle with red *guilloché* enamel
on all sides, set with four rose-cut diamonds.

Literature: Snowman, 1962/64, pl. XV

231 Vodka cup shaped like the head of a blackamoor

Wm: Michael Perchin – Hm: St. Petersburg,
before 1899
Height: 2¹/₄″

Matt dark brown agate, with polished lips
and neck; gold-mounted rose-cut diamond
eyes, yellow and red-gold palm-leaf border.

Exhibited: Victoria & Albert 1977, no. R 25
Literature: Snowman, 1962/64, ill. 274 –
Habsburg, 1977, p. 75

232 Oval gold bonbonnière

Mm: Fabergé – Wm: Michael Perchin – Hm:
St. Petersburg, before 1899
Width: 2¹/₄″

Compressed spherical shape, with alternat-
ing vertical bands of opaque white enamel
and gold; the lid set with a sardonyx cameo
carved with Aurora in her chariot within a
rose-cut diamond border.

Exhibited: Victoria & Albert 1977, no. R 4?

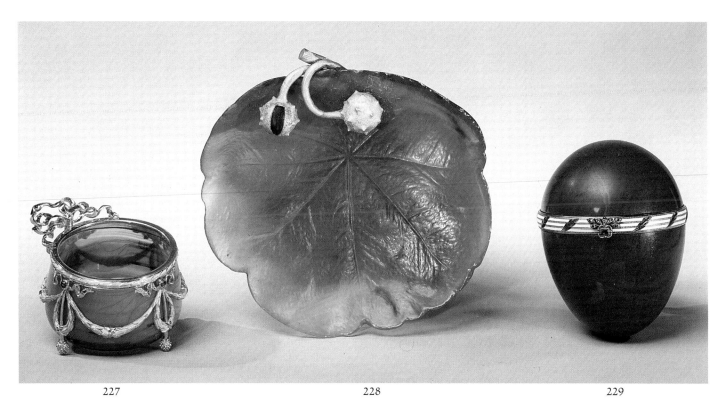

227 228 229

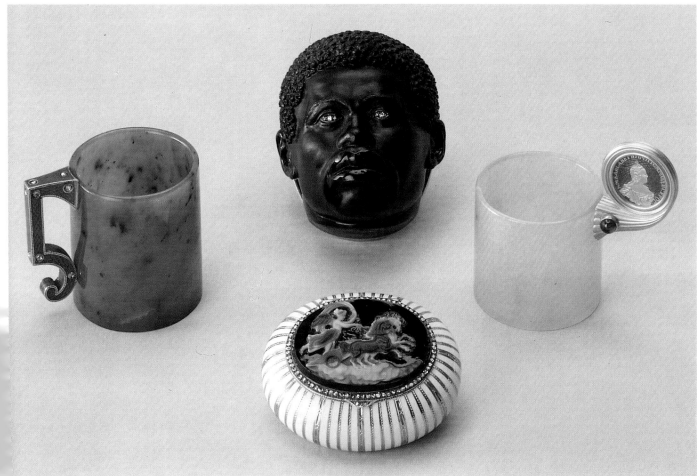

230 231, 232 233

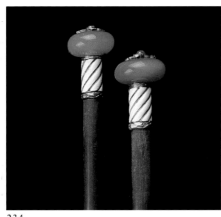

234

233 Cylindrical bowenite tcharka

Wm: Erik Kollin – Hm: St. Petersburg, before 1899 – Inv: 4573
Height: 2¹/₈″

Trumpet-shaped fluted matt gold handle, set with grivennik of Czarina Elisabeta Petrovna, partly enameled in red.

For a similar tcharka in the Collection of H. M. Queen Elizabeth II of Great Britain, cf. Snowman, 1962/64, pl. XXX.

Illustration p. 167.

234 Two knitting needles

Wm: Henrik Wigström
Length: 9³/₈″

Ebony; gold mounts enameled with swirling opaque white bands, with stained chalcedony finials, each set with a cabochon ruby.

Exhibited: Lugano 1987, no. 82
Literature: Waterfield/Forbes, 1978, no. 92

The Forbes Magazine Collection, New York

235

235 Pen-rest shaped like a bootjack

Inv: 58952
Length: 1⁵/₈″
Original fitted case

Nephrite with gold mounts and cabochon ruby.
Similar pen-rests are illustrated by Bainbridge, 1949/62, ill. 87 and Habsburg, 1977, p. 72.

Provenance: Mrs. Josiane Woolf (Christie's, Geneva, November 18, 1980, lot. 114).
Exhibited: Victoria & Albert 1977, no. P 19
Lugano 1987, no. 18
Literature: Snowman, 1979, pl. 138

The Forbes Magazine Collection, New York

236 Jasper kovsh

Wm: Michael Perchin
Length: 4⁵/₁₆″

Reddish-brown banded agate; gold handle in the form of intertwined dolphins enameled in green with diamond eyes, flanking an anchor set with a cabochon ruby.

Acquired 1897 from Fabergé at the Art and Industrial Exhibition in Stockholm

National Museum, Stockholm

237 Nephrite pen

Mm: Fabergé – Wm: Michael Perchin – Hm: St. Petersburg, before 1899 – Inv: 1244
Length: 7″

Reeded gold mounts with two diamond-set snakes, each with a cabochon ruby head.

Exhibited: Lugano 1987, no. 17
Literature: Waterfield/Forbes, 1978, ill. 110

The Forbes Magazine Collection, New York

238 Seal of the Dowager Empress Marie Feodorovna

Mm: Fabergé – Wm: Michael Perchin – Hm: St. Petersburg, before 1899 – Inv: 59050
Height: 2³/₁₆″

Egg-shaped nephrite handle with applied yellow gold rococo scrolls and reed-and-tie base; agate matrix carved with "Hvidøre".
Villa Hvidøre was acquired by Dowager Empress Marie Feodorovna in 1905. Here she often met her sister Queen Alexandra and it was here that she lived in exile after the Russian revolution until her death in 1928.

Provenance: Dowager Empress Marie Feodorovna – her daughter, Grand Duchess Xenia – her son Prince Vassili of Russia
Exhibited: Lugano 1987, no. 21

The Forbes Magazine Collection, New York

239 Owl seal

Wm: Henrik Wigström – Inv: 18241
Height: 2¹/₈″

Spherical nephrite handle with a band of rose-cut diamonds and cabochon rubies; surmounted by a chalcedony owl with spread wings and cabochon ruby eyes; reeded gold foot.

Exhibited: Lugano 1987, no. 60
Literature: Waterfield/Forbes, 1978, no. 55

The Forbes Magazine Collection, New York

240 Art nouveau match-holder

Mm: Fabergé – Wm: Henrik Wigström
Inv: 7664
Height: 2¹¹/₁₆″

Octagonal gray-green jasper bowl applied with yellow gold bullrushes and flowers set with demantoids and rubies, on openwork base chased with dolphins' and lions' heads.

Exhibited: Lugano 1987, no. 7
Literature: Waterfield/Forbes, 1978, no. 133

The Forbes Magazine Collection, New York

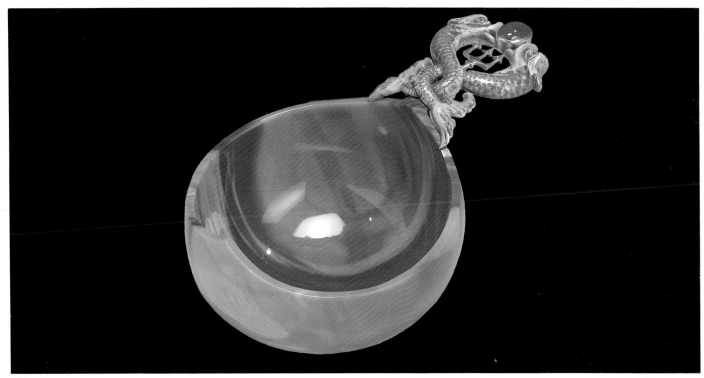

236

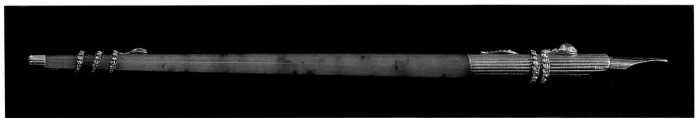

237

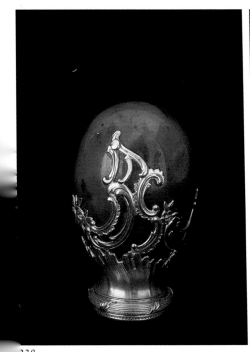

238

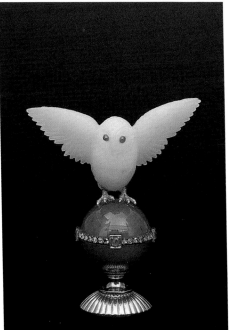

239

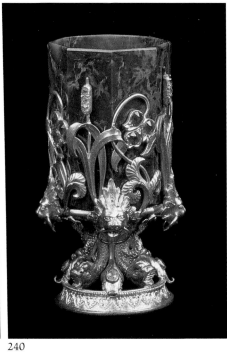

240

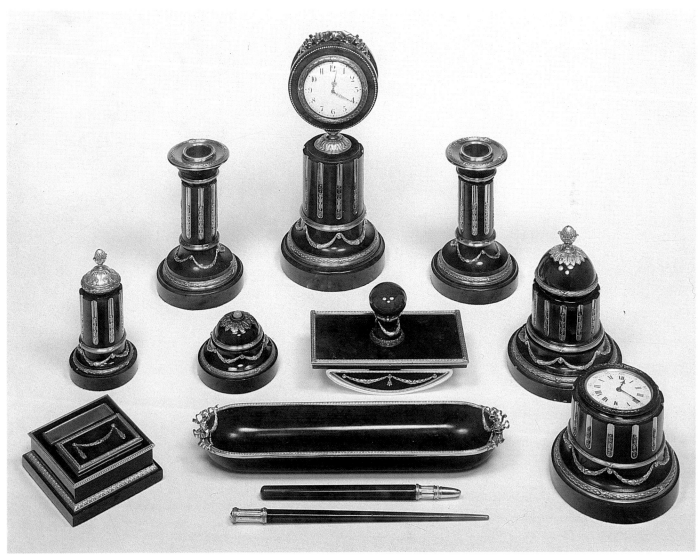

241

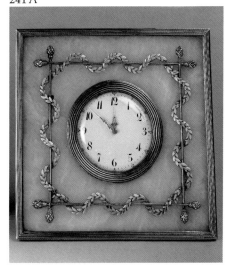

241 A

241 Composite nephrite desk set in the Louis XVI style

Mm: Fabergé — Wm: Henrik Wigström — Hm: St. Petersburg, 1898–1903 — Am: A. Richter
Height of clock: 8¹/₁₆″

Gold and silver gilt mounts. Comprising: 1. Upright desk clock, 2. Inkwell, 3. Stamp-box, 4. Electric bell, 5. Blotter, 6. Pen tray, 7. Pen, 8. Pencil, 9. Horizontal desk clock, 10. Pair of candlesticks, 11. Glue-pot.

Provenance: nos. 1–8 King Farouk of Egypt (Sotheby's, Cairo, March 11, 1954, no. 146) — Sir Bernard Eckstein; nos. 9–11 Dr. James Hasson

Exhibited: A la Vieille Russie 1983, no. 314

Literature: Bainbridge 1949/68, pl. 41 (nos. 9–11) — Thyssen 1984, no. 125

Baron Heinrich von Thyssen-Bornemisza, Lugano

241 A Square bowenite desk clock

Mm: Fabergé — Wm: Michael Perchin — Hm: St. Petersburg, before 1899 — Inv: 46 145
Height: 4⁵/₁₆″

Reeded silver mounts, applied with maenad's staffs and entwined gold laurel swags; ivory backing and silver strut.

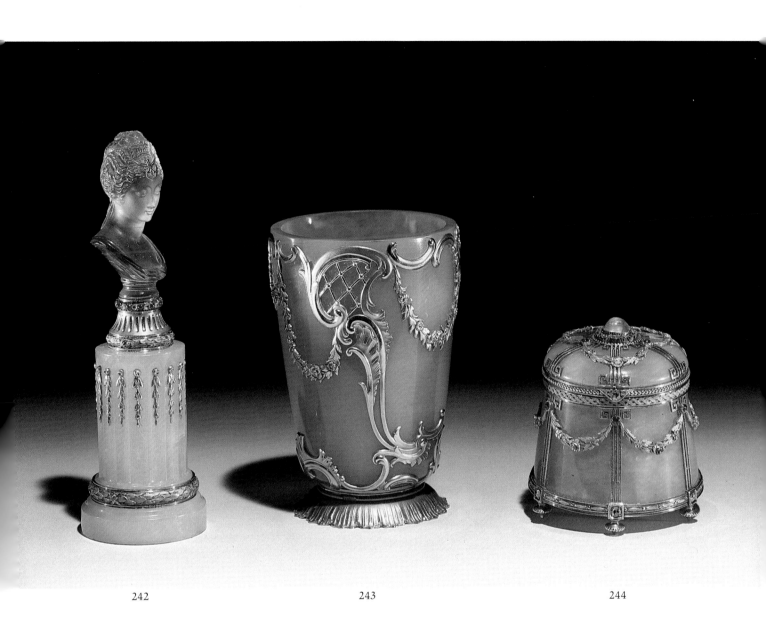

242 243 244

242 Smoky quartz bust of Diana

Wm: Michael Perchin – Hm: St. Petersburg,
before 1899
Height: 4⁵/₁₆″

With a Louis XVI-style fluted yellow-gold
base chased with laurel wreath, set with dia-
monds and rubies; standing on fluted bowen-
ite column applied with gold husks and with
yellow and red-gold laurel-wreath.

Mrs. Josiane Woolf

243 "Rococo" bowenite beaker

Wm: Michael Perchin – Hm: St. Petersburg,
before 1899 – Inv: 45 684
Height: 3¹/₄″

Applied with yellow-gold scrolls, trelliswork
and flower swags.

Exhibited: Helsinki 1980, no. A 48

Mrs. Josiane Woolf

244 Bowenite glue-pot
in the Louis XVI style

Mm: Fabergé – Wm: Michael Perchin – Hm:
St. Petersburg, before 1899
Height: 2³/₁₆″

Of tapering cylindrical shape with domed
cover; applied with four-color gold flower-
swags suspended from cabochon rubies, en-
trelac, husk and bead borders and pilasters

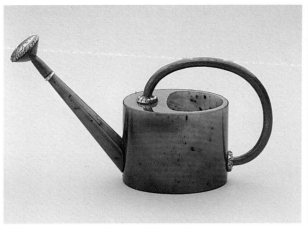 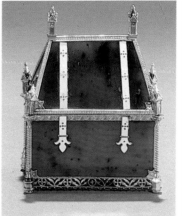 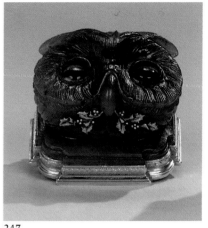

245 246 247

with Greek key pattern terminals; cabochon moonstone finial in rose-cut diamond setting.

Mrs. Josiane Woolf

245 Miniature nephrite watering can

Inv: 4709
Length: 4^1/$_8$"
Original fitted case stamped with Iwm, St. Petersburg, Moscow

Gold handle and nozzle with scarlet *guilloché* enamel set with rose-cut diamonds.

A similar watering can was in the King Farouk Collection (Sotheby's, Cairo, March 10, 1954, no. 149).

Provenance: Mme. Elizabeth Balletta of the Imperial Michael Theater – Lansdell K. Christie, Long Island
Exhibited: Corcoran 1961, no. 11 – A la Vieille Russie 1961, no. 274 – Metropolitan Museum 1962/66, no. L 62.8.11 – A la Vieille Russie 1968, no. 343 – Victoria & Albert 1977, no. L 11 – Lugano 1987, no. 65
Literature: Snowman, 1962/64, p. XXX, – Waterfield/Forbes, 1978, no. 56 – Snowman, 1979, no. 126 – Solodkoff, 1984, p. 25

The Forbes Magazine Collection, New York

246 Box shaped like a reliquiary casket in the Gothic style

Mm: Fabergé – Wm: Michael Perchin – Hm: St. Petersburg, before 1899 – Inv: 57995
Length: 2^3/$_{16}$"

Nephrite, with gold mounts, surmounted by six turrets, the panels mounted *à cage* within bands and columns chased with swirling flutes, the base with flamboyant Gothic openwork decoration; applied with two opaque white enamel bands.
One of the rare examples in this style in Fabergé's œuvre.

Exhibited: Lugano 1987, no. 49
Literature: Solokoff, 1984, p. 14

The Forbes Magazine Collection, New York

247 Nephrite owl bellpush

Mm: Fabergé – Wm: Michael Perchin – Hm: St. Petersburg, 1899–1908
Length: 2^3/$_8$"

Stylized head of an owl with cabochon tiger's eye pushpieces and applied gold holly sprays; shaped stepped base chased with palm-leaf border.
A similar model was produced by Cartier.

Provenance: Countess Mona Bismarck, Paris (Christie's, Geneva, November 30, 1982, no. 264)
Exhibited: Lugano 1987, no. 61
Literature: Solokoff, 1984, p. 29

The Forbes Magazine Collection, New York

248 Nephrite bonbonnière in the Chinese style

Mm: Fabergé – Wm: Michael Perchin – Hm: St. Petersburg, before 1899 – Am: 72 zolotniks
Height: 1^9/$_{16}$"

Irregular compressed spherical shape, carved

with rococo cartouches; reeded gold mount set with rose-cut diamonds and cabochon ruby thumbpiece.
Interesting combination of European and Oriental styles.

Literature: Ross, 1965, p. 18, pl. 4

The Marjorie Merriweather Post Collection, Hillwood, Washington D.C.

249 Oviform agate bonbonnière in the rococo style

Mm: Fabergé – Wm: Michael Perchin – Hm: St. Petersburg, 1899–1908
Height: 3^1/$_4$"

Mottled brown agate, applied with rococo scrolls and flower swags.
Inspired by a George II bonbonnière.

Exhibited: A la Vieille Russie 1961, no. 288
Literature: Ross, 1965, p. 26

The Marjorie Merriweather Post Collection, Hillwood, Washington D.C.

250 Parcel-shaped nephrite box

Iwm: K. Fabergé – Hm: Moscow, 1899–1908
Length: 3^3/$_8$"

Rectangular, with stepped cover, tied with red-gold ribbons, with opaque white enamel band and rose-cut diamond thumbpiece.
Inspired by 18th century originals (cf. G von Habsburg, Gold Boxes from the Gilbert Collection, 1983, no. 25; A.K. Snowman, Eighteenth Century Gold Boxes, 1966, pl. 663)

Metropolitan Museum of Art, New York

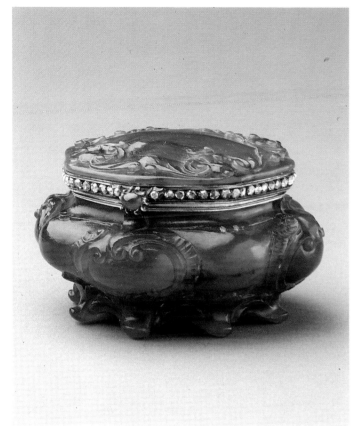

248

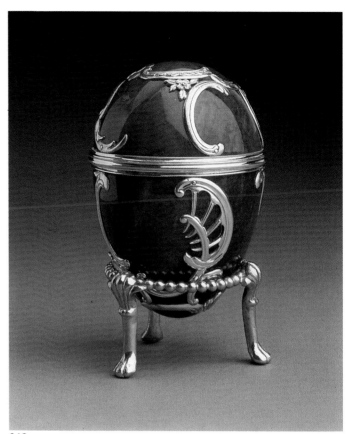

249

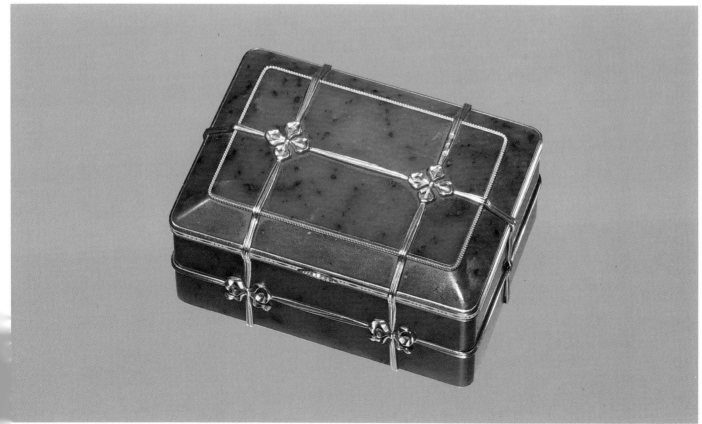

250

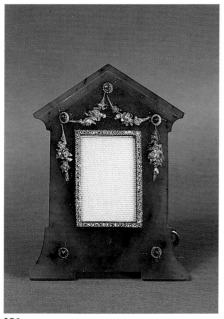

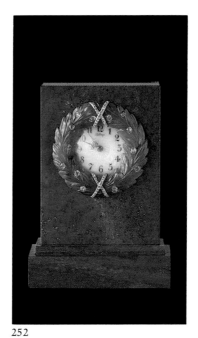

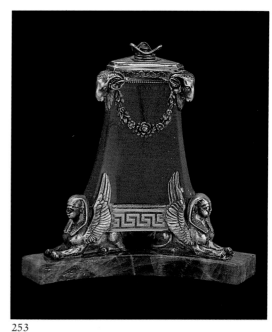

251

252

253

251 Nephrite miniature frame

Wm: Hjalmar Armfelt – Hm: St. Petersburg
Height: 2¹/₄"

Aedicula-shaped, the square aperture with
rose-cut diamond border, applied with five
cabochon rubies and three-color gold flower
swags; mother-of-pearl backing and silver
strut.

H.M. Queen Elizabeth, The Queen Mother

252 Lapis lazuli clock

Mm: Fabergé – Wm: Henrik Wigström –
Am: 72 zolotniks
Height: 2"

Upright rectangular lapis lazuli slab with
opalescent white *guilloché* enamel dial in-
scribed "Faberge", and gold hands; carved
nephrite laurel-wreath surround, set with
emeralds and tied with diamond-set ribbons;
gold door to back.
For a similar purpurine clock, cf. A la Vieille
Russie 1983, no. 105

The Brooklyn Museum (Bequest Helen B.
Sanders)

253 Table lighter shaped like an
Antique altar

Mm: Fabergé – Hm: St. Petersburg, before
1899 – Inv: 40 408
Height: 3¹⁵/₁₆"

Purpurine, with silver mounts shaped like
rams' heads, suspending flower swags;
standing on shaped triangular labradorite
base and three winged sphinxes.

Provenance: Princess Henry of Prussia, née
Princess Irene of Hesse and the Rhine, sister
of Empress Alexandra Feodorovna.

254 Nephrite clock shaped
like an aedicula

Wm: Michael Perchin – Hm: St. Petersburg,
1899–1908
Height: 4¹/₈"

Of tapering rectangular shape, with opaque
white enamel dial, gold hands and rose-cut
diamond border; applied with five cabochon
rubies, four-color gold flower swags and a
central motif of crossed arrows and a torch
tied with flowers and ribbons.

Provenance: From the Estate of Dowager
Queen Louise of Denmark (1851–1926), July
2, 1926

Chronological Collection of the Queen of
Denmark, Rosenborg Castle, Copenhagen

255 "Rococo" aide mémoire

Mm: Michael Perchin – Hm: St. Petersburg,
before 1899 – Am: 72 zolotniks
Length: 4⁵/₈"
Original fitted case stamped with Iwm

254

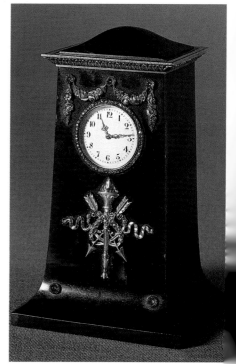

Green jasper, applied with profusion of rococo scrolls, cartouches and flowers set with rose-cut diamonds. Gold pencil with jasper cameo finial, the interior fitted with yellow satin.

Other, possibly mid-19th century examples, which may have served as prototypes, are in the collections of Baron von Thyssen (cf. Cocks/Truman 1984, no. 109), the Rijksmuseum, Amsterdam and Enrico Caruso, USA.

Literature: Snowman, 1962/64, ill. 50/51

The Wernher Collection, Luton Hoo

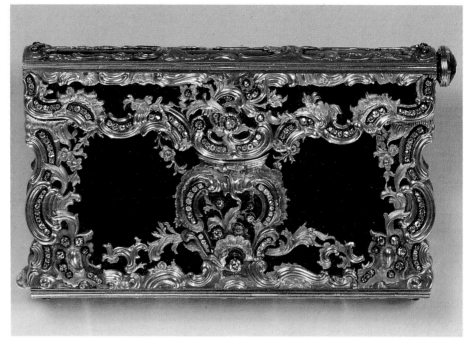

255

256 Bonbonnière shaped like a Louis XVI table

Mm: Fabergé – Wm: Michael Perchin – Hm: St. Petersburg, 1899–1908
Length: 2^{15}/$_{16}$"

Dark brown agate imitation of wood; gold mounts with applied acanthus motifs, openwork gallery chased with Greek key pattern, gadroon and bead borders.

Provenance: Acquired by the Acquisitions Committee of the State Hermitage
Exhibited: Lugano 1986, no. 127
Literature: Lopato, 1984, p. 44

State Hermitage, Leningrad (Inv. E-15 603)
(L. Y.)

256

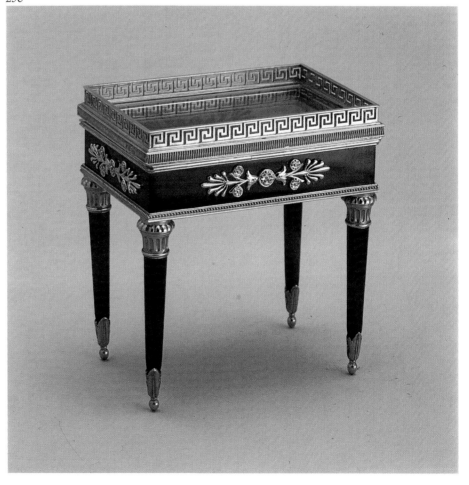

257 Oval gold bonbonnière

Mm: Fabergé – Wm: Michael Perchin – Hm: St. Petersburg, 1899–1908 – Inv: 7234
Length: 2^{1}/$_{16}$"

Cover with lapis lazuli top, set with stars and a crescent moon in diamonds within a border of half-pearls; reeded gold sides and plain gold base.
A highly original novelty of Fabergé's most inventive craftsman.

Provenance: Acquired 1984 by the Acquisitions Committee of the State Hermitage

State Hermitage, Leningrad (Inv. ERO 9406)
(N. K.)

258 Cylindrical chalcedony seal

Wm: Michael Perchin – Hm: St. Petersburg, 1899–1903 – Am: A. Richter
Length: 1^{9}/$_{16}$"
Original fitted case stamped with Iwm, St. Petersburg, Moscow, Odessa

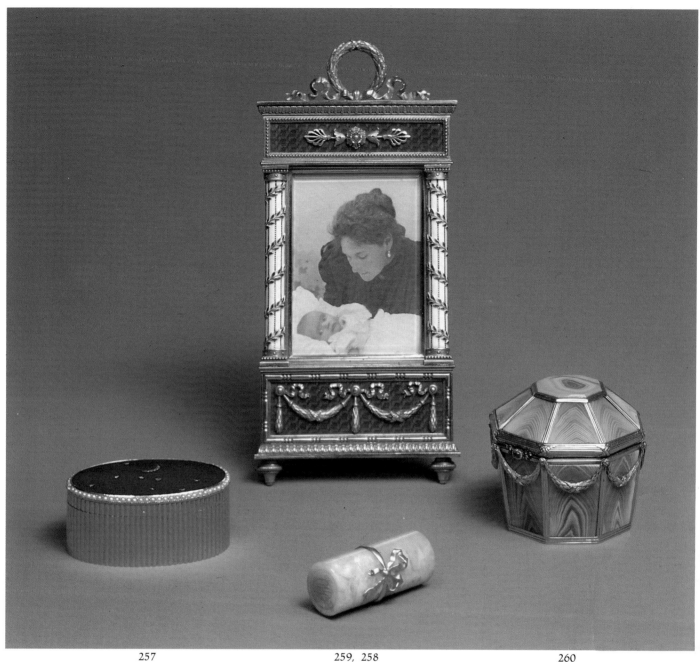

257 259, 258 260

Shaped like a scroll and tied with a gold ribbon. The seal-face is carved with the Russian monogram "AS".

Provenance: A.G. Savina (1854–1915), actress at the Tragic Theater, St. Petersburg. Transferred 1925 to the State Ethnographic Museum

Exhibited: Leningrad 1974, no. 28

State Hermitage, Leningrad (Inv. ERO 6364)
(N.K.)

259 Silver gilt photograph frame

Mm: Fabergé – Wm: Michael Perchin – Hm: St. Petersburg, before 1899 – Am: 88 zolotniks – Inv: 58 606
Height: 5⁵/₈″

Shaped like a window; with red *guilloché* enamel pediment and frieze applied with laurel swags and acanthus motifs; flanked by a pair of white opaque enamel half-columns with entwined green laurel sprays, surmounted by a laurel crown and gold tied ribbons. Ivory backing and silver strut.

Photograph of Grand Duchess Xenia, inscribed on the back: "from Nicolas and Alix, May 25, 1889".

Provenance: Given by Nicholas II and Alexandra to Grand Duchess Xenia, daughter of Czar Alexander III and sister of Nicholas II – State Commission for Art (Inv. 989) Transferred to the National Ethnographic Museum in 1941

State Hermitage, Leningrad (Inv. ERO 6761
(N.K.)

260 Octagonal agate bonbonnière

Wm: Henrik Wigström – Hm: St. Petersburg, 1899–1908 – Am: A. Richter
Height: 2"

Gray-banded agate panels mounted *à cage*, reeded gold mounts, the sides applied with two-color gold laurel swags, the thumbpiece set with rose-cut diamonds and a ruby. Inspired by a George III snuffbox.

Provenance: Acquired 1982 by the Acquisitions Committe of the State Hermitage.

State Hermitage, Leningrad (Inv. ERO 9322)
(N.K.)

261 Vodka cup shaped like an elephant's head

Length: 3⁹/₁₆"

Obsidian, with rose-cut diamond eyes; the upward-curving trunk serving as a handle.

Provenance: Transferred from the State Museum Depository in 1951
Exhibited: Lugano 1986, no. 129

State Hermitage, Leningrad (Inv. E-17 154)

262 Nephrite box in the shape of a scallop shell

Mm: Fabergé – Wm: Michael Perchin – Hm: St. Petersburg, before 1899
Width: 2¹/₂"

The cover naturalistically carved, the hinge and clasp set with rose-cut diamonds and cabochon rubies.

Provenance: Transferred from the State Museum Depository in 1951
Exhibited: Lugano 1986, no. 122

State Hermitage, Leningrad (Inv. E-17 151)
(L.Y.)

263 Oval nephrite bowl

Length: 2¹³/₁₆"

Of waisted shape, with everted lip; surrounded by a band set with rose-cut diamonds suspending a diamond-set tassel.

Provenance: Transferred from the State Museum Depository in 1951
Exhibited: Lugano 1986, no. 128

State Hermitage, Leningrad (Inv. E-17 152)
(L.Y.)

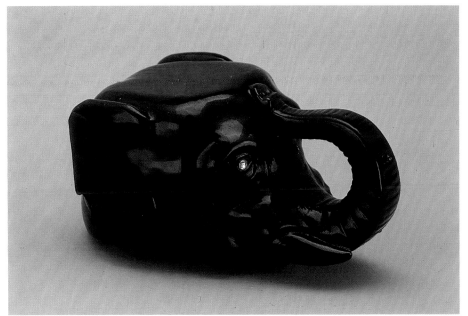

261

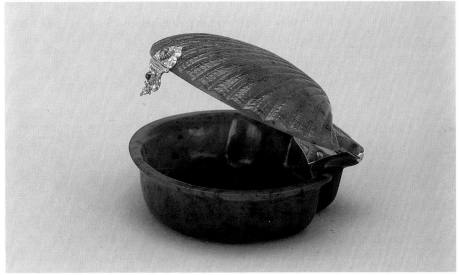

262

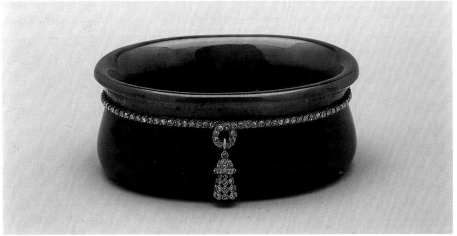

263

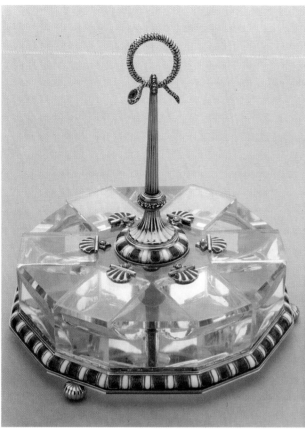

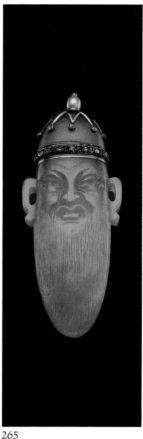

264 265

266

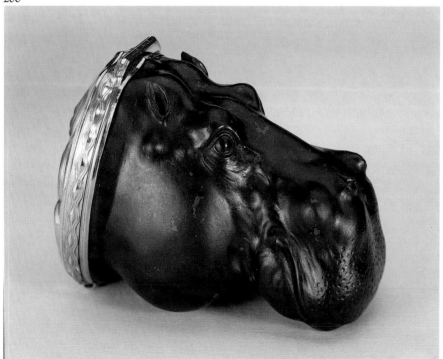

264 Duodecagonal rock-crystal stamp-dispenser

Mm: Fabergé – Wm: Michael Perchin – Hm: St. Petersburg, 1899–1908
Height: 4⁷/₁₆″

Gold-mounted; all parts with red *guilloché* and opalescent white enamel stripes; twelve lidded compartments with scallop-shaped hinges, trumpet-shaped reeded gold handle with serpent-shaped finial ring, standing on three ball feet.

Provenance: Ordered from Fabergé in 1903 by the Maharaja of Kashmir
Exhibited: Lugano 1987, no. 22

The Forbes Magazine Collection, New York

265 "Chinese" jade snuff bottle

Mm: Fabergé – Wm: Henrik Wigström – Hm: St. Petersburg, 1899–1908 – Inv: 11 974
Height: 2⁹/₁₆″

Carved in the form of a sage's head, the gold mounts set with alternating rubies and rose-cut diamonds, the cover with star-shaped red enamel motif and pearl finial.
For other examples of this model inspired by a Chinese original, cf. Snowman 1962/ 64, ill. 67/68

Exhibited: Lugano 1987, no. 23

The Forbes Magazine Collection, New York

266 Jasper snuffbox shaped like a hippo's head

Mm: Fabergé – Wm: Michael Perchin – Hm: St. Petersburg, before 1899
Length: 3¹/₂″

Bloodstone carving of a smiling hippo, the gold mount and cover chased with rococo motifs, ruby and diamond-set thumbpiece. One of Fabergé's most succesful creations inspired by 18th century Dresden originals.

Provenance: Countess Zoubov (Christie's, Geneva, May 1, 1974, lot 218)
Exhibited: A la Vieille Russie 1983, no. 452
Literature: Habsburg, 1977, p. 77

267 Smoky quartz box shaped like a scallop shell

Mm: Fabergé – Wm: Michael Perchin – Hm: St. Petersburg, before 1899
Width: 2¹/₈″

Gold-mounted; the base and cover naturalistically carved, the rim set with rose-cut diamonds between green enamel bands; flower-shaped thumbpiece set with rose-cut diamonds.

Exhibited: A la Vieille Russie 1983, no. 175

268 Smoky quartz bonbonnière shaped like a fish's head

Mm: Fabergé – Wm: Michael Perchin – Hm: St. Petersburg, before 1899
Length: 2³/₈″

Carved with scales, with cabochon ruby eyes, diamond-set mouth and nostrils; scallop-shaped gold lid.

Exhibited: A la Vieille Russie 1961, no. 138 – A la Vieille Russie 1968, no. 326 – A la Vieille Russie 1983, no. 178

269 Chrysopras bonbonnière shaped like a horse's hoof

Mm: Fabergé – Wm: Michael Perchin – Hm: St. Petersburg, before 1899
Width: 1⁹/₁₆″

Green chalcedony box, the cover carved like a hoof, the horseshoe set with rose-cut diamonds and rubies; reeded gold mount chased with leaves.

Exhibited: A la Vieille Russie 1983, no. 139

270 Agate bonbonnière shaped like a snail

Mm: Fabergé – Wm: Michael Perchin – Hm: St. Petersburg, before 1899
Width: 1¹¹/₁₆″

Dark-brown banded agate; gold cover with alternating blue and white enamel stripes. Oval moss agate panel in rose-cut diamond border, ruby and diamond-set thumbpiece. Inspired by an 18th century original similar to one in the Treasury at the Hermitage (cf. cat. 650)

Exhibited: A la Vieille Russie 1983, no. 177
Literature: Bainbridge, 1949/68, pl. 54 (bottom left)

271 Agate bonbonnière shaped like a bulldog's head

Wm: Michael Perchin – Hm: St. Petersburg, before 1899
Length: 2⁹/₁₆″

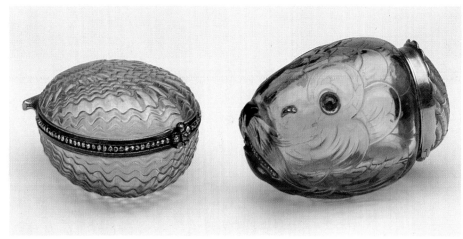

267, 268

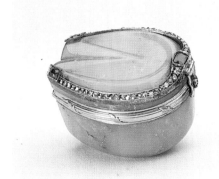 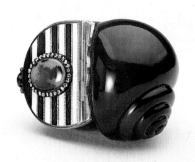

269, 270

271

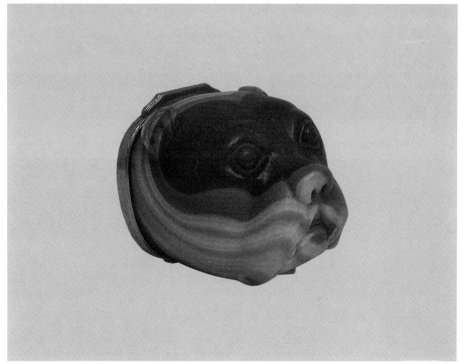

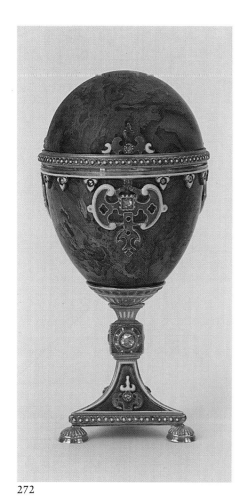

Gray-brown banded agate with white and orange stripes; the gold lid with diagonal reeding, applied with Imperial double-headed eagle enameled in black and with monogram "E I" and a diamond.

Inspired by a mid-18th century English or Dresden box. The cover derives from a snuffbox of Empress Elisabeta Petrovna in the Treasury at the Hermitage.

Exhibited: A la Vieille Russie 1961, no. 49 (p. 16)

272 Moss agate Easter egg in the Renaissance style

Mm: Fabergé – Wm: Michael Perchin – Hm: St. Petersburg, before 1899 – Am: 72 zolotniks – Height: 3⁷/₈″

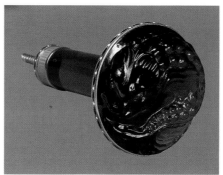

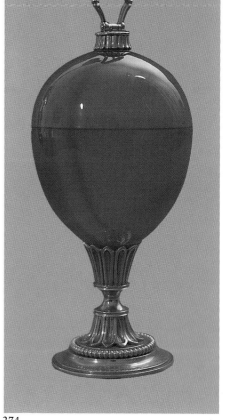

272

273

274

275

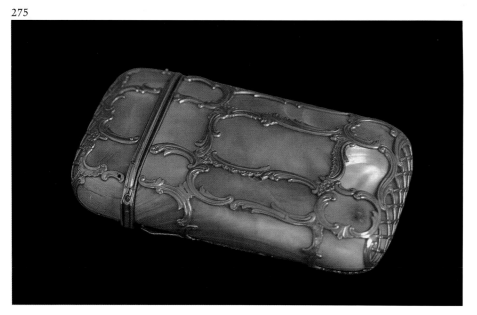

Triangular base with stud feet, green enamel decoration within white enamel bands, applied with red and white enamel strapwork, set with a rose-cut diamonds; green and white enamel entrelac borders.

Provenance: Wilfrid Johnson, London
Exhibited: Wartski 1949, no. 347
Literature: Snowman, 1962/64, ill. 48

Stavros S. Niarchos

273 "Chinese" topaz parasol handle

Height: 5³/₁₆″
Felt case

Carved with a curled-up dragon; gold moun with green and white enamel decoration an pink *guilloché* enamel band.

Possibly a Fabergé copy of a Chinese original.

Provenance: Transferred from the State Museum Depository in 1929
Exhibited: Leningrad 1974, no. 37

State Hermitage, Leningrad (Inv. ERO 6452)
(N. K.)

274 Oviform agate bonbonnière

Wm: Erik Kollin – Hm: St. Petersburg, 1899–1908
Height: 4⁵/₁₆″

Honey-colored agate body; on circular red-gold fluted and gadrooned base; fan-shaped gadroon finial.
Elegant example of Kollin's late work after his departure from Faberge's workshop.

Exhibited: Helsinki 1980, ill. 4

275 Mother-of-pearl cigarette-case in the rococo style

Mm: Fabergé – Wm: Michael Perchin – Hm: St. Petersburg, before 1896
Length: 3⁹/₁₆″

Gold-mounted mother-of-pearl panels applied with scrolls and trelliswork.
Fabergé's interpretation of a mid-18th century étui.

Literature: Uljanova, Fabergé, p. 10

Historic Museum, Moscow (Inv. 98 923 – ok 15 877)
(N. P.)

276 Twenty-fifth anniversary clock

Wm: Henrik Wigström – Am: 91 zolotniks
Height: 6¹/₂″

Upright shaped rectangular nephrite slab; opalescent white *guilloché* enamel dial with gold hands and seed pearl border; set in a shield-shaped panel of oyster enamel over *guilloché* sunray pattern with gold laurel-leaf border, red-gold tied ribbons and diamond-set flowerheads; with a similar circular panel below applied with the Roman numeral XXV; silver gilt backing and strut.

Exhibited: Victoria & Albert 1977 no. L 5 – Lugano 1987, no. 26
Literature: Snowman, 1962/64, ill. 142 – Solodkoff, 1986, p. 35

The Forbes Magazine Collection, New York

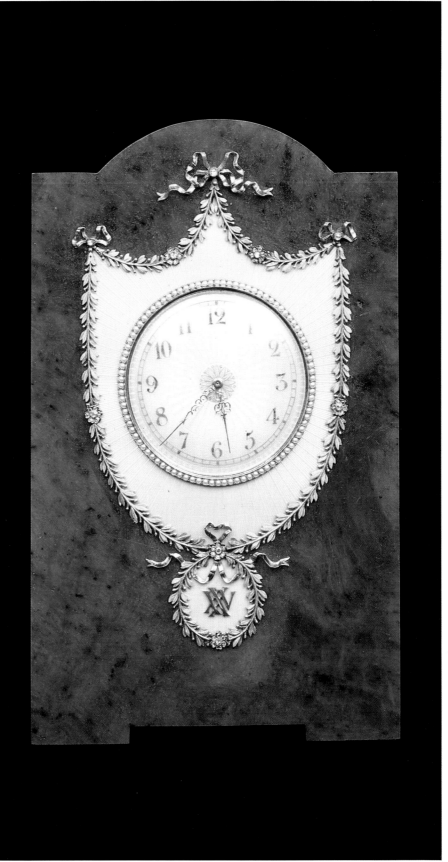

276

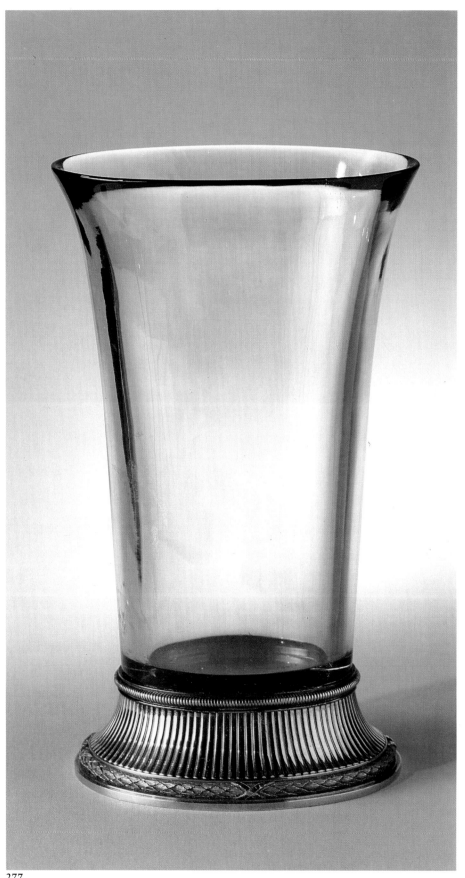

277 Smoky quartz vase of Madame Balletta

Mm: Fabergé – Wm: Michael Perchin – Hm: St. Petersburg, 1899–1908 – Am: 72 zolotniks
Height: 7$^7/_8$"

Of tapering shape and oval section; standing on reeded yellow-gold base with gadrooned upper border and a tied laurel wreath below.

Provenance: Presented to Madame Elizabeth Balletta, Prima Ballerina at the Michael's Theater in St. Petersburg, by a Russian Grand Duke.

Exhibited: Belgrave Square 1935, no. 504 – A la Vieille Russie 1961, no. 261 – San Francisco 1964, no. 135 – A la Vieille Russie 1968, no. 366 – A la Vieille Russie 1983, no. 309

Literature: Bainbridge, 1949/66, pl. 7 and p. 8 "… perhaps the most beautiful thing Fabergé ever made"

The Brooklyn Museum (Bequest Helen B. Sanders)

277

278 Revolving photograph frame

Mm: Fabergé — Wm: Victor Aarne — Hm:
St. Petersburg, before 1899
Height: 9$^1/_{16}$"
Original fitted box stamped with Iwm,
St. Petersburg, Moscow

Eight glazed double photographs of the
royal families of Russia, Britain, Denmark
and Greece in silver gilt mounts chased with
laurel leaves. Circular stepped bowenite base
with laurel-leaf band, the stand on three
scrolled acanthus-leaf feet and with urn-
shaped finial.

The photographs represent:
 1. The Prince of Wales (later King Edward
 VII),
 2. King George V, Queen Alexandra,
 Queen Mary, King Christian IX of Den-
 mark and the Prince of Wales,
 3. Prince Aage of Denmark, son of Prince
 Waldemar, and Princess Marie of
 Orleans,
 4. Prince Vigo of Denmark, brother of the
 above,
 5. Princess Margaret of Denmark, sister of
 the above,
 6. King Christian IX of Denmark,
 7. Queen Louise of Denmark, with her
 daughter, the Duchess of Cumberland,
 8. King Christian IX with the Prince of Wa-
 les and Princess Margaret of Denmark,
 9. King George V, Queen Mary and the
 Prince of Wales,
10. King George V and Queen Mary,
11. The Prince of Wales and Princess Marga-
 ret of Denmark,
12. The Duchess of Cumberland with others,
13. Queen Louise of Denmark and her
 grandson, Prince George of Greece,
14. Prince George of Greece,
15. Queen Louise, Prince Waldemar, Prince
 George and King Constantin of Greece,
16. Queen Mary.

Exhibited: Lugano 1987, no. 41
Provenance: Dowager Empress Marie Feo-
dorovna (1847–1928)
Literature: Solodkoff, 1984, p. 170

The Forbes Magazine Collection, New York

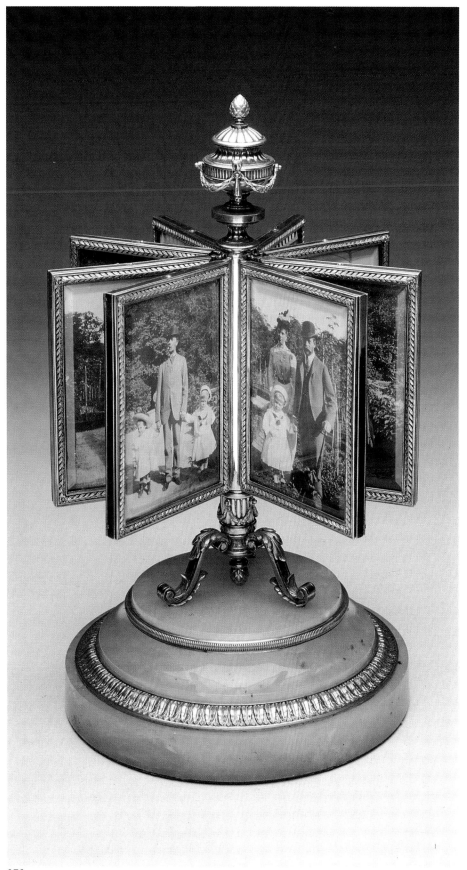

278

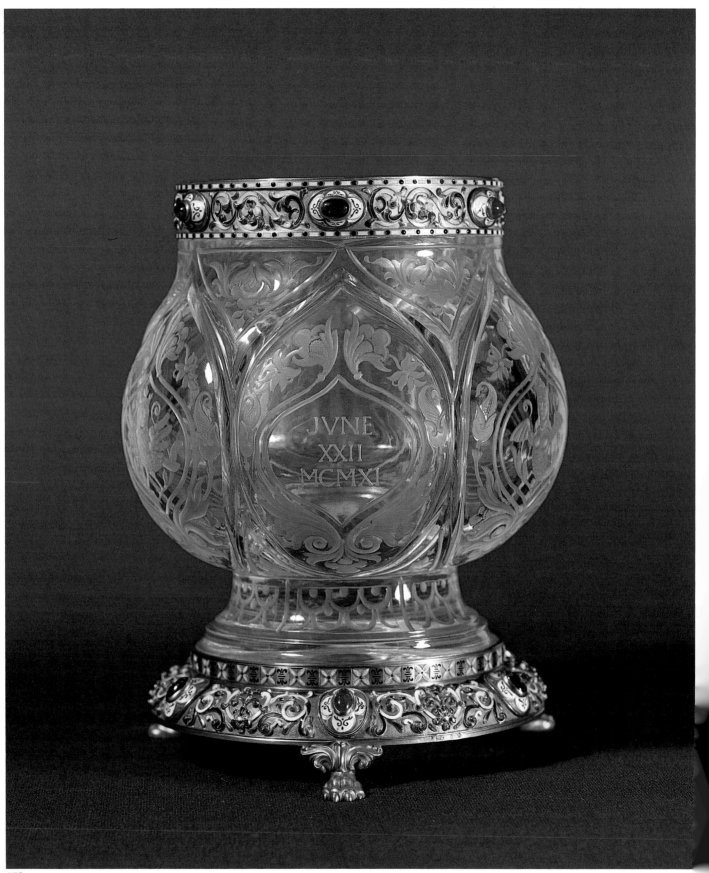

279 Rock-crystal vase in the Renaissance style

Wm: Michael Perchin – Hm: St. Petersburg, 1899–1908 – Inv: 8011 – Height: 6^1/$_2$"

Lotus-shaped lobed body engraved with stylized scrolling foliage, the British royal coat-of-arms and date JUNE XXII MCMCI. Yellow-gold mount with four claw feet and two matted gold bands chased and enameled with polychrome scrolling foliage, set with alternating ruby and sapphire cabochons.

Provenance: Acquired by Leopold de Rothschild at Fabergé's in London ("Cup, rock-crystal, eng., gold 72° en diff. stones, no. 8011, nett £430 (cost) Rubles 2100." Presented to King George V and Queen Mary on the occasion of their coronation on June 22, 1911, filled with orchids from the glasshouses at Gunnesbury Park. Style, inventory number, authorship and hallmarks point to a date around 1900 (Perchin died 1903). The acquisition and presentation date tend to prove that this is an earlier item reutilized by Fabergé.

Exhibited: Victoria & Albert 1977, no. F 4 – Queen's gallery 1985/86, no. 150
Literature: Bainbridge, 1949/68, pl. 90 – Snowman, 1962/64 pl. XX – Habsburg/Solodkoff, 1979, pl. 151

H.M. Queen Elizabeth II of Great Britain

280 Table clock in the manner of James Cox

Wm: Julius Rappoport – Hm: St. Petersburg, before 1899 – Height: 11^1/$_4$"

Bowenite base with silver gilt mounts, standing on four lizard feet, with two drawers; the sides with oval hinged compartments containing miniatures of Czar Nicolas II and Empress Alexandra Feodorovna; the back applied with the engraved monogram "MF" (in Russian) in a profusion of rococo ornament. This is surmounted by the clock with white enamel dial and gold hands flanked by two silver gilt putti, a vase above contains a bouquet of gem-set flowers.

Copy after a clock from the Imperial collection by James Hagger, London circa 1735 (Walters Art Gallery, Baltimore) – Cat. 664.

Provenance: Presented by Nicolas II and Alexandra to the Dowager Empress, Marie Feodorovna

Literature: M.C. Ross, "A musical clock by James Cox", in *The American Collector*, April

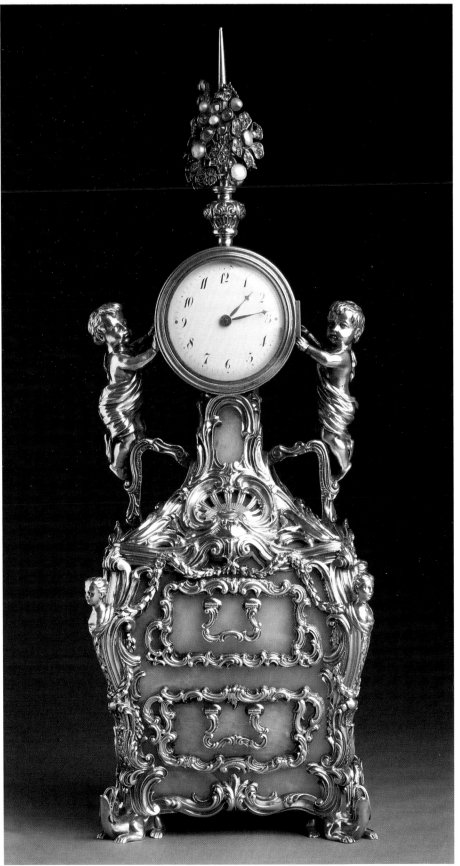

280

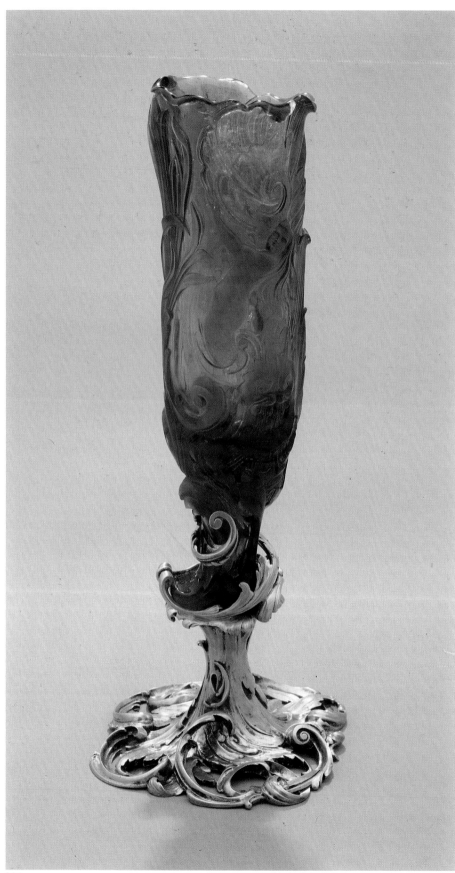

1942, p. 5 – Ross, 1965, p. 65, pl. XXIV – Habsburg, 1987, p. 75

The Marjorie Merriweather Post Collection, Hillwood, Washington, D.C.

281 Smoky quartz vase

Mm: Fabergé – Wm: Julius Rappoport – Hm: St. Petersburg, before 1899
Height: 14⁹/₁₆″

Carved with rococo scrolls and foliage from a large smoky quartz crystal, with gold base chased in the art nouveau manner.
Typical combination of Louis XV and art nouveau motifs, but work unusual for Fabergé's main silversmith, Rappoport.

Provenance: From the Winter Palace Collection, 1931
Exhibited: Leningrad 1974, no. 23 – Lugano 1986, no. 120
Literature: Lopato, 1984, p. 44

State Hermitage, Leningrad (Inv. E-17 576)
(L. Y.)

282 Rock-crystal presentation dish in the Renaissance style

Mm: Fabergé – Wm: Michael Perchin – Hm: St. Petersburg, before 1899 – Am: 88 zolotniks
Length: 15³/₈″

Twelve rock-crystal panels engraved with swirling foliage or with flutes, set around an oval panel engraved with the coat-of-arms of the City of St. Petersburg. The back is inscribed: "From the Nobility of the Government of St. Petersburg, 1896." Matt gold mounts chased and enameled with stylized scrolling foliage in green, red and blue hues and set with rose-cut diamonds.
Typical product of Perchin's workshop in the Renaissance style prevailing at the time and also illustrated by the work of Reinhold Vasters. A similar dish is at the Kunsthistorisches Museum, Vienna. Most of the objects in rock-crystal and with Renaissance-style mounts were intended for royal presentation.

Provenance: Presented by the nobility of St. Petersburg to Czar Nicholas II on the occasion of his coronation on May 14, 1896. From the Diamond Chamber of the Winter Palace, 1922
Exhibited: Lugano 1986, no. 118
Literature: Lopato, 1984, p. 48

State Hermitage, Leningrad (Inv. E-6788)
(L. Y.

281

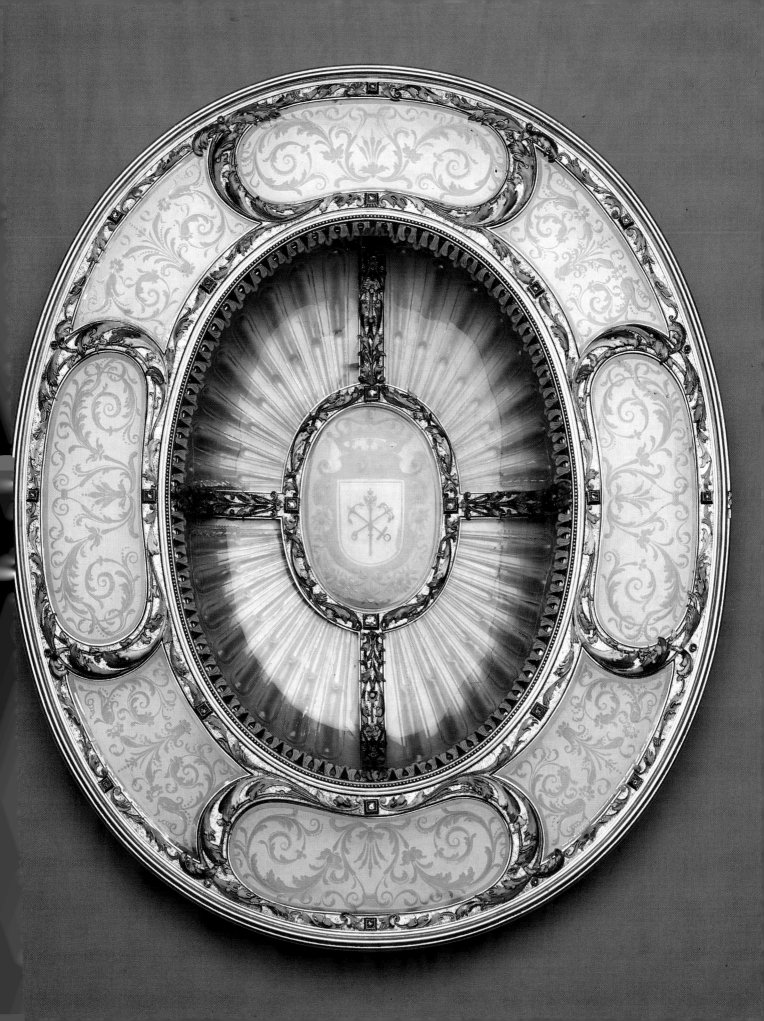

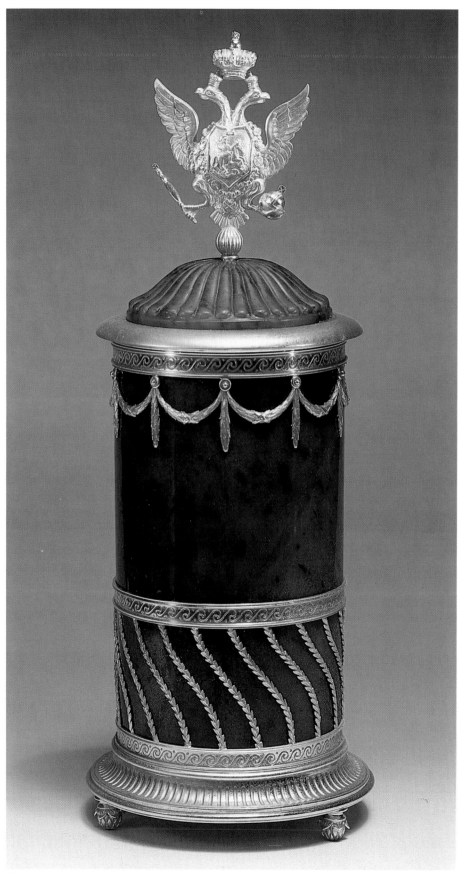

283 Nephrite Freedom Box

Mm: Fabergé – Wm: Michael Perchin – Hm: St. Petersburg, before 1899 – Inv: 531(?)05
Height: 9⁷/₁₆"

Cylindrical nephrite casket applied with swirling bands of laurel leaves, two-color gold laurel swags and borders chased with entrelacs; standing on gadrooned gold base with three pine cone feet. The domed cover is carved with flutes and surmounted by a crowned double-headed eagle.

Provenance: Presented by Czar Nicolas II to Sydney Herbert, 14th Earl of Pembroke, on the occasion of his visit to Balmoral in 1896
Exhibited: Belgrave Square 1935, no. 508 (15th Earl of Pembroke) – Wartski 1949, no. 204 – Washington 1985/86, p. 654
Literature: Bainbridge, 1949/68, pl. 8 – Snowman, 1962/64, ill. 275 – Habsburg/Solodkoff, 1979, pl. 155

The Wernher Collection, Luton Hoo

284 Circular nephrite tray

Mm: Fabergé – Wm: Michael Perchin – Hm: St. Petersburg, before 1899
Length: 13"
The rococo-style yellow-gold handles shaped like cartouches with scarlet *guilloché* enamel reserves are surrounded by scrolls and foliage on matted ground set with rose-cut diamonds.

One of a series of nephrite dishes including a similar Imperial presentation tray in the Forbes Magazine Collection (cf. Solodkoff 1984, p. 47)

Exhibited: Belgrave Square 1935, no. 527 (Lady Ludlow) – Wartski 1949, no. 216 – Washington 1985/86, p. 654
Literature: Bainbridge, 1949/68, pl. 22 (above) – Snowman, 1962/64, ill. 279

The Werner Collection, Luton Hoo

284

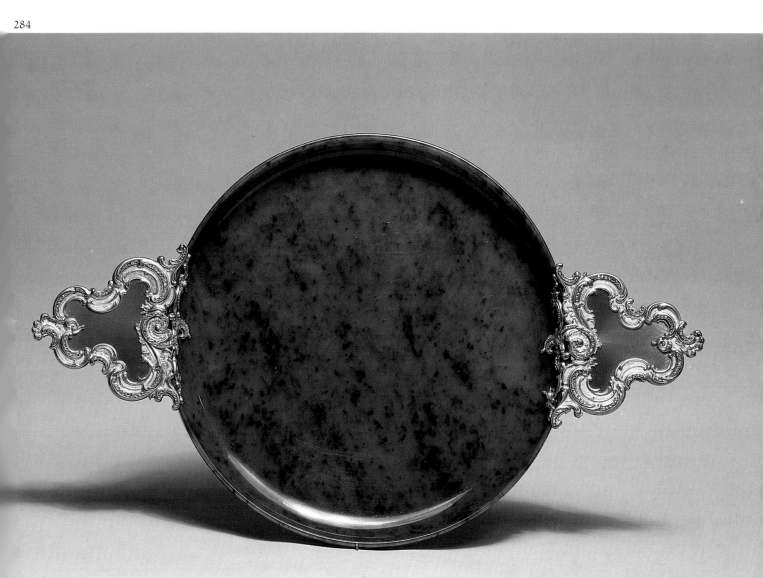

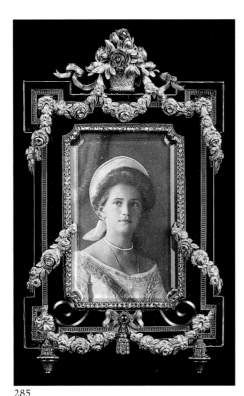

285

285 Rock-crystal frame

Wm: Michael Perchin – Hm: St. Petersburg, 1899–1908 – Inv: 5956 – Height: 4″

Gold-mounted, applied with flower swags in two-color gold, a four-color gold basket of flowers above, a diamond-set and ruby tassel beneath; the border and stud feet also set with rose-cut diamonds. Ivory backing and gold strut; later photograph of Grand Duchess Maria.

Exhibited: A la Vieille Russie 1949, no. 179
Lugano 1987, no. 32
Literature: Waterfield & Forbes, 1978, no. 72
Solodkoff, 1984, p. 39

The Forbes Magazine Collection, New York

286 Nephrite Imperial presentation kovsh

Mm: Fabergé – Wm: Michael Perchin – Hm: St. Petersburg, 1899–1908 – Inv: 6926
Length: 9⁷/₈″

Boat-shaped; gold handle with white *guil-loché* enamel reserve with rococo style scrolls and foliage, applied with diamond-set monogram "N II".

Provenance: Presented by Czar Nicholas II to Monsieur Boutiron, French Ambassador to the Imperial Court.
Literature: Habsburg/Solodkoff, 1979, ill. 43

Musée des Arts Décoratifs, Paris

287 Nephrite cannon

Mm: Fabergé – Wm: Michael Perchin – Hm: St. Petersburg, before 1899
Length of base: 8¹/₄″

Applied gold decoration in the 17th century manner.
Miniature replica of the cannon of Peter the Great in the Hermitage, St. Petersburg.

Provenance: Given by Czar Nicholas II to Kaiser Wilhelm II, whose bellicose inclinations he was well aware of
Exhibited: Hanau 1985/86, no. 231

Foundation Huis Doorn

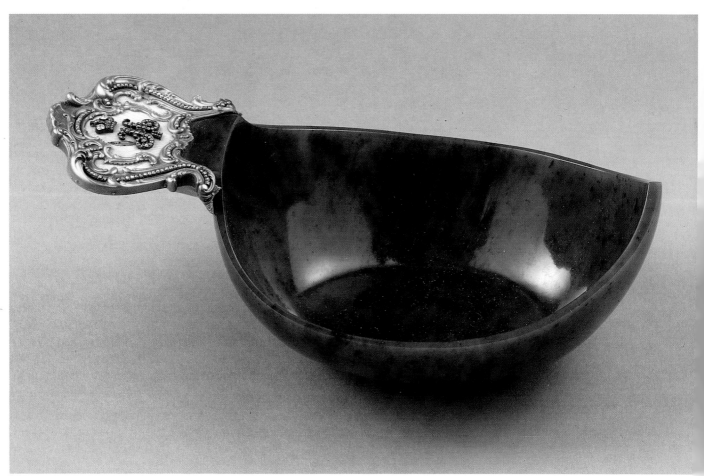

286

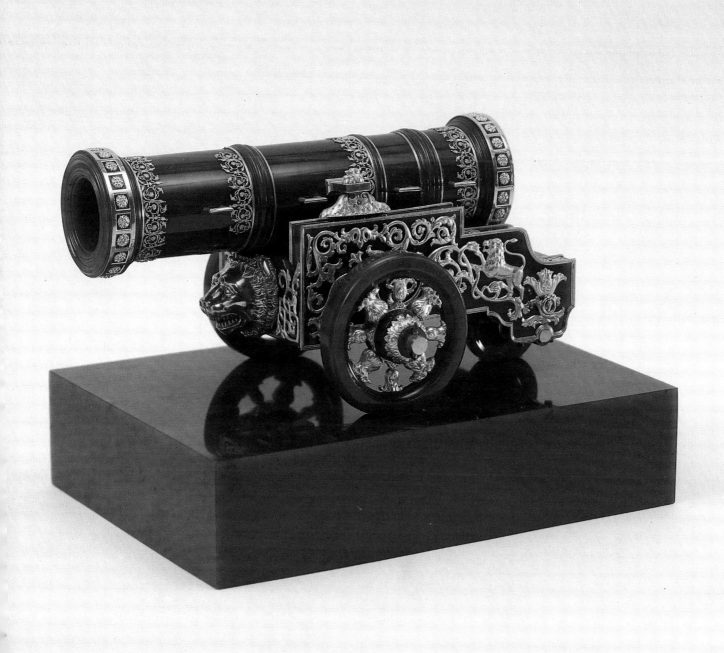

287

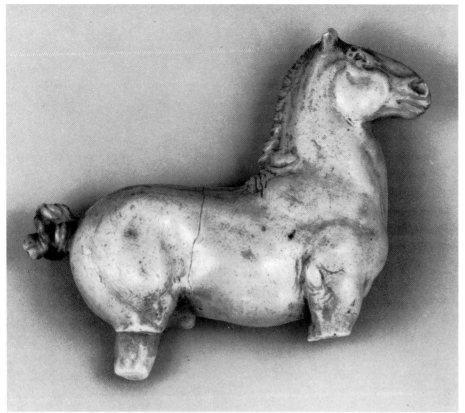

288

Animals

288 Wax model of a stallion

Length: 5¹/₈″

One of two extant models from Fabergé's workshop, possibly made by Alfred Pocock, and inspired by the Elgin Marbles.

Provenance: Given by H.C. Bainbridge to A.K. Snowman
Literature: Victoria & Albert, 1977, p. 25 – Snowman 1979, p. 37

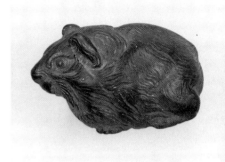

289

289 Wax model of a guinea-pig

Length: 1¹/₂″

For authorship and provenance, cf. cat. 288

290 Electric bellpush shaped like a crab

Mm: Fabergé – Wm: Henrik Wigström – Hm: St. Petersburg 1908–1917 – Am: 9? zolotniks
Length: 4¹⁵/₁₆″

Naturalistically cast and chased in silver with inset blue chalcedony shell, articulated legs and claws; cabochon ruby eyes acting as pushpieces.
Inspired by a Japanese articulated bronze crab similar to cat. 636. For a similar model cf. Snowman 1979, p. 44

Provenance: Grand Duchess Anastasia Michaelovna
Literature: Munn, 1986, p. 41

291 Sniffing bloodhound

Length: 2⁷/₁₆″

Brown gray agate, with gold-mounted ruby eyes.

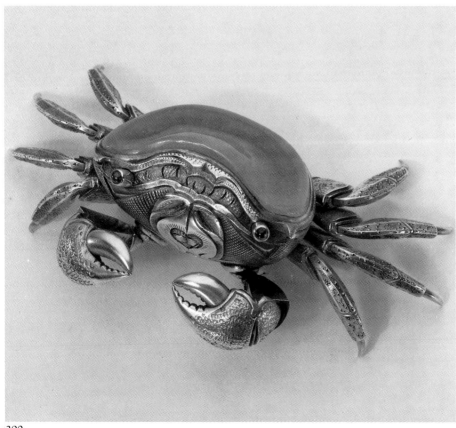

290

Carved by Alfred Heine in the workshop of Moritz Stern, Idar-Oberstein, c. 1913, after a Fabergé model.

Museum Unter der Felsenkirche, Idar-Oberstein

292 Bulldog

Length: 2³/₈″

Brown gray jasper, with gold-mounted ruby eyes.
For authorship and provenance, cf. cat. 291

Museum Unter der Felsenkirche, Idar-Oberstein

293 Goose

Height: 3¹/₈″

Polished orange white agate, with rose-cut diamond eyes.
After a Chinese original

294 Fledgling crow

Height: 2³/₁₆″
Original fitted case stamped with Iwm, St. Petersburg, Moscow

Obsidian, with yellow gold legs and rose-cut diamond eyes.

Provenance: Miss Yznaga della Valle, sister of the Duchess of Manchester (Christie's, Geneva, November 11, 1982, lot 263)

295 Stylized crouching toad

Length: 1⁹/₁₆″

Brown-black obsidian, with gold-mounted rose-cut diamond eyes.

296 Duckling

Wm: Henrik Wigström – Hm: St. Petersburg, 1908–1917 – Am: 72 zolotniks
Height: 2⁹/₁₆″

Yellowish chalcedony, with added beak; gold feet and peridot eyes.

For a similar model in the collection of H. M. Queen Elizabeth II of Great Britain, cf. Snowman, 1979, p. 69.

297 Pig

Length: 2″

Pink aventurine quartz with gold-mounted rose-cut diamond eyes.
Illustrated p. 194

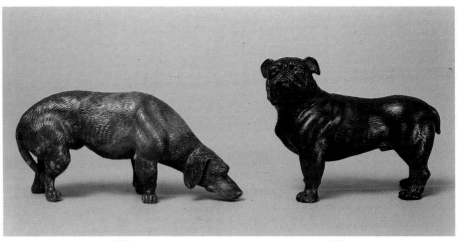

291 292

298 Pig

Length: 2″
Original fitted case stamped with Iwm, St. Petersburg, Moscow

Pink aventurine quartz with gold-mounted rose-cut diamond eyes.
Almost identical to cat. 297
Illustrated p. 194

H. M. King Carl XVI Gustaf of Sweden

299 Indian elephant

Length: 1³/₄″

Amethyst, with gold trunk and gold-mounted rose-cut diamond eyes.

300 Ant-eater

Length: 2³/₁₆″

Pink aventurine quartz, with gold-mounted rose-cut diamond eyes.

293 294, 295 296

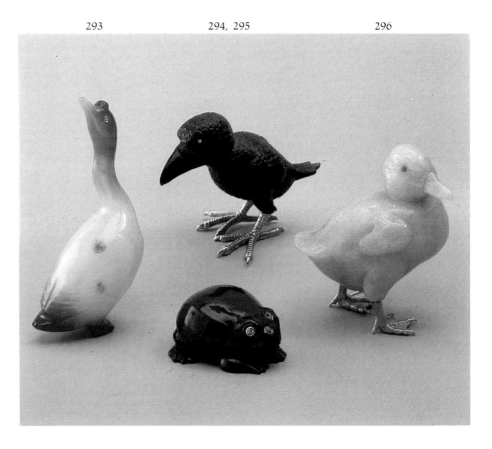

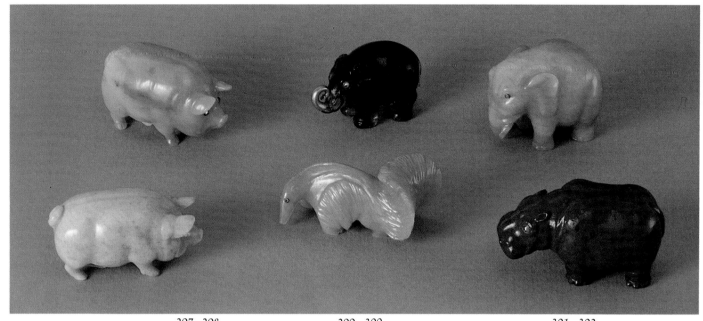

297, 298 299, 300 301, 302

301 Indian elephant

Length: $1^9/_{16}''$

Pink aventurine quartz with gold-mounted rose-cut diamond eyes.

302 Hippopotamus

Length: $1^1/_8''$

Reddish brown jasper, with gold-mounted rose-cut diamond eyes.

303 Bear cub

Length: $1^7/_8''$

Bowenite, with cabochon ruby eyes.
Cf. also cat. 359

304 307 309

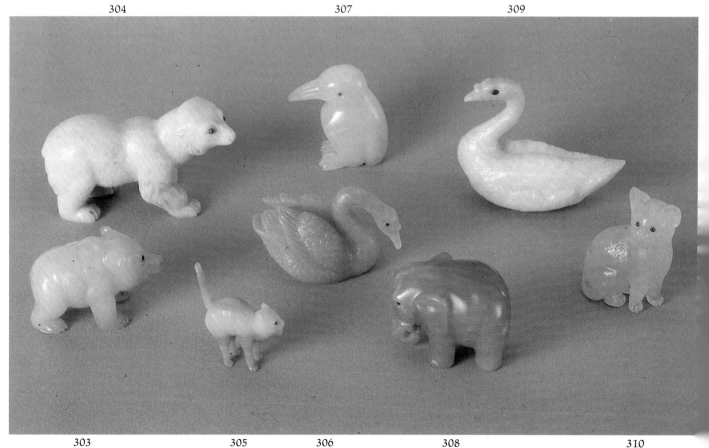

303 305 306 308 310

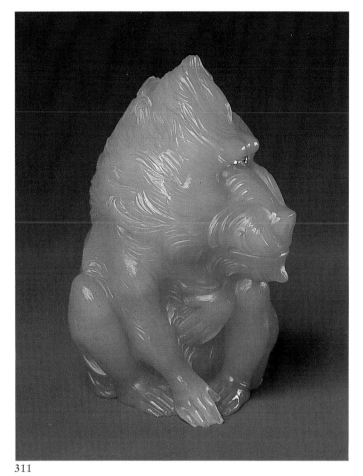

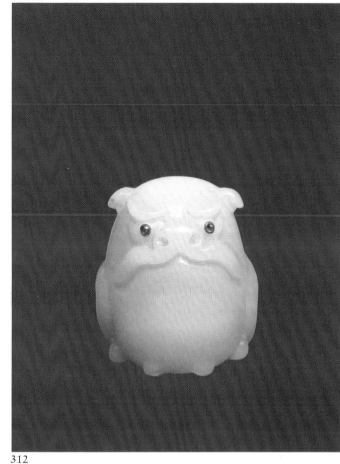

311

312

304 Polar bear

Length: $2^{15}/_{16}''$

White aventurine quartz, with gold-mounted cabochon ruby eyes.

305 Cat

Height: $1^9/_{16}''$
Original fitted case stamped with Iwm, St. Petersburg, Odessa

Pale gray banded agate, with cabochon ruby eyes.
For another version of this model, cf. cat. 353

306 Swan

Length: $2^1/_8''$

Pale gray agate, with ruby eyes.

307 Kingfisher

Height: $1^3/_4''$

Bowenite, with peridot eyes.
For two similar birds in the collection of H. M. Queen Elizabeth II of Great Britain, cf. Snowman 1979, p. 46.

308 Indian Elephant

Height: $1^3/_8''$

Bowenite, with gold-mounted cabochon ruby eyes.

309 Swan

Height: $2^1/_8''$
Original fitted case stamped with Iwm, St. Petersburg, Moscow

Milky white bowenite, with cabochon ruby eyes.

310 Seated cat

Height: $1^{15}/_{16}''$
Original fitted case stamped with Iwm, St. Petersburg, Odessa

Pale gray agate, with cabochon emerald eyes.

Provenance: Given by the Dowager Empress Marie Feodorovna (pencil note: "främ de löde, Minny, December 1905, Amalienborg")

311 Seated mandrill

Height: $3^1/_8''$

Pale gray agate, with yellow rose-cut diamond eyes.
One of Fabergé's most evocative creations with its evilly glinting eyes.

Provenance: Transferred 1920 from the Imperial Collection to the Armory Museum
Literature: Snowman, 1962/64, ill. 253 – Catalog of the Armory, 1964, p. 166/7 – Rodimtseva, 1971, p. 20, ill. 10

Armory Museum, Kremlin, Moscow (Inv. DK-89) (T. N. B.)

312 "Kara Shishi"

Height: $1^9/_{16}''$

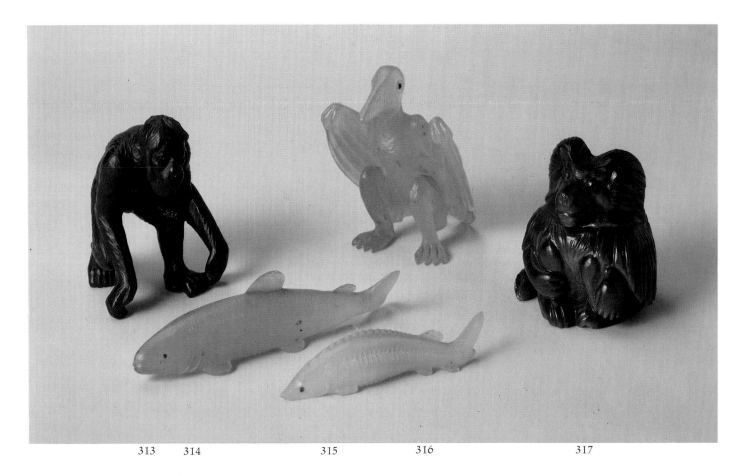

313 314 315 316 317

Original fitted case stamped with Iwm, St. Petersburg, Moscow

Bowenite, with gold-mounted cabochon ruby eyes.
Mythical animal, probably inspired by a Chinese original.

Provenance: Acquired 1982 by the Acquisitions Committee of the State Hermitage

State Hermitage, Leningrad (Inv. ERO 9329)
(N. K.)

312 A

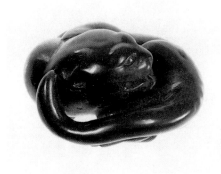

312 a Japanese tiger

Length: 1³/₈″

Obsidian, curled up, licking its hind quarters. Inspired by a Japanese netsuke.

313 Standing Chimpanzee

Length: 2¹/₄″

Nephrite.

314 Salmon

Length: 2¹⁵/₁₆″

Bowenite, with ruby eyes.

315 Sturgeon

Length: 2³/₈″

Pale white bowenite, with ruby eyes.

316 Pterodactyl with spread wings

Height: 2⁹/₁₆″

Bowenite, with ruby eyes.
One of Fabergé's rare prehistoric beasts.

317 Seated baboon

Height: 2¹/₈″

Obsidian, with rose-cut diamond eyes.
For a bowenite version of this model from the collection of King Paul of the Hellenes, cf. Sotheby's, London, November 25, 1957, lot 113.

318 Kangaroo

Height: 2¹¹/₁₆″
Original fitted case stamped with Iwm, St. Petersburg, Moscow, London

Honey-colored agate, with rose-cut diamond eyes.
For a nephrite version of this model in the collection of H.M. Queen Elizabeth II of Great Britain, cf. Victoria & Albert 1977, no 0 36.

319 Piglet

Length: ⁵/₈″
Original fitted case stamped with Iwm

Pinkish agate with an orange spot.
This minute carving is possibly the smalles made in Fabergé's workshops.

196

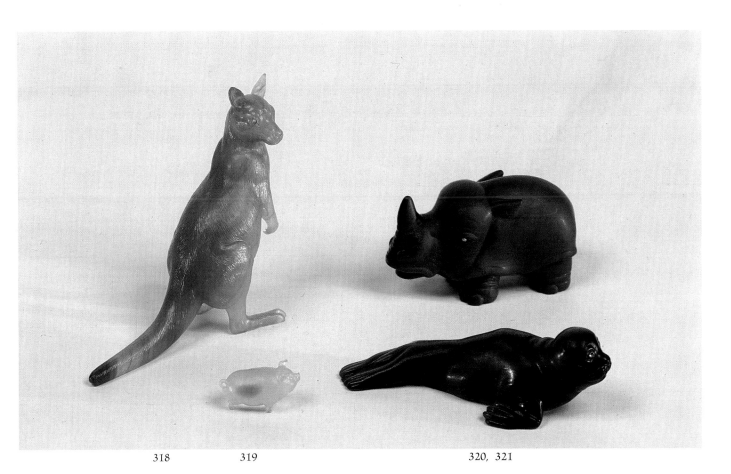

318 319 320, 321

320 Caricature of a rhinoceros

Length: 2³/₁₆″
Original fitted case stamped with Iwm,
St. Petersburg, Moscow

Gray Kalgan jasper, with rose-cut diamond
eyes.

Provenance: Edward James

Mrs. Josiane Woolf

321 Seal

Length: 2⁹/₁₆″

Obsidian, with rose-cut diamond eyes.

322 Owl seated on a perch

Inv: 7827
Height: 2⁹/₁₆″

Honey-colored agate, with rose-cut dia-
mond eyes and gold claws. Seated on silver
gilt perch on square chalcedony base.

323 Frog

Length: 1¹/₂″

Nephrite, with gold-mounted rose-cut dia-
mond eyes.

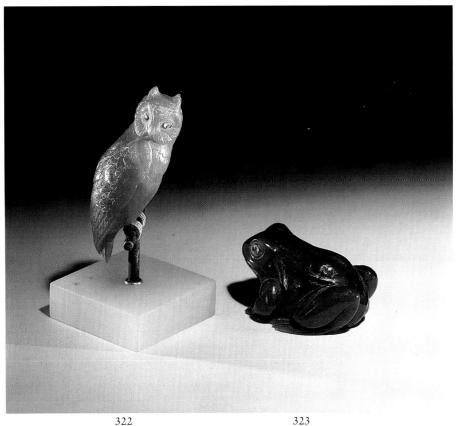

322 323

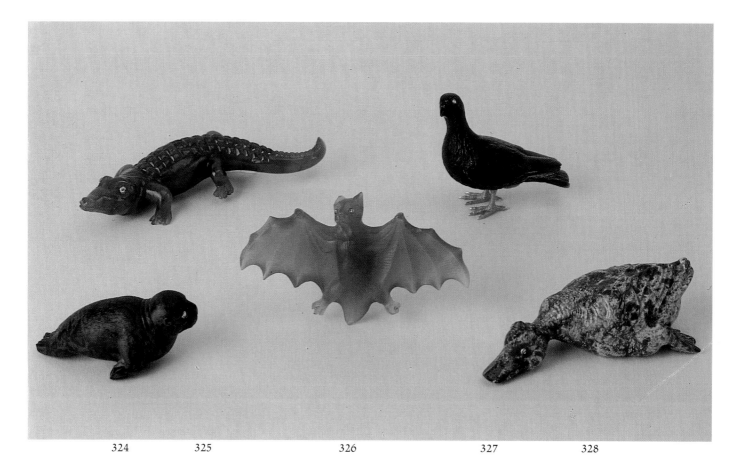

324 325 326 327 328

324 Sea lion

Length: 1⁷/₈″

Brown-gray obsidian, with rose-cut diamond eyes.

325 Crocodile

Length: 3⁹/₁₆″

Nephrite, with gold-mounted rose-cut diamond eyes.

326 Bat with spread wings

Width: 2³/₄″

Pale gray agate, with gold-mounted rose-cut diamond eyes.

327 Carrier pigeon

Height: 1¹¹/₁₆″
Original fitted case stamped with Iwm, St. Petersburg, Moscow

Obsidian, with gold feet and rose-cut diamond eyes.

Provenance: Presented by Grand Duchess Olga of Russia (pencil note inscribed: "from Olga of Russia, Xmas 1907")

328 Swimming feeding duck

Length: 2³/₄″

Mottled reddish-white jasper, with gold-mounted rose-cut diamond eyes.

329 Elephant standing on its head

Height: 1³/₄″

Gray Kalgan jasper, with rose-cut diamond eyes.

330 Seated elephant

Length: 2¹/₂″

Bowenite, with ruby eyes.

331 Elephant

Length: 1¹/₈″

Rock-crystal, with cabochon ruby eyes.

332 Elephant-shaped pendant

Length: ¹¹/₁₆″

Gray Kalgan jasper, with rose-cut diamond eyes and diamond-set suspension ring.

333 Elephant

Length: ¹¹/₁₆″

Lapis lazuli, with rose-cut diamond eyes.

334 Elephant-shaped pendant

Wm: Michael Perchin – Hm: St. Petersburg, before 1899
Length: ¹¹/₁₆″

Chalcedony, with ruby eyes, the gold saddle-cloth with yellow *guilloché* enamel and rose-cut diamonds.

335 Walking elephant

Length: 2³/₄″

Smoky quartz, with silver-mounted cabochon ruby eyes.

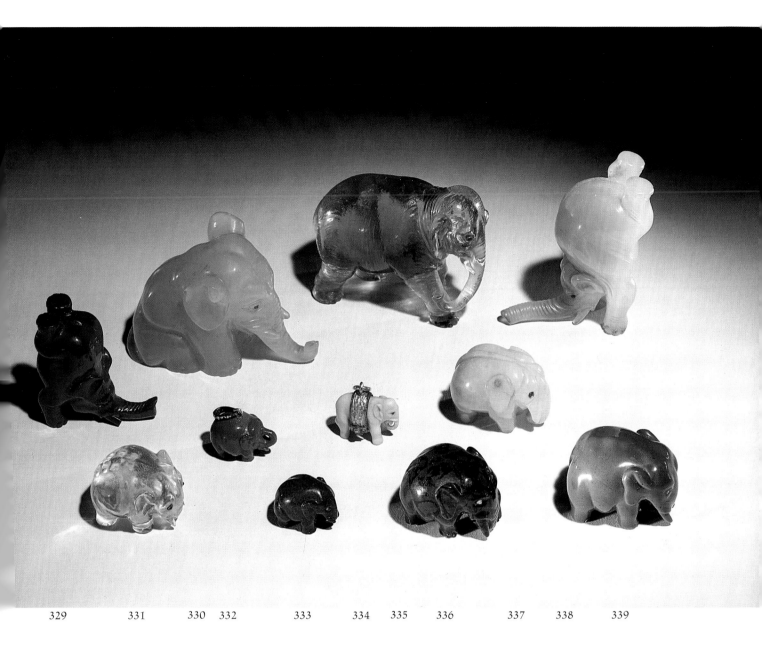

329 331 330 332 333 334 335 336 337 338 339

336 Elephant

Length: $1^1/_8''$

Brown-black obsidian, with rose-cut diamond eyes.

337 Elephant

Length: $1^1/_8''$

Pink aventurine quartz, with ruby eyes.

338 Elephant standing on its head

Height: $2^1/_4''$

Bowenite, with ruby eyes.
Similar model to cat. 329.

339 Elephant

Length: $1^1/_4''$

Gray Kalgan jasper, with rose-cut diamond eyes.

340 Seated chinchilla

Height: $2^1/_4''$

Gray agate, nibbling a gold ear of corn, with gold-mounted cabochon sapphire eyes.
Illustrated p. 200

Literature: Bainbridge, 1949/69, pl. 85

341 Sturgeon

Length: $2^3/_4''$

Pinkish-gray banded agate, with rose-cut diamond eyes.
For another version of this model in the collection of H.M. Queen Elizabeth II of Great Britain, cf. Snowman 1979, p. 68
Illustrated p. 200

Literature: Bainbridge, 1949/68, pl. 85

342 Flamingo

Height: $4^3/_8''$

Original fitted case stamped with Iwm, St. Petersburg, Moscow

Baroque pearl body, neck and tail set with rose-cut diamonds, red-brown beak, cab-

199

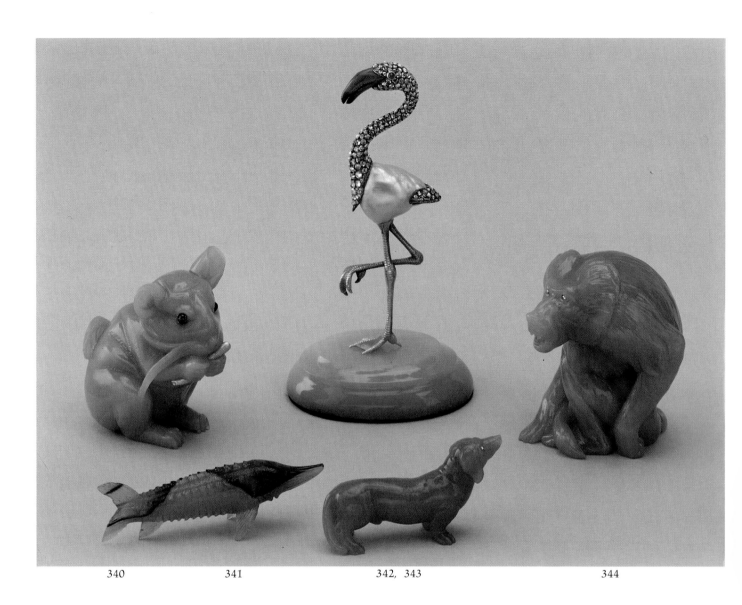

<div style="text-align:center">340 341 342, 343 344</div>

ochon ruby eyes, gold legs. Standing on an oval bowenite base.
Probably inspired by an 18th century original in the manner of Dinglinger.

Exhibited: Victoria & Albert 1977, no. S 19
Literature: Snowman, 1979, p. 43

343 Dachshound

Length: 2″

Orange aventurine quartz, with rose-cut diamond eyes.

344 Angry baboon

Height: $2^1/_4$″

Gray agate, with rose-cut diamond eyes.

Literature: Bainbridge, 1949/68, pl. 85

345 Cockerel

Height: 4″

Nephrite, with cabochon ruby eyes and gold claws.
Inspired by a Chinese bronze original of the Meiji period. For a related Japanese netsuke, cf. cat. 647.

Exhibited: Washington 1985/6, p. 654
Literature: Snowman, 1962/64, ill. 249

The Wernher Collection, Luton Hoo

346 Elephant with two raised legs

Length: $2^1/_{16}$″
Original fitted case stamped with Iwm, St. Petersburg, Moscow

Nephrite, with rose-cut diamond eyes.

Literature: Snowman, 1962/64, ill. 246
The Wernher Collection, Luton Hoo

347 Climbing frog

Height: $3^3/_4$″

Nephrite, with gold-mounted circular-cut diamond eyes, on (later) velvet base.
For other versions of this obviously popular model, cf. Victoria & Albert 1977, no. P 13 (collection H.R.H. The Prince of Wales) Habsburg/Solodkoff 1979, ill .76; Parke-Bernet, New York, December 7, 1967, lot 36 (Collection Landsdell K. Christie).

Exhibited: Washington 1985/86, p. 656
Literature: Snowman, 1962/64, ill. 249

The Wernher Collection, Luton Hoo

348 Royal Danish elephant

Wm: Michael Perchin
Height: 1³/₁₆″
Original fitted case stamped with Iwm, St. Petersburg, Moscow

Gray Kalgan jasper, with rose-cut diamond eyes, the turret enameled in white, with rose-cut diamonds.

The Wernher Collection, Luton Hoo

349 Royal Danish elephant

Inv. 5450
Height: ¹³/₁₆″

Gray banded agate, with rose-cut diamond eyes, the turret enameled in white, set with rose-cut diamonds, with red *guilloché* enamel saddle-cloth.
Similar elephants, doubtlessly connected with the Danish Elephant Order (Empress Marie Feodorovna was a Danish princess)

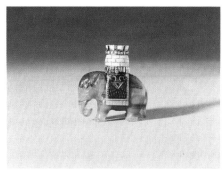
349

345 346 347 348

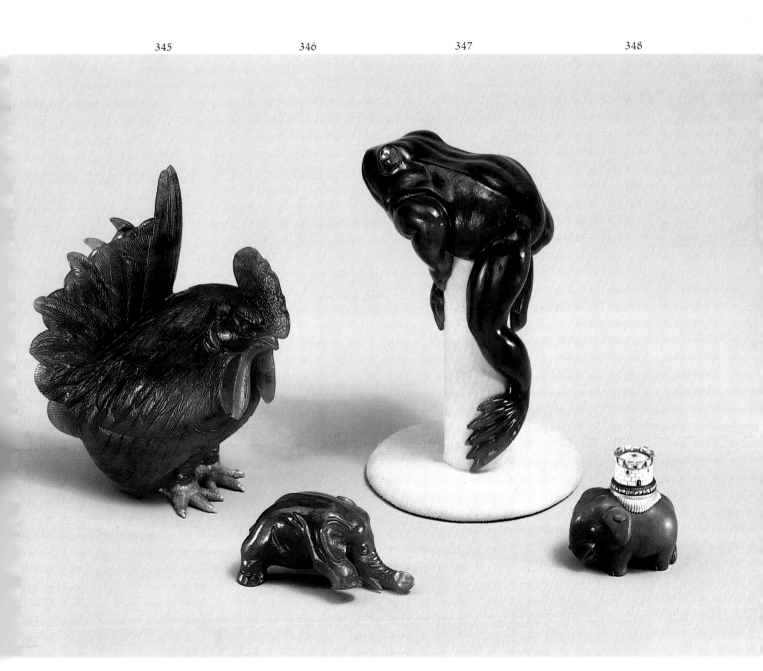

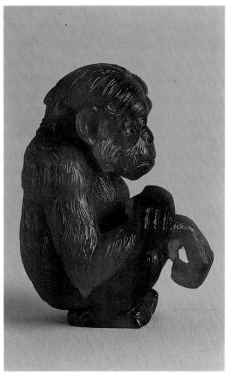
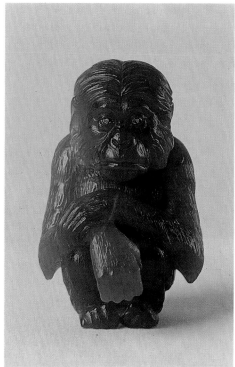
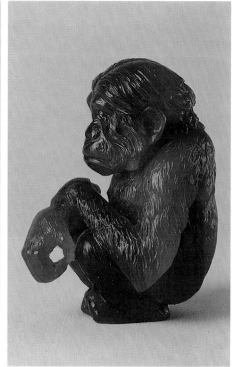

350

are in the collection of H.M. Queen Elizabeth II of Great Britain (Victoria & Albert, 1977, nos. C19 and 20).

Provenance: Wedding present of Empress Marie Feodorovna to Princess Victoria Alberta, of Hesse and the Rhine (1863–1950), who married in 1884 Prince Louis of Battenberg, 1. Marquess of Milford Haven (1854–1921)

Exhibited: A la Vieille Russie 1983, no. 453

350 Seated Chimpanzee

Height: 2³/₄″

Gray brown agate, with gold-mounted rose-cut diamond eyes.
For a similar figure in the collection of H.M. Queen Elizabeth II of Great Britain, cf. Bainbridge 1949/68, pl. 73 (above)

351 Barking dog

Length: 1¹³/₁₆″

Honey-colored banded agate, with rose-cut diamond eyes.

Exhibited: A la Vieille Russie 1983, no. 432

The Brooklyn Museum (Bequest Helen B. Sanders)

352 Mouse

Length: 1¹/₈″

Seated on an overturned saucer. Smoky quartz, with rose-cut diamond eyes.
Inspired by a Japanese netsuke (cf. cat. 637/38)

The Brooklyn Museum (Bequest Helen B. Sanders)

353 Cat

Length: 1¹/₂″

Pinkish gray banded agate, with rose-cut diamond eyes.
For other versions of this model, cf. cat. 305 and Victoria & Albert 1977, no. A 14

Exhibited: A la Vieille Russie 1983, no. 432

The Brooklyn Museum (Bequest Helen B. Sanders)

354 Toad

Length: 2″

Pale green jade, with gold-mounted cabochon ruby eyes.
Inspired by a Japanese netsuke (cf. cat. 643)

The Brooklyn Museum (Bequest Helen B. Sanders)

355 Angry bull

Length: 2¹/₄″
Original fitted case stamped with Iwm, St. Petersburg, Moscow

With lowered head, pawing the ground. Nephrite, with rose-cut diamond eyes.

The Brooklyn Museum (Bequest Helen B. Sanders)

356 Bear

Height: ⁷/₈″

Seated on its hind quarters. Obsidian, with ruby eyes.

Exhibited: A la Vieille Russie 1983, no. 39

The Brooklyn Museum (Bequest Helen B. Sanders)

357 Rabbit

Length: 1³/₄″
Original fitted case stamped with Iwm, St. Petersburg, Moscow

Seated on its hind quaters. Obsidian, with rose-cut diamond eyes.
Inspired by a Japanese netsuke (cf. cat. 641).

The Brooklyn Museum (Bequest Helen B. Sanders)

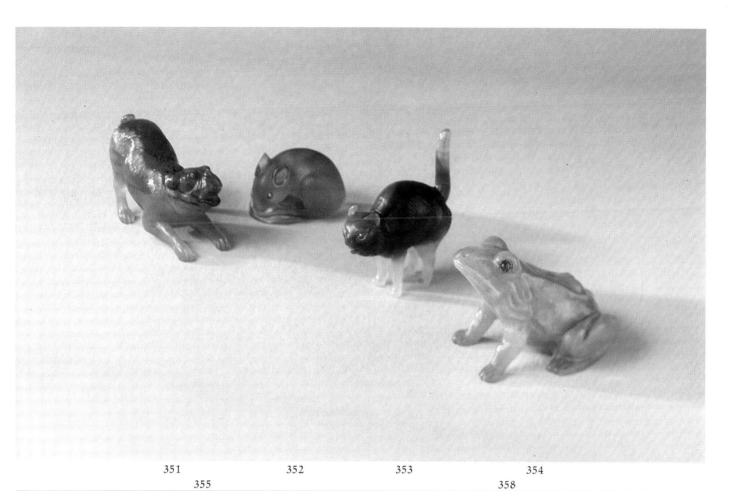

351 352 353 354

355 358

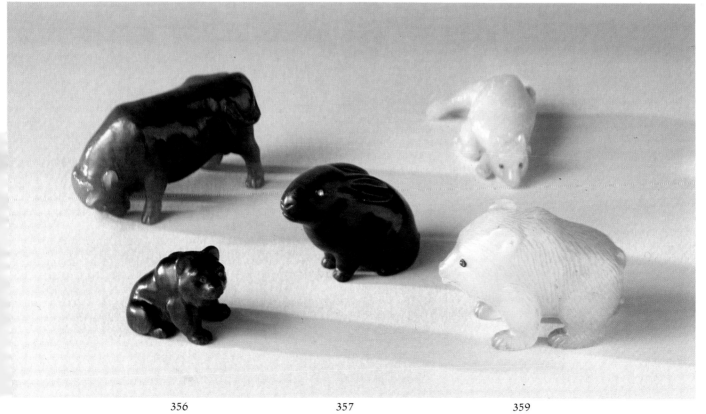

356 357 359

358 Resting lamb

Length: 2"
Original fitted case stamped with Iwm, St. Petersburg, Moscow

White agate, with ruby eyes. Ill. p. 203

Exhibited: A la Vieille Russie 1983, no. 389

The Brooklyn Museum (Bequest Helen B. Sanders)

359 Bear cub

Length: 2"

Bowenite, with gold-mounted cabochon ruby eyes.
For other versions of this model, cf. cat. 303 and Victoria & Albert 1977, no. C 30.
Illustrated on p. 203

The Brooklyn Museum (Bequest Helen B. Sanders)

360 Snail

Length: 3¹/₈"

Nephrite.
For other versions of this model, cf. the examples from the Robert Strauss Collection (Christie's, London, March 9, 1976, lot 46) and the collection of H.M. Queen Elizabeth II (Snowman, 1962/64, ill. 273).

Literature: Munn, 1987, p. 39

The Trustees of the Victoria & Albert Museum, London

361 Rabbit

Height: 2³/₈"

Rhodonite, with rose-cut diamond eyes.

Exhibited: A la Vieille Russie 1983, no. 396

362 Mystic ape

Height: 1¹/₄"

Covering its eyes, ears and mouth with its paws. Nephrite.
Copied from a Japanese netsuke possibly by Mitsuhiro school of Osaka (cat. 639). For other versions of this model, cf. cat. 366, 369, and Snowman 1979, p. 65.

Exhibited: A la Vieille Russie 1983, no. 416

363 Toad

Length: 1⁷/₈"
Original fitted case stamped with Iwm, St. Petersburg, Moscow

Bowenite, with gold-mounted cabochon ruby eyes.
For a nephrite version of this model in the collection of H.M. Queen Elizabeth II, cf. Victoria & Albert 1977, no B 5.
Copied from a Japanese netsuke, possibly by Masanao, school of Yamada (cf. cat. 643).

Literature: Munn, 1987, p. 39

Mrs. Josiane Woolf

364 Frog chewing a worm

Height: ¹³/₁₆"

Nephrite, with gold-mounted rose-cut diamond eyes.
Literature: Snowman, 1979, p. 65 – Munn, 1987, p. 39

365 Frog chewing a worm

Height: 1¹³/₁₆"

Bowenite, with gold-mounted facetted topaz eyes.
Literature: Munn, 1987, p. 39

Mrs. Josiane Woolf

366 Mystic ape

Height: 1¹/₂"

Obsidian.
For the prototype and other versions of this model, cf. cat. 362.

Literature: Snowman, 1979, p. 65 – Munn, 1987, p. 39

367 Mouse

Mm: Fabergé – Wm: Henrik Wigström
Length: 2¹/₁₆"

Opal, tail and ears set with rose-cut diamonds, cabochon ruby eyes.
For other versions of this model in the collection of H.M. Queen Elizabeth II, cf. Victoria & Albert 1977, nos. B 28, 30.
Inspired by a Japanese netsuke.

Literature: Munn, 1987, p. 39

368 Rabbit

Height: 1³/₁₆"
Original fitted case stamped with Iwm, St. Petersburg, Moscow

Smoky quartz, with rose-cut diamond eyes.
Inspired by a Japanese netsuke (cf. cat. 641)

Literature: Munn, 1987, p. 39

369 Mystic ape

Height: 1¹/₂"
Original fitted case stamped with Iwm, St. Petersburg, Moscow

Green amazonite.
For the prototype and other versions of this model, cf. cat. 362.
Exhibited: Victoria & Albert 1977, no. R 27
Literature: Snowman, 1962/64, pl. XXXIV – Snowman, 1979, p. 65 – Munn, 1987, p. 39

360

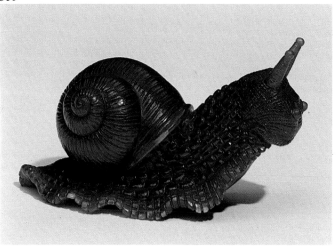

361, 362

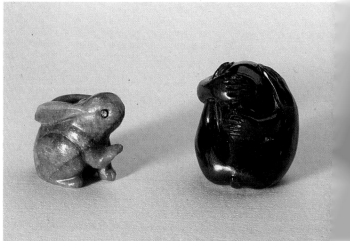

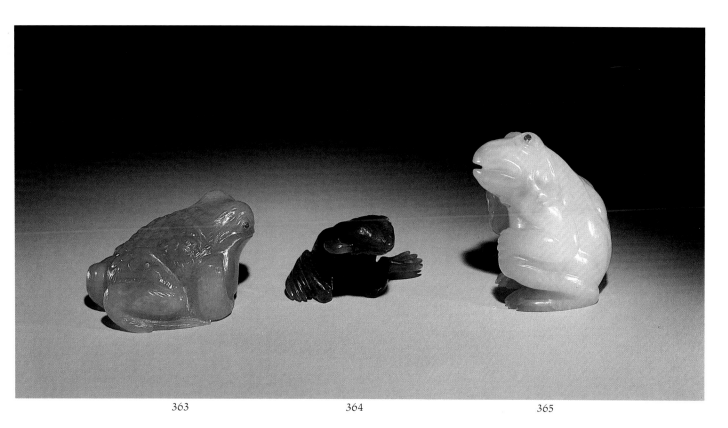

363 364 365

366 367 368 370 369

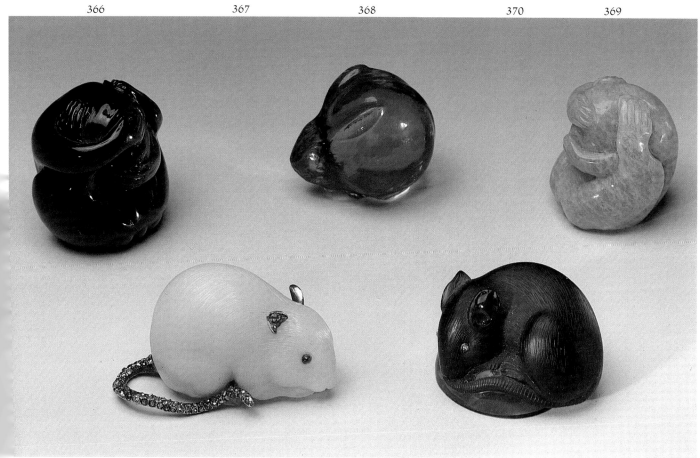

370 Mouse

Length: 1⁷/₈″

Smoky quartz.
Another version of cat. 352.
Illustrated p. 205

Literature: Munn, 1987, p. 39

Mrs. Josiane Woolf

371 Playful cat

Length: 1⁹/₁₆″
Original fitted case stamped with Iwm, St. Petersburg, Moscow, Odessa

Honey-colored agate, with rose-cut diamond eyes.
For another version of this model in the collection of H.M. Queen Elizabeth II, cf. Victoria & Albert 1977, no. A 13.

Provenance: Edward James

Mrs. Josiane Woolf

372 Capercailzie cock

Height: 2³/₄″
Original fitted case stamped with Iwm, St. Petersburg, Moscow, Odessa

Gray-brown banded agate with rose-cut diamond eyes and gold legs.
For another version of this model, cf. Christie's, Geneva, May 12, 1982, lot 123.

Provenance: Miss Yznaga della Valle (Christie's, Geneva, April 28, 1976, lot 190)
Exhibited: Belgrave Square 1935, no. 588B

Mrs. Josiane Woolf

373 Seated spaniel

Length: 1³/₄″
Original fitted case stamped with Iwm, St. Petersburg, Moscow, London
Opal, gold-mounted cabochon ruby eyes.

Provenance: Baron von Blücher, Geneva

Mrs. Josiane Woolf

374 Squirrel

Length: 1³/₄″
Original fitted case stamped with Iwm, St. Petersburg, Moscow, Odessa

Honey-colored agate, with rose-cut diamond eyes.

Provenance: Miss Yznaga della Valle (Christie's, Geneva, November 15, 1978, lot 501)
Exhibited: Belgrave Square 1935, no. 588 Y

Mrs. Josiane Woolf

375 "Field Marshall", the shire horse

Height: 7″

Aventurine quartz, with gold-mounted cabochon sapphire eyes.
One of Fabergé's best documented animal figures. Modelled 1907 after Queen Alexandra's champion shire horse in Sandringham.

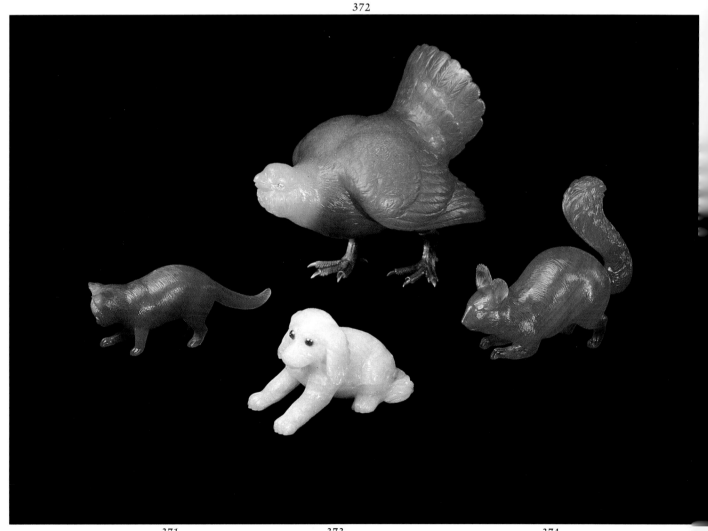

372

371 373 374

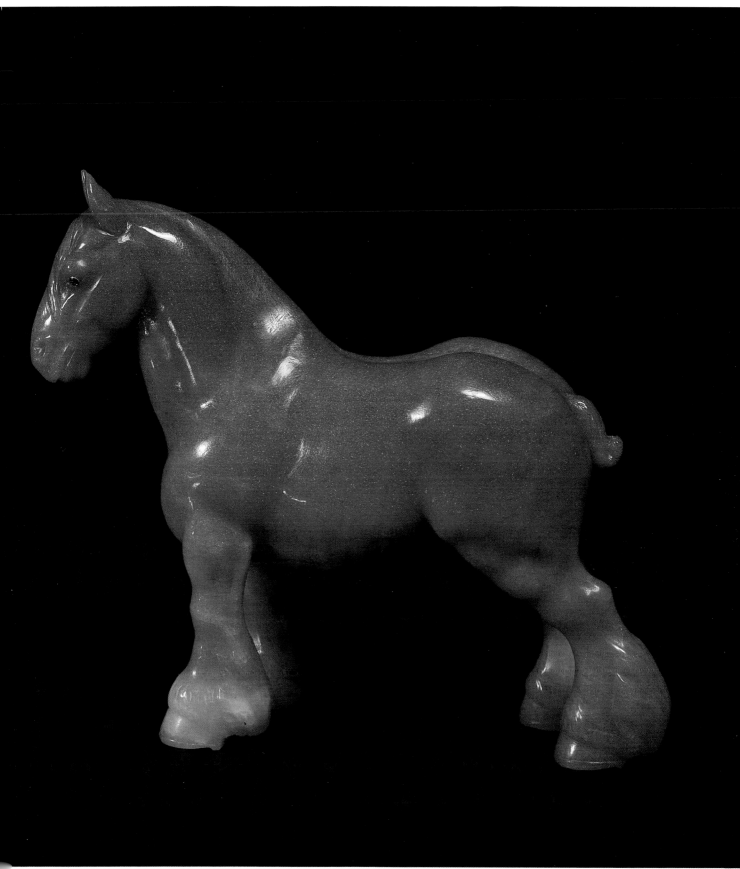

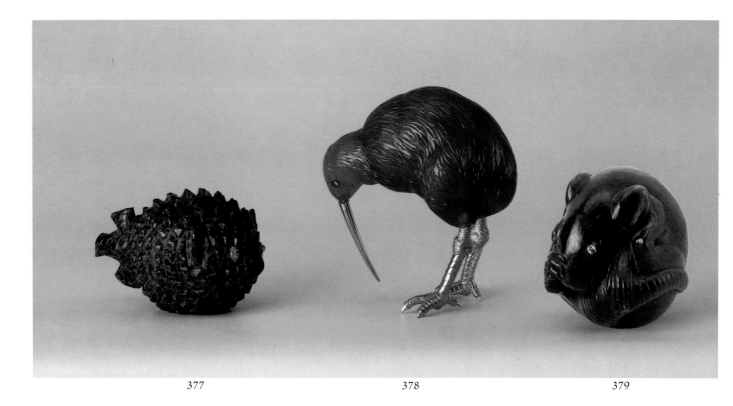

377 378 379

Given by King Edward VII to his wife for her birthday, December 1, 1908.

Exhibited: Victoria & Albert 1977, no. B 14
Cooper-Hewitt 1983, no. 73 – Queen's Gallery 1985/86, no. 248
Literature: Bainbridge, 1949/68, pl. 96 – Snowman, 1962/64, pl. XLII – Snowman, 1979, pl. 60

H.M. Queen Elizabeth II of Great Britain

376 Japanese sparrow

Width: 1³/₄″

Nephrite, with rose-cut diamond eyes.

376

For other versions of this model in the collection of H.M. Queen Elizabeth II of Great Britain, cf. Snowman 1979, p. 64.
Copied from a Japanese netsuke by Masanao, school of Kyoto (cf. cat. 639).

H.M. Queen Elizabeth, The Queen Mother

377 Puffer

Length: 2″

Brown-black jasper, with gold-mounted rose-cut diamond eyes.

378 Kiwi

Height: 2¹/₈″

Gray agate, with gold legs and beak and rose-cut diamond eyes.
For other versions of this popular model, cf. Snowman 1962/64, ill. 239; Habsburg/Solodkoff 1979, ill. 106; A la Vieille Russie 1983, no. 433; Christie's, Geneva, November 13, 1985, lot 9 (Collection Sir Charles Clore)

379 Spherical field-mouse

Diameter: 1⁹/₁₆″

Obsidian, with gold-mounted rose-cut diamond eyes.

Copied from a Japanese netsuke by Masakio, school of Yamada (cat. 645).

Literature: Habsburg, 1987, p. 79

380 "Caesar", King Edward VII's Norfolk terrier

Length: 2¹/₄″

Brown white chalcedony with cabochon ruby eyes, wearing a gold collar enameled in brown, inscribed: "I belong to the King". Caesar was the King's favourite dog. He followed the King's coffin at the funeral procession ahead of the Royal family and all the foreign monarchs.

Provenance: Acquired at Fabergé's, London "Mrs. Ronald Greville, 28. November 1910 Dog "Caesar", white onyx, brown enameled collar with inscription "I belong to the King", no. 18 521, £35, (cost price) 157 roubles". Probably ordered as a present for Queen Alexandra, since the King died on May 10 1910.
Exhibited: Victoria & Albert 1977, no. A 1
Cooper-Hewitt 1983, no. 70 – Queen's Gallery 1985/86, no. 243
Literature: Bainbridge, 1949/68, pl. 9 (above) – Snowman, 1962/64, ill. 255
Snowman, 1979, pl. 70, no. 3

H.M. Queen Elizabeth II of Great Britain

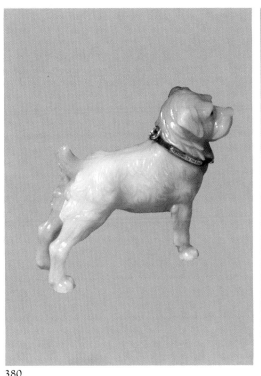

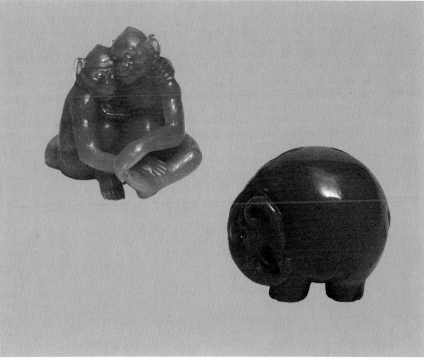

380

381

382

381 Amorous macaques

Height: 1³/₄″

Chalcedony, with rose-cut diamond eyes.

Exhibited: Victoria & Albert 1977, no. C 5
Cooper-Hewitt 1983, no. 191 – Queen's
Gallery 1985/86, no. 283

H. M. Queen Elizabeth II of Great Britain

382 Spherical Indian elephant

Length: 1³/₄″

Purpurine, with rose-cut diamond eyes.
One of Fabergé's most endearing caricatures.

Exhibited: Victoria & Albert 1977, no. C 15
Queen's Gallery 1985/86, no. 297

H. M. Queen Elizabeth II of Great Britain

383 Clockwork rhinoceros

Inv: 17 591
Length: 2⁷/₈″

Original fitted case stamped with Iwm,
St. Petersburg, Moscow, London. Gold key.

Naturalistically shaped in oxidized silver.
Moves on wheels, nodding its head and
swishing its tail.
One of three known examples (cf. Solodkoff,
1984, p. 18 and Christie's, New York, 1984,
no. 676).

Exhibited: A la Vieille Russie 1983, no. 454 –
Lugano 1987, no. 56
Literature: Solodkoff, 1984, p. 18

The Forbes Magazine Collection, New York

384 Table-clock shaped like an Indian elephant

Mm: Fabergé – Wm: Henrik Wigström
Hm: St. Petersburg, 1899–1908
Height: 8³/₈″

Obsidian, white enamel eyes with cabochon garnets. Turret-shaped silver howdah in white opaque and red *guilloché* enamel, set with quartzes, standing on red *guilloché* enamel saddle-cloth attached by red enamel straps. White enamel dial with gold hands.

Provenance: According to tradition from the collection of Dowager Empress Marie Feodorovna, born a Danish princess (red and white are the royal Danish colours). Acquired in Russia in 1925 by the father of the present owner.

Sam Josefowitz

383

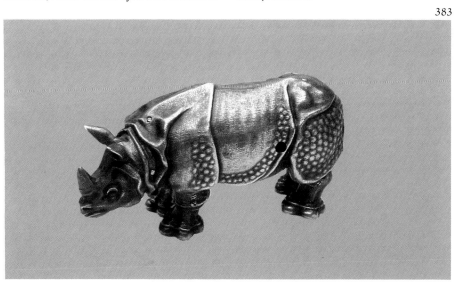

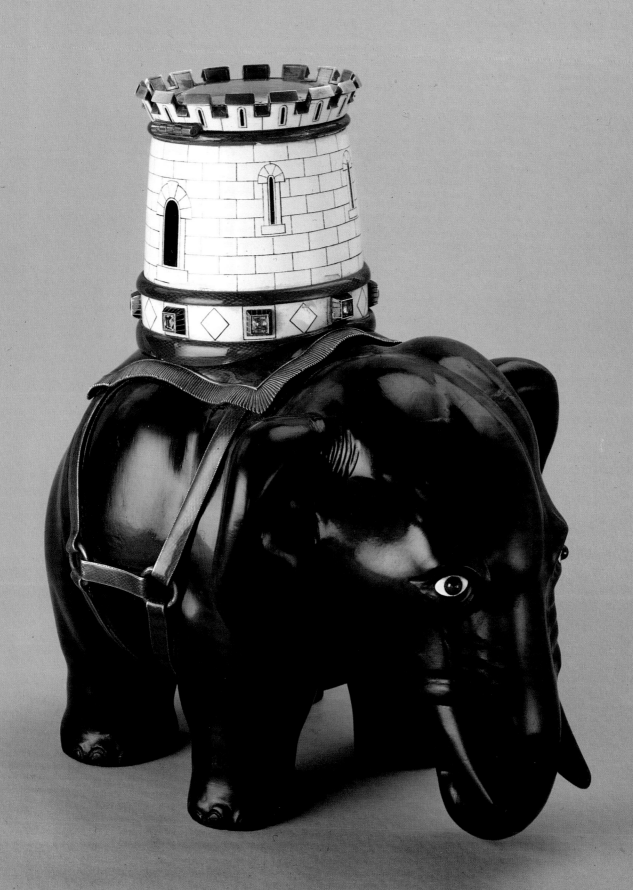

Hardstone Figures

385 Chelsea Pensioner

Height: 4⁵/₁₆″

Purpurine coat, aventurine quartz hands and face, black jasper cap and boots, blue steel cuffs, gold buttons, enameled medals and cane, cabochon sapphire eyes.

Provenance: Acquired by King Edward VII ("22 November 1909, H. M. the King, Model of a Chelsea Pensioner in purpourine, black onyx, silver, gold, cal. 2 sapphires, no. 181913, £49. 15s")

Exhibited: Victoria & Albert 199, no. K 5 – Cooper-Hewitt 1983, no. 197 – Queen's Gallery 1985/86, no. 341
Literature: Snowman, 1962/64, ill. 263 – Habsburg/Solodkoff, 1979, pl. 113

H. M. Queen Elizabeth II of Great Britain

386 Captain of th 4th Harkovsky Lancers

Wm: Henrik Wigström – Am: 72 and 88 zolotniks – engraved with the dates "1914–1915"
Height: 4¹⁵/₁₆″

Lapis lazuli uniform with agate facings, agate head and hands, cabochon sapphire eyes, gold buttons and cross belt, silver épaulettes, belt, sword and spurs, obsidian boots, gold helmet enameled black with silver tassel.

385

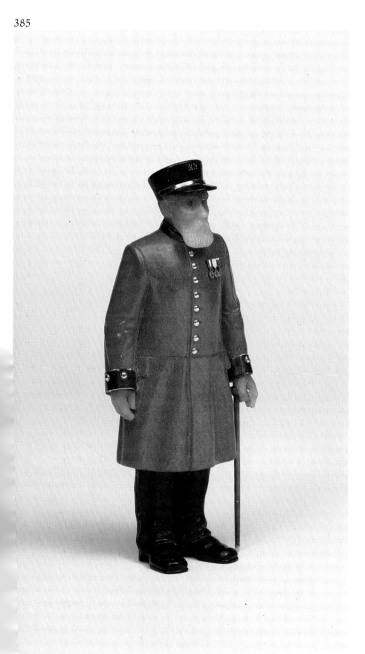

386

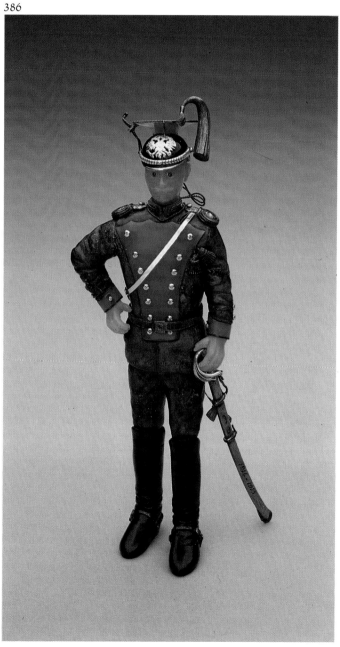

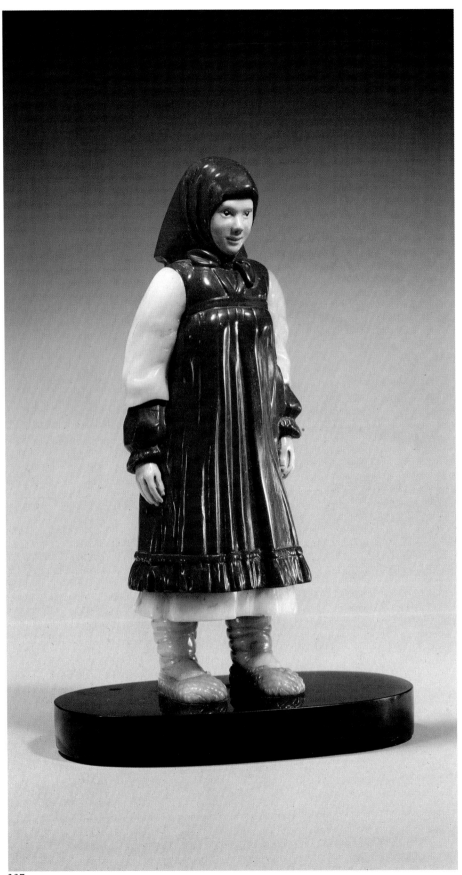

Exhibited: Lugano 1986, no. 51
Literature: Waterfield/Forbes, 1978, no. 50 –
Solodkoff, 1984, p. 34/35

The Forbes Magazine Collection, New York

387 Russian peasant woman

Signed "C. Fabergé" (under one slipper)
Height: 6$^{1}/_{8}$"

Purpurine dress and scarf, white chalcedony
shirt and skirt, agate stockings and slipper,
eosite face and hands, cabochon sapphire
eyes.
One of Fabergé's folkloristic figures.

Provenance: Lord Revelstoke, London –
R. Thornton Wilson, 1954
Literature: Snowman, 1962/64, ill. 264

Metropolitan Museum of Art, New York

388 Cook

Height: 1$^{3}/_{8}$"

Lapis lazuli skirt, rhodonite cap and blouse,
quartz apron, agate face and arms, obsidian
hair, sapphire eyes.

Provenance: Transferred from the Imperial
collections to the Armory
Literature: Snowman, 1962/64, ill. 269 –
Catalog of the Armory, 1964, p. 167 –
Rodimtseva, 1971, ill. 13

Armory of the Kremlin, Moscow (Inv. DK-
91) (T.N.B.)

389 Street vendor (Raznoshik)

Signed and dated: "Fabergé, 1914" (in Rus-
sian) under one boot.
Height: 6$^{1}/_{4}$"

Gray natural rock coat, chalcedony apron
Kalgan jasper boots, obsidian and lapis lazul
hat, gray granite mitts, marble tea-tray and
bagels, gray marble tea urn with gold spigot
three rock-crystal glasses in tray, smok
quartz glass in hand, alabaster hair and bear
eosite face with cabochon sapphire eyes.
Example of a folkloristic figure from a lat
"naturalistic" group (cf. p. 83)

Exhibited: A la Vieille Russie 1961, no. 285
Literature: Bainbridge, 1949/64, pl. 10
(lower right) – Cooper-Hewitt, 1983, no. 19

388

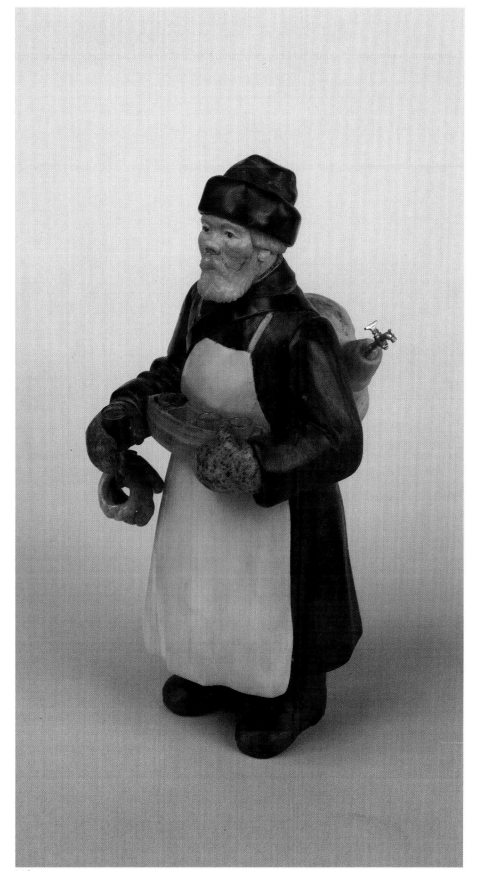

389

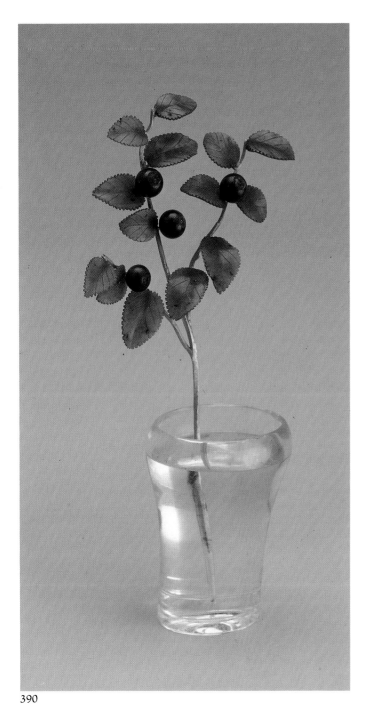

390

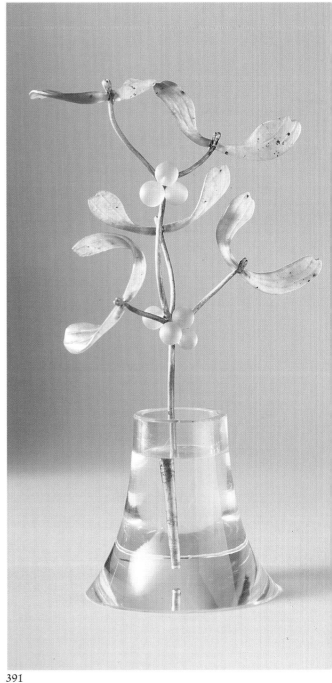

391

Flowers

390 Blueberry spray

Height: 5¹/₂″

Gold stem, four lapis lazuli berries, nephrite leaves, rock-crystal vase imitating water content.

Provenance: A.K. Rudanovsky, 1919
Exhibited: Leningrad 1984, no. 21 – Lugano 1986, no. 117

State Hermitage, Leningrad (Inv. E-14 893)
(L.Y.)

391 Mistletoe spray

Height: 5¹/₂″

Gold stem, seven moonstone berries, ne phrite leaves, rock-crystal vase simulatin water content.

Exhibited: A la Vieille Russie 1968, no. 337 A la Vieille Russie 1983, no. 460

The Brooklyn Museum (Bequest Helen I Sanders)

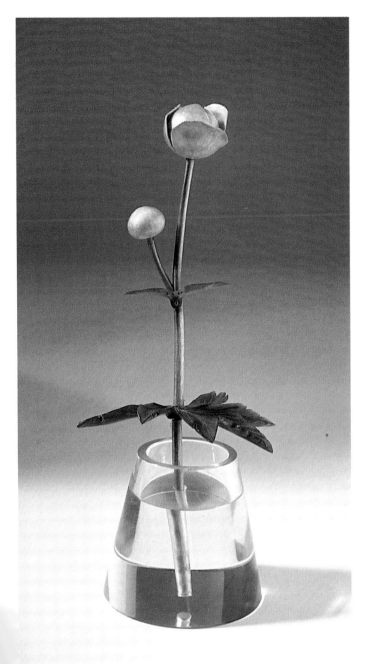

392

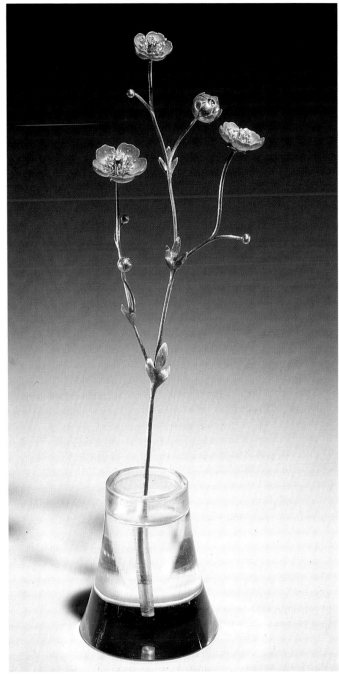

393

392 Trollius europaeus

Mm: Fabergé — Wm: Henrik Wigström —
Hm: St. Petersburg, 1908–1917 — Am: 72
zolotniks
Height: 5^{13}/$_{16}$″

Gold stem, yellow *guilloché* enamel flowers,
nephrite leaves, rock-crystal vase simulating
water content.

Provenance: Robert Strauss Collection
(Christie's, London, March 9, 1976, lot 53)

Exhibited: Helsinki 1980, cat. p. 60
Literature: Snowman, 1962/64, pl. XLIX —
Habsburg/Solodkoff, 1979, pl. 109

National Museum, Stockholm

393 Ranunculus

Height: 6^{1}/$_{2}$″

Gold stem and leaves, yellow *guilloché* en-
amel flowers with rose-cut diamond centers,
rock-crystal vase with simulated water
content.

One of Fabergé's most elegant floral cre-
ations.

Exhibited: Victoria & Albert 1977, no. 0 18
Literature: Snowman, 1979, p. 82 — Charles
Truman, "The Master of the Easter Egg",
Apollo CI, 1977, p. 73, ill. IV

Mrs. Josiane Woolf

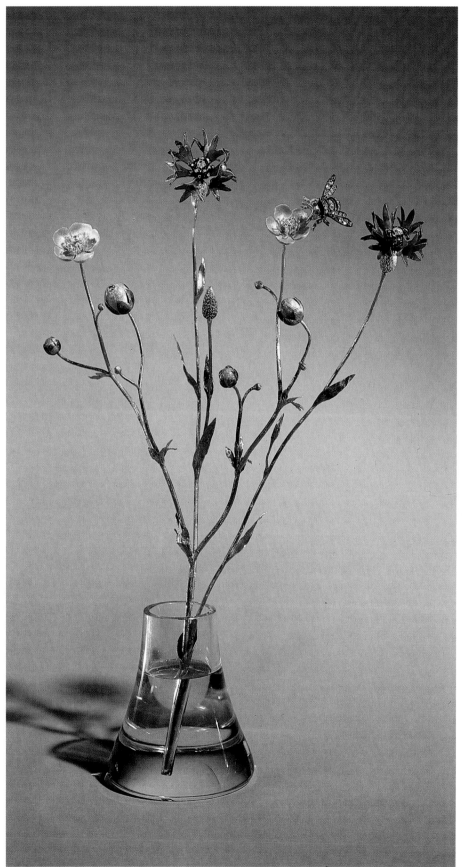

394

394 Cornflowers and ranunculus

Height: 8⁷/₈″

Gold stem and leaves, the cornflowers with blue translucent enamel blossoms and diamond-set pistils; the ranunculus with yellow *guilloché* enamel petals and rose-cut diamond centers, three buds with green enamel leaves; gold bumble-bee set with rose-cut diamonds and ruby eyes; rock-crystal vase simulating water content.

Fabergé's most exquisite flower composition.

Exhibited: Wartski 1953 – Wartski 1971, no. 139 – Victoria & Albert 1977, no. F. 9 – Cooper-Hewitt 1983, no. 27 – Queen's Gallery 1985/86, no. 43
Literature: Snowman, 1962/64, ill. 304 – Snowman, 1979, p. 127 – Habsburg, 1987, p. 77

H. M. Queen Elizabeth, The Queen Mother

395 Wild strawberry

Engraved signature: "C. Fabergé, St. Petersburg"
Height: 4″

Gold stem, three red *guilloché* enamel berries, nephrite leaves, blossom with half pearl petals and rose-cut diamonds, facetted rock-crystal vase with simulated water content.

Exhibited: Wartski 1949, no. 205 – Washington 1985/86, p. 654 f.

The Wernher Collection, Luton Hoo

396 Forget-me-not

Height: 6¹/₄″

Gold stem, green enamel leaves, blossoms set with turquoises and rose-cut diamonds; rock-crystal vase simulating water content.

Exhibited: Washington 1985/86, cat. p 654 f.

The Wernher Collection, Luton Hoo

397 Lily-of-the-valley

Height: 4¹/₄″

Gold stems, nephrite leaves, pearl blossoms with rose-cut diamond petals; rock-crystal vase simulating water content.

Exhibited: Washington 1985/86, cat. p 654 f.

The Wernher Collection, Luton Hoo

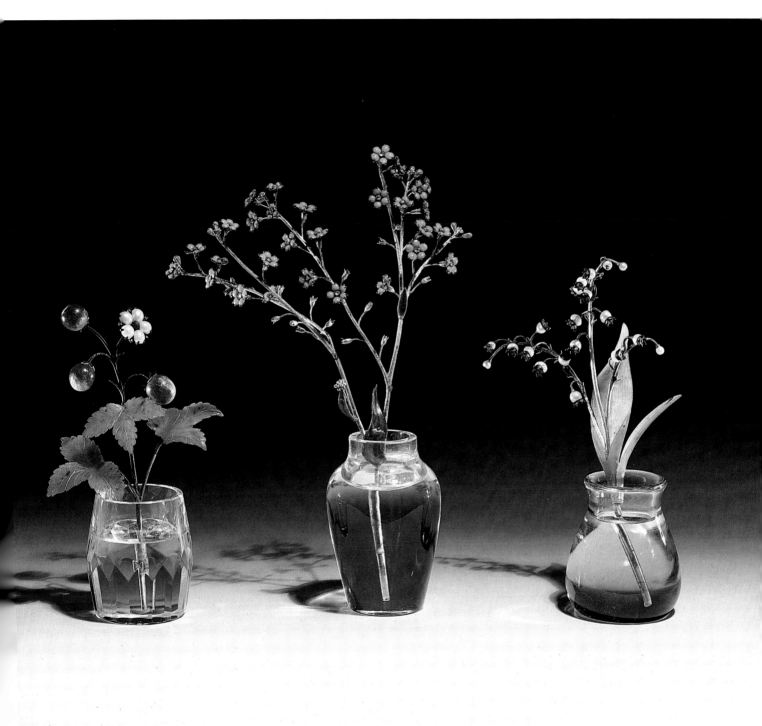

395

396

397

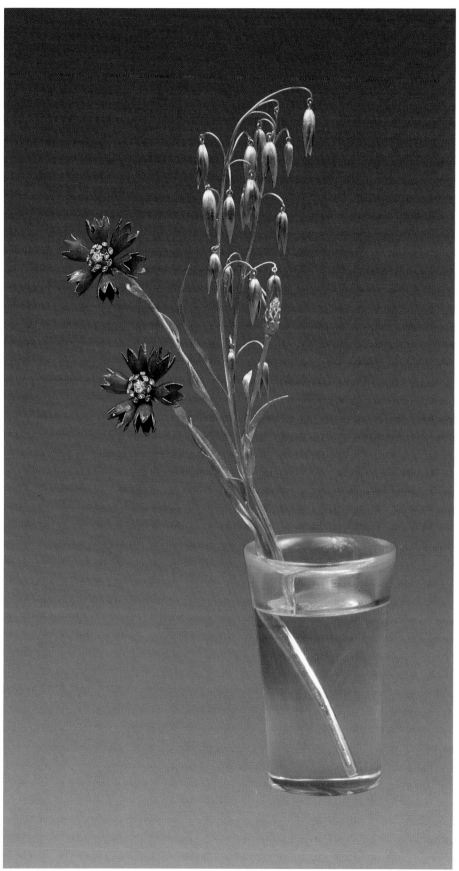

398

398 Cornflowers and oats

Height: 7$^1/_2$"

Gold stems, two cornflowers with blue enamel petals and rose-cut diamond pistils, freely swinging stem of oats; rock-crystal vase simulating water content.
For another version of this composition, cf. cat. 399

Provenance: Prince Youssoupov, 1922
Exhibited: Leningrad 1974, no. 17 – Helsinki 1980, no. N 2 (ill. p. 7)

State Hermitage, Leningrad (Inv. E-13 353)
(L.Y.)

399 Cornflower and oats

Height: 7$^3/_{16}$"

Variant of cat. 398, here the rock-crystal vase with everted lip.
Interesting example of similar, but not identical floral compositions in Fabergé's œuvre.

Exhibited: Warstki 1949, no. 4 – Wartski 1971, no. 141 – Victoria & Albert 1977, no. F. 8 – Cooper-Hewitt 1983, no. 26 – Queen's Gallery 1985/86, no. 42
Literature: Bainbridge, 1949/68, pl. 37 – Snowman, 1962/64, ill. 285 – Snowman, 1979, p. 127

H. M. Queen Elizabeth, The Queen Mother

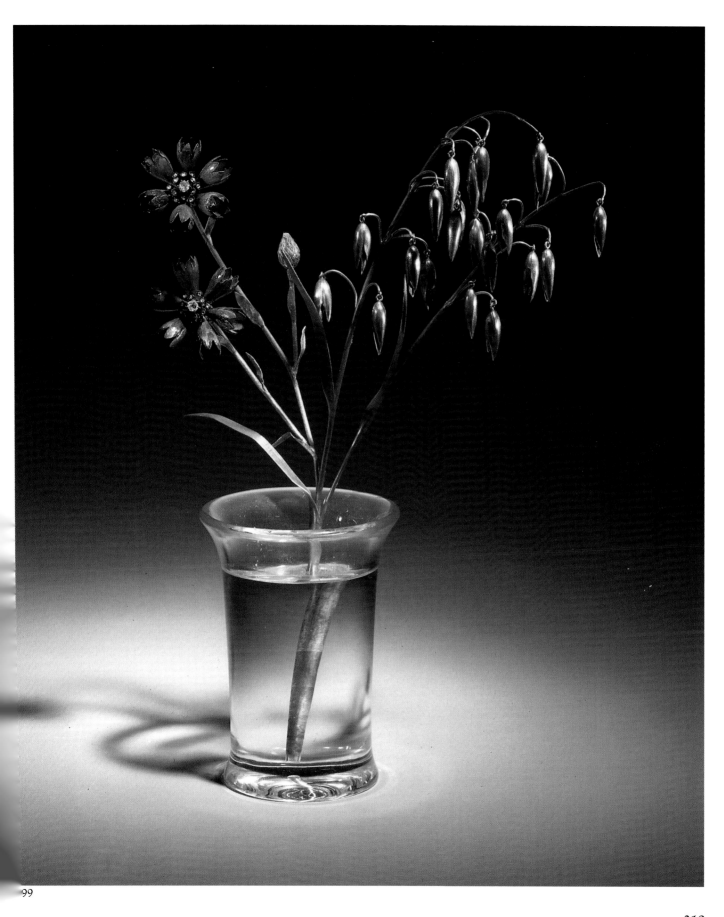

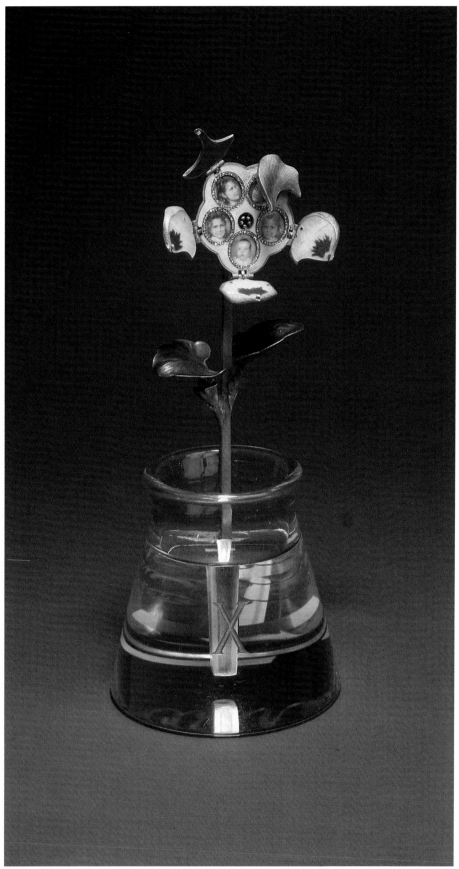

400 Miniature frame shaped like a pansy, 1904

Mm: Fabergé – Wm: Michael Perchin – Hm: St. Petersburg, 1899–1908
Height: 6¹/₈″

Gold flower with five enameled petals opening to reveal five circular miniature portraits of the Imperial Children within rose-cut diamond borders; gold stem, green enamel leaves, rock-crystal vase simulating water content, engraved with Roman numeral "X". The miniatures are those of the Grand Duchesses Maria, Olga, Tatiana, Anastasia and the Czarevitch Alexei.
Begun under the aegis of Michael Perchin (who died 1903).

Provenance: Given by Czar Nicholas II to his wife, Alexandra, on the occasion of their Tenth Wedding Anniversary on November 26, 1904 – Transferred to the Armory 1923
Literature: Snowman, 1962/64, ill. 298, p. 168 – Goldberg, 1967, p. 139, 212 – Catalog of the Armory, 1964, p. 168 – Rodimtseva, 1971, p. 23, ill. 14

Armory Museum of the Kremlin, Moscow (Inv. MR. 564/1–2) (T.N.B.)

401 Imperial basket of lilies-of-the-valley, 1896

Mm: Fabergé – Wm: August Holmström – Hm: St. Petersburg, before 1899
Length: 8¹/₂″
Original fitted mauve velvet case, with applied blue *guilloché* enamel plaque bearing an Imperial crown surrounded by the Insignia of the Order of St. Andrew. Stamped with Iwm, St. Petersburg, Moscow

Nine lily-of-the-valley plants embedded in a moss cushion standing on an oval basket. The flower sprays have gold stems, nephrite leaves, pearl blossoms and rose-cut diamond petals; yellow gold woven moss, yellow gold basket imitating wickerwork. Inscribed beneath: "To her Imperial Majesty, Czarina Alexandra Feodorovna from the Management of the Ironworks and from the dealer in the Siberian iron section of the Fair of Nijegorod in the year 1896."
Arguably Fabergé's best known and most popular work of art.

Provenance: Presented to the Empress on the occasion of her coronation. It stood on her desk until the October Revolution, 191

400

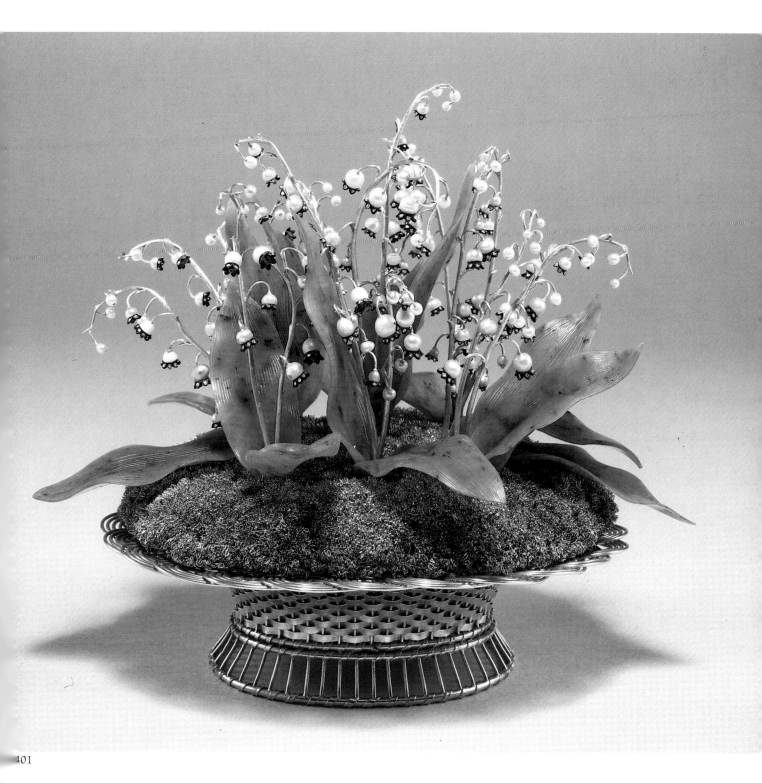

401

Exhibited: Hammer 1951, pl. 18
Literature: Snowman, 1962/64, pl. LXIII –
Grady/Fagaly, 1972, no. 1 – Habsburg/So-
odkoff, 1979, pl. 112 – Snowman, 1979,
. 84

The Mathilda Geddings Gray Foundation
Collection, New Orleans

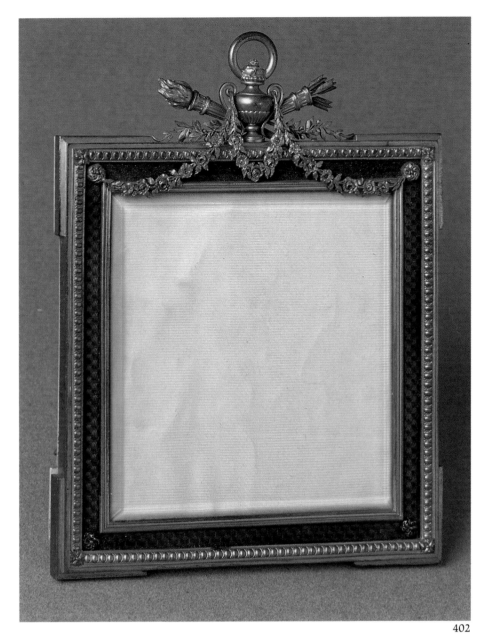

402

Enamel

402 Square photograph frame

Wm: Michael Perchin – Am: 88 zolotniks
Height: 6¹/₈″

Silver gilt, purple *guilloché* enamel, reeded
inner and gadrooned outer rim; surmounted
by a trophy of crossed quivers and a vase,
suspending varicolored gold flower swags;
ivory backing, silver gilt strut.
Early work, probably dating from the mid-
1880's.

403 Oval snuffbox
in Louis XVI style

Mm: Fabergé – Wm: Michael Perchin – Hm:
St. Petersburg, before 1899 – Am: 72 zolot-
niks – Inv: 7690
Length: 3¹/₄″

Gold, with green *guilloché* enamel panels, the
cover applied with an oval enamel plaque
painted in *camaïeu-brun* and *rose* with Venus
and Cupid, within rose-cut diamond and
green enamel laurel frame; *sablé* gold borders
chased and enameled with green leaves and
opalescent pellets.
Pastiche by Fabergé of a Louis XVI snuffbox

by Joseph Etienne Blerzy which belonged to
the Imperial collection, traditionally made
as proof of his technical ability. Excellent
imitation, which much impressed the Czar,
who ordered that both original and copy
should be exhibited in the Hermitage.

Provenance: Czar Alexander III – Landsdell
K. Christie, Long Island
Exhibited: Corcoran 1961, no. 16 – Metro-
politan 1962/66, no. L 62.8.16 – A la Vieille
Russie 1968, no. 321 – Victoria & Albert
1977, no. L 17 – Lugano 1987, no. 103
Literature: Snowman, 1962/64, pl. IX –
Waterfield/Forbes Magazine, 1978, no. 66 –
Solodkoff, 1984, p. 52 – Habsburg, 1987,
p. 73

The Forbes Magazine Collection, New York

403 a Oval Louis XVI snuffbox

Mm: Joseph Etienne Blerzy – Hm: Paris 1777
– Am: J. B. Fouache, 1774–80
Length: 3¹/₄″

Gold, with scarlet *guilloché* enamel panels,
the cover applied with an oval enamel plaque
painted with a Classical scene; *sablé* gold
borders chased and enameled with entwined
bands of green foliage and opalescent white
pellets.
Original upon which Fabergé based his
"masterpiece". Cf. cat. 403

Provenance: Empress Catherine the Great –
Exhibited in the Hermitage – Landsdell K.
Christie, Long Island.
Exhibited: Corcoran 1961, no. 15 – Metro-
politan 1962/66, no. L 62 815 – A la Vieille
Russie 1968, no. 320 – Victoria & Albert
1977, no. L 16
Literature: Snowman, 1962/64, ill. 52 –
Waterfield/Forbes, 1978, no. 65 – Solodkoff,
1984, p. 52 – Habsburg, 1987, p. 73

The Forbes Magazine Collection, New York

404 Imperial snuffbox presented
to Chancellor Bismarck in 1884

Mm: Fabergé – Wm: Michael Perchin – Hm:
St. Petersburg, before 1899
Length: 4¹/₈″
Original fitted gray velvet case with gold
Iwm

Gold, with scarlet enamel panels over *guil-*
loché sunray pattern, yellow gold palm-lea
borders. The cover inset with an oval minia

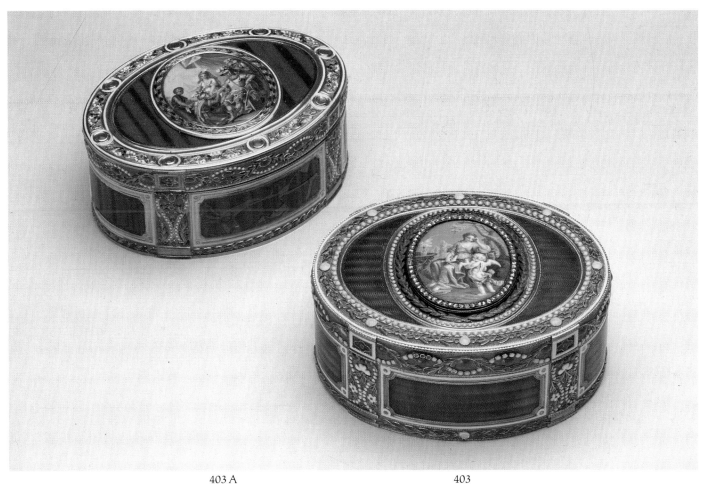

403 A 403

404

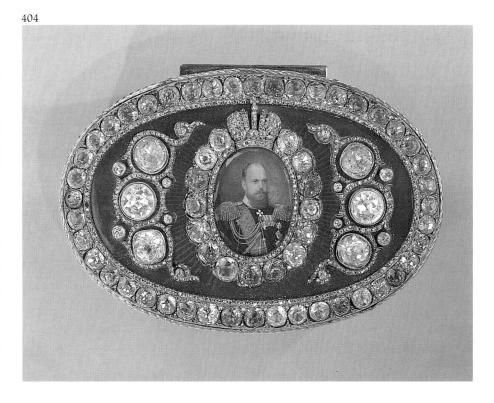

ture of Czar Alexander III within a border of (imitation) circular-cut diamonds, a diamond-set crown above, flanked on either side by three (imitation) circular-cut and rose-cut diamonds; outer border of (imitation) circular-cut and rose-cut diamonds.

If the date is to be believed, this is one of Fabergé's earliest enamels. The box, still stylistically mid-19th century in taste with its overladen decoration, is without parallel in Fabergé's œuvre. The enamel is uneven, showing its experimental quality. The warrant mark in the case also points to a very early date. Hitherto it was thought that Perchin joined Fabergé as head-workmaster in 1886.

Provenance: Presented by Czar Alexander III to Prince Bismarck. An inscription on the base reads: "Presenté par S.M.I. l'Empereur de Russie à S.A.S. le prince Bismarck, Chancelier de l'Empire Allemand, 1884". Possibly given on the occasion of the Renewal of the Agreement of Neutrality between Germany, Austria and Russia of 1881.

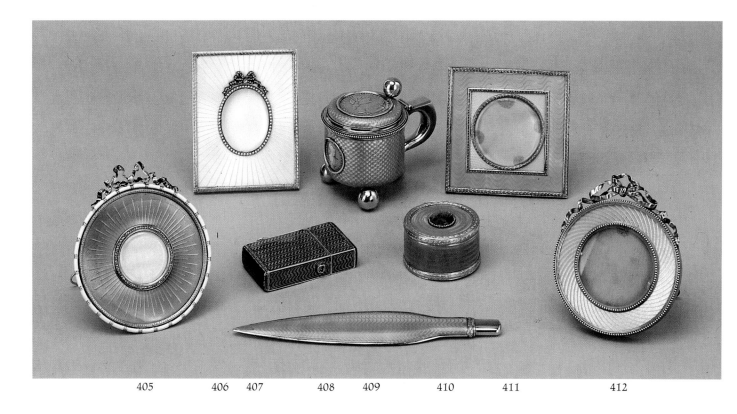

405 406 407 408 409 410 411 412

405 Circular silver gilt frame

Mm: Fabergé – Wm: Michael Perchin – Hm:
St. Petersburg, before 1899 – Inv: 51 643
Height: 3³/₈″

Pale mauve translucent enamel over *guilloché*
sunray ground; aperture with rose-cut dia-
mond border, white opaque enamel outer
border surmounted by a gold tied bow;
ivory backing, gold strut.
For a similar frame, cf. cat. 431

406 Rectangular gold frame

Mm: Fabergé – Wm: Henrik Wigström
Hm: St. Petersburg, 1908–1917
Height: 3¹/₈″

White translucent enamel over *guilloché*
sunray ground; aperture with seed pearl
border surmounted by a diamond-set bow;
outer border chased with palm leaves with
red-gold flower-heads at corners; ivory
backing with gold strut.

407 Silver gilt lighter

Wm: Vladimir Soloviev – Inv: 20 767
Length: 2¹/₄″

Mauve translucent enamel over waved *guil-
loché* ground; with gold suspension ring and
facetted citrine pushpiece.

408 Gold combined paperknife and pencil

Mm: C.F. – Wm: Vladimir Soloviev (under
the enamel) – Hm: St. Petersburg,
1908–1917
Length: 5¹¹/₁₆″
Original fitted case stamped with Iwm,
St. Petersburg, Moscow, London

Pale blue translucent enamel over waved
guilloché ground; palm-leaf border.
Standard example of an item made for the
English market, subjected to the strict
hallmarking regulations for imported articles
in precious metals. After a lawsuit against
the London Goldsmith Company (cf. Solod-
koff, 1984, p. 25 ff.), items intended for en-
ameling had to be sent to London unfinished.
There they were hallmarked, returned to St.
Petersburg for enameling and finally sent
back to London for sale.

409 Silver miniature tankard

Mm: Fabergé – Wm: Anders Nevalainen
Hm: St. Petersburg, 1899–1908
Height: 2⁹/₁₆″

Lime green *guilloché* enamel, the cover set
with a silver ruble of Peter the Great, the
side with a grivennik of Elizabeth I.

A popular item, with other versions known,
in scarlet and blue *guilloché* enamel. Based on
a late 17th century original.

410 Circular gold bonbonnière

Mm: Fabergé – Wm: Michael Perchin – Hm:
St. Petersburg, before 1899 – Am: 72 zolot-
niks – Inv: 59 343
Diameter: 1⁹/₁₆″

Pink *guilloché* enamel with palm-leaf borders,
the cover set with a dendritic moss agate in
rose-cut diamond surround.

Provenance: Ludwig Nobel (Christie's,
Geneva, November 17, 1981, lot. 134)

411 Square silver gilt frame

Mm: Fabergé – Wm: Michael Perchin – Hm:
St. Petersburg, 1899–1908 – Inv: 7730
Height: 2¹³/₁₆″

Circular aperture in pale blue *guilloché* panel
pale blue *guilloché* enamel band, with oute
palm-leaf border; ivory backing and silve
gilt strut.

412 Circular silver frame

Wm: Andrej Gorianov – Hm: St. Petersbur
Height: 3¹/₈″

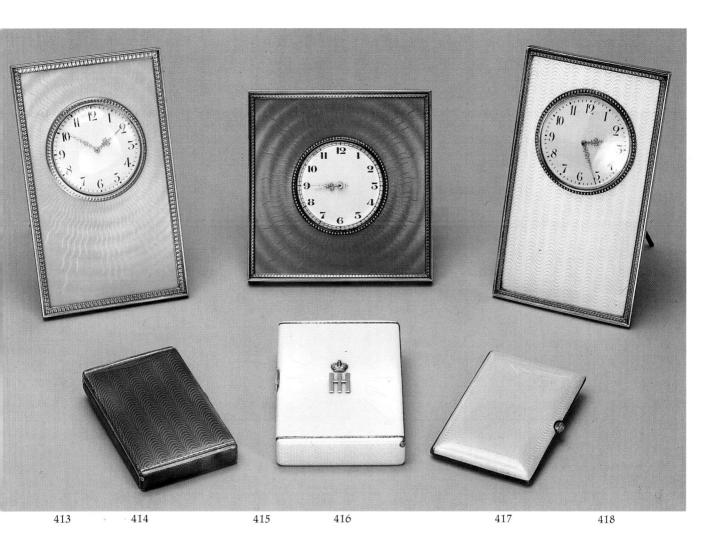

413 414 415 416 417 418

ink translucent enamel over spiralling *guilloché* ground with beaded borders, surmounted by a bow; birchwood backing, silver strut.

13 Rectangular silver gilt clock

Mm: Fabergé – Wm: Michael Perchin – Hm: t. Petersburg, 1899–1908 – Am: 91 zolotks – Inv: 15 011
eight: 5¼"

palescent pink enamel over waved *guilloché* sunray ground; white enamel dial, old hands, ivory backing and silver strut.

rovenance: Lady Brougham and Vaux, acuired at Fabergé's, London ("4 January. lock, pink enamel, no. 15 011, £23 nett ost) 139 roubles")

14 Silver gilt powder compact

Mm: Fabergé – Wm: Henrik Wigström – m: St. Petersburg, 1908–1917
ength: 3⁵/₁₆"

Steel gray translucent enamel over *guilloché* moiré ground; interior with mirror and two fitted compartments; thumbpiece set with rose-cut diamonds.

415 Square silver clock

Mm: Fabergé – Wm: Henrik Wigström – Hm: St. Petersburg, 1899–1908 – Am: 91 zolotniks – Inv: 16 556
Height: 4¹/₈"

Pink translucent enamel over *guilloché* sunray ground; with outer laurel-leaf border, ivory backing and silver strut.

416 Silver gilt cigarette-case

Mm: Fabergé – Wm: August Hollming – Hm: St. Petersburg, 1908–1917
Length: 3⁵/₈"

White translucent enamel over *guilloché* sunray ground, the cover applied with gold monogram "NN" (in Russian).

Provenance: Grand Duke Nikolai Nikolaievitch (1856–1929)
Literature: Habsburg/Solodkoff, 1979, ill. 74

417 Flat silver gilt cigarette-case

Mm: Fabergé – Wm: August Hollming – Hm: St. Petersburg, 1908–1917 – Inv: 24 875
Length: 3³/₈"

Pale pink translucent enamel over *guilloché moiré* ground; cabochon moonstone pushpiece.

418 Rectangular silver clock

Mm: Fabergé – Wm: Henrik Wigström – Hm: St. Petersburg, 1908–1917 – Am: 91 zolotniks – Inv: 18 353
Height: 5⁵/₁₆"

White translucent enamel over *guilloché moiré* ground.

419 Circular silver gilt bonbonnière

Mm: Fabergé – Wm: Michael Perchin – Hm: St. Petersburg, 1899–1908 – Am: 88 zolotniks
Diameter: 1⁹/₁₆″
Original fitted case stamped with Iwm, St. Petersburg, Moscow, Odessa

Alternating concentric opaque white and red *guilloché* enamel bands, the thumbpiece and center of lid set with a rose-cut diamond.

Provenance: Given by the Dowager Empress Marie Feodorovna to her sister Thyra Duchess of Cumberland (pencil note: "Min Engle Thyra, fra Minny, 1904.")

420 Hat-shaped gold electric table-bellpush

Mm: Fabergé – Wm: Michael Perchin – Hm: St. Petersburg, 1899–1908 – Inv: 2466
Diameter: 2¹/₁₆″

Pale mauve *guilloché* enamel, the "hat band" in white *guilloché* enamel, painted with laurel-leaves, the "rim" applied with laurel swags; cabochon moonstone pushpiece.

421 Circular silver gilt bonbonnière

Mm: Fabergé – Wm: Henrik Wigström – Hm: St. Petersburg, 1899–1908 – Am: 88 zolotniks – Inv: 14 707
Diameter: 1⁹/₁₆″

Pink translucent enamel over waved *guilloché* ground; palm-leaf border and central rose-cut diamond.

422 Circular silver gilt powder compact

Mm: Fabergé – Wm: Henrik Wigström – Hm: St. Petersburg, 1908–1917 – Am: 88 zolotniks – Inv: 18 174
Diameter: 1⁹/₁₆″

Original fitted case stamped with Iwm, St. Petersburg, Moscow

Lime green *guilloché* enamel, palm-leaf border, central facetted garnet; the interior with mirror and gold-mounted powder puff.

423 Gold frame shaped like a miniature fire-screen

M: Fabergé – Mm: Victor Aarne – Hm: St. Petersburg, before 1899 – Inv: 5999
Height: 2¹/₄″

Salmon pink *guilloché* enamel, applied with four-color gold flower swags and pearls; photograph of King George I of Greece in split-pearl frame.

Provenance: King George I of Greece (Prince William of Denmark, 1845–1913) brother of the Dowager Empress Marie Feodorovna
Exhibited: A la Vieille Russie 1983, no. 83

424 Heart-shaped silver gilt frame

Wm: Michael Perchin
Height: 2³/₄″
Original fitted case stamped with Iwm, St. Petersburg, Moscow, Odessa

Red *guilloché* enamel, with oval miniature portrait of Czarina Marie Feodorovna, signed Zehngraf, in split-pearl frame; ivory backing, "A"-shaped strut.

Provenance: Given by Czarina Marie Feodorovna to her sister, Thyra Duchess of Cumberland (pencil note: "Mine elskede Thyra, Juleaften 1905.")

420

419 421 422

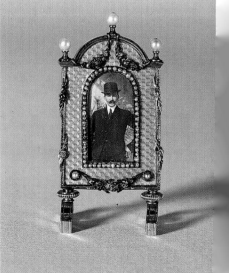

423

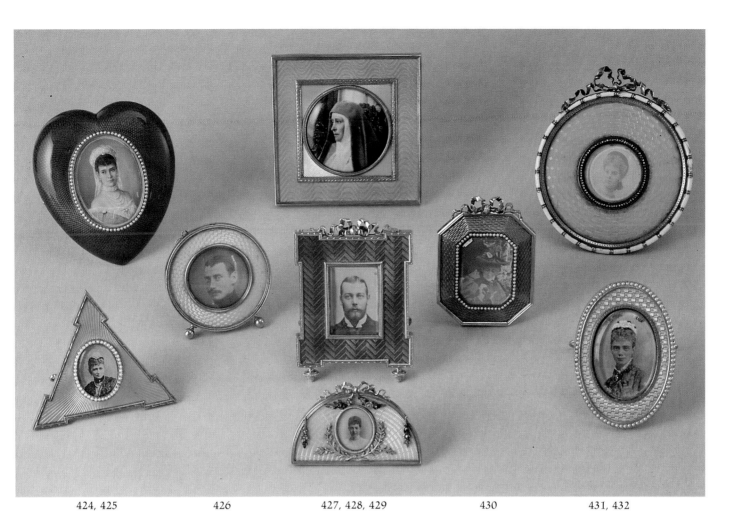

424, 425 426 427, 428, 429 430 431, 432

425 Triangular silver gilt frame

Mm: Fabergé − Wm: Victor Aarne − Hm: St. Petersburg, before 1899 − Am: 88 zolotniks − Inv: 1138
Height: 2¹/₁₆″

Original fitted case stamped with Iwm, St. Petersburg, Moscow

Pale green translucent enamel over *guilloché* sunray ground; photograph of Queen Louise of Denmark in split-pearl border; ivory backing, "M"-shaped strut.

Provenance: Given by Grand Duchess Olga of Russia to Duchess Thyra of Cumberland (pencil note: "From sweet little Olga of Russia for my birthday at Bernstorff, 29. September 1899.")

426 Circular silver gilt frame

Mm: Fabergé − Wm: Victor Aarne Hm: St. Petersburg, 1899−1908 − Inv: 7052
Height: 2″

Pale blue *guilloché* enamel, standing on two ball feet; photograph of King Christian X of Denmark; ivory backing, silver gilt strut.

427 Square silver gilt frame

Mm: Fabergé − Wm: Michael Perchin − Hm: St. Petersburg, 1899−1908 − Inv: 7725
Height: 2³/₄″

Inner frame transluscent pale blue enamel over sunray ground; outer frame translucent yellow enamel over waved *guilloché* ground; circular sepia enamel miniature of Grand Duchess Serge in a nun's robe.

Provenance: Grand Duchess Serge, born Princess Elisabeth of Hesse and the Rhine, sister of Czarina Alexandra Feodorovna. The yellow and blue color of the frame point to a royal Swedish connection.

H.M. King Carl XVI Gustaf of Sweden

428 Rectangular silver gilt frame

Mm: Fabergé − Wm: Victor Aarne − Hm: St. Petersburg, 1899−1908 − Am: 88 zolotniks − Inv: 2461 − Height: 2³/₄″

Translucent strawberry enamel over *guilloché* zig-zag pattern, gold ribbon cresting; photograph of George, Duke of York, then King George V of England ivory backing, "M"-shaped strut.

429 Semi-circular gold frame

Mm: Fabergé − Wm: Victor Aarne − Hm: St. Petersburg, 1899−1908 − Height: 1³/₈″

Turquoise translucent enamel over sunray and concentric ring pattern with applied laurel sprays, four-color gold flower swags and ribbon cresting; unidentified original photograph; ivory backing, "M"-shaped strut.

430 Octagonal silver gilt frame

Mm: Fabergé − Wm: Victor Aarne − Hm: St. Petersburg, before 1899 − Am: 88 zolotniks − Inv: 1145 − Height: 2³/₈″

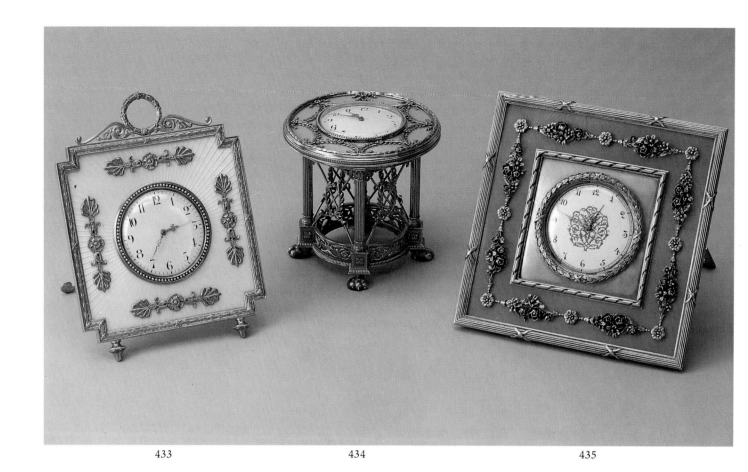

Original fitted case stamped with Iwm, St. Petersburg, Moscow

Mauve *guilloché* enamel with split-pearl inner, and reeded gold outer border, ribbon cresting; photograph of Queen Louise of Denmark; ivory backing and "M"-shaped strut.
Illustrated p. 227

Provenance: Given by Dowager Empress Marie Feodorovna (pencil note: "Lille Lila Emailli Ramen med Mamas Photographie i fra Minny, Januar 1899.")

431 Circular gold frame

Mm: Fabergé – Wm: Michael Perchin – Hm: St. Petersburg, before 1899 – Inv: 54 612
Height: 3³/₈"

Pale blue *guilloché* enamel, outer opaque white enamel border, ribbon cresting; unidentified original photograph, in rose-cut diamond frame; ivory backing and gold strut.
For a similar frame, cf. cat. 405
Illustrated p. 227

432 Oval gold frame

Mm: Fabergé – Wm: Michael Perchin – Hm: St. Petersburg, before 1899 – Inv: 55 205
Height: 2³/₈"

Primrose yellow *guilloché* enamel, outer split-pearl border; photograph of Dowager Empress Marie Feodorovna; ivory backing and gold strut.
Illustrated p. 227

433 Square silver gilt clock

Mm: Fabergé – Wm: Michael Perchin
Hm: St. Petersburg, before 1899
Height: 5⁵/₈"

White translucent enamel over *guilloché* sunray ground, applied acanthus leaves, outer laurel-leaf border and laurel crown cresting; white enamel dial with gold hands and split-pearl border; ivory backing with silver gilt strut.

434 Gold clock shaped like a Louis XVI table

Mm: Fabergé – Hm: Moscow, 1899–1908
Height: 3³/₈"

Salmon pink *guilloché* enamel laurel swags, flowers and tied bows in red and yellow gold; white opaque enamel dial with gold hands in gadrooned frame; fluted column legs with paw feet alternating with crossed arrows and laurel crowns.
For a similar clock in the Marjorie Merriweather Post Collection, cf. Ross 1965, p. 40, ill. 11

435 Square silver clock

Mm: Fabergé – Wm: Michael Perchin – Hm St. Petersburg, 1899–1908
Height: 5¹/₈"

Opalescent pink enamel over *guilloché* sunray pattern, applied flower swags and rosettes; opaque white enamel dial painted with gilt arabesques, gold hands, laurel-leaf border in square matt silver panel; reed-and-tie outer border, ivory backing and silver strut.

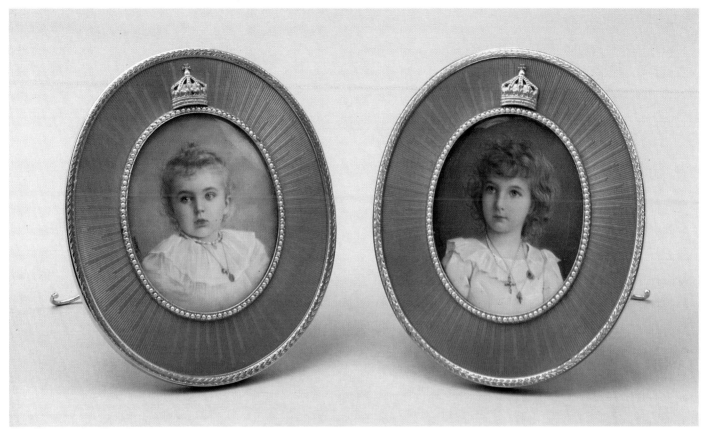

436, 437

436 Oval gold frame

Wm: Michael Perchin – Hm: St. Petersburg, 1899–1908
Height: 3¹/₂″

Translucent raspberry enamel over *guilloché* sunray pattern with outer palm-leaf border; painted miniature of Princess Nadejda of Bulgaria, signed Zehngraf, in split-pearl border, surmounted by the Bulgarian crown; ivory backing, gold strut.

Provenance: Princess Nadejda of Bulgaria (1899–1958), daughter of King Ferdinand, later Duchess of Württemberg.

437 Oval gold frame

Wm: Michael Perchin – Hm: St. Petersburg, 1899–1908
Height: 3⁹/₁₆″

Original fitted case stamped with Iwm, St. Petersburg, Moscow

Pair to the preceding cat. 436. Miniature of Princess Eudoxia of Bulgaria, signed Zehngraf.

Provenance: Princess Eudoxia of Bulgaria (1898–1985), sister of Princess Nadejda, daughter of King Ferdinand of Bulgaria

438 Gold-mounted electric double bellpush

Mm: Michael Perchin – Hm: St. Petersburg, 1899–1908 – Inv: 2679
Length: 2¹/₄″

Chalcedony, with strawberry *guilloché* enamel, cabochon moonstone and sapphire pushpieces surrounded by applied laurel sprays, flanking a white enamel panel painted with dendritic motifs; gadrooned gold base.
Illustrated p. 230

The Wernher Collection, Luton Hoo

439 Gold sealing wax case in the Louis XVI style

Wm: Michael Perchin – Hm: St. Petersburg, before 1899 – Inv: 3046
Length: 5¹¹/₁₆″

Opalescent salmon pink enamel bands painted with trailing *camaïeu-brun* foliage, alternating with opaque white enamel stripes; yellow-gold palm-leaf borders.
Illustrated p. 230

The Wernher Collection, Luton Hoo

440 Silver gilt thermometer shaped like an obelisk

Mm: Fabergé – Wm: Michael Perchin – Hm: St. Petersburg, before 1899 – Inv: 58 962
Height: 11¹/₄″

Square blue *guilloché* enamel base applied with laurel swags, standing on chalcedony plinth with four stud feet; surmounted by vase-shaped finial on stepped circular blue *guilloché* enamel base.

Literature: Snowman, 1962/64, ill. 156

The Wernher Collection, Luton Hoo

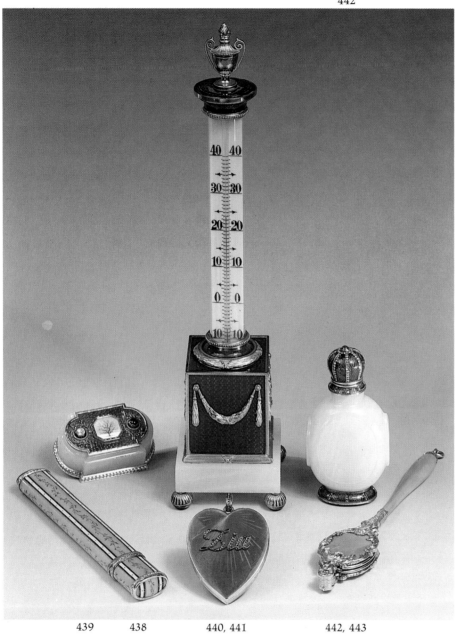

439 438 440, 441 442, 443

White jade, the oval base and spherical cover in green *guilloché* enamel set with rose-cut diamonds, cabochon ruby finial.

The Wernher Collection, Luton Hoo

443 Gold lorgnette in the Louis XV style

Wm: Michael Perchin – Hm: St. Petersburg, 1899–1908
Length: 6¼″

Bright pink *guilloché* enamel, yellow gold mounts chased with rococo scrolls and foliage.

The Wernher Collection, Luton Hoo

444 Circular gold bonbonnière in the Louis XVI style

Wm: Fabergé – Wm: Henrik Wigström – Hm: St. Petersburg, 1899–1908 – Am: 72 zolotniks
Diameter: 2⅛″

Panels of steel gray translucent enamel over *guilloché* sunray pattern, *sablé* gold borders chased and enameled with green foliage, red and white ribbons.
A faithful replica of a French Louis XVI box from the 1770's.

Metropolitan Museum of Art

445 Gold pendant cigar-cutter

Mm: K.F. (Russian) – Hm: St. Petersburg, before 1899
Height: 1⁷⁄₁₆″

444

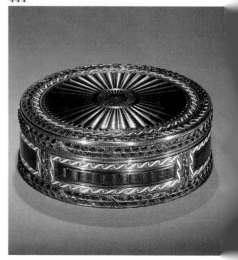

441 Heart-shaped gold pendant frame

Wm: August Hollming
Height: 2¼″

One side with translucent bright pink enamel over *guilloché* sunray ground, the other in mauve *guilloché* enamel, applied with "Zia" and "Nadejda" set with rose-cut diamonds. Containing photographs of the two Torby sisters as children.

Provenance: Anastasia (Zia), Lady Wernher (1892–1977) and Nadejda (Nada), Marchio-

ness of Milford Heaven (1896–1963), daughters of Grand Duke Michael Michaelovitch (1861–1929), who married Countess Sophia von Merenberg, created Countess Torby

The Wernher Collection, Luton Hoo

442 Gold-mounted Chinese snuff bottle

Wm: Michael Perchin – Hm: St. Petersburg, before 1899 – Am: 72 zolotniks
Height: 3¾″

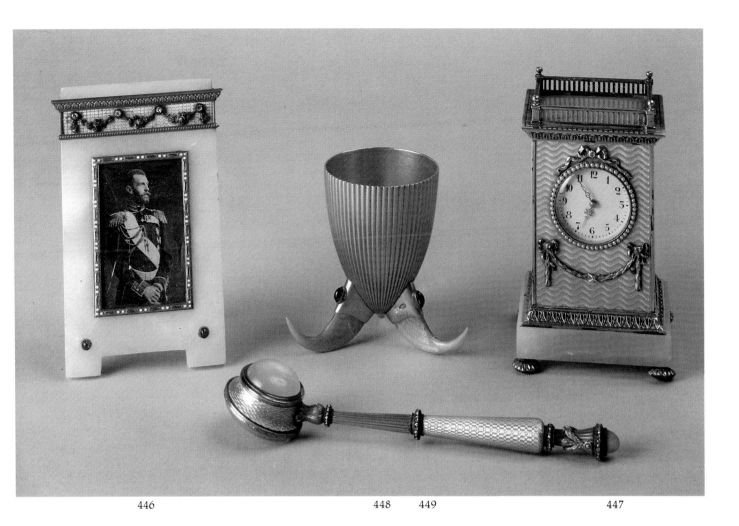

446 448 449 447

Pink *guilloché* enamel, applied yellow gold swags, red-gold ribbon cresting, set with two cabochon sapphires.

A typical "novelty", illustrating the inventive genius of Fabergé.

Literature: Uljanova, Fabergé, p. 19

Historic Museum, Moscow (Inv. 73 839 – ok 6936) (N.P.)

445

446 Rectangular chalcedony frame

Wm: Fabergé – Wm: Hjalmar Armfelt – Hm: t. Petersburg, 1899–1908 – Height: 3⁵/₁₆″

448 Gold tcharka

Wm: Erik Kollin – Hm: St. Petersburg, before 1899 – Inv: 38 651 – Height: 2¹/₈″

Gold-mounted; upper frieze of salmon pink *guilloché* enamel applied with four-color gold flower swags suspended from rose-cut diamonds, with two cabochon rubies below; photograph of Grand Duke Sergei.

Provenance: Grand Duke Sergei (1857–1905), son of Czar Alexander II, married to Princess Elisabeth of Hesse and the Rhine

447 Turret-shaped silver gilt clock

Apparently unmarked
Height: 3¹/₄″

Pink translucent enamel over waved *guilloché* pattern; white enamel dial with gold hands, split-pearl border, ribbon cresting and yellow-gold laurel swags beneath; chalcedony base with gold stud feet, gold openwork gallery above.

Of circular tapering shape, in fluted matt yellow gold, standing on three curved tiger's claws, each set with a cabochon sapphire.

Typical work of Kollin in the Antique manner.

449 Gold seal shaped like a warming pan

Wm: Henrik Wigström – Hm: St. Petersburg, 1899–1908
Length: 4¹/₂″

Pale mauve *guilloché* enamel, cabochon mecca stone top, chalcedony matrix carved with crowned initial "E", reeded gold handle set with bands of rose-cut diamonds and a cabochon moonstone.

For another variant of this seal from the collection of Queen Victoria Eugenia of Spain, cf. Snowman, 1962/64, pl. XXI.

Provenance: Grand Duchess Sergei of Russia, née Princess Elisabeth of Hesse and the Rhine

231

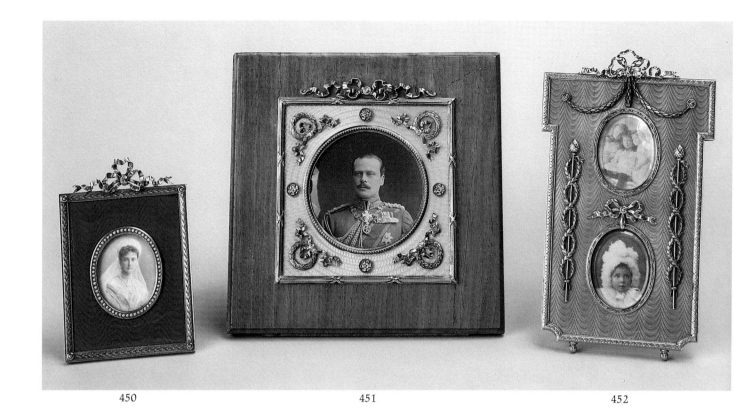

450 451 452

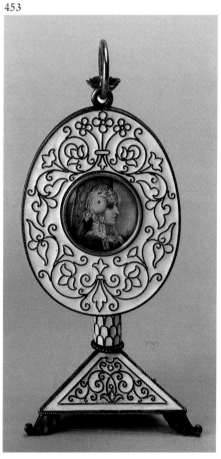

453

450 Rectangular silver gilt frame

Wm: Michael Perchin – Hm: St. Petersburg, before 1899
Height: $3^5/_8''$

Prussian blue translucent enamel over moiré *guilloché* ground, chased laurel-leaf border, gold ribbon cresting; *camaïeu-rose* porcelain miniature of Czarina Alexandra Feodorovna in split-pearl border; ivory backing with gold strut.

451 Square beechwood frame

Apparently unmarked
Height: $5^5/_{16}''$

Inner square silver panel of pale green *guilloché* enamel applied with laurel crown, ribbons and rosettes; circular photograph of Grand Duke Ernest Louis of Hesse and the Rhine; wooden backing and strut.

Provenance: Grand Duke Ernest Louis (1868–1913), brother of Czarina Alexandra Feodorovna

452 Rectangular silver gilt double-frame

Wm: Michael Perchin – Hm: St. Petersburg, before 1899 – Inv: 51 830 – Height: $5^{11}/_{16}''$

Translucent orange enamel over moiré *guilloché* ground, applied maenad staffs, laurel swags and gold ribbons; oval photographs of Princess Elisabeth of Hesse and the Rhine (1895–1903), daughter of Grand Duke Louis and of Victoria Melita, Princess of Saxe-Coburg-Gotha.

453 Silver gilt frame in the Old Russian style

Mm: Fabergé – Wm: Michael Perchin – Hm: St. Petersburg, 1899–1908
Height with stand: $4^1/_2''$

Column standing on pyramid base suspending an oval pendant, both in opaque white *cloisonné* enamel, the *cloisons* forming spirals and arabesques; miniature portrait of Grand Duchess Sergei in traditional Russian costume, signed Salenko 1904.
Unusual work for Perchin, a special commission commemorating a fancy-dress ball.

454 Lozenge-shaped gold Imperial presentation frame

Mm: Fabergé – Wm: Michael Perchin – Hm: St. Petersburg, before 1899
Height: $3^9/_{16}''$

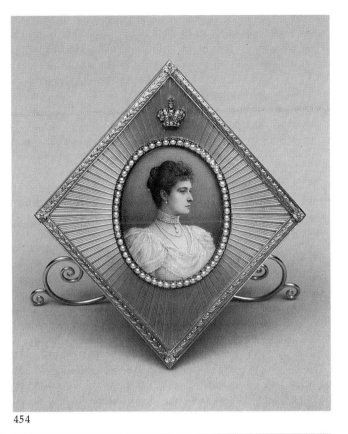

454

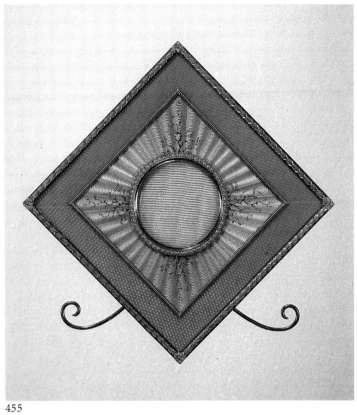

455

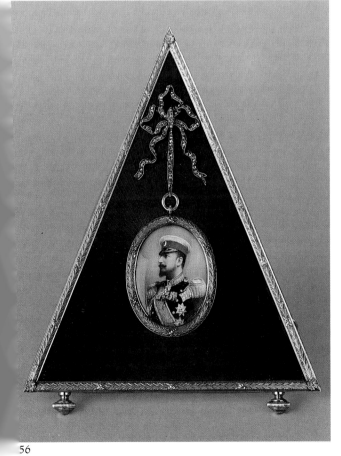

56

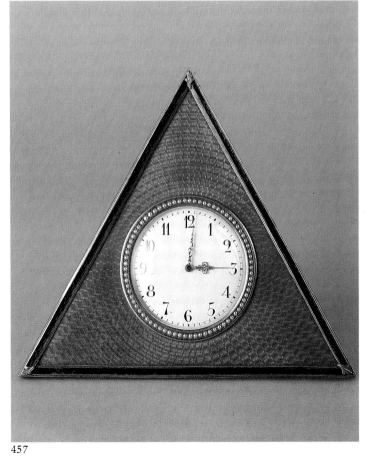

457

233

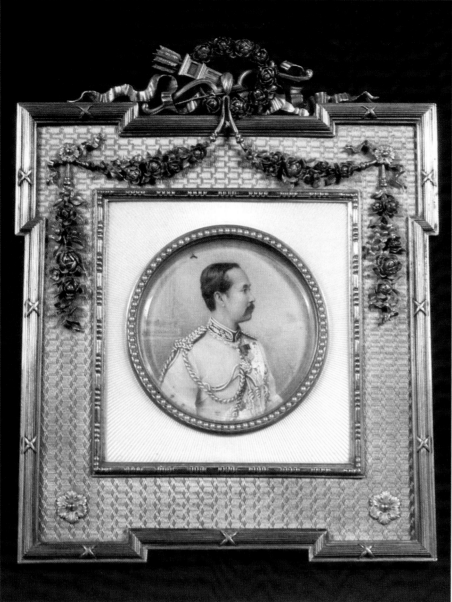

458

Christie's, Geneva, November 17, 1981, lot. 109

H.I. and R.H. Dr. Louis Ferdinand, Prince of Prussia, Berlin

457 Triangular silver gilt clock

Mm: Fabergé – Wm: Michael Perchin – Hm: St. Petersburg, before 1899 – Am: 88 zolotniks – Inv: 56 214
Height: $4^5/_8''$
Original fitted case stamped with Iwm, St. Petersburg, Moscow; price tag: 245 rubles.

Translucent raspberry enamel over *guilloché* pattern of concentric waved rings; outer green *guilloché* enamel border, white enamel dial with gold hands and split-pearl border; ivory backing and silver strut.
The white, green and pink colors of this clock point to royal Bulgarian provenance.
Illustrated p. 233

458 Square silver gilt royal frame

Mm: Fabergé – Wm: Victor Aarne – Hm: St. Petersburg, before 1899
Height: $5^{13}/_{16}''$

Lime green *guilloché* enamel band applied with flower swags and rosettes, cresting of flowers wreath, quiver and bow, reed-and-tie border; inner panel of opalescent white *guilloché* enamel. Circular miniature of King

459

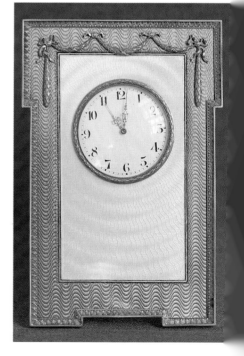

Translucent primrose yellow enamel over sunray *guilloché* pattern, yellow-gold palm-leaf border; oval miniature of Czarina Alexandra Feodorovna, signed Zehngraf, in split-pearl border, a diamond-set crown above; ivory backing with gold strut.

Exhibited: A la Vieille Russie 1983, no. 82

455 Square gold frame

Mm: Fabergé – Mm: Henrik Wigström
Hm: St. Petersburg, 1899–1908
Height: $3^3/_4''$

Lozenge-shaped; outer pink *guilloché* enamel band with palm-leaf border, inner panel of lime green translucent enamel over waved sunray *guilloché* pattern painted with

dendritic motifs; circular aperture with split-pearl border, ivory backing and gold strut.

Provenance: Mrs. Josiane Woolf (Christie's, Geneva, November 18, 1980, lot. 133)

456 Triangular gold frame

Mm: Fabergé – Wm: Michael Perchin – Hm: St. Petersburg, before 1899
Height: $5^5/_8''$

Prussian blue translucent enamel over *guilloché* sunray pattern with applied diamond-set ribbon; miniature of King Ferdinand of Bulgaria in uniform, signed Zehngraf, in a palm-leaf border; ivory backing and gold strut.
For a very similar frame with photograph of a daughter of Alfred, Duke of Edinburgh, cf.

Chulalongkorn of Siam, in split-pearl border; ivory backing and silver strut.

King Chulalongkorn of Siam (Rama V, 1868–1910) met Czarevitch Nikolai (the later Czar Nicholas II) in 1890 during his World Tour. In 1897 the King of Siam visited the Czar in St. Petersburg, receiving a Fabergé cigarette-case (cf. Krairiksh, 1984, no. 96). The King sent one of his sons, Prince Chakrabongkse, to be educated in Russia. From 1904 on, Fabergé produced numerous works of art for the Siamese court, many of them in nephrite.

Literature: Krairiksh, 1984, p. 96f. – Solodkoff, 1984, p. 142

H.M. King Bhumiphol Adyuladej of Siam

459 Rectangular gold clock

Mm: Fabergé – Wm: Henrik Wigström – Hm: St. Petersburg, 1899–1908
Height: 6³/₈″

Translucent opalescent white enamel panel over waved sunray *guilloché* pattern; white enamel dial with gold hands; outer band of translucent pale blue enamel over *guilloché* waved pattern, applied with laurel swags, outer stiff leaf border; bone backing and silver strut.

Literature: Postnikova, 1985, no. 143

Historic Museum, Moscow (Inv. 98 360 – ok 15 706) (N.P.)

461

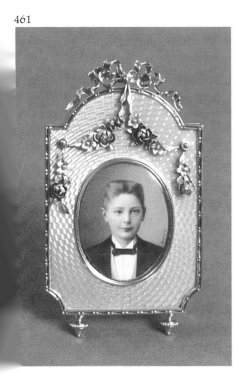

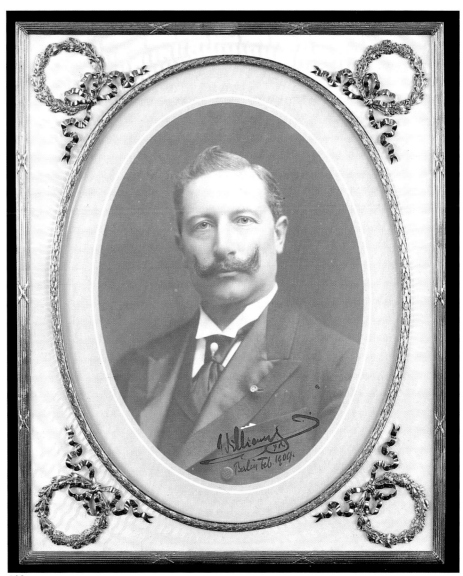

460

460 Large silver gilt photograph frame

Mm: Fabergé, double-headed eagle – Wm: Anders Nevalainen – Hm: St. Petersburg, 1898–1903 – Am: A. Richter
Height: 11³/₄″

Translucent pale blue oaplescent enamel over *guilloché* sunray pattern, applied with oak-leaf and laurel-leaf crowns, tied with ribbons, outer reed-and-tie border, oval aperture containing photograph of Kaiser Wilhelm II, signed and dated 1909; wooden backing and strut.

Provenance: Presented by Kaiser Wilhelm II

Exhibited: Lugano 1984 no. 36

Literature: Waterfield/Forbes, 1978, no. 81 – Solodkoff, 1984, p. 171

The Forbes Magazine Collection, New York

461 Gold miniature frame

Mm: Fabergé – Wm: Victor Aarne – Hm: St. Petersburg, before 1899
Height: 2¹⁵/₁₆″

Pale blue *guilloché* enamel applied with four-color gold flower swags, standing on two stud feet surmounted by ribbon cresting; oval photograph of Prince August-William of Prussia; ivory backing, gold strut.
Prince August-William (1887–1957), son of Kaiser Wilhelm

Exhibited: Helsinki 1980, ill. 12

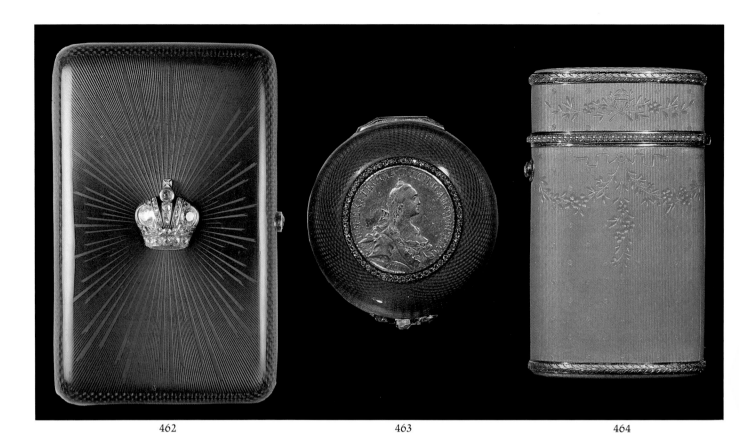

462 463 464

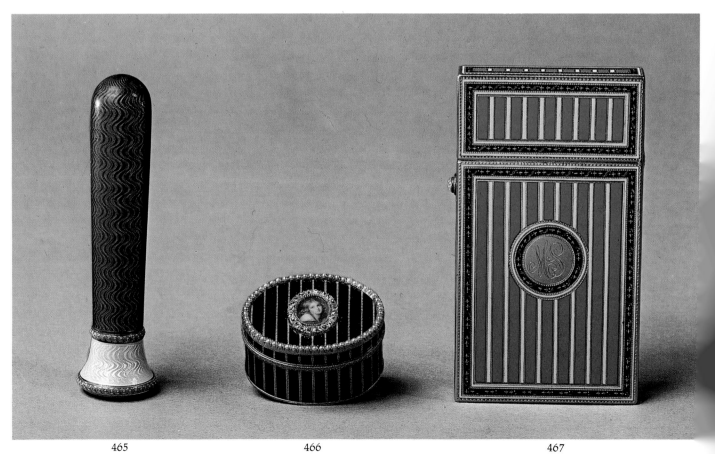

465 466 467

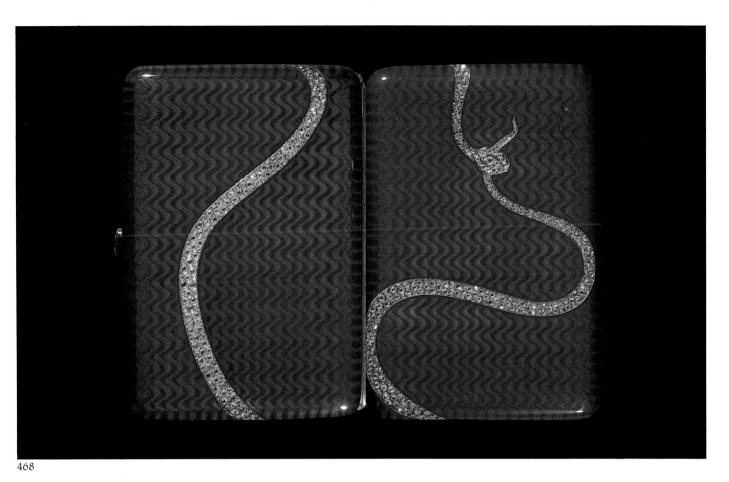

468

462 Gold cigarette-case

Mm: Fabergé – Wm: August Holmström
Hm: St. Petersburg, before 1899
Length: 3³/₄″
Original fitted red morocco case applied
with gilt double-headed eagle

Translucent Prussian blue enamel over *guilloché* sunray pattern, the cover applied with
an Imperial crown set with diamond imitations and rose-cut diamonds, diamond pushpiece; inscribed Ludwig Castenskiold.

Provenance: Presented by Czar Nicholas II
to Ludwig Castenskiold (1823–1905),
A. D. C to King Christian IX of Denmark
Exhibited: Lugano 1987, no. 98
Literature: Solodkoff, 1984, p. 27

The Forbes Magazine Collection, New York

463 Circular gold bonbonnière

Mm: Fabergé – Wm: Michael Perchin – Hm:
St. Petersburg, before 1899 – Inv: 43170
Diameter: 2¹/₄″

Red *guilloché* enamel, set with two gold rubles of Catherine the Great dated 1765 and

1779, rose-cut diamond border and diamond-set thumbpiece.

464 Gold cigarette-case

Mm: Fabergé – Wm: Henrik Wigström –
Hm: St. Petersburg, 1898–1903 – Am: A.
Richter – Inv: 14013 – Height: 3¹/₄″

Salmon pink *guilloché* enamel over engraved
flower swags, palm-leaf borders, the mount
set with a band of split pearls; circular-cut
diamond pushpiece.

465 Gold seal

Height: 3⁵/₁₆″
Original fitted case stamped with Iwm,
St. Petersburg, Moscow, London

Translucent dark blue and white enamel over
waved *guilloché* ground, chased gold mounts,
agate matrix cut with monogram "MC".

466 Oval gold box

Mm: Fabergé – Wm: Michael Perchin – Hm:
St. Petersburg, 1899–1908 – Am: 72 zolotniks – Length: 1¹/₂″

Dark-blue *guilloché* enamel bands alternating
with gold stripes, the cover set with oval
miniature of a girl, after Greuze, in diamond-set border; outer split-pearl border.

Literature: Snowman, 1962/64, pl. 13

467 Gold card-case

Mm: Fabergé – Wm: Michael Perchin – Hm:
1899–1908 – Inv: 7149
Height: 3¹/₂″

Alternating bands of pale blue and white
opaque enamel, outer black enamel borders
with green and gold foliage, with central
medallion engraved with monogram "MS",
rose-cut diamond pushpiece.
After a Louis XVI original.

468 Art nouveau gold cigarette-case

Iwm: K. Fabergé Hm: Moscow, 1899–1908
Length: 3¹¹/₁₆″

Translucent dark blue enamel over waved
guilloché ground decorated on both sides
with rose-cut diamond snake; rose-cut diamond pushpiece.

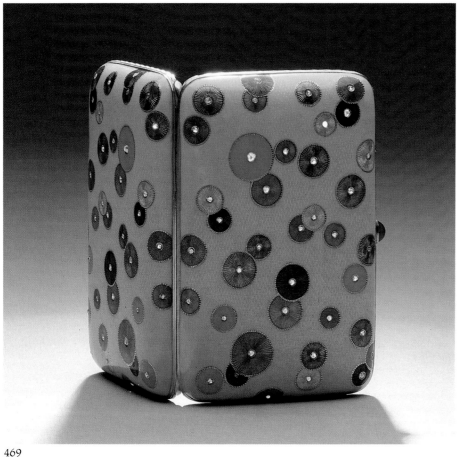

469

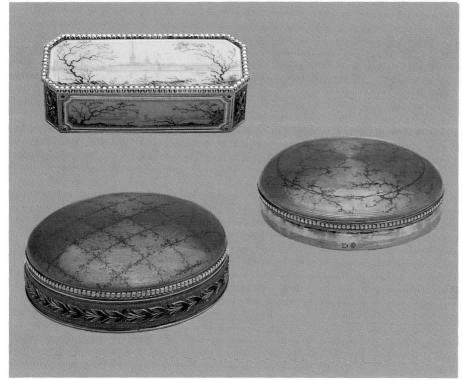

470, 471

Provenance: Presented by Mrs. George Keppel to King Edward VII, 1908 – Presented by Queen Alexandra to Mrs. Keppel, 1936 – Presented by Mrs. Keppel to Queen Mary
Exhibited: Victoria & Albert, 1977, no. K2
Cooper-Hewitt 1983, no. 203 – Queen's Gallery 1985/86, no. 313
Literature: Bainbridge, 1949/68, pl. 70
Habsburg, 1977, p. 71, Habsburg / Solodkoff, 1979 dustcover and pl. 81, Snowman, 1979, p. 51

H. M. Queen Elizabeth II of Great Britain

469 Gold cigarette-case

Iwm: K. Fabergé – Hm: Moscow, before 1899
Length: 3¹/₂″

White *guilloché* enamel decorated with numerous *guilloché* enamel discs in polychrome colors, each with rose-cut diamond centre.
Novel "Aesthetic Movement" design possibly based on a Chinese original; for a miniature Easter egg with similar motifs, cf. Christie's, Geneva, November 17, 1981, lot 80.

Exhibited: Lugano 1987, no. 99

The Forbes Magazine Collection, New York

470 Oblong gold bonbonnière in the Louis XVI style

Mm: Fabergé – Wm: Henrik Wigström – Hm: St. Petersburg, 1899–1908
Length: 2¹/₄″

Pink enamel painted in *camaïeu-rose* with the Fortress of St. Peter and St. Paul's, St. Petersburg; split-pearl border.
After a Louis XVI original in the manner of Joseph Etienne Blérzy (cf. cat. 658).

Provenance: Miss Yznaga della Valle, Paris (Christie's, Geneva, May 11, 1982, lot 329)
Exhibited: Lugano 1987, no. 112
Literature: Solodkoff, 1984, p. 137

The Forbes Magazine Collection, New York

471 Circular gold bonbonnière

Mm: Fabergé – Wm: Michael Perchin – Hm: St. Petersburg, before 1899
Diameter: 2³/₁₆″

Salmon pink *guilloché* enamel painted with *camaïeu-rose* trelliswork, *sablé* gold mount

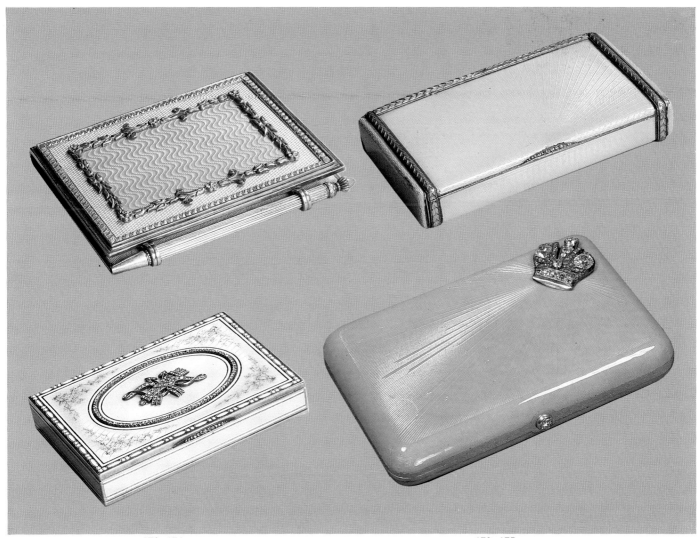

472, 474 473, 475

chased and enameled with laurel-leaf foliage, white pellet border.

Cf. a similar bonbonnière, Christie's, Geneva, May 12, 1981, lot 117

Exhibited: A la Vieille Russie, 1983, no. 147

472 Gold agenda-holder

Wm: Henrik Wigström – Hm: St. Petersburg, 1899–1908
Length: 3¹/₁₆″

Translucent pink enamel over *guilloché* (moiré) ground with stylized foliage border, outer pale green, *guilloché* enamel band; reeded gold pencil with cabochon moonstone finial.

H. M. Queen Beatrix of the Netherlands

473 Silver gilt cigarette-case

Mm: Fabergé – Wm: Henrik Wigström – Hm: St. Petersburg, 1908–1917 – Am: 88 zolotniks
Length: 3⁵/₁₆″

Translucent pale blue enamel over *guilloché* sunray pattern, palm-leaf borders, diamond-set thumbpiece.

H. M. Queen Beatrix of the Netherlands

474 Gold powder compact

Mm: Fabergé – Wm: Henrik Wigström – Hm: St. Petersburg, 1908–1917 – Am: 72 zolotniks
Length: 2³/₄″

Opalescent white enamel painted with *camaïeu-brun* branches over *guilloché* sunray

pattern; the cover applied with diamond-set bow and quiver in oval panel with diamond-set border, diamond-set thumbpiece; the interior fitted with mirror and three compartments.

H. M. Queen Beatrix of the Netherlands

475 Gold cigarette-case, 1896

Wm: A. Holmström – Hm: St. Petersburg, before 1899
Length: 3³/₄″

Opalescent pale blue enamel over *guilloché* sunray pattern, the cover applied on one side with Imperial crown set with circular-cut and rose-cut diamonds; circular-cut diamond pushpiece.

Cf. similar cigarette-case in yellow enamel,

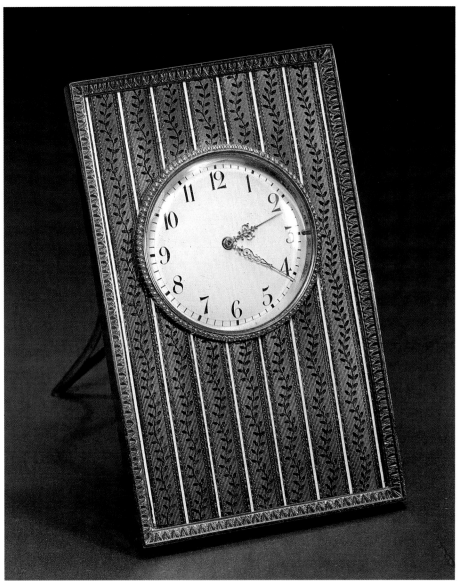

476

Provenance: The Rothschild Family. The colors are those of the Rothschild racing stable. Numerous objects in blue and yellow enamel were ordered by the Rothschilds from Fabergé in London.

Exhibited: A la Vieille Russie 1983, no. 160

478 Oblong gold cigar-case

Mm: Fabergé – Wm: Michael Perchin – Hm: St. Petersburg, before 1899 – Am: 72 zolotniks
Length: 3^{15}/₁₆″

Alternating bands of scarlet *guilloché* enamel and chased palm-leaf stripes, circular-cut diamond pushpiece.

Exhibited: A la Vieille Russie 1983, no. 200

479 Gold comb-case

Mm: Fabergé – Wm: Henrik Wigström – Hm: St. Petersburg, 1908–1917 – Am: 72 zolotniks
Length: 4^3/₁₆″

Translucent scarlet enamel over waved *guilloché* ground; ivory comb.

Exhibited: A la Vieille Russie 1983, no. 167

477

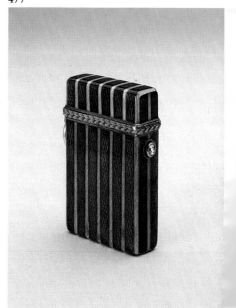

collection of the King of Siam (Krairiksh 1984, p. 174 f).

Provenance: Presented by Czar Nicholas II to Crown Prince Frederick (the later King Frederick VIII) of Denmark at the occasion of his coronation on May 26, 1896, in Moscow

Chronological Collection of the Danish Queen, Rosenborg Castle

476 Rectangular gold clock

Mm: Fabergé – Wm: Henrik Wigström – Hm: St. Petersburg, 1899–1908 – Inv: 15182
Height: 5″

Alternating bands of steel gray enamel with laurel leaves and opaque white enamel; white enamel dial, gold hands, split-pearl border; outer stiff-leaf border, ivory backing, silver strut.

H. R. H. Grand Duchess Josephine Charlotte of Luxemburg

477 Gold match-holder

Mm: C. F. – Wm: Henrik Wigström – Hm: St. Petersburg, 1908–1917 – English import marks 1911 – Inv: 21769
Height: 1^{11}/₁₆″

Alternating dark blue and yellow *guilloché* stripes, palm-leaf border, rose-cut diamond pushpiece.

480 Gold powder compact

Mm: C.F. – Wm: Henrik Wigström – Hm: St. Petersburg, 1908–1917 – Am: 72 zolotniks, made for the foreign market
Length: 3³/₈″

Bands of opaque white enamel gilt with laurel-leaf stripes, oval central medallion with diamond-set laurel-leaf border, outer border and thumbpiece set with rose-cut diamonds; the interior with mirror, lidded compartment and lipstick tube.

481 Gold-mounted table-lighter

Wm: Henrik Wigström – Hm: St. Petersburg, 1908–1917
Height: 4¹/₈″

White *guilloché* enamel with palm-leaf borders, reeded gold stopper with cabochon sapphire finial; circular nephrite base.

482 Gold-mounted fan in the Louis XV style

Mm: Fabergé – Wm: Michael Perchin – Hm: St. Petersburg, before 1899
Length: 12³/₈″
Original fitted case stamped with Iwm, St. Petersburg, Moscow

Pink *guilloché* enamel, applied with entwined diamond-set stripes and gold flower swags, rose-cut diamond borders; lace fan with ivory ribs, silk tassel.
Cf. similar fan in The Forbes Magazine Collection, New York (Waterfield/Forbes 1978, n. 83)

483 Gold parasol handle

Mm: Fabergé – Wm: Michael Perchin – Hm: St. Petersburg, before 1899 – Am: 72 zolotniks – Inv: 14137
Length: 3¹/₈″

Pink *guilloché* enamel painted in *camaïeu-rose* with branches, *sablé* gold borders chased and enameled with red and white pellets, green foliage within opaque white enamel frames; pink *guilloché* band applied with entwined gold laurel-leaf branches and set with rose-cut diamonds; hinged top containing mirror and compartment for powder.
Based on a Louis XVI original.

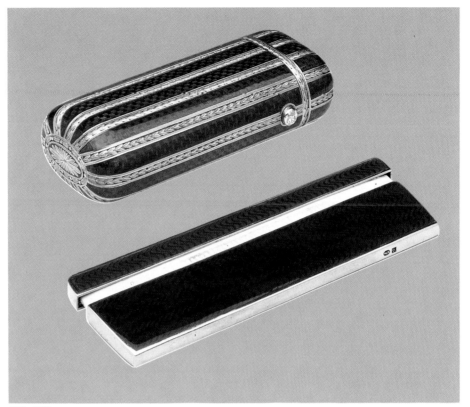

478, 479

480, 481

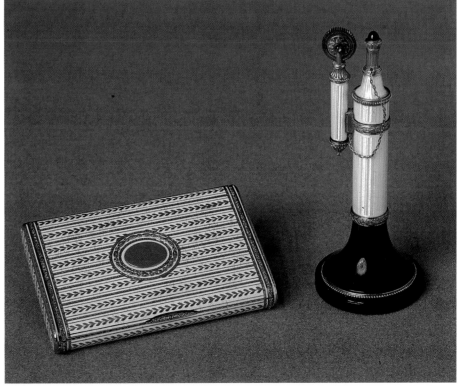

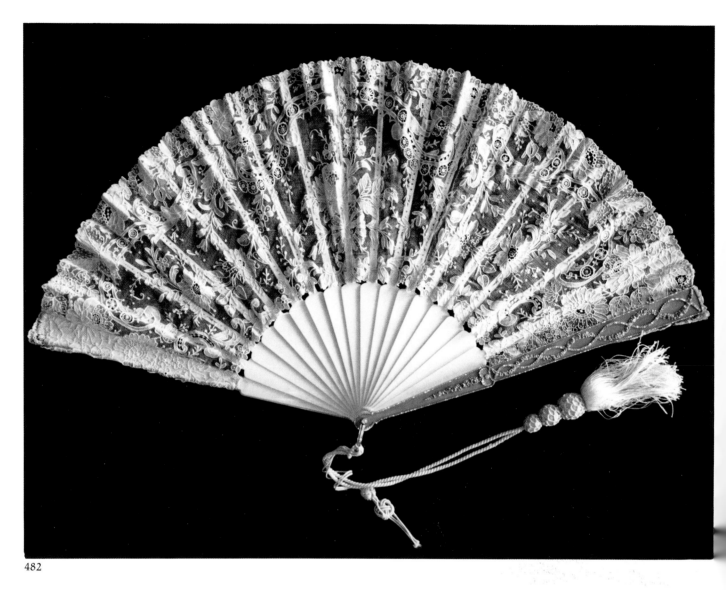

482

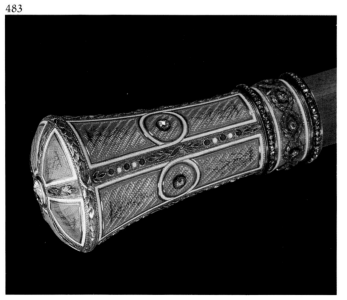

483

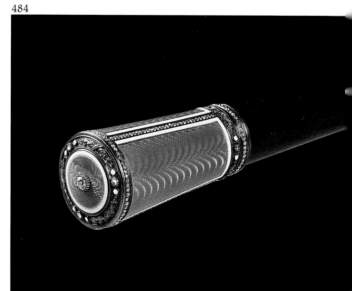

484

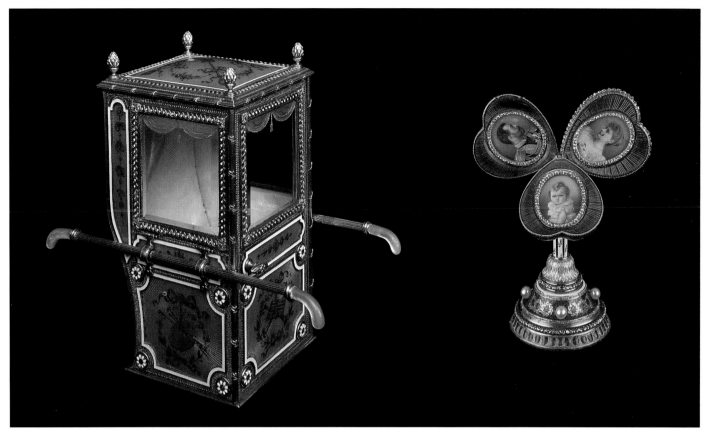

485, 486

Provenance: Acquired by Henry Walters from Fabergé, St. Petersburg, 1900
Exhibited: Hammer 1951
Literature: Ross, 1952, p. 8 – Snowman, 1953, ill. 174 – Snowman, 1962/64, ill. 195

The Walters Art Gallery, Baltimore

484 Gold parasol handle

Mm: Fabergé – Wm: Michael Perchin – Inv: 3941
Length: 1¹/₈″

Translucent pink enamel over *guilloché moiré* ground, diamond-set borders; original parasol of Chantilly lace.

H. M. Queen Beatrix of the Netherlands

485 Gold sedan chair in the Louis XVI style

Mm: Fabergé – Wm: Michael Perchin – Hm: St. Petersburg, 1899–1908 – Am: 72 zolotniks
Height: 3³/₈″

Pink *guilloché* enamel panels painted in *ca-*

maïeu-rose with trophies of Music, the Arts and Love within opaque white enamel borders; reeded gold handles with chalcedony terminals, rock-crystal windows, the interior inlaid with mother-of-pearl.

Cf. a similar sedan chair Christie's, Geneva, April 28, 1978, no. 382 (Habsburg/Solodkoff, 1979, pl. 39/40)

Provenance: J. P. Morgan, acquired at Fabergé's in St. Petersburg (Parke-Bernet, New York, January 6/8, 1944, lot 430) – Mrs. and Mrs. Jack Linsky, New York – Landsdell K. Christie, Long Island

Exhibited: A la Vieille Russie, 1949, no. 183 Hammer, 1951, no. 293 – Corcoran, 1961, no. 9 – A la Vieille Russie, 1961, no. 269 – Metropolitan, 1962/66 no. L 62/89 – A la Vieille Russie, 1968, no. 357 – Victoria & Albert, 1977, no. L 14 – Lugano, 1987, no. 45

Literature: Snowman, 1953, no. 519 – Snowman, 1962/64, p. ? L – Waterfield/Forbes, 1978, no. 58 – Snowman, 1979, p. 38

The Forbes Magazine Collection, New York

486 Heart-shaped gold frame inscribed "C. Fabergé" beneath

Height: 3¹/₄″

Scarlet *guilloché* enamel applied with diamond-set date 1897, the stem with bands of opaque white enamel gilt with laurel leaves; scarlet enamel base with rose-cut diamond bands, applied with four pearls. The heart opens to a three-leaf clover shape, revealing three oval miniature of Czar Nicholas II, Czarina Alexandra Feodorovna and their daughter Tatjana (1897–1918), each in a diamond-set frame on green *guilloché* enamel background.

Probably presented by Czar Nicholas II to his wife on the occasion of the birth of Grand Duchess Tatjana. For a similar heart-shaped frame, cf. the Rocaille Egg of Barbara Kelch, dated 1902 (Snowman, 1962/64, ill. 389)

Provenance: Lydia, Lady Deterding (Christie's, Geneva, April 26, 1978, no. 381)
Exhibited: Lugano 1987, no. 68
Literature: Snowman, 1962/64; ill.103 – Waterfield/Forbes, 1978, no. 70 – Solodkoff, 1984, pp. 40f., 170

The Forbes Magazine Collection, New York

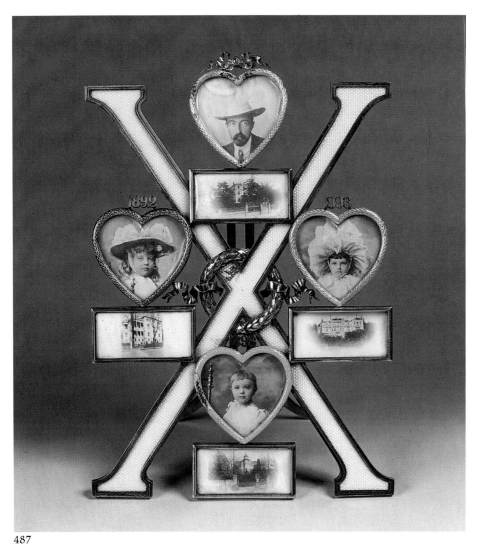

487

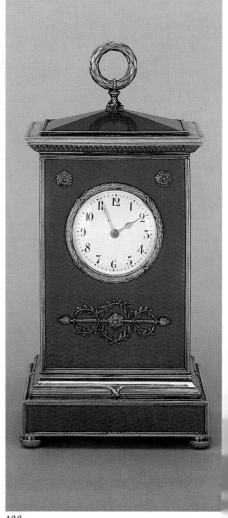

488

487 X-shaped silver gilt photograph frame

Mm: Fabergé – Wm: Victor Aarne
Hm: St. Petersburg, 1899–1908
Height: 7¹/₂″

Of white *guilloché* enamel flanked by four *guilloché* enamel hearts containing photographs of Grand Duke Michael Michailovitch (1860–1929) and his three children Anastasia (born 1892), Nadejda (born 1896) and Michael (born 1898), Count and Countesses Torby. The Grand Duke married Sophie, Countess Merenberg in 1891, so the "X" signifies the tenth wedding anniversary and the frame can be dated in 1901. The views of castles and houses have not been identified.

488 Aedicula – shaped silver gilt half-hour repeating clock

Mm: Fabergé – Wm: Henrik Wigström –
Hm: St. Petersburg, 1899–1908 – Inv: 4744
Height: 6⁵/₁₆″

Royal blue *guilloché* enamel applied with laurel swags, maenad staffs and rosettes, laurel crown handle.

489 Gold bonbonnière shaped like a doge's hat

Mm: Fabergé – Am: 72 zolotniks – Inv: 6659
Height: 1⁷/₁₆″

Translucent yellow enamel over engraved scrolling foliage, opaque white enamel bands

set with rubies, emeralds, diamonds and pearls.
Cf. a similar white enamel box, A la Vieille Russie 1961, no. 129.

Mrs. Josiane Woolf

490 Heart-shaped silver gilt photograph frame

Mm: Fabergé – Wm: Victor Aarne – Am
1899–1908 – Inv: 3383
Height: 2³/₄″

White *guilloché* enamel, applied with four color gold swags ribbon cresting; ivor backing, silver gilt strut.

Mrs. Josiane Woolf

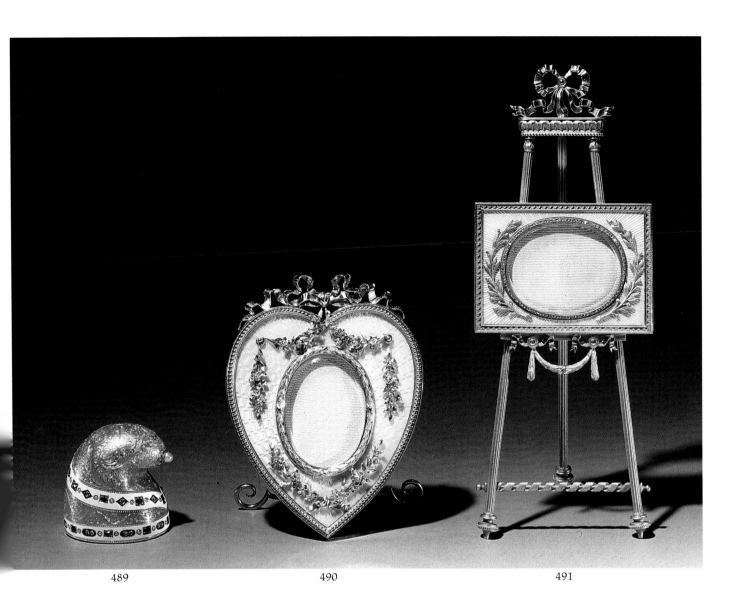

489 490 491

491 Gold photograph frame shaped like an easel

Mm: K.F. (in Russian) – Hm: Moscow, 1899–1908 – Inv: 23403
Height: 6¹/₈″
Original fitted case stamped with Iwm, St. Petersburg, Moscow, Odessa

The rectangular "painting" of white *guilloché* enamel, applied with laurel sprays, the aperture with rose-cut diamond borders; the easel with three reeded gold feet and ribbon cresting.

Exhibited: Victoria & Albert 1977, no. O 19

Mrs. Josiane Woolf

492 Gold compass shaped like an Empire table

Mm: Fabergé – Wm: Michael Perchin – Hm: St. Petersburg, before 1899 – Inv: 1375
Height: 1¹/₂″

Dark-blue *guilloché* enamel, applied with stars set with rose-cut diamonds; the top with magnifying glass standing on three winged legs, similar circular base on three artichoke feet.
Illustration p. 252

Provenance: Transferred 1951 from the Deposits of the State Museum, illustrated p. 252, State Hermitage, Leningrad (Inv: E-17 145) (L.Y.)

493 Gold double frame shaped like a Louis XV fire-screen

Mm: Fabergé – Wm: Henrik Wigström – Am: 72 zolotniks
Height: 7¹/₁₆″

Original fitted case stamped with Iwm, Petrograd, Moscow, Odessa

Opalescent white enamel over *guilloché moiré* ground applied with varicolored gold husks and four-color gold flower swags; reeded gold stand with four stud feet, opaque white enamel columns with pearl finials; laurel-leaf and flower swag cresting; photographs of the Czar and Czarina of later date.

Provenance: Maurice Y. Sandoz, Switzerland – Landsdell K. Christie Long Island

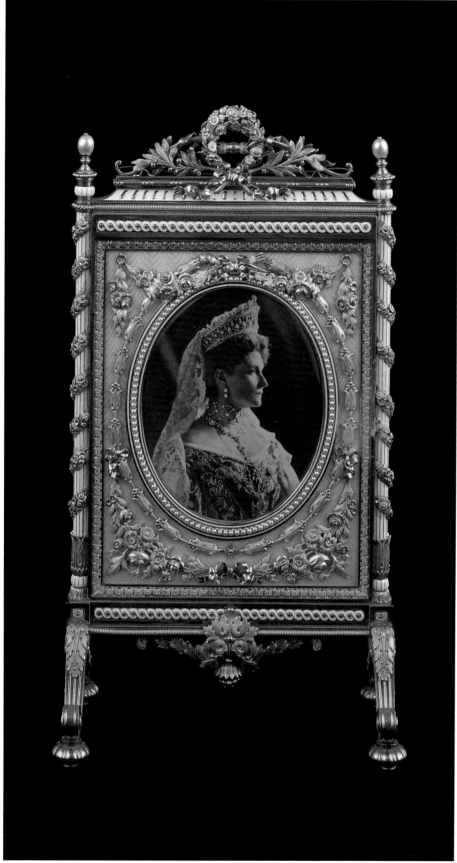

493

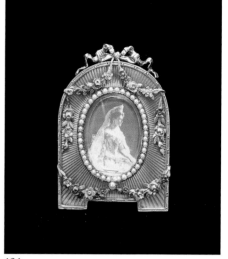

494

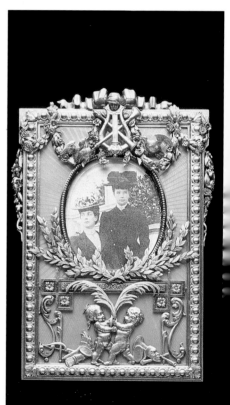

495

Exhibited: Corcoran, 1961, no. 6 – Metro
politan, 1962/66, no. L 62. 8. 6 – A la Vieille
Russie, 1968, no. 365 – Victoria & Albert
1977, no. L 1 – Lugano, 1987, no. 29
Literature: Snowman, 1962/64, pl. XXVII
Waterfield/Forbes, 1978, no. 71

The Forbes Magazine Collection, New York

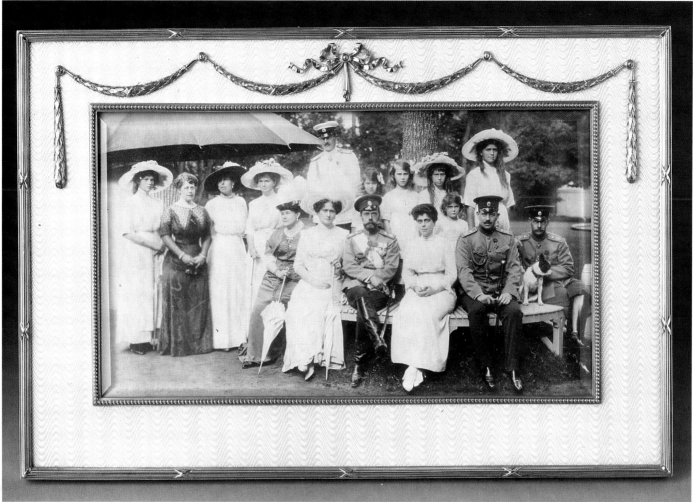

496

494 Miniature gold photograph frame

Mm: Fabergé – Wm: Victor Aarne – Hm: St. Petersburg, before 1899 – Inv: 3076
Height: 1³/₄″

Translucent pink enamel over *guilloché* sunray pattern, oval opening with split-pearl border applied with four-color gold flower swags, gold ribbon cresting; mother-of-pearl backing with silver gilt strut. Photograph of Czarina Alexandra Feodorovna of later date.

Exhibited: Lugano 1987, no. 39
Literature: Solodkoff, 1984, p. 171

The Forbes Magazine Collection, New York

495 Rectangular gold photograph frame

Mm: Fabergé – Wm: Michael Perchin – Hm: St. Petersburg, before 1899 – Inv: 45847
Height: 4¹/₈″

Opalescent pink enamel over *guilloché* sunray pattern, applied with laurel sprays, putti holding palms, scrolls, four-color gold flower swags and a lyre; ivory backing and gold strut. Photograph of Czarina Marie Feodorovna and her sister Queen Alexandra, of later date.

Literature: Waterfield/Forbes, 1978, no. 76
Solodkoff, 1984, p. 39, 171
Exhibited: Lugano 1987, no. 38

The Forbes Magazine Collection, New York

496 Rectangular silver gilt photograph frame

Mm: Fabergé – Wm: Hjalmar Armfelt – Am: St. Petersburg, 1899–1908
Length:· 11″

Translucent white enamel over *guilloché moiré* ground, applied with laurel swags.

Original photograph of the Czar, his family and relatives; wooden backing with silver gilt strut.

The photograph shows (standing from left to right): Grand Duchess Tatjana, daughter of Czar Nicholas II; a lady-in-waiting; Grand Duchess Victoria Feodorovna, wife of Grand Duke Kyrill; Grand Duchess Olga, daughter of Nicholas II; Grand Duke Kyrill; Marina, later Duchess of Kent; Olga, later Princess Paul of Yugoslavia; Grand Duchess Anastasia, daughter of Nicholas II; Grand Duchess Elizabeth; Grand Duchess Maria, daughter of Nicholas II. (Seated): Grand Duchess Maria, mother of Kyrill, Boris and Andreas; Czarina Alexandra Feodorovna; Czar Nicholas II; Grand Duchess Helen, Princess of Greece; Grand Duke Boris; "Bobtail", Grand Duke Andrew.

The Marjorie Merriweather Post Collection, Hillwood, Washington D.C.

247

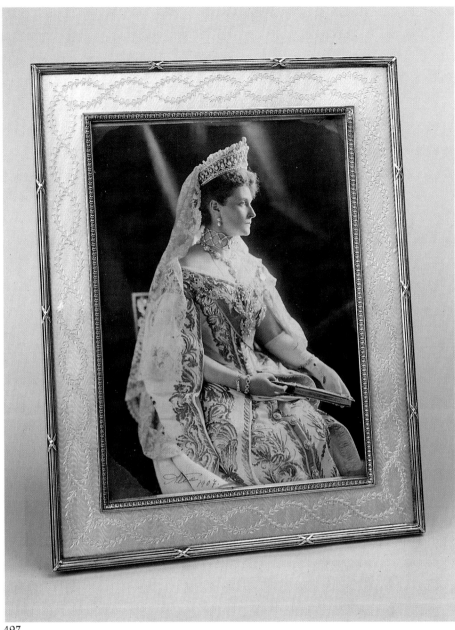

497

497 Rectangular silver gilt photograph frame

Mm: Fabergé – Wm: Hjalmar Armfelt – Hm: St. Petersburg, 1898–1903 – Am: A. Richter
Inv: 15811
Height: 10⁷/₁₆″

Translucent lime green enamel over *guilloché moiré* ground engraved with entwined laurel swags. Photograph of Czarina Alexandra Feodorovna, signed Alix 1907; wooden backing with silver strut.

498 Rectangular silver photograph frame

Mm: Fabergé – Wm: Victor Aarne – Hm: St. Petersburg, 1899–1908
Height: 2″

Lozenge panel of pale blue translucent enamel over *guilloché* sunray pattern, the four corners of aquamarine *guilloché* enamel applied with laurel crowns. Oval photograph of Queen Alexandrine of Denmark; wooden backing with silver strut.

Chronological Collection of the Danish Queen, Rosenborg Castle, Copenhagen

499 Circular silver photograph frame

Mm: Fabergé – Wm: Victor Aarne – Hm: St. Petersburg, 1899–1908 – Inv: 3324
Diameter: 3⁹/₁₆″

Scarlet *guilloché* enamel, applied with laurel sprays and rosettes. Photograph probably of Crown princess Cecilia of Prussia with her family; wooden backing and silver strut.

H. R. H Henrik Prince of Denmark

500 Triangular silver gilt photograph frame

Mm: Fabergé – Wm: Victor Aarne – Hm: St. Petersburg, before 1899 – Inv: 59687
Height: 3¹/₂″
Original fitted case stamped with Iwm, St. Petersburg, Moscow

Translucent orange enamel over pattern of sunrays and concentric circles. Circular photograph of Queen Louise of Denmark in split-pearl border; ivory backing with silver strut.

Provenance: Given by Czarina Marie Feodorovna to her father, King Christian IX (pencil note: "Min Engle Papa fra Minny, 1898")

Chronological Collection of the Danish Queen, Rosenborg Castle, Copenhagen

501 Rectangular gold miniature frame

Mm: Fabergé – Wm: Michael Perchin – Hm: St. Petersburg, before 1899
Height: 3³/₄″

Pale-blue *guilloché* enamel, applied with gold laurel swags, ribbon cresting above. Oval miniature of Grand Duchess Anastasia of Mecklenburg, mother of Queen Alexandrine, in split-pearl border; ivory backing silver gilt strut.

H. M. Queen Margrethe II of Denmark

502 Rectangular silver gilt photograph frame

Mm: Fabergé – Wm: Michael Perchin – Hm: St. Petersburg, before 1899
Height: 3⁷/₈″

Translucent orange enamel over *guilloché moiré* ground, ribbon cresting. Oval photograph of Queen Alexandrine of Denmark

502

499

500

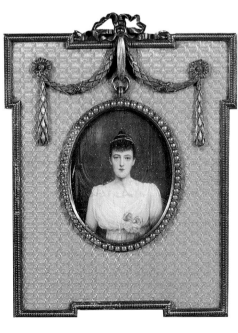

501

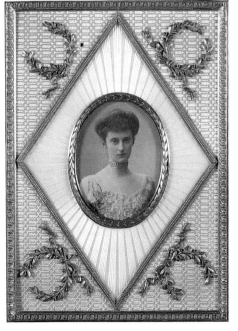

498

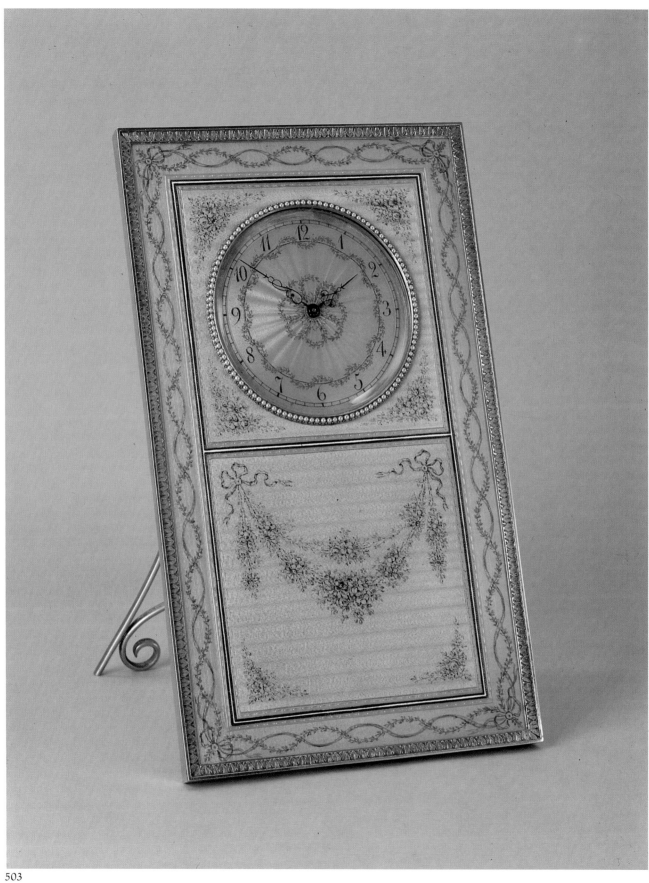

(born Princess of Mecklenburg-Schwerin, 1879–1952); ivory backing, silver gilt strut.

Chronological Collection of the Danish Queen, Rosenborg Castle, Copenhagen

503 Rectangular gold table-clock

Mm: Fabergé – Wm: Henrik Wigström
Hm: St. Petersburg, 1898–1903 – Am: A.
Richter – Inv: 23119
Height: 6⁷/₈″

Translucent yellow enamel dial over *guilloché moiré* ground painted with *camaïeu-brun* laurel foliage, steel blue hands, split-pearl border; lime green *guilloché* enamel panel painted in *camaïeu-brun* with flower swags and ribbons. Yellow *guilloché* enamel frame painted in *camaïeu-brun* with ribbons and laurel swags; outer palm-leaf border, ivory backing with silver gilt strut.

Exhibited: Victoria & Albert 1977, no. R 10
Literature: Snowman, 1962/64, pl. XXVI

504 Circular silver gilt bonbonnière

Mm: Fabergé – Wm: Henrik Wigström
Hm: St. Petersburg, 1908–1917
Diameter: 2⁷/₁₆″

The cover with two folkloristic articulated figures in painted ivory on black background with stiff-leaf border; the sides in pale blue *guilloché* enamel applied with laurel swags.

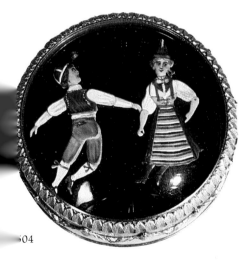

504

The costumes are those of the Swedish province of Dalarna.

…or similar boxes with articulated figures, cf. …nowman, 1962/64, pl. LX and LXI and two

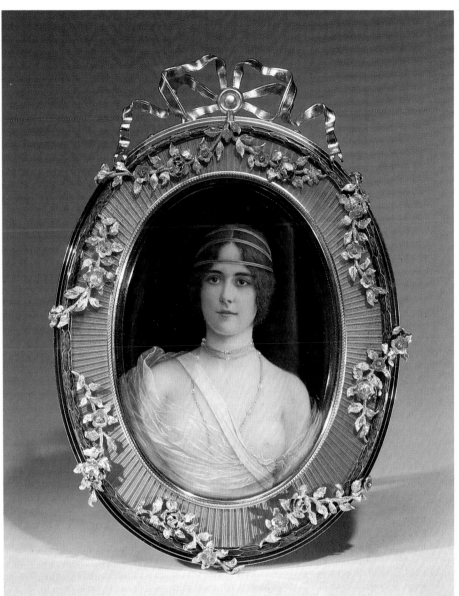

505

further boxes in the State Hermitage, Leningrad.

Provenance: Given by Czar Nicholas II, 1908, on the occasion of the marriage of Prince William of Sweden (1884–1965) to Grand Duchess Maria Pavlovna (1890–1958)

Literature: Snowman, 1962/64, pl. LVII

505 Oval silver gilt frame

Iwm: K. Fabergé – Hm: Moscow, 1896
Height: 5⁵/₁₆″

Translucent yellow enamel over *guilloché* sunray pattern applied with flower swags in four-color gold, outer green enamel laurel-leaf border, gold ribbon cresting. Oval miniature of Cléo de Mérode in diaphanous clothing, wearing three gold headbands; ivory backing, silver gilt strut.

Rare example of an object of vertu from the Moscow workshops with an *osé* representation of the famous Courtisan. Prize for a beauty contest, 1896.

Exhibited: Victoria & Albert 1977, no. R 24
A la Vieille Russie, 1983, no. 84
Literature: Snowman, 1979, p. 18 and 138

Mrs. Josiane Woolf

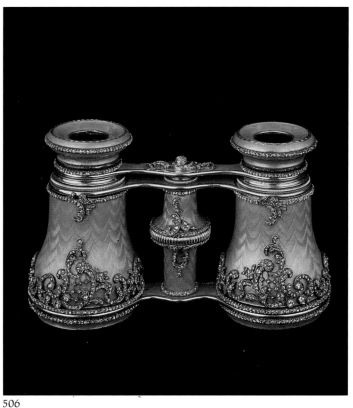

506

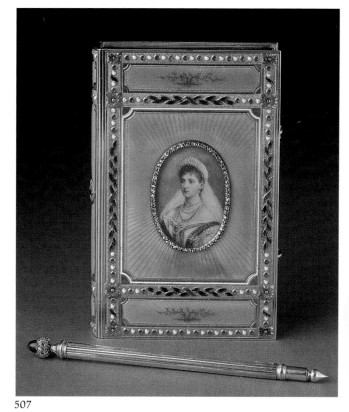

507

506 Gold opera glasses

Mm: Fabergé – Wm: Michael Perchin – Hm:
St. Petersburg, 1899–1908
Inv: 3945
Length: 4¹/₈"

Translucent pink enamel over *guilloché moiré*

ground applied with diamond-set rocaille
motifs.

Exhibited: Lugano 1987, no. 69
Literature: Waterfield/Forbes, 1978, no. 89 /
Solodkoff, 1984, p. 30

The Forbes Magazine Collection, New York

507 Gold carnet de bal in the Louis XVI style

Mm: Fabergé – Wm: Michael Perchin – Hm:
St. Petersburg, before 1899 – Am: 72 zo-
lotniks
Height: 3⁷/₈"

Opalescent pink enamel over *guilloché* sun-
ray pattern, *sablé* gold borders chased and
enameled with green enamel *guilloché* laurel
leaves, white and red pellets. Oval miniature
of Czarina Marie Feodorovna, signed Zuiev,
in rose-cut diamond mount; reeded gold
pencil with cabochon emerald finial.
After a Louis XVI original from the 1780's.

Exhibited: A la Vieille Russie 1980, no. 214
Literature: Ross, 1965, p. 30, pl. IX

The Marjorie Merriweather Post Collection,
Hillwood, Washington D.C.

507 A Rock-crystal box shaped like a fan

Mm: Fabergé – Wm: Michael Perchin – Hm:
St. Petersburg, before 1899 – Am: 72 zo-
lotniks
Length: 3"

The lid engraved with Louis XVI motifs

507 A 492

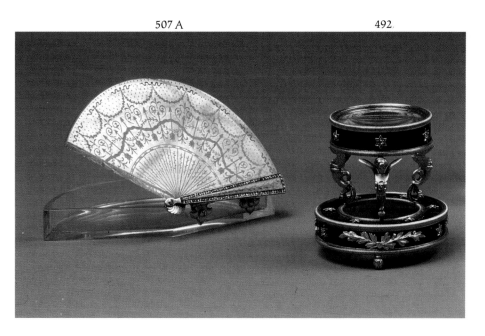

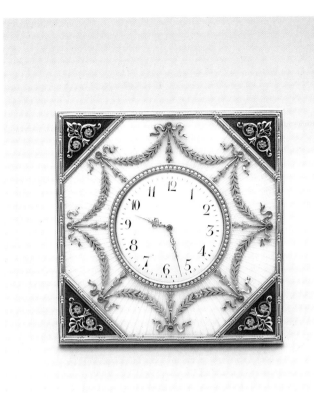

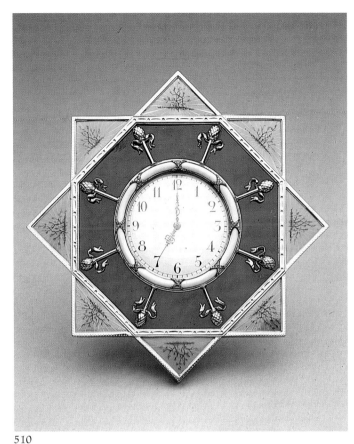

509

510

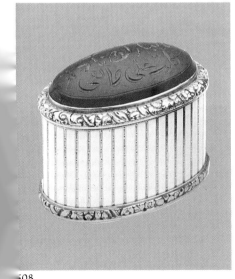

508

gold mounts with pink *guilloché* enamel and rose-cut diamond borders.

Provenance: Transferred 1931 from the Deposits of the State Museum
Literature: Lopato, 1984, p. 49

State Hermitage, Leningrad (Inv. E 11 729)
(L. Y.)

508 Oval gold bonbonnière

Mm: Fabergé – Wm: Henrik Wigström – Hm: St. Petersburg, 1908–1917 – Am: 72 zolotniks
Length: 2¹/₄"

Vertical opaque white enamel bands alternating with gold stripes, yellow gold borders chased with scrolled foliage; the lid inset with a red carnelian engraved with the inscription "Allah is great, Mohammed is his Prophet" in Turkish.

Exhibited: A la Vieille Russie 1983, no. 164

509 Square gold table-clock

Mm: Fabergé – Wm: Michael Perchin – Hm: St. Petersburg, before 1899
Height: 3⁹/₁₆"

Octagonal panel of translucent white enamel over sunray *guilloché* pattern, applied with laurel swags, cabochon sapphires and ribbons, the corners of scarlet *guilloché* enamel applied with acanthus foliage; white enamel dial with gold hands and split-pearl border; ivory backing with silver gilt strut.

The red and white colors of this clock indicate royal Danish provenance.

Exhibited: Lugano 1987, no. 24

The Forbes Magazine Collection, New York

510 Octagonal silver gilt table – clock from the yacht "Polar Star"

Mm: Fabergé – Wm: Michael Perchin – Hm: St. Petersburg, before 1899
Height: 5⁵/₁₆"

Octagonal nephrite panel applied with maenad staffs; white enamel dial with gold hands, the bezel shaped like a life-buoy in opaque white enamel tied with diamond-set ribbons; the "points" in pink *guilloché* enamel painted with dendritic motifs; ivory backing, silver gilt strut.

Provenance: From Nicholas II's yacht "Polar Star"
Exhibited: A la Vieille Russie 1983, no. 107
Lugano 1987, no. 25
Literature: Snowman, 1962/64, pl. X – Habsburg/Solodkoff, 1979, pl. 88

The Forbes Magazine Collection, New York

511 Square gold Imperial presentation cigarette-box

Mm: Fabergé – Wm: August Hollming – Hm: St. Petersburg 1899–1908 – Inv: 1208
Width: 3¹/₈″

Translucent primrose enamel over *guilloché* ground of sunrays and concentric rings, the sides with pellets; the cover applied with crowned diamond-set monogram of Nicholas II flanked by four gold laurel-wreaths centering on rose-cut diamonds; outer palm-leaf border.

Exhibited: Wartski 1949, no. 5 – Victoria & Albert 1973, no. F 10 – Cooper-Hewitt 1983, no. 192 – Queen's Gallery 1985/86, no. 330
Literature: Bainbridge, 1949/66, pl. 104

H. M. Queen Elizabeth, The Queen Mother

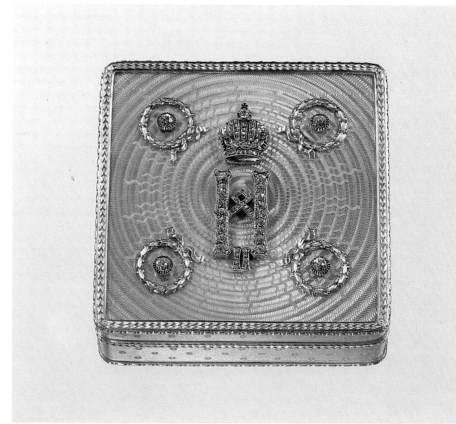

511

512

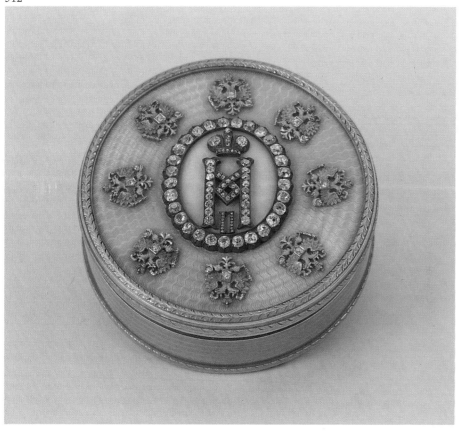

512 Circular gold Imperial presentation box

Mm: Fabergé – Wm: Michael Perchin – Hm: St. Petersburg, before 1899
Diameter: 3¹/₈″

Translucent primrose enamel over *guilloché* ground of sunrays and concentric circles; applied with eight gold double-headed eagles each set with rose-cut diamonds, the center with crowned diamond-set monogram "N II" on *guilloché* white enamel ground within rose-cut diamond border; outer palm-leaf border. The interior inscribed (in Russian): "For Her Royal Highness Princess Elizabeth on the occasion of her Wedding with Hearty Congratulations. Zematov Bessarabia February 27, 1921".

Stavros S. Niarchos

513 Rectangular gold Imperial presentation cigarette-box

Mm: Fabergé – Wm: August Hollming – Hm: St. Petersburg, before 1899 – Inv: 106?
Length: 3³/₄″
Original green morocco case applied with gilt double-headed eagle.

The lid applied with crowned diamond-set monogram "N II" on oval white *guilloché* enamel panel within rose-cut diamond border; further decorated with diamond-set trelliswork over yellow *guilloché* enamel panels, applied with black double-headed eagles set with a rose-cut diamond; outer laurel-leaf border.

The color scheme of this box is based on the Coronation robes of Czar Nicholas II.

Provenance: According to tradition presented by Czarina Alexandra Feodorovna to her husband, 1897 – Sidney Hill London, New York – Arthur Bradshaw, London – Lansdell K. Christie, Long Island
Exhibited: Corcoran 1961, no. 14 – A la Vieille Russie 1961, no. 93 – Metropolitan 1962/66, no. L 62. 8. 14 – Victoria & Albert 1977, no. O 14 – Lugano 1987, no. 95
Literature: Henry Sidney Hill, *Antique Gold Boxes*, New York 1953, p. 194 – Snowman, 1962/64, pl. I – Waterfield/Forbes, 1978, no. 61 – Solodkoff, 1984, p. 27

The Forbes Magazine Collection, New York

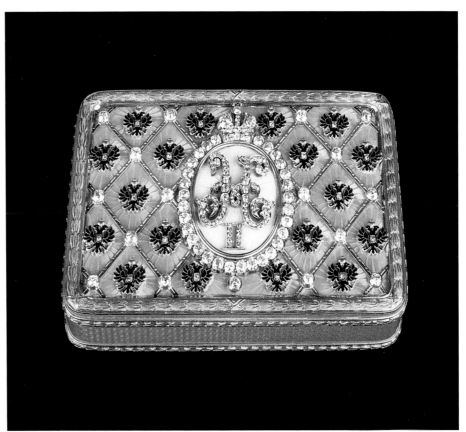

513

514

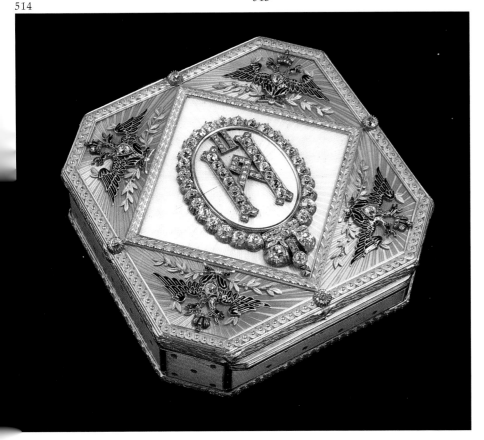

514 Octagonal gold Imperial presentation cigarette-box

Mm: Fabergé – Wm: Michael Perchin – Hm: St. Petersburg, 1899–1908
Width: 3¹/₄"

The lid applied with crowned diamond-set monogram "N II" on oval white *guilloché* enamel panel within rose-cut diamond surround, on a lozenge-shaped translucent white enamel panel over *guilloché* sunray pattern; the corners of translucent primrose enamel over *guilloché* sunray pattern applied with black enamel double-headed eagles, gold laurel sprays and rose-cut diamonds; yellow *guilloché* enamel sides.

Provenance: Presented by Czar Nicholas II – Collection Sir William Seeds, K. C. M. G.
Literature: Bainbridge, 1949/68, pl. 30 – Snowman, 1962/64, p. IV – Snowman, 1979, p. 118

Trustees of the Victoria and Albert Museum, London

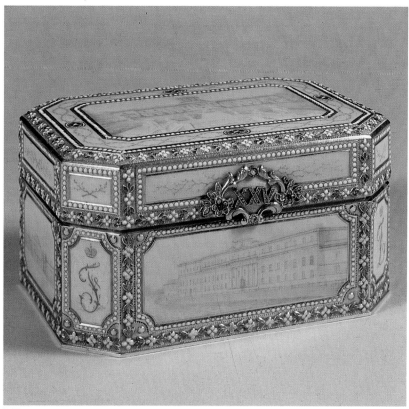

515

516

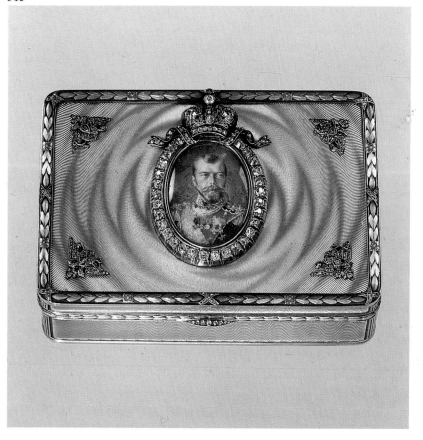

515 Octagonal gold music box of the Youssoupov Family, 1907

Mm: Fabergé – Wm: Henrik Wigström
Hm: St. Petersburg, 1899–1908
Length: 3⁹/₁₆"

Opaque white *guilloché* enamel panels painted in *camaïeu-rose* with six views of the Youssoupov palaces, the corners painted with the initials of "F" and "Z"; *sablé* gold borders chased and enameled with opalescent pellets and green foliage, the thumbpiece applied with diamond-set Roman numerals "XXV". The views are of:

1. cover – Archangelskoje near Moscow
2. front – Palace on the Mojka, St. Petersburg
3. base – Palace in Koreis (Crimea)
4. back – Youssoupov Palace in Czarskoje Selo
5. left – Palace in Rakitnoje (Kursk)
6. right – The shooting lodge of Ivan the Terrible.

Provenance: Presented by Prince Nicholas and Felix Youssoupov to their parents, Felix and Zenaïde Youssoupov, on the occasion of their 25th wedding anniversary, 1907. Also cf. cat. 543

Exhibited: Corcoran 1961, no. 18 – A la Vieille Russie 1983, no. 222

Literature: Bainbridge, 1949/68, pl. 4 – Snowman, 1962/64, pl. VIII – Habsburg/Solodkoff, 1979, ill, 153 f. – Snowman, 1979, p. 122

The Marjorie Merriweather Post Collection, Hillwood, Washington D. C.

516 Rectangular gold-mounted silver gilt Imperial presentation box

Mm: Fabergé – Wm: Henrik Wigström –
Hm: St. Petersburg, 1908–1917 – Am: 72
zolotniks
Length: 4"

Panels of translucent mauve enamel over *guilloché* sunrays and concentric rings; the cover applied with miniature of Nicholas II in crowned diamond-set border, the spandrels applied with diamond-set double-headed eagles, outer border of laurel leaves and diamond-set ribbons.

Exhibited: Victoria & Albert 1977, no. F 7 – Cooper-Hewitt 1983, no. 194 – Queen's Gallery 1985/86, no. 329
Literature: Bainbridge, 1949/69, pl. 110

H. M. Queen Elizabeth, The Queen Mother

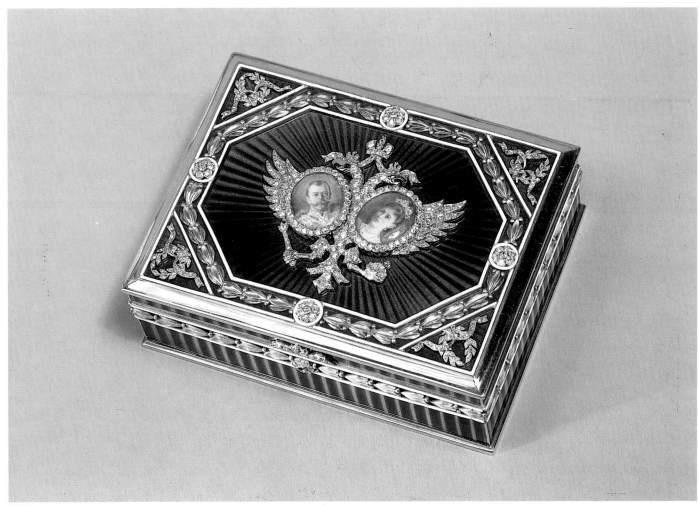

517

517 Rectangular gold Imperial presentation box

Mm: Fabergé
Length: 4¹/₈″

Dark-green translucent enamel panels over *guilloché* sunray pattern, the cover applied with diamond-set double-headed eagle containing two oval miniatures of Czar Nicholas II and Czarina Alexandra Feodorovna; octagonal red *guilloché* enamel outer border applied and chased with laurel leaves; green *guilloché* enamel spandrels applied with diamond-set laurel crowns and ribbons.

The base inscribed with commemorative inscription for the Romanov Tercentenary.

Exhibited: Wartski 1949, no. 207
Literature: Snowman, 1962/64, ill. 137

The Wernher Collection, Luton Hoo

518

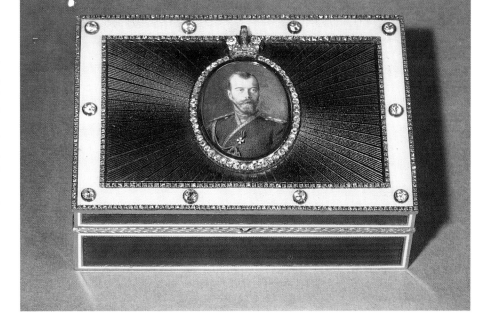

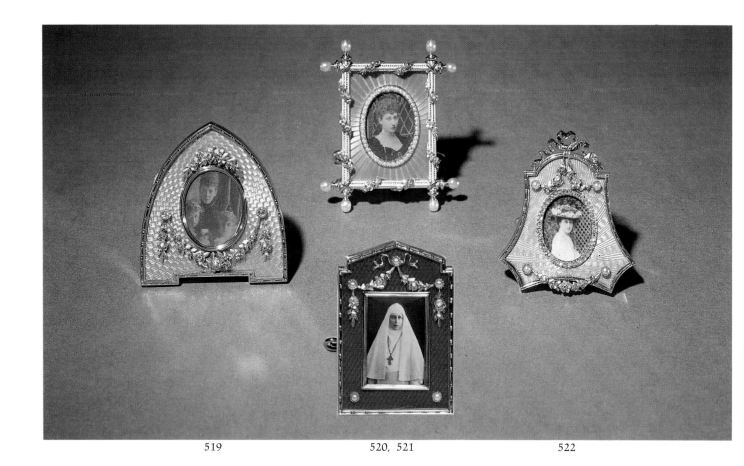

519 520, 521 522

518 Rectangular gold Imperial presentation cigarette-case

Mm: Fabergé – Wm: Henrik Wigström – Hm: St. Petersburg, 1908–1917 – Am: 72 zolotniks
Length: 3¹³/₁₆″

Translucent blue-gray enamel panels over *guilloché* sunray pattern, the cover applied with miniature of Czar Nicholas II in crowned diamond-set border; white enamel *guilloché* border set with circular-cut diamonds, outer rose-cut diamond border.

Provenance: Presented by Czar Nicholas II to General Trepov – Given by Queen Mary to King George V on the occasion of his birthday, June 3rd, 1934
Exhibited: Victoria & Albert 1977, no. K 22 – Cooper-Hewitt 1983, no. 194 – Queen's Gallery 1985/86, no. 327

H. M. Queen Elizabeth II of Great Britain

519 Ogee-shaped gold miniature frame

Mm: Fabergé – Wm: Victor Aarne – Hm: St. Petersburg, 1899–1908 – Height: 1³/₄″

Lime-green *guilloché* enamel applied with four-color gold swags suspended from rose-cut diamonds. Oval photograph of Alexandra, Princess of Wales and the daughters of Louise, Duchess of Fife, Alexandra and Maud; mother-of-pearl backing, silver gilt strut.

Exhibited: Victoria & Albert 1977, no. K. 10 Cooper-Hewitt 1983, no. 171 – Queen's Gallery 1985/86, no. 13
Literature: Snowman, 1962/64, ill. 85 – Snowman, 1979, p. 135

H. M. Queen Elizabeth II of Great Britain

520 Rectangular gold miniature frame

Mm: Fabergé – Wm: Victor Aarne – Hm: St. Petersburg, 1899–1908 – Inv: 3740
Height: 1⁷/₈″

Translucent salmon pink enamel over *guilloché* sunray pattern, with a border of white opaque enamel staffs entwined with gold flower swags, each with pearl finials. Oval photograph of Princess Louise in split-pearl border; mother-of-pearl backing, silver gilt strut.

Exhibited: Victoria & Albert 1977, no. K 12 – Cooper-Hewitt 1983, no. 175 – Queen's Gallery 1985/86, no. 16
Literature: Snowman, 1962/64, ill. 85 – Snowman, 1979, p. 135

H. M. Queen Elizabeth II of Great Britain

521 Aedicula-shaped gold miniature frame

Mm: Fabergé – Wm: Victor Aarne – Hm: St. Petersburg, 1899–1908
Inv: 4518
Height: 1¹¹/₁₆″

Scarlet *guilloché* enamel, applied with varicolored gold swags suspended from split pearls; Rectangular photograph of Grand Duchess Serge, born Princess Elizabeth of Hesse and the Rhine, as abbess of the order of St. Martha and Mary.

Exhibited: Victoria & Albert 1977, no. K Cooper-Hewitt 1983, no. 170, Queen's Gallery 1985/86, no. 15
Literature: Snowman, 1979, p. 135

H. M. Queen Elizabeth II of Great Britain

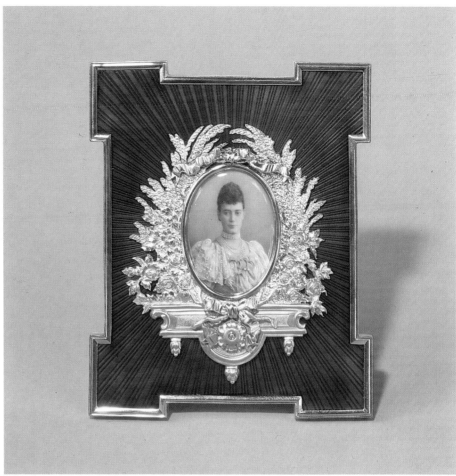

524

522 Shaped gold miniature frame

Mm: Fabergé – Wm: Victor Aarne – Hm: St. Petersburg, 1899–1908
Height: 1¹¹/₁₆"

Translucent aquamarine enamel, applied with four-color gold flower swags suspended from split-pearls. Oval photograph of Princess Maud (1869–1938), Princess Charles of Denmark, later Queen of Norway, in rose-cut diamond border; mother-of-pearl backing with gold strut.

Exhibited: Victoria & Albert 1977, No. K 15
Queen's Gallery 1985/86, no. 15
Literature: Snowman, 1962/64, ill. 85 – Snowman, 1979, p. 135

H.M. Queen Elizabeth II of Great Britain

523 Shaped gold miniature frame

Mm: Fabergé – Wm: Hjalmar Armfelt – Hm: St. Petersburg
Height: 2⁹/₁₆"

Translucent white enamel over *guilloché* sun-

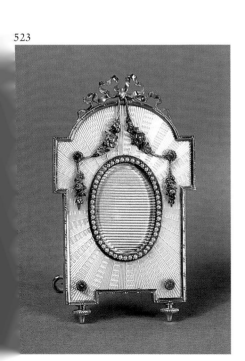

523

ray pattern, applied with four-color gold swags suspended from cabochon rubies; ribbon cresting aperture with split-pearl border, mother-of-pearl backing, silver strut.

H.M. Queen Elizabeth, The Queen Mother

524 Rectangular gold frame

Mm: Fabergé – Wm: Michael Perchin – Hm: St. Petersburg, before 1899
Height: 3³/₄"

Translucent mauve enamel over *guilloché* sunray pattern. Oval miniature of Czarina Marie Feodorovna, flanked by four-color gold sheaves of wheat, flowers and ribbons; ivory backing, silver gilt strut.

Exhibited: Victoria & Albert 1977, no. K. 3
Cooper-Hewitt 1983, no. 174 – Queen's Gallery 1985/86, no. 20
Literature: Bainbridge, 1949/68, pl. 87 – Snowman, 1962/64, ill. 85 – Snowman, 1979, p. 135

H.M. Queen Elizabeth II of Great Britain

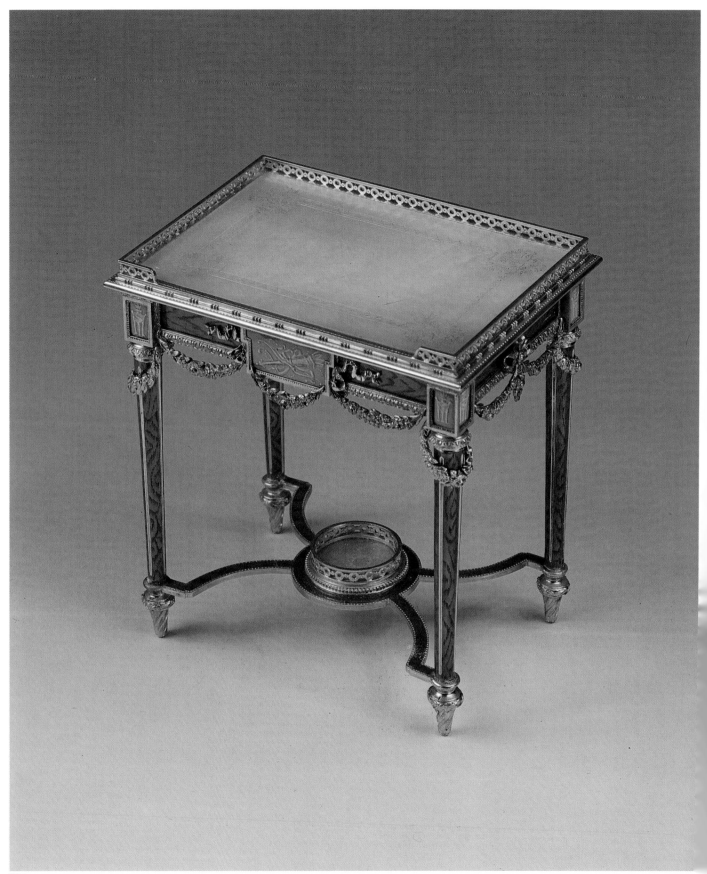

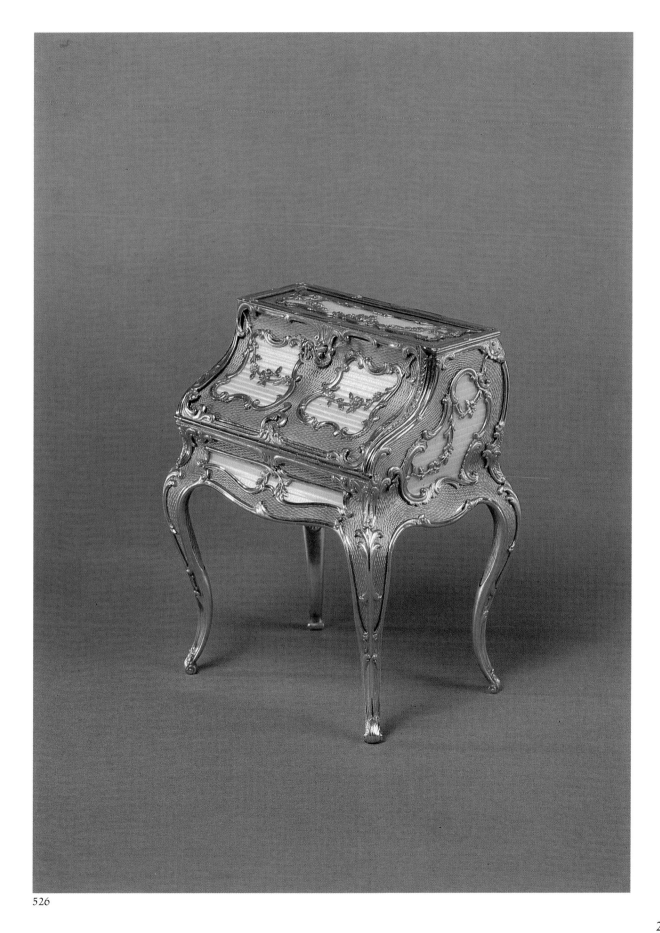

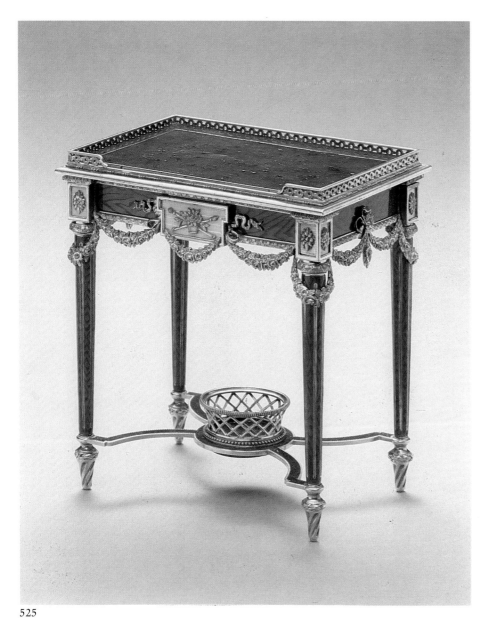

525

525 Gold guéridon table in the Louis XVI style

Mm: Fabergé – Wm: Michael Perchin – Hm: St. Petersburg, 1899–1908
Height: 3¹/₈″
Original fitted case stamped with Iwm, Moscow, St. Petersburg

Nephrite top with gold gallery, the sides and tapering legs in red *guilloché* enamel imitating woodgrain; inset with white *guilloché* enamel panels applied with gold motifs, suspending gold flower swags.

For a similar table in the Collection of H. M. Queen Elizabeth II, cf. cat. 527

Exhibited: Lugano 1987, no. 48

The Forbes Magazine Collection, New York

526 Gold bureau de dame in the Louis XV style

Engraved signature: "Fabergé" – Mm: Fabergé – Hm: St. Petersburg, 1899–1908 – Inv: 12430
Height: 4″

Mauve *guilloché* enamel with inset panels of pale-blue *guilloché* enamel, the mounts with rococo scrolls and foliage, the interior applied in mother-of-pearl; original gold key.

Provenance: Acquired by Leopold de Rothschild at Fabergé's, London, June 12, 1909, for £150.15 s.
Exhibited: Victoria & Albert 1977, no. F 6
Cooper-Hewitt 1983, no. 183 – Queen's Gallery 1985/86, no. 157

H. M. Queen Elizabeth, The Queen Mother

527 Gold guéridon table in the Louis XVI style

Mm: Fabergé – Wm: Michael Perchin – Hm St. Petersburg, 1899–1908
Height: 3⁹/₁₆″

Mother-of-pearl top with gold gallery, the sides and tapering legs in scarlet enamel imitation woodgrain; turquoise panels painted in *camaieu-gris* with Antique motifs

For a similar table in The Forbes Magazine Collection, New York, cf. cat. 526

Exhibited: Victoria & Albert 1977, no. K 4 – Queen's Gallery 1985/86, no. 179
Literature: Snowman, 1962/64, pl. LIV

H. M. Queen Elizabeth II of Great Britain

Easter Eggs

528 Miniature Easter eggs
(from top left to bottom right)

1. purpurine, with diamond-set clover
2. matt gold, set with rubies and diamonds (A. K., St. Petersburg, 1899–1908)
3. purpurine, with diamond-set snake
4. set with rose-cut diamonds and emeralds (St. Petersburg, before 1899)
5. set with diamonds and four cabochon sapphires
6. acorn-shaped, blue *guilloché* enamel and cabochon moonstone (F. Köchli (?), St. Petersburg, before 1899)
7. rose quartz, with rose-cut diamonds (A. K., St. Petersburg, 1899–1908)
8. yellow and white *guilloché* enamel applied with foliage set with diamonds (M. Perchin)
9. rose quartz applied with gold lilies-of-the-valley
10. openwork gold set with diamonds and cabochon rubies
11. openwork gold set with diamonds and three cabochon turquoises (F. Köchli, St. Petersburg, 1899–1908)
12. gold set with diamonds and four cabochon sapphires (E. Schramm, St. Petersburg, 1899–1908)
13. gold egg set with cabochon sapphire, gold knife
14. acorn-shaped facetted topaz applied with diamond-set trelliswork (A. K., St. Petersburg, 1899–1908)
15. bowenite, with rococo gold mount (M. Perchin, St. Petersburg, 1899–1908)
16. opaque white enamel set with four cabochon rubies painted with laurel sprays (A. Hollming, St. Petersburg 1899–1908)
17. ivory enamel studded with gold pellets (M. Perchin, St. Petersburg, 1899–1908)
18. acorn-shaped red *guilloché* enamel, reeded gold mount (M. Perchin)
19. yellow gold set with diamonds and sapphires applied with gold foliage (A. K. St. Petersburg, before 1899)
20. bowenite set with diamonds and rubies (M. Perchin, St. Petersburg, 1899–1908)
21. pink *guilloché* enamel applied with gold, rose set with rose-cut diamond (M. Perchin)
22. yellow gold applied with flowers set with rose-cut diamonds and cabochon emeralds (F. Köchli, St. Petersburg, 1899–1908)
23. yellow gold crossed anchors and crowned inital "A" (A. Thielmann, St. Petersburg, 1899–1908)
24. Acorn-shaped pink *guilloché* enamel, rose-cut diamonds and bowenite (M. Perchin)
25. Pink opalescent enamel decorated with flowers set with rose-cut diamonds and cabochon sapphires (K. Fabergé, Moscow, 1899–1908)

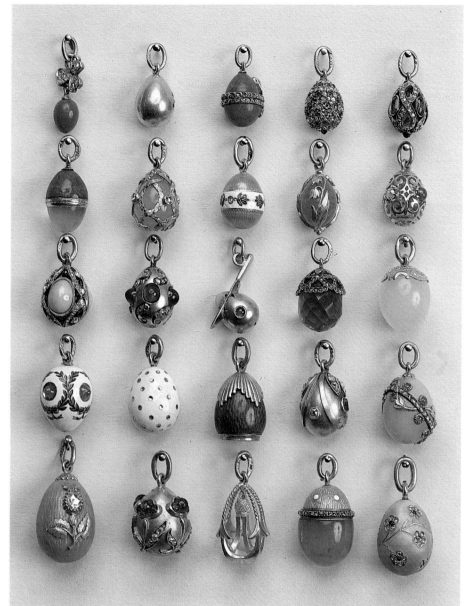

528

529 Gold chain suspending 34 miniature Easter eggs

Of these, the following six are hallmarked:
Gold, set with sapphire and cabochon rubies (E. Schramm)
Gold, white *guilloché* enamel, cabochon sapphire (August Hollming)
Gold crossed anchors with crowned initial "A" (Moscow, 1899–1908)
Turquoise enamel (August Hollming)
Rhodonite (F. Köchli)
Agate (Michael Perchin)

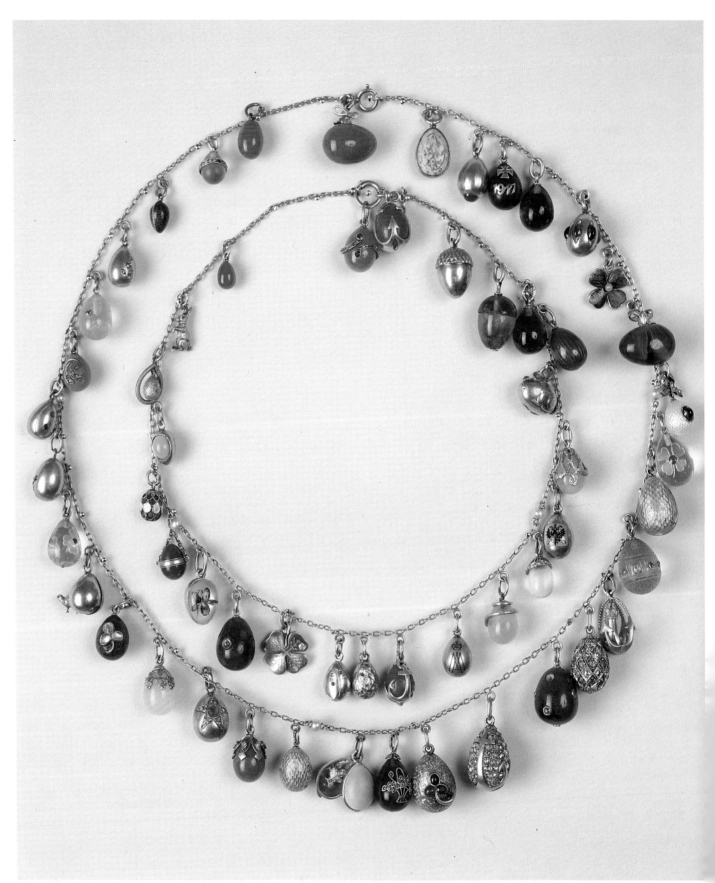

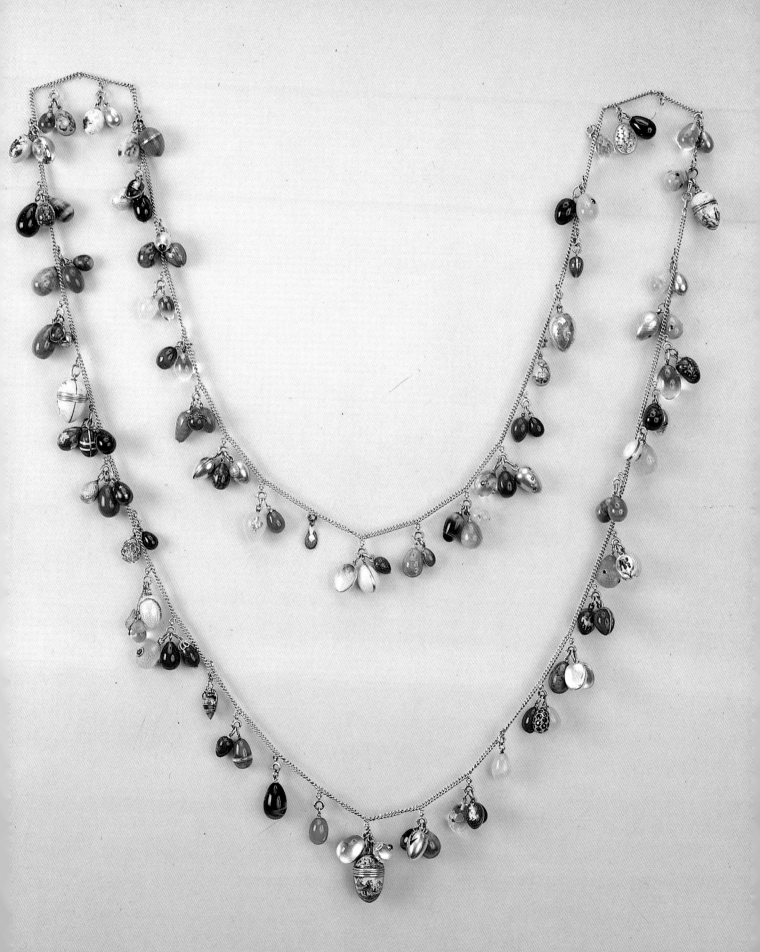

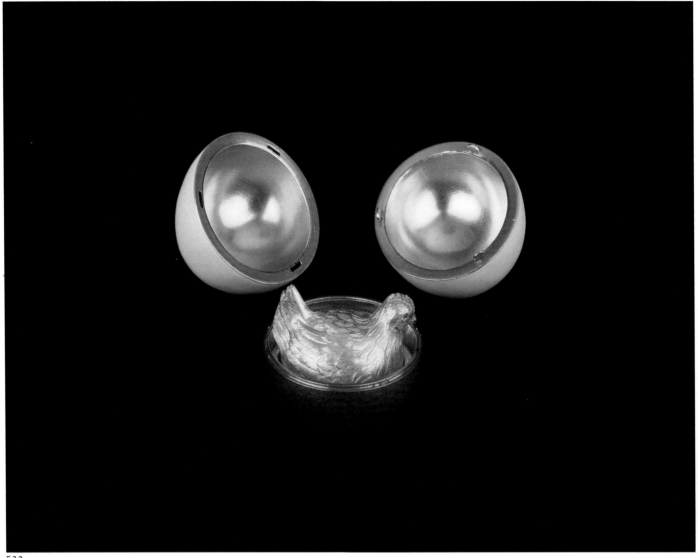

532

530 Gold chain suspending 24 miniature Easter eggs

Of these, the following eight are hallmarked:

Purpurine, with gold anchor (E. Kollin)
Acorn-shaped gold (E. Kollin)
Red *guilloché* enamel (E. Kollin)
Gold mouse with ruby eyes (M. Perchin)
Chalcedony, two-color gold mount (A. Thielemann)
Gold, enameled with Russian flag (W. Reimer?)
Purpurine, with gold anchor (A. Hollming)
Yellow *guilloché* enamel, with rose-cut diamond (E. Kollin)

531 Gold chain suspending 118 miniature Easter eggs

A chain of record length, suspending miniature Easter eggs of varying origins, typical of the way these eggs were worn in Russia.

532 Fabergé's first gold Imperial Easter egg, 1885

Length: 2¹/₂″

The "shell" in opaque white enamel, containing a gold "yolk" which in turn contains in gold chicken naturalistically chased and set with ruby eyes.
The hen originally contained a diamond-set crown with pendant ruby (now lost), cf. Lopato 1984, p. 43

Fabergé's first Easter egg, dated 1885, is traditionally connected with an 18th Century Easter egg in the Danish Royal Collection, Rosenborg Castle, Copenhagen (cat 662). The Rosenborg egg, which contains an enameled gold hen, a diamond-set crown and diamond-set ring, belongs to a mid 18th Century tradition of which at least one further example is known in the Kunsthistorisches Museum in Vienna (cat. 663). This tradition continued well into the 19th Century (cf. cat. 660).

Provenance: Presented by Czar Alexander II to his wife Czarina Marie Feodorovna, 1885 – Lady Grantchester (Christie's, London March 15, 1934, lot 55)

Exhibited: Wartski 1953, no. 156 – Victo

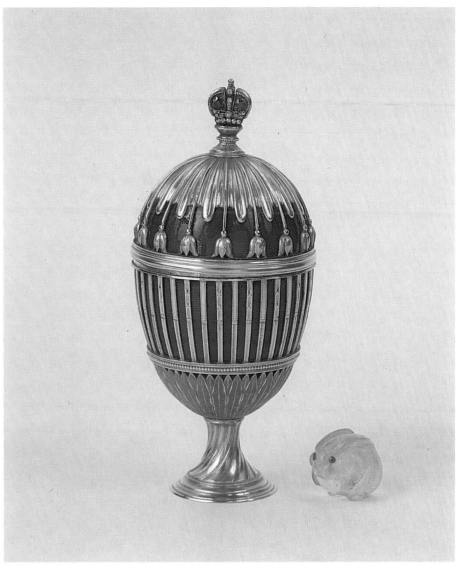

533

ria & Albert 1977, no. 03 – Lugano 1987, no. 116

Literature: Bainbridge, 1933, p. 174 – Bain-bridge, 1949/66, p. 70 – Snowman, 1962/64, ill. 313–6 – Habsburg, 1977, pp. 56, 62, 72 – Waterfield/Forbes, 1978, no. 1 – Habsburg/Solodkoff, 1979, p. 158 – Solod-koff, 1984, p. 54 – Habsburg, 1987, p.79

The Forbes Magazine Collection, New York

533 Enameled gold Imperial Easter egg

Mm: Fabergé – Wm: Michael Perchin – Hm: St.Petersburg, before 1899
Height: 4⁵/₁₆″

Royal blue *guilloché* enamel, applied with vertical gold bands, the cover with lilies-of-the-valley; surmounted by diamond and sapphire-set crown standing on spirally fluted base.

Fabergé's interpretation of an 18th century original in the Hermitage Treasury (cat. 654).

Provenance: According to tradition pre-sented by Czar Alexander III to his wife between 1885 and 1890. Alternatively, pre-sented to the Czarevitch between 1890 and 1894 (cf. p. 94)

Exhibited: Hammer 1951, no. 157

Literature: Snowman, 1962/64, pp. 80–81, ill. 319 – Habsburg/Solodkoff, 1979, p. 159 Solodkoff, 1984, p. 60 – Habsburg, 1987, p.74

Stavros S. Niarchos

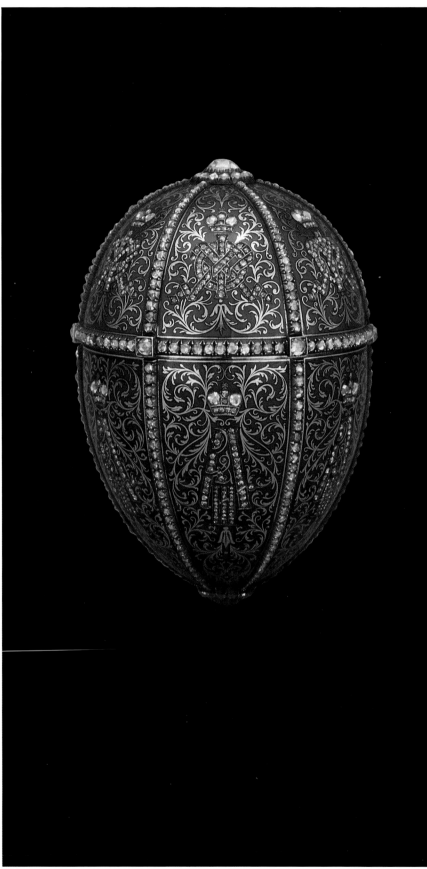

534 Imperial presentation "Monogram Egg"

Mm: Fabergé – Wm: Michael Perchin – Hm: St. Petersburg, before 1899
Height: 3¹/₈″

Gold, the cover and base with six blue *guilloché* enamel panels gilt with scrolls and decorated with Imperial monogram "MF" and "A III", set in rose-cut diamonds within rose-cut diamond borders; a large rose-cut diamond above and below; interior lined with red velvet. The surprise is lost.

Provenance: Presented by Czar Alexander III to his wife Marie Feodorovna, possibly in 1892 for their Silver Wedding Anniversary – Mrs. Herbert May
Exhibited: Hammer 1949, no. 122 – Hammer 1951, no. 163 – A la Vieille Russie 1961, no. 2 – A la Vieille Russie 1983, no. 554
Literature: Snowman, 1962/64, ill. 381 – Ross, 1965, p. 16, col. ill. 2 – Habsburg/Solodkoff, 1979, p. 158 – Solodkoff, 1984, p. 66

The Marjorie Merriweather Post Collection, Hillwood, Washington D.C.

535 Imperial Easter egg with model of the "Pamiat Azova", 1891

Mm: Fabergé – Wm: Michael Perchin – Hm: St. Petersburg, before 1899 – Am: 72 zolotniks
Length: 3¹¹/₁₆″

Gold-mounted jasper shell applied with rococo scrolls partially set with rose-cut diamonds. Opening to reveal a gold and platinum model of the cruiser "Pamiat Azova", set with rubies, standing on gold and aquamarine base.
This Easter egg commemorates the Czarevitch's world tour 1880–91. The model of the cruiser was produced by the workshop of August Hollming (cf. model sketch, p. 57)

Provenance: According to tradition, presented in 1891 by Czar Alexander III to his wife. Alternatively, presented to the Czarevitch (cf. p. 94). Transferred from the Imperial Collection to the Armory, 1927
Exhibited: Paris, 1900, Exposition Universelle (cf. p. 68)
Literature: Chanteclain, 1900, p. 66 f. – Snowman, 1962/64, p. 82, ill. 321 – Catalog of the Armory Moscow, 1964, p. 82, no. 5 – Goldberg, 1967, pp. 202/3 – Rodimtseva

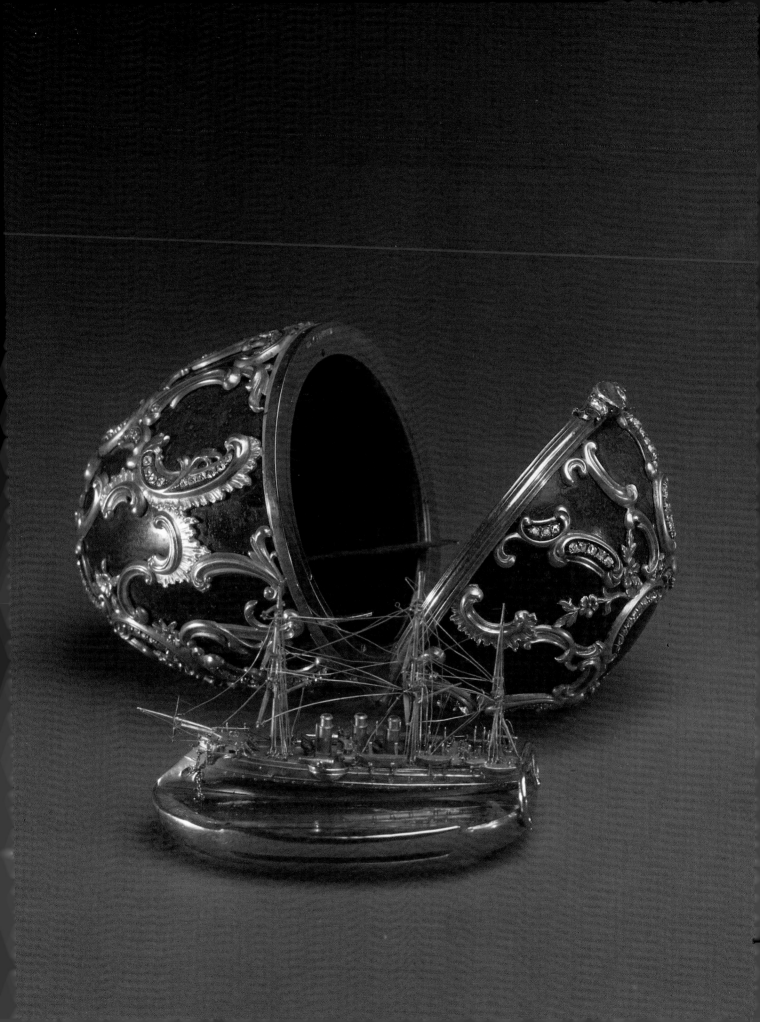

1971, p. 8, ill. 2 – Habsburg/Solodkoff, 1979, p. 157, no. 8 – Snowman, 1979, p. 91 – Solodkoff, 1984, p. 63 – Habsburg, 1987, p. 74

Armory of the Kremlin, Moscow (Inv. MR-645/1–2) (T.N.B.)

536 Imperial "Rosebud Egg", 1895

Mm: Fabergé – Wm: Michael Perchin – Hm: St. Petersburg, before 1899
Length: 2¹⁵/₁₆″

Gold, red *guilloché* enamel, applied with laurel swags suspended from rose-cut diamonds, diamond-set arrows, laurel crowns and diamond-set ribbons, with diamond-set and white opaque enamel borders. Opening to reveal a surprise in the form of a yellow and green enamel rosebud containing a diamond and ruby-set Imperial crown.

Provenance: Presented by Czar Nicholas II, presumably to his wife Czarina Alexandra Feodorovna, 1895 – Charles Parsons – Henry Talbot de Vere Clifton
Exhibited: Belgrave Square 1935, no. 578 – Lugano, 1987, no. 118
Literature: Snowman, 1962/64, pl. 325 – Habsburg/Solodkoff, 1979, p. 162 – Snowman, 1979, p. 97 – C. Forbes, "Fabergé's Imperial Easter eggs in American Collections", *Antiques*, June 1979, CXV, no. 6, p. 1228–41 – Solodkoff, 1984, p. 69 – C. Forbes, "Imperial Treasures", *Art and Antiques*, April 1986, p. 56 and cover

The Forbes Magazine Collection, New York

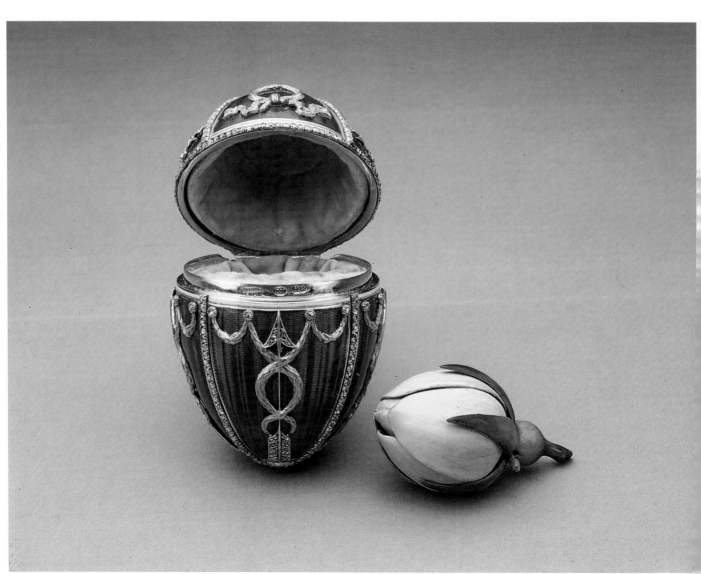

536

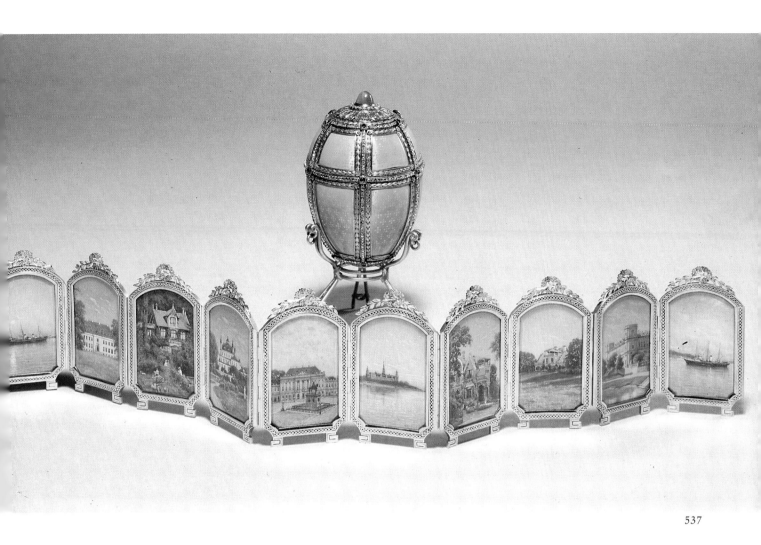

537 Imperial Easter egg with Danish palaces, 1895

Mm: Fabergé – Wm: Michael Perchin – Hm: St. Petersburg, before 1899
Height: $3^{15}/_{16}$"
Fitted velvet case inscribed 1895

Gold, with opalescent pink enamel panels within palm-leaf and diamond-set borders, with cabochon emeralds at the intersections; the cover with cabochon star-sapphire in rose-cut diamond mount. Opening to reveal a ten-leaf gold miniature screen set with miniatures on mother-of-pearl, signed K. Krijitskij, 1891, representing ships and palaces of the Dowager Empress Marie Feodorovna.

No. 1: The yacht "Nordstern"
No. 2: Amalienborg Castle, Copenhagen
No. 3: Hvidøre
No. 4: Fredensborg Castle, the Summer Residence
No. 5: Bernsthorff Castle, Copenhagen
No. 6: Kronborg Castle, Elsinore
No. 7: Alexandria, near Peterhof
No. 8: Gatschina, near St. Petersburg
No. 9: Gatschina Palace, near St. Petersburg
No. 10: The Yacht "Czarevna"

Provenance: Presented by Czar Nicholas II to the Dowager Empress Marie Feodorovna, 1895
Exhibited: Hammer 1937, no. 3 – Hammer 1939 – Hammer 1951, no. 157 – A la Vieille Russie, 1949, no. 129 – Victoria & Albert 1977, no. M 8
Literature: Bainbridge, 1949/68, pl. 65 – Snowman, 1962/64, p. 85, ill. 326 – Grady/ Fagaly, 1972, no. 25 – Habsburg/Solodkoff, 1979, p. 160 – Snowman, 1979, p. 95 – Solodkoff, 1984, p. 70 f.

The Mathilda Geddings Gray Foundation Collection, New Orleans

538 The Imperial "Renaissance Egg", 1894

Mm: Fabergé – Wm: Michael Perchin – Hm: St. Petersburg, before 1899
Length: 5¹/₂"
Original gray velvet fitted case

Gray agate, mounted in gold, the cover applied with white enamel trelliswork and rose-cut diamonds, with diamond-set date 1894 on oval red *guilloché* enamel medallion; with two lions-head handles suspending gold rings; red *guilloché* enamel mounts to lip; oval base with green stiff leaves and gold husks on white enamel ground.
Fabergé's copy of an original retailed by Le Roy and dating from the early 18th century, in the Grünes Gewölbe, Dresden (cf. cat. 661)

Provenance: Presented by Czar Alexander III to his wife Marie Feodorovna, 1894 – Armand Hammer, New York – Henry Talbot de Vere Clifton – Mr. and Mrs. Jack Linsky, New York
Exhibited: Hammer 1939 – A la Vieille Russie 1949, no. 123 – Hammer 1951, no. 26 – A la Vieille Russie 1961, no. 292 San Francisco 1964, no. 148 – Victoria & Albert 1977, no. L 15 – Lugano 1986, no. 117.
Literature: Bainbridge, 1933, (illustrated) – Bainbridge, 1949/68 pl. 63 – Snowman, 1962/64, pl. LXXII – Habsburg, 1977, p. 61 – Waterfield/Forbes, 1978, no. 4 – Habsburg/Solodfkoff, 1979, pl. 137 – Snowman, 1979, p. 94 – Solodkoff, 1984, p. 68 – Habsburg, 1987, p. 76

The Forbes Magazine Collection, New York

539 Imperial "Coronation Egg", 1897

Wm: Michael Perchin – Hm: St. Petersburg, before 1899
Length: 5"

Gold, with panels of translucent primrose enamel over *guilloché* sunray pattern; applied with laurel-leaf bands, with black enamel double-headed eagles at intersections, each set with a rose-cut diamond, the cover applied with monogram of "AF" (in Russian) under table-cut diamond. The interior with gray velvet lining contains a miniature replica of the Coronation coach in gold, red *guilloché* enamel and diamonds.
Arguably Fabergé's most celebrated creation, signed by Perchin and inscribed by Wigström. The color scheme of this egg is based on the coronation robes of Czar Nicholas II. The replica of the Coronation coach was made by George Stein.

Provenance: Presented by Czar Nicholas II to his wife, Czarina Alexandra Feodorovna, 1897 – Wartski, London
Exhibited: Belgrave Square 1935, no. 586 – Wartski 1949, no. 6 – Victoria & Albert 1977, no. 01 – Lugano 1987, no. 119

538

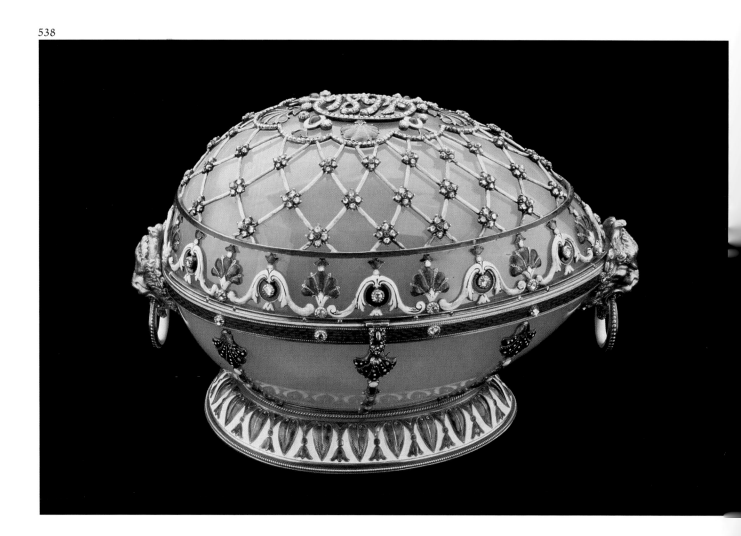

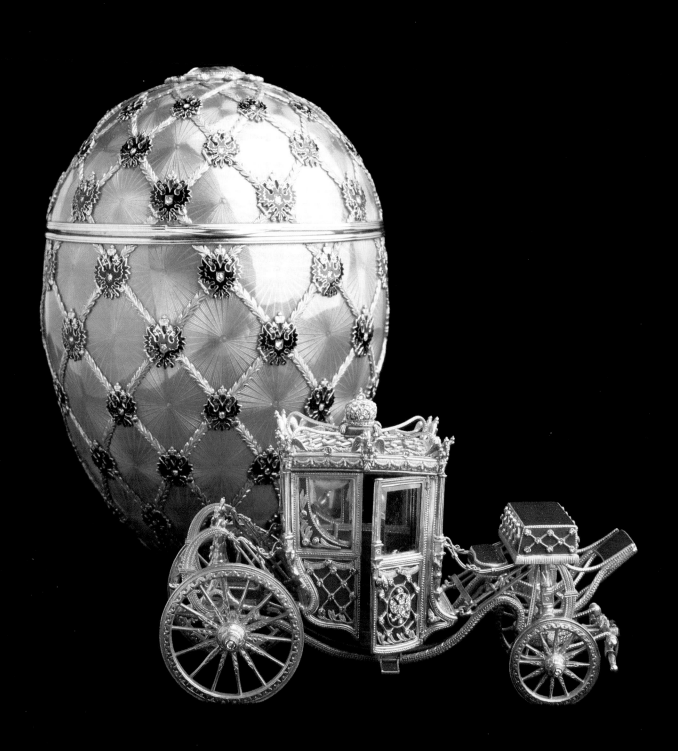

Literature: Bainbridge, 1949/66, pl. 89 – Snowman, 1962/64, color ill. LXXIII, p. 86 – Habsburg/Solodkoff, 1979, p. 162 – Snowman, 1979, p. 97

The Forbes Magazine Collection, New York

540 Imperial Easter egg with Trans-Siberian Express, 1900

Mm: Fabergé – Wm: Michael Perchin – Hm: St. Petersburg, 1899–1908
Height of egg: $10^1/_4$" – Length of train: $15^{11}/_{16}$"

White silver band engraved with a map of Russia from Moscow to Vladivostok, showing the stations of the Trans-Siberian railway, inscribed: "Great Siberian railway, 1900". The cover and base of green *guilloché* enamel applied with motifs in the Old Russian style in yellow and blue *guilloché* enamel; the cover surmounted by a crowned triple Imperial eagle. Standing on a triangular shaped onyx base, with three griffons each holding a shield and a sword. The velvet-lined interior contains a clockwork miniature replica of the Trans-Siberian Express in gold and platinum, with diamond-set head lamps and ruby-set rear lamps. The last coach is the Imperial Chapel, other coaches are inscribed: "For smokers" or "Ladies only".

Provenance: Presented by Czar Nicholas II to his wife, 1900 (the Trans-Siberian railway line was inaugurated in the same year) – Transferred from the Imperial Collection to the Armory 1927
Exhibited: Paris 1900, Exposition Universelle – Mexico 1892, no. 50 – Florence 1982, no. 49 – Belgrade 1985, no. 152
Literature: Snowman, 1962/64, p. 91, ill. 336 Catalog of the Armory, Moscow 1964, p. 168 – Goldberg, 1967, pp. 61, 139, 202/3 – Rodimtseva, 1971, p. 15 – Habsburg/Solodkoff, 1979, p. 157, no. 40 – Snowman, 1979, p. 102 – Solodkoff, 1984, pp. 82, 83

Armory Museum, Moscow (Inv. M.R. 646/1–3) (T.N.B.)

541 Imperial Easter egg with Gatchina Palace, 1901

Wm: Michael Perchin – Hm: St. Petersburg, 1899–1908
Height: $4^{15}/_{16}$"

Gold, opalescent white enamel panels over *guilloché moiré* ground painted with red rib-

bons, green laurel sprays and trophies, applied with bands of split pearls. The interior containing a miniature replica of Gatchina Palace in four-color gold.
One of Fabergé's most endearing creations. The replica of the castle is faithful to the very last detail.
Gatchina Palace was the favorite residence of Dowager Empress Marie Feodorovna.

Provenance: Presented by Czar Nicholas II to his mother, Dowager Empress Marie Feodorovna, 1901 – Henry Walters, Baltimore
Exhibited: 1902 at a Charity Bazaar, St. Petersburg – Hammer 1949, no. 12 – Hammer 1951, no. 172 – Victoria & Albert, no. M 20 – A la Vieille Russie 1983, no. 559
Literature: Niva, 1902, p. 234 – Ross, 1952, p. 4 and dustcover – Snowman, 1962/64, ill. 339 f. – Habsburg, 1977, pl. 50 – Habsburg/Solodkoff, 1979, ill. 131 – Snowman, 1979, p. 101 – Solodkoff, 1984, p. 86

The Walters Art Gallery, Baltimore

542 Imperial "Napoleonic" Egg, 1912

Mm: Fabergé – Wm: Henrik Wigström
Hm: St. Petersburg, 1908–1917
Height: $4^5/_8$"

Gold with green *guilloché* enamel panels applied with gold double-headed eagles and trophies of war within rose-cut diamond borders and laurel-leaf bands; a table-cut diamond above, over monogram of "MF"; a table-cut diamond beneath over date "1912". The interior fitted in gray velvet containing a six-leaf enameled and diamond-set gold miniature frame, each panel painted with figures from the favorite regiments of Empress Marie Feodorovna, signed Zuiev, in rose-cut diamond frames with green enameled laurel-leaf exteriors. The reverse with octagonal white *guilloché* enamel panels, green *guilloché* enamel discs applied with diamond-set crowned monogram of "MF".
The date of this egg, 1912, and the martial symbols, point to a connection with the 100th anniversary festivities of the victory at Borodino, 1812 over Emperor Napoleon.

Provenance: Presented by Czar Nicholas II to Dowager Empress Marie Feodorovna, 1912
Exhibited: Hammer 1937, no. 8 – Hammer 1939 – Hammer 1951, no. 160 – Victoria & Albert 1977, no. o 26
Literature: Snowman, 1962/64, p. 103, ill.

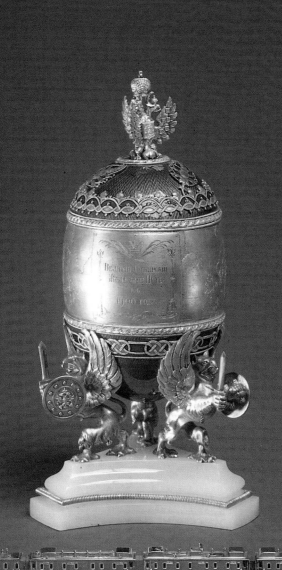
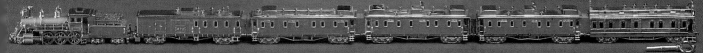

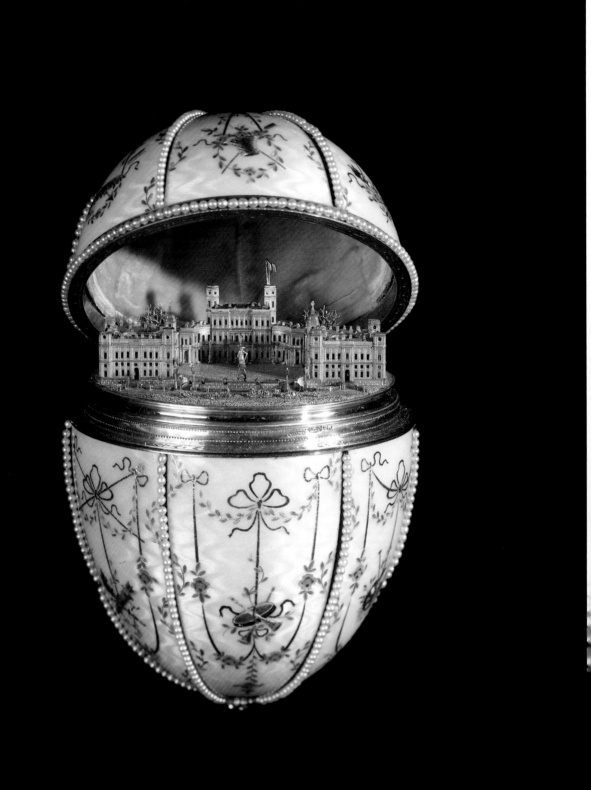

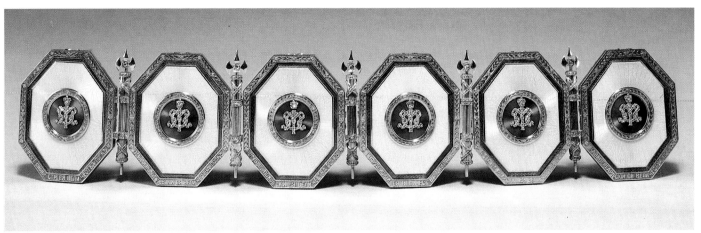

542

542

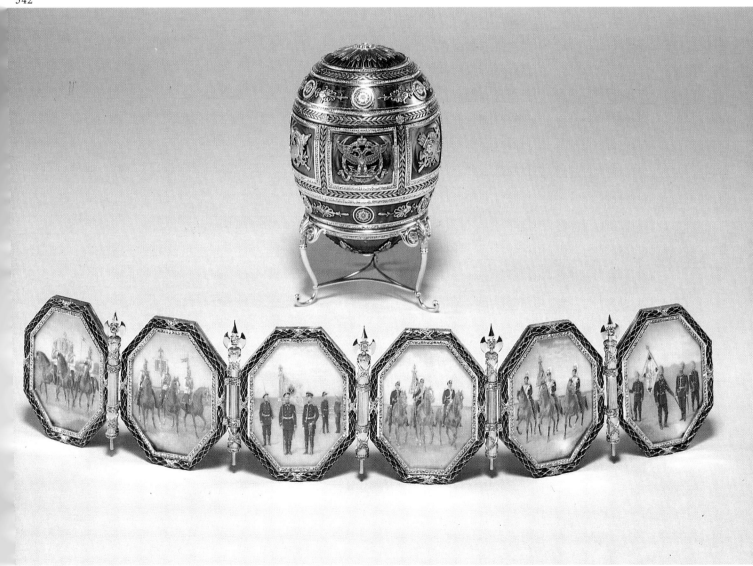

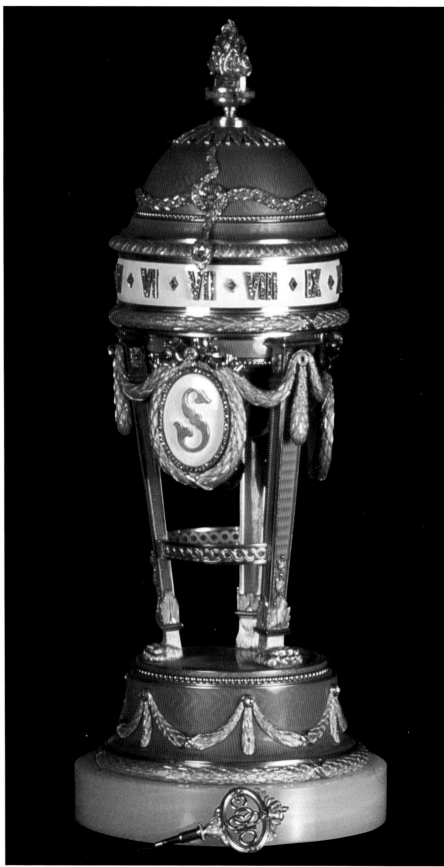

370–327 – Grady/Fagaly, 1972, no. 26 – Habsburg/Solodkoff, 1979, ill. 132 – Snowman, 1979, p. 110 – Solodkoff, 1984, p. 98 and 99

The Matilda Geddings Gray Foundation Collection, New Orleans

543 The Youssoupov Easter Egg, 1907

Mm: Fabergé – Wm: Henrik Wigström
Hm: St. Petersburg, 1899–1908
Height: 9⅝"
Original fitted case stamped with Iwm, St. Petersburg, Moscow, Odessa

Gold and raspberry enamel table-clock in the Louis XVI style, the revolving opaque white enamel dial set with diamond-set Roman numerals; standing on three pilasters and lion-paw feet, suspending laurel swags and three oval medallions chased with gold letters "M", "Y", "S" within rose-cut diamond borders. Raspberry *guilloché* enamel base applied with laurel swags suspended from rose-cut diamonds; circular onyx plinth. The domed cover applied with diamond-set snake and surmounted by a gold vase. The eight-day movement signed Hy. Moser, Le Locle.

Provenance: Presented by Prince Felix Youssoupov to his wife Zenaïde on the occasion of their 25th anniversary. The medallions originally contained miniatures of Prince Felix Youssoupov and his two sons Nicholas and Felix. For another object presented on the same occasion, cf. cat. 515
Literature: Bainbridge, 1949/68, pl. 5 (showing original miniatures) – Snowman, 1962/64, pl. 390/393 – Habsburg/Solodkoff, 1979, pl. 140

Collection Maurice Y. Sandoz

544 Imperial Mosaic Egg, 1914

Engraved signature: "C. Fabergé"
Engraved signature on miniature stand: "G. Fabergé, 1914"
Height: 3⅝"

Platinum mesh exterior, set with a profusion of calibrated rubies, emeralds, sapphires, diamonds, topazes, quartzes and garnets; with oval panels imitating *petit point* within opaque white enamel and split-pearl borders. The hinged cover with moonstone over monogram "AF" (Russian). Opening to reveal a jeweled and enameled gold miniature frame painted with the profiles in *camaïeu-*

543

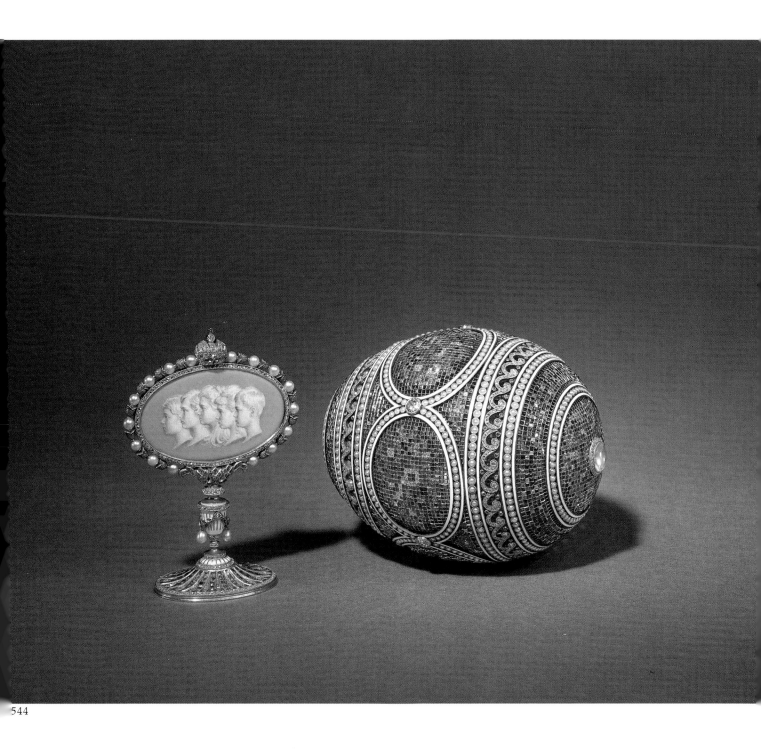

544

…run of the five Imperial children on opalescent pink enamel background, within a border of green enamel husks and pearls, surmounted by a diamond-set Imperial crown. The reverse enameled with the names of the Imperial children, a vase of flowers and date, 1914. The oval base set with diamonds and emeralds, vase-shaped white enamel stem set with diamonds and pearls.

The oval panels of this egg are based on an embroidery by Alma Theresia Pihl (1888–1976). The central motif is recorded in Fabergé's sketch books from the workshop of Albert Hollming (cf. p. 53).

Provenance: Presented by Czar Nicholas II to his wife Alexandra Feodorovna, 1914 – Acquired by King George V and Queen Mary, 1934

Exhibited: Victoria & Albert 1977, no. F 5

Cooper-Hewitt 1983, no. 105 – Queen's Gallery 1985/86, no. 79

Literature: Bainbridge, 1949/68, pl. 55 and 51 (frame) – Snowman, 1962/64, pl. LXXIX, LXXX – Habsburg, 1977, p. 83 – Habsburg/Solodkoff, 1979, pl. 136 – Snowman, 1979, p. 115 – Helsinki 1980, cat. p. 50 – Solodkoff, 1984, p. 100

H. M. Queen Elizabeth II of Great Britain

Fabergé's Competitors

SILVER

545 Eagle-shaped stirrup cup

Mm: E.S. – Hm: St. Petersburg, before 1899
Height: 4$\frac{1}{2}$"

Naturalistically chased harpy eagle's head with plain silver lip, engraved "1 April 1895" with the crowned monogram "W".

Provenance: Kaiser Wilhelm II (1859–1941)

546 Art nouveau cigarette-case

Mm: Bolin – Wm: K.L. – Hm: Moscow, before 1899
Length: 3$\frac{9}{16}$"

Chased on both sides with acanthus foliage; cabochon emerald pushpiece.

Literature: Habsburg/Solodkoff, 1979, ill. 144

547 Reeded silver gilt cigarette-case

Mm: I. Marshak – Hm: Kiev, 1908–1917
Length: 3$\frac{3}{4}$"

548 Art nouveau tea glass

Mm: S.A. (Samuel Arndt) – Hm: Moscow, before 1899
Height: 4$\frac{1}{2}$"

Tea glass applied with silver gilt water-lilies and leaves.

549 Danish royal tea and coffee service, 1867

Iwm: Sazikov
Hm: St. Petersburg, 1867

Eleven items comprising samovar, stand and tray, coffee and teapot, sugar bowl, cream jug, marmalade bowl, sieve, sugar tongs and tray. Each item parcel gilt and decorated in the Old Russian style with strapwork, rosettes and inscriptions, surmounted by an Imperial crown. The inscriptions, in Danish, read: "To our beloved Danish Royal Couple for their Silver Anniversary on May 26, 1867 from the Czarevitch of Russia and his wife".

Provenance: Presented by the Czarevitch Alexander and Czarevna Marie Feodorovna to the Czarevitch's parents, King Christian IX of Denmark and Queen Louise

H.M. Queen Margrethe II of Denmark

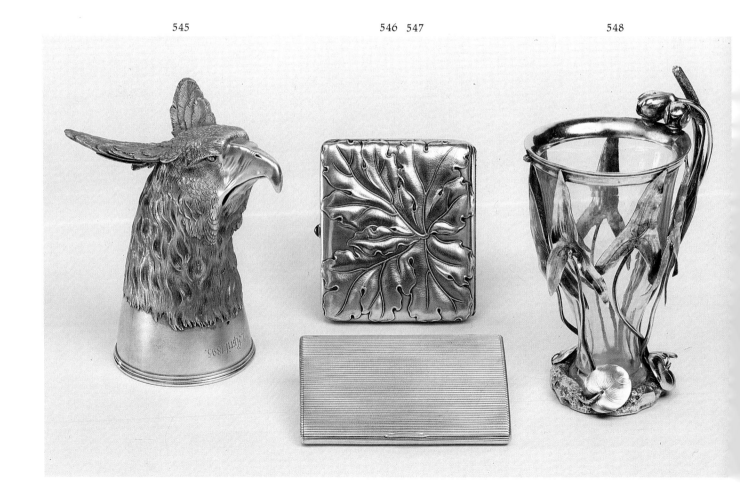

545 546 547 548

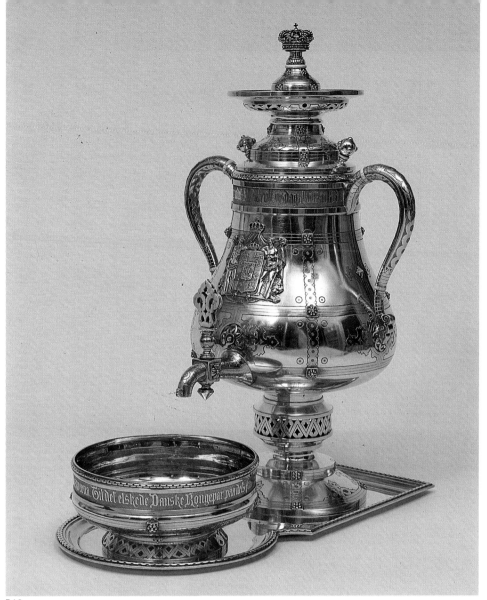

549

549

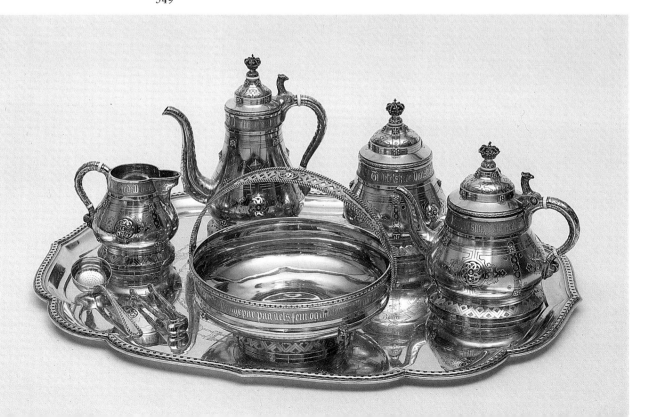

CLOISONNÉ ENAMEL

550 Perfume bottle

Mm: NA
Height: 5^1/$_8$"

Panels of shaded *cloisonné* enamel foliage on cream and brick red backgrounds; turquoise and white enamel borders.

551 Kovsh and serving spoon

Mm: Ivan Saltikov – Hm: Moscow, 1899–1908
Length: 9^7/$_{16}$"

Stylized, shaded *cloisonné* enamel foliage on brick red ground, the front with stylized double-headed eagle.

552 Three-handled vase

Mm: Fedor Rückert – Hm: Moscow, 1907–1917 – Inv: 9125
Height· 3"

Pear-shaped panels of shaded *cloisonné* enamel foliage, griffons and flowers on cream, turquoise and olive-green grounds.

553 Cloisonné and plique-à-jour enamel teacup and saucer

Mm: Gratchev – Wm: AP (Russian) – Hm: Moscow, before 1899

Unusual decoration of *plique-à-jour* fishes and bullrushes on pale-blue *cloisonné* enamel background.

554 Teacup and saucer

Mm: Vassili Agafanov – Hm: Moscow, 1899–1908
Diameter of saucer: 4^3/$_4$"

Panels of shaded *cloisonné* enamel flowers on turquoise and white backgrounds.

555 Cigar-box

Mm: Fedor Rückert – Hm: Moscow, 1908–1917
Length: 3^9/$_{16}$"

The cover painted en plein with a troika scene; the cover and sides with art nouveau *cloisonné* enamel geometric motifs on olive-green, brown, blue and gray grounds.

556 Kovsh

Mm: Fedor Rückert – Hm: Moscow, 1899–1908
Length: 3^{15}/$_{16}$"

The interior with a shaded *cloisonné* enamel bird on olive-green background; turquoise borders decorated with shaded *cloisonné* enamel foliage; roped border and fleur-de-lys handle.

550 551 552

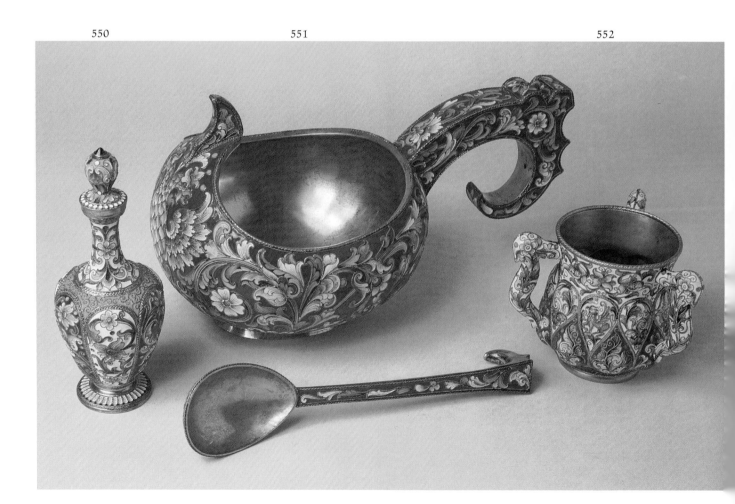

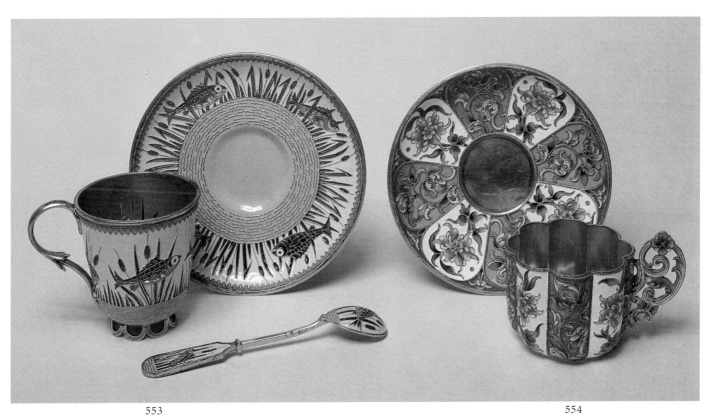

553 554

555 556

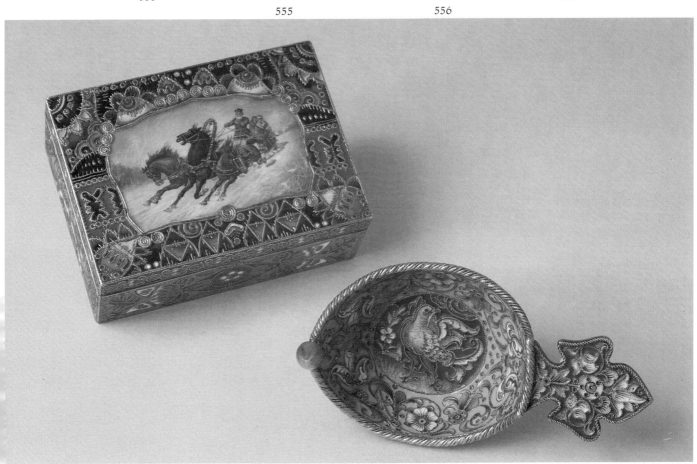

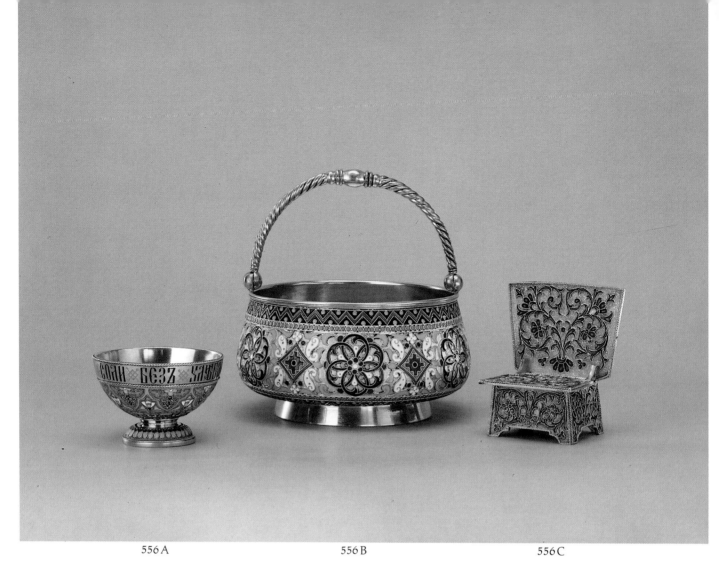

556 A 556 B 556 C

556 A Salt cellar

Mm: P. Ovchinnikov – Hm: Moscow, 1878
Am: 91 zolotniks
Diameter: 2³/₁₆″

Traditional decoration in the Old Russian style, the lip with *champlevé* enamel inscription.

556 B Marmalade bowl

Iwm: P. Ovchinnikov – Hm: Moscow, 1891
Diameter: 3¹³/₁₆″

Cloisonné enamel decoration of green rosettes, blue and red lozenges, turquoise and dark blue enamel borders; swing handle and engraved inscription "1873–1891".

556 C Throne-shaped salt cellar

Mm: Gratchev – Wm: AD – Hm: St. Petersburg, before 1899
Height: 2¹/₂″

Cloisonné and *plique-à-jour* enamel decoration of blue and red scrolled foliage.

557 Presentation charger and salt cellar

Iwm: P. A. Ovchinnikov – Hm: Moscow, 1894
Diameter of charger: 21″

Decorated in the Old Russian style with scrolled foliage in turquoise and dark blue *cloisonné* enamel, the center applied and enameled with a crowned Danish royal coat-of-arms and an inscription. The salt cellar on three ball feet, its cover surmounted with the coat-of-arms of the City of St. Petersburg.

Provenance: Presented by the Mayor and the Council of St. Petersburg to King Christian IX on the occasion of his visit in Russia for the burial of Czar Alexander III and the accesion to the throne of Nicholas II

H. M. Queen Margrethe II of Denmark

558 Enameled charger and salt cellar, 1894

Iwm: Gratchev – Hm: St. Petersburg, 1894
Diameter of charger: 16⁷/₈″

The center engraved with the Danish and Russian coats-of-arms and with presentation inscription, applied with the crowned monogram "C IX". The border decorated in the Old Russian style with scrolling foliage and strapwork in dark blue and turquoise *cloisonné* enamel.

Provenance: Presented by Priory Councillor W. de Ratkov Roinov and Chamberlan P. Glonkkonski to King Christian IX on the occasion of his visit to Russia for the burial of Czar Alexander III and the accession to the throne of Nicholas II.

H. M. Queen Margrethe II of Denmark

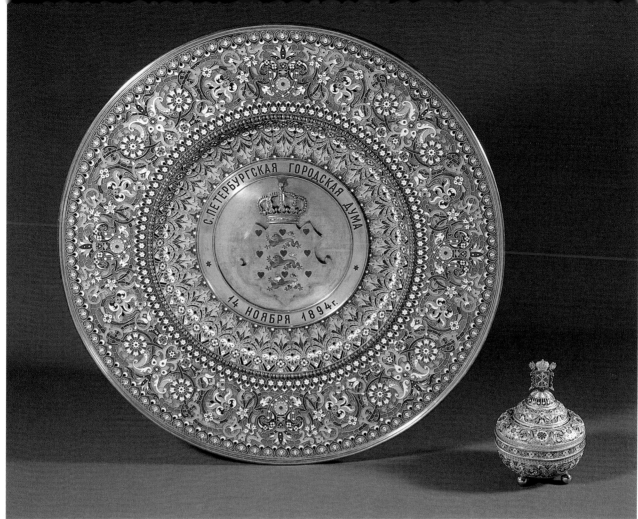

557

558

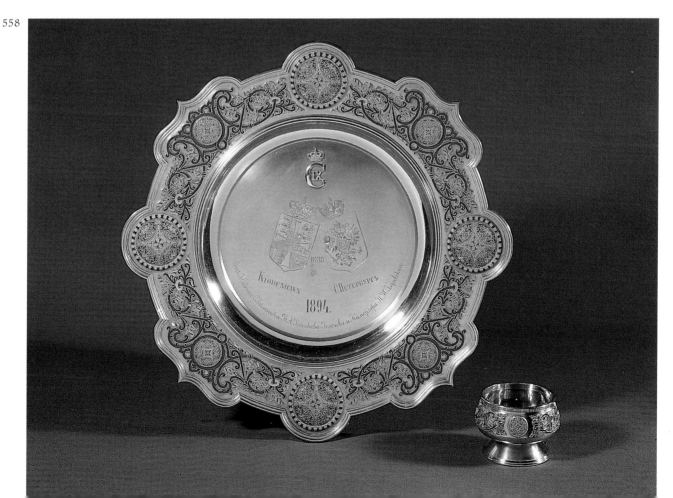

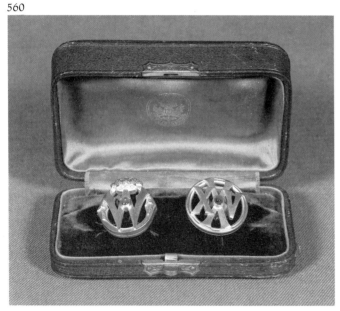
559

JEWELRY

559 Pair of jeweled and enameled gold studs

Wm: (Russian) S.W. (workmaster of K. Hahn)
Diameter: $1^1/_8"$

Set with photographs of Czar Nicholas II and Czarina Alexandra Feodorovna, within diamond-set borders; outer turquoise *guilloché* enamel border.

H.M. Queen Margrethe II of Denmark

560 Pair of gold cuff links

Wm: A.W.
Original red morocco case stamped Fz. Butz, St. Petersburg

Chased and engraved with crowned monogram "W" and Roman numeral "XXV", with cabochon sapphire and ruby.

Provenance: King George I (born Prince William of Denmark, 1845–1913) and Queen Olga of Greece (1851–1926), probably presented on the occasion of their Silver Anniversary

H.M. Queen Margrethe II of Denmark

560

562

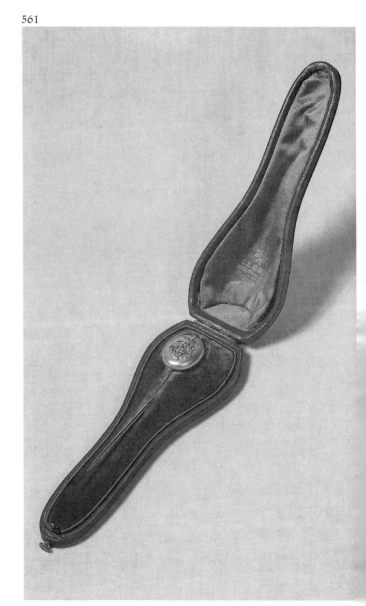
561

561 Gold tie pin

Wm: C. A. – Hm: St. Petersburg
Original fitted case stamped with Iwm, C. E. Bolin, Joaillier de la Cour, St. Petersbourg

Oval gold medallion applied with diamond and ruby-set crowned monogram "WO".

Provenance: King George I and Queen Olga of Greece. Probably presented on the occasion of their Silver Wedding Anniversary

H. M. Queen Margrethe II of Denmark

562 Gold tie pin

Original fitted case stamped with Iwm, C. E. Bolin, Joaillier de la Cour, St. Petersbourg

Entwined ribbon-shaped top set with a child's milk tooth.

H. M. Queen Margrethe II of Denmark

563 Jeweled gold brooch in the shape of a Monomakh's crown

Wm: R. Schven (workmaster of Bolin)
Height: 3¹/₄"

Set with two cabochon star rubies and rose-cut diamonds (cf. cat. 564).

Provenance: Presented by Czar Nicholas II on the occasion of the Romanov Tercentenary, 1913

564 Jeweled gold heart-shaped pendant

Wm: R. Shven – Hm: St. Petersburg, before 1899
Height: 3"
Original fitted case stamped with Iwm, C. Bolin, St. Petersburg, Moscow

Set with circular-cut diamonds, rose-cut diamonds and a half pearl; suspending three pearls.

Provenance: Queen Louise of Denmark (1843–1912), wife of King Frederick VIII

565 Jeweled gold bracelet

Wm: A. K. – Hm: St. Petersburg, before 1899
Original fitted case stamped with C. Nicholls Ewing, 4 Perspective de Nevsky, St. Petersbourg

Yellow-gold link bracelet with cabochon sapphire within circular-cut diamond surround.

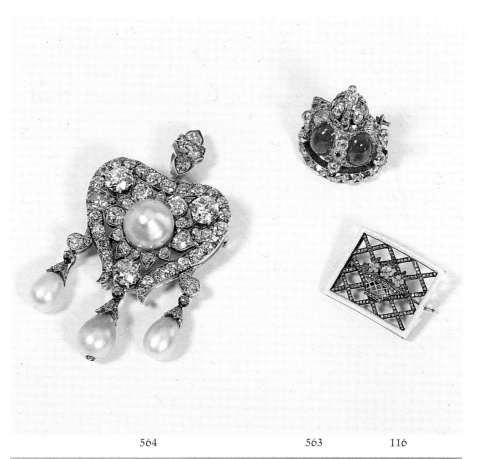

564 563 116

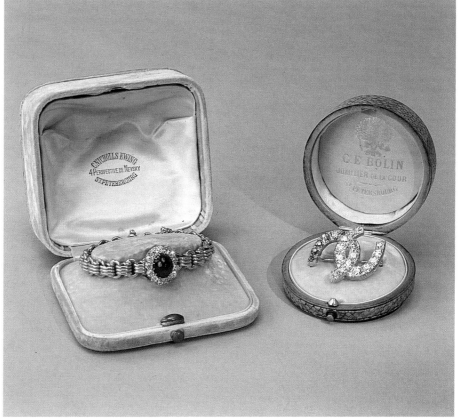

565 566

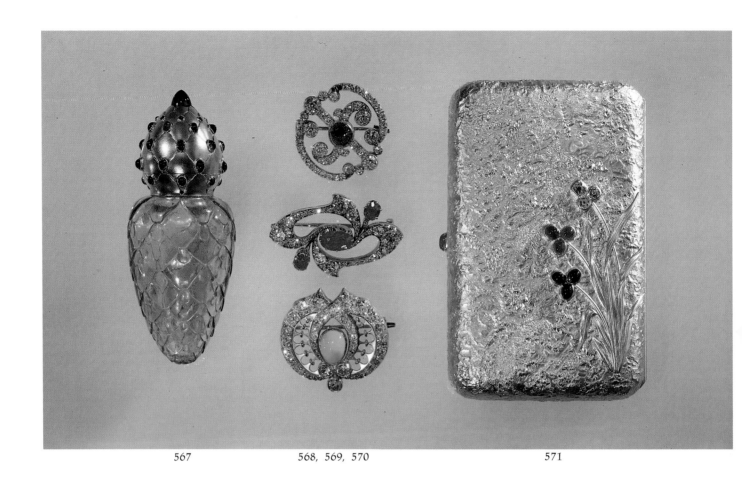

567 568, 569, 570 571

566 Gold-mounted diamond-set brooch in the shape of two horseshoes

Wm: W.S. (in Russian)
Width: 1³/₈″
Original fitted shagreen case stamped with Iwm, C.E. Bolin, Joaillier de la Cour, St. Petersbourg

One horseshoe set with white circular-cut diamonds, the other with yellow circular-cut diamonds.

Provenance: Acquired in St.Petersburg at Bolin's in 1883

567 Pine cone smoky quartzshaped perfume flask

Mm: F✳K (Friedrich Köchli), and engraved Iwm –
Hm: St.Petersburg, before 1899
Height: 3″

The flask naturalistically carved, the cover similarly decorated in matt gold, set with cabochon sapphires.

568 Gold-mounted jeweled brooch

Mm: F✳K (Friedrich Köchli)
Hm: St.Petersburg, before 1899
Length: 1¹/₁₆″

Central cabochon sapphire, S-shaped scrolls and outer border set with rose-cut diamonds and circular-cut diamonds.

569 Gold-mounted jeweled brooch

Mm: F✳K (Friedrich Köchli)
Hm: St.Petersburg, before 1899
Length: 1³/₈″

Of double scroll shape, set with three oval rubies and circular-cut diamonds.

570 Gold-mounted jeweled brooch

Mm: F✳K (Friedrich Köchli)
Hm: St.Petersburg, before 1899
Height: 1¹/₄″

Two pear-shaped motifs with central cabochon turquoise and circular-cut diamonds.

573

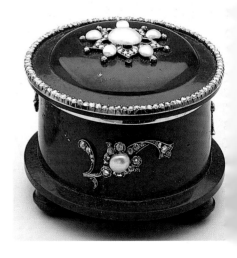

571 Jeweled gold cigarette-case

Mm: F✳K (Friedrich Köchli)
Hm: St. Petersburg, before 1899
Length: 3$^1/_2$"
Original fitted case stamped Fred. Köchli,
Rue aux Pois no. 17, St. Petersbourg

Samorodok gold, chased with bullrushes,
set with three cabochon sapphires, three
cabochon rubies and three circular-cut
diamonds; cabochon ruby pushpiece.

OBJECTS IN HARDSTONE

572 T-shaped nephrite cane handle

Mm: A.T. (Alexander Tillander)
Hm: St. Petersburg, before 1899
Length: 3$^{15}/_{16}$"

Gold mount, in the shape of two entwined
snakes with cabochon ruby heady; *guilloché*
band with beaded borders, ill. p. 156

573 Circular lapis lazuli box

Mm: F✳K (Friedrich Köchli)
Hm: St. Petersburg, before 1899
Height: 1$^7/_8$"
Fitted box stamped with Iwm K. Fabergé,
St. Petersburg, Moscow

Gold-mounted, standing on three stud feet,
applied with flowers set with pearls and rose-
cut diamonds; rose-cut diamond borders.

Provenance: Grand Duchess Xenia of Russia
Exhibited: A la Vieille Russie 1983, no. 157

574 Rhodonite pectoral

Mm: K. Hahn – Wm: SW (Russian)
Hm: St. Petersburg, before 1899
Height with pendant: 6$^5/_{16}$"
Chain, Wm: AK
Original fitted red morocco case stamped:
"Deposit of the Imperial Cabinet", applied
gilt double-headed eagle

Gold-mounted, the borders set with split
pearls, with diamond-set gold rays at inter-
sections; gold figure of Christ.
Example of Hahn's work for the Imperial
Cabinet.

Bayerisches Nationalmuseum, Munich (Inv.
7/40–118)

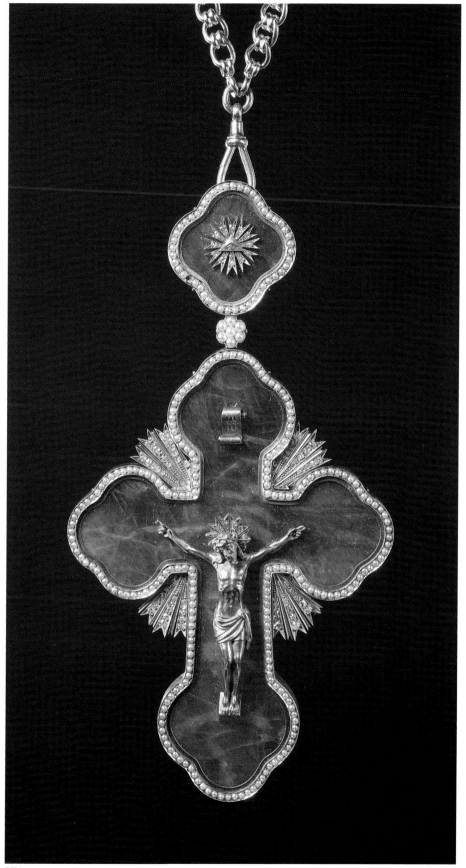

574

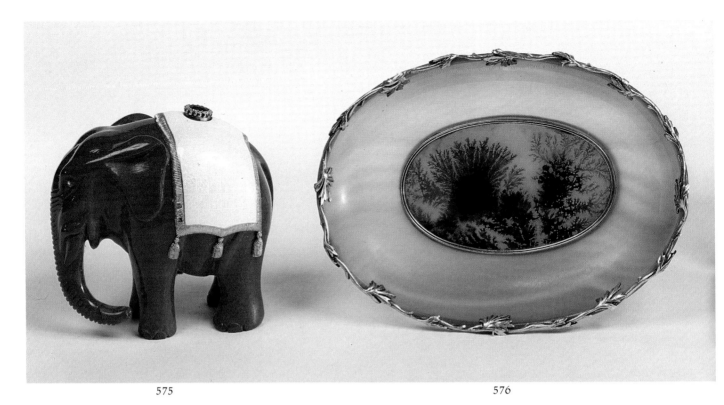

575

576

575 Purpurine elephant-shaped bellpush

Mm: (Russian) IB (Ivan Britzin)
Hm: 1908–1918
Height: $2^7/_8$"

Purpurine elephant with rose-cut diamond eyes and silver gilt and white *guilloché* enamel saddle-cloth; sapphire pushpiece in rose-cut diamond mount.
Proof of the use of purpurine by stone carvers other than Fabergé.

576 Oval agate bowl

Signed "F. Boucheron"
Length: $4^3/_4$"

Banded agate with chased silver gilt border and moss agate center.

577 Chalcedony fish

Length: $1^{11}/_{16}$"
Original fitted case stamped "A. I. Sumin Nevski-Prospekt 60"

Oviform stylized fish carved from gray chalcedony.
Rare example of an animal by a Fabergé competitor in its original imitation Fabergé case.

578 Rhodonite owl

Attributed to Sumin
Height: $5/_8$"

Oviform rhodonite owl with olivine eyes.

577

578 579 580 582 581 583 584

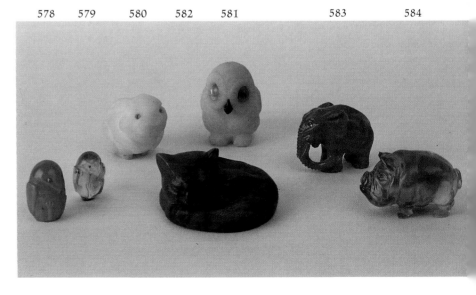

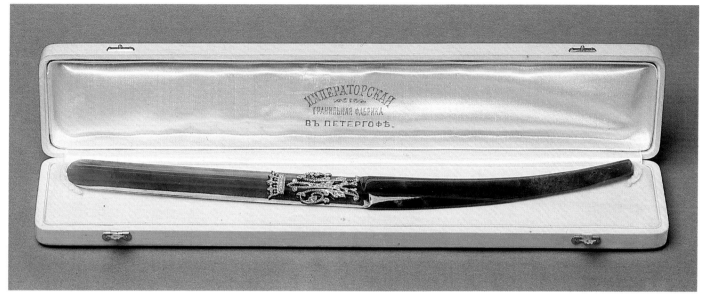

585

579 Amethyst owl-shaped pendant

Attributed to Sumin
Height: $^{19}/_{32}$"

580 Chalcedony rabbit

Attributed to Sumin
Height: 1"

Caricatured rabbit in matt white chalcedony with cabochon ruby eyes.
For a similar animal, cf. Christie's, Geneva, November 17, 1981, no. 92

581 Chalcedony owl

Attributed to Sumin
Height: $1^7/_{16}$"

Matt white chalcedony with cabochon moonstone eyes.

582 Rhodonite cat

Attributed to Sumin
Diameter: $1^9/_{16}$"

Stylized cat, possibly after a drawing by Rudolph Steinlen.
Cf. the same model Christie's, Geneva, November 17, 1981, no. 91

583 Purpurine elephant

Attributed to Ivan Britzin
Height: $^{13}/_{16}$"

Purpurine, with cabochon ruby eyes.

For an almost identical larger model, cf. cat. 75

584 Amethyst pig

Fabergé school
Length: $1^1/_2$"

Amethyst, with cabochon ruby eyes.

585 Nephrite paperknife

Length: $8^5/_8$"
Original fitted case stamped "Imperial Stone Carving Factory Peterhof". The cover applied with initial "M".

Dagger-shaped tapering paperknife applied with diamond-set crowned initial "W".
Example of a "Fabergé" case used by a competitor.

Mrs. Adelaide Morley, Miami

586 Bowenite kovsh

Mm: A.T. (Alexander Tillander)
Hm: St. Petersburg, before 1899
Length: $3^9/_{16}$"

The circular gold-mounted bowl with red *guilloché* enamel foot, rim and handle.

587 Nephrite paperknife

Mm: A.T. (Alexander Tillander)
Hm: St. Petersburg, before 1899
Length: $6^1/_2$"

Tapering paperknife applied with yellow-gold acanthus leaves and diamond and ruby decoration.

586 587 588

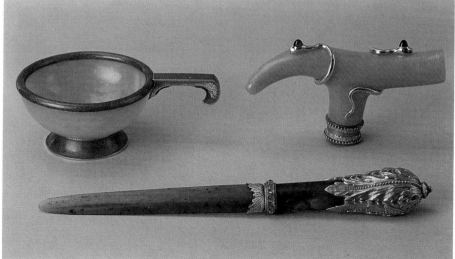

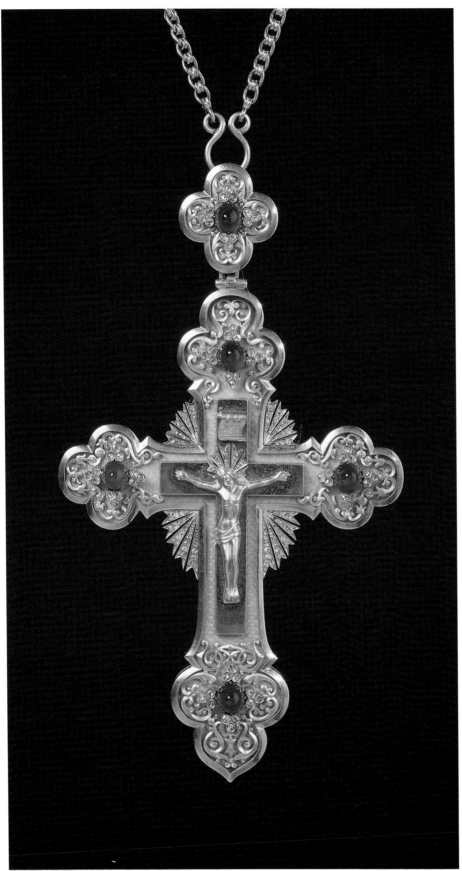

588 **T-shaped aventurine quartz parasol handle**

Mm: AT
Length: 3⁹/₁₆″
Original fitted case stamped "K. Ghan (Hahn), Newski Prospekt 26, St. Petersburg"

Applied with two entwined gold snakes, each with cabochon sapphire head.

589 **Gold pectoral**

Wm: VL − Hm: St. Petersburg, before 1899
Height with pendant: 6¹/₂″
Chain Wm: AK
Original fitted red morocco case

Trefoil arms and quatrefoil pendant set with cabochon emeralds and rose-cut diamonds, chased with yellow-gold foliage; polished gold cross with gold figure of Christ on pink *guilloché* enamel background.

Bayerisches Nationalmuseum, Munich (Inv. 44/40–125)

590 **Oval gold vodka bowl**

Mm: WF (Russian) − Hm: St. Petersburg, before 1899
Length: 2¹⁵/₁₆″

Matt exterior engraved with geometric motifs set with cabochon rubies and rose-cut diamonds.
The hitherto unidentified initials of "WF's" (Russian) may be those of Wassili Finnikov, who worked for Bolin, or those of Victor Fick. The style of this master is similar to that of Erik Kollin. Many of his items also bear inventory numbers in the manner of Fabergé. He was possibly employed by Fabergé as an occasional worker.

Exhibited: Fabergé and Imperial St. Petersburg, Florida, March 1967

591 **Square silver clock**

Mm: 3rd Artel − Hm: St. Petersburg 1899–1908
Height: 4⁵/₁₆″

White enamel dial with steel hands and Roman numerals, white *guilloché* enamel panel with pale blue *guilloché* enamel border, ivory backing and silver strut.

Literature: Habsburg/Solodkoff, 1979, ill. 144
Not illustrated.

589

592 Oviform match-container

Mm: I. T. (Russian) – Hm: St. Petersburg, before 1899
Height: 1^{11}/$_{16}$"

Hammered silver, inset with triangular panels of reeded gold, standing on three reeded gold feet set with cabochon garnets.

593 Square silver clock

Mm: (Russian) IB (Ivan Britzin) – Hm: St. Petersburg, 1908–1917 – Hm: 91 zolotniks – London import mark, 1910
Height: 2^{7}/$_{8}$"

Opalescent pale blue enamel dial with gilt numerals and gold hands, pale blue *guilloché* enamel bezel and spandrels applied with gold laurel sprays.

Cf. similar clock, Christie's, Geneva, November 19, 1979, no. 256

594 Silver gilt cigarette-case

Mm: A. A. (A. Astreyden)
Hm: St. Petersburg, 1908–1917
Length: 3^{3}/$_{4}$"

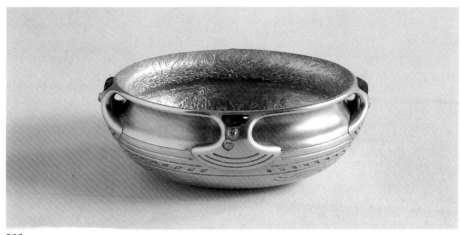

590

Translucent pale blue enamel over waved *guilloché* pattern; lidded match compartment to one side, gold tipped tinder-cord, cabochon moonstone thumbpiece. The interior inscribed: "To dear Georgie with much love from Nada's parents. April 1916".

Provenance: George, 2 Marquis of Milford-Haven. The parents of his wife Nadejda (Nada) were Grand Duke Michael of Russia and Countess Torby

595 Jeweled gold kovsh

Mm: K. Hahn – Wm: A. T.
Hm: St. Petersburg, before 1899
Length: 4^{1}/$_{4}$"

Sides applied with three chased stylized double-headed eagles set with cabochon sapphires; fleur-de-lys handle with cabochon sapphire; fluted base set with cabochon rubies. (c. f. also cat. 588).

592　　　　　　　　　　593, 594　　　　　　　　　595

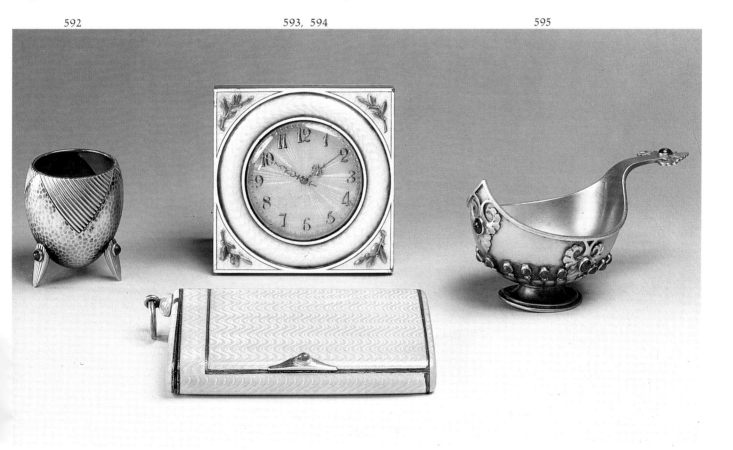

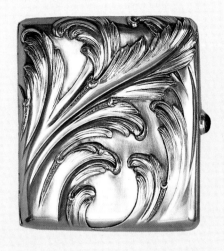

596

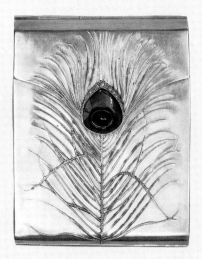

597

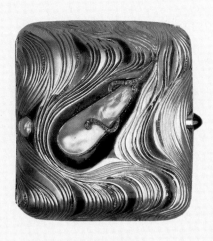

598

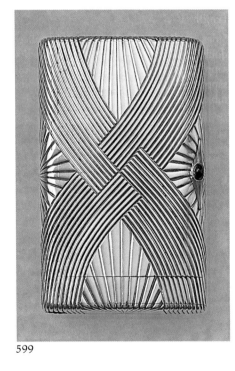

599

596 Art nouveau silver cigarette-case

Mm: Bolin – Hm: Moscow, before 1899
Length: 3⁹/₁₆″

Chased with acanthus leaves partially set with rose-cut diamonds; cabochon sapphire pushpiece.

597 Art nouveau silver cigarette-case

Mm: Bolin – Wm: K.L. – Hm: Moscow, 1899–1908
Length: 3³/₈″

Chased with a peacock feather with the "eye" enameled green, set with cabochon sapphire within rose-cut diamond border.

598 Art nouveau silver cigarette-case

Mm: Bolin – Wm: K.L. – Hm: Moscow, 1899–1908
Length: 3³/₁₆″

Chased with seaweed motifs partially enameled in green, the cover applied with a baroque pearl and diamond-set snake; cabochon sapphire pushpiece.

599 Gold cigarette-case

Wm: S.W. (Russian) – Hm: St. Petersburg, before 1899
Length: 3⁵/₈″

Ribbed fan-shaped motifs and entwined reeded bands, match-compartment to one side, gold tipped tinder-cord; cabochon sapphire thumbpiece. The interior inscribed: "Alfred, Marie, 9 September, 1895".
Master S.W. worked for the firm of Hahn. Cf. cat. 613, 614

Provenance: Given by the Duke and Duchess of Edinburgh, later Dukes of Saxe-Coburg-Gotha, to their future son-in-law, Ernest, Prince of Hohenlohe-Langenburg (1863–1950)

600 Enameled silver gilt cigarette-case

Mm: 3rd Artel – Hm: St. Petersburg, 1908–1917
Length: 3¹/₈″

Salmon pink translucent enamel over waved *guilloché* ground; match-compartment to one side, gold tipped tinder-cord, gold-mounted cabochon sapphire thumbpiece.

601 Enameled silver gilt match-container

Mm: 3rd Artel – Hm: St. Petersburg, 1908–1917
Height: 2³/₁₆″

Salmon pink translucent enamel over waved *guilloché* ground; palm-leaf borders, cabochon sapphire pushpiece.

602 Enameled silver gilt cigarette-case

Mm: 3rd Artel – Hm: St. Petersburg, 1908–1917
Length: 3⁵/₈″

White translucent enamel over waved *guilloché* ground with gold-mounted cabochon sapphire thumbpiece. The interior inscribed: "En souvenir des soirées du 26 mars et du 8 avril 1914".

603 Enameled silver gilt cigarette-case

Hm: St. Petersburg, 1899–1908
Length: 3³/₈″

Translucent dark blue enamel over waved *guilloché* ground; gold-mounted cabochon moonstone thumbpiece. The interior inscribed: "For darling Irene with tender love "Fr. N. A.".

Provenance: Given by Czar Nicholas II and his wife, Alexandra Feodorovna, to Princess Henry of Prussia, born Princess of Hesse, sister of the Czarina (1866–1953)

604 Silver cigarette-case

Mm: 2nd Kiev Artel – Hm: Kiev, 1908–1917
Length: $3^7/_8''$

Polished silver, the cover chased with a lion and lioness on red *guilloché* enamel background and with a blue and green enamel cornflower.

605 Enameled silver gilt cigarette-case

Mm: 3rd Artel – Hm: St. Petersburg, 1908–1917
Height: $3^3/_8''$

Translucent apple-green enamel over *guilloché moiré* ground; yellow-gold palm-leaf borders, cabochon ruby pushpiece.

606 Enameled gold cigarette-case

Mm: (Russian) IB (Ivan Britzin) – Hm: St. Petersburg, 1898–1903 – Am: A. Richter
Length: $3^5/_{16}''$

White translucent enamel over *guilloché moiré* ground; yellow-gold palmette borders on red-gold ground; cabochon sapphire pushpiece.

607 Enameled silver gilt cigarette-case

Mm: (Russian) IB (I. Britzin) – Hm: St. Petersburg, 1908–1917 – Am: 91 zolotniks – London import mark, 1910
Length: $3^5/_8''$

Translucent pale blue enamel over waved *guilloché* ground; match-compartment to one side, rose-cut diamond thumbpiece.

608 Enameled silver gilt cigarette-case

Mm: (Russian) IB (I. Britzin) – Hm: St. Petersburg, 1908–1917
Length: $3^{11}/_{16}''$

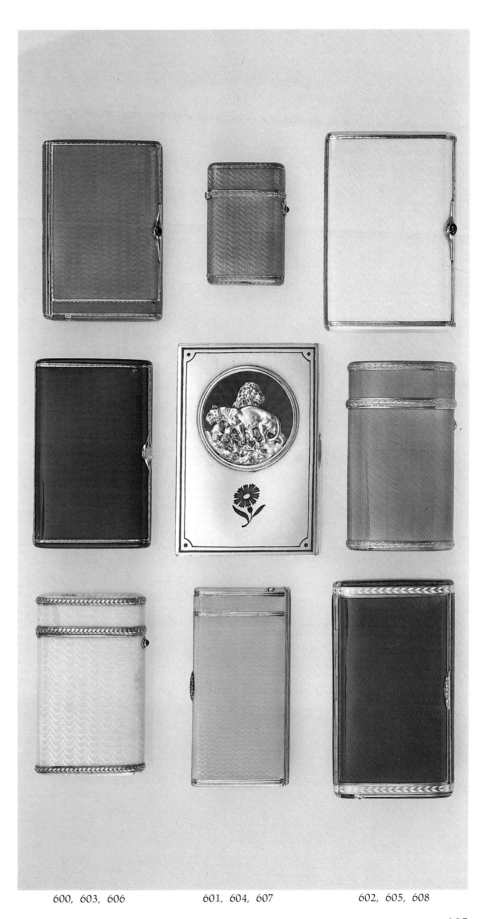

600, 603, 606 601, 604, 607 602, 605, 608

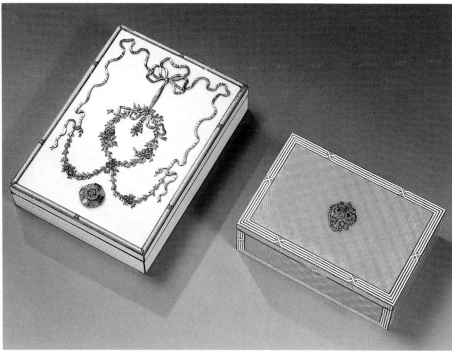

609, 610

613 Imperial presentation box

Mm: K. Hahn – Wm: S.W. (Russian) – Hm: St. Petersburg, 1899–1908
Length: $3^{13}/_{16}$"

Gold, red *guilloché* enamel, the cover applied with crowned diamond-set monogram "N II" on white *guilloché* enamel medallion within rose-cut diamond border; further embellished with diamond-set trelliswork and seed-pearl border.

Provenance: Presented by Czar Nicholas II to J. Pierpont Morgan

Metropolitan Museum of Art, New York (Bequest J. Pierpont Morgan 1917)

Translucent dark blue enamel over waved *guilloché* ground; match-compartment to one side, borders enameled with white laurel leaves, rose-cut diamond thumbpiece.

609 Enameled silver gilt cigar-box

Mm: A. Glassov – Hm: St. Petersburg, before 1899
Length: $6^{5}/_{16}$"

White translucent enamel over *guilloché moiré* ground; applied with silver gilt ribbons and flower swags, diamond-set red *guilloché* enamel red cross; pink *guilloché* enamel border.

The Wernher Collection, Luton Hoo

610 Enameled silver gilt cigar-box

Mm: (Russian) IB (I. Britzin), St. Petersburg, before 1899
Length: $5^{3}/_{16}$"

Translucent pale blue enamel over waved *guilloché* ground; the cover applied with diamond-set double-headed eagle, opaque white enamel borders.

The Wernher Collection, Luton Hoo

611 Enameled silver gilt frame

Mm: (Russian) IB (I. Britzin)
Height: $4^{5}/_{8}$"

Translucent pale blue enamel over *guilloché* ground of sunrays; applied with orange and black enamel bands of the Order of St. George; photograph of the Czarevitch on horseback, with white enamel star of the above-mentioned order.
Probably presented 1916, when the Czarevitch was awarded the Order of St. George. Cf. Fabergé's Imperial Easter egg decorated with Insignia of the same order, dated 1916, in The Forbes Magazine Collection, New York (Solodkoff, 1984, p. 108).

Literature: Ross, 1965, p. 92/93, color ill. 33

The Marjorie Merriweather Post Collection, Hillwood, Washington D.C.

612 Enameled silver gilt table-clock

Mm: 3rd Artel – Hm: St. Petersburg, 1908–1917
Height: $7^{11}/_{16}$"

Translucent raspberry enamel over waved *guilloché* ground, applied with maenad staffs, laurel swags and ribbons; white enamel dial with black numerals and blue steel hands.

614 Rectangular gold Imperial presentation cigarette-case

Mm: K. Hahn – Wm: S.W. (Russian) – Hm: St. Petersburg, before 1899
Length: $3^{3}/_{4}$"

The cover applied with crowned diamond-set monogram "AF" (Russian) flanked by lilies-of-the valley on blue *guilloché* enamel panel; the sides and base with fan-shaped reeding.

Provenance: Presented by Czarina Alexandra Feodorovna
Literature: Ross, 1965, p. 90, pl. 32

The Marjorie Merriweather Post Collection, Hillwood, Washington D.C.

615 Enameled gold photograph frame

Mm: AT (Alexander Tillander) – Hm: St. Petersburg, before 1899
Height: $5^{1}/_{2}$"

Translucent scarlet enamel over *guilloché* sunray and wave pattern; standing on three stud feet, ivory backing and gold strut.
Cf. similar frame, Habsburg/Solodkoff, 1979, ill. 146

Mrs. Josiane Woolf

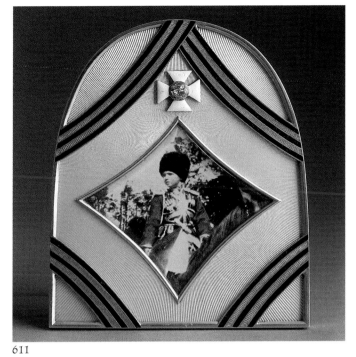

611

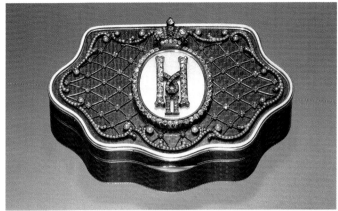

613

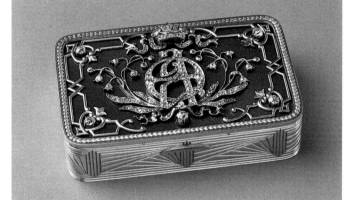

614

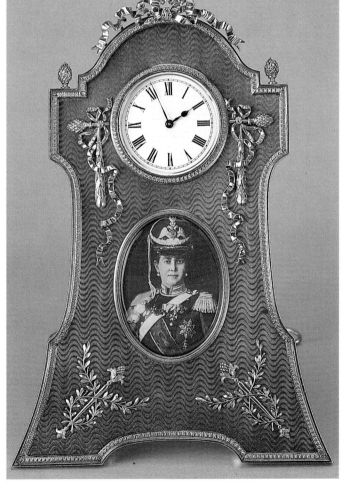

612

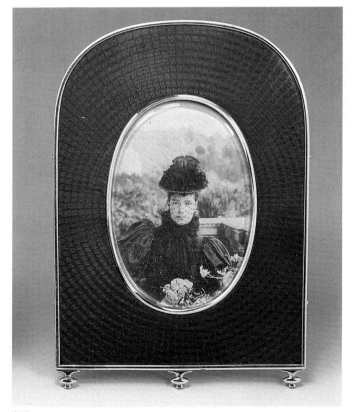

615

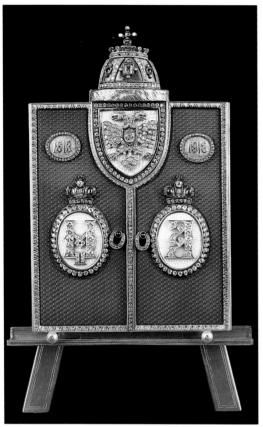

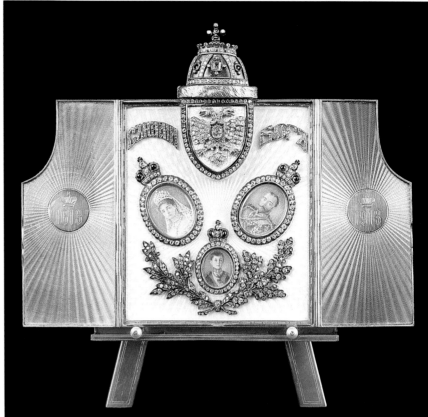

616

616

616 Romanov Tercentenary gold tryptich, 1913

Iwm: K. Hahn – Wm: H.W. (?) – Hm: St. Petersburg, before 1899 – Am: 72 zolotniks
Height (with stand): 6³/₄"

Exterior: blue *guilloché* enamel applied with crowned diamond-set monograms "N II" and "A" on white *guilloché* enamel ground within rose-cut diamond borders; chased gold medallions with dates "1613" and "1913" in rose-cut diamond borders; surmounted by diamond-set red *guilloché* enamel Monomakh's crown, over diamond-set gold double-headed eagle on white *guilloché* enamel ground within rose-cut diamond border.
Interior: white translucent enamel over *guilloché* sunray pattern, applied with miniatures of the Czar, the Czarina and the Czarevitch in rose-cut diamond borders surmounted by sapphire and diamond-set crowns; diamond-set inscription above "God be with us", diamond-set laurel sprays beneath; *guilloché* gold interior to wings engraved with dates "1613", "1913".
Possibly Hahn's major Imperial commission begun before (?) 1899, completed 1913

on the occasion of the Tercentenary of Romanov rule.

Provenance: Czar Nicholas II – Mrs. George Hirst
Exhibited: Wartski, London 1949, no. 201
Literature: Waterfield/Forbes, 1978, no. 138
Habsburg/Solodkoff, 1979, ill. 147

The Forbes Magazine Collection, New York

617 Enameled silver gilt bellpush

Mm: AT (A. Tillander) – Hm: St. Petersburg, 1899–1908
Diameter: 2"

Pale mauve *guilloché* enamel with cabochon moonstone pushpiece.

Exhibited: Helsinki 1980

618 Art nouveau silver beaker

Mm: Bolin – Wm: KL – Hm: Moscow, 1899–1908 – Am: 88 zolotniks
Height: 3"

Sides chased with laurel trees partially decorated in red *guilloché* enamel; the base in-

scribed "To my dear Totosha from his Godfather".

Provenance: Transferred 1922 from the State Museum's Fund
Exhibited: Leningrad 1985, no. 11

State Hermitage, Leningrad (Inv. E.-9540)
(L. Y.)

617

619 Oval enameled silver dish

Mm: (Russian) IB (I. Britzin) — Hm: St. Petersburg, 1908–1917 — Am: 88 zolotniks
Length: 7″

White *guilloché* enamel center, the handles set with 15 kopeks showing of Empress Catherine the Great, 1779.

Provenance: Acquired 1981 by the Acquisitions Committee of the State Hermitage

State Hermitage, St. Petersburg (Inv. ERO 9303) (N. K.)

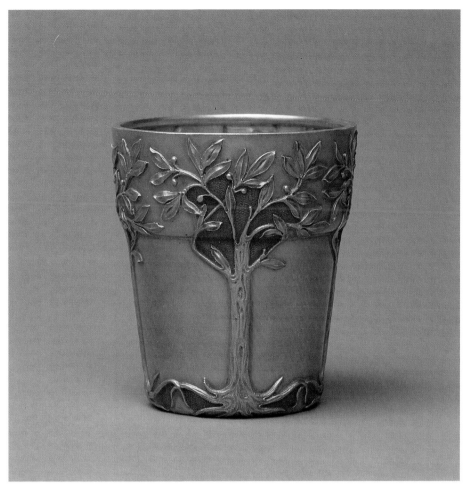

618

619

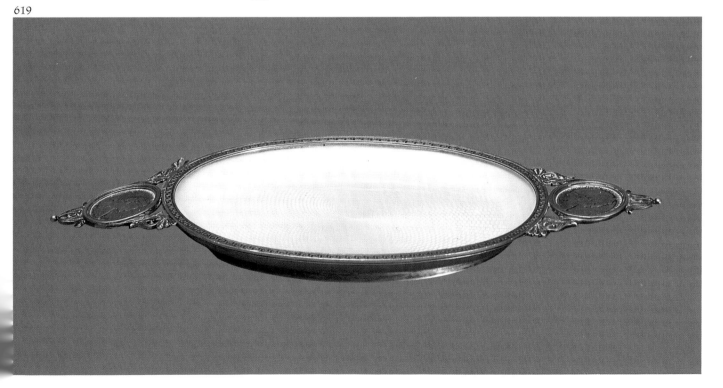

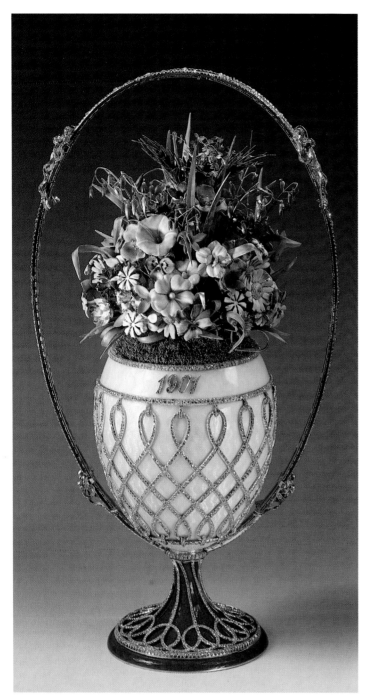
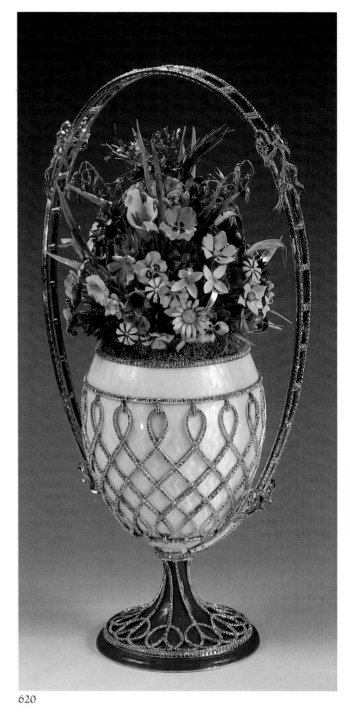

620

620

620 Jeweled and enamel gold flower basket, 1901

Apparently unmarked
Height: 9¹/₁₆"

Elaborate composition of wild flowers in matt pink and yellow enamel with gold grasses and leaves standing on a bed of gold thread moss; set in a silver and white *guilloché* enamel vase applied with diamond-set trel-liswork and date "1901"; dark-blue *guilloché* enamel foot applied with diamond-set border and decoration; diamond-set handle tied with diamond-set ribbons.

Listed as by Fabergé in Bainbridge; and as by Boucheron by Snowman, 1979 and Habsburg/Solodkoff, 1979

This exquisite object, not recorded in Boucheron's photographic archives and in no way comparable to this firm's production, must to-day be attributed to Fabergé. Similarities exist in the quality of enameling, diamond-setting and in the gold thread moss (cf. lily-of-the-valley basket, cat. 401).

Provenance: Queen Alexandra
Literature: Bainbridge, 1949/68, pl. 35 – Snowman, 1979, p. 46 – Habsburg/Solodkoff, 1979, ill. 116

H.M. Queen Elizabeth II of Great Britain

621 Imperial Easter egg, by Cartier 1906

Height: 4⁹/₁₆″

Gold, dark blue *guilloché* enamel applied with stylized foliage set with rose-cut diamonds; white opaque enamel band with green laurel foliage, the front with Imperial monogram "N II" on green enamel field; surmounted by diamond and pearl-set Imperial crown. Opening to reveal a circular photograph of Czarevitch Alexei. Green fluorite cushion with diamond-set tassels, square yellow gold base.

Cartier's Easter egg obviously derives from Fabergé's Imperial Easter egg series. Fabergé's eggs were shown by Imperial command at the 1900 Paris World Exhibition alongside his diamond-set platinum replicas of the Romanov Coronation Insignia (the base and cushion are directly inspired by the latter (cf. Habsburg/Solodkoff, 1984, ill. 177.)

Provenance: Presented by the City of Paris to Czar Nicholas II, 1910 (Cartier Archives, Paris, no. 1977) – Laird Schields, Goldsborough, 1951

Literature: Habsburg/Solodkoff, 1979, ill. 117 – Nadelhoffer, 1984, color ill. 2, p. 122 and note 17

Metropolitan Museum of Art, New York

622 Lily-of-the-valley, by Cartier

Signed "Cartier"
Height: 6¹¹/₁₆″

Chalcedony blossoms, nephrite leaves, enameled stems, standing in a cylindric agate pot with chalcedony handles on pink quartz base. Glass case with mahogany base inscribed with signature in the Chinese style.

Typical production of the Cartier workshops which later inspired numerous Fabergé fakes.

622

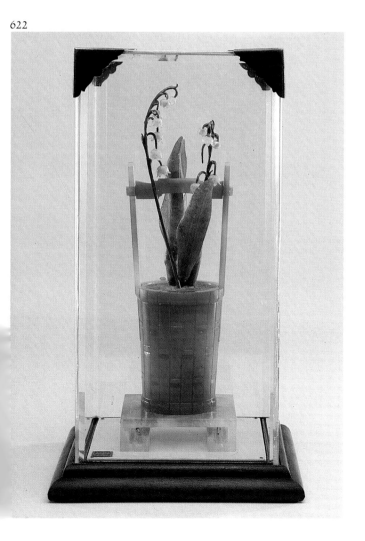

621

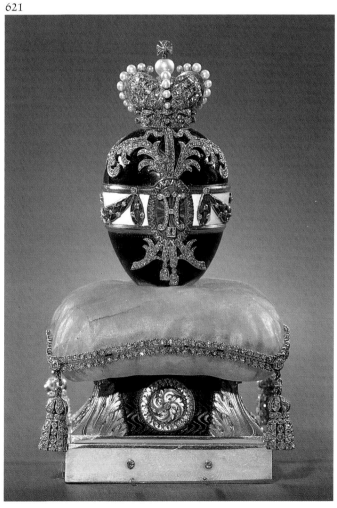

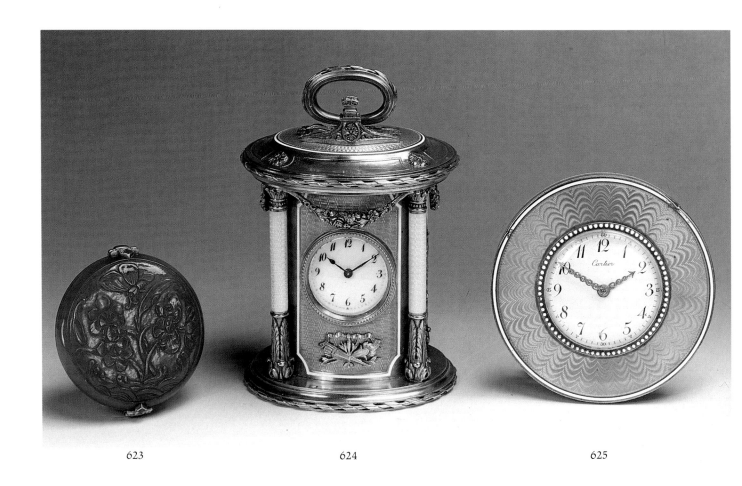

623 624 625

623 Chinese jade bonbonnière, by Cartier

Signed "Cartier Paris, London, Madrid"
Diameter: 2^7/$_{16}$"

Green jade, the cover carved with stylized flowers and a butterfly, hinge and thumbpiece set with diamonds and rubies.

624 Silver gilt table-clock

Mm: DBS
London import mark for 1912
Height: 3^3/$_8$"

Shaped like a Roman temple, with four white *guilloché* enamel columns suspending silver gilt flower swags; the mauve *guilloché* enamel clock-case with white enamel dial and blue steel hands; oval base and swing handle.

A French object in the manner of Fabergé.

625 Silver gilt clock, by Cartier

Signed "Cartier"
Diameter: 3^1/$_4$"

Silver gilt with white enamel dial and diamond-set hands; split-pearl border surrounded by primrose yellow *guilloché* enamel; ivory backing.

626 Gold cigarette-case, by Cartier

Inscribed "Cartier, Paris, London, New York"
Length: 3^1/$_8$"

Lozenge-shaped, alternating red and yellow-gold bands, applied with gold Imperial double-headed eagle; cabochon sapphire pushpiece.

Ordered from Cartier, Paris, July 22nd, 1912. Interesting comparison to Fabergé's cigarette-cases, obviously produced for the Russian market.

Musée Cartier, Geneva

626

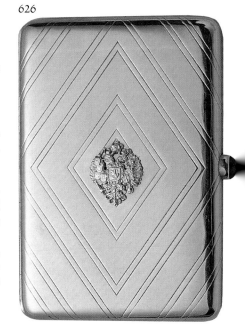

627 Jeweled gold royal presentation box

Attributed to Friedländer, Berlin
Am: 582 (14 ct.)
Length: 4¹/₈"

Miniature of King Ferdinand of Bulgaria in uniform, signed E. Asper, Berlin, within circular-cut diamond frame surmounted by Bulgarian crown; translucent white enamel panel over *guilloché* sunray ground, outer border with diagonal bands of circular-cut diamonds, rubies and emeralds.
The miniature and the use of the Bulgarian royal colors point to royal presentation.

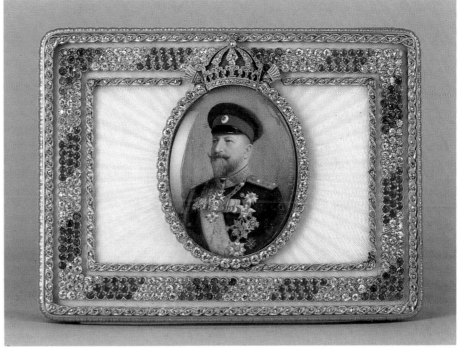

627

628 Pair of circular silver gilt frames by Cartier

Signed "Cartier"
Diameter: 2"

Green *guilloché* enanel frame with outer opaque white enamel border, applied with laurel sprays surmounted by gold ribbon cresting, photograph of Grand Duchess Olga; pink *guilloché* enamel frame similarly decorated with photograph of Grand Duchess Tatjana. Both with ivory backing and silver struts.
Examples of Cartier's work circa 1910. Produced for a member of the Imperial family.

The Marjorie Merriweather Post Collection, Hillwood, Washington D.C.

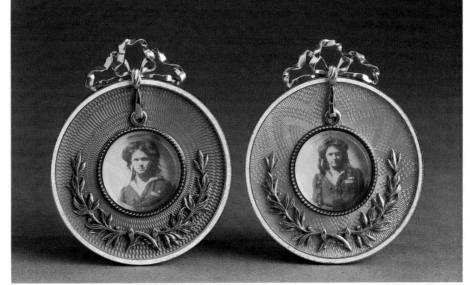

628

303

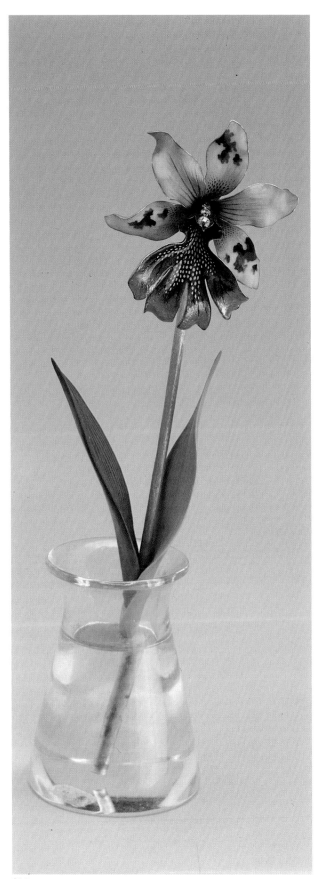

629 Jeweled orchid

Hm: Paris, 1847–1919
Height: 6⁷/₈″

Gold flower, stem and leaves, the blossom in colored enamel, its center set with rose-cut diamonds.
Interesting example of Fabergé's influence outside Russia, probably made in Paris, circa 1910.

Provenance: Transferred in 1919 from the A. K. Rudanovski Collection
Exhibited: Leningrad 1974, no. 47 – Lugano 1986, no. 154
State Hermitage, Leningrad (Inv. E-14 892)
(L. Y.)

630 Art nouveau beaker by Lalique

Signed Lalique, Paris 1902
Height: 6⁵/₁₆″

Silver gilt, applied and chased with thistle leaves and flowers in oxidized silver; interior pale yellow glass.
Lalique's interpretation of a Russian niello beaker.

Provenance: Acquired by Baron Stieglitz in Paris, 1902. Transferred from the Stieglitz Museum, 1921
Exhibited: Leningrad 1974, no. 65 – Lugano 1986, no. 158
Literature: Sigrid Barten, *René Lalique, Schmuck and Werkkatalog.* Munich, 1977, no. 1705

State Hermitage, Leningrad (Inv. E-15 362)
(L. Y.)

629

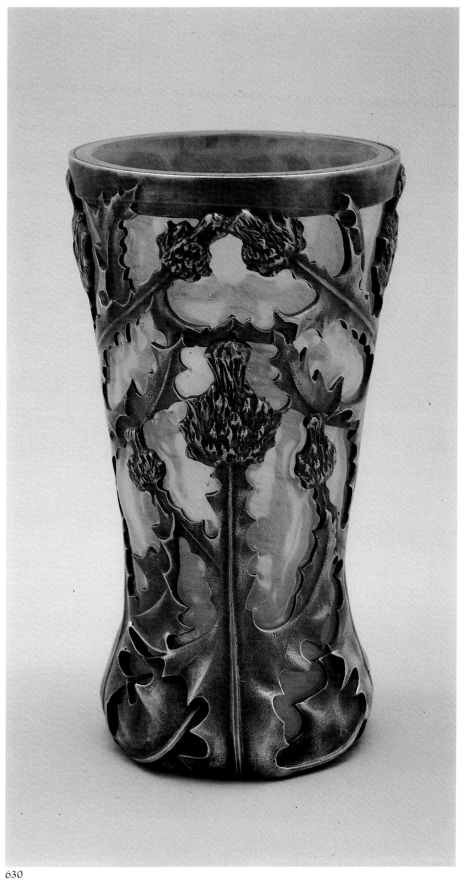

630

632

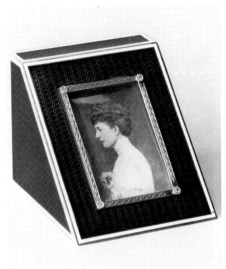

633

632 Rose quartz piglet, by Cartier

Circa 1911
Length: 2⁹/₁₆"

Similar animals were ordered by Cartier from Varangoz in Paris in 1911.

Musée Cartier, Geneva

633 Silver gilt photograph frame, by Cartier

Signed "Cartier"
Circa 1906 – Inv: 22 + 7
Price label inscribed 2 + 7 OTI 325
Height: 2"

Rhombus-shaped, decorated in dark violet *guilloché* enamel with white opaque enamel borders. Photograph of Queen Alexandra of England in gold frame set with four rose-cut diamonds.
For a similar frame, cf. Nadelhoffer, 1984, color pl. 6, p. 16

631 Birchwood paperknife

Length: 11¹¹/₁₆"
Original case stamped with retailer's mark: Nobel & Cie, London

Stained birchwood, applied with silver gilt laurel crown.
The firm of Nobel in London specialised in retailing Russian works of art.
Not illustrated.

634 Double photograph frame

Height: 4⁵/₈"
Original fitted case stamped
Collingwood, London, 46 Conduit Street, London

Gilt metal with translucent pale gray enamel over waved *guilloché* ground, outer green *guilloché* enamel frame with white enamel scrolls; circular miniatures of Kind Edward VII and Queen Alexandra. Gilt reverse with A-shaped strut.
Example of Fabergé's influence on English goldsmiths, made circa 1900.

635

634

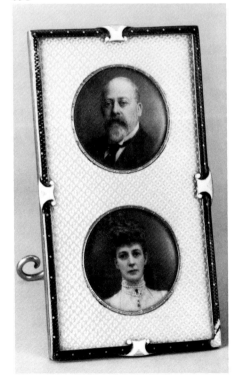

635 Paperknife, by Cartier

Paris, 1908
Inv: 1496
Length: 9⁷/₁₆"
Original fitted case stamped "Cartier, Paris, 13 rue de la Paix, London, 4 New Burlington Street"

Ivory blade, yellow-gold handle with pale mauve *guilloché* enamel applied with laurel leaves, laurel-leaf ring.
Another example of Fabergé's influence on Cartier.

Musée Cartier, Geneva

Fabergé's Origins

JAPANESE ART

636 Japanese bronze crab, 19th century

Width: 5^{10}/$_{16}$"

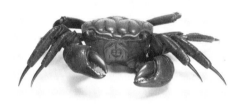

636

Articulated bronze crab (Okimono) of the Meiji period.
This type of crab served Fabergé as inspiration for two of his bellpushes (cf. cat. 290).

Literature: Munn, 1987, p. 40/1

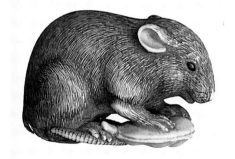

637

637 Netsuke in the shape of seated rat

Signed "Okamoto"
19th Century
Height: 1^1/$_2$"

Ivory, with inlaid eyes.
For Fabergé's interpretation of this model, cf. cat. 352.

Musée Baur, Geneva (Baur 1977, C 1134)

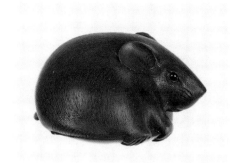

638

638 Netsuke in the shape of a seated rat

Signed "Ikkan", Nagoya school, 19th century

Boxwood, with horn eyes and ivory teeth. For Fabergé's interpretation of this model, cf. cat. 352.

Mrs. Josiane Woolf

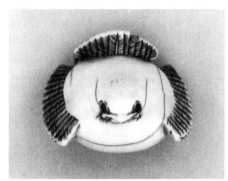

639

639 Netsuke in the shape of a sparrow

Masanao, Kyoto school, 18th century
Width: 1^3/$_{16}$"
Ivory, with red stone eye.
A popular model, of which several versions by Fabergé exist (cf. cat. 376).

640

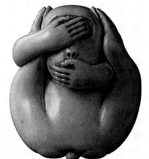

640 Netsuke in the shape of a mystic ape

Signed "Mitsuhiro", with Ohara seal, 19th century
Height: 1^3/$_{16}$"

Ivory.
Another favorite model of Fabergé's (cf. cat. 362, 336, 369).

Musée Baur, Geneva (Baur 1977, C 1049)

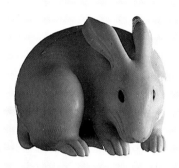

641

641 Netsuke in the shape of a seated hare

Signed "Kaigyokusai", with Masatsagu seal, 19th century
Height: 1"

Ivory, with amber eyes.

For Fabergé's interpretation, cf. cat. 357.

Musée Baur, Geneva (Baur 1977, C 1116)

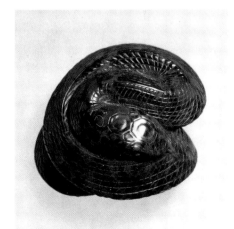

Obsidian snake by Fabergé from the Collection of H.M. Queen Elizabeth II. Copy after a Japanese netsuke (cf. cat. 642)

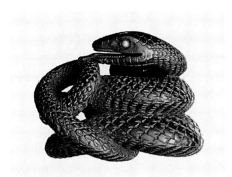

642

642　Netsuke in the shape of a snake

Signed "Shunchosa"
Height: 1¹/₈″

This model inspired several Fabergé creations, including a snake in the collection of H.M. Queen Elizabeth II (cf. p. 308).

Musée Baur, Geneva (Baur 1977, C 956)

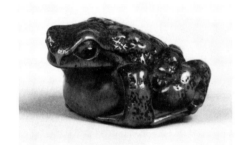

643

643　Netsuke in the shape of a toad

Signed "Masanao", school of Yamada, 19th century
Length: 2¹/₄″

Polished wood, with inset eyes.
This model and cat. 644 served as models for Fabergé toads (cf. cat. 636).

644

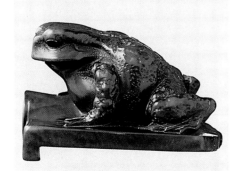

644　Netsuke in the shape of a toad

Masanao, Yamada school, 19th century
Length: 1¹/₄″

Wood, with white inlaid eyes
(Cf. cat. 363).

Musée Baur, Geneva (Baur 1977, C 935)

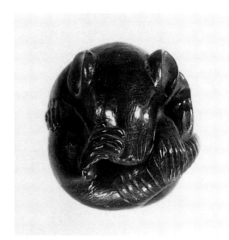

Fabergé rat, cat. 379

645　Netsuke in the shape of a curled-up rat

Signed "Masakio", Yamada school, 19th century
Height: 1³/₈″

Boxwood, with inset eyes.

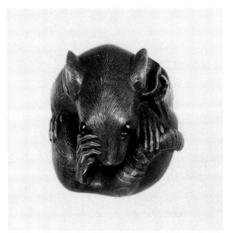

645

This netsuke and cat. 646 served as models for Fabergé's rat, cat. 379.

Literature: Habsburg, 1987, p. 79

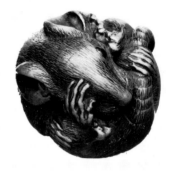

646

646　Netsuke in the shape of a curled-up rat

Signed "Masanao", 19th century
Height: 1³/₈″

Wood, with inlaid eyes.
Cf. cat. 645, 379.

Musée Baur, Geneva (Baur 1977, C 1128)

647　Netsuke in the shape of a cockerel

Signed "Masakatsu", 19th century
Height: 2″

Wood.
This type of Japanese carving served as model for Fabergé's cockerels, cf. cat. 345.

Musée Baur, Geneva (Baur 1977, C 994)

647

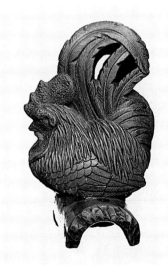

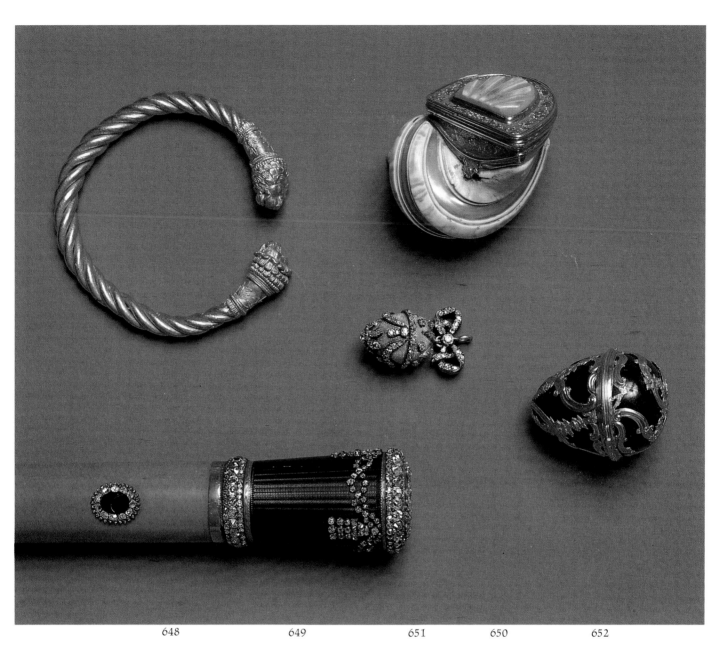

648 649 651 650 652

OBJECTS OF VERTU

648 Gold bangle from the Scythian Treasure

Greek, end of the 4th century B.C.
Diameter: $2^3/4''$

Two twisted gold wires form the bracelet, with chased gold lion head terminals.

Found in Kertch 1867, in the necropolis of Panticapeus, by A.E. Ljuzenko.
One example among many others, of the monumental gold find of Kertch. Fabergé produced a number of gold copies after these Antique originals in 1882, following a suggestion of Count Sergei Stroganov, President of the Imperial Archeological Commission. For Fabergé's interpretation, cf. cat. 88.

Literature: *Comte rendu de la Commission impériale archéologique pour 1867*, St. Petersburg, 1868, p. IV – Hoffmann H., *Greek Gold Jewelry from the Age of Alexander*, Boston, Mass. 1965, p. 165, ill. 61 c (incorrect indication of location and inventory number) – Habsburg, 1987, p. 72

Treasury of the State Hermitage, Leningrad
(Ju. K)

649 Jeweled gold cane handle

St. Petersburg, 1770–80
Length: 2″
Blue *guilloché* enamel applied with diamond-set swags, with diamond-set border and monogram of "E II".
Russian 18th century cane handles such as this served as prototypes for Fabergé's numerous parasol and cane handles.

Provenance: Catherine the Great. In the Arsenal of Zarskoje Selo. Tranferred from the Winter Palace Collection, 1918
Literature: Lieven, 1902, p. 114

Treasury of the State Hermitage, Leningrad
(Inv. E-2192) (O. K.)

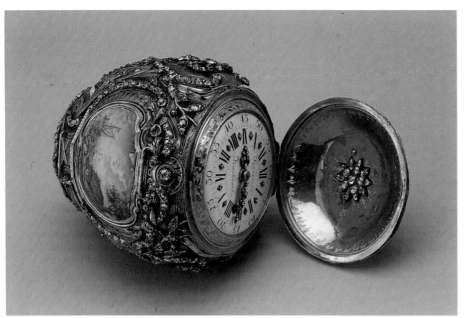

653

opaque enamel bands inscribed: "Tout les moments vous sont (v)oués" and "Si vous me regard je sera regarde. Né pour orner une couronne". The cover opens to reveal a white enamel dial with gilt Roman numerals and diamond-set gold hands. The base contains a necessaire with scent bottle, scissors and knife.

This necéssaire was used by Fabergé as the prototype for his "Peter the Great Egg", dated 1903, in the Lillian Pratt Collection, Richmond Museum of Arts. (Cf. ill. p. 96 and Lesley, 1976, No. 46)

Provenance: Presumably presented to Empress Elizabeth I (1741–61) – In the Jewelry Cabinet 19th century – Transferred from the Imperial Collection in the Winter Palace in 1918.

Literature: Lieven, 1902, p. 101 – Torneus, "Elegance and Craftsmanship", *Apollo*, June, 1975.

Exhibited: Paris 1974, No. 415 – Lugano 1986, No. 142

Treasury of the State Hermitage, Leningrad (Inv. E-4274) (O.K.)

650 Snuffbox in the shape of a snail

German, circa 1730
Width: 1¹⁵/₁₆″

Natural shell with gold mount chased in the Régence style with foliage and trelliswork on *sablé* ground.
Fabergé's shell-shaped snuffboxes (cf. cat. 270) derive from such prototypes.

Provenance: Mentioned in the inventories of the Imperial Cabinet, 1761 (Central Archives, Moscow, Fond 1215, no. 61 753) and in a manuscript inventory of the Treasures at the Winter Palace from 1789 (no. 98)

Treasury of the State Hermitage, Leningrad (Inv. E 3672) (O.K.)

651 Jeweled gold pendant in a miniature Easter egg

St. Petersburg, 1770–1780
Height: 1³/₈″

Yellow gold, applied with bands and swags, set with rose-cut diamonds, suspended from a diamond-set ribbon; opening to reveal a gold jeton chased with monogram of "E II" within laurel crown.
Presumably an Easter present given by Empress Catherine the Great. This type of 18th century Imperial Easter present served as a prototypes for Fabergé's series of miniature Easter eggs (cf. cat. 528–530).

Provenance: In the Jewelery Cabinet during the 19th century – transferred from the Imperial Collection in the Winter Palace in 1918.
Literature: Lieven, 1902, p. 102

Treasury of the State Hermitage, Leningrad (Inv. E-2782) (O.K.)

652 Oviform bonbonnière

England, mid-18th century
Height: 1¹/₄″

Bloodstone, applied with gold rococo motifs and flower swags.
This type of 18th century bonbonnière served as prototype for Fabergé's "Pamiat Azova" Easter egg dated 1891 (cf. cat. 535).

Provenance: Princess Worontsóv-Dashkov

Treasury of the State Hermitage Leningrad (Inv. E-10 941) (O.K.)

653 Oviform jeweled gold necessaire

Mm: François Beeckaert, dial and work signed – Hm: Paris 1757-8 – Am: Eloy Brichard
Height: 2¹/₂″

Chased and applied with foliage and bullrushes set with rose-cut diamonds; two enamel panels painted with landscapes, white

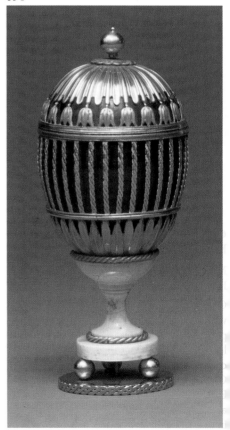

654

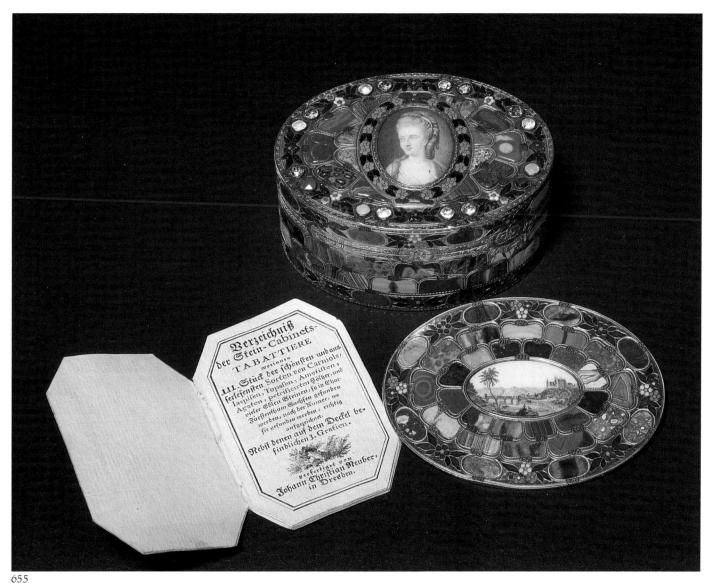

655

654 Egg-shaped gold vodka beaker

Mm: D – Hm: St. Petersburg, 1780
Height: 4¹/₁₆″

Green glass body mounted in gold, applied with openwork gold decoration of fluted pilasters, laurel leaves and lilies-of-the-valley. Turned ivory base on four ball feet; circular gold plinth.
One of a set of four similar vodka cups (Inv.: E-2171, 2267 and 2268). Used by Fabergé as the prototype for his Imperial Easter egg in the Stavros Niarchos Collection (cat. 533).

Provenance: In the Jewelry Gallery – transferred from the Imperial Collection in the Winter Palace.
Literature: Habsburg, 1987, p. 74

Treasury of the State Hermitage, Leningrad (Inv. E-2169) (O. K.)

655 Oval "Steinkabinett-Tabatière"

Johann-Christian Neuber, Dresden, ca. 1770
Length: 3¹/₁₆″

Gold snuffbox inlaid with 110 numbered stone samples from the Saxon mines. The cover with a miniature of a lady within enameled border of laurel leaves and turquoise forget-me-nots; the base with oval porcelain plaque painted with a view of the Albrechtsburg. Secret compartment containing a printed catalog of the stones used, inscribed "made by Johann Christian Neuber in Dresden".

Example of the hardstone carving techniques in use in Dresden in the 18th century, available for study to Fabergé.

Bayerisches Nationalmuseum, Munich

311

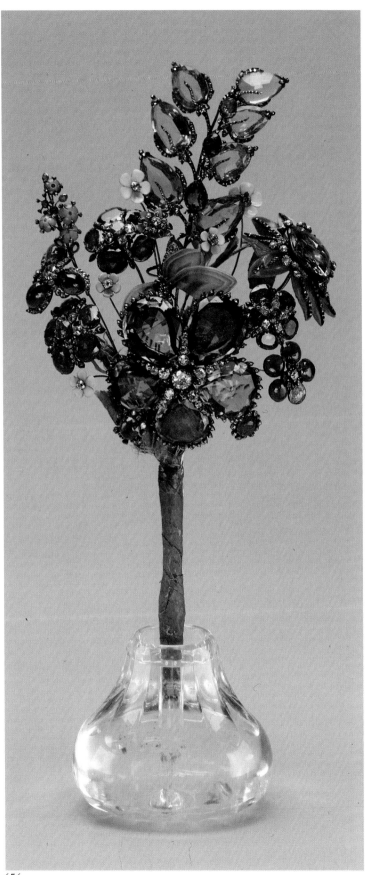

656

656 Jeweled "Bouquet de Corsage"

Maker: Jérémie Pauzié
St. Petersburg, ca. 1740
Height: $7^{11}/_{16}$"

Flowers and leaves of diamonds, emeralds, topazes, garnets, corals, peridots and enamel; gold stems; rock-crystal vase of later period.

This elaborate flower belongs to an 18th century tradition of jeweled bouquets, of which the most lavish example is that made by Grosser, jeweler of Empress Maria Theresia, in 1736. Two further similar works by Pauzié are in the State Hermitage. Objects in this manner influenced Fabergé to his floral creations (cf. cat. 390–400).
Jérémie Pauzié (1716–1779), born in Geneva, was apprenticed to Gravero in St. Petersburg, opened a workshop in 1740 and worked in St. Petersburg as court jeweler until 1764.

Provenance: Jewelry Cabinet. In the 19th century Jewelry Gallery of the Czars. Transferred 1918 from the Imperial Collection in the Winter Palace.
Exhibited: Lugano 1986, No. 71
Literature: Habsburg, 1987, p. 77

Treasury of the State Hermitage, Leningrad
(Inv.: E-1864) (O.K.)

657 Jeweled madonna lily

Master: Louis-David Duval – St. Petersburg, end of 18th century
Height: $9^7/_8$"

Metal stem with three gold flowers inset with numerous seed pearls and rose-cut diamonds; the glass of later period.

Provenance: According to tradition presented to Grand Duchess Alexandra Pavlovna, daughter of Czar Paul I. – In the Jewelry Gallery, 19th century – Transferred in 1918 from the Imperial Collection in the Winter Palace.
Literature: Snowman, 1962/64, ill. 291

Treasury of the State Hermitage, Leningrad
(Inv.: E. 1958) (O.K.)

658 Oblong enameled gold Swiss toothpick-case

Geneva, ca. 1770
Length: $2^9/_{16}$"

Painted on enamel with river landscapes in

camaieu rose; outer border of white enamel pellets on red *guilloché* enamel ground.
This type of object made in Paris or Geneva, ca. 1770, inspired Fabergé to a number of similar creations (cf. cat. 470).

659 Silver Easter egg

Mm: I.N. (Joseph Nordberg) – Hm: St.Petersburg, before 1899
Height: 4⁵/₁₆″

Applied with chased sunray pattern, standing on four cross-shaped feet engraved with Imperial monogram of "A II". Opening to reveal an icon of the Virgin Mary; the surprise is lost.

Example of an Imperial Easter present predating Fabergé, pointing to an older tradition in Russia. For a similar example cf. Solodkoff, 1982, ill. 141.

Provenance: Presented by Czar Alexander II (1818–1880)

The Forbes Magazine Collection, New York

660 Enameled gold Easter egg

Vienna, mid-19th century
Length: 1⁹/₁₆″
Original leather fitted case

Opaque white enamel exterior, yellow gold "yolk", containing an enameled gold chicken, enameled gold crown and jeweled ring.
One of a series of mid-19th century Easter eggs in the tradition of earlier French 18th century prototypes. For a similar example in The Matilda Geddings Gray Collection, New Orleans, cf. Grady/Fagaly, 1972, Nr. 21f)

The Forbes Magazine Collection, New York

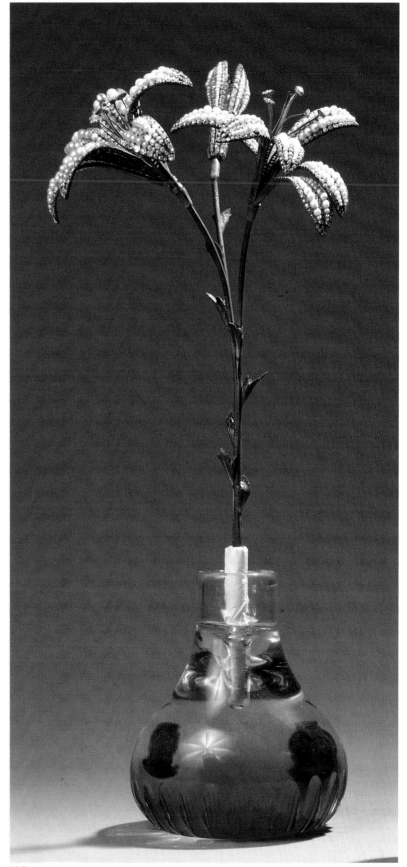

657

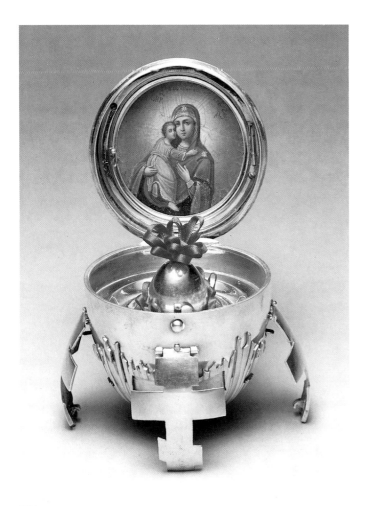

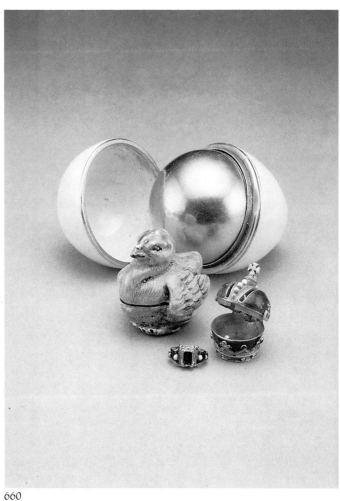

659

660

658

661 Oviform chalcedony necessaire

Unmarked, Amsterdam, ca. 1700
Height: 3¹/₈″

Applied with enameled gold trelliswork, rose-cut diamonds, scrolled foliage and acanthus leaves; with chased gold lion-head handles, holding rings; on oval enameled gold base chased with stiff leaves.

This item has been traditionally ascribed to a hitherto unrecorded goldsmith, Le Roy. Fabergé's Renaissance Egg of 1894 (cat. 538) is obviously based on the Dresden original. Original and copy differ considerably in shape and in the decoration of the interior. This has led scholars to believe that Fabergé's pastiche is based on a mid-19th century color print rather than on the original.

Literatur: Snowman, 1962/64, ill. 324 – Habsburg, 1987, p. 76

State Art Collection Albertinum, Grünes Gewölbe, Dresden, (Inv. M. VI. 15)

662 Royal jeweled and enameled Danish gold Easter egg

Unmarked – First half 18th century
Length: 2¹/₂″

White ivory exterior, containing gold egg, yellow and white enameled "yolk". The hinged cover opening to reveal an enameled gold chicken with rose-cut diamond eyes standing on a carnelian cameo, carved with an eagle and "il defend". The hinged chicken opens to reveal a diamond-and-pearl-set crown and a diamond-set ring, of which the bezel is engraved with the crowned monogram of "CC". The base of the egg can be unscrewed and contains a vinaigrette with sponge.

The Faberge literature has always insisted on a direct derivation of his first Imperial Easter egg of 1885 (The Forbes Magazine Collection, New York, cat. 532) from the Rosenborg egg, based on the Danish origin of Empress Marie Feodorovna, wife of Czar

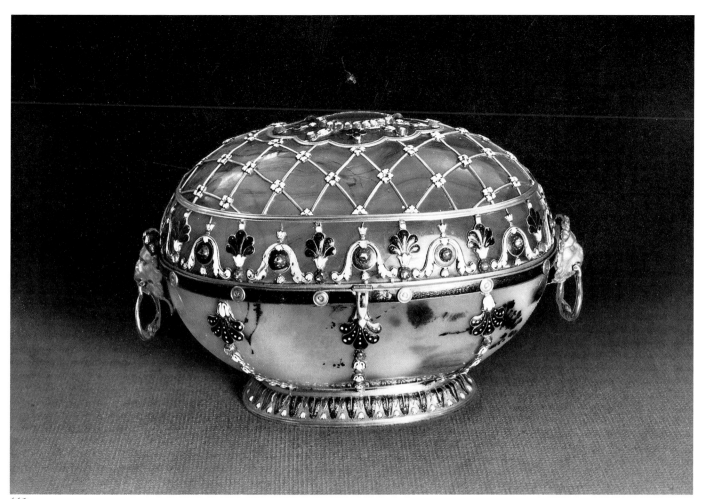

661

Alexander III. It is however an accepted fact today that the Rosenborg egg is but one example of an European tradition, of which further examples exist both in Vienna and in Dresden.

Provenance: According to a handwritten note by Duchess Wilhelmine of Glücksburg (1808–1891), daughter of Frederick VI, this egg descended through Queen Charlotte of England, wife of King George II, to her granddaughter, Princess Louise of Denmark, and her daughter in turn, Queen Louise, born Princess of Hesse-Kassel. – From the Collection of King Christian IX and Queen Louise of Denmark. – Since 1900 exhibited in Rosenborg Castle.

According to Holck Dolding, *Dronning Louise, Malerier og Pretiosa*, Copenhagen, 1951, p. 128, another similar egg existed in the Danish Royal Collection, presented by King Frederick IV to his second wife, Anna Sophie Reventlov, on June 26, 1722.

Exhibited: Kunst og Industriudstillingen, Copenhagen 1879
Literature: Habsburg, 1987, p. 78

Chronological Collection of the Danish Queen, Rosenborg Castle, Copenhagen

663 Jeweled and enameled gold Easter egg

Unmarked
First half 18th century
Height: $1^7/_8$"

Polished gold exterior, yellow enameled "yolk", pale blue enameled "white". Hinged, opening to reveal an enameled gold chicken with cabochon ruby eyes. The hinged chicken opens shouting a diamond-set gold crown, standing on a carnelian base carved with a sun and "pour sa gloire". The crown contains a diamond-set gold ring with a large rose-cut diamond over a gold heart

and the numeral "3". The base of the egg can be unscrewed to reveal a vinaigrette.
This egg obviously derives from the same workshop as the Danish Rosenborg egg. Another, probably similar, egg is described in the inventory of Margravine Fransisca Sybilla Augusta of Baden-Baden (1675–1733) and was auctioned in Strassburg, Hotel Königshof on May 8, 1775, lot 134.

Provenance: Mentioned in an inventory of 1775 to 1785 of the Imperial Treasury, p. 330 (*Jahrbuch der Kunsthistorischen Sammlungen des Allerhöchsten Kaiserhauses*, Vol. XVI, part 2, p. XL)

Kunsthistorisches Museum, Vienna

664 Musical clock in the manner of James Cox, 1735

Movement signed: James Hagger
Height: $9^1/_{16}$"
Original fitted red marocco case.

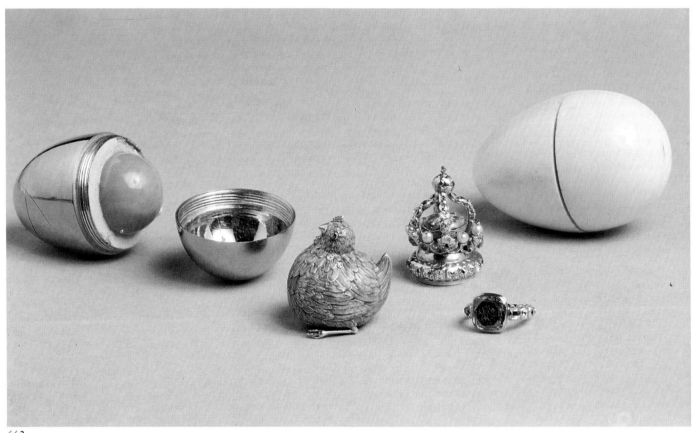

662

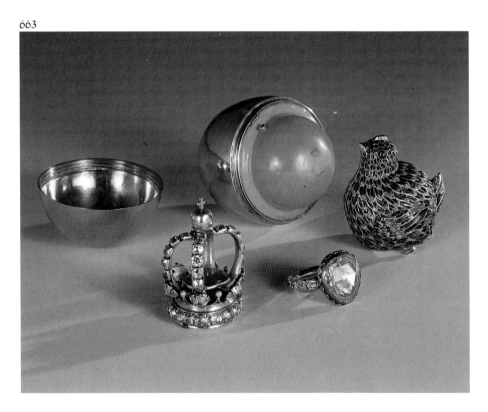

663

The clock, with white enameled dial, black Roman numerals and black steel hands, is flanked by two golden putti. The clock and its base are applied with rococo scrolls, flower swags and cartouches over glass panels imitating orange banded agate. The base, shaped like a rococo commode with female therms at the corners and standing on four animal feet with diamond and pearl-set buttons, contains the musical automaton. This English clock, possibly retailed by James Cox, was in the Russian Imperial Collection and served as inspiration for Fabergé's clock (cat. 280).

Provenance: Empress Alexandra Feodorovna of Russia

Exhibited: Baltimore Museum of Art, Age of Elegance, 1959, no. 375.

Literature: M.C. Ross, "A Musical Clock by James Cox", *The American Collector*, April 1942, p. 5 – Ross, 1965, p. 88 – Habsburg 1987, p.75

The Walters Art Gallery, Baltimore

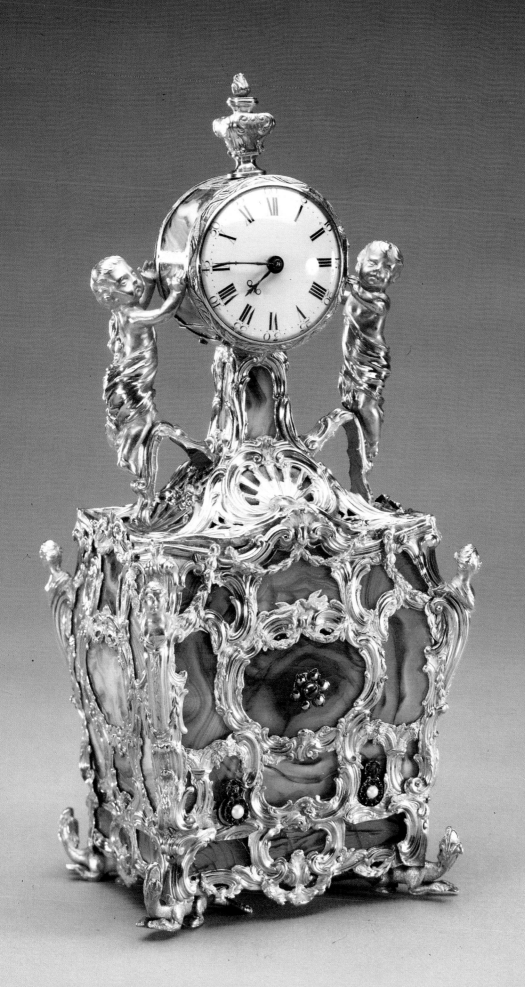

The catalog numbers listed below were lent by or through:

Galerie Almas, Munich
81, 122, 182

A la Vieille Russie, New York
19, 21, 32, 34, 39-40, 50, 80, 85, 116, 266-270, 349, 361-362,
454, 470-471, 504, 508, 563-564, 573, 575-577

Antique Procelain Company, New York
590

H. Beyer, Munich
55-57

Ermitage Ltd., London
37,455

Eskenazi Ltd., London
638, 644, 646

Heide Hübner, Würzburg
56

Leo Kaplan, New York
84, 550-556

Oy A. Tillander AB, Helsinki
3, 59-60, 106, 108-114, 274, 461, 523, 617

Wartski, London
2, 3, 6, 14, 22-23, 38, 42, 43, 98-101, 125-131, 159, 162-163,
166, 177-179, 180-182, 204, 230-233, 288-289, 318, 319, 321, 340-344, 364,
366-370, 389, 465-467, 503, 545-548, 575-577, pp. 56 & 57

Fabergé's Workshops

Although factual evidence has not been preserved, there can be no doubt that Fabergé began his career of goldsmith and jeweler as an apprentice (possibly under the guidance of Hiskias Pendin) before departing for Dresden. Later he also underwent further training with his father and the Frankfurt jeweler Friedman in preparation for his examination for the title of Master. Although Fabergé's training undoubtedly qualified him as a craftsman in his own right, not a single piece of work is recorded as having been made by his own hand. However, the profound knowledge of technical skills that he acquired in the West, his innate sense of good taste and his striving for perfection, coupled with commercial training and an outstanding ability to lead and inspire a team of very differing and mostly foreign craftsmen in the attainment of a common goal made the Fabergé workshops an institution without parallel in their day.

St. Petersburg

At the beginning of his career in 1870, Fabergé found himself head of a small business at 12 Bolshaya Morskaya Street, which mainly consisted of August Homlström's jewelry workshops. He began producing *objets d'art* in a revivalist style with his first head-craftsman, Erik Kollin, who worked at the same time in his own workshops at 9 Kazanskaya Street. Fabergé's original premises soon became too small for the expanding business and craftsmen like August Hollming, a jeweler and goldsmith who began working for Fabergé in 1880, and Gabriel Nuikkanen, who was an enameler and goldsmith, worked in their own workshops at 35 and 39 Kazanskaya Street respectively. Viktor Aarne, who also joined the team in 1880, worked at 58 Demidoff Cross Street close to Ekatarinski Canal, not far from the working quarters of Julius Rappoport, the silversmith. Stephan Wäkeva, a silversmith who also supplied Fabergé with objects, worked from 5 Rozenstvenskaya Street, next to the premises of his son-in-law, Adam Hertuianen, at no. 6, who also occasionally sold pieces of silverwork to Fabergé.

In 1882, the first move became necessary and the workshops were set up anew at 16 Bolshaya Morskaya Street. Michael Perchin, who replaced Kollin in 1886, stayed on at his own workshops at 11 Morskaya Street until 1900, when Fabergé moved for the last time to 25 Morskaya Street, where Perchin joined him. These new premises enabled Fabergé to gather most of his craftsmen together under one roof, with the exception of Rappoport and Wäkeva, who were silversmiths, and the employees at the Obvodny Canal hardstone-cutting factory, which was bought from the German Karl Woerffel.

The workmasters whom Fabergé took under contract worked under ideal conditions. Many had begun working for him as apprentices and later acquired their titles as master

craftsmen under the guidance of his workmasters. (Photographs of the workshops show the tender age at which training began.) The workmasters neither had to pay rent for their premises nor provide material and tools. Ideas and designs were provided by Fabergé and his sons and designers – of whom the most famous was the Swiss François Birbaum – meaning that it was the head-workmasters who were in charge of technical execution. Fabergé also guaranteed the sales of finished articles, presumably giving the workshops a percentage of the profits.

The work of all the different craftsmen employed in St. Petersburg was coordinated by Carl Fabergé, a kindly but somewhat strict and patriarchal figure, who controlled everything from his centrally located office, including advertising and distribution.

Fabergé's fruitful imagination and his first-hand knowledge of all styles past and present were undoubtedly the driving force behind all the work that left his workshops. He acted as a catalyst, providing a never-ending stream of new ideas which he brought to paper in quick, rough sketches (see p. 95). These ideas were then discussed in great detail with the head-workmaster in question before being drawn to scale.

His most important assistants were Erik Kollin (1870–1886), Michael Perchin (1886–1903) and Henrik Wigström (1903–1917), who were succesively his head-goldsmiths. These were backed up in turn by a rapidly growing team of gifted goldsmiths, jewelers and silversmiths, who were mainly Finnish in origin; purely technical work was generally carried out by craftsmen of Russian extraction.

The head-workmaster's role was to supervise every detail involved in the production process, no matter the workshop that took on a piece of work. If an object was made by an outside contractor or a subsidiary workshop not under exclusive contract to Fabergé, it was stamped with the workmaster's hallmark alone. Objects which were produced on Fabergé's own premises were marked by the head-workmaster in question while those requiring the involvement of several workshops were stamped by Fabergé's head-goldsmith. After being marked, the objects were submitted to Fabergé for his approval and then hallmarked (if possible) with his surname and given an inventory number, before being packed into wooden cases and brought away to be sold.

Erik Kollin, Fabergé's first workmaster, who had been trained in Holmström's workshops and who was Fabergé's senior in the company hierarchy by ten years, was responsible for the company's first *objets d'art*, solid creations in gold or gold-mounted hardstone. In 1886, the company took on a new dimension however in the person of *Michael Perchin*, who took over the supervision of the workshops from Kollin at the age of 26. This self-taught man with a touch of genius executed superbly-crafted works of art. Under the guidance of Fabergé, he also introduced the use of varicolored gold and *guilloché* enamel to the company's range of techniques and it was under his supervision that the flower arrangements, the animal figures and other basic themes were developed. On his death he was succeeded by *Henrik Wigstöm*, who became head-workmaster during Fabergé's most productive period, supervising the production of tens of thousands of objects which were all of the same high standard of quality. Wigström's specialities were enameled clocks and cigarette-cases, as well as mounted objects made of hardstone.

Without exception, the most important objects were either made by the head-workmaster or produced under his supervision in his workshops or elsewhere. This applied in particular to all the Imperial Easter eggs, apart from the 1891 Azova Egg and the 1914 Mosaic Egg, which were designed and produced in Holmström's jewelry workshops.

Virtually all the jewelry made came from either the workshop belonging to *August Holmström*, (the most senior member of the firm, who was succeeded in 1903 by *Albert*, his

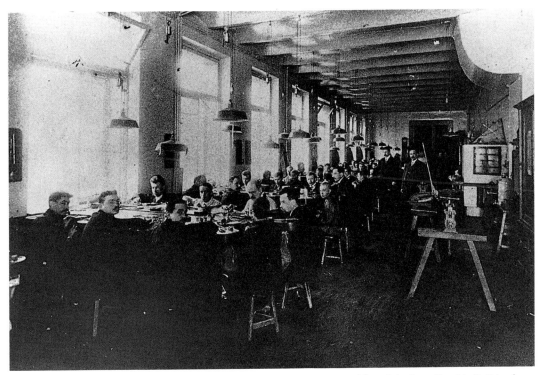

The workshop of the brothers August Wilhelm and Albert Holmström at 24 Bolshaya Morskaya Street in St. Petersburg.

gifted son); or was produced by *August Hollming*, a specialist in small *guilloché* enamel objects and jewels, including Fabergé's celebrated cigarette-cases. Another specialist was *Hjalmar Armfelt*, who fabricated small enameled pieces in gold and silver and created most of the miniature frames; *Fedor Afanassiev* and *Viktor Aarne* produced small gold or silver-mounted hardstone and enamel objects. *Anders Nevalainen* created most of the larger enameled frames and wooden frames mounted in silver. *Julius Rappoport* mounted wooden objects in silver and both he and members of the *Wäkeva* family were Fabergé's most important silversmiths. Of the master craftsmen who occasionally worked for Fabergé or whose products he also sold, *Gabriel Nuikkanen*, *Andrei Gorianov* and *Eduard Schramm* worked mainly on golden cigarette-cases, while *Anders Mickelson*, *Theodor Ringe Vladimir Soloviev* and *Wilhelm Reimer* produced small enameled articles. Flowers, hardstone objects and animal figures on the other hand, were carved at the factory on the Obvodny Canal and assembled and mounted in gold or silver at the workshop of the head-workmaster.

Moscow (1887–1919)

The hierarchic structure of the Moscow branch at 4 Bolshoi Kiselni Street differed to that in St. Petersburg, for while Carl Fabergé and later Eugène, his eldest son, were responsible for all the decision-making in St. Petersburg, the Moscow branch was managed by three partners, the brothers *Alan, Arthur* and *Charles Bowe*. On the recommendation of August Holmström, Fabergé also sent the young jeweler *Knut Oskar Pihl* to Moscow to take over the position of head-workmaster. The silver workshops came under the responsibility of *Michael Tchepournov*, who was aided by the St. Petersburg silversmiths Rappoport and Wäkeva. *Guilloché* enamel was occasionally supplied by *Nevalainen*. The Moscow branch made considerable use

of the services of *Fedor Rückert*, who was a specialist for *cloisonné* enamel and who became Fabergé's main supplier for this kind of work. In 1906, when Fabergé dissolved his business relationship with the Bowe brothers, *Otto Jarke* and *Andrea Marchetti* managed the Moscow branch until Alexander Fabergé was able to take over the business.

While Fabergé catered to the taste of cultivated, aristocratic circles in St. Petersburg, his main clientèle in Moscow consisted of the rich bourgeoisie and wealthy Boyar families, all of very traditonal taste. The some 100 craftsmen who were employed in Moscow made very few objects in hardstone or *guilloché* enamel and those that were produced were not only rather clumsy in style but also lacked the élan and superb craftsmanship of the St. Petersburg products. Following local demand, Fabergé's silversmiths made copies of 17th century objects kept in the Kremlin Armory, which were soon to become a speciality of the Moscow branch along with services and cutlery made of silver. The *cloisonné* enamel objects made by Fedor Rückert and sold by Fabergé differed to those of rival companies, in that they were imbibed with the spirit of art nouveau and less gaudy in the choice of color with their pastel tones. At the same time, Rückert also made use of *email en plein* for his copies of famous paintings depicting scenes of Russian history and mythology.

Odessa (1890–1918)

The Odessa establishment employed approximately 25 craftsmen, including *Gabriel Niukkanen* and *Gustav Lundell,* who originally did occasional work for Fabergé in St. Petersburg. Small items of jewelry were produced in gold and silver at the Odessa branch.

Kiev (1905–1910)

About ten craftsmen were employed in the production of small jewels at the Kiev branch, which was incorporated into the Odessa establishment in 1910.

London (1903/1907–1917)

Encouraged by visits made to St. Petersburg by Alexandra, Queen of England; Consuelo Vanderbilt, the Duchess of Marlborough (in 1902); Lady Sackville and Lady Diana Cooper, Fabergé decided to send Arthur Bowe to London, where he opened a shop in Berners Hotel in 1903. A year later, a Fabergé charity bazaar was organized in the Royal Albert Hall by Lady Paget. *Henry Bainbridge* and *Nicholas Fabergé* were able to open up premises at 46 Dover Street in 1906/07 and now nothing stood in the way of the company's success. A final move was later made to 173 New Bond Street.

The encouragement of the Royal Family, which culminated in commissions to model the animals at the Queen's zoo in Sandringham, sparked off a craze for Fabergé objects which brought about an unending number of orders from the Edwardian set. Miraculously, the sales ledgers of the London branch are still in existence today and provide a wealth of information about this period (cat. no. 18). They were begun on October 6, 1907 and brought to a close on January 9, 1917, and since they state dates of sale, names of purchasers, descriptions of the objects sold, inventory numbers and retail and cost price, they have enabled the identification of many objects imported and sold in England by Fabergé. The modelers Frank Lutiger and Alfred Pocock were employed by the London branch.

Fabergé's Sons

Eugène Fabergé (1874–1960)

Like all his brothers, Eugène was educated at St. Peter's School in St. Petersburg. After he left, he went to the Royal Art School at Hanau on Main from 1892 to 1896. It was here that the foundation for his later artistic activity was laid and it was here that he discovered his predilection for portraits. On his return to St. Petersburg, he entered his father's business, where his ideas and drawings inspired the creation of many objects, including jewelry. His main task in the company was that of draftsman.

After his father's death in 1920, he founded the company of Fabergé et Cie in 1924 in Paris, where he worked with his brother Alexander. Andrea Marchetti, who had worked at the Moscow branch for many years, was employed at the Paris firm as well as Guilio Guerrieri, who had previously worked as a jeweler for Lorié in Moscow for 25 years. Eugène Fabergé established business relationships with Idar-Oberstein, where animals and flowers were carved according to models created by Micael Ivanov, Olga Yversen and Alexander Fabergé. He was a member of the Akademische Verbindung Cellini in Hanau for many years and was made an Honorary Member in 1953.[1]

Agathon Fabergé (1876–1951)

Blessed with great artistic talent, it was Agathon who became the company gemologist. After the Revolution, he stayed on in St. Petersburg, where his reputation was so outstanding that the Soviet Government commissioned him to catalog the jewelry that had been expropriated from the Imperial Family. His son Théo later worked for the jeweler Lombard in Geneva, while another son, Igor, did a lot of goldsmith work for members of Geneva society.

Alexander Fabergé (1877–1952)

Alexander, who became a painter and modeler, studied at Baron Stieglitz's School of Applied Arts in St. Petersburg, before going on to the Strogonov Art School in Moscow and continuing his studies under Professor Cachot in Geneva. After the Revolution, he took up work in Paris with his brother Eugène as draftsman and modeler.

Nicholas Fabergé (1884–1939)

Nicholas was also blessed with artistic talent and became a pupil of the painter John Singer Sargent in London. From 1906 on, he managed the London branch with Henry Bainbridge.

1 I am much indebted to Mr. D. Schneider of the Zeichenakademie Hanau for this information.

The Workmasters of Fabergé

The Head-Workmasters

Erik August Kollin
Born in Pohja on December 28, 1836 – Died July 16, 1901 in St. Petersburg

Erik Kollin was apprenticed to the goldsmith Alexander Palmen in Tammisaan in 1852 and
registered as a goldworker in the Parish Records of St. Catarina in St. Petersburg in 1858,
where he was employed by August Holmström, workmaster at Fabergé's workshops in
Bolshaya Morskaya Street. In 1867, Kollin married Henrika Eleonora Backmann (born on
December 13, 1841 and last mentioned in Petrograd in 1920) and qualified as a master in
1868, opening up his own workshop at 9 Kazanskaya Street. In 1870, he became Carl
Fabergé's head goldsmith until he was replaced in 1886 by Michael Perchin. He then worked
independently, delivering Fabergé with occasional pieces of work.

 Erik Kollin's work was *revivalist* in style and he reproduced objects discovered in archeo-
logical finds. His most celebrated creations were the gold reproductions of jewels and objects
from the Scythian treasure unearthed in Kertch. Kollin worked almost exclusively in yellow
gold, which was often hammered, matted and chased with flutes. His objects are rare and
much coveted since he worked for Fabergé before his fame had reached its height.

Michael Evamplevitch Perchin
Born in Petrosavodsk (Karelia) in 1860 – Died August 28, 1903 in St. Petersburg

Perchin was a self-taught goldsmith who learnt his trade from rural craftsmen before entering
Kollin's workshop. In 1884 he qualified as a master and in 1886 he became Fabergé's head
goldsmith. He had his workshops at 11 Bolshaya Morskaya Street until he joined Fabergé
in his new premises at 24 Bolshaya Morskaya Street in 1900.

 Perchin is the most famous of Fabergé's workmasters. His workshops created the most
exquisite of objects in gold and enamel (often using the *quatre-couleur* gold technique of 18th
century France) as well as in silver and enamel to a lesser extent. Fine jewels also bear his
mark, as well as the earliest hardstone animals sold by Fabergé at the turn of the century.
His greatest claim to fame was the crafting of the Imperial Easter eggs, which began in 1885/
86 and with which he was entrusted until the time of his death in 1903. With the exception
of the first to be produced, all the eggs made during his tenure bear his hallmark. His work
is often reminiscent of the european rococo and Louis XV styles and includes *rocailles* and
scrolls which sometimes tend towards the plant idioms of art nouveau.

Henrik Emanuel Wigström
Born in Tamminsaarie on October 2, 1862 – Died March 14, 1923 in Kivinapa

Wigström came to St. Petersburg from Finland on May 10, 1878 and was registered in the
Parish Records of St. Katarina as a goldworker. In 1884, he obtained a post as journeyman

under Michael Perchin and later became his assistant. On Perchin's death in 1903 he took over his position as head-workmaster. In 1884 he married Ida Johanna Turunen (1866–1911) and had four children. He taught his trade to his son Henrik Wilhelm (1889–1934), who worked with him until 1917. After the Revolution, Henrik Wigström returned to Finland, where he and his son continued to work together.

Wigström was Fabergé's head goldsmith during the company's most productive period. He was in charge of over 500 persons employed in various workshops and thousands of objects bear his hallmark. All the eggs produced between 1904 and 1917 were created under his personal supervision. Some were only stamped with Fabergé's hallmark, but others (from 1905, 1908, 1909 (?), 1912, 1913, 1914, 1915, 1916 and 1917) also bear Wigström's hallmark and are masterpieces of his art.

His style is easily recognizable and in most cases has the elegance and the light touch of the Louis XVI and Empire periods.

Practically all the flowers and animals Fabergé made were assembled in Wigström's workshops, where their gold mounts were stamped with his hallmark. He also specialized in frames, cigarette-cases and *objets de vitrine* made of gold, hardstone and enamel as well as jeweled enamel objects and miniature eggs made of hardstone.

Workmasters
(in alphabetical order)

Johann Viktor Aarne
Born in Tampere on May 6, 1863 – Died June 30, 1934 in Viipuri

In 1875, Aarne was apprenticed to Johan Erik Hellsten in Tampere, Finland, where he became a journeyman in 1881. Between 1880 and 1890 he worked for Fabergé, qualifying as a master in 1890 in Tampere and returning to St. Petersburg in 1891. In 1904, he sold his workshop at 58 Demidov Cross Street (on the Jekatarinski Canal) for 8,000 rubles to Hjalmar Armfelt, who had twenty journeymen and three apprentices at the time. Aarne then settled down in Viipuri, where he carried on his occupation of goldsmith for thirty years. He was married to Hilda Emilia Kosonen (1867–1954) and had ten children.

Aarne's hallmark is to be found on high quality objects made of gold, silver and enamel. His specialities were picture frames and bellpushes.

Fedor Afanassiev

Very little is known about Afanassiev but for the fact that his hallmark is to be found on small objects of high quality, including miniature Easter eggs, small picture frames and *objets d'art* made of gold, silver and enamel.

Karl Gustav Halmar Armfelt
Born in Artjarvi on April 6, 1873 – Died July 22, 1959 in Helsinki

Armfelt came to St. Petersburg in 1886, where he was apprenticed to Paul Sohlmann at 58 Gorohovaya and qualified as a journeyman in 1891. He worked under Anders Nevalainen for Fabergé from 1895 until 1904. After having studied at Baron Stieglitz's School for Applied Arts between 1885 and 1904, he qualified as a master and bought Viktor Aarne's workshop for 8,000 rubles, working there under contract to Fabergé until 1916. In 1920 he returned to

Finland with his wife Olga Josefina Lindroos (1875–1932) and his two children. He specialized in enameled gold and silver as well as hardstones, *objets d'art* and miniature picture frames.

Andrei Gorianov

Gorianov seems to have occasionally supplied Fabergé with finished products. He took over Wilhelm Reimer's workshop after his death in 1898 and specialized in gold cigarette-cases, which only bear his hallmark and not that of Fabergé's.

August Frederik Hollming
Born in Loppi, December 3, 1854 – Died March 4, 1913 in Helsinki

Hollming entered into apprenticeship with the goldsmith Fridhoff Ekholm in 1870 in Helsinki. In 1876 he was registered as being a goldworker in the Parish Records of St. Maria in St. Petersburg. He qualified as a master in 1880, and worked on his own premises at 35 Kazanskaya Street before moving to Fabergé's new premises at 24 Bolshaya Morskaya Street. He was married to Gustava Abrahamson (1856–1909) and his eldest son, Vaino (1885–1934) trained to become a goldsmith in his father's workshops, which he then took over with Hollming's assistant, Otto Hanhinen, from 1913 to 1917.

Hollming made very fine enameled cigarette-cases as well as enameled gold jewelry.

August Wilhelm Holmström
Born in Helsinki on October 2, 1829 – Died 1903 in St. Petersburg

Holmström was apprenticed to the jeweler Herold in St. Petersburg. He became a journeyman in 1850 and qualified as a master in 1857. He bought the workshop of the goldsmith Frederik Johan Hammarström and became Gustav Fabergé's principal jeweler in 1857. He was married to Maria Sofia Welene (1840–?) until 1866 and then remarried, wedding Hilma Rosalie Sundberg (1850–1925). Holmström's most famous pieces of work were the miniature replicas of the Imperial Crown Insignia, which were exhibited at the Universal Exposition in Paris in 1900; and the basket of lilies-of-the-valley, which he made in 1896 (cat. no. 401). His workshop was responsible for the company's production of jewels. Holmström's daughter, *Fanny*, married Knut Oskar Pihl, one of Fabergé's goldsmiths.

His daughter *Hilma Alina* (1875–1936), who studied at Baron Stieglitz's School for Applied Arts, was a talented jewelry designer who created ornamental designs for Fabergé.

Holmström taught his trade to his son *Albert* (born in St. Petersburg on October 21, 1876, died on April 16, 1925 in Helsinki), who took over the workshops after his father's death in 1903 and ran them with Lauri Ryynanen. Albert continued to make jewels with his father's hallmark after the latter's death. His masterpieces are the Mosaic Egg of 1914 and the Winter Egg of 1913. In 1920, he went to Finland and opened up a business there with Vaino, August Hollming's son, where they carried out commissions and modifications and did repair work until 1925.

Karl Gustav Johansson Lundell
Born in Loppi on September 26, 1833 – Died May 29, 19?? in St. Petersburg

Lundell was employed in St. Petersburg as a goldworker. Although it is traditionally thought that he was Fabergé's workmaster in Odessa, there is no proof of his ever having become a

Henrik Wigström (1862–1923)
Hjalmar Armfelt (1873–1959)

Johann Viktor Aarne (1863–1934)
August Hollming (1854–1913)

Albert Holmström (1876–1925) Anders Nevalainen (1858–1933)
Oskar Pihl (1860–1897) Alma Theresia Pihl (1888–1976)

August Holmström (1829–1903)
Stephan Wäkeva (1833–1910)

Oskar Woldemar Pihl (1890–1958)
Alexander Wäkeva (1870–1957)

master craftsman. His hallmark is to be found on cigarette-cases but seldom in combination with Fabergé's.

Anders Mickelson

Born in Pyhtää on January 8, 1839 – Died November 8, 1913 in St. Petersburg

Mickelson came to St. Petersburg in 1855 and became a master goldsmith with his own workshop in 1867. There is evidence that he and his colleague Vladimir Soloviev took over Philipp Theodor Ringe's workshop at 12 Malkaya Morskaya Street. In 1863 he married Maria Helena Tijlander (1835–1907). Mickelson produced cigarette-cases and small enameled objects for Fabergé.

Anders Johansson Nevalainen

Born in Pielisjärvi on January 1, 1858 – Died April 15, 1933 in Terijoki

Nevalainen came to St. Petersburg in 1874 where he was registered as a goldworker in 1875. He qualified as a master in 1885 and started to work for August Holmström. Later he became independent, working for Fabergé exclusively. He married Maria Karolina Liljerot (1860–1936) in 1884. Nevalainen made enameled objects and silver picture-frames and was also a specialist in mounting ceramics and wooden objects in silver.

Gabriel Sakarinpoika Niukkanen

Niukkanen was mentioned as working at 39 Kazanskaya Street between 1898 and 1912. He made gold and silver cigarette-cases, which seldom bore Fabergé's hallmark however. For a while he was manager of Fabergé's workshop in Odessa.

Knut Oskar Pihl Born in Pohja on April 13, 1860 – Died August 22, 1897 in Moscow

Pihl was an apprentice in August Holmström's workshop and qualified as a master in 1887, the same year that he married Holmström's daughter *Fanny* (1869–1949). He was the principal goldsmith between 1887 and 1897 at Fabergé's Moscow branch at 4 Bolshoi Kiselni Street. Pihl specialized in small objects of jewelry.

His son *Oskar Woldemar* (born in Moscow on February 11, 1890, died August 22, 1959 in Helsinki) became chief assistant workmaster at Holmström's workshop in 1913, where he mainly worked as a designer. He later entered the Tillander company in Helsinki as a partner.

Julius Alexandrovitch Rappoport 1864–1916

Rappoport was trained in Berlin under the silversmith Scheff. He settled down in St. Petersburg in 1883, where he was employed at 65 Jekatarinski Canal. Rappoport was Fabergé's leading silversmith and specialized in large silver objects, animal figures and silver services.

Wilhelm Reimer Born in Pernau/Latvia – Died around 1898

Reimer made small objects of enamel and gold.

330

Philipp Theodor Ringe

T.R Ringe had his own workshop from 1893 on. It is probable that he worked for Fabergé occasionally, delivering small enameled objects in gold and silver.

Fedor Rückert

Ф.Р. Rückert, born in Moscow of German extraction, started working independently in 1877, supplying both Fabergé and other customers with his objects. Many of his *cloisonné* enameled objects sold by Fabergé bear the hallmarks of both companies, either positioned side by side or superimposed. A number of Rückert's works, which are easily recognized with their pastel tones and the use of art nouveau themes, are stamped with his hallmark alone, indicating that they were sold independently of Fabergé.

Eduard Wilhelm Schramm

ES Schramm was born in St. Petersburg of German extraction and probably delivered objects to Fabergé on occasion. He made gold cigarette-cases and small *objets d'art*, which often had hammered surfaces set with cabochon stones. Most of his articles bear only his own initials.

Vladimir Soloviev

BC Soloviev took over Theodor Ringe's workshop after his death, where he made small enameled objects. His hallmark is often to be found under the enamel on pieces that were destined for the London market.

Alfred Thielemann

AT Thielemann was born in St. Petersburg of German parentage and qualified as a master in 1858. From 1880 on he supervised production in Fabergés second jewelry workshop, where he made small jewels and trinkets. His hallmark is not to be confused with those of Alexander Tillander (who made *objets d'art*), A. Tobinkov (a silversmith who worked with Nichols and Plincke) or A. Treiden (who was possibly another independent jeweler). Thielemann's son Karl Rudoph took over the workshop after his father's death sometime between 1908 and 1910.

Stephan Wäkeva

Born in Sakkijarvi on November 4, 1833 – Died June 17, 1910 in St. Petersburg

S.W

A.W Wäkeva came to St. Petersburg in 1843 as an apprentice silversmith. He became a journeyman in 1847 and qualified as a master in 1856, opening up his own workshop at 5 Rozhdestvenskaya Street. His company delivered Fabergé with silver articles, tea and coffee services and table silver. He married Lovisa Wilhelmina Ekstrom (1838–1905) in 1856. His son Alexander took over the workshop on Wäkeva's death, using his own initials of A. W. as a hallmark between 1910 and 1917. His brother Constantin (1867–1902) also worked in the family business.

The Hallmarks of Competitors or Other Silversmiths and Goldsmiths Sometimes Found in Combination with Fabergé's Mark

		Proof
AA	A. Astreyden	Cat. no. 594
ICA	The First Moscow Silver	Cat. no. 70, Snowman[1], AVR[2], H/S[3], Helsinki[4]
3ᴿA	The Third Artel	Cat. nos. 591, 600 ff., 605, 612, 621, H/S, Helsinki
AC	(Russian AS?)	Cat. no. 45
AK	(Antip Kuzmitshev? / Workmaster of Nicholls Ewing?)	Cat. nos. 135, 528, 565, AVR, Helsinki
AR		Cat. no. 34, Snowman, Helsinki
ВФ	Viktor Finck (Postnikova 2351) or Vassili Finnikov (a workmaster of Bolin's) ? (Russian W.F.)	Cat. nos. 92, 95, 102, 590
EH		Cat. no. 93
ФР	(Russian FR), often mistaken for Rückert	
EW		AVR, Snowman
IN		AVR
HB	(Russian NW ?)	Cat. no. 56
ИБ	Ivan Britzin	AVR, H/S, Helsinki
ИП	(Russian IP)	AVR, H/S, Helsinki
ИС	(Russian IS) Ivan Saltikov	Cat. no. 80, AVR
JW		AVR, Helsinki
KW	(Member of the Wäkeva family, possibly Konstantin Wäkeva ?)	Cat. no. 49

1 Snowman, 1962/64
2 A la Vieille Russie, 1968
3 Habsburg/Solodkoff, 1979
4 Helsinki, 1980

Fabergé's Hallmarks

St. Petersburg

Fabergé's hallmark in Russian, without the initial. As a rule, all items made in his workshops or retailed by him bear this mark. Exceptionally, some objects produced in St. Petersburg bear neither his hallmark nor his initials. In some cases this was no doubt due to lack of space (as on the borders of cane handles), while in others it probably indicates that the objects in question were made for Fabergé by one of his "occasional" suppliers. Fabergé's initials and surname are to be found on the work of the St. Petersburg workmasters Nevalainen and Rappoport, frequently in connection with a double-headed eagle in a round punch.

Moscow

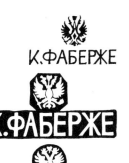

Most of the objects made in Moscow by Fabergé bear the Imperial Warrant mark, a double-headed eagle positioned above the Russian name of the supplier. Here the Russian "K. Fabergé" and the double-headed eagle denote that Fabergé had been awarded the title of Court Jeweler (in 1884). As opposed to St. Petersburg, where the master craftsmen applied their own hallmarks, most of the pieces made in Moscow only bore the company mark while small objects were frequently stamped with Fabergé's Russian initials alone.

The only initials to be found on the (mostly silver) articles bearing Fabergé's Moscow marks are those of the First Silver Artel as well as those of Anders Nevalainen, Julius Rappoport and Stephan and Alexander Wäkeva, who were Fabergé's workmasters in St. Petersburg. This was probably because the objects involved were not only intended for sale in Moscow but also in St. Petersburg.

London

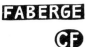

Articles which were produced for London and the European market were hallmarked with Fabergé's name or his initials (C.F.) in European letters. The initials of Vladimir Soloviev and occasionally those of other workmasters are sometimes to be found beneath the enamel on objects bearing London import stamps.

Nearly all of Fabergé's objects were given an inventory number consisting of three to six figures scratched into the metal. Objects sold in London can be identified by comparison of their respective inventory numbers with the entries made into the London sales ledgers.

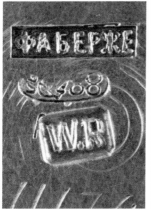
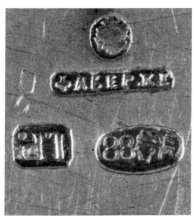
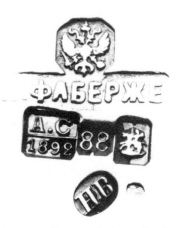

Left: Mm: Fabergé, Wm: W. Reimer, Hm: St. Petersburg, 1899–1908, Am: Jakov Ljapunov, Silver standard: 88 zolotniks, Inv: 11174; middle: Mm: Fabergé with double-headed eagle, Wm: Julius Rappoport, Hm: St. Petersburg, 1899–1908, Am: Jakov Ljapunov, silver standard: 88 zolotniks; right: Iwm: K. Fabergé, Wm: HW (in Russian), Hm: Moscow, 1892, Am: AS (in Russian), silver standard: 88 zolotniks[2] (A table of abbreviations is to be found on page 106).

Russian Hallmarks

The Russian State Hallmarks

19th century (until 1899)

St. Petersburg
This hallmark consisted of the city coat of arms (crossed anchors and scepter) in combination with the metal standard, or both in combination with the assayer's mark and the date.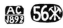

Moscow
Moscow's hallmark consisted of the city coat of arms (St. George and the dragon) in combination with the metal standard, or both in combination with the assayer's mark and the date.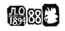

1898–1908

St. Petersburg
The St. Petersburg hallmark consisted of a "kokoshnik" (or female profile) looking left, in combination with the Russian initials of the assayer (in this case Ja L for Jakov Ljapunov) and the metal standard.
Another version consisted of the kokoshnik looking left in combination with the Russian initials of the assayer, A. Richter, (AR) and the metal standard (1893–1903).

Moscow
During this period, the Moscow hallmark consisted of a kokoshnik looking left with the Russian initials (I.L.) for Ivan Lebedkin as well as the metal standard.

1908–1917

St. Petersburg
St. Petersburg's hallmark consisted of a kokoshnik looking right, combined with the Greek letter alpha and the standard of the metal used.

Moscow
Moscow's hallmark was of a kokoshnik looking right, with the Greek letter delta.

Marks used for the official standards of precious metals

In Russia, the standard of silver and gold was represented in zolotniks, with 96 zolotniks corresponding to pure silver or 24-carat gold.

The marks found on Russian objects made of silver correspond to 84, 88 and (more rarely) 91 zolotniks, which in turn correspond to 875, 916 and 947/1000 standard silver in the West. Objects intended for the English market, where sterling silver (or 925/1000) was usual, were made of 91 zolotnik silver.

56 or 72 zolotnik gold was the standard used in Russia and corresponds to 14 or 18-carat gold in the West. The latter was invariably used for export articles.

334

The Competitors

One of the main aims of this book is to show Fabergé within the context of his day and age. He did not work in a creative vacuum but was surrounded by numerous artists and craftsmen vying with him for custom. In 1882 he was still only making jewelry, and although he received a medal at the Pan-Russian Exhibition held the same year, his rivals Chlebnikov, Ovchinnikov and Sazikov were made Purveyors to the Court[1] on the same occasion. In 1883 his name was mentioned in Imperial Cabinet documents, in connection with the sale of rings, brooches and crucifixes[2] worth 6,367 rubles, while the court jewelers O. Zeftingen, K. Bolin and F. Butz were granted commissions worth 30,178, 27,483 and 48,694[3] rubles respectively the same year. However, on April 16, 1885, Fabergé was granted the right to use the Imperial State Emblem[4] and it was also in this year that his workshops produced the first Imperial Easter egg, establishing his reputation as a producer of *objets d'art*. While Bolin and Butz and later Cartier and Boucheron were to compete with him on the jewelry sector (and win commissions he would normally have been granted) Fabergé was to outdo them all with regard to *objets d'art*. Even so, it was not until the beginning of the 1890's that his name made an appearance in Imperial Cabinet documents in connection with hardstone and enameled objects.[5]

When he started producing hardstone objects, Fabergé fell back on an old Russian tradition and bought ready-made items from the Peterhof (cat. no. 585) and Kolyvan factories.[6] (Both of these factories were to exhibit their products at the same time as Fabergé at the 1897 Stockholm Exhibition, where he sold an agate kovsh to the National Museum in Stockholm (cat. no. 236)). During his stay in Idar-Oberstein around 1890, he then took up contact with the local hardstone-carving workshops. Soon after, he acquired Karl Woerffel's stone-carving factory, which continued to be managed by P.M. Kremlev. The same factory also delivered to Fabergé's competitors, as Cartier's sales ledgers prove[7] and Derbyshev, who was trained in Paris and Oberstein and who was to become Fabergé's most celebrated stone-carver, did not join the company until as late as 1908. Other Russian companies in competition with Fabergé in the field of hardstone figures were those of Svietshnikov, Sumin, Ovchinnikov, Dennisov-Ouralski and Britzin. Cartier, for example, ordered an assortment of 160 hardstone objects from Svietshnikov in 1904 (which he found very expensive in comparison to the objects Woerffel's factory produced[8]) and also bought an obsidian elephant and a purpurine toad from Ovchinnikov[9] and other animal figures and hardstone objects from Dennisov-Uralski. Sumin (cat. no. 577) and Britzin (cat. no. 575) were further rivals, and Fabergé's idea of having fitted cases made for the transportation of his stone figures was emulated everywhere.

Cartier's 1907 sales ledgers make mention of about 200 animal figures and some of the descriptions involved sound very reminiscent of Fabergé's work.[10] Although many of Cartier's animal figures were produced in Paris, his archives also contain documents concerning the

purchase of models from China through the agency of a J.P. Worth[11], as well as the astonishing acquisition of a series of six Fabergé animals, bought through the services of a certain Mr. Stopford[12].

It was Cartier who also proved to be Fabergé's most dangerous rival in the sales of flower arrangements. In 1907/08, the Parisian company already had a selection of about 60 flowers, which had mainly been obtained from local workshops such as Berquin-Varangoz, Lavabre and Cesard. This stock was enlarged to over 160 items in 1913. Cartier also bought one of Fabergé's "Cornflower with Oats" arrangements in 1910.[13] An orchid, which was acquired from the collection of A.K. Rudanovski in 1919 and is now kept in the State Hermitage in Leningrad, conveys an idea of what Fabergé's contemporaries were producing in Paris at the time, for despite the fact that it bears French hallmarks, it is strongly reminiscent of his work (cat. no. 629). Tiffany was also a specialist in the production of exquisite flowers made of jewels and enamel, especially orchids.[14] In this connection, attention must be drawn to the magnificent basket of flowers (cat. no. 620) in the possession of the British Royal Family, which had previously been associated with Boucheron[15]. Recent findings now prove that it is indeed a Fabergé object.

There was also stiff competition in the sector of enameled work. Not only did the Chlebnikov workshops have four *tours à guilloche* for decorating metal surfaces as early as 1882, but the translucent enamel imported by Fabergé from Switzerland does not seem to have been exclusive to him either. K. Hahn also produced *objets d'art* in combined gold and *guilloché* enamel (cat. nos. 613 & 614) as well as Glassov (cat. no. 609) and Britzin (cat. no. 610). On the occasion of the Paris *Exposition* in 1900, when Fabergé exhibited his Imperial Easter eggs, reaping the highest praise, Boucheron displayed *objets d'art*, such as opera glasses (ill. on p. 336), parasol handles and cigarette-cases very much in the style of the Russian master.[16] Cartier was soon competing with Fabergé in this area too. The assortment mentioned in his 1904 sales ledgers includes objects very reminiscent of those produced by Fabergé. (cat. nos. 626 & 628).[17]

Although recently published archives prove that Fabergé did not break ground to quite the extent once assumed, the pioneering effect of his work on a whole generation of Russian decorative art cannot be denied. His local rivals may have imitated his techniques, but they were never to achieve the quality of his work or his standard of originality. Sumin, Ovchinnikov, Britzin, Dennisov-Uralski and Cartier may have produced animal figures; Britzin, Hahn, Astreyden, the Third Artel, Tillander, Sumin, Boucheron and Cartier might have imitated his

Bonbonnière and opera glasses made by Boucheron, Paris 1900. (Photo: Boucheron Archives) Compare to cat. no. 506

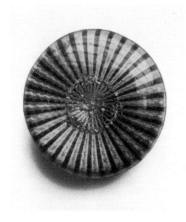 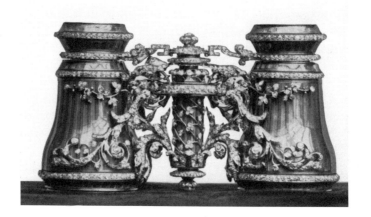

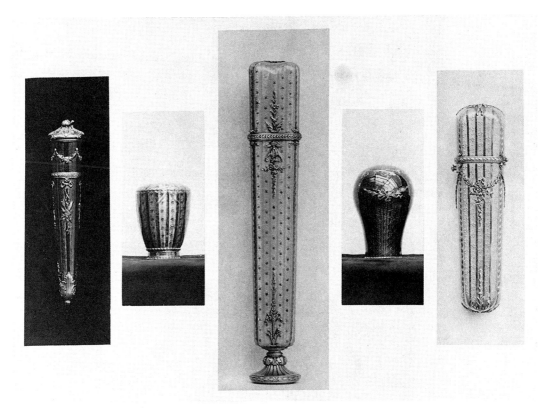

Objects exhibited by Boucheron at the Universal Exposition in Paris, 1900

enamelwork (although not to the same degree of quality) but none could imitate Fabergé's genius, his inventiveness, his wealth of ideas. No hardstone-carver imbued animals with the character of Fabergé models, no goldsmith produced so many new ideas, no enameler achieved such a range of colors as Fabergé did with his palette of 144 shades.

The proverbial wealth of Fabergé's traditional clientèle soon caused his envious competitors to take a closer look at the Russian market. In 1899, Frédéric Boucheron engaged Georges and Henri Delavigne to represent his company in Moscow, while Louis Cartier sent his son Pierre to St. Petersburg in 1904, where he opened up a shop for a short time in 1908. Meanwhile in London the big jewelers had to fight for their custom. Cartier opened a branch in Burlington Street in 1902, Boucheron had premises in Sackville Street and Fabergé was competing with them on the London market by 1903. He also exhibited regularly in Paris, Cannes, Rome and Monte Carlo. Marshak of Kiev and Bolin of Moscow also had branches in Paris. These companies had no other choice than to share the patronage of their clientèle. Such wealthy customers as the Grand Dukes of Russia, Mrs. Keppel, J.P. Morgan, Mrs. Leeds, Mrs. Kelch, the Aga Khan, Baron James de Rothschild, Lady Wernher and Sir Ernest Cassel made their purchases from Cartier, Boucheron and Fabergé in turn. Not even King Edward's set was to remain faithful only to Fabergé[18], and in Russia, Cartier, Hahn and Bolin, who were Fabergé's main competitors, were equally granted commissions by the Imperial Family.

Fabergé's influence spread far, reaching both England, where the King's Court Jeweler, Collingwood, did work in his style (cat. no. 634), and Berlin, where Friedländer sold objects designed in the Fabergé manner (cat. no. 627) and Vienna, as Köchert's work proves. Although Cartier may be more famous for his jewelry, Fabergé can justifiably claim priority in the field of *objets d'art*, for his genius determined the taste of a whole generation.

Fabergé's Main Competitors (in alphabetical order)

A. Astreyden

Astreyden, who was active in St. Petersburg between 1900 and 1917, produced small objects in *guilloché* enamel and specialized in the production of miniature Easter eggs, cigarette-cases and visiting-card-cases, as did Sumin, Britzin and the Third Artel (cat. no. 594).

Samuel Arndt

Arndt was a master craftsman between 1845 and 1890. He produced jewelry in the style of the Second Empire as well as small articles made of *guilloché* enamel (cat. no. 548).

The Third Artel (St. Petersburg)

The Third Artel was one of a group of about 30 workshops which were jointly run by silver and goldsmiths. The first one was founded in Moscow around 1896 and the rest to follow were designated with ordinal numbers. The Third Artel, which was active around 1908–1917, produced objects in *guilloché* enamel, specialising in miniature Easter eggs and card and cigarette-cases held in the pastel shades of pale blue, mauve, salmon pink and white. The Third Artel delivered objects to Fabergé and apparently also carried out commissions for the Imperial Family (cat. no. 612).

Karl Bok

Bok was a Moscow craftsman who made gold cigarette-cases.

Bolin

In the 1830's, Carl Edvard Bolin founded the firm of jewelers of the same name in St. Petersburg. Around 1850 his brother Henrik Conrad established the company of Bolin & Jahn in Moscow, which later obtained the Imperial Warrant as Court Jewelers. After Henrik Bolin's death in 1888, the business was carried on by his son Vasili Andreiewitch. On the retirement of Jahn, the two branches in St. Petersburg and Moscow merged to form what was to become one of the foremost jewelry businesses in Russia, second only to Hahns'. The only known workmaster was R. Shven. The other workmasters marked their work with K Z, KS, WS, KL and CA.

Bolin was making fine jewelry for aristocratic circles long before Fabergé and Hahn became famous in their own right. One of his documented pieces was the diamond and ruby parure that Czar Alexander II gave to his daughter, the Grand Duchess Maria Alexandrovna, on the occasion of her wedding to Alfred, Duke of Edinburgh. Bolin's silver products tended to be bombastic in style and were influenced by French and German pieces of the Second Empire. The company derived many ideas for their *objets d'art* from Fabergé. However, their gold cigarette-cases were encrusted in diamonds and lacked the refinement and elegance of Fabergé's work. As a jeweler, Bolin liked to achieve striking effects with contrasts of different colored hardstones. One of his Easter eggs, which was made in Fabergé's style and very much influenced by art nouveau, is still in existence.

Boucheron

The firm of Boucheron was founded in Paris at the Palais Royal in Paris by Frédéric Boucheron. Twenty years later the company won the first prize at the 1875 International Exhibition in Philadelphia, while medals were gained at the Paris exhibitions of 1889 and 1900. The

company moved to 26 Place Vendôme in 1893 and opened up a branch in Moscow six years later. In 1911 two of the company's representatives, Georges and Henri Delavigne, were brutally murdered. According to the labels on his fitted cases, Boucheron had branches at 7 Sackville Street in London, on the Pont des Maréchaux in Moscow and at 26 Place Vendôme in Paris in 1900. By 1915 the company had moved its London branch to 66 Picadilly, and opened up new branches at 26 Newsky Prospect in St. Petersburg and on the 5th Avenue in New York. Boucheron was mainly known for his jewelry, but between 1900 and 1910 he began to produce *objets d'art* in competition with Fabergé.

Andrei Stephanovitch Bragin

АБ Bragin became a master craftsmen in St. Petersburg in 1852. He opened a workshop in 1880, where he produced gold cigarette-cases.

Ivan Savelevitch Britzin

БРИЦЫНЪ

ИБ Britzin had his workshop in the Malaya Konyushenaya (Small Horse Alley) in St. Petersburg and seems to have occasionally supplied Fabergé with his objects, since some pieces bear Fabergé's name in addition to his initials. Britzin specialized in producing *guilloché* enamel objects very much in the Fabergé manner, such as cigarette-cases, clocks and miniature Easter eggs, which were invariably held in pastel shades of green, blue, turquoise, gray and white. He exported his work, which is comparable to that of Sumin and the Third Artel, to Great Britain and America between 1900 and 1917 (cat. no. 593).

E. Burchard

Burchard, who was active around the turn of the century, made burnished gold cigarette-cases.

Alexander Franz Butz (1813–1857)

Butz became a journeyman in 1841 and obtained the title of master in 1849. He founded the company of Butz & Bollin. His son Julius Agathon Butz took over the company in Bolshaya Morskaya Street after his death and managed it until 1893. J.A. Butz was a friend of Fabergé's. He accompanied him to Italy during his time of study and later introduced him into Court circles (cat. no. 560).

Cartier

The company of Cartier was founded in Paris in 1847. Alfred Cartier (1841–1925) took over the company in 1874 and in 1898 Louis Cartier (1875–1942) became an *associé*. The company moved to Rue de la Paix a year later. In 1902 branches were opened in Burlington Street in London and the company was also represented in St. Petersburg. In 1905 there were branches at 175 New Burlington Street in London and at 712 5th Avenue in New York. The company was appointed Crown Jeweler to Edward VII of Great Britain and Alfons XIII of Spain in 1904, to King Carlos of Portugal in 1905, and to the King of Siam and Czar Nicholas II in 1907. In 1904 Pierre Cartier travelled to St. Petersburg and the company took part in a Christmas bazaar there in 1908. Cartier was Fabergé's main competitor in the market for jewelry and also sold flowers, animal figures and *objets d'art* in Fabergé's style.

Г.ЧЕРЯТОВ

Yegor Kusmitch Cheryatov

Originally employed by the Moscow jeweler Lorié as a workmaster, Cheryatov opened up a workshop of his own between 1912–1916, where he produced gold cigarette-cases.

Chlebnikov

Ivan Petrovitch Chlebnikov founded a company of the same name in St.Petersburg in 1867 and moved to Moscow in 1871. Here he employed some 200 craftsmen and received the Imperial Warrant in 1882. His workshops produced many pieces worked in *cloisonné* and *plique à jour* enamel and also made cigarette-cases in silver.

Denissov-Uralski

Denissov-Uralski had a workshop in St.Petersburg, where hardstone objects were carved and occasionally mounted in enamel. Both Cartier and presumably Fabergé acquired *objets d'art* and figures made of semiprecious stone from this company, which was active between 1900 and 1917.

C. Nicholls Ewing

The jeweler Ewing had premises at 4 Newsky Prospect in St.Petersburg (cat. no. 565). His workmaster (with the initials of AK) specialized in the production of miniature Easter eggs.

A. Glassov

The silversmith Glassov, who was active between 1900 and 1917 in St.Petersburg, made silver and enamel objects in Fabergé's manner (cat. no. 609).

Gavril Petrovitch Gratchev

Gratchev founded a company of the same name in St.Petersburg in 1866, which he ran until 1873, when his sons Michail and Semen took over the management under the name of Gratchev Bros. The company, which produced samorodok cigarette-cases, also specialized in silver and electroplate sculptures and *objets d'art* as well as *cloisonné* and *plique à jour* enamel and was appointed Court Jeweler in 1896. Gratchev's workmasters used the hallmarks of KR (in Russian) and AP.

Hahn (Ghan)

In or about 1880, Karl Karlowitch Hahn founded a jewelry company in St.Petersburg, with premises at 26 Newsky Prospect. From 1911 on the company was apparently managed by Hahn's son, Dmitri.

 The Imperial Family took great interest in Hahn's work (appointing him Goldsmith to the Crown at the end of the 19th century) and commissioned him to deliver a copy of the "small crown of the Empress", a kokoshnik-shaped diadem which Marie Feodorovna wore at the coronation of Nicholas II in 1896. Hahn competed with Fabergé in the production of Imperial presentation boxes, which he decorated with a profusion of precious stones. Hahn's most important commission was the "Romanov Tercentenary Triptych" (cat. no. 616), which was carried out in a combination of *guilloché* enamel and diamonds typical of the company's work. An Easter egg designed in the Fabergé manner is also known to have been made by Hahn's workshops.[19] However, when compared to Fabergé, Hahn's work lacks his elegance and lightness and is more traditional in style. His range of enamel colors was mainly restricted to gray, salmon-pink, blue and white, which he combined in a characteristic manner. His workmasters had the hallmarks of S.W. (in Russian) and A.T. A presentation box, which may have been produced by Cartier and then sold by Hahn, is to be found in the Walters Art Gallery in Baltimore (inventory no. 57198).

Köchli (Kekhli)

Friedrich Köchli founded a company of the same name in St. Petersburg in 1874. In 1898 he was made a delegate of the Chamber of Industry and Commerce and moved into premises at 17 Gorokhovaya Street. The company specialized in gold presentation cigarette-cases and fine jewelry, making lavish use of cabochon sapphires amd diamonds (cat. nos. 567–571 & 573).

Antip Ivanovitch Kuzmitchev

The company of Kuzmitchev was situated in Moscow and produced cigarette-cases in samorodok and plain gold. In 1897 Kuzmitchev had 23 craftsmen and 15 apprentices in employment.

Fedor Anatolevitch Lorié

Lorié, the jeweler, had premises in Moscow between 1871 and 1917, where golden cigarette-cases were produced. Lorié's workmaster Y.K. Cherjatov hallmarked his objects with the Russian initials E.Ch.

Josif Abramovitch Marshak

Marshak was a Kiev jeweler and goldsmith who had a branch in Paris. His company produced samorodok and plain gold cigarette-cases between 1878 and 1917.

Ivan Yevdokimovitch Morozov

Morozov was a retailer and goldsmith from 1849 on in St. Petersburg, where he was appointed Court Goldsmith. His company produced silverware, cigarette-cases and enamel objects until 1917. His workmasters signed with the initials IP and BK.

Jakov Mikhailovitch Rosen

Rosen was active in St. Petersburg from 1900 until 1917, where he produced cigarette-cases in burnished gold.

Ovchinnikov

The company was founded in 1853 by Pavel Ovchinnikov in Moscow and expanded very rapidly to become the largest producer of silver and enamelware in the Pan-Slavic style, with 173 craftsmen in 1873 and 300 in 1881. In 1873, Ovchinnikov opened up a branch in St. Petersburg which was run by his son Michael, who took over the whole company in 1898. Ovchinnikov was famous for his *cloisonné* and *plique à jour* enamel objects, which won

ПО

him numerous prizes at home and abroad.

The company also produced articles and *objets d'art* made of semiprecious stone which were sold in wooden boxes very similar to those used by Fabergé.

Avenir Ivanovitch Sumin

Sumin had premises at 6c Newsky Prospect in St. Petersburg from around 1900 until 1917. He made *guilloché* enamel objects in Fabergé's style, using pastel tones similar to those used by Britzin and Astreyden, and also produced stylized animal figures made of hardstone. In the 1908 and 1914 Directories he advertized "stones from Siberia and the Ural Mountains" (cat. no. 577).

Tillander

Alexander Edvard Tillander, who was born in Finland in 1837, was apprenticed to the goldsmith Fredcrik Adolf Holstenius in Zarskoje Selo. In 1860 he gained the title of master and had his own workshop at Bolshaya Morskaya Street in St. Petersburg. In 1870 he moved to larger premises at number 6 of the same street, where he mainly worked as a wholesaler, delivering to retail companies like Bolin and Hahn. His son, Alexander Theodor, who went into apprenticeship with him in 1885, became a director in 1900 and took over the company in 1910. In 1911, Tillander moved into Hahn's old premises at 26 Newsky Prospect. In 1917, when the business was transferred to Helsinki, the turnover consisted of 4 million rubles per annum. Tillander produced fine jewelry, a large number of commemorative medals, miniature Easter eggs, cigarette-cases, miniature picture frames, cane handles, table bells and other *objets d'art* in gold and enamel (cat. no. 615).

Fedor Andreievitch Verkhovtsev

Verkhovtsev had a goldsmith business, in existence from from 1819 till 1917, where gold cigarette-cases were made.

1 Illustrated catalog of the Pan-Slavic Exhibition in Moscow, 1882, p. 162. Quoted according to Marina Lopato, "New Light on Fabergé", *Apollo*, January 1984, p. 43. The article by M. Lopato contains extracts taken from the archives of the Imperial Cabinet (Central State Historical Archives (CHSA)).

2 CSHA, stock 468, inventory 7, file 216.

3 CSHA, stock 468, inventory 7, file 357.

4 CSHA, stock 468, inventory 7, file 180.

5 CSHA, stock 468, inventory 13, file 162.

6 CSHA, stock 468, inventory 8, file 277.

7 Nadelhoffer, 1984, *Im Banne Fabergés*, (chapter 6).

8 Svietshnikov demanded 50 rubles for a nephrite beaker and 20 rubles for a parasol handle, while Woerffel's prices for the same objects consisted of 30 and 17 rubles respectively. Cartier bought 8 parasol handles from Woerffel, 2 letter-openers and ashtrays, 1 seal in the form of a mushroom, 2 tomatoes and pears and 1 apple.

9 Cost 265 rubles. In the Cartier archives further purchases from Ovchinnikov, such as "Obsidian seal lying on a rock-crystal ice-floe" (no. 131), "large jade elephant" (no. 226) and "electric bell in the form of an owl's head with red enamel eyes" (no. 327) are to be found under the heading of 'Objets Pierres Dures, 1904–1907'.

10 1905 (no. 212) "Seated gray agate elephant with diamond eyes".
 1905 (no. 303) "Agate squirrel with diamond eyes".
 1905 (o. 379) "Nephrite kangaroo with diamond eyes".

11 I.e. no. 275 "Large nephrite rogue elephant with ruby eyes".

12 1910 (no. 1141) "1 pink jade pig with ruby eyes".
 1910 (no. 1142) "1 carnelian fox with rose-cut diamond eyes".
 1910 (no. 1143) "1 obsidian penguin standing on a rock-crystal ice-floe".
 1910 (no. 1144) "1 owl made of petrified wood with olivine eyes".
 1910 (no. 1145) "1 brown jade bear with olivine eyes".
 1910 (no. 1146) "1 pink jade duck with emerald eyes and gold feet".

13 January 1910, no. 81: "1 enamel cornflower with a golden stem and green leaves and a golden stem of seven oats, standing in a crystal vase".

14 Louis Comfort Tiffany (1848–1933). Compare: *Art Nouveau Jewelry*, J. Salatoff, Bryn Mawr, 1984, where six orchids are illustrated.

15 Snowman, 1979, p. 146.

16 Boucheron Archives, Paris "Exposition 1900, Objets d'Art" (photo album), nos. 2206, 2214, 2220, 2300 & 2303. Boucheron also made atomizers (vol. 1903-5, no. 2986), bellpushes (no. 3034), parasol handles (no. 3054), thermometers (no. 3077) and cigarette-cases (vol. 1907-8, no. 13,936).

17 As well as "Gold and pink enamel whistle" (1904, no. 789).

18 For example, Sir Ernest Cassel bought an enameled cigarette-case with a tartan pattern and a diamond crown, which was most probably intended for Edward VII, from Boucheron; Lady Paget bought a brooch which was decorated with the crowned monogram of GR in diamonds, most very likely for George V, from the same source.

19 Christie's, London, July 13, 1964, no. 114.

Fake Fabergé Objects

The controversial topic of Fabergé fakes was first openly discussed in 1979[1]. Although it is generally avoided by experts, dealers and specialists for good reason, it is one that must be addressed within the framework of a didactic exhibition. The following chapter summarizes and analyzes the information presently available.

By employing the occasional services of "outside" craftsmen, selling objects bought from wholesalers and factories and having articles made abroad, Fabergé was acting in accordance with the custom of his time. No matter where his objects were made, they all met with his approval and can be regarded as genuine "Fabergés" with every justification. Articles that were sold on Fabergé's own premises were usually hallmarked when sufficient space was available. However, there are exceptions to this rule and not too much attention should be paid to the presence or absence of marks when an object is being evaluated. Instead, quality alone should be the touchstone.

After Carl Fabergé died, his son Eugène founded the company of "Fabergé et Cie." in Paris with his brother, Alexander, and Andrea Marchetti, who was a silver expert and gemologist from Moscow. The firm specialized in repairing, modifying and embellishing Fabergé objects, and Fabergé's grandson Igor can remember flowers and other *objets d'art*, being mounted in their workshops. All these pieces bear the same tell-tale hallmark. Igor's brother, Theo, also created "Fabergé" objects for the jeweler Lombard in Geneva. Some were his own creations and were hallmarked with "Th. Fabergé" in Russian writing, while others were simply marked "Fabergé". A further group of objects bear the hallmark of "A. Fabergé". These have been identified as having been made by either Agathon Fabergé (1862–1895) or by Carl Fabergé's son, Agathon (1876–1951). They are mostly made in hardstone and are of post-revolutionary origin[2].

It is interesting to note that Bainbridge voiced his concern about fakes as early as 1934 in an article titled "Particulars which will assist collectors to confirm the genuineness of Fabergé pieces" in answer to the much wider interest that had come about since the house of Fabergé ceased to exist, making identification a matter of importance. His publication of 1949 has proved to be of great use to forgers with its hand-drawn section on hallmarks on p. 144.

From the very beginning, Paris was the hotbed of Fabergé faking and it was here that two very talented craftsmen, Silvio Marucelli and a certain Monsieur Stiquel, were involved in the production of imitations of outstanding quality. It is said that the notorious forger, Königsberg, was also responsible for many of the "Fabergé" flowers that now grace certain American collections.[2]

Since Cartier started imitating Fabergé's animals and flowers with the help of several stonecarving establishments as early as 1904, it is more than probable that these early products are falsely ascribed to Fabergé today. This kind of imitation is also said to have been carried on in Paris until after the end of the Second World War.

As a result of the first Fabergé exhibitions to be held in the West (in 1933, 1935, 1937 and 1949) and the publication of the pioneering books of Bainbridge (1949) and Snowman

(1953), copies of Fabergé objects began to surface which had been made in Idar-Oberstein, where there was a long-standing association with Fabergé's work. Produced as pious repetitions without the least intention of fraud, they were bought by dishonest jewelers who "upgraded" them by stamping them with Fabergé hallmarks.

In the 60's, an endless stream of Russian fakes, ascribed to a certain Naum Nikolaievsky and his brother-in-law, Vassili Konovalenko, began to turn up in the West, with Fabergé hallmarks stamped onto silver and *cloisonné* enamel objects made by Semenova, Saltikov, Sazikov, Chlebnikov and Ovchinnikov. Clever imitations of animals and hardstone animals surfaced in Western auction-rooms, earning their maker the epithet of "Fabergé's Successor". The same objects were sometimes sold in the Soviet Union to diplomats, who paid for them in hard currency and brought them out of the country in Diplomatic Bags.[3]

The recent explosion in prices has brought about a spate of new fakes, mainly produced in Brooklyn, South Africa and Israel. Of interest is the fact that the fake of today is provided with "real" fitted cases, "proofs of origin" and "original" inventory numbers.

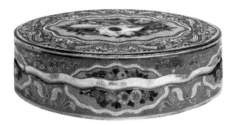

Swiss snuffbox made in Geneva around 1830 for the Turkish market. A fake Fabergé hallmark was added later

Recognizing fakes

Hallmarks

The forgers of old were neither a match for the intricacies of the Russian system of hallmarking, nor did they have access to information concerning the output of Fabergé's different workmasters. Objects faked with Moscow hallmarks are sometimes claimed to have been made in St. Petersburg, or vice versa. In other cases, objects made in *cloisonné* enamel are stamped with the hallmark of Michael Perchin, who never used the technique, while Fedor Rückert, who did, is claimed to have made Easter eggs in *guilloché* enamel.

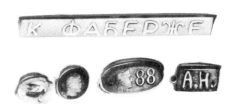

Faked Fabergé hallmark: Silver object with badly struck maker's mark, a "Moscow" mark and the hallmark of Holmström, a workmaster who only made jewelry in St. Petersburg

Fake hallmarks can be recognized by the way they have been struck. Original hallmarks are flush with the surface and produce virtually no indentation, while faked ones are driven more deeply into the metal, causing a dent which is visible on the reverse side. Furthermore, imitated hallmarks usually demonstrate faults in the Russian letters when strongly magnified.

344

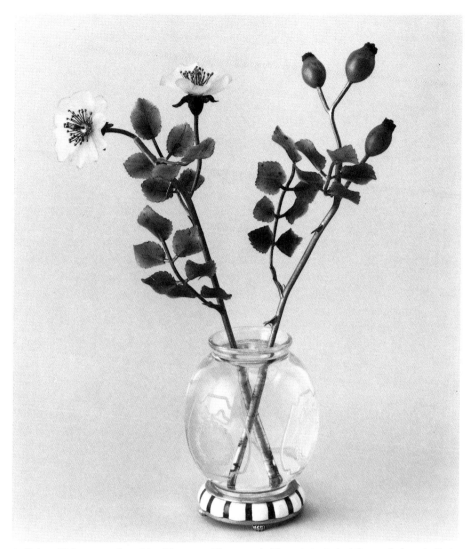

A "Fabergé" flower made in Idar-Oberstein. The enameled base is typical of the work done in Paris workshops. Fabergé's flower objects also had only one stem apiece

Style, quality and technique

Experts usually recognize a Fabergé fake on sight, but there are a number of reliable factors the less experienced collector can go on. Fabergé's style is clearly recognizable. All the objects produced in his workshops bear his imprint and differ strongly in style from those of his competitors (and imitators), as can be seen in his choice and combination of enamel colors and hardstones. The technical perfection of his work is also immediately apparent. A further clue will be the way an object "feels". Fabergé's enamel was polished to a very high degree, giving it a glossy, velvety look, while that of imitators is seen to be pocked and uneven and may even tend to "run". Fabergé also had all the roughness chased and polished away from his metals, going to lengths that forgers will seldom imitate. When a Fabergé product is strongly magnified, the quality of chasing will prove to be crisp and well-defined with no residues. This is not always the case with forged objects.

With regards to hardstone animals, which can usually only be judged subjectively, Fabergé's best pieces are characterized by a careful, detailed treatment of the surfaces, which are more difficult to imitate than the polished finish of his stylized, less naturalistic models. Only the experienced expert who has held hundreds of these little figures in his hands can venture an opinion on such objects. Flowers are easier to identify, for Fabergé's were elegant and full of life while those of forgers are unnaturally stiff and lifeless. Fabergé's hardstone figures may well be a welcome prey for imitators, but it must be remembered that with only a few exceptions they are all virtually unique, meaning that even repetitions with "impeccable pedigrees" are to be regarded with scepticism.

The fitted cases

All Fabergé objects were delivered in fitted cases, with smaller articles generally being provided in little boxes made of polished maplewood, or holly, with lobed hinges and clasps. The lids, which bore the company emblem on the inside in black or gold, were lined in white silk and the interiors were moulded perfectly to the shape of the object in cream-colored velvet. More voluminous items were packed in oak boxes lined with chamois or felt, while presents intended for the Imperial Family were laid into red or green morocco cases with a gilt Imperial eagle on the lid. Jewelry and miniature Easter eggs were sometimes sold in little bags or boxes made of chamois leather or velvet.

Forgers often make use of the wrong kind of material for the boxes and lining. They frequently pay little attention to hinges and clasps and may even use the wrong sign denoting appointment to the Crown.[4]

Other categories of forgery

1. Increasing the value of genuine unmarked Fabergé articles through the addition of later hallmarks.

2. Increasing the value of genuine Fabergé articles by embellishing them with diamonds or miniatures of donors. Sometimes the double-headed eagle is added to feign Imperial presentation. A close look at the chasing, the cut of the stones and the way in which the eagle emblem has been attached will generally help to determine such "improvements".

3. Increasing the value of damaged but genuine articles by repairing them in a manner that escapes immediate detection. This is done because serious collectors shie away from damaged objects, which then automatically lose in value. Enamel can be invisibly repaired by stripping it off and re-firing the object if damage is extensive, or by covering smaller chips with "cold" or soft enamel. This kind of forgery can be detected with a pin since hard enamel cannot be scratched.

4. Increasing the value of objects made by Fabergé's competitors by adding his hallmark.

1 Habsburg/Solodkoff, 1979, p. 149 f.
2 Earlier assumptions that Fabergé's son Agathon was connected with the production of fakes in Finland have proved to be fallacious.
3 The appartment of Countess Bismark in Paris contained over two dozen such flowers made by Fabergé, all acquired from the same impeccable source, which continued to deliver forged flowers to the USA after 1938, when Russia stopped exporting originals.
4 Brokhin, Yuri, *Hustling on Gorki Street*, pp. 163–185.
5 Boxes can be dated by the branch offices indicated on the lining. Boxes with only the St. Petersburg branch were made before 1887. Boxes with St. Petersburg and Moscow date from 1887 until 1890. Boxes inscribed St. Petersburg, Moscow and Odessa were made between 1890 and 1903. Boxes marked St. Petersburg, Moscow and London date between 1903 and 1914, while the mark St. Petersburg, Moscow, London, Odessa and Kiev denotes an origin between 1905 and 1910. Finally, "Petrograd" instead of "St. Petersburg" points to a date between 1914 and 1917.

APPENDIX

Glossary

Bratina A Russian ornamental bowl often presented in the 17th century by the Czar for special services rendered.

Brûle-parfum Parfum (Fr.) Recipient for burning perfume.

Cabochon Term used for gems that have been rounded off at the top or bottom.

Calibre To cut a gemstone on all sides.

Camaieu-rose See enamel.

Champlevé See enamel.

Cloisonné See enamel.

Enamel

camaieu-rose (Fr.) Pink translucent enamel painted with landscapes, flowers and genre scenes in darker colors.

champlevé (Fr.) The design is excavated in the metal, using an engraving tool, and then filled with enamel.

cloisonné (Fr.) Wires are soldered onto the surface, thereby forming cells (cloisons), which are then filled with enamel.

en plein (Fr.) A scene is painted directly onto the enamel.

en ronde bosse (Fr.) Technique of applying translucent enamel onto curved surfaces.

Oyster enamel Iridescent or opalescent white enamel with pink undertones like mother-of-pearl, due to a coat of orange enamel.

Entrelac An ornamental band consisting of a continuous wave form.

Four-colored gold or varicolored gold, also known as *or à quatre couleurs*, an 18th century technique of dyeing gold with other minerals. Known forms are yellow gold (gold in its natural form), red gold (with copper), green gold (with silver) and white gold (with nickel or palladium).

Freedom Box Recipient for a document or object, commemorating the granting of freedom to a city.

Gadrooning Technical term used in gold and silversmithing, describing the chasing of ornamental grooves or moldings on an object, with the ornamentation often consisting of convex curves or flutes.

Granulation Gold-smithing technique in which tiny balls of gold or silver are soldered onto a metal base. Known in Classical times and reintroduced during the revivalist period.

Guilloché (Fr.) Means of working and engraving metal with a lathe-like machine called the *tour à guilloche*. The most popular *guilloché* patterns were moiré, sunrays and waves.

Kokoshnik Name given to the traditional crescent-shaped headgear of Russian women. Hallmark used in Russia between 1899 and 1917.

Kovsch Russian drinking bowl in the shape of a ship or duck, originally made of wood. From the 17th century onwards it became one of the czars' favorite gifts in appreciation of services rendered. Later on it was purely ornamental in function.

Lukutin Russian city. Has come to mean one of its products, namely red or black lacquered objects made of papier-mâché.

Mecca Stone A cabachon chalcedony, foiled with pink underlay.

Mir Iskusstva ("The World of Art", Russ.) The name of a group of artists and their publication. The movement, which existed from 1899 to 1904, included artists such as Alexandre Benois and Sergei Diaghilev and was the Russian equivalent of art nouveau.

Moiré (Fr.) Watered pattern on material or metal. The lines, which give the effect of moving water, are caused by the reflection of light.

Navette Elongated oval, boat-like shape, coming to a point at each end.

Netsuke Japanese term used to describe a button-like object made of wood, ivory or horn, which was used to fasten tobacco boxes (or inros) to belts.

Niello (Ital.) Method of ornamenting metal, especially silver, by engraving and filling up the lines with a black composition.

Okhlad (Russ.) Metal covering of an icon leaving face and hands free.

Oyster enamel See enamel.

Parure Suite of jewelry often comprising a necklace, earrings, bracelet and ring.

Pastiche (Fr.) Used to describe a work of art that imitates another's style.

Pedigree Proof of ancestry or lineage.

Pietra dura, (Ital., hard stone) Designates inlaid work done with hard stones such as different-colored marbles. The *Opificio delle Pietre Dure* in Florence was a celebrated school and workshop where this technique was taught and practised.

Revivalist Term used to designate a classicist style largely based on works of art found in excavations. It developed during historism and is to be found in the applied arts of Europe from 1870 until 1918.

Rocaille Basic motif of rococo art (between 1730 and 1770) based on the shape of a shell.

Sablé (Fr. sable = sand) Indicates a sandy metal surface. This was a technique commonly used during the 18th century that was reintroduced to Russia by Fabergé.

Samorodok (Russ.) Technique by which gold or silver is heated to shortly before the melting point and then abruptly cooled down. The result is a nugget-like finish.

Stoneware Earthenware or pottery, compact nontranslucent glazed mass.

Tcharka (Russ.) Small vodka cup.

Tortoise-shell The dried horny plate of the shell of the hawksbill turtle.

Vermeil Gilded silver.

The statement of occurrence has been chiefly restricted to the Russian and European deposits that Fabergé preferred.

Agate is made up of thin differently-colored layers of → chalcedony and is generally found in vulcanic rock cavities. Since classical times (Plinius), the dyeing of gray agate to a honey color in a solution of honey has been common practice, and one made use of by Fabergé. The main deposits in Europe are at Idar-Oberstein, where various other methods of dyeing have been practiced since 1819. The most common colors achieved are red (imitation carnelian), gray (imitation chrysoprase), blue (natural chalcedony) and black (onyx). See also under moss agate.

Almandin is a → garnet, sometimes with a tendency to violet. Fine specimens occur at Obergurgl in the Ötz Valley of Austria.

Amazonite is one of the triclinic feldspars. Its green coloring is caused by a slight occurrence of copper. It can be confused with a similar green stone which occurs in the River Amazon. The Ural Mountains are one of the main sources of this stone.

Banded agate is a kind of agate with streak-like inclusions. It is generally brown or gray in color.

Bloodstone → Heliotrope

Bowenite is a pale green or yellowish silky serpentine named after its discoverer G.T. Bowen.

Brilliant cut is especially used for cutting diamonds to a circular shape, facetted as an octadedron with a polished table.

Cacholong → opal.

Carnelian is a variety of chalcedony which fills cavities in amygdaloid rock. It is usually a warm orange color but can also be reddish-white or, more rarely, milk white.

Chalcedony is a fine-grained white or silky-bluish mineral consisting mainly of silicic acid. It is found in cavities, especially those formed in basalt rock, and is either kidney-shaped, botryoidal or layered in form. Subforms of this quartz are → agates, the black → mocha stone and the green moss agate. Further subvarieties are onyx, sardonyx, → carnelian, → heliotrope, → chrysoprase, → jasper and plasma.

Chrysoberyl is a rhombic mineral with a glossy shine ranging from greenish-white in color to grass green and olive green. Stones having an especially attractive color or a bluish sheen (e.g. chrysoberyl cat's-eye) are made use of in jewelry. Alexandrite (named after Czar Alexander II because it was first discovered on the day of his coming-of-age in 1834), is an emerald green chrysoberyl which turns blood red under artificial light, and was a favorite stone because it combined the Russian military colors of red and green. In Russia it is found in the Urals.

Chrysoprase is a variety of → chalcedony made green by inclusions of nickel oxide. The area around Frankenstein in Silesia has been recorded as being a major source since the 14th century. In Russia, chrysoprase is to be found in the Urals.

Citrine → rock crystal.

Corundum is a form of aluminium oxide which sometimes crystallizes into pyramids, prisms or rhombohedrons. Very transparent varieties attain gem quality, the red ones being → rubies and blue ones → sapphires.

Diamonds, one of the most valuable of precious stones, are colorless and water-clear in their purest form but can also be slightly colored. Diamonds consist of pure carbon and will burn to carbon dioxide without trace if exposed to incandescent heat. The stone frequently occurs in alluvial sands, usually along with other precious stones. Diamonds are found in South Africa, Brazil, East India, Borneo, Sumatra, Australia and Russia.

Emerald is a precious stone which is a transparent green variety of beryl. This is a mineral which occurs in the form of hexagonal crystals or columns with striations parallel to their length. It occurs in granite, mica schist and, more frequently, in pegmatic veins.

Fluorite, a regular, mainly cubically crystallized mineral, is either colorless or of a variety of colors and has a glossy luster. The crystals of some finds fluoresce. Examples of deposits can be found in the Upper Palatinate in Germany and in the Urals.

Garnets, a widespread group of regular minerals, are of great hardness and have a beautiful glossy luster. They are generally of a reddish color (→ almandine) and can be translucent or transparent. The carbuncle stone of classical and medieval times was the garnet (or → the ruby). The most valuable variety of garnet, the demantoid, is found in the Urals.

Heliotrope, or bloodstone, is a dark green chalcedony with blood red specks. It is mainly found in Poona, India.

Jade is the trade name for jadeite and → nephrite, two green decorative stones. Jadeite, a fine-grained or compact mass, is a mineral belonging to the group of pyroxenes which contain sodium. In China jade has been used since time immemorial for symbolical objects, religious utensils, ornamental vessels and other decorative articles.

Jasper is an opaque chalcedony colored by oxide – a crypto or micro crystalline quartz of varying color gradations which include red, yellow, brown and green. The gray variety is called → Kalgan jasper and the dark green stones with blood red specks are called → heliotrope or bloodstone.

Kalgan jasper is gray jasper found in Kalgan, Inner Mongolia.

Labradorite, or Labrador stone, is a triclinic plagioclase feldspar which generally occurs in grained masses. On the cleavage surface it often displays magnificent blue coloring, a phenomenon known as "to labradoresce". The first block of labradorite is supposed to have arrived in Europe from St. Paul's Isle off the coast of Labrador in 1755, and in 1781 another deposit was discovered in Russia. The Urals, the area south of the White Sea and the Ukraine are the localities of Russian deposits.

Lapis lazuli is a dark blue stone with gold spangles or pyrites. There are deposits at Lake Baykal in Siberia.

Malachite is a bright green hardstone with pale veins that is deposited in narrow layers. The most important deposits are to be found in Russia (near Nishne-Tagilsk in the Urals) and in France (at Chessy).

Mocha stone is a dark brown-black chalcedony.

Moonstone has a bluish luster and is a variety of adular or ice spar, which is a clear

and generally colorless feldspar. It occurs in Norway and Russia.

Moss agate is a green or brown variety of → chalcedony and has dendritic inclusions. It is chiefly mined in India.

Mother-of-Pearl is the inner layer of shells and sea-snails and consists of many thin layers of calcereous wafers. It iridesces strongly and can be carved, turned and sawn.

Nephrite is a spinach-colored → jade with darkish inclusions which can either be opaque or transluscent. Old deposits are to be found around Lake Baykal in Siberia.

Obsidian is a dark gray or almost black natural vulcanic glass with velvety reflections, used for tools in prehistoric times. In Europe it is found above all in Czechoslovakia, Hungary and Italy (on the island of Lipari).

Olivine, also called peridot, is a widespread mineral that occurs in the shape of rhombic, short columnar crystals and in granular form. It is a combination of magnesium silicate (forsterit) and iron silicate (fayalite). Its coloring ranges from olive to asparagus green. There is also a transparent version, called chrysolite. It is found chiefly in Norway and throughout the rest of Europe.

Onyx is a black and white striped → chalcedony.

Opal is a lustrous mineral made up of aqueous silicic acid and generally has a conchoidal fracture. It can be translucent or transparent and possesses a vivid chatoyance. There are numerous varieties of opal. *Mother-of-pearl opal (cacholong)* has a mother-of-pearl luster and is milky-white in color

while the *fire or sun opal* is hyacinth red. The *common opal* is also milk white, but has occasional arborescent markings and is then known as *moss opal*. *Wood opal* is a white version containing petrified wood material and is occasionally striped or mottled, while Silesian *prasopal* is apple-green. Up until the 1880's, Hungary was the main supplier of opals.

Purpurine is a heavy dark red vitreous substance produced by the crystallization of lead chromate in a glass matrix. It was first produced in the 17th century and introduced to Russia by the Imperial Glass Factory. It was reinvented by Fabergé, and also used by his competitors.

Quartz, when pure, is a colorless and water-clear mineral, but there are many colored varieties. Quarzes are divided into → *rock crystal*, the violet → *amethyst* and the many varieties of common quartz. As their names suggest, *milk quartz* is milk white while *rose quartz*, a non-lightfast variety found in the Urals, is rose-colored. *Sapphire quartz* is indigo blue, *prase* is leek green, *cat's-eye* is greeny-white to gray-green and → *aventurine* is a red-brown or brilliant green in color. *Smoky quartz* see → rock crystal. See also → chrysoprase, → carnelian and → tiger's-eye.

Smoky quartz, smoky topaz → rock crystal.

Rhodonite is a pink manganous silicate with small black inclusions. In Russia it is found in the Urals.

Rock crystal, the purest form of quartz, often occurs in the form of very large crys-

tals but in river-beds it can take on the shape of rounded pebbles, as in the case of *rhine stones*. In its purest form, rock crystal is clear as water. If the quartz is smoky gray or brownish, it is known as *smoky quartz* and *smoky topaz* respectively. Both forms are found in the Ukraine and Ural areas of Russia.

Citrine denotes a yellow quartz and *morio* a black version.

Rose quartz → quartz.

Ruby, a precious stone, is a vivid red transparent → corundum. It is found in Burma, India, Sri Lanka and Siam.

Rutile, a mineral which occurs in columnar to needle-shaped crystals, is colored red or black and has a metallic diamond luster. Appears often in rock crystal formations.

Sapphire, a precious stone, is a blue → corundum and is found in Sri Lanka and India.

Serpentine, is a yellowy-green to dark green rhombic mineral which is mostly formed from → olivine. See also → bowenite.

Tiger's-eye is a yellow quartz that used to be found near Hof in the Fichtel Mountains in West Germany.

Topaz is a mineral made up of columnar crystals. Basically it is colorless but pigmentation generally causes it to become yellow, green, blue or red. Blue topazes from the Urals and yellow ones from Brazil are highly esteemed as gems.

Turquoise is a somewhat lusterless opaque mineral, ranging from sky blue to pale green in color, and can be polished.

Bibliography

Selected Literature

Armory 1967
Catalog of The Armory, Moscow, 1967 (in Russian).

Bäcksbacka 1951
Bäcksbacka, L., *St. Petersburgs Juvelare Guld och Silversmeder, 1714–1870*, Helsingfors, 1951.

Bainbridge 1933
Bainbridge, H.C., *Twice Seven*, London, 1933.

Bainbridge 1934
Bainbridge, H.C., "Russian Imperial Gifts: The Work of Carl Fabergé", *The Conoisseur*, May/June 1934, pp. 299–348.

Bainbridge 1935
Bainbridge, H.C., "The Workmasters of Fabergé", *The Conoisseur*, August 1935, p. 85 ff.

Bainbridge 1949
Bainbridge, H.C., *Peter Carl Fabergé*, 1949, (new editions in 1966, 1974).

Bandini 1980
Bandini, L., "Fabergé", *The Netsuke Collectors Journal*, vol. 8, no. 2, September 1980, pp. 27–32.

Baur 1977
Coullery, M.-T. and Newstead, M.S., *The Baur Collection*, Geneva 1977.

Berniakovitch 1974
Berniakovitch, H.C., "Fabergé's Goldsmith's Work" (in Russian), *The State Hermitage Bulletin*, XXXXVIII, 1974, p. 61 ff.

Bettely 1983
Bettely, R., *Fabergé at Hillwood*, Washington, 1983.

Chanteclair 1900
Chanteclair, R., "La Bijouterie Etrangère à l'Exposition de 1900", *Revue de la Bijouterie, Joaillerie et Orfèverie*, VI, October 1900, p. 61 ff.

Cooper-Hewitt 1983
Fabergé, Jeweler to Royalty, From the Collection of Her Majesty Queen Elizabeth II and other British Lenders, Cooper-Hewitt Museum, New York, 1983.

Fagaly/Grady 1972
Fagaly, W.A., and Grady, S., *Treasures by Peter Carl Fabergé and other Master Jewelers*, The Matilda Geddings Gray Foundation Collection, New Orleans, 1972.

Foelkersam 1907
Foelkersam, A. von, *Description of the Silver Objects at the Court of His Imperial Majesty (in Russian)*, St. Petersburg, 1907.

Goldberg 1961
Goldberg, T.; Mishukov, F.; Platonova, N.; Postnikova-Loseva, M.; *Russisches Gold- und Silberschmiedewerk XV-XX. Jahrhundert*, Moscow, 1961.

Habsburg 1977
Habsbrug-Lothringen, G. von, "Carl Fabergé, Die glanzvolle Welt eines königlichen Juweliers", *DU Europäische Kunstzeitschrift*, no. 442, December 1977, p. 51 ff.

Habsburg/Solodkoff 1979
Habsburg-Lothringen, G. von and Solodkoff, A. von, *Fabergé, Court Jeweler to the Tsars*, Fribourg, 1979, (new ed. 1984; German ed., Wasmuth, 1979).

Habsburg 1981
Habsburg-Lothringen, G. von, "Die Uhren des Peter Carl Fabergé", *Alte Uhren*, January 1981, p. 23 ff.

Habsburg 1987
Habsburg-Lothringen, G. von, "Carl Fabergé – Ein Plagiator?", *Kunst und Antiquitäten*, II, 1987, pp. 72–79.

Hawley 1967
Hawley, H., *Fabergé and his Contempories*, The India Minshall Collection of the Cleveland Museum of Art, Cleveland, Ohio, 1967.

Hill 1953
Hill, H.S., *Antique Gold Boxes*, N.Y., 1953.

Houillon 1900
Houillon, L., "Les Émaux à l'Exposition de 1900", *Revue de la Bijouterie, Joaillerie et Orfèvrerie*, no. 7, November 1900, p. 98 ff.

Krairiksh (ed.),
Fabergé in the Royal Collection, Thailand, n.d., (1984).

Lesley 1976
Lesley, P., *Fabergé, a Catalog of the Lillian Thomas Pratt Collection of Russian Imperial Jewels*, Richmond, 1976.

Lieven 1902
Lieven, G.E., *Guide through the Cabinet of Peter the Great and the Jewelry Gallery* (in Russian), St. Petersburg, 1902.

Lopato 1984
Lopato, Marina, "New Light on Fabergé", *Apollo* 1984, pp. 43-49.

McNab Dennis
McNab Dennis, J., "Fabergé's Objects of Fantasy", *The Metropolitan Museum of Art Bulletin*, N.S. 23, New York, 1964/1965, p. 229 ff.

Munn 1987
Munn, Geoffrey, *Castellani and Giuliano*, Fribourg, 1984.

Nadelhoffer 1984
 Nadelhoffer, H., *Cartier, Jeweller Extraordinary*, London, 1984.

Postinovka 1985
 Postinovka-Losseva, M.; Platonova, N.; Uljanova, G.; Somorodinova, G.; *Historic Museum, Moscow* (in Russian), Leningrad, 1985.

Rodimtseva 1971
 Rodimtseva, I.A., *Fabergé's Goldsmith's Work* (in Russian), The Armory Museum, The Kremlin, Moscow, 1971.

Ross 1952
 Ross, M.C., *Fabergé*, The Walters Art Gallery, Baltimore, 1952.

Ross 1965
 Ross, M.C., *The Art of Carl Fabergé and his Contemporaries (The Collection of Marjorie Merriweather Post, Hillwood, Washington, D.C.)*, Oklahoma, 1965.

Snowman 1953
 Snowman, A.K., *The Art of Fabergé*, London, 1953 (2nd revised and enlarged edition 1962, reprinted in 1964 and 1968).

Snowman 1955
 Snowman, A.K., "The Works of Carl Fabergé: The English Royal Collection at Sandringham House", *The Connoisseur*, June 1955, p. 3 ff.

Snowman 1962
 Snowman, A.K., "A group of Virtuoso Pieces by Carl Fabergé and an Easter Egg in the Collection of H.M. the Queen", *The Conoisseur*, June 1962, p. 96 ff.

Snowman 1962/64
 2nd revised and enlarged edition of Snowman, 1953.

Snowman 1979
 Snowman, A.K., *Carl Fabergé, Goldsmith to the Imperial Court of Russia*, London, 1979.

Snowman, Landsell Christie
 Snowman, A.K., *The Landsell Christie Collection*, The Corcoran Gallery, Washington, D.C., n.d.

Solodkoff 1981
 Solodkoff, A. von, *Russian Gold and Silver 17th–19th Century*, Fribourg, 1981.

Solodkoff 1982
 Solodkoff, A. von, "Fabergé's London Branch", *The Connoisseur*, February 1982, p. 105 ff.

Solodkoff 1984
 Solodkoff, A. von, *Masterpieces from the House of Fabergé*, New York, 1984.

Stolitsa i Usadba 1914
 Something about Fabergé (in Russian), *Stolitsa i Usadba*, no. 2, January 1914, 13 ff.

Stolitsa i Usadba 1916
 "The gifts of Czarina Alexandra Feodorovna" (in Russian), *Stolitsa i Usadba*, no. 55 (April 1916), p. 3 ff.

Thyssen 1984
 Somers-Cocks, A., Truman, C., *Renaissance Jewels, Gold Boxes and Objets de vertu the Thyssen-Bornemisza Collection*, London 1984.

Truman 1977
 Truman, C., "The Master of the Easter Egg", *Apollo*, CI. 185, July 1977, p. 73.

Uljanova
 Uljanova, B.L., *Fabergé Jewelery* (in Russian), Historic Museum, Moscow, n.d.

Vever 1906
 Vever, H., *Là Bijouterie Française au XIX Siècle*, vol. I ff., Paris, 1906 ff.

Waterfield/Forbes
 Waterfield, H., *The Forbes Magazine Collection*, New York, n.d.

Waterfield/Forbes
 Waterfield, H., and Forbes, C., *C. Fabergé Imperial Easter Eggs and Other Fantasies*, New York, 1978, London, 1979.

Exhibitions

A la Vieille Russie 1949
 Peter Carl Fabergé: An Exhibition of his Works, A la Vieille Russie, New York 1949

A la Vieille Russie 1961
 The Art of Peter Carl Fabergé, A la Vieille Russie, New York 1961

A la Vieille Russie 1968
 The Art of the Goldsmith and the Jeweler, A la Vieille Russie, New York 1968

A la Vieille Russie 1983
 Fabergé, A Loan Exhibition, New York 1983

Belgrade 1985
 Kremlin Treasures, Belgrade 1985

Belgrave Square 1935
 Catalog of the Exhibition of Russian Art, 1 Belgrave Square, London 1935

Cologne 1982
 Treasures of the Applied Arts of Russia from the 17th to the 20th Century at the Kremlin, Moscow and at the State Hermitage, Leningrad, Cologne 1982

Corcoran 1961
 Easter Eggs and Other Precious Objects by Carl Fabergé (The Landsell Christie Collection), The Corcoran Gallery, Washington 1961

Darmstadt 1982
 Hessisches Landesmuseum Darmstadt, Art Nouveau Catalog 1982

Florence 1982
 Tesori del Cremlino, Florence 1982

Hammer 1937
 Fabergé: His Works, Hammer Galleries, New York 1937

Hammer 1939
 Presentation of Imperial Russian Easter Gifts by Carl Fabergé, Hammer Galleries, New York 1939

Hammer 1951
 A Loan Exhibition of the Art of Peter Carl Fabergé, Hammer Galleries, N.Y. 1951

Hanau 1985–86
 Imperial Gold and Silver. Treasures of the Hohenzollern Dynasty at Doorn Palace, German Goldsmiths' Museum, Hanau

elsinki 1980
Carl Fabergé and His Contemporaries, Museum of Applied Arts, Helsinki 1980

ningrad 1974
Applied Arts of the Late 19th Century and the Beginning of the 20th Century, State Hermitage, Leningrad 1974

gano 1986
Ori e Argenti dall'Ermitage, Villa Favorita, Castagnola, 1986

gano 1987
Fabergé Fantasies. The Forbes Magazine Collection, also shown at the Musée Jacquemand André, Paris

exico 1982
Tesoros del Kremlin, Mexico 1982

oscow 1882
Catalog of the Art Industry's Pan-Russian Exhibition, (in Russian), Moscow 1882

Nuremberg 1885
International Exhibition of Precious Metals and Alloys, Nuremberg 1885

Queen's Gallery 1985/86
Fabergé from the Royal Collection, The Queen's Gallery, Buckingham Palace, London 1985/86

San Francisco 1964
Fabergé, catalog of an exhibition at the M.H. de Young Memorial Museum, San Francisco 1964

St. Petersburg 1902
Exhibition of Objets d'Art and Miniatures, (in Russian), NIVA, 1902, 12, p. 234

St. Petersburg (Florida) 1967
Fabergé and Imperial St. Petersburg, the Museum of Fine Arts, 1967

Victoria & Albert 1977
Fabergé, 1846–1920, (on the occasion of the Queen's Silver Jubilee), Victoria and Albert Museum, London 1977

Warski 1949
A Loan Exhibition of the Works of Carl Fabergé, Wartski, London 1949

Wartski 1953
Carl Fabergé, Wartski Coronation Exhibition, Wartski, London 1953

Wartski 1971
A Thousand Years of Enamel, Wartski, London 1971

Wartski 1973
Fabergé at Wartski: The Famous Group of Ten Russian Figures, Wartski, London 1973

Washington 1985/86
Treasure Houses of Britain, National Gallery, Washington, D.C. 1985/86

Acknowledgements

e authors and publishers would like to press their gratitude to the following persons and institutions for their permission to blish photographs:

M. Queen Elizabeth II of Great Britain: 9, 375, 380–382, 385, 468, 518–522, 524, 7, 544, 620 and p. 17, 20

M. Queen Margrethe II of Denmark: 36, –72, 76–77, 165, 216–221, 254, 475, 8–502, 549, 557–562, 652

M. Queen Beatrix of the Netherlands: 78, 2–474, 484

M. King Bhumipol Adulyadej of Thailand: 8

M. King Carl XVI Gustaf of Sweden: 298, 7

M. Queen Elizabeth, The Queen Mother: 1, 376, 394, 399, 511, 516, 523, 525

R.H. Grand Duchess Josephine of Luxemrg: 476

e photographs of loans from the Soviet ion were made by L.B. Bogdanov and 5. Trebenin

varian Administration of State–owned stles, Gardens and Lakes: p. 37

Boucheron, Paris: pp. 336–337

Chaumet, Paris: 266, 401, 480–481

A.C. Cooper, London: 2, 22–23, 30, 33–34, 37–38, 41–43, 57–58, 63, 67–68, 98–101, 125, 130, 140, 166–168, 177–182, 204–208, 222–224, 227–233, 242–244, 251, 255, 279, 283–284, 288–290, 318–323, 329–339, 345–348, 361–376, 380–382, 385, 393–397, 399, 438–443, 463–468, 487–489, 503, 505, 516–525, 527, 544–548, 575–577, 585, 592–595, 599, 609–610, 615, 620, 623–625, 636, 638–639, 644–645 and p. 49–57

P. Cummings Ass. Ltd., London: 639, 643, 645

H. Peter Curran: 31, 234, 237–240, 276, 285, 458, 485–486, 495, 506, 513, 616

Ermitage Ltd., London: p. 42

Fabergé Family Archives: 31–32

Thomas Haartsen, Doorn: 43, 74, 287

Walter Haberland, Munich: 86, 121–122, 134–135, 476, 574, 589, 655

Marianne Haller, Vienna: 663

Scott Hyde, Brooklyn: 252, 277, 351–359, 391

Karin Kiemer, Hamburg: 44–45

Christian Krantz, Luxemburg: 476

Lennard Larsen, Copenhagen: 36, 71–72, 76–77, 165, 216–221, 254, 475, 498–502, 549, 557–562, 652

Werner Neumeister, Munich: 24–28, 47–49, 51–56, 61–63, 79, 81–82, 89–97, 102–104, 117–119, 136–139, 141–142, 145–150, 155–159, 164, 169–176, 183–203, 209–215, 225–226, 230–233, 241A, 253, 293–310, 313–317, 324, 328, 340–344, 350, 377–379, 384, 404–422, 424–437, 446–453, 455–457, 488, 497, 503, 528–531, 556 A–C, 565–571, 578–584, 586–588, 596–597, 599, 600–608, 612,627, 633–634, 658 and p. 41, 55–57, 345

Edward Owen, Washington: 248–249, 280, 496, 507, 515, 534, 611, 614, 628

Johannes Sieber, Freising: 87

Larry Stein: 123, 237, 245, 264–265, 403, 462, 494, 525

A.K. Snowman: 162–163, 389 and pp. 31–35, 63 (above), 88

A. Tillander, Helsinki: p. 34, 321, 327–329

H. Robert Wharton, Fort Worth, Texas: 195–106, 115, 246–247

Unless otherwise indicated, photographs were provided by the owners.

Index

Abbreviations: C. = Count – Cz. = Czar – Cza. = Czarina – D. = Duke – Dch. = Duchess – DK = Denmark
GB = Great Britain – Gr. D. = Grand Duke – Gr. Dch. = Grand Duchess – K. = King – Pr. = Prince
Prss. = Princess – Q. = Queen – R. = Russia.
Dowager Empress → Czarina.
Page references are set in normal type, italics refer to catalog items.